I. M. PEI

I. M. PEI
COMPLETE WORKS

Edited by Philip Jodidio
By Philip Jodidio and Janet Adams Strong

Foreword by I. M. Pei
Introduction by Carter Wiseman

CONTENTS

ARCHITECTURE *IS* ART AND HISTORY

I. M. Pei

When I was a young man in China, I didn't really know what architecture was. I thought it was about engineering. Design was not on my mind. I studied physics or mathematics, but not art and history. I learned later that architecture *is* art and history. I went to MIT to study engineering, where William Emerson first made me think about architecture.[1] The School of Architecture at MIT had a number of joint programs with Harvard, so I got to know about that institution before Walter Gropius arrived.[2] MIT was still steeped in the Beaux-Arts tradition in those days so the arrival of Gropius and Marcel Breuer at Harvard raised my interest and led to my graduate studies there.

In my last year of graduate school at Harvard, I was in the studio of Gropius, and he allowed each of his students to select their own subject. I told him that I wanted to do something about China. He did not disagree with my opinion that history and architecture had to be linked. He simply responded, "Fine, prove it." I chose to design a museum for Shanghai. All the museums that had been built in China at that time were Neoclassical. For me, the columns and pediments of the Beaux-Arts style were wrong because Chinese objects are often small. I did know about Chinese art because my family had always collected it. I proposed a museum that would fit with the art, and Gropius agreed. The building I designed in 1946 in my last year at Harvard was not unlike the Suzhou Museum — sixty years before the fact.

I was teaching at Harvard in 1948 when William Zeckendorf decided to create an architecture department in his firm Webb & Knapp.[3] He asked Philip Johnson for a list of architects. I was on the list, and I went to work in New York. We looked at properties, and I learned real estate. For a long time we produced only big ideas — nothing was built until Kips Bay, a project that opened me up and gave me confidence. By that time, I had become an admirer of Mies van der Rohe. I was very ambitious and I didn't know much, but I wanted to go a step beyond Mies. He favored a curtain wall solution — a frame covered with glass and metal. I said, suppose the wall itself becomes the facade — one step instead of two. That's how Kips Bay and later low-cost housing projects with Zeckendorf were designed.

I worked with William Zeckendorf for ten years and didn't build much, but the kind of work I did with the team that I created provided us with a scope unavailable to other young architects at that time. It was urban design on a very large scale. After Kips Bay, I began to feel that low-cost housing had limits and I wanted to do something else. The first occasion came from Denver. Dr. Walter Orr Roberts of the National Center for Atmospheric Research (NCAR) invited me to build a research center on a mesa, and I took the job.[4] NCAR gave me an opportunity to think about architecture as an art form for the first time.

After Dr. Roberts, my next important meeting was with Jackie Kennedy who interviewed me for the Kennedy Library in 1964. I was probably the least likely choice amongst the architects she saw, but she selected me. A project such as the East Building of the National Gallery came

to me in part because of the exposure I gained through the Kennedy Library. As Emile Biasini makes clear, the National Gallery was one of the reasons that another notable figure in my life, François Mitterrand, selected me to design the Grand Louvre. You always need a person with a vision to pull you upward, and I have been fortunate to know a number of such exceptional individuals.

I have always been most interested in civic work, and in my opinion the best civic project is a museum. The museum has been my preference because it sums up everything. The Louvre is about architecture, but even more, it is the expression of a civilization. I learn a great deal when I build a museum, and if I don't learn, I can't design. From my first project in the studio of Gropius at Harvard, to my most recent work, the museum has been a constant and present reminder that art, history, and architecture are indeed one.

INTRODUCTION

Carter Wiseman

When the Eiffel Tower was dedicated, in 1889, it was greeted enthusiastically by the Parisian public, but the reaction of the art and architecture establishment was one of widespread condemnation. Even before the structure's completion, a petition had been signed by the likes of Charles Garnier, architect of the Paris Opera, declaring the tower to be something "which even commercial America would not have," and damning it as "without a doubt the dishonor of Paris."[1] Of course, the public prevailed, and Eiffel's structure soon supplanted the cathedral of Notre Dame as the city's most recognizable architectural icon.

Exactly a century later, a remarkably similar drama played out around I. M. Pei's glass pyramid, designed as the principal entrance for a massive renovation and reorganization of the Louvre Museum. Early shock at plans to alter France's most sacred cultural institution ("inadmissible," fumed *Le Figaro*,[2] "an atrocity," declared *France-Soir*[3]) was displaced by almost universal praise. Indeed, Pei's pyramid has now largely replaced the Eiffel Tower as the city's symbol on postcards, travel brochures, and even school children's textbooks.

What links the two stories is not so much the power of the popular will in determining architectural success, but the power of fundamental principles in design. Eiffel's tower was a triumphantly efficient work of engineering; its formal elegance was persuasive to the eye as well as to the mind. Pei's pyramid was an irreducibly simple geometric form; its modern, high-tech iteration was equally convincing as historical image and technological tour de force. And here

is a key to Pei's work over his more than seventy years in architecture — from his student days at MIT and Harvard, to the completion in 2006 of a museum in his ancestral Chinese home: He is a modernist architect grounded in engineering who has never lost touch with enduring artistic and cultural values.

Rigidly formal as some of Pei's buildings may seem, the best are inflected with an appreciation of the user's experience as well as that of the critic's analysis. Beyond this, they are enriched by a personal history that is quintessentially American: a Chinese immigrant who took savvy advantage of what the United States had to offer, but who never abandoned his origins in another land. Happily, he has also been able late in life to embrace the culture of old Europe with the passion of a young convert, and then reach out to the traditions of Japan and the Middle East with undiminished curiosity.

The complexity of Pei's sensibility took some time to assert itself. Born in 1917 as a child of privilege in China (his father was a manager of the Bank of China), he was educated in elite schools in Shanghai, but like many from his economic and social class, he was sent abroad, in 1935, for advanced training. His first stop was the architecture program at the University of Pennsylvania in Philadelphia. But he was so intimidated by the high quality of his classmates' draftsmanship that he despaired of a career in design and dropped out, transferring to MIT to study architectural engineering.

For all of its power as a center of technical training, MIT, like most other architecture schools

in the United States at the time, was still committed to the traditions of the Ecole des Beaux-Arts in Paris, a program based on classical precedents and principles. Although MIT's training was above reproach, it was already behind the times. In France, Le Corbusier was advancing the idea of the house as "a machine for living in," and like-minded reformists from Germany and Holland were pushing for a radical rejection of the Neoclassical architecture that had come to stand for failed empires.

Among the leaders of this movement was Walter Gropius, formerly head of the Bauhaus in Germany, who had been lured to Harvard's Graduate School of Design (GSD) as chairman of the architecture program after the Nazis took power. Gropius offered a thrilling prospect to young architects, a chance to "change the world" by sweeping aside the tired aesthetic of the recent past and embarking on a program that embraced contemporary materials and modern ideals of social betterment. Pei was one of legions who were drawn to the cause, and after finishing at MIT, he enrolled at the Graduate School of Design, where he discovered another universe. Gropius was dedicated to the "honest" expression of structure and opposed to any applied ornament, feeling that architectural history was actually a barrier to creativity, and that students might be intimidated by the masters of ancient Greece, Rome, or Renaissance Florence. (Gropius went so far as to ban plaster casts of classical sculpture from Harvard's architecture building, and eliminated the study of architectural history from the graduate school curriculum.)

Even though Pei was wary of Gropius's unflinchingly logical approach, the young immigrant did his thesis project under the chairman. But in the process, he declared a limited independence from European modernist orthodoxy. The result was a plan for an art museum in Shanghai surrounded by a garden and set off from its environs by a wall.

The sources for the design were deeply rooted in Pei's personal history. His family had owned a villa in the ancient Chinese city of Suzhou, northwest of Shanghai. Suzhou, laced by canals, had been considered for centuries to be a center of Chinese culture—the "Venice of the East," as some writers called it. The main features of the villas of the Suzhou elite were walled enclosures that sheltered carefully landscaped gardens meant to be understood as microcosms of the larger natural world. They were embellished by rocks that had been deliberately eroded by "rock farmers," who placed them in rivers and lakes and then transported them to the gardens to remind visitors of the power of time. The pathways and pavilions of the gardens were no less deliberately contrived to expose visitors to pleasing vistas. All were examples Pei would remember as his career matured.

The tradition of the Chinese garden could not have been less like the background of Pei's Harvard contemporaries, who included such future luminaries as Edward Larrabee Barnes, John Johansen, Philip Johnson, and Paul Rudolph. But Pei took an even less predictable course after graduation. Instead of designing additions for the vacation houses of friends or relatives,

as most recent graduates did, he went to work as the resident design architect for a developer. And this was no ordinary developer, but William Zeckendorf, the quintessentially flamboyant New York impresario of what people wanted and what would sell. From Zeckendorf, Pei began to learn about high finance, city planning, government regulations, and practicality in both the business and personal worlds. (Zeckendorf was not above renting a plane, flying over a city, and landing with a proposal to the mayor for wholesale redevelopment of his domain.) But there was much more to the relationship. Indeed, Zeckendorf became something of a surrogate father to the young architect, filling him, as Pei's wife said, "like an empty vessel" with the sort of real-world knowledge and experience that MIT and Harvard did not offer, but also exposing him to the sort of emotional warmth that his own formal upbringing had denied him.[4]

Not surprisingly, Zeckendorf's extravagant business operations eventually led to financial strains and creative frustration, and as the empire began to falter, Pei decided to set out on his own, bringing along some of his younger colleagues, including Henry N. (Harry) Cobb.

Over the years, the firm of I. M. Pei & Associates would design hundreds of buildings, many of them financially profitable but not aesthetically memorable. The senior partner usually assigned the lesser commissions to other members of the team, but because his name was the only one on the stationery, the firm's — and Pei's — finest work was to some degree diluted by its business success.

However commercially powerful it became, though, I. M. Pei & Associates retained a dedication to the art of architecture. Early evidence of that was clear in what became the fledgling firm's first building of national importance. It was the National Center for Atmospheric Research (NCAR), outside Boulder, Colorado. NCAR was a scientific institution, but its director, Walter Orr Roberts, was determined that his building would embrace the dramatic site at the base of the Rocky Mountains with artistic sensitivity. An eccentric visionary who favored both belt and suspenders, Roberts engaged Pei in intense conversations about the scientific mission of his building, and its place in the landscape. (Some of the conversations were lubricated with red wine consumed late at night on the mesa.) The result was a futuristic concrete structure consistent with the Brutalist architectural style of the time (it was later used as a set for Woody Allen's film, *Sleeper*), but mitigated by a circuitous approach road that recalled the pathways to Suzhou.

The success of NCAR, which was finished in 1967, helped open the door to the commission that would establish Pei as a major architect. It was for the library to be built in Cambridge, Massachusetts, in memory of President John F. Kennedy. The most sought-after commission of its time, it pitted the relatively inexperienced Pei against the leading architects of the day — including Louis Kahn, Mies van der Rohe, and Paul Rudolph — and Pei won. Central to his victory was a deeply empathetic relationship with the client, Jacqueline Kennedy. ("I thought I would take a flying leap with I. M.," said the

president's widow.[5]) However, what began so happily became an architectural quagmire. Members of the Cambridge community (dubbed "the Brattle Street elite" by some) rose up against the building, fearing that it would overwhelm the area with tourists. Eventually, the library was relocated to a remote landfill on Boston harbor, and by the time it was completed, in 1979, much of the artistic blood had been drained from its veins. Resigned to the less-than-happy outcome, Mrs. Kennedy commented, "You do the best you can, and then to hell with it."[6]

The Kennedy commission alone, however, had secured the Pei firm's position at the top of the architectural establishment. But at that moment, the firm — now known as I. M. Pei & Partners — suffered a near-fatal setback when the windows of its John Hancock office tower (1966–76) in Boston, for which Pei's partner Harry Cobb was the primary designer, began to fail. The cause was eventually traced to problems with the fabrication of the glass, but the publicity surrounding what the press gleefully dubbed "the world's tallest wooden building" in response to the plywood panels that replaced the missing windows, threatened the firm's very existence.

On the verge of collapse, I. M. Pei & Partners was helped through the crisis by a series of smaller commissions, some already under way, including the Everson Museum of Art in Syracuse (1961–68), the Johnson Museum at Cornell (1968–73), and an arts building for the Choate School (1968–73). The client for the Choate building was Paul Mellon, one of the wealthiest and most cultivated men in America. Like Pei, Mellon was the son of a remote father who was also a prominent banker. How much their family backgrounds influenced their relationship is a matter of speculation, but the two developed far more than a professional connection, and the upshot was the commission for an addition to the National Gallery of Art, which had been paid for by Mellon's father. What became known as the East Building of the National Gallery (1968–78) will surely remain one of the monuments of late-modern architecture. Its pristine geometry, rich materials, and flawless detailing are a tribute to a happy combination of opportunity, talent, and wealth. More important to the outcome, however, were the intensely shared sensibilities of client and architect.

The absence of that component undoubtedly contributed to the mixed results of two more major commissions. One was the Fragrant Hill Hotel (1979–82), northwest of Beijing, a project of the Chinese government that Pei hoped could be leveraged as an example of modern design that was still sensitive to Chinese traditions. Although the architecture went far to satisfy Pei's ambitions, the oversight of the commission by government and military bureaucrats, who had little understanding of the potential of the building, left Pei disappointed.

The disappointment was as personal as it was professional. Perhaps naively, Pei had hoped that his design would be a catalyst that might aid his homeland make a transition from Soviet-style design to a new approach that would be at once authentically Chinese and contemporary. To this end, the architect reimmersed himself

in Chinese history, and went to extraordinary lengths to locate just the right rocks from distant mountains to ornament the hotel's gardens, all the while straining to preserve the spectacular natural setting and its ancient trees. But dealing with the Chinese government as client, let alone Third World construction practices, produced innumerable snarls and frustrations. Finally, in a meeting with Chinese officials, Pei found himself "shouting and pounding the table like any good American businessman who thinks he's being ill-treated by foreigners. But, suddenly, I got what I wanted. I guess I'm not as completely Chinese as I thought."[7]

A commission for the Jacob K. Javits Convention Center in New York City (1979–86), designed primarily by Pei's longtime partner, James Ingo Freed, also ran afoul of municipal bureaucracy and was further hampered by problems with the fabrication of the structure — problems that eerily recalled the Hancock crisis.

During a rather gloomy period in the office, Pei's partner Harry Cobb, who had suffered his own special pain over the Hancock tower, pointed out that one of his partner's greatest buildings was the firm he had created. Indeed, it was. Although some of the partners and other members of the staff may have felt that they were not always given the credit or prominence they deserved, virtually all agreed that I. M. Pei & Partners was a unique, and uniquely successful, architectural undertaking. It had a worldwide reputation for competence and professionalism. At least in part because of Pei's own background in engineering, its technical services were beyond

compare for a firm that was also known as artistically innovative. And its internal culture was unlike that of any other firm of its type or size. Many employees felt very much like members of a family; if the decor in the reception area was strictly abstract, the odor of popcorn wafting through it at the end of a difficult day suggested that real people ran the organization. (Not all clients enjoyed the experience, and the popcorn ritual was suspended in the late 1980s.)

The sense of shared purpose and collaborative effort supported a durable design philosophy that survived such setbacks as Hancock, Fragrant Hill, and Javits. In the next few years, Pei and his partners produced a series of outstanding works of architecture, most notably the Morton H. Meyerson Symphony Center in Dallas (1981–89), and a skyscraper for the Bank of China in Hong Kong (1982–89).

Powerful as these buildings were, they were evidently overshadowed in Pei's mind by an invitation that came in 1983 from the president of France, François Mitterrand, who asked Pei to undertake a reorganization of the Louvre Museum. This extraordinary assignment drew on all that had gone before in Pei's career: his city planning experience under Zeckendorf, his political battles over the Kennedy Library, his museum experience with Mellon in Washington, and his exploration of cultural heritage at Fragrant Hill. Partly because of that compelling combination, the Louvre engaged Pei as no other project had. Surely that engagement was augmented by some putative similarities between the French and the Chinese. Both consider themselves

members of cultures more than governments. Once again, however, the role of the client was crucial. Pei and Mitterrand understood each other as custodians of a priceless cultural legacy, and Mitterrand had the authority and the resources to see the mission through.

The Louvre project seemed to spark a longing in Pei for the creative independence he had sacrificed when he had gone to work for Zeckendorf right out of architecture school. But it also expanded his interest in other cultures. And he seemed eager to put the nagging identity of "corporate architect," under which he had labored so long, behind him to pursue one as an architect more concerned with art than commerce.

The first step in that process was to change the name of his firm from I. M. Pei & Partners to Pei Cobb Freed & Partners, in recognition of the roles played by his major collaborators over the years. The next step was to retire from the firm altogether, which he did in 1990, establishing himself as a sole practitioner, while maintaining links to the partnership for help on major projects.

Much of what made Pei's separation from his firm possible was what came to be known as the "Louvre Effect." The huge success of his work for Mitterrand had persuaded other heads of state that Pei's touch could work publicity magic. Among them was Helmut Kohl, the chancellor of Germany, who was eager to have Pei design a museum in Berlin, and the government of Luxembourg, which hoped that a museum by Pei might give its tiny dukedom added stature. The projects went forward (Berlin was finished in 2003, Luxembourg in 2006), but the lack of like-minded clients with the power to assert the value of architecture over local politics and bureaucracies produced buildings that may not rank among Pei's major achievements.

The architect's frustrations with the work in Germany and Luxembourg were relieved by what could only be considered a dream commission for Pei: an art museum in a mountainous landscape for a client who imposed virtually no financial limitations. It was the Miho Museum, south of Osaka in Japan. The client was Mihoko Koyama, the matriarch of a religious group that considers art and nature to be conduits to spiritual fulfillment. Although Japanese, Mrs. Koyama had read the same classic fables Pei had known as a child, and while they shared no spoken language, they agreed on aesthetic principles. The result was a serpentine museum dug into the hills and approached through a tunnel and across a spectacular bridge — a building rather uncharacteristically fluid for the geometrically inclined Pei. And it marked a return to the territory he had first explored in his thesis project for Walter Gropius at Harvard.

Pei went even farther afield in 2000, when he was invited to design an Islamic art museum in Doha, Qatar. But in an almost impossible stroke of symmetry, he was also asked, in 2001, to do yet another art museum, this time in Suzhou. The commission (which had grown out of city planning work undertaken by Pei's eldest son, T'ing Chung, who died in 2003) allowed Pei to engage his two younger sons, Chien Chung Pei and Li Chung Pei, both of them architects, in a sentimental journey that spanned centuries.

Located near his family's own former garden, the new building recalled Pei's earlier attempts to reinvigorate contemporary Chinese architecture at Fragrant Hill, but in this case the welcome was far warmer and the program was far more attractive. A blend of traditional and modern—in both design and materials—the Suzhou Museum represented an elegant tribute to the place where the architect had begun his personal journey, but at the same time to where he had traveled since—artistically, culturally, and personally.

I. M. Pei has contributed several undisputed masterworks to the history of modern architecture—the East Building of the National Gallery and the Louvre primary among them—and his reputation is likely to survive those of many contemporaries. His fellow Harvard GSD alumnus Philip Johnson was long referred to in the press as "the dean of American architecture." Yet only two years after Johnson's death at the age of ninety-eight, his architectural legacy is based largely on the Glass House, the retreat he built for himself in 1949, at the age of forty-three. (His legacy as a provocateur and historian is another matter.) The reputations of Paul Rudolph and Edward Larrabee Barnes, two other GSD graduates who went on to major careers, are also receding. So is the work of the so-called Postmodernists like Robert Venturi and Michael Graves, who reached near-celebrity status in the 1970s and 80s, but have already seen their stars begin to fade.

Some of Pei's critics over the years have found him (perhaps enviously) too comfortable with wealth and power. But that judgment overlooks the fact that appreciating the wishes and resources of a prominent client is a highly valuable skill when one's goal is to create significant architecture. And it also overlooks the fact that, perhaps alone among members of his architectural generation, Pei has been able to evolve as an artist. While grounded in principles of geometry, he has never been captive to any ideology. The orthodox modernism of Walter Gropius proved too limiting to Pei, even as a student, and the reinvestigation of history trumpeted by Postmodernism struck him, as he often said, as ultimately superficial. Without ignoring technology, Pei has remained apart from the celebration of it for its own sake that has been brought about by computer-aided design. One need only look at the Bank of China tower to see what Pei was able to do by combining structural innovation with aesthetics to refine the conventional modern skyscraper. The Miho Museum is a powerful testament to his ability to address anew the concept of a museum in the landscape that he had first encountered as a student. Few architects have displayed such a remarkably agile artistic sensitivity maturing over time.

Not the least of Pei's achievements, however, is that he has done more than perhaps any other modern architect to bring consistently high-quality design to an enormous number of users—including those in his native land.

At the age of ninety, I. M. Pei has demonstrated that perhaps one can fulfill the promise of youth, and still go home again.

1948–1995: I. M. PEI, CONTINUUM AND EVOLUTION

Janet Adams Strong

I. M. Pei has often expressed his wish to be known as an architect of his time, one who makes use of new technologies in modernist terms without resort to stylistic remnants of former eras. In elegant fulfillment of that wish, his buildings have also mirrored with exceptional scope and prominence some of the defining events of our age: the end of World War II, the rise of commercial aviation, urban renewal, racial unrest, coeducation; and more globally, the rise of Communist China, Hawaii's statehood in the Pacific theater, the Cold War, the birth of modern atmospheric science, John F. Kennedy's assassination, the founding of the Republic of Singapore; and, later in his career, China's opening to the West, the return of Hong Kong from British rule, the reunification of Germany, and the recent ascendancy of the Middle East.

Pei's career began with an accident of timing. Prevented from returning to China after attending MIT and Harvard, he acceded to the economic dynamism of the postwar United States. Opportunities were boundless, particularly for the country's more fortunate immigrants, among them the gifted Bauhaus refugees who taught Pei at Harvard Graduate School of Design, and Pei himself, who brought an Eastern perspective to their Western philosophies. It was a time when the early cubists and Picasso, in particular, stirred life into American art and defined for Pei the beginning of modern architecture in the sculptural manipulation of solids and voids. Significantly, postwar prosperity and increased leisure time launched the first of more than a dozen museums by Pei to establish him, like few architects in history, at the center of popular culture.

Pei's formative influences included the Bauhaus leader and theorist Walter Gropius and real estate developer William Zeckendorf—from opposite poles, both taught him to analyze a problem before beginning. Also important was Pei's friend Marcel Breuer who imparted a humanistic approach to architecture. But perhaps more significant than Breuer was Le Corbusier, Pei's acknowledged "mentor," who he did not meet until years later but whose published work guided Pei through his years at MIT, still steeped in the Beaux-Arts tradition. Balancing these influences, again antithetically, were Pei's engineering background and Chinese heritage. As the discerning son of a cultivated family in one of the world's oldest civilizations—one that honors continuity—it was inconceivable for Pei to disregard history and tradition. The search for cultural roots has been a dominant theme in his work since Fragrant Hill Hotel (1979), yet it was evident from the beginning. The senior statesman of modernism is a traditionalist in the purest sense. Notwithstanding his use of geometry as basic building blocks and technical means in the achievement of aesthetic goals, Pei has steadfastly resisted a signature style, preferring to draw inspiration from place and the history it encompasses. His remarkably consistent buildings have been evolutionary rather than revolutionary, yet on technology's cutting edge—confidently unaffected by architecture's shifting -isms.

Pei laments that his twelve years at Zeckendorf's firm Webb & Knapp delayed his creative development since executive responsibilities often forced him to delegate design. But this

experience informed his understanding of urban development and introduced him to the powers behind it. Pei's diplomacy and pragmatism allowed him to address complex urban problems in terms of the larger whole within the economic and political apparatus of an open society. This experience clearly informed his later work such as the Grand Louvre.

Pei has always enjoyed the conceptual aspects of architecture, while encouraging others to share in the making of a building, reducing his daily involvement. His ability to return to a project and achieve major breakthroughs after a brief meeting is legendary, his tremendous powers of concentration and visual mastery of architecture leading quickly to solutions. The process is described by Chinese colleagues like the decisive stroke of a master watercolorist, quick and fresh, in the clear knowledge of what is required.

Pei's approach to architecture is not unlike the classic Chinese forms of expression he learned as a child — using few words to express a great deal. "Why use two strokes when one will do?" he asks. "You need to recognize and accept the constraints of a project and prioritize them so that you can get to the crux of the matter. Only when this is done can you address the solution because if you dream a solution without reference to a problem, it is just a waste of time. Design at this point is still a long way off. In other words, before you can deal with form, space, light, and movement — the things that go into architecture — you need to reduce very complicated requirements down to their essence. This is not easily accomplished. It takes time. You have to peel away the less significant, and abstract. I learned this from Lao Tse, who eliminated words until only the essential remained; my approach is also to simplify. Once you identify the key issues, you solve them one by one, always keeping the heart of the matter in clear view. Thus the process starts out very complicated, becomes simpler, simplest, and then returns to complexity in the development and detailing of the completed building."

Pei has not often explained his thought processes and methodologies and rarer still has he committed his ideas to paper, though in the preface to this book, he does explain some of the influences that informed his designs. His work has been extensively published for decades without a core treatise for students to latch onto. No "school of Pei" has formally developed. Yet a solid following does exist in the firm Pei founded and which made possible his success, much as the firm itself depended on Pei. Often called his greatest creation, its cumulative population totaled some two thousand people by the time he retired, like a small company town dispersed over decades and continents, many alumni in positions of considerable influence. To be sure, not all took away the same lessons, but certain core values remained, including a collaborative spirit and commitment to urban issues, precision design, the fine craftsmanship of buildings, and an intense loyalty to and love of I. M. Pei. With the approach of his retirement from Pei Cobb Freed & Partners in 1990, Pei resumed anew his evolving search for historical continuum, focusing the latest chapter of his long career on the deep cultural roots of Europe and Asia.

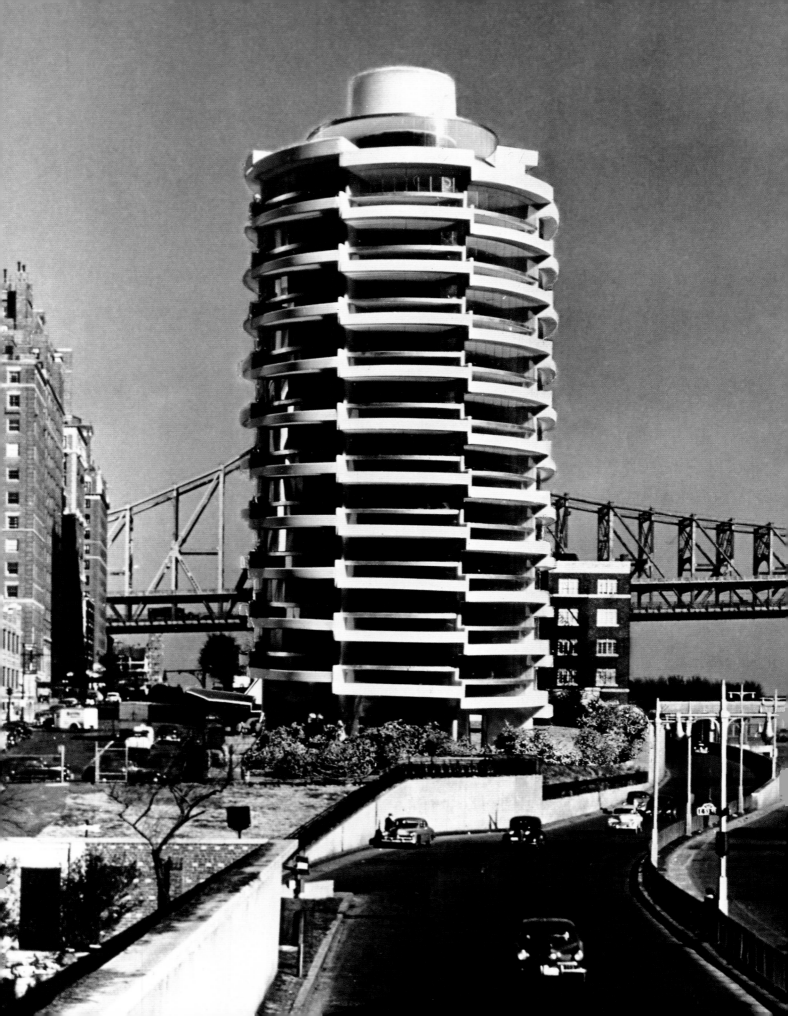

THE HELIX

New York, New York
1948–49 (unbuilt)

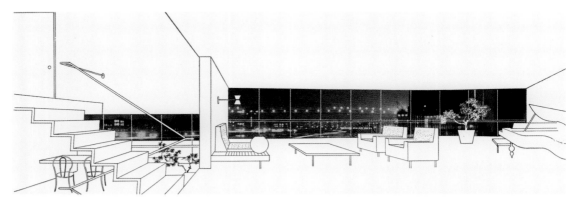

Split-level section

As New York's wealthy moved to the suburbs, William Zeckendorf found himself with a hefty inventory of palatial pre-war apartments. At the same time soldiers returning from the war created an unprecedented demand for one-bedroom efficiencies. Subdividing and renovating the obsolete residences would have cost as much as new construction, and Zeckendorf was confident that the cyclical real estate market would eventually renew demands for large suites. He turned to his architect: "Ieoh Ming, if you can make an apartment building that can expand and contract, we've got it made."[1] Zeckendorf described, only half in jest, a residential tree with a trunk that branched out into individual platforms, or lots, on which families could build houses of different size according to need.

Two weeks later Pei presented a revolutionary twenty-one-story cylindrical tower.[2] The design was conceived organically as a continuous chain of flexible wedge-shaped apartments that spiral up in half levels around a central trunk housing mechanical systems. In plan the tower radiates out, tree-like, in concentric rings from the dark core to living spaces of increasing size, natural light, and views. Load-bearing concrete fin walls separate the apartments and keep them column free.

In the hub of every floor are fire stairs and two elevators that each serve four apartments from a short curved corridor. The surrounding mechanical ring keeps plumbing and HVAC close to the living areas for an absolute minimum of horizontal piping and ductwork.

Tapping into the utilities in the narrow tip of the apartments, is a third ring of interchangeable kitchens and bathrooms. These, in turn, fan out to a 25-foot-deep (7.6 m) subdividable space for living, sleeping, and dining, enclosed by floor-to-ceiling windows. In the outermost ring of the Helix are expansive terraces, 8 feet deep by 35 feet long (2.4 x 10.7 m). Protected from neighbors' views by the tower's curvature and shielded from the sun by deep overhangs, the terraces offered the urban luxury of a large private outdoor space.

Helix on FDR Drive near the 59th Street Bridge, photomontage

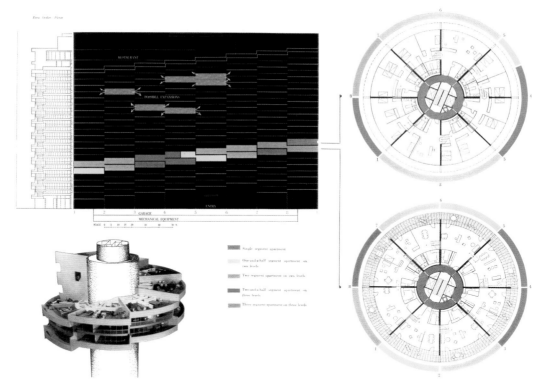

Sample configurations of living units

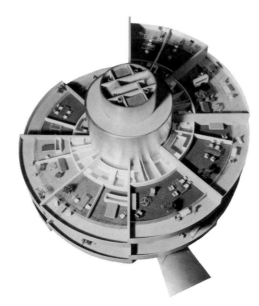

Spiral model section from above

Although Buckminster Fuller and Frank Lloyd Wright had previously explored the central core concept, the Helix stood apart in the ascent of its apartments in half level increments so that they abut a greater number of neighbors — vertically, horizontally, diagonally. The increased adjacencies maximized flexibility so that, for example, empty nesters had greater opportunity to sell off surplus space. Conversely, tenants looking for additional space could more easily expand into adjacent units, wholly or in part, to create duplex, triplex, or larger apartments in endlessly varied configurations, using the interchangeable wet ring to convert surfeit kitchens into extra bathrooms. Conversions could be achieved without sacrificing space for long corridors, the only requirement being a half-level stair up or down. Within the apartment wedges themselves, each about 800 square feet (74 sq m), spaces could be customized with modular walls.

The Helix was heralded in the press as "the most imaginative and revolutionary answer yet given . . . to present-day American apartment house design."[3] It was, according to leading engineers, "nothing short of sensational."[4]

Zeckendorf was so thrilled with the scheme that he filed for the first patent ever granted for an apartment building.[5] "Look at the fashion industry where one dress can affect styles all over

Helix proposal for Battery Park, 1958

the world," he said. "The Helix could easily be another Christian Dior."[6]

Zeckendorf never missed an opportunity to show off the Helix, least of all when Le Corbusier visited during work on the United Nations. The architect studied the model for a long time before launching an oblique defense of his own *brises soleil* designs: "Where is the sun? This building ignores it!" Pei gamely explained that air conditioning was available in New York so the building could be nondirectional; it was the view, not the sun, that was important. Le Corbusier left without further comment but wrote soon after to express his interest in the Helix and to request a plan and section.[7]

John D. Rockefeller, Jr., who found the scheme "most ingenious," praised Zeckendorf for his courage in abandoning the faulty building traditions of the day and applauded his vision for improvement. Whatever the outcome of the Helix, he wrote, "it will mark definite and important progress" in the field of urban housing.[8] Notwithstanding widespread praise and construction estimates twenty percent below conventional alternatives, Zeckendorf could not secure financing for the Helix. For years he tried doggedly to build it at the top of Russian Hill in San Francisco, in Los Angeles, along the Charles River in Boston, in Havana, and finally in Battery Park City in New York.

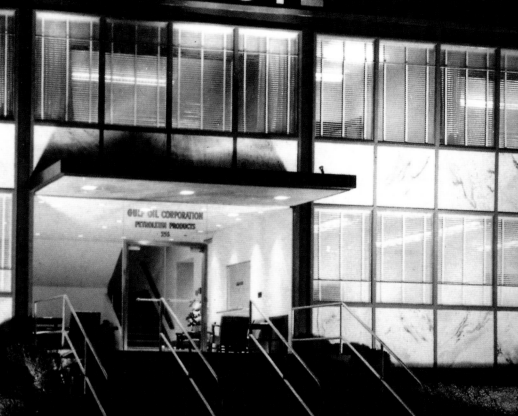

GULF OIL BUILDING

Atlanta, Georgia
1949−50

FIRST FLOOR

188'-9"

18'-9" 18'-9" 95'-0"

N

18'-9" 18'-9"

Plan

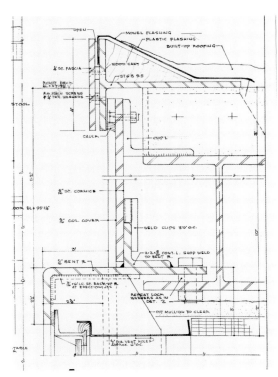

Marble wall section

William Zeckendorf owned several commercial properties in downtown Atlanta, including a highly visible corner at the busy intersection of Juniper and Ponce de Leon. In late 1949, even before a design existed, he leased a would-be office building on the site to Gulf Oil Company, which was then cresting on wartime oil consumption and wanted a solid local presence.

Zeckendorf took Pei out of the cushioned world of conceptual design and thrust him into the hard-nosed, bottom-line arena of investment building. "Ieoh Ming, go to Atlanta. We have a budget of $7 per square foot. See if you can make a building for me."[1]

The challenge was daunting not just because the budget seemed impossible but more so because Pei had come to Webb & Knapp straight from academia and had never built anything. He visited the Georgia Marble Company, located just blocks from the site, and captivated its president with reports of New York's extensive use of his product—for toilet partitions—and then nimbly brokered a deal in which Pei would showcase Georgia marble on his new building in exchange for discounted material. Pei freed this classic

Front entrance

building material from its thin modern role as a cosmetic veneer on masonry walls since here the 4-foot (1.2 m) stone panels are themselves the wall.[2] Within the exposed steel framework, the veined white marble added a variable natural element to the otherwise coolly rational design.

The clear influence of Mies on the building was due in large part to the economies afforded by his machine aesthetic. The two-story structure was prefabricated in bays, 18-foot-wide-by-22-foot-2-inches-high (5.5 x 6.8 m) from ground floor to roof. The skeletal frame was erected in two weeks; the entire building in a mere four months. Costly scaffolding was unnecessary as

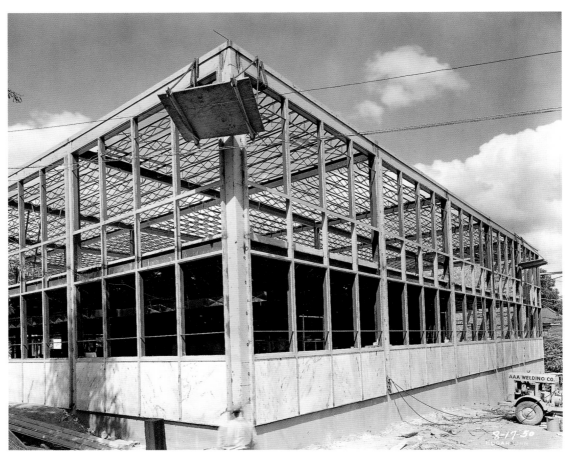

Skeletal frame construction

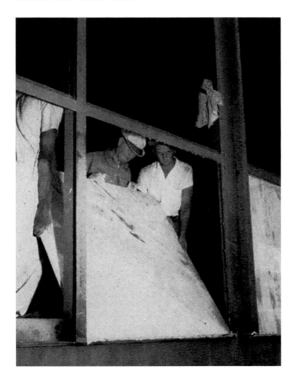

Installation of marble panels

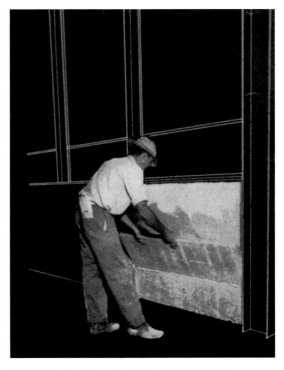

Installation of paint-ready chipboard plank insulation

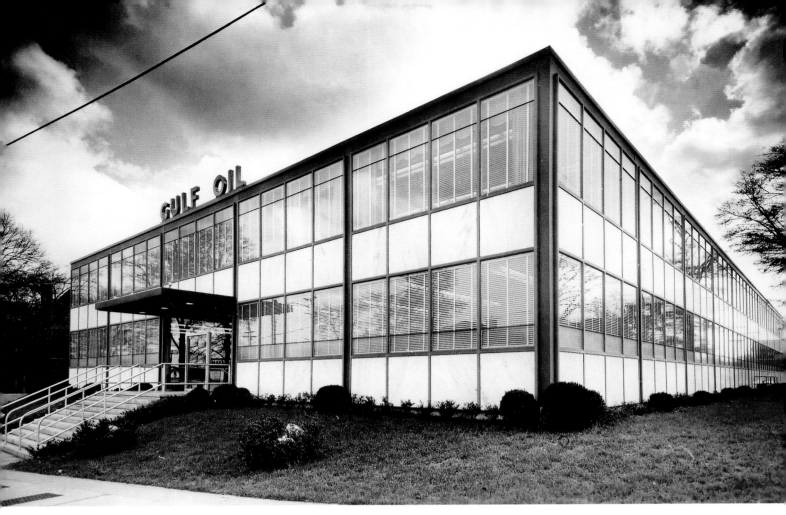

General view at Juniper and Ponce de Leon

both marble and glass were installed from inside and caulked from outside on ladders. The facade was insulated with chipboard planks, plaster finished and ready for painting. Additional savings were realized by using fixed rather than operable windows in the fully air-conditioned building, with a layer of crushed white marble on the roof to further reduce HVAC loads.

The end result was a simple rectangular box planted firmly on the ground, animated only by its hovering entrance canopy, patterned marble, and structural and glazing rhythms, notably in the hoppers and transoms. Details are few. The double square plan provided a loftlike interior with a central pool of open work space surrounded by a ring of executive offices.

If not quite a masterwork, the building nonetheless introduced a new sophistication amid downtown clutter, presenting a simple self-assuredness and elegance of proportion, even monumentality, which far exceeded its small size and budget. Zeckendorf trumpeted the building as an example of what Webb & Knapp could do to improve downtown Atlanta.[3] A half century later, it remains largely intact among newer, much taller buildings.[4]

Not only was the building constructed with all its mechanical systems for a phenomenal $7.50 per square foot, but it won Zeckendorf's confidence and launched Pei's career. Within a couple of years the previously untested architect had some 3 million square feet (280,000 sq m) of work in hand.

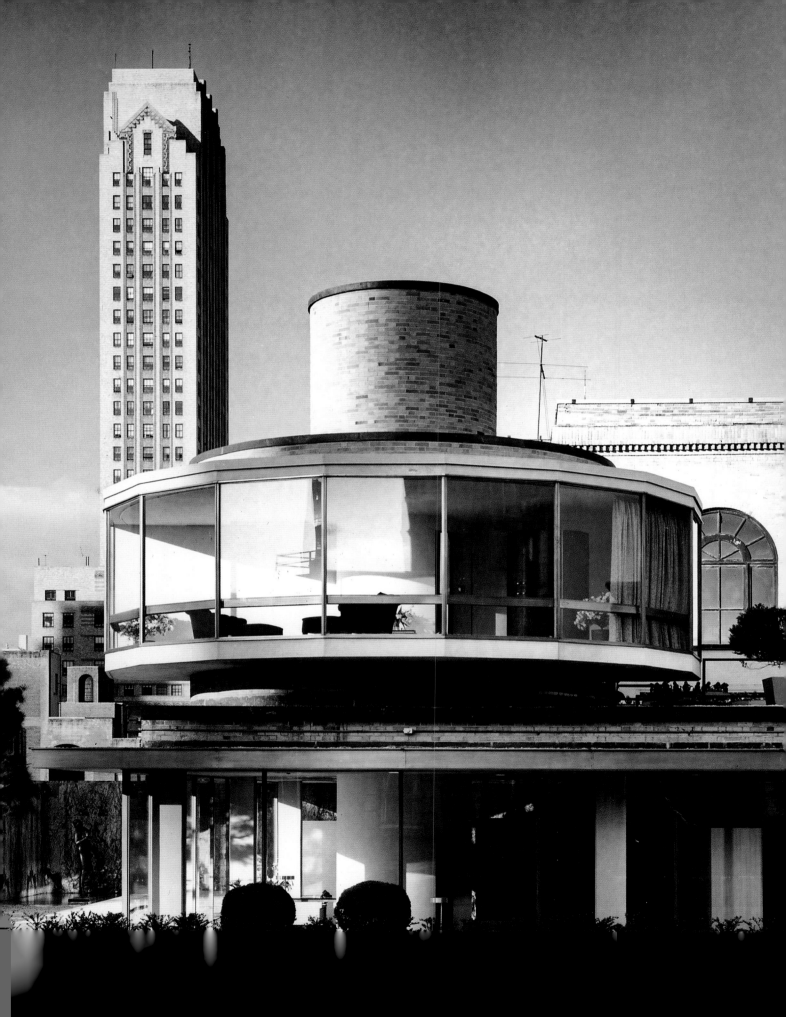

WEBB & KNAPP EXECUTIVE OFFICES

New York, New York
1949–52

When I. M. Pei first met William Zeckendorf in the summer of 1948, the developer was not yet the sensation of later years. He occupied an office with water-stained curtains, an old Victrola converted into a bar, and a desk piled high with papers and telephones. The walls were covered by drawings of mechanical parking systems beside renderings by Alexander Leydenfrost and Hugh Ferriss. In between nonstop phone calls Zeckendorf, an admitted modern Medici in search of the new Michelangelo, painted a glowing word picture of what he had in mind.[1] "I was a little afraid that I was in the wrong place," Pei confessed. "The office was so shabby but I was fascinated by Zeckendorf, by the way he talked, how he explained his ideas. . . . He was a man of imagination, unafraid to try new things."[2] It was a heady notion for a young architect, especially right after the war when most practitioners considered themselves fortunate to win a house commission.

The first step in Zeckendorf's big plan, and Pei's first executed work, was the remodeling of the flagship building where Webb & Knapp was founded in 1922 as "383 Madison Avenue, Inc." Twelve floors above, and a world apart, Pei recast the fast-talking tycoon in new headquarters befitting the privileged world into which Zeckendorf gained entry when he brought the United Nations to New York. Realizing that everything at Webb & Knapp revolved around Zeckendorf, Pei transformed the president's would-be corner office into the hub of the design, and placed him in a freestanding teak cylinder some 25 feet (7.6 m) in diameter, prominently situated in a large open reception area that occupied

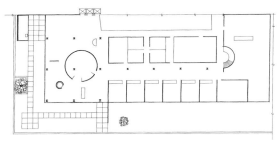

Main floor plan

383–385 Madison Avenue at 46th Street

nearly a third of the company's 12,000-square-foot (1,100 sq m) main floor. The self-contained drum, effectively a headquarters within the headquarters, was immediately visible upon arrival but strategically rotated so that from the waiting area an unending parade of visitors could be seen slipping around to the entrance on the opposite side. Beyond, the open lobby

Penthouse offices and upper dining pavilion

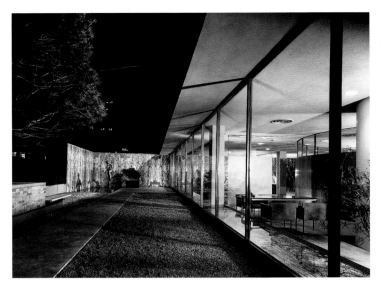

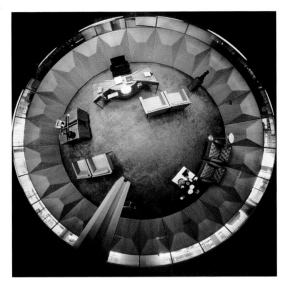

Outdoor terrace

Zeckendorf's circular office from above

expanded through glass walls to a rooftop terrace where a shapely Gaston Lachaise bronze stood in a shallow reflecting pool against a veined marble backdrop and the midtown skyline. On the opposite leg of the L-shaped terrace was a forty-five-year-old pine tree that Pei selected from his own property in Katonah, New York, and had hoisted into place on an early Sunday morning. If the scheme reveals the clear influence of Mies, particularly the Barcelona Pavilion, it also manifests the intimate balance of nature with architecture and art that would characterize Pei's work throughout his career.

Within the drum there were no windows, as the architect concluded "it would be ridiculous to create any environment for [Zeckendorf] other than one consisting exclusively of himself."[3] Instead, natural light was admitted through a transom and small domical skylights that telescoped 4 feet (1.2 m) up to the roof, each equipped with colored spots that Zeckendorf controlled from his desk to mood-light his meetings. The finely crafted oak walls were acoustically engineered, and offset by a precious Ch'ien Lung vase and a Matisse bronze that Pei bought for $2,500. In a corporate climate more accustomed to generic reproductions, the museum quality pieces conferred a weighty mantle of sophistication; they also intro-

duced Pei to the galleries and the world of art, which would play so important a role in his life.

A smaller cylinder outside Zeckendorf's office housed a private elevator to an upper-level dining room and lounge. Perched on the roof, like the captain's bridge of a great vessel cresting over midtown, the futuristic glass turret enthroned Zeckendorf in clear view of his growing empire. The headquarters was so widely praised and published for many years that, despite its higher than expected cost, Zeckendorf maintained he couldn't have afforded to spend a penny less on it.[4]

Together Pei's team of largely Harvard-educated architects detailed every aspect of the headquarters—from custom cabinetry, furnishings, and lighting fixtures to desks and seating, all custom designed, in part to accommodate the portly Zeckendorf but more so to create a total environment wherein every surface, space, and joint was carefully considered and connected.[5] According to *Fortune Magazine,* it was "one of the most extraordinary office interiors in the U.S."[6] With Zeckendorf's full trust and support, Pei had a free hand to develop the penthouse without budgetary constraints. He would not enjoy the same freedom until he took on the National Gallery some two decades later, by which point Zeckendorf's empire had long since collapsed.

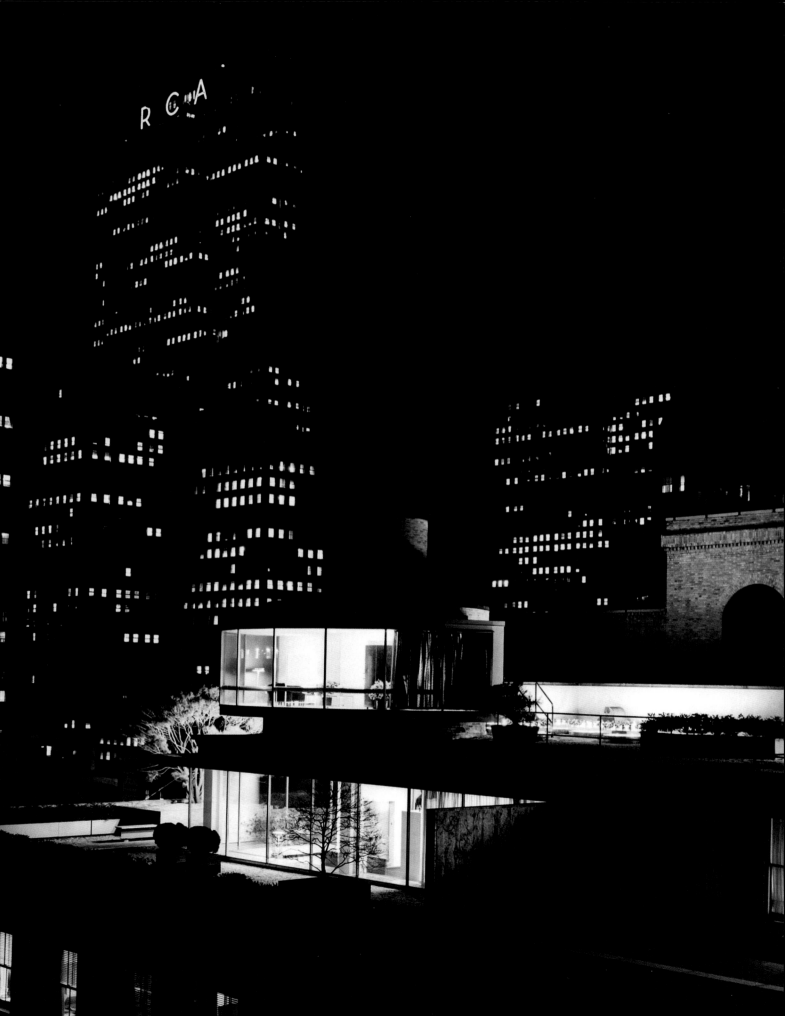

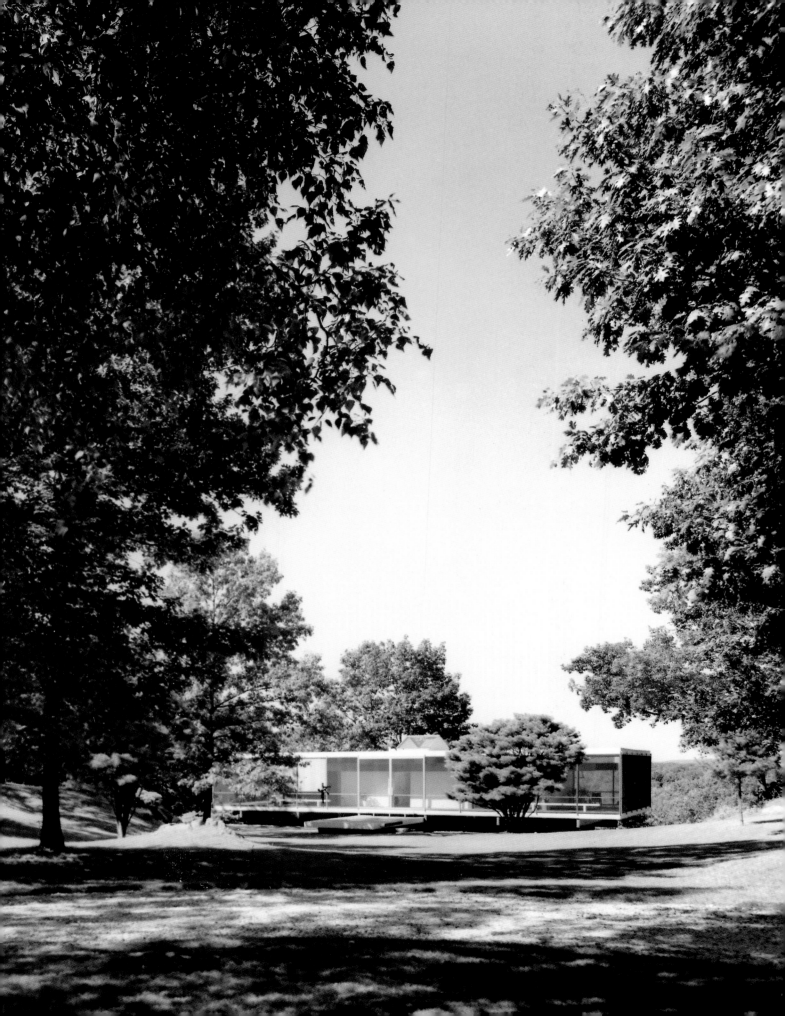

PEI RESIDENCE

Katonah, New York
1952

In 1952 Pei built a weekend home in then-rural Katonah, about thirty miles northeast of New York City. A modernist box, it recalls Mies' recently completed Farnsworth House (1951) and Philip Johnson's Glass House (1949), with a critical distinction. "This was not a showpiece," Pei explained. "We were raising young children so we had a real need."[1] Free from client demands, the 990-square-foot (84 sq m) structure demonstrates with purity and simplicity Pei's personal blend of East and West, using technology and economy of means to balance utilitarian and aesthetic goals.

"I had very little money in those days, but just because your budget is limited doesn't mean you can't build. It just means you do something different."[2] Concerns over the cost of laborers traveling miles to the country led to "an instant structure" of prefab components. Industrial beams of laminated pine were delivered in specified lengths and personally guided by Pei through the trees to a hilltop terrace. Workers set four uprights on either long side of the house, and bolted them to pairs of 60-foot-long (18 m) beams, cantilevered 6 feet (2 m) at both ends. The beams support six joists, also cantilevered, which span the house perpendicularly across its full 36-foot (12 m) width. Atop the joists massive 72-foot-long (24 m) beams comprise the main structure, cantilevering an additional 6 feet (2 m) to support the floor and roof decks. This simple method of cross-layered cantilevers was "something I learned from Chinese temples," Pei explained. "They were built with wood, which shrinks and warps, therefore the members

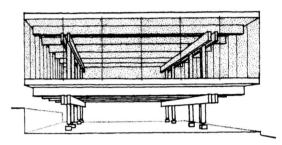

Perspectival section

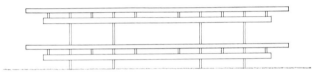

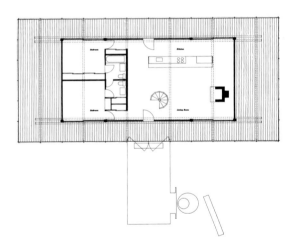

Longitudinal section and plan

cannot be too long. Instead, the structure is built up, one piece on top of another, and in this way both weight and shrinkage are distributed."[3]

Workers erected the structure in a day and roofed it within a week. The entire house was completed in months following directives Pei scribbled on unfinished walls.[4] Pei himself installed

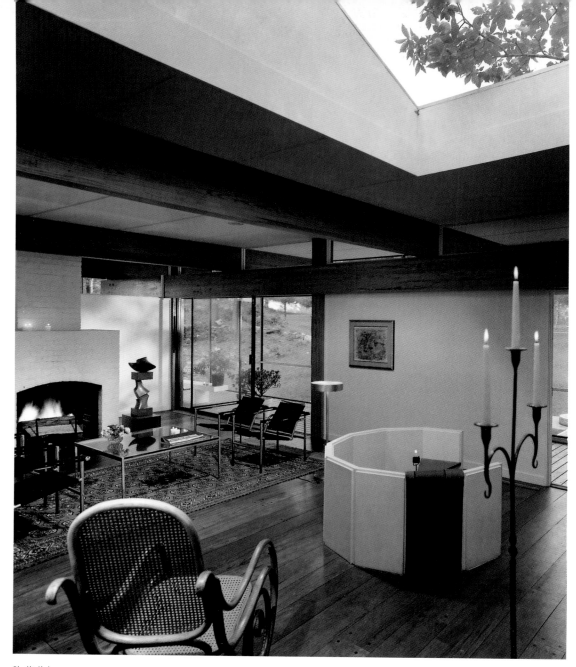

Skylit living area

the insect screen, adding dimensional exterior mullions for rhythm in the manner of Mies.

The basic concept was two houses in one: a small enclosed core for winter weekends (heated by fireplace and radiant teak floors) and wrapped around it, a larger summer home that expands out to the deck and cool cross-ventilating breezes through a pair of wooden doors and four sets of sliders that make the walls all but disappear.[5]

Airy furniture and glazed transoms reinforce the spatial continuum, as do the freestand-ing fireplace, kitchen, and faceted stair enclosure.[6] Hovering over and into the landscape with quiet equilibrium, the house buoyantly reveals Pei's more typically grounded pursuit of architecture in unity with nature improved by man. A sculptural entry sequence steps up some 6 feet (2 m) to a free-floating platform from an open area, more field than lawn, which the house shares with a solitary pine. "What you see is not planting, but removal," said Pei. "I planted only that one tree. The rest is nature with a lot of selective pruning."[7]

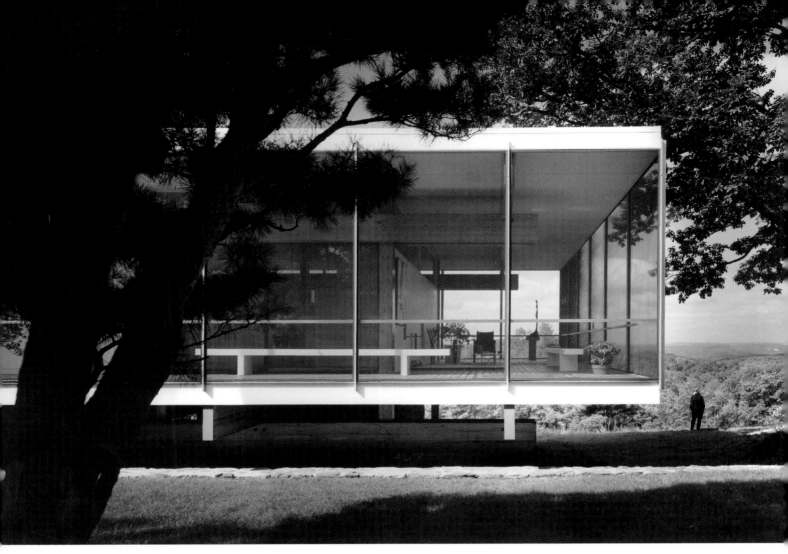

Cantilevered corner

The house in Katonah was the first of very few houses ever built by Pei, an earlier design having been refused a mortgage "because it had a flat roof." So significant was this challenge to modernism that decades later, Pei recalled it as a shibboleth in his acceptance speech for the Pritzker Prize in 1983.[8]

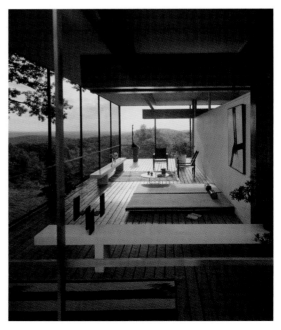

Screened deck

MILE HIGH CENTER

Denver, Colorado
1952–56

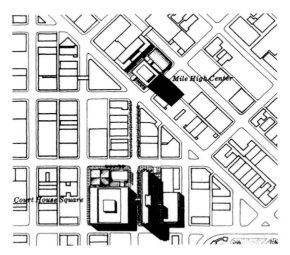

Location plan: Mile High and Courthouse Square

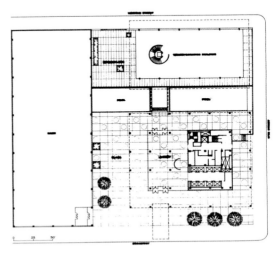

Site plan

Tower curtain wall
with public spaces,
barrel vaulted pavil-
ion and remodeled
limestone bank
building

By 1950 Denver's increasing population had steadily expanded its suburbs, while its city core atrophied without significant construction since before the Depression, an insular old guard actively rebuffing progressive "foreign" influences. When Zeckendorf arrived, he was still just a buyer and seller of real estate, and Pei, a largely untested designer of individual buildings. In Mile High, their first private urban redevelopment project, they provided a trail-blazing mix of public and private spaces in a planned center city commercial development. Together with Courthouse Square, completed a block away in 1960, Mile High began a building boom that reversed Denver's decentralization and set in motion what is today among the most vibrant urban centers in the country.[1]

Mile High centers around a twenty-three-story speculative office building (Denver's first skyscraper), offset in form, materials, and func-tion by a two-story glass exhibition pavilion with a curved concrete roof and a remodeled limestone bank. An underground tunnel was designed to connect the three buildings to an adjacent garage.

Taking full advantage of the sloped corner site, Pei pulled the buildings back to create broad public plazas on both the upper and lower street levels, and enlivened them with custom lighting, outdoor seating, flowers, trees, patterned pavements (heated in the winter), and varied spaces that continued seamlessly into the tower's glazed lobby. Conceived as a pocket-sized Rockefeller Center to animate Denver's aging downtown, Mile High drew strollers well into the night as music played and illuminated fountains sprayed from a 200-foot-long (61 m) refrigerated pool stocked with Colorado trout.

Bucking established real estate conventions, Pei insisted that the tower's ground floor remain

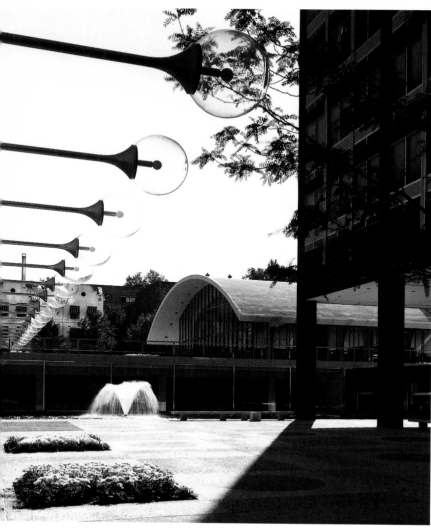

Lower plaza

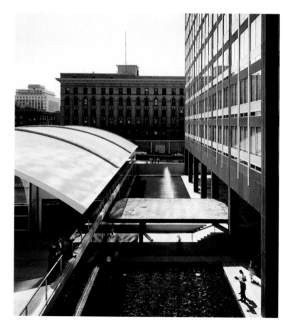

Canopied building link, recessed between trout pools

free of cluttered storefronts. An increase of just five cents for each square foot would recover the lost income, he assured Zeckendorf, "and because this will be such a beautiful building, you'll be able to get your premium rent."[2] He relocated shops and restaurants to the lower concourse of the exhibition building where, looking out to the trout pools and opening up the middle of the 2.7-acre (1 ha) site to prime retail, they thrived.

Like most of Pei's early buildings, the tower relies on a Miesian vocabulary but is at once both more ornamental and expressive. Its tapestry-like curtain wall traces the structural skeleton with dark gray aluminum panels, while beige enamel "threads" interweave the horizontal

heating/cooling units under each window and the narrower vertical air ducts. Between the window units and floors, 12-inch-wide (30 cm) fixed glass ribbons dramatize, especially at night, the depth of its deceptively flat walls.

"To do good architecture you don't need a lot of money," Pei explained, "just a lot of thought. I told Zeckendorf that I was not a magician but just five to ten percent more would make the difference. We struck a bargain."[3] At Mile High, Pei's first real attempt at place-making, he used the space in between buildings—typically neglected as just leftover air—and shaped it into an essential component of architecture, "not as something for Sunday, not for advertising,[4] but as a guarantee of greater permanent worth." Zeckendorf touted Mile High as "an office complex much ahead of its time that has withstood time's passing."[5] It had one of the lowest vacancy rates in Denver despite its doubling of the $3-per-square-foot average rental, and attracted important tenants, who, in turn, drew their competitors and new buildings into the area.

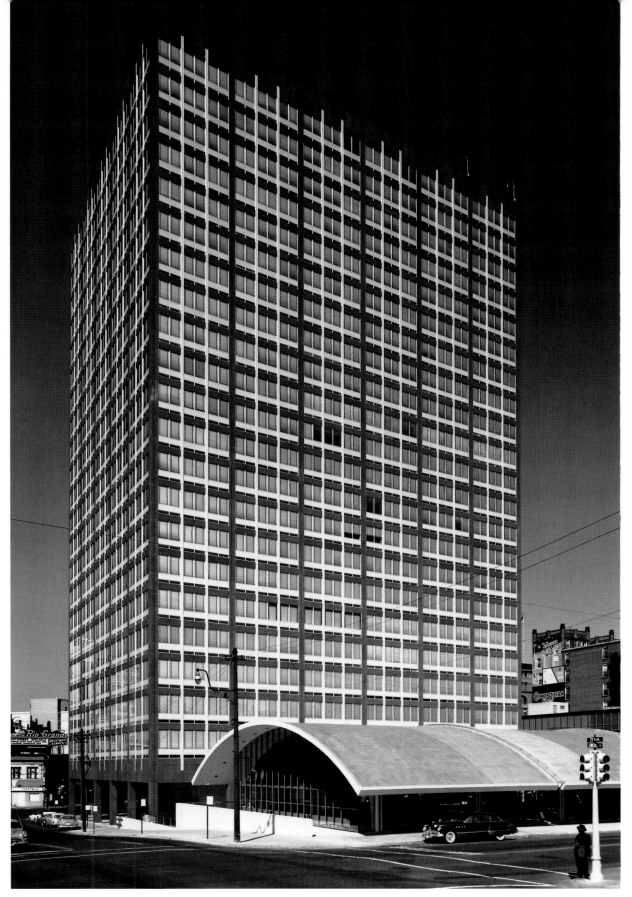

Tower and transportation building on sloped site

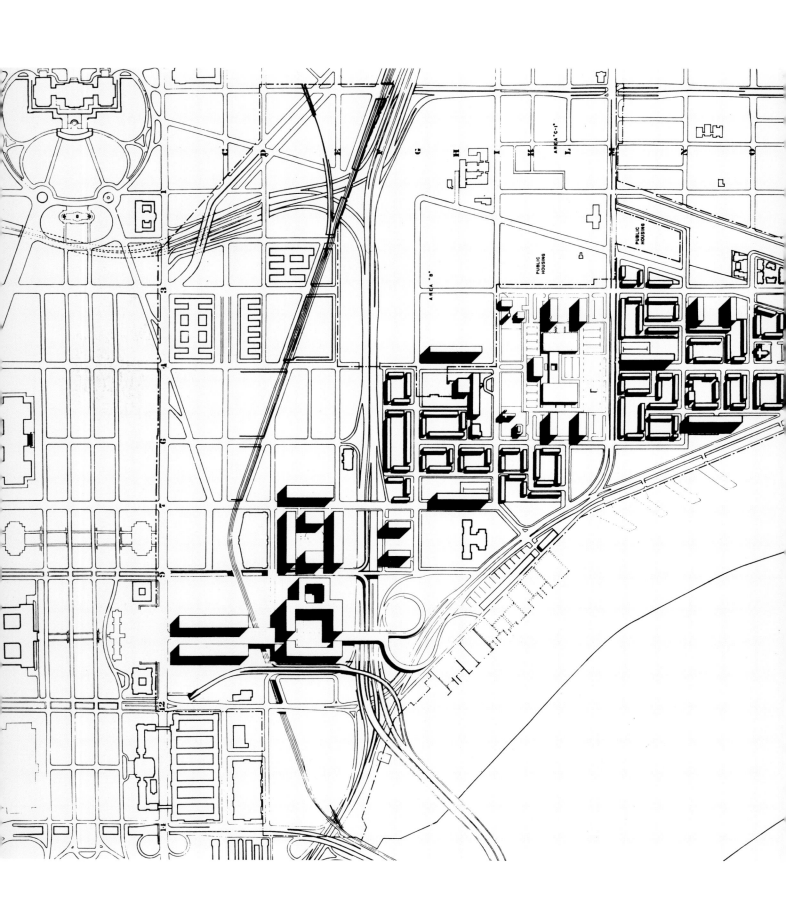

SOUTHWEST WASHINGTON URBAN REDEVELOPMENT

Washington, D.C.

1953–62

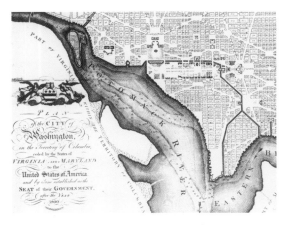

Southwest Washington plan, 1800

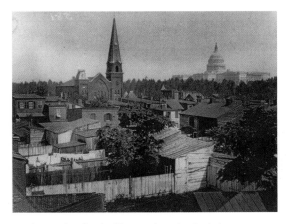

Southwest shanties, looking north to the Capitol

Part of the Federal City laid out by Pierre L'Enfant in 1791, Southwest Washington was separated from downtown by a creek, later a canal, and decisively by the Baltimore and Potomac Railroad in 1856. The effects of isolation were such that federal authorities labeled the area "a neglected slum, a disease-ridden, crime-infested eyesore in the very shadow of the Capitol."[1] Thus, when Congress passed Title I legislation in 1949, local newspapers clamored to make the government's own backyard the first, and at 522 acres (211 ha) the largest, national laboratory for urban renewal. *Washington Post* publisher Phil Graham convinced Zeckendorf to become involved.

From downtown one had to pass under the railroad viaduct to reach Southwest, which was literally on the wrong side of the tracks. Pei realized during his initial site inspection that the solution lay in 10th Street, where the railroad dipped below grade. If the open cut could be bridged at ground level, he reasoned, the physical, visual, and psychological barriers would dissolve.

In early 1954 Zeckendorf and Pei presented a master plan to Washington authorities.[2] The backbone of the scheme was the 10th Street Mall, a 300-foot-wide (91 m) esplanade lined by federal and public buildings tying Southwest to the heart of downtown. Organized around it were L'Enfant Plaza (an office, cultural, and exhibition center enlivened by outdoor cafes and activities with underground parking adjoining the Expressway), Town Center Plaza (an innovative blend of shopping, community facilities, town houses, and high-rise apartments interlocking around private patios and shared open greens) and, in the first proposal for major public spaces since the McMillan Plan of 1901, parkland and waterfront development with restaurants and marinas.

The scheme received the unprecedented endorsement of the *Washington Post* and its rival *Washington Star,* reinforced by critics like Jane Jacobs, who declared, "In overall concept, mall, plaza, and terminating outlook are brilliantly and harmoniously suited to their local, citywide,

Mixed-use master plan

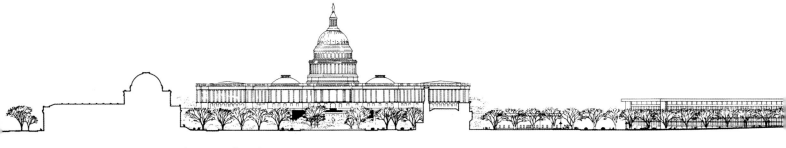

Tenth Street Mall section

Bird's-eye rendering of proposed development

and national functions, each aspect supporting the others and the whole adding up to a genuine architecture of city space."[3] The plan was nonetheless thwarted by the National Capitol Planning Commission, which battled to keep Southwest under its exclusive control, while other interests lobbied to keep the largely black ghetto contained. Adding to inertia was the involvement of nearly thirty (often competing) federal and local agencies, virtually none with experience in redevelopment. Bureaucratic entanglements were such that President Eisenhower's personal intervention was required, prompting Pei to later compare Southwest to his travails at the Louvre.[4]

The process dragged on for years, during which major changes were wrought by traffic and other urban pressures while various developers and architects were brought in to achieve broader participation and architectural variety. By the time things began to percolate in the early 1960s, Zeckendorf and Pei had already pulled out. Pei's partner Araldo Cossutta took over and built the first phase of L'Enfant Plaza and the Mall. Pei's involvement in executed buildings was limited to the twin concrete apartment slabs in Town Center Plaza, which he sited around existing trees, his focus throughout having been the larger picture. "The project's importance for me is civic,"

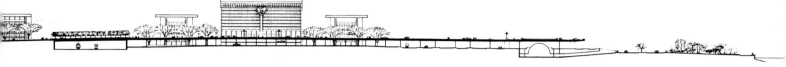

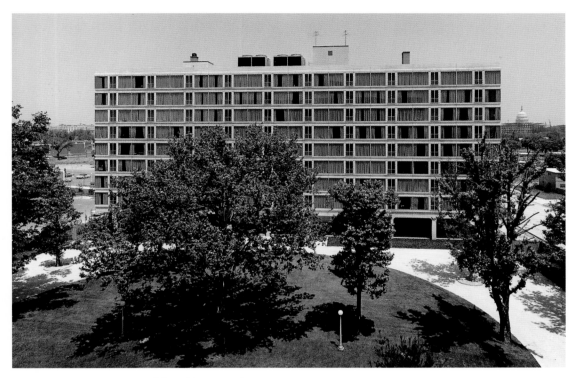

Town Center Plaza apartment building with preserved street trees

Pei explained. "It's planning not architecture. The issue was how to make the area an important place to develop."[5] Approximately eighty percent of the plan was implemented. If the end result did not quite possess the urban continuity Pei envisioned, it proved flexible enough to withstand inevitable changes, including most damagingly the guillotine-like construction of a federal office building across the head of the 10th Street Mall, which undermined the essential notion of open entrance.

When the project began in the early 1950s, Washington was a stalwart Southern city controlled by segregationalists adamantly opposed to meddling by liberal outsiders. Thus the proposal for integrated mixed-use by the flamboyant New York Jewish developer and his Chinese architect was as bold as it was visionary, infusing Southwest not just with new commerce and vitality but a hope-filled vision of what it could become. With its many fine trees and beautiful waterfronts along the Potomac and Anacostia Rivers, Zeckendorf and Pei looked beyond the slums they saw to the thriving federal, business, cultural, and residential community that exists today.[6]

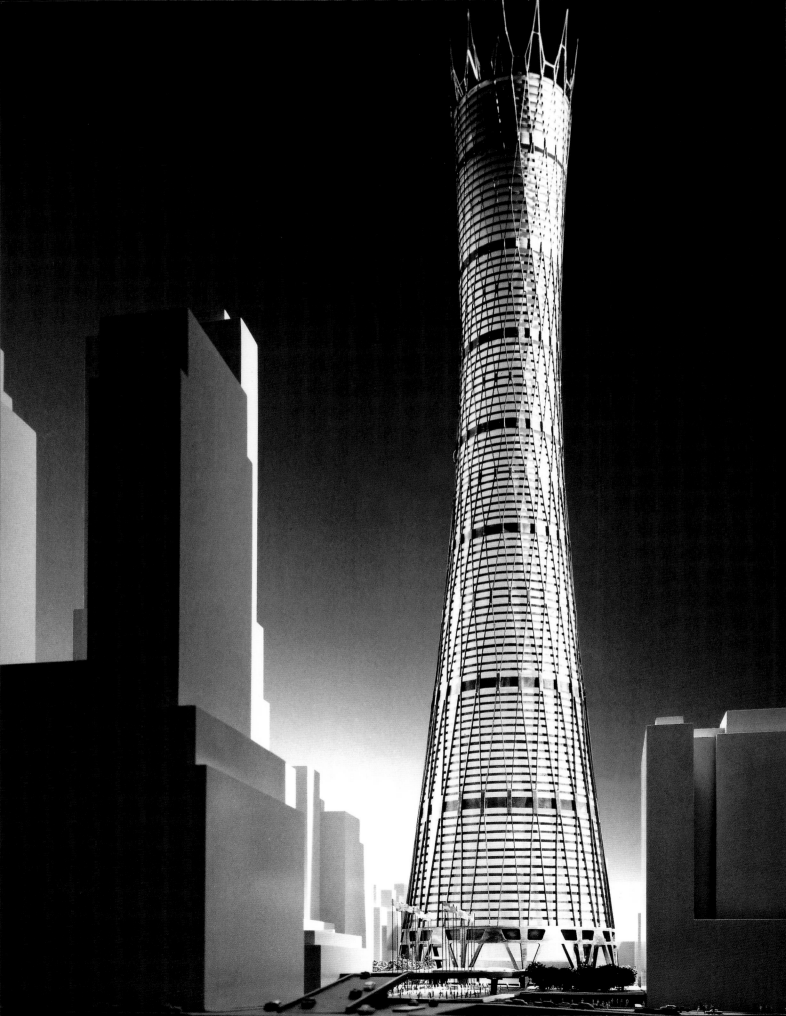

THE HYPERBOLOID

New York, New York
1954–56 (unbuilt)

In a mid-century fight for survival against commercial aviation, suburbanization, and "heavy terminal costs in the East," railroads across America eyed their vast real estate holdings for critical revenue.[1] Zeckendorf, always on the lookout for large land parcels, especially in New York, took a one-year option on the replacement of Penn Station. But when the project collapsed under astronomical cost, he focused on Grand Central Terminal, redevelopment proposals for which had already been solicited by Robert Young, newly elected chairman of the ailing New York Central Railroad (NYCR).

Pei welcomed the break from urban renewal, and three months later he and Zeckendorf presented the Hyperboloid in Young's private railway car en route to Manhattan. The soaring 1,497-foot-high skyscraper (456 m) — Pei's first — was to be the largest and most technologically advanced office building in the world, with 108 floors of various sizes to meet different corporate needs. Below, a new skylit transportation center would marshal trains, subways, buses, and cars.

Narrowing as the number of elevators diminished in upper floors before widening in a crowning flourish, the intrinsically economical tower reduced wind forces to roughly half of those in a conventional building of comparable size. So while the 3.8-million-square-foot (350,000 sq m) Hyperboloid was seventy percent larger than the Empire State Building, its steel requirement was the same. A postwar development brochure pointed out that its aerodynamic curvature was also more blast resistant to nuclear explosions.[2] The scheme grew out of the long-

Model, view north
along Park Avenue

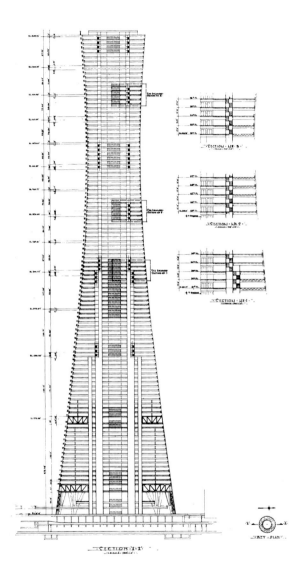

Measured section

span thin-shell structures of Eduardo Catalano, but typical of Pei's innovative approach to technology, he vertically up-ended the normally horizontal parabolic form for high-rise use in a way that had not been done before.[3]

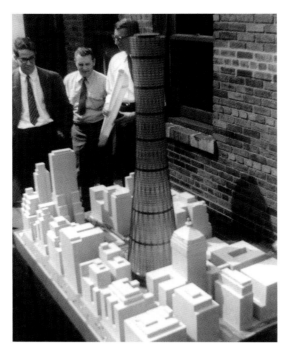

Model inspected on roof of Webb & Knapp offices

As in New York's World Trade Center, the strength of the Hyperboloid was in the small components that formed a dense structure around its perimeter. A lattice of diagonal columns redistributed the building's loads across its entire surface and down to twelve giant footings. The V-shaped supports opened up the lower floors without expensive spanning members while reducing foundation costs and also minimizing interference with the active train tracks below.

Driving the design were urbanistic concerns about how to create an appropriate visual terminus to Park Avenue but yet allow its space to flow through, and how also to alleviate midtown congestion even while incorporating the city's tallest building. The thin-waisted Hyperboloid was pulled back on the three-block site to give Park Avenue an open green worthy of its name, simultaneously increasing the value of surrounding properties (most owned by NYCR). Importantly, the scheme called for the reconfiguration of Park Avenue for more fluid traffic

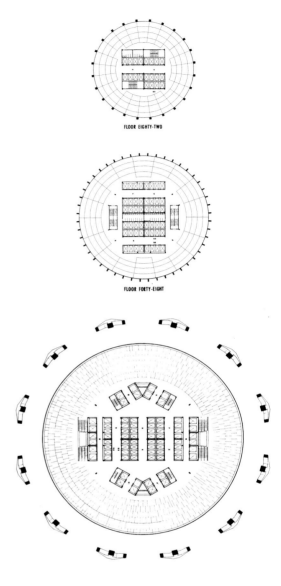

FLOOR EIGHTY-TWO

FLOOR FORTY-EIGHT

Lobby, typical mid- and high-rise floor plans

flow on curved viaducts instead of tunneling through what is now the Helmsley Building in treacherous sharp angled turns.

That construction of the Hyperboloid would have required the demolition of Grand Central Terminal and the adjacent New York Central Building is today unthinkable, but in Zeckendorf's swashbuckling view of postwar New York, destruction of the then derelict and outmoded terminal was progress. For Pei, the question was

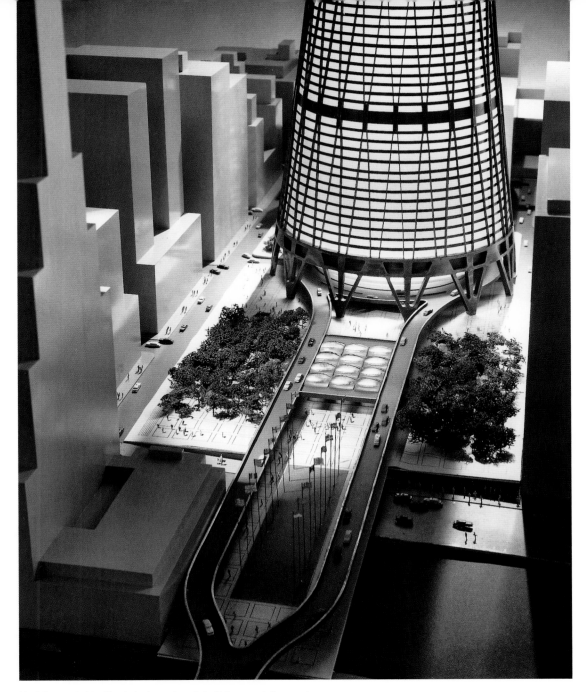

Model, rerouted traffic viaducts, park and skylit transportation center

whether a park would be more valuable than a "second rate Beaux-Arts building." The main hall, he explained, "is to me not really a great space. One look and you've seen it all. Great spaces should be infinitely varied, constantly changing."[4] Pei was not alone. A small but prominent group of architects, including Marcel Breuer and Yamasaki, rallied on the side of modernism, countered however by a growing grass-roots preservation movement.[5]

The Hyperboloid was by far the most spectacular of several schemes under consideration by the forward-looking Robert Young. But in January 1957 a U.S. Senate investigation of the "sick and declining" railroad industry revealed that the NYCR was at gravest risk of collapse, having lost $500 million on passenger service over the preceding eight years.[6] Two weeks later Robert Young committed suicide. Prospects for realization of the Hyperboloid passed with him.

KIPS BAY PLAZA

New York, New York
1957–62

Within the dull economic formula for urban renewal, Kips Bay was an attempt to transform large-scale city housing into architecture. To a singular degree it was the personal achievement of William Zeckendorf and I. M. Pei, and most certainly would have stalled had either wavered. "We created something new in city housing," said the developer, "and have ever since been proud of what resulted."[1] For the architect, this first major project in New York was among the most important of his early career, firmly establishing the character of his practice with respect to environmental planning, precision detailing, and unsurpassed technical expertise. The wellspring of a large family of increasingly refined architectural concrete buildings, it was the foundation upon which Pei would build his firm.

Kips Bay clearly shows the influence of Mies's machine aesthetic, but also clear is a movement away toward the more sculptural expression of Le Corbusier—transformed by Pei, however, into something uniquely his own.

Work began in 1957 by which point Pei had spent nearly a decade in Zeckendorf's office, much of it devoted to planning, urban renewal, and unbuilt projects. Kips Bay held the promise of actual construction in center stage New York—although, as it turned out, against almost insurmountable obstacles.

The three-block site between First and Second Avenues, 30th and 33rd Streets, was originally envisioned as employee housing for the new New York University–Bellevue Hospital medical center across First Avenue. When the original sponsors failed to build, Robert Moses

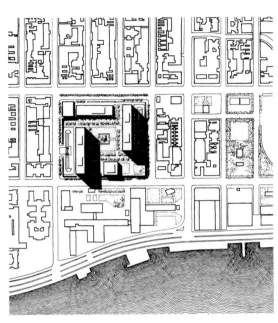

Location plan

enlisted William Zeckendorf to assume the property (renamed Kips Bay) together with Manhattantown, another troubled renewal site at West 96th Street (renamed Park West Village) and also a sprawling apartment complex near Lincoln Center. In an instant, Zeckendorf became the largest Title I redeveloper in New York, ultimately the largest in the country.

Zeckendorf dispatched Pei to learn housing basics at Stuyvesant Town and Peter Cooper Village, multibuilding projects recently completed just south of Kips Bay. Pei found them "big, repetitive, anonymous" and determined to change the related six-building master plan that Skidmore, Owings & Merrill (SOM), as consultants to Moses, had prepared for his site. He consulted his friend Gordon Bunshaft at SOM who told

Concrete wall detail

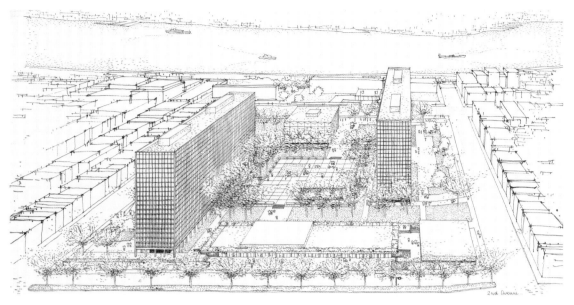

Illustration for leasing brochure, view across Second Avenue toward East River

Pei to do as he wished but preferably to do nothing at all since good public housing was impossible: "Leave it to the lawyers." And in large degree it was there, in the thicket of government bureaucracy, that Pei would triumph.[2]

He reduced Kips Bay to two 410-foot-long (125 m) slabs, leaving open more than half of the 10-acre (4 ha) site as a park, and then sculpturally shifted the twenty-one-story masses to vent and yet contain the space. Whereas architects at the time typically focused on the individual building within its property lines, Pei's experience with Zeckendorf had given him the broader perspective of how the city works and, importantly, the confidence to engage its difficult problems.

The slabs were aligned with the city grid but positioned so that the narrow streets emerge into Kips Bay's greater open space. Pathways continue key axes inside on the east and west while ramps on the north and south access surface parking and an underground garage from widened streets. The slabs nod formally to the extruded hospital while neighborhood connections are strengthened along First Avenue by a proposed medical building, or alternately by a school for the United Nations ten blocks north (on the site Zeckendorf personally secured).

On the opposite side of the superblock, a retail-cinema spine and service road reinforce the Second Avenue commercial corridor. Meanwhile enormous windows brought high-rise midtown inside, even as Kips Bay's park and playground offered respite from the city on the ground. Each gesture, conceived within the framework of a carefully balanced composition, grew from a high-density aesthetic wherein complexity gives way to simplicity and building masses defer to the priority of surrounding spaces. In marked contrast to the disparate setting it linked to and anchored, Kips Bay presented a cohesive planned environment.

The formulaic construction of postwar housing projects was rigidly adhered to by FHA authorities, builders, and developers, including Zeckendorf's own people, who saw profit in imitation, not innovation. Pei undermined the system with a comparative bricklaying study in which he (erroneously) projected diminished output and skyrocketing cost. He convinced Zeckendorf that far from being a bottom-line solution, the practice of concealing a structural frame behind a brick facade was a wasteful way to build.

Mies offered an alternative with his curtain wall apartment buildings, one of which, the

Apartment interior

Colonnade, was under construction in nearby Newark, New Jersey. It was not so much the building but more the idea of making architecture by very simple means that was important since Kips Bay's tight budget precluded a steel solution, just as it had scuttled an early scheme for precast concrete. In either case the objection, both practical and philosophical, was the separation of structure and skin. Pei took a momentous step by combining the two in a single operation. Concrete was poured into a form and what came out of the form was the building itself: fireproof structure, facade, window frame, and finish, interior and exterior, all molded together in an honest whole, with nothing hidden or added. Pei sought to develop an attractive yet low-cost repetitive building unit, in effect, a modern answer to brick but more akin in quality to liquid limestone.

A solid knowledge base existed for structural concrete but not for finished architecture. Pei, who had worked in concrete design at the engineering firm of Stone & Webster during college, recognized the need for in-house expertise. For the next three years, Kips Bay was transformed into a research laboratory wherein every aspect of concrete production, from material sources to finishing techniques, was analyzed and tested. Ultimately, full-scale test bents were produced in rehearsal for the actual building. A newly developed light tan cement from Lehigh Valley was poured into innovative plastic-faced Douglas fir formwork that had been made by a Brooklyn cabinetmaker according to the architect's specifications. It was perhaps the first time working drawings had been drawn up for formwork, as surface impact had not previously been considered. Like so much else at Kips Bay the practice became an industry standard. Zeckendorf underwrote the entire enterprise, convinced that cast-in-place architectural concrete would eventually become a cost-effective means to build—this, when other developers wanted only immediate risk-free returns.

The practical need to reuse formwork and the desire for a regularized facade led to the abandonment of scatter-column construction. Standard practice since World War II, interior supports had been placed at will to accommodate variable plans so there was no uniformity of facade. By contrast, Kips Bay's load-bearing walls permitted virtually column-free, and thus larger, rooms, each rationally expressed in 5-feet-8-inch (1.7 m) bays.

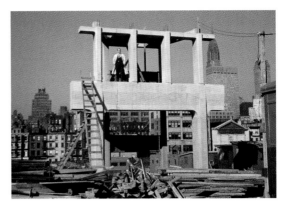

FHA Multifamily Housing Standards Committee, February 19, 1960; Pei, right foreground

Full-scale concrete test bent on site

The module introduced into the enormous slabs a key element of human scale that was articulated with an attention to detail without precedent in low-cost housing. Columns on the facade were made more vertical by recessed horizontal elements and the deep shadow play of windows set back 14½ inches (37 cm) into the wall. The radiused window heads broke free of the Miesian mold to suggest the plasticity of concrete; structurally they increased rigidity and wind resistance. The curvature also permitted large unframed panes of glass to be slid directly into the concrete walls without requiring the corners to be fit. A straightforward structural statement, the honeycomb walls provided collateral benefits in reduced glare, increased privacy and, unlike flat curtain wall alternatives, minimized clutter from curtains and other tenant preferences. But the real amenity was the near floor-to-ceiling windows themselves. With sprawling city views, light, air, and open space, Kips Bay was the promise of early Modernism delivered. According to the *New York Times*, Kips Bay was "the nearest approach to glass houses of any apartment project in the city."[3]

To secure government financing for Zeckendorf, Pei had to conquer the complicated arithmetic of FHA housing, which assigned different values to rooms as calculators for mortgage insurance; the higher the room count the greater the funding. But under existing guidelines Pei could not claim the generous half-room count (worth several thousand dollars) that the FHA awarded for a balcony. Pei challenged the allocation, arguing that urban dwellers didn't need infrequently used outdoor dust-catchers; what they really needed was more habitable year-round space. Why not fold balconies—and their precious subsidies—inside to create larger bedrooms and living rooms?

The architect took his case to Washington. Elected to represent the AIA on the advisory Multi-Family Housing Committee of the FHA, he massaged the system to win room credit for the deep embrasures of Kips Bay's gridded walls. It was a small but significant victory with long-term consequence. Pei had confronted an intractable problem for which there previously was no choice but to follow established rules, and opened the door to change.[4]

Having finally resolved the project's technical and bureaucratic challenges, Pei left for a vacation in Europe in April 1958. He returned several weeks later to learn that Kips Bay was dead, the apparent victim of conservative opponents at Webb & Knapp who attacked the project as "an immoral misuse of money" and contractors who had no interest in change. Bids solicited from leading builders in Pei's absence came in upwards of $18 per square foot, roughly double the housing standard. As had happened before with so many imaginative schemes, the abandonment of Kips Bay's design seemed inevitable. To Pei's amazement and redoubled loyalty,

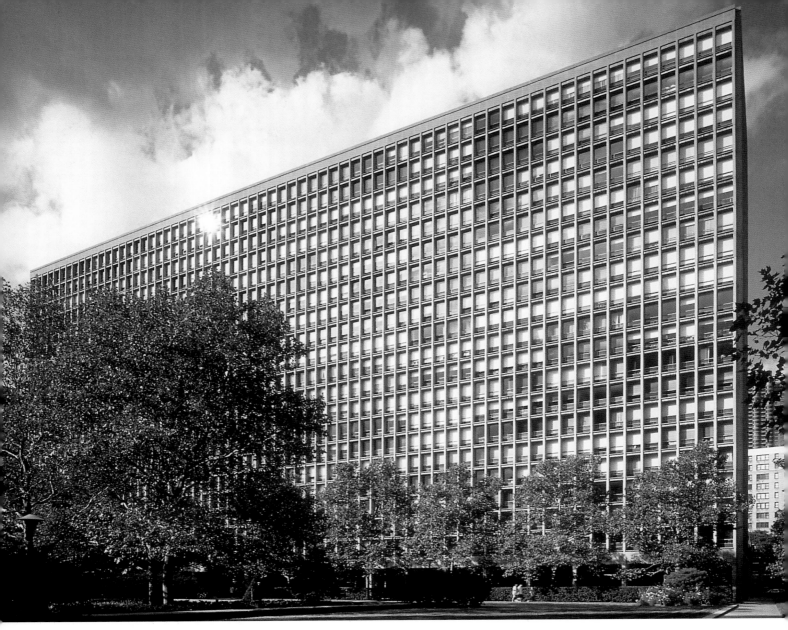

Building and mature gardens, 1999

Zeckendorf, quietly but with characteristic bombast, bought the Industrial Engineering concrete company to privately build the project.[5]

Although the budget had been exhausted, Pei was concerned that Kips Bay was too open and needed a centerpiece to anchor the space. He tried to persuade Zeckendorf to buy a monumental Picasso but the developer, ever committed to Pei but overextended on this and other projects, countered with a choice: the sculpture or fifty saplings. Pei chose the trees, having envisioned a park from the very beginning. "The park is what makes Kips Bay," he said. "It's the most important part of the project."[6] On May 20, 1993, the residents of Kips Bay dedicated it to the architect.

The fact that Kips Bay was executed on a very limited budget was not in itself important but, the fact that it presented an alternative to established practice was. In a way that superseded a neglected building type, Kips Bay demonstrated that good architecture did not depend on big budgets and that low-cost housing need not be unimaginative. It also said that architecture involved more than buildings, and that thoughtful, well-executed design could make an enduring contribution to the city experience.

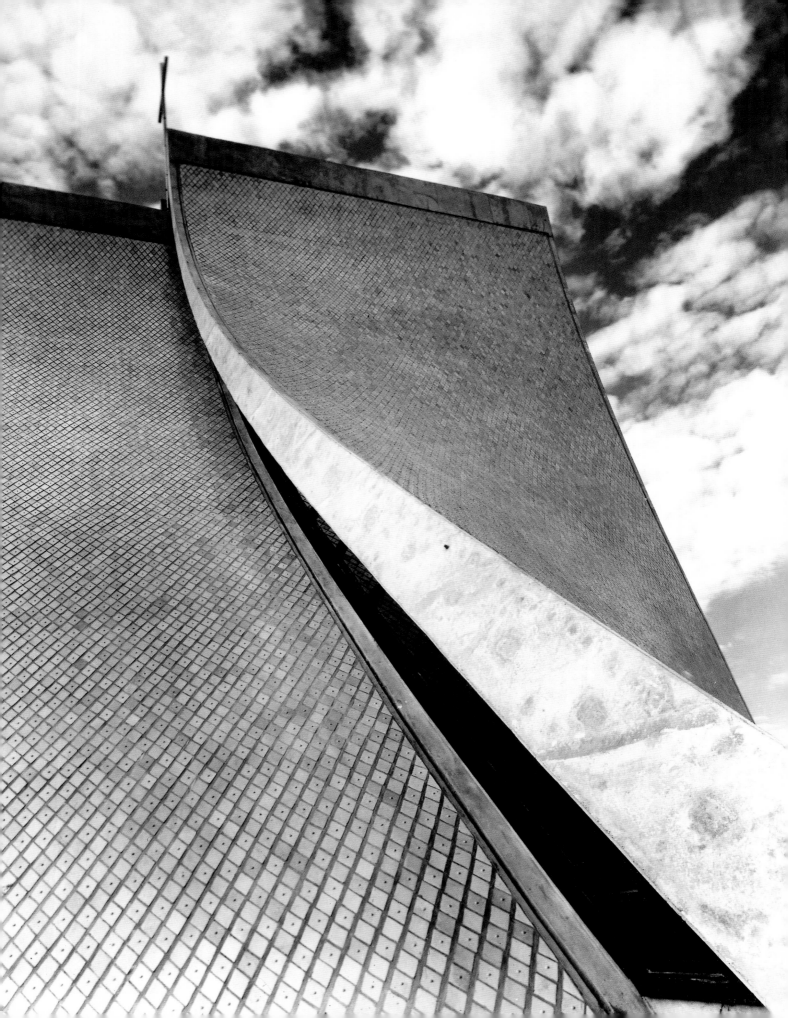

LUCE MEMORIAL CHAPEL

Tunghai University
Taichung, Taiwan
1956–63

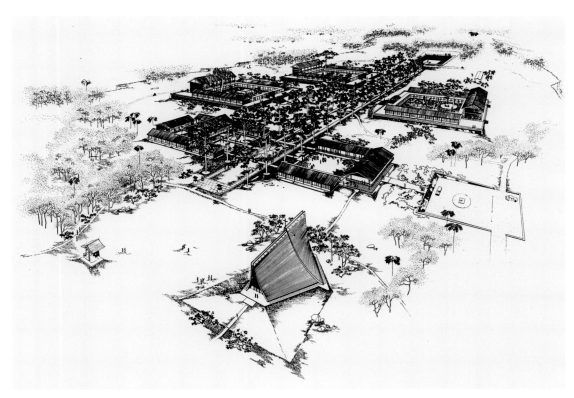

Tunghai University master plan, bird's-eye view

Exterior detail: wall
overlap and glass slot

The United Board for Christian Colleges founded Tunghai University in Formosa (now Taiwan) on a 345-acre (140 ha) site donated by the government, after being forced from mainland China in 1949. For help with master planning they contacted Pei, who had attended a United Board middle school in Shanghai and had consulted with Walter Gropius on the Board's unbuilt university there.[1] Zeckendorf allowed Pei to bring Tunghai into the office as an independent project — his first. The chapel was dedicated to the missionary father of Henry Luce III, publisher of the Time-Life empire, and funded by a grant from the Luce Foundation.

Pei organized the sloped site along a central spine, with three colleges, the library, and administration disposed in courtyards to create a sense of community. He located the centerpiece chapel next to the only tree on "the barren windswept hill" and inclined it off axis in its own open space. Pei turned over the master plan for development in Taiwan, designing only the chapel in New York as permitted by its simple program for a 500-seat space for worship.[2] No other guidelines were given.

Pei felt a deep personal attachment to the project since, himself cut off from China, it was

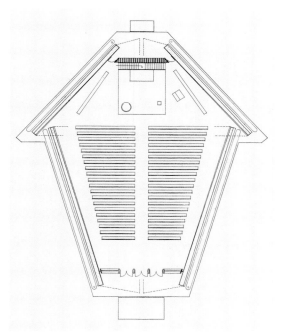

Chapel plan

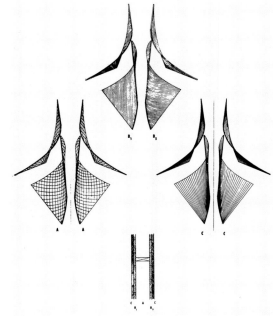

Lamella wall construction: layered shells and section

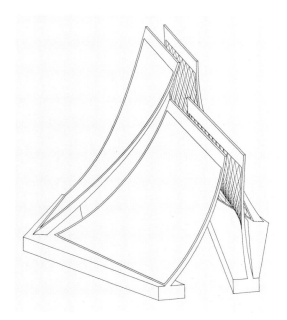

Axonometric

the closest he could get to home. He sought to combine in it the East and West of his own experience, marrying the golden roof tiles of ancient temples and the imperial palace in Beijing with the expressive verticality of Gothic cathedrals and the thin warped shells championed by Félix Candela.[3]

The chapel consists of four warped shells, the back pair barely overlapping the lower front pair on a modified hexagonal base to form both the walls and roof of the 65-foot-high (20 m) column-free interior. Light slips in through glazed slots between the overlap and through a narrow skylight that continues to infinity in Eastern tradition. Each shell's curvature permits it to stand alone unsupported, but for reinforcement against Taiwan's typhoons and earthquakes small, almost invisible, bowtie connections forge the whole into a rigid structural pyramid. Like Pei's contemporaneous scheme for the vastly larger Hyperboloid, the hyperbolic paraboloids cantilever up from the ground. Yet it was not simply the rotation, but the combination of four conoids together that was so innovative in the creation of the hovering sculptural space.

Realization of the small chapel took seven long years, undermined by budget and technological problems, before a brilliant Taiwanese engineer, Heon-san Fong, submitted thirty pages of preliminary calculations to prove structural feasibility.[4] The pre-computer challenge was, according to Dr. Fong, "so original that there

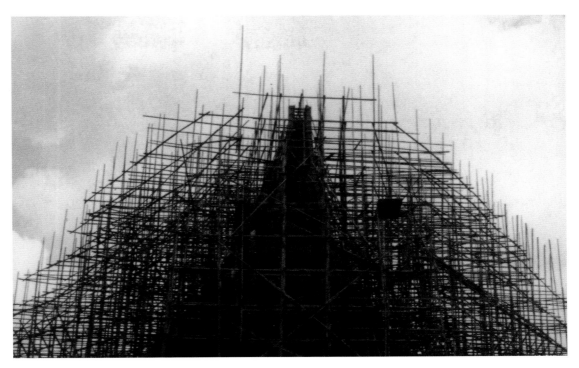

Construction: bamboo scaffolding

[was] no engineering literature at all available to deal with it."[5] Ribs were introduced to prevent the concrete shells from buckling under their own weight and, following Pei's often repeated directive "honest design, not interior design," they were left exposed in clear expression of the structural forces at work. The ribs thicken as they descend and the lozenge-shaped voids in between become smaller since the greatest stresses are concentrated near the ground.

Formwork for the ribs was executed with some refinement by twenty-five local carpenters who, in the course of six weeks, built the tremendous piece of cabinetry using eighteen-thousand pieces of contoured lumber according to a full-size drawing on the ground. Concrete was poured from a freestanding bamboo scaffolding starting on June 20, 1963, continuing round and round, from one shell to another, until completion two months later. Wedges supporting the formwork were driven out, one by one, as the architect's representatives stood inside to demonstrate confidence in what they had built. C. K. Chen described how the formwork seemed to hang in the air before

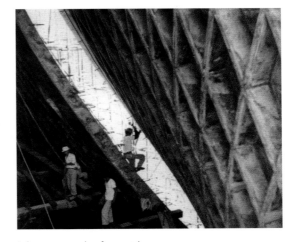

Laborers removing formwork

the tremendous wooden frame dropped six inches (15 cm). "The ground and the whole building trembled a little. . . . I sensed that all the dead weight had been transferred to the walls. At that moment the building began to stand on its own."[6]

Madame Chiang Kai-shek dedicated Luce Chapel on November 2, 1963, by which time it was already the widely recognized symbol of Tunghai University and the icon of nearby Taipei, Taiwan's capital city. United Board Secretary William Fenn

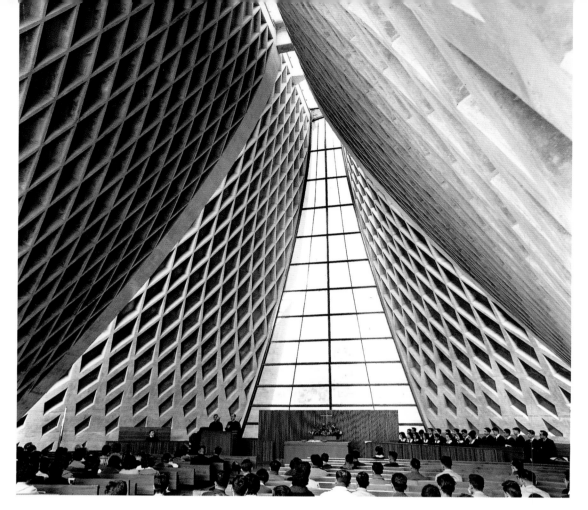

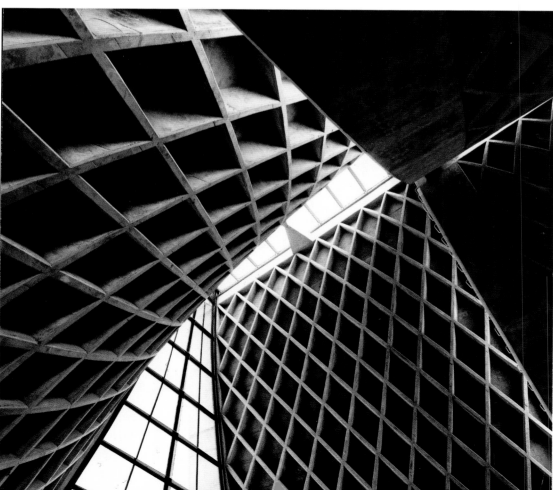

Interior views
toward altar and up
to ridge skylight

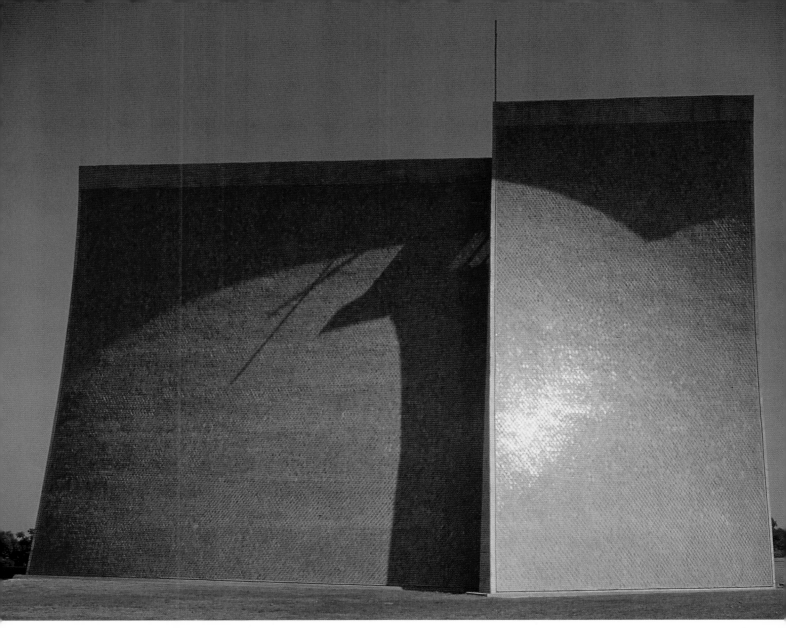

Side elevation

joked that Pei, not being Christian, had approached the chapel from the mystery of art rather than from the mystery of faith.[7] The architect countered quickly that it was not mystery at all but structure. Unlike Mies's rationalistic chapel at the Illinois Institute of Technology or Le Corbusier's expressionistic chapel at Ronchamps, Luce follows a pure structural approach to the creation of form in space. According to Pei, "it adheres closely to the principles of the structural system and material used, and follows through with logic and discipline."[8]

An early example of Pei's mature approach to architecture—engaging advanced technology in the service of art, distilled to essentials and sculpturally expressed from historical roots— Luce did not afford Pei the opportunity for further development because of prohibitive labor costs in the United States. In New York, it was a major victory just to introduce concrete to low-cost housing, simple and endlessly repetitive, at contemporaneous Kips Bay. Undertaken when Pei was thirty-nine and beginning his career, Luce Chapel would be his only religious building until 2007 when the ninety-year-old architect accepted the commission to design a chapel in Kyoto, Japan.

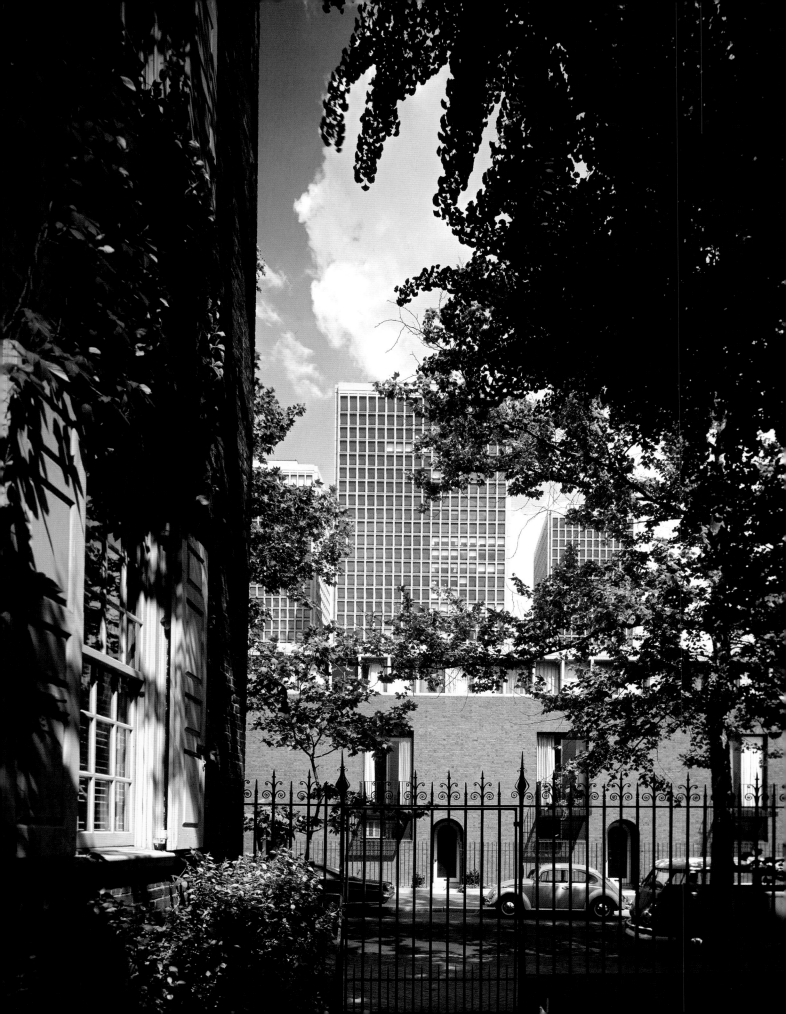

SOCIETY HILL

Philadelphia, Pennsylvania
1957–64

As cities across the country bulldozed scattered downtown areas for redevelopment, Philadelphia mounted a coordinated plan to revitalize America's most historic city with some seventy-five urban renewal projects under the enlightened leadership of Edmund Bacon, director of the City Planning Commission. Also unique, the initiative had the enthusiastic support of government, business, and banking institutions, and various public-private agencies like the Old Philadelphia Development Corporation, which was established to foster the process.[1]

One of the most challenging areas was Society Hill, named for the eighteenth-century Society of Free Traders, where historic buildings and once elegant homes stood blighted by generations of neglect amid warehouses, factories, and the rotting waste and congestion of Philadelphia's wholesale produce market. Four developer-architect teams were invited to submit proposals for the 56-acre (23 ha) area. Instead of the typical tabula rasa practice of total demolition followed by new construction, guidelines mandated selective preservation, mingling old and new, high-rise and low. Even more extraordinary, the winning entry was to be selected on the merits of design rather than cost. Although Pei was still employed by Webb & Knapp, he and Zeckendorf entered the competition as equals and won despite the other contestants' strong local ties.

A schematic master plan indicated which buildings were to be restored with different zones specified for low-rise residential and high-density towers and slabs. Pei alone ignored the recommended twelve-story slabs and instead

Area study with hatched site boundaries

concentrated 720 new apartments in three slender thirty-one-story towers, set back from historic buildings in a park along the Delaware River. Two other towers were proposed off Washington Square. Between the tower clusters were new town houses on three nearly adjacent sites intermixed with and continuing the finer scale of their historic neighbors, all of the components threaded together in a greenway system outlined by the City Planning Commission.

Pei used his research at Kips Bay to apply architectural concrete to high-rise construction

Towers and town houses in context with Colonial neighborhood

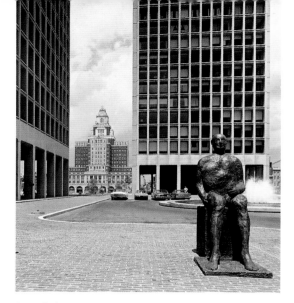

Central plaza

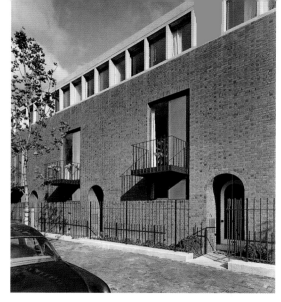

Locust Street town houses

and introduced Philadelphia to new heights of urban living. He envisioned the towers organically, at city scale, and responded to forces impinging on the site from outside. Philadelphia's tranquil skyline, rich in history and tradition, required simplicity, he explained, to convey "an impression of dignity and quietness, much like a church steeple."[2] The 308-foot-high (98 m) towers were of a scale consistent with both the waterfront and the proposed Expressway, and provided a baffle for residential areas. The towers also created a landmark identity for a project that came to symbolize Philadelphia's rebirth in its remarkable transformation from slum to a once-again-fashionable neighborhood in barely a decade.

Yet it was not height but grouping that was the main issue. Regularity proved the solution as three equally tall buildings were quieter than staggered masses, and unlike slabs, the towers were slender enough to see between and around. In a pinwheel configuration that created both sculptural tension and balance, the location of each tower was precisely determined to provide historic vistas along tree-lined pedestrian passages. Commissioner Bacon likened the strategy to the obelisks Pope Sixtus V erected in sixteenth-century Rome to lead pilgrims from one major monument to another.[3]

Similar linkages tied the city to the new town houses, which were grouped in residential

squares in the manner of old Philadelphia and, while clearly modern, they complemented historic neighbors in materials and scale. A limestone frieze of windows visually relates the town houses to the tower grids, which Bacon saw in turn as a proportional echo of the area's colonial windows; the entire precinct, past and present, came together in an architectural continuum.[4]

A related theme was attempted by Leonard Baskin with a three-piece sculpture in the towers' central court. Like the full-bodied Gaston Lachaise that so gracefully centers the townhouses, the Baskin was funded by "1% for Art" in yet another Society Hill milestone. The program, introduced by the Philadelphia Redevelopment Authority, was adopted by the FHA in late 1961 to guarantee loans with a percentage of construction cost set aside for public art. The $400,000 allowed Pei to commission, rather than simply purchase, art but also confronted him with the limits of human-based sculpture. He resolved the conflict at University Plaza several months later, and ever after, with abstract compositions at a scale more appropriate for modern architecture.

opposite:
Delaware River skyline

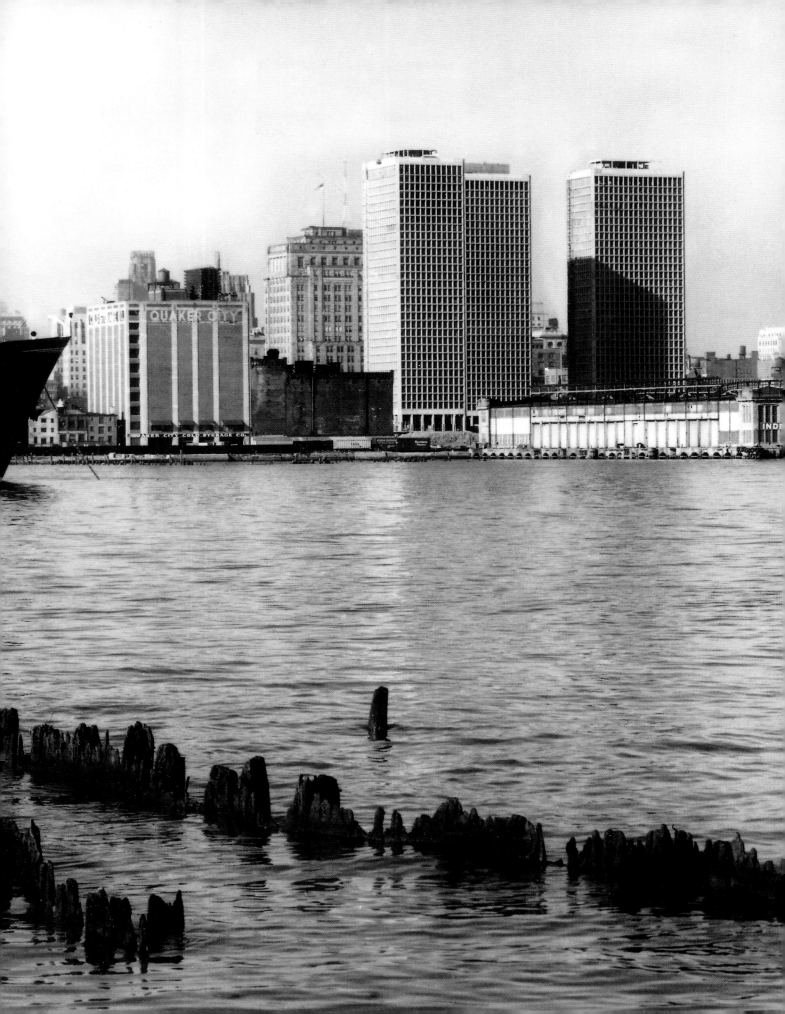

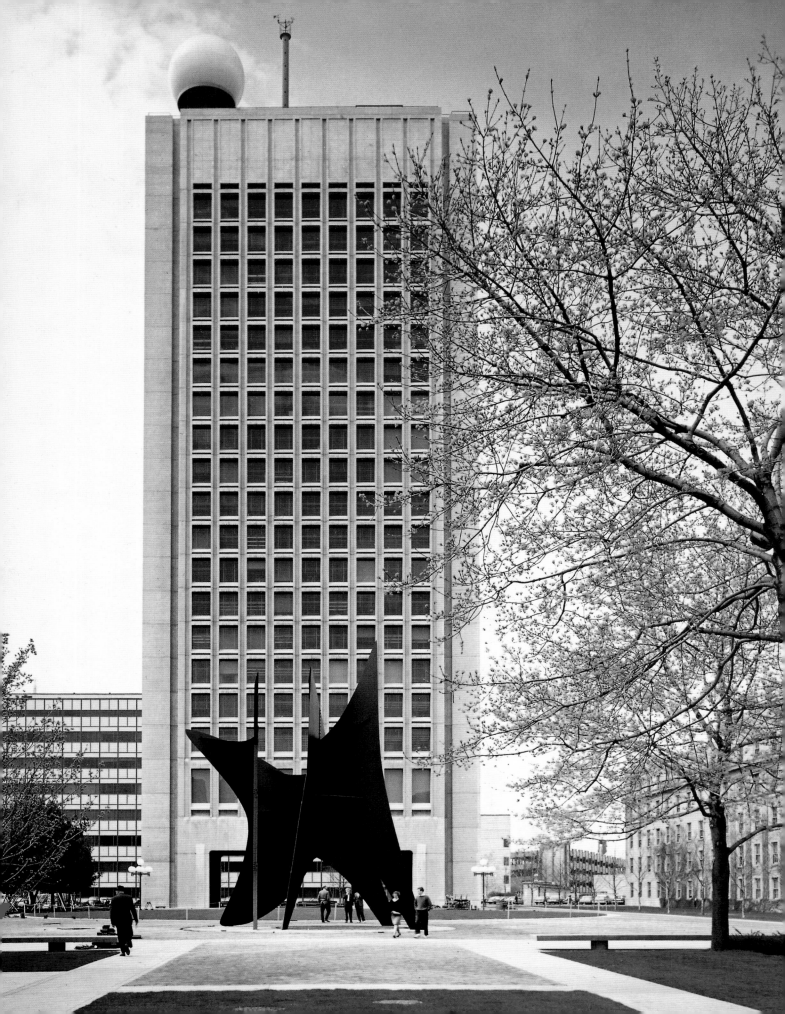

MASSACHUSETTS INSTITUTE OF TECHNOLOGY

Cecil and Ida Green Center for Earth Sciences (1959–64)
Camille Edouard Dreyfus Chemistry Building (1964–70)
Ralph Landau Chemical Engineering Building (1972–76)

Cambridge, Massachusetts

In 1958 MIT launched a building campaign to meet its expansion needs in a way that would humanize the existing campus and better harmonize new additions. Pietro Belluschi, dean of the School of Architecture, suggested that top architects be assigned different campus precincts, "giving each his head with only a light hand on the reins."[1] Pei was asked to focus on an area east of the school's main buildings—"a formless muddy field," which he'd overlooked as a MIT student from his fifth-floor dorm room window.[2]

To define and make more intensive use of land so close to the academic core, Pei convinced MIT to break with its long-established tradition of low-rise interconnected buildings to construct a twenty-one-story tower for emerging atmospheric and metallurgic sciences, complete with a rooftop laboratory high above city pollution. The freestanding tower would link by tunnel to the school's continuous circulation network. Pei indicated the placement of future buildings, which, he explained, the tower would focus "like a flagpole in a public square" in a unified composition with existing neighbors. The goal was "not to create great architecture but to create an ensemble of background buildings that would eventually enclose and organize space."[3] The primary concern was not the solids but the voids around and between them.

Despite initial reservations over the still-experimental use of concrete in a tall building, MIT's scientific tradition disposed it to accept

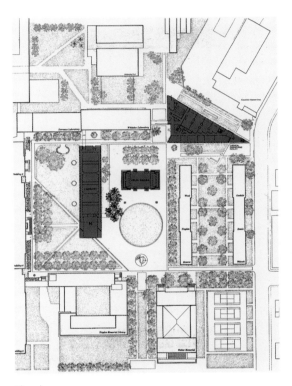

Site plan

the lessons newly learned at Kips Bay. The humble new material also promised to match the color and texture of the school's original buildings without the expense of limestone. MIT would now learn from its student, even as it continued his education: MIT provided Pei with his first paid commission outside of Webb & Knapp, his first signed contract and, unlike Zeckendorf's expansive in-house operations, a more traditional relationship with a client committed to timely construction on a firm budget.

Green Center for
Earth Sciences with
Calder stabile

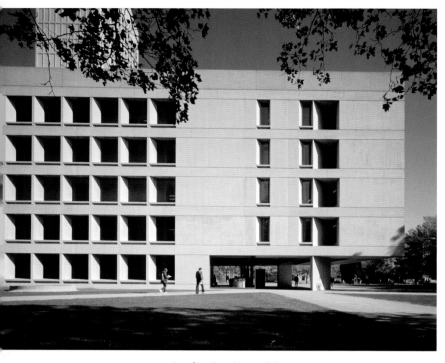

Dreyfus Chemistry Building

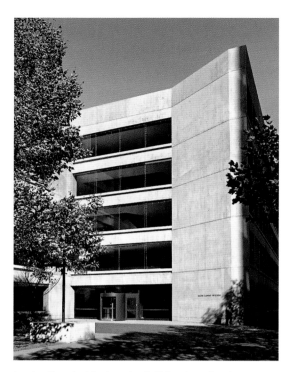

Landau Chemical Engineering Building, base facade

Zeckendorf allowed Pei to take on the job for his alma mater, but as in-house pressures mounted and with the general scheme established, Pei transferred detailed design to Araldo Cossutta, who shared his interest in concrete and long span structure. Cossutta developed the tower as a stack of bridges spanned between solid ends, with oval windows to express active stresses. To Pei's dismay, MIT registered the "strong feeling that the [ovals] did not recall or harmonize with the other rectangular forms around it" and requested design alternatives.[4] Reluctant to intrude, he felt compelled to act when construction bids came in significantly over budget; Pei volunteered to redesign the tower without cost to MIT. He eliminated the costly long-span structure by the introduction of intermediate supports and a great 10-foot-deep (3 m) beam that helps transfer the building's loads to the ground. Because the gridded concrete facades are load-bearing, the interior of the building is column-free, leaving the second floor open for tall McDermott Auditorium and the third floor for the library. Upper levels are maximally flexible to meet changing office, laboratory and classroom needs. The now-orthogonal windows were made to echo both the 9-foot (2.7 m) module and classic serenity of MIT's historic core.

The tallest building at MIT, and indeed the tallest building in all of Cambridge, the landmark tower was dedicated in 1964. Pei accomplished this, despite problems that greater experience might have prevented, most embarrassingly wind forces that under certain conditions prevented the doors from opening. The entrance porticoes were ultimately redesigned and the wind tunnel visually transformed into an open frame for *Great Sail*, a 40-foot-high (12 m) Alexander Calder stabile that adds a colorful organic foil to the formal buildings.[5]

Pei lamented the opportunity lost in his first independent building. "I was so involved with Zeckendorf when the project came in," he explained. "But even if I'd had the time my thinking was very rigid because of low-cost housing. It's very difficult to think freely. I only gradually loosened up enough to start thinking about architecture as art. . . . If I had a little more experience, more time, it would have been an important beginning."[6]

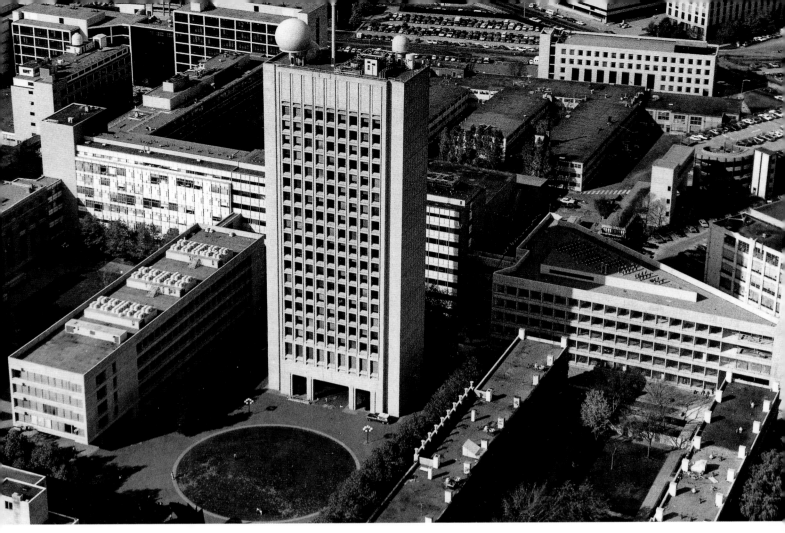

Bird's-eye view over Eastman Court

If the Earth Science Building wasn't all that Pei might have wished, it nonetheless served him as a strategic springboard, most immediately with an important credential for the commission to design NCAR.[7] MIT went on to commission three additional buildings.

The first was Dreyfus Chemistry Building, which began directly after the tower's completion. Its long, low mass sculpturally balances the focal "flagpole" and shapes courtyards on either side. It facilitates circulation with pathways continued on one end through a cantilevered open portico, and on the other, with a link to an adjacent building.

In 1972 Pei executed his third building at MIT, Landau Chemical Engineering, whose triangular form drew comparisons with the contemporaneous National Gallery of Art. Both buildings grew

directly from their sites, Landau from a narrow wedge at the intersection of two campus grids, but there the similarity ends, as MIT's building has none of the museum's defining spatial play. In Landau, the key issue was connection. A two-story open portico in its angled prow forms a new portal to the campus; a four-story bridge at the opposite end feeds into MIT's all-weather circulation network.

Pei would later design the Wiesner Building at the gateway to MIT's developing east campus.

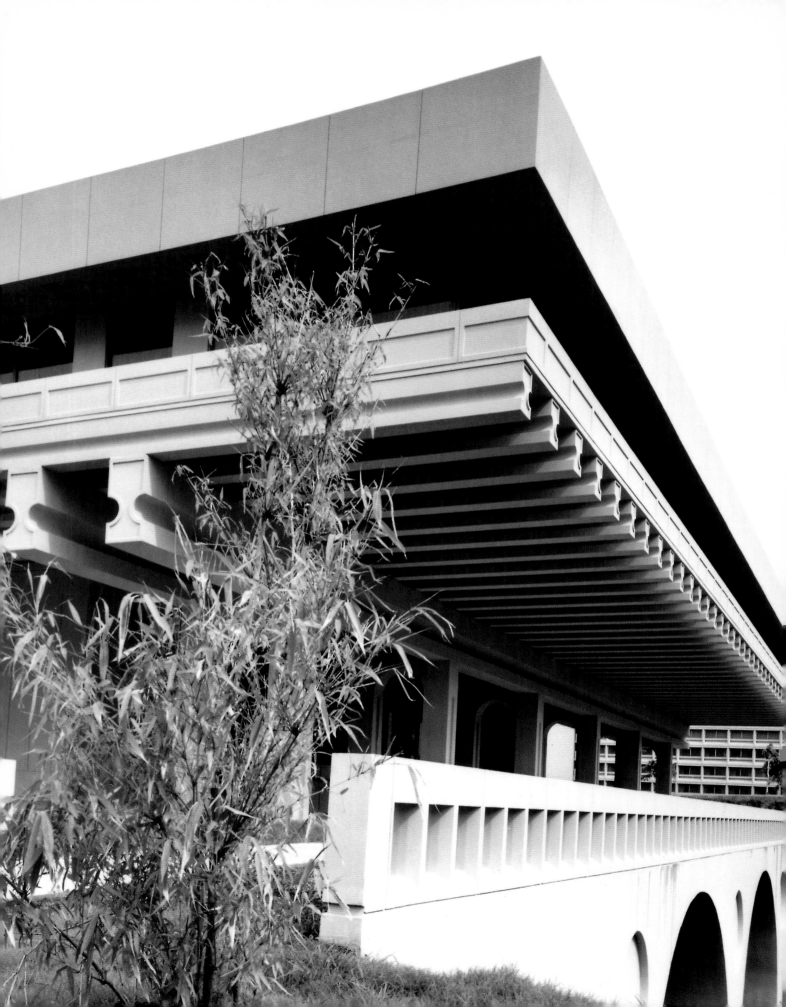

EAST-WEST CENTER

University of Hawaii
Manoa, Hawaii
1960–63

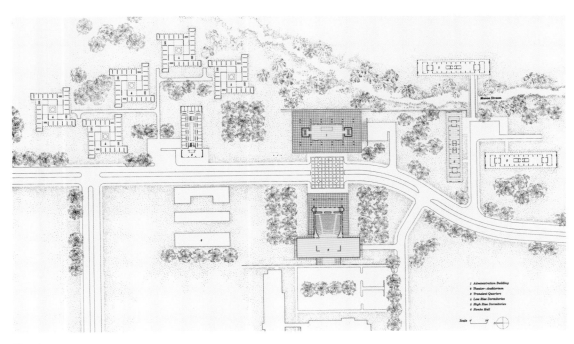

Site plan

In April 1959, barely a month after Hawaii's statehood, Senate Majority Leader Lyndon Baines Johnson called for an international education center in Hawaii as a meeting place for East and West.[1] A draft proposal from the University of Hawaii eight days later became the framework for the East-West Center. With many underdeveloped Asian countries peering into an uncertain future, East-West Center was to be the instrument of an enlightened Cold War foreign policy that sought defense through cultural exchange and understanding rather than in weapons.

The University of Hawaii made available twenty-one acres (8.5 ha) and in the process transformed itself from a struggling land grant college on the distant Pacific frontier into a hub of higher learning, drawn closer to the mainland by the advent of regular passenger jet service in 1959. Local architect Cliff Young was asked to associate with a leading designer, whereupon he contacted Pei, whom he had met in a college as members of the same Chinese fraternity.

Pei undertook a comprehensive master plan, from which three buildings, an administration building, a theater, and a dormitory, were ultimately realized with his involvement. Bearing certain formal similarities with his plan for Southwest Washington, the complex was disposed to integrate with the larger campus but at the same time, to stand apart in the greater formality of its federal affiliation. Amid the feverish postwar building boom that gave rise to more than

Jefferson
Administration
Building, garden
facade

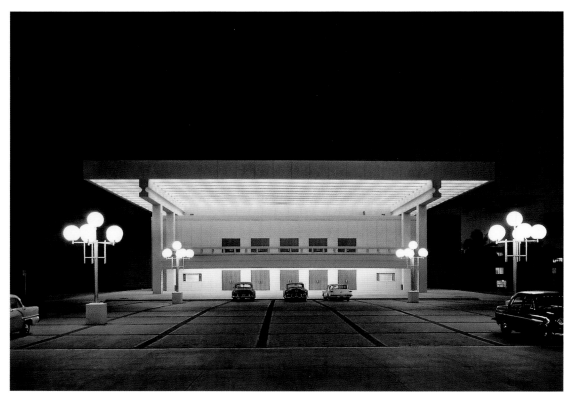

John Fitzgerald Kennedy Theater, main facade with original globe lights

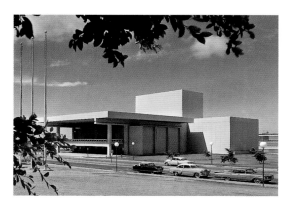

Kennedy Theater, oblique view

half of the university's buildings in a "hodge-podge" of architectural styles, East-West Center introduced a coordinated family of buildings that visually and functionally interlock.[2]

In a grand gesture two gateway buildings and a connecting plaza establish the character of the complex with uniform rooflines, palettes, and a heady display of technical prowess. A shared, although varied, vocabulary reveals their different functions and also the individual design

sensibilities of their architects. "In those days," Pei explained, "I had to delegate, and that made I. M. Pei & Partners possible. Fortunately, I had good people I could depend on."[3]

The glazed ground floor and perimeter arcade of Jefferson Hall humanize this large administrative center with cooling spaces that invite lingering and views of the nearby mountains. Offices, libraries, and conference rooms cantilever out from four 216-foot-long (66 m) girders, as an arcaded dining hall opens to a Japanese garden below.[4]

From an outdoor area, theatergoers proceed inside to a narrow "lobby" and up the stairs at either end to the second-floor auditorium entrance. The real lobby is the outdoor lanai, wide open against the hermetic theater, with sweeping views and cooling trade winds under the 88-foot (27 m) long-span beams. Inside, the warm teak theater was designed for maximum flexibility and equipped with elaborate staging technology to present both Eastern and Western performances.[5]

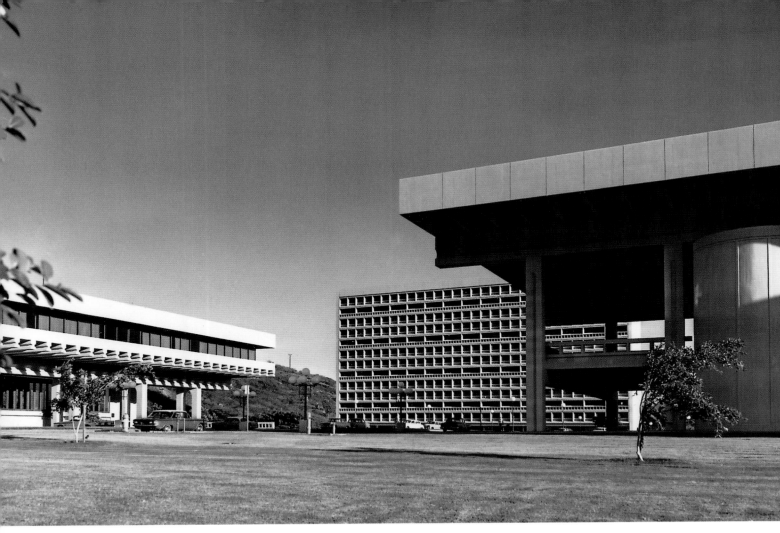

General view

Nearby a thirteen-story men's dorm houses groups of ten students (limited to two from any country) who share one of forty-eight living rooms and connecting open balconies. Like the theater and administration building, the dormitory took full advantage of the tropical landscape, which was enriched by now mature monkeypods, rain trees, and lush ground cover. "The job was big and important," said Pei, "but it had a very limited budget" ($4.2 million inclusive).[6] To ensure quality at minimal cost all three buildings were executed in precast, rather than poured-in-place concrete, and then painted for protection against a tempestuous daily weather cycle.

After nearly a half-century the complex remains largely intact and in remarkably good condition, although compromised in its serenity by a steep rise in campus traffic.

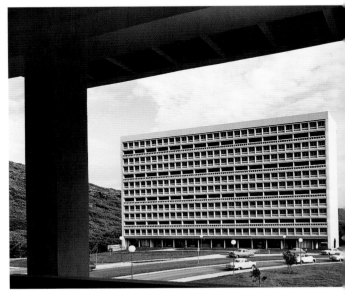

Dormitory, view from Kennedy Theater portico

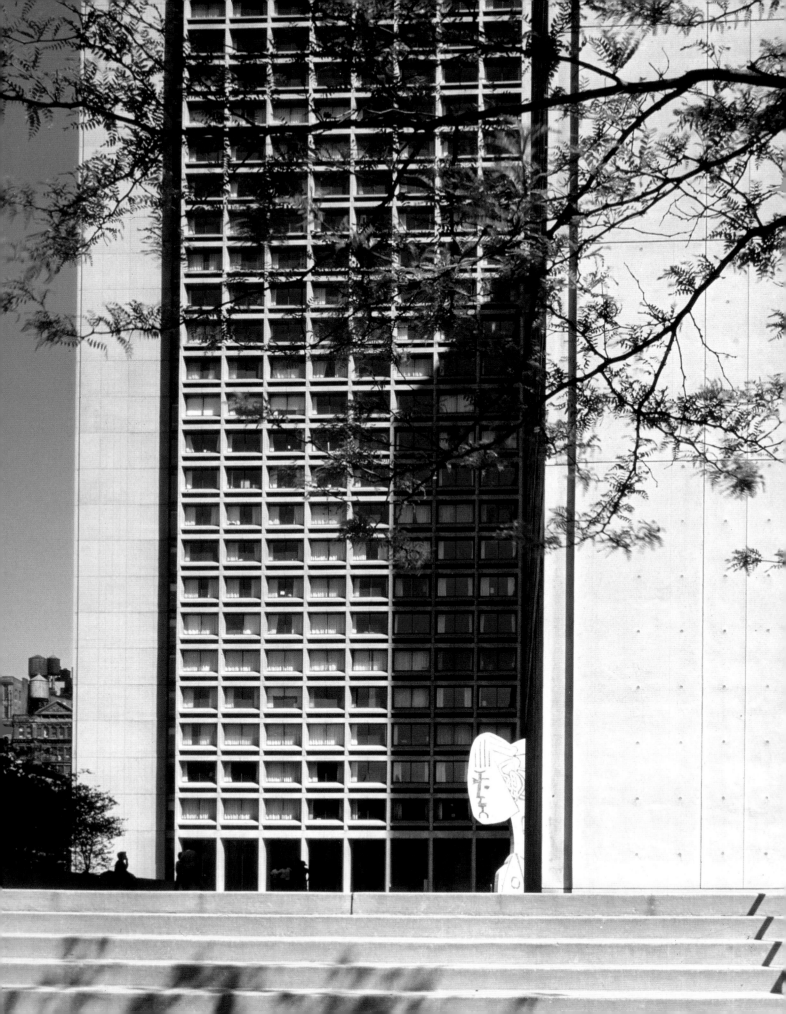

UNIVERSITY PLAZA

New York University
New York, New York
1960–66

University Plaza, Pei's first commission after separating from Webb & Knapp, was a transitional work that bridged a decade of urban renewal to institutional commissions and the greater artistic opportunities they afforded. Identified by Fortune Magazine as one of "Ten Buildings that Climax an Era," it refined the pioneering achievements of Kips Bay, which the same magazine heralded two years earlier as one of "Ten Buildings that Point to the Future."[1]

The 5.5-acre (2.2 ha) site was originally part of Washington Square Village, a Title I redevelopment slated for three "superslab" apartment buildings, each nearly 600 feet (183 m) long. But upon completion of the second, the developer offered the remaining parcel to New York University (NYU). City officials approved the sale provided a third of the units were reserved under the state's Mitchell-Lama Act for low-cost housing.

Early concepts envisioned one or two mid-rise buildings surrounded by additional housing in scale with the Greenwich Village neighborhood. But to accommodate the required number of apartments, the peripheral units bulked significantly higher than adjacent brownstones and fronted on Houston Street, a congested cross-town corridor. It was decided instead to deploy 534 apartments in three tall slender towers—two for NYU, one for Mitchell-Lama—turned away from Houston Street and onto a central plaza. The towers are unified at city scale by their shared design, but separated on the ground by an internal road (the segment of Wooster Street closed by the superblock). They are also distinguished

View from
West Broadway

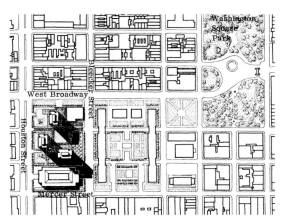

Location plan

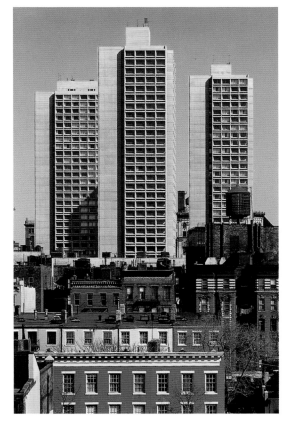

Greenwich Village skyline

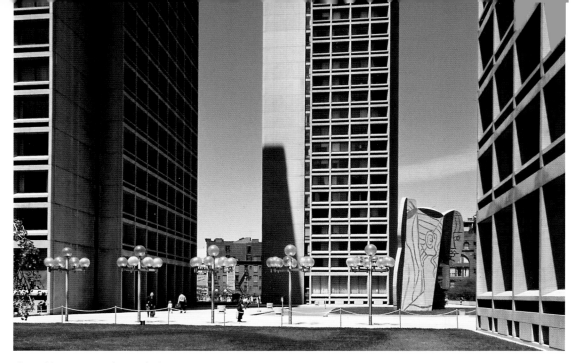

Plaza with monumental *Bust of Sylvette*

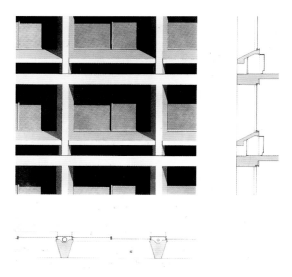

Concrete wall details: elevation, section, and plan

by their orientation so that NYU's buildings front onto the plaza, while the other tower opens onto its own landscaped mews. Mass is minimized by solid fins, or shear walls, projecting window grids, and narrow slot windows in between, all of which visually slice the towers into leaner, more vertical slivers.[2]

University Plaza evolved the Kips Bay prototype. The architectural concrete structure was now poured in smooth fiber glass forms, with raised window sills over integral air-conditioning

units and triangular columns that honed weighty structure down to an elegant narrow edge at front.

It also grew from Society Hill, and it was John O'Mara, head of NYU's Development Office and previously the owner's representative at Society Hill, who first contacted Pei. The same pinwheel composition was adopted so that the long flanks of two towers are offset by the short end of the other (in airy contrast to the superslabs nearby). But here, instead of allowing space to flow through and out to the city as in Philadelphia, the New York towers contain their space in a loophole that opens in and out to Bleecker Street, the two-way dynamic charged by Picasso's monumental *Bust of Sylvette* (1968). Pei had previously hoped to install the same sculpture at Kips Bay, having discovered it several years earlier in a Paris café where he overheard two Norwegians at the next table. When Pei introduced himself, Carl Nesjar explained that he collaborated with Picasso in fabricating his work at large scale and showed Pei photos of a small bent-metal prototype. "It was so simple, so active, so filled with cubist movement and change," said Pei. "I realized right then the incredible potential to make sculpture in scale with modern buildings."[3]

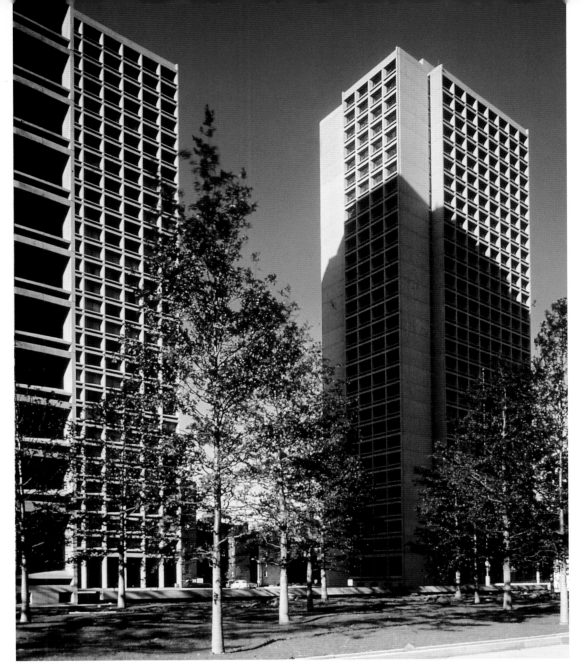

Bleecker Street view

Pei lobbied at length to win $75,000 for *Sylvette*. He traveled to Oslo at his own expense, after which he asked Nesjar to make a small maquette, positioned it in a model of University Plaza, and sent the whole to Picasso who was happy to have a major work in New York's emerging SoHo arts district. *Sylvette*'s size and playful peek-a-boo engagement from the street were painstakingly worked out in photographs and on site where balloons were floated to determine her optimum three-story height. A 20-foot-by-36-foot (7 x 11 m) zigzag wall executed in the same buff-colored concrete as the towers, the 60-ton (54,000 kg) sculpture was placed directly on the grass to create a unity of architecture, sculpture, nature, and open space—the kind of total environment often discussed by modern architects but rarely achieved. The rich result was brought about only by Pei's personal commitment and an expenditure of time and effort that far surpassed the narrow limits of the low-budget building program ($11.3 million inclusive).

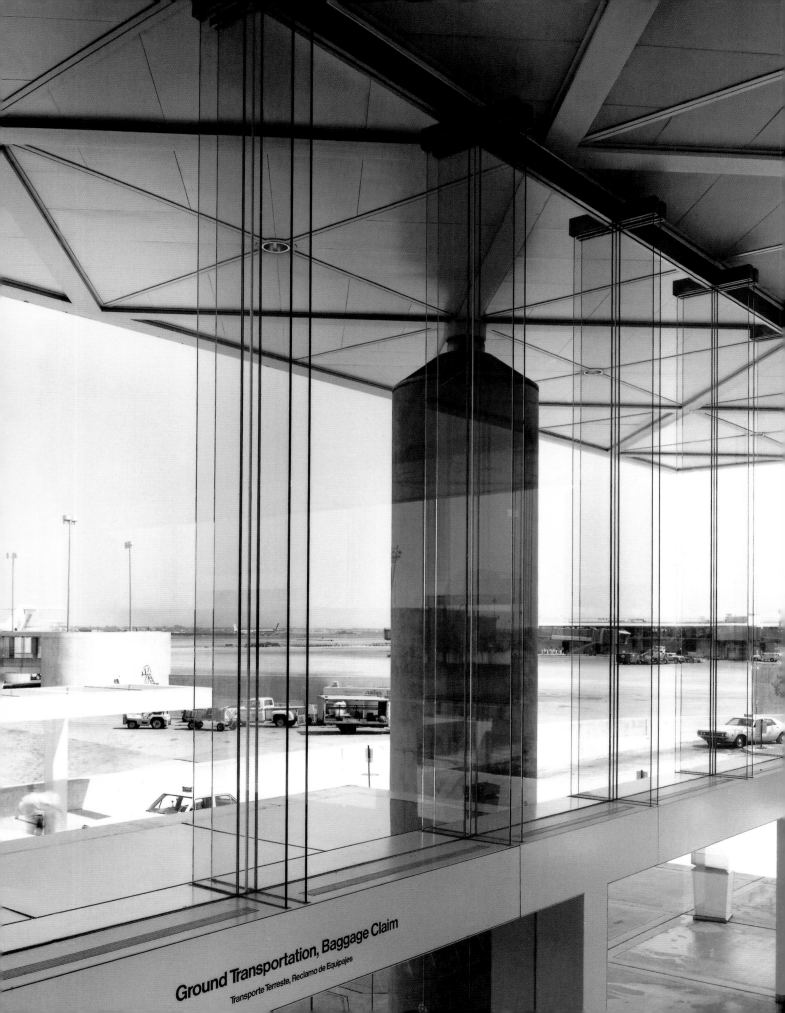

Ground Transportation, Baggage Claim

Transporte Terreste, Reclamo de Equipajes

NATIONAL AIRLINES TERMINAL

John F. Kennedy International Airport
New York, New York
1960–70

Premiated competition entry, exterior rendering

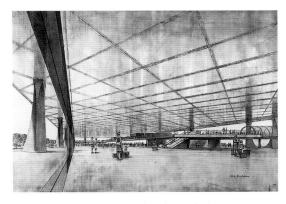

Premiated competition entry, interior rendering

Suspended glass wall
system, interior view
out to airfield

In August 1960 Pei won an invited competition in which the Port Authority of New York and New Jersey asked five prominent New York architects to submit designs for a domestic multi-airline terminal at Idlewild Airport (now John F. Kennedy International). Like every other terminal, Pei's was unique but rather than compete with its neighbors, particularly Saarinen's expressionistic TWA terminal under construction on the adjacent site, it aimed for tranquility. A 600-foot-long (183 m) glass pavilion combined indoors and out to create a sense of continuous open space with its own quiet excitement. With its 10-foot-high (3 m) horizontal roof hovering on sculptural concrete pylons outside the building's glass walls, it drew from Pei's experience as a world traveler to create clear circulation paths in a serene building. Influenced by Mies's clear-span structures, the scheme yet reveals Pei's own aesthetic with a sculptural sense of classical form, mastery of technological means, and a characteristically analytical approach to the management of great numbers of people in transit.

Eason Leonard, Pei's managing partner of a half century, recalled how, after the team struggled for two weeks with complex traffic flow on the constrained 22-acre (8.9 ha) site, Pei provided the solution with a simple circulation diagram wrapped all the way around to include the back side of the terminal, which was traditionally reserved for baggage transfer.[1] The scheme was developed without the tiered arrival and departure ramps that cut across the street facades of other terminals. Instead, departing passengers approach along the building's extended curb frontage under the shelter of its deep roof overhang, proceed inside to a central freestanding check-in counter, take an escalator up to a retail/dining/lounge mezzanine, and cross a bridge to the boarding gates. Arriving passengers, herded unceremoniously out of other terminals, were here greeted by a grand space before collecting their luggage and exiting the terminal on a separate roadway along the airfield side of the building. Celebrating the gateway experience as it streamlined internal circulation, the solution

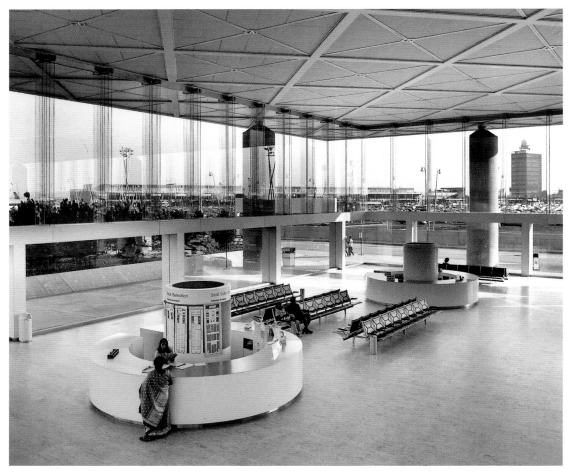

Departures terminal, interior

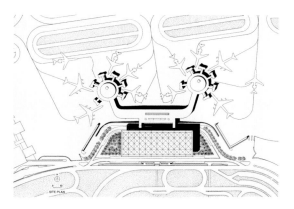

Plan, with enlarged satellites and arrivals pavilion

Progress stalled shortly after the competition when the multi-tenant airlines expected by Port Authority failed to materialize. National Airlines then took over and commissioned Pei to adapt the design to its more limited needs in a smaller building. The airline's sagging finances wrought further delays, only to be dramatically revived by the introduction of passenger jets and a rapid mid-decade rise in travel, all of which prompted new requests for a 100,000-square-foot (9,300 sq m) expansion. In response, the roadways were augmented and in place of the two long original jetways, circular boarding satellites were added to facilitate aircraft docking and concentrate gateway access for passengers. In between the satellites, a new two-story concrete and glass pavilion for arriving passengers was built whereupon the original glass box was remodeled for departures

also relieved vehicular congestion which, already by the early 1960s, had become one of the most critical problems in airport design.

The scheme's simplicity was to prove its salvation since extensive changes were implemented as the challenges of air travel continued to evolve.

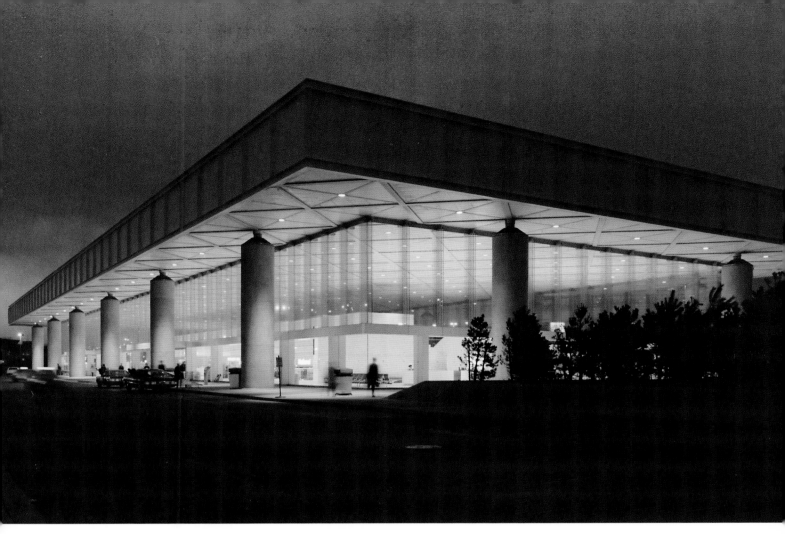

Departures terminal, exterior

only. Shortly before opening, National requested yet additional changes to accommodate new 747 jumbo jets. The terminal was taken over by TWA for domestic flights in 1981, and customized by Jet Blue in 2002. Despite nearly a half-century of change, the basic design has remained remarkably intact as the big open space allowed internal functions to be reshuffled with relative ease.

The building, distilled to essentials, is supported on just six concrete columns along the front and back and two on either side. Its 7-million-pound (3,200,000 kg) roof balances on 21-inch (53 cm) stainless-steel ball joints whose simplicity belies all the draining, ventilation, and electrical conduits housed inside. From the outset, the great mullion-less glass walls were to be defining.[2] According to Pei, when the TWA terminal was engineered against the wind, its mullions "looked strong enough to support the building" but here where "the mullions are glass, there is no doubt about what is holding up the roof."[3]

Although budgetary constraints led ultimately to the use of a conventional steel truss, the ceiling retains the crisscross pattern of the spaceframe originally envisioned. It is an expressive anomaly in a building that dramatizes pure structure, yet the patterning plays an important role in visually unifying a building wherein signage was fully integrated, indoor and outdoor lighting levels carefully balanced, and all the joints in the ceiling, walls, and terrazzo pavement made to match up in a balanced whole. Such resolution is a hallmark of Pei's work (according to legend, careers have ended over misaligned joints), where the end result is not so much seen but rather sensed in an overall harmony.

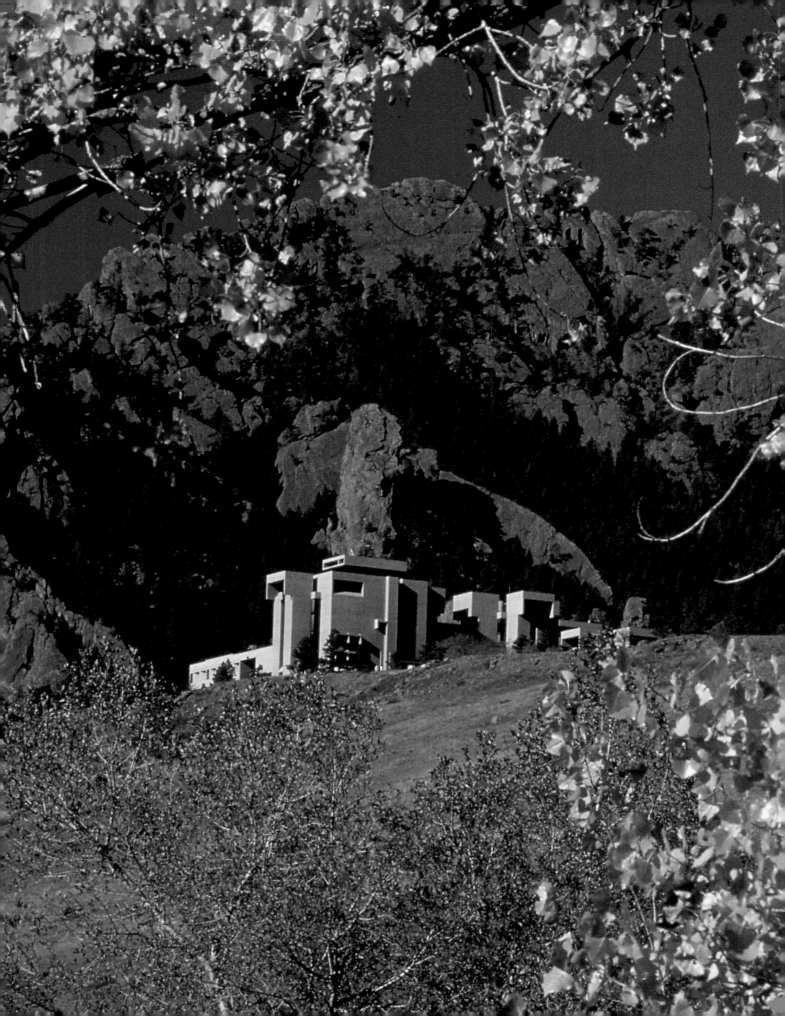

NATIONAL CENTER FOR ATMOSPHERIC RESEARCH

Boulder, Colorado
1961–67

The greatest opportunity, and most difficult challenge, of Pei's early career came with the commission to design the National Center for Atmospheric Research (NCAR), just ten months after he began independent practice. The building type, the client dynamic, the context, site, and even the architectural process required him to "rinse his brain" and, at age forty-four, to start anew.[1]

As scientists lobbied to redirect radar and other wartime technologies, the National Academy of Sciences urged a major Cold-War initiative in the United States. Fourteen schools formed the national University Corporation for Atmospheric Research (UCAR) and chose as its first director Dr. Walter Orr Roberts, a pioneering astrophysicist and visionary administrator. He accepted the position provided a new research laboratory under his direction would be built in Boulder, Colorado.

A 600-foot-high (183 m) mesa (admired by Roberts for years from his living room window) was selected amid the Flatirons of the Rocky Mountains, and purchased by the Colorado State legislature. Meanwhile as some fifty architects from Alvar Aalto to Minoru Yamasaki were considered, it was decided instead to rely on recommendations from the deans of the eight schools of architecture within UCAR's member universities. Pietro Belluschi served as committee spokesman and introduced Pei, then working on MIT's Earth Science Building. Daylong interviews were conducted with the candidates, followed by site visits by plane and on foot. As an urban architect largely focused on slum

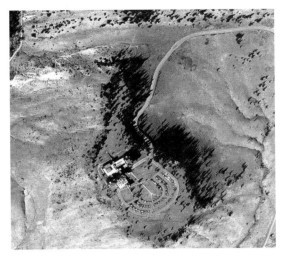

Aerial view

clearance, Pei appeared to have little relevant experience. With some $68 million of work, there were also doubts about how much time he would have for NCAR's relatively small building. Pei assured Dr. Roberts that he would be "very selfish" with the project as it was precisely the escape he sought from the "modern speculative rut." Finally independent, he told the committee: "Each job must be my very best in order to prove myself in a wider field."[2]

NCAR was to be a formidable test completely at odds with the clean efficient buildings he had designed before. The underlying challenge was Roberts' determination to combine group-oriented, often noisy, and cluttered experimental science with individual, sedentary, and quiet theoretical research. Interaction among the scientists was paramount as was maximum flexibility since NCAR was unsure about future needs. The building was to symbolize the dignity and

Mesa labs glimpsed
from below

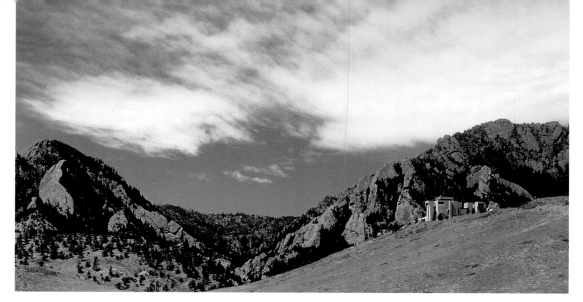

General view with Rocky Mountains

importance of the new national institution yet in spartan terms, humble and intimate rather than grand.

To interpret such an idealistic program on such a magnificent site would seem the perfect opportunity for an architect eager for a breakthrough, but Pei found himself overwhelmed. It was not simply the virgin landscape, he explained, but the scale. "It was infinite; there was no scale. It was so completely different from urban architecture where nothing stands alone and where every building relates to other buildings and to streets and plazas and the spaces in between."[3] He walked the mesa and camped on it overnight to get a sense of the sun, the wind, the boundless open space.

Pei visited the United States Air Force Academy in Colorado Springs where Skidmore, Owings & Merrill (SOM) was completing a metal-and-glass chapel in gleaming contrast to the mountain. Despite his own modernist inclinations, it was not a strategy Pei could follow. NCAR would have to join nature rather than stand apart to win approval; to deter development, the mesa was above the Blue Line beyond which no water, electricity, or other services were supplied.[4]

Inspiration was sought in widespread rugged sources as Pei floundered with multiple ideas developed and quickly abandoned.[5] He didn't arrive at a solution until, driving with his wife from Sante Fe to Boulder, he discovered the thirteenth-century cliff dwellings of the Anasazi Indians at Mesa Verde. Pei concluded the reason they appeared to grow from the ground was the use of native stone. But denied masonry by NCAR's tight budget, he added sand and gravel from a local quarry to concrete and then bush-hammered the surface to reveal the dark pink aggregate — in effect reconstituting the mountain — to bring the building to life with a mica shimmer.[6] A special jig was designed to guide laborers using five-point pneumatic chisels in perfect alignment to the building's stepped 98 foot (30 m) height to disguise the layer cake effect of multiple concrete pours and create instead a weighty unity, as if the building were hewn from a single block of stone. Pei told the Planning Commission that in five thousand years NCAR would be indistinguishable from the mountain.

Nine-foot-thick (2.7 m) load-bearing walls allow the interior flexibility to keep pace with constantly evolving scientific needs (an in-house joke maintains NCAR stands for National Center of Always Remodeling). Outside, the walls protect against climatic extremes and winds that blow up to 140 mph. Glazing was limited to just ten percent of the surface, tinted and hooded against intense high-altitude glare, and tucked into isolated shafts that disguise

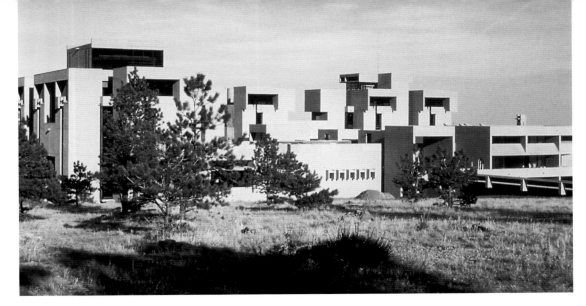

Rear elevation from mesa

Elevation with unbuilt tower cluster stepping down from mesa

Ground-floor plan

the number of floors behind. By removing identifiable human references the building melded into a scaleless whole at peace with scaleless nature. As in the large elemental forms of Mesa Verde, the geometric cubes and cylinders stand up powerfully to the mountains in a way that more delicate or complex buildings could not.

In the past Pei had consulted almost exclusively with Zeckendorf, but now he required complex thinking and listening strategies to satisfy the disparate needs and interests of the scientists. The unifying force was Dr. Roberts who himself profoundly impacted Pei as the first

in a series of extraordinary clients with whom he would develop an enduring friendship. Roberts was "a very exceptional man, a visionary like Zeckendorf, but entirely different," recalled Pei.[7] Working together closely on a single project for years was a new experience unlike the fast-fire multicourse menu he'd been served at Webb & Knapp. Despite major hurdles, chiefly budgetary, NCAR grounded Pei's lifelong conviction that the client is as important as the assignment.

Roberts did not want another Pentagon with endless corridors, but an environment filled with ferment where scientists could clutter, work alone or in groups, and be encouraged, even required, to interact. Rather than spread a low-rise building across the 28-acre (11.3 ha) mesa, the urban architect created a city in the wild, fragmented into narrow five-story towers with nearly half of its facilities underground. The interior is organized in "neighborhoods" with isolated crow's nests at top for quiet contemplation amid spectacular views. The towers are linked by bridges and a central core of communal facilities kept separate from more private research areas. Zigzagging through the whole is a horizontal and vertical circulation system that Dr. Roberts insisted be so complex that visitors would need a guide. Multiple overlapping routes connect every destination with wide passageways, conversation alcoves, and strategic views that make one want

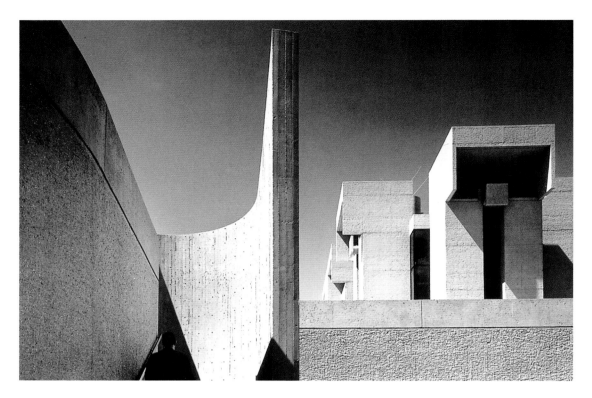

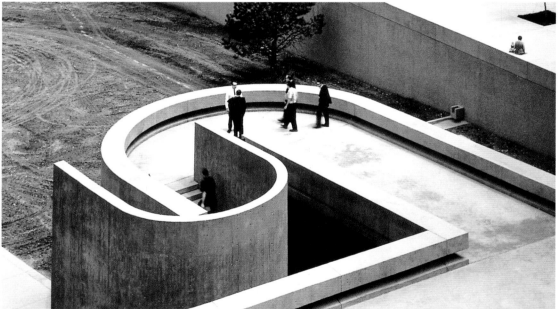

Exterior arrival stair

to linger, all with the aim of inviting spontaneous meetings and exchange of ideas. The element of chance resulted from a rigorously developed grid that maximized cross ventilation (although ultimately the National Science Foundation insisted on air conditioning).

To disguise bulk, the 193,000-square-foot (18,000 sq m) building was located in a far corner of the site with vehicular access hidden behind rocks and pines. Engineers had proposed a minimally invasive road zigzagged along mountain contours but Pei felt a big gesture was needed

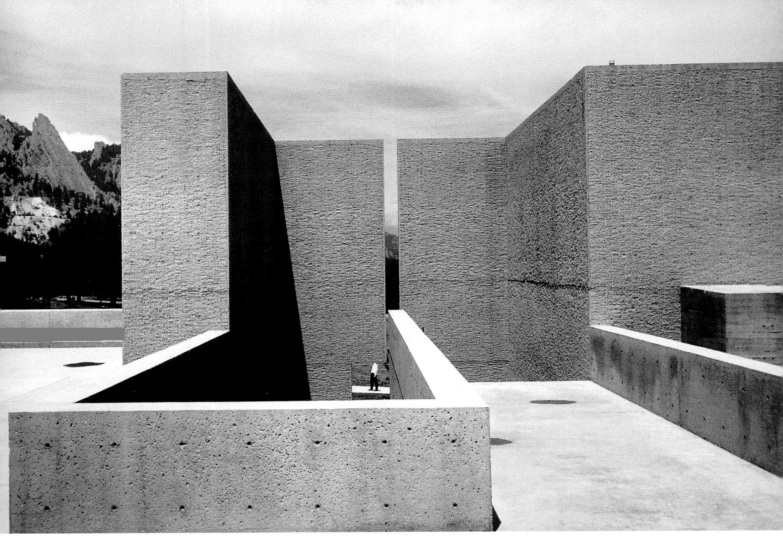

Keyhole window and stairwell

and paced the mesa with landscape architect Dan Kiley, step by step, to locate a sweeping curve that made dramatically clear his belief in the essential oneness of architecture and the land. As in the Acropolis, the mile-long upward procession is an important part of the experience, with the building revealed only at the end.[8] Although there was no conscious connection, it is tempting to see emboldened traces of the intimately scaled Suzhou gardens of Pei's youth, where twisting paths beckon with surprise and where strategically placed windows in large mural expanses quietly put nature on display.

The wild is unchallenged up to the very walls of the building where the manmade environment, geometric and rational, sharply asserts its own order in a tension that holds the two worlds in balance. Sculptural form would have been even more pronounced had a third tower cluster stepped down from the mesa's back slope as originally planned. Pei laments the budgetary cut to this day. "The towers would have grabbed onto the ledge to root the building visually and structurally into the mesa instead of just being perched on top. The south tower would have completed and significantly improved the whole."[9]

NCAR was Pei's first opportunity to explore the art of architecture. If it was unresolved in some areas, particularly at close range, it nonetheless held the germ of a language and approach to design that he would develop more fluidly and with greater confidence, starting with his related design for Everson Museum where Pei first explored public space.

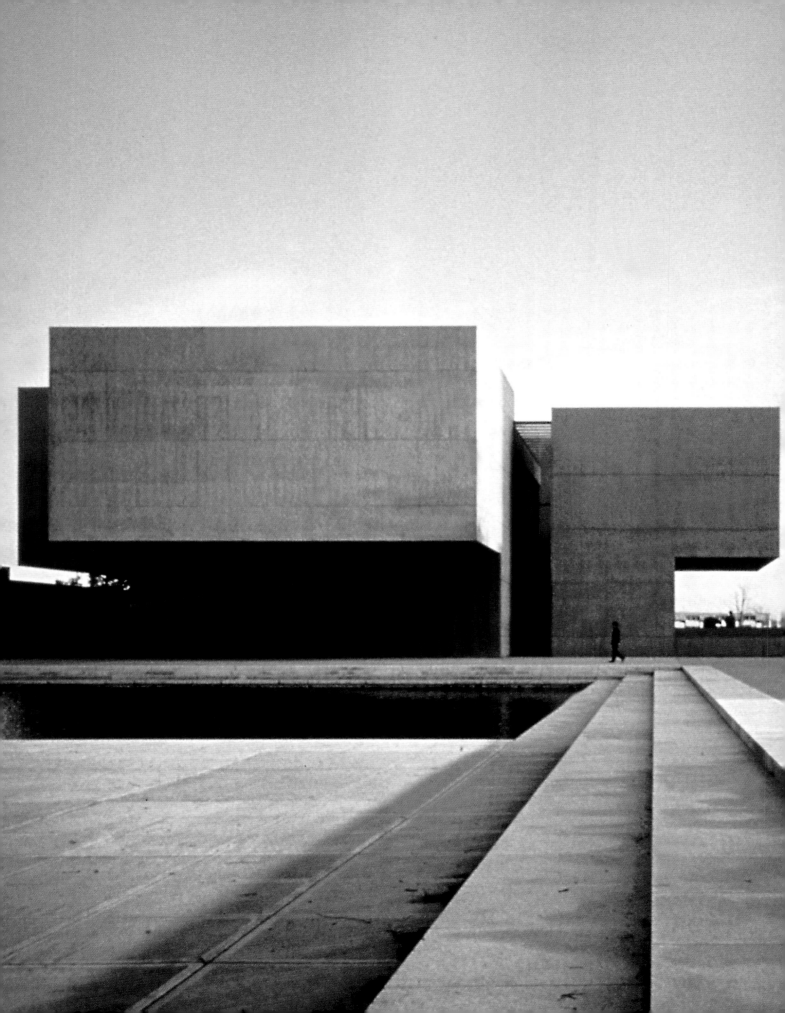

EVERSON MUSEUM

Syracuse, New York
1961–68

Everson Museum was both a summary and momentous advance over everything Pei had done before because, he explained, "it was here that I discovered form, and also space."[1] Celebrated as "a sculpture to house sculpture, a work of art for other works of art," it was the seed of the many museums Pei would champion, and a rehearsal in miniature for the National Gallery of Art.[2] Four decades and scores of commissions later, this small building remains among Pei's favorites.

The museum was part of an ambitious plan to invigorate downtown Syracuse with a new civic center. Since no one else wanted the small low-budget project, the commission went to the relatively unknown Pei, then in town for Newhouse Communications Center at Syracuse University. He had no relevant experience other than a student thesis for a museum in Shanghai.[3]

The challenge lay not only in the museum's limited finances but in its small site in the middle of a sprawling rubble-filled redevelopment area, without context save an old county auditorium and a municipal steam plant. "I was no stranger to urban renewal," said Pei. "I'd made many, many plans for Zeckendorf for slum clearance all over the country, but they were always filled with buildings. Here I had to design one tiny building in the middle of an urban desert. . . . What's more," he continued, "they did not have a collection or a powerful board of trustees, both of which are important for a good museum project. But what Everson offered was freedom."[4]

Pei realized the small building had to be strong enough to stand alone, probably for years,

I. M. Pei, impromptu elevation sketch, 2003

Site plan

and therefore convinced the trustees to include a plaza and reflecting pool on the low-lying roof of a municipal garage directly behind "to eat up some space" and create an open precinct around which future buildings could rise.[5]

Rear elevation with reflecting pool and plaza

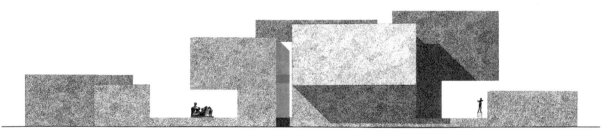

Rendered elevation

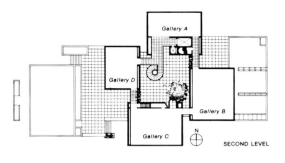

Gallery A

Gallery D

Gallery B

Gallery C

N

SECOND LEVEL

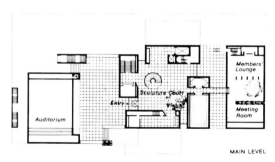

Members' Lounge

Sculpture Court

Entry

Meeting Room

Auditorium

MAIN LEVEL

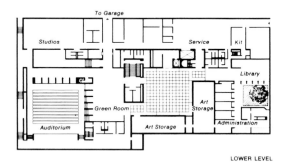

To Garage

Studios

Service

Kit

Library

Green Room

Art Storage

Auditorium

Art Storage

Administration

LOWER LEVEL

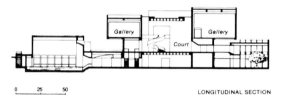

Gallery

Gallery

Court

0 25 50

LONGITUDINAL SECTION

Floor plans and section

With only small ceramics to exhibit, the museum would mainly host traveling shows. To meet its unknown future needs, Pei boldly departed from the prevailing museum trend toward universal, infinitely flexible space and instead created a two-story sculpture court at the center of four volumes, each housing a gallery of different character, size, and height to ensure that objects, large and small, could be appropriately displayed. Team member William Henderson recalled how Pei presented a sketch of L-shaped blocks separated to provide fundraising opportunities for different donors. Initially the cantilevers faced inward, but for greater potency the forms were reversed. "After that, it came together pretty fast. About a month later we basically had the building designed."[6]

Everson belonged to a family of hooded buildings that Pei was developing at the time but unencumbered by programmatic requirements, it was purer, with big simple volumes. "I learned a lot from NCAR," he allowed, "but it was still somewhat reminiscent of Kahn. We went beyond that here. Everson is more of a personal breakthrough for me. I had sensed a close relationship between Cubism and architecture very early on and thus it was natural for me to be interested in exploring form, given the opportunity."[7]

Since the museum needed continuous wall surface for display and since, in any event, there was nothing outside to see, Pei exploited the inherent strength of a solid wall to create four enormous cantilevers in a tour de force integra-

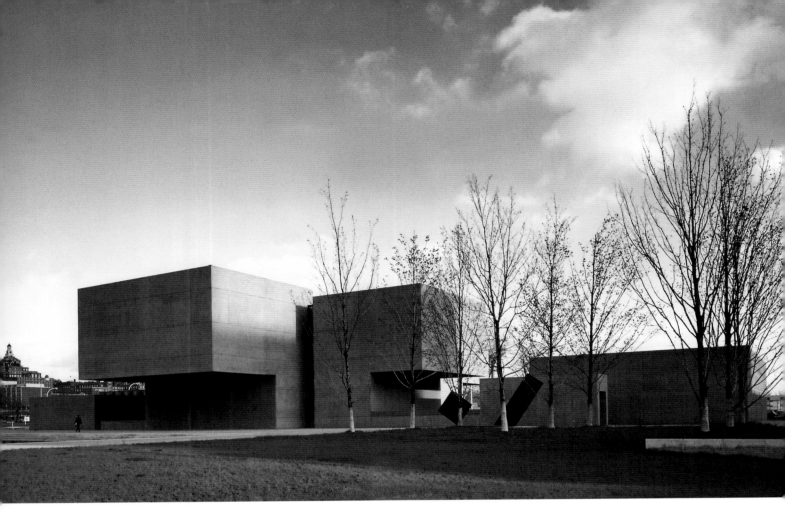

View from garden plaza

tion of engineering, architecture, and art. The individual blocks are joined only by narrow slots of glass so that they hover with a drama that wouldn't have existed had they been more completely joined. "Architecture," Pei explained, "has had a very difficult time getting beyond the Beaux-Arts tradition of buildings as solids in space. In many cases it is the interstitial space that is more important. The void is the key to exciting volumetrics."[8]

The museum rests on a podium base, flanked on one side by an administrative wing with its own small courtyard for natural light and on the other by a 320-seat auditorium, both components recessed into the ground to minimize bulk. It also houses reception, a kitchen, and board room as well as a members' lounge, a green room off the auditorium, a library, classrooms, storage, laboratories, and work areas—in other words,

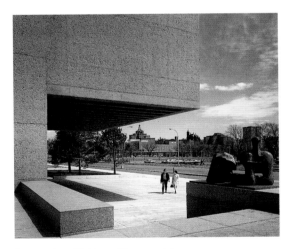

Street entry with Henry Moore sculpture

all the facilities of a large modern museum, just smaller. By relegating functional bulk to the biggest part of the building underground, Pei was free to sculpt above-ground mass into iconic form, as he often did, most clearly at the Louvre.

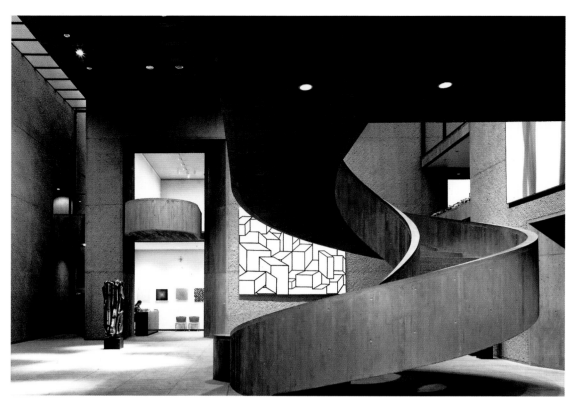

Spiral stair in sculpture court

Pei had hoped to form each snorkel-like component as a whole but when this proved impossible, concrete was laid in successive pours and then bush-hammered, as at NCAR, to conceal joints for a more monolithic appearance, revealing also the glistening red granite aggregates that were added to relate the museum to the dark red sandstone and brick city. Since the elemental blocks have only texture for articulation, bush-hammering patterns were carefully studied on sample walls but none seemed quite right until Pei noticed the slanted grooves made by laborers testing their tools. "The decision to go diagonal," Pei smiled, "was just because it's kind of fun. Why not?"[9] The slanted furrows help visually to support the building, like optical suspenders against weighing down too heavily. A border of smooth face concrete keeps the edges of each plane crisp and obviates the difficulty of matching converging diagonals at the corners.

Bush-hammering continues inside the building where issues of interior and exterior, solid and void, come into play around the intimate 50-square-foot (4.6 sq m) sculpture court that might be called an atrium were it not for its concrete ceiling (a preview of what was originally intended at the East Building). The waffle slab floats overhead between narrow glass strips so that light slips down the sides of the court to separate the four gallery blocks, like individual buildings pinwheeled around a roofed public square. Consciously or not, the arrangement is similar to traditional quadrangle houses in China, where separate living units surround a central courtyard that is the core of family life.

Galleries are interconnected by open bridges around the central space in a richly varied path through the museum, sparked by mystery and surprise. Visitors exiting the first room look into the court, itself an exhibition space, and then proceed in and out, glimpsing and experiencing different spaces on the way from one gallery to another, separated and unified by the court. "The space opens, sideways and up," said Pei.

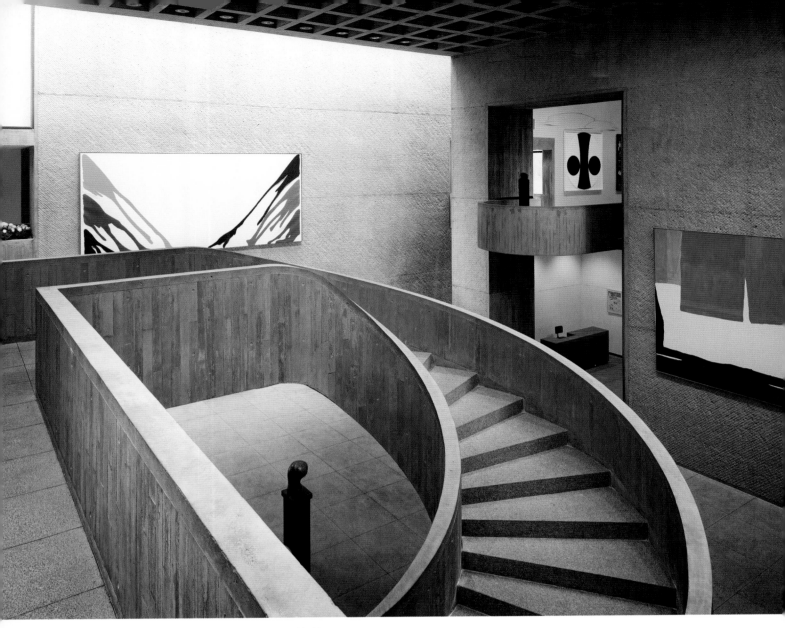

Sculpture court from upper level bridge

"It provides a change of pace between the exhibition areas and gives your eyes a rest. Fatigue is not limited to the feet; it's in the mood."[10]

The whole climaxes in a muscular concrete stair that spirals up to the second floor with changing light and views. According to Max Sullivan, the first director of the museum, it was the "greatest sculpture in the museum."[11] It was also the only major object in the completed building, in consequence of which Pei used his by then well-established contacts in the art world to help Everson acquire some of its finest pieces, including the Henry Moore sculpture at the entrance. He also commissioned important paintings by Morris Louis and Al Held, each for a specific wall and view.

Many years later Pei reflected, "Everson presented me with greater freedom than I ever had before and more than I would have enjoyed had the museum had a collection. I got pretty much what I wanted here. You see, you can do things in a museum that you cannot do in schools, dormitories, or public housing. You have to wait for the right program. I couldn't do it before because there had been no opportunity. But now I had a chance. I was beginning to find my way."[12]

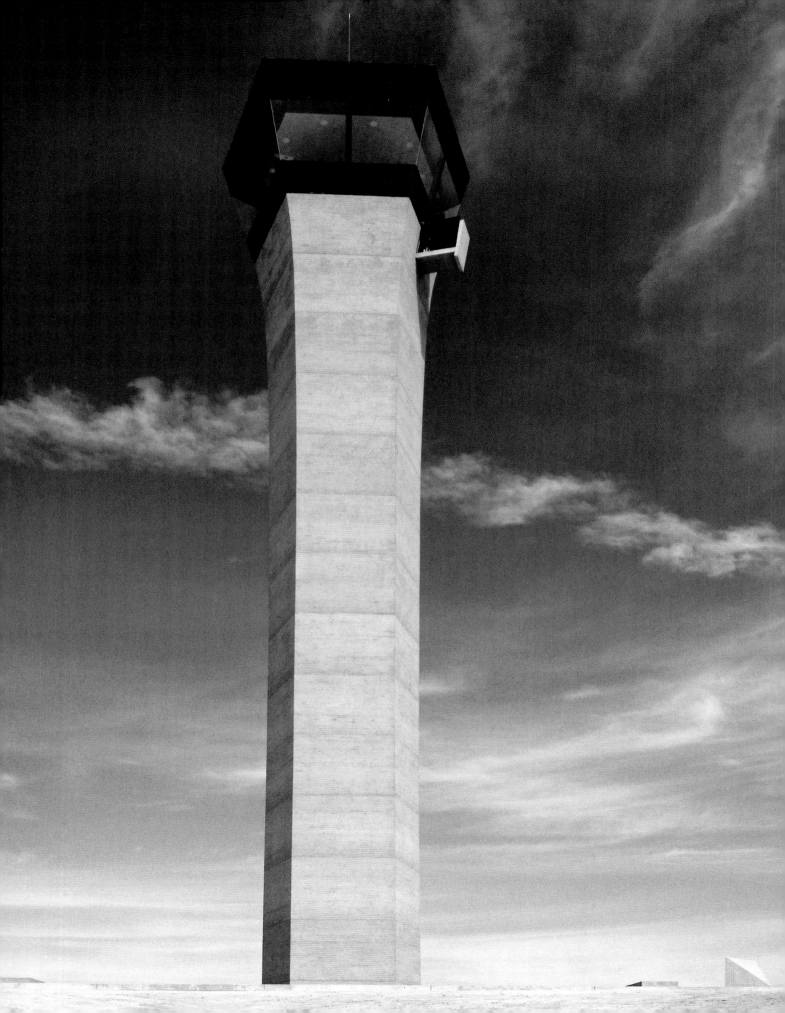

FEDERAL AVIATION ADMINISTRATION AIR TRAFFIC CONTROL TOWERS

Various locations
1962–65

The commission to design a prototypical Federal Aviation Administration (FAA) air traffic control tower was the first initiative of the Kennedy administration's resolve to improve the quality of federal buildings. Shortly after his appointment as head of the Federal Aviation Administration, Najeeb Halaby, with the encouragement of the president and first lady, invited Gordon Bunshaft, Eliel Saarinen, Henry Dreyfus, William Walton, and several others to advise him on design. A competition of ideas was staged in interviews with leading architects, and won by Pei in early 1962. The victory seeded a connection to the Kennedys, which would catapult Pei to national prominence.

Up until 1961, air traffic control towers were individually designed and built by local communities or airport operators, often on top of passenger terminals. The FAA determined to overhaul the system with freestanding state-of-the-art towers that would serve as a uniform symbol of air safety in airports, large and small, with and without radar. It was a unique challenge for an architect who throughout his career designed site-specific buildings.

The towers were conceived as an assemblage of three generic parts: cab, shaft, and base building, which could be mixed and matched according to need. Since the site was anywhere, Pei opted for a nondirectional pentagon.[1] Control tower personnel were separated by visual requirements. The very few who needed to

Prototypical tower,
El Paso, Texas

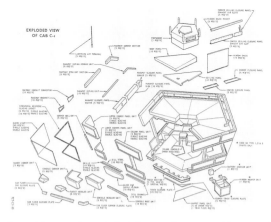

Control-tower cab, exploded diagram from assembly manual

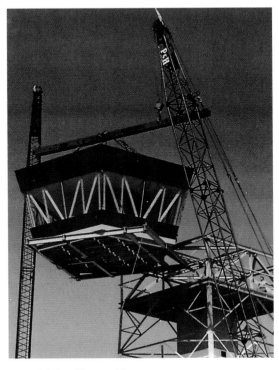

Test cab hoisted into position

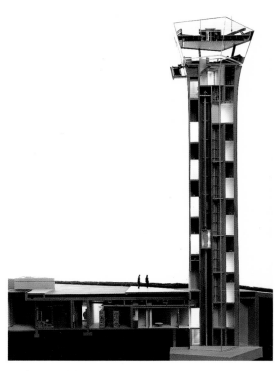

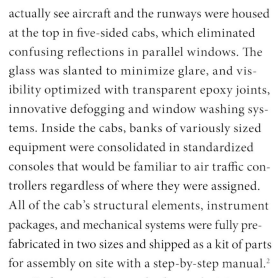

Sectional model

Central stairwell

actually see aircraft and the runways were housed at the top in five-sided cabs, which eliminated confusing reflections in parallel windows. The glass was slanted to minimize glare, and visibility optimized with transparent epoxy joints, innovative defogging and window washing systems. Inside the cabs, banks of variously sized equipment were consolidated in standardized consoles that would be familiar to air traffic controllers regardless of where they were assigned. All of the cab's structural elements, instrument packages, and mechanical systems were fully prefabricated in two sizes and shipped as a kit of parts for assembly on site with a step-by-step manual.[2]

Radar specialists and other technicians who needed only to see their instrument panels were relocated from traditionally tight quarters in the narrow tower shaft to sound-protected facilities excavated into the ground, which could be adapted to any terrain in expandable layouts, ranging from 3,500 to 17,000 square feet (325-1,600 sq m). The partially submerged base building opened away from the airfield,

while toward the runways it became a landscape element with a gentle slope or flat plane to ensure unobstructed sight lines.

The tower shaft, now empty of function, flares out to the cab at top, splays slightly at bottom to increase lateral stability, and tapers gracefully at center to the minimum required for the elevator, stairs, and electronic cables housed inside. To establish a curvature that could be uniformly applied at five different heights ranging from 60 feet to 120 feet (18–36 m) — 150 feet (46 m) at O'Hare in Chicago — a sailmaker's warehouse was rented in Brooklyn where the contours were worked out at full size on the open floor. Wooden templates were cut and crated to contractors for pouring the architectural concrete shafts.[3] A squat silolike alternative, prefabricated in metal panels, was also designed for smaller airports.

Evoking in its sculptural simplicity the freestanding "Joy of Angels" Bell Tower Pei would build some forty years later in Japan, the tower is a clear expression of its limited but highly

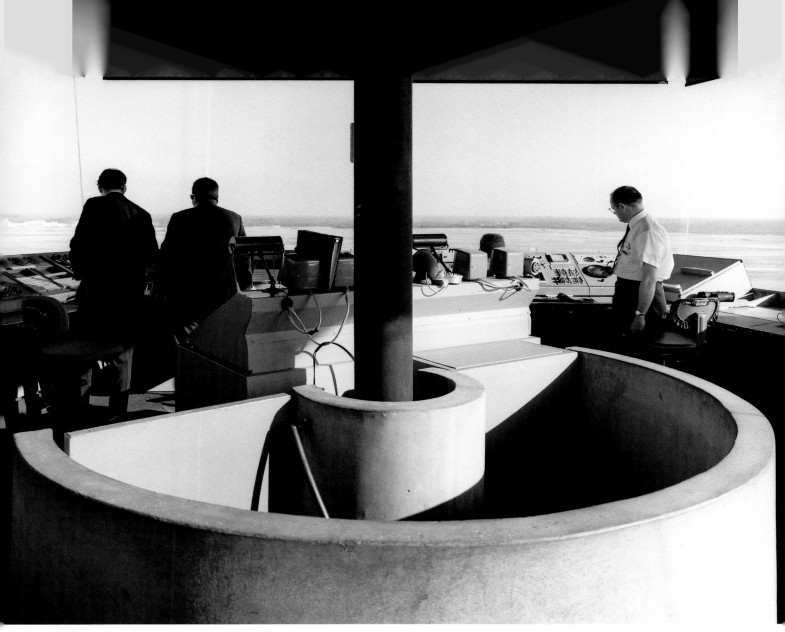

Standardized cab interior

technological program. "Everything you see is the result of a purely functional requirement," Pei explained. All of the mechanical and electrical equipment was buried, "just like sewer lines. Everybody can see the important part. It becomes powerful because it is so simple."[4] As *Architectural Forum* observed, "Here the functionalist and the artist are in a rare and happy marriage."[5]

Of the seventy control towers originally envisioned, sixteen were constructed in the early 1960s under full or partial supervision of Pei's office. Najeeb Halaby left the FAA in 1965,

after which his successor agreed to build less expensive towers under pressure from the United States Comptroller General who believed the FAA had given "undue merit to aesthetic factors" over cost.[6]

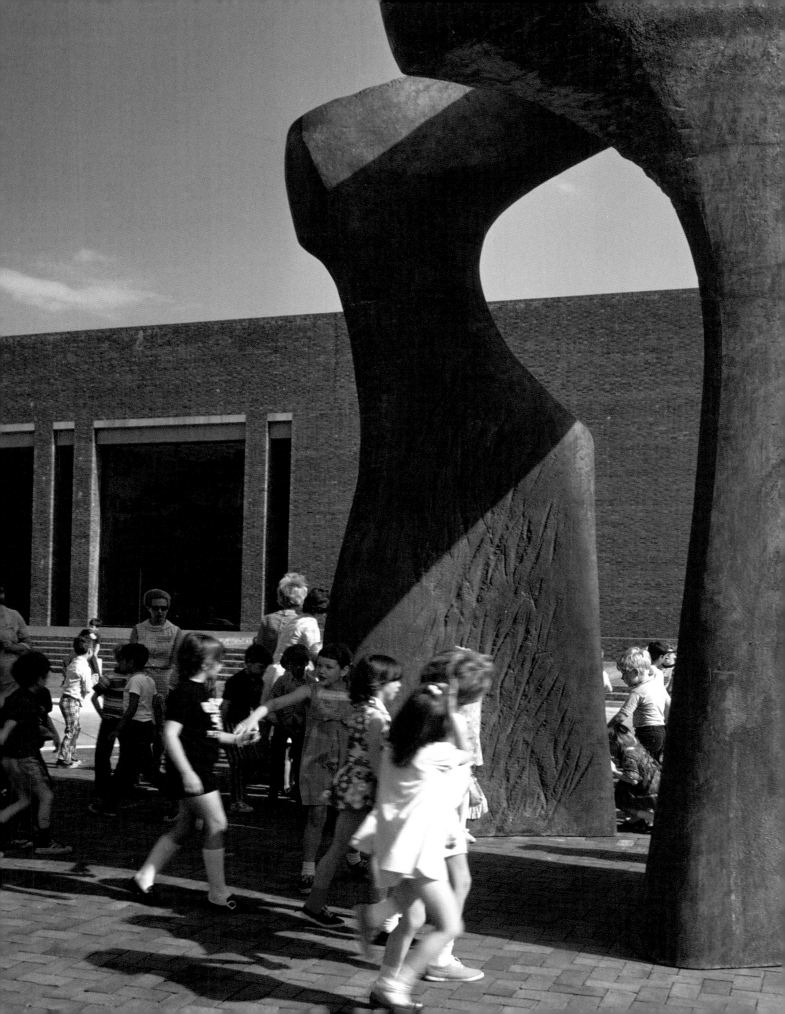

CLEO ROGERS MEMORIAL COUNTY LIBRARY

Columbus, Indiana
1963–71

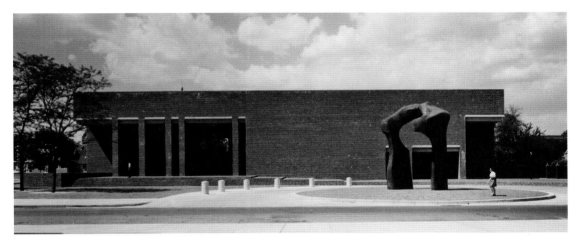

Main elevation

Columbus, Indiana, "Athens of the Prairie," far outranks most cities for the number of buildings by leading architects. The phenomenon was brought about by J. Irwin Miller, chairman of Cummins Engine Company, world's largest diesel manufacturer, who realized a stimulating environment with good schools attracted top talent to his company. In 1954, through the Cummins Foundation, he offered to pay architectural fees for new schools (and later, civic buildings also) provided the architects were selected from a list prepared by consultants.

Miller encouraged variety in an attempt to avoid the heavy stamp of a company town, hoping also to seed a domino effect whereby residents, grown accustomed to quality design, would engage top architects on their own. Both issues came to fruition in 1963 when the Bartholomew County Library Association, assisted by Pietro Belluschi, independently interviewed eight architects to design a new building with public

Site plan

and private funds. They selected Pei, who was still relatively unknown.

Cleo Rogers Memorial County Library brought urban planning to a city that had none. Miller's call for variety had produced a group of unrelated architectural gems spread far apart, in some cases by miles. Pei recognized in this small cornfield-surrounded city the same decentralization that he'd battled for years in major

Plaza with Henry Moore's 20-foot-high *Great Arch*

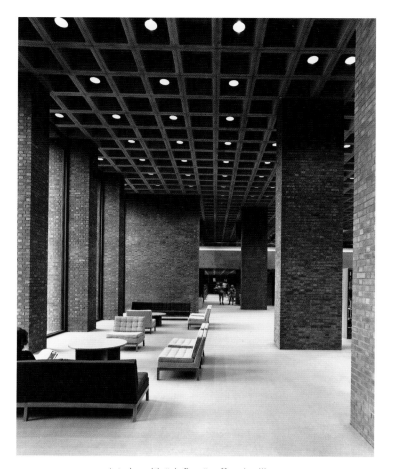

Interior with "air floor" coffered ceilings

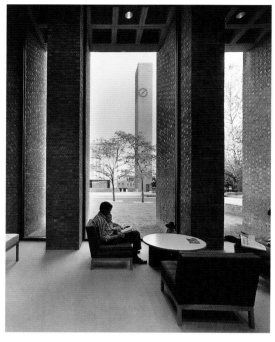

Interior, framed view of Saarinen's First Christian Church

metropolitan centers. He gave Columbus not simply a library but a public space — a real physical center where thousands attend art shows and concerts, children explore, and townspeople daily define their community. "Up to that point," Miller recalled, "we were trying to solve things on an individual basis."[1]

The site stood opposite Eliel Saarinen's First Christian Church (1942), which introduced the church-going town to modern architecture. Immediately west stood the Irwin House (1874). Pei lobbied to preserve the town's roots and proposed to bring church, house, and library into harmony with a new plaza. The key was closing an existing street and pushing the library back in the site to create a pedestrian precinct — a super-block. The library director confided to Pei, "Perhaps not everyone was aware of what was being accomplished, but everyone did have the feeling that

it was right."[2] The plan was the nucleus of a multiblock revitalization that was to incorporate city hall and a proposed municipal auditorium.

The library was named for Miss Cleo Rogers, whose thirty-seven-year tenure as librarian was Bartholomew County's longest. It was to be the new community center. The unassuming native brick structure grew naturally from the plaza as it cut back on the east in response to Irwin House's stepped eaves, and stretched on the west with elongated windows that frame Saarinen's church. Two stories high, it was excavated into the ground and opened along the back with skylights and courtyards. Inside, the free-flowing space has lots of little nooks to occupy and lose oneself in, while the whole is unified overhead by one of the concrete "air floors" developed by Pei's firm to replace traditional suspended ceilings and the utilities hidden above.[3]

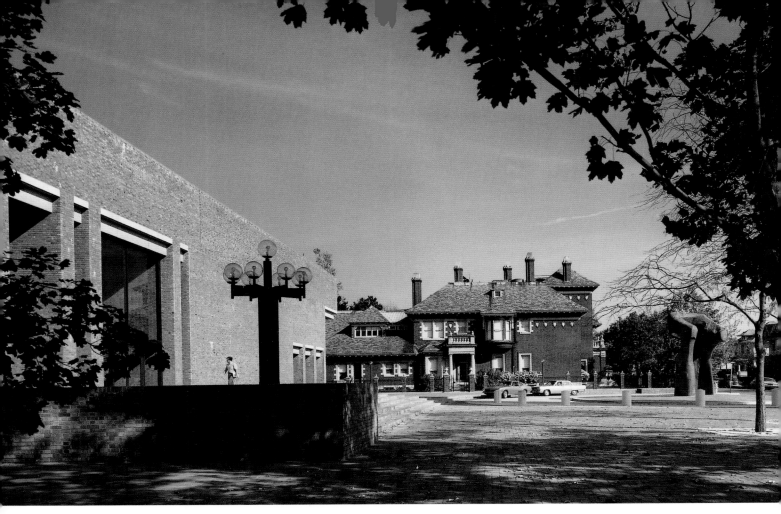

Library with Irwin House

Since neither library nor church nor house was strong enough to be "the duomo" in the city square, Pei proposed a large sculpture to anchor the space and bring the buildings together "like a conductor of three soloists."[4] He visited Henry Moore at his Much Haddam studio, where he recalled his delight at having seen his young daughter playfully slip through one of Moore's arch pieces in the Museum of Modern Art in New York. For Columbus, he wanted a work large enough for couples to stroll through hand-in-hand, but, he and Moore agreed, not so big that cars could drive through. Large Arch was a gift to the residents of Columbus from Mr. and Mrs. Miller, and also from Pei. The Millers donated $75,000 and Pei did the rest, traveling at his own expense to Moore's studio in England, planning and siting the sculpture and, in broader scope, interpreting

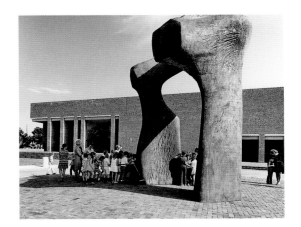

the program for a small county library in terms so urbane as to include a major public space and an important work of art.[5]

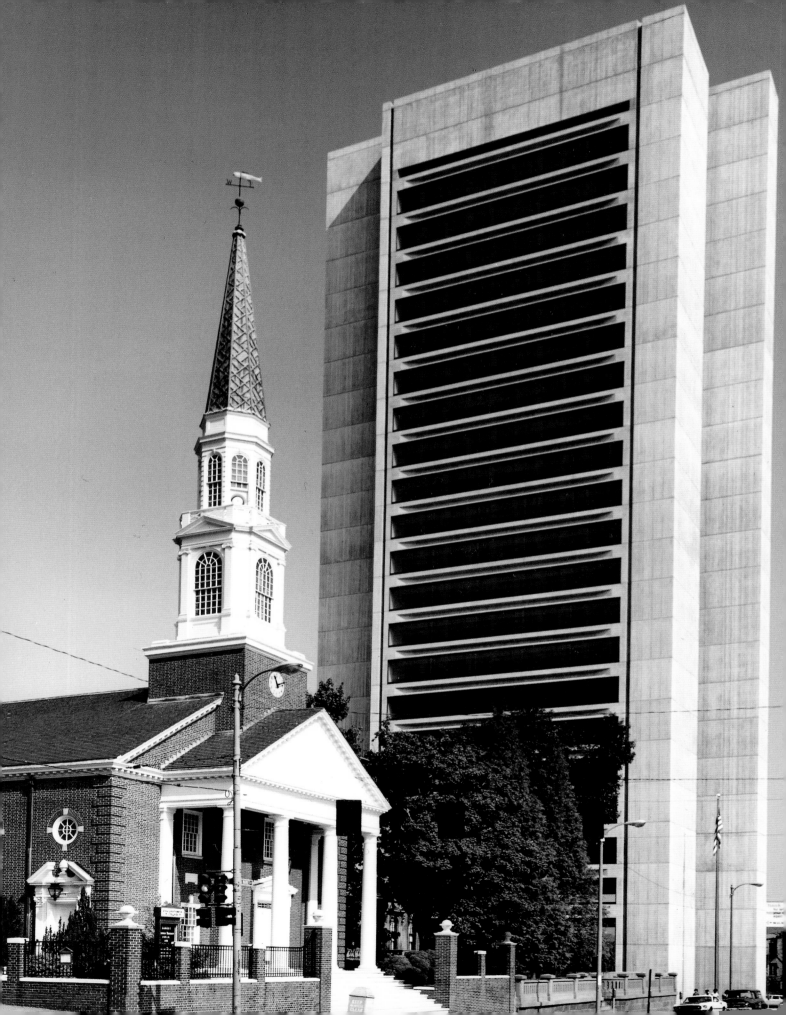

ALICO (WILMINGTON TOWER)

Wilmington, Delaware
1963–71

In 1963, the American Life Insurance Company (ALICO) decided to build a new headquarters in Wilmington, Delaware, where the company had been founded in 1921. C. V. Starr, founder of AIG, the parent company of ALICO, and an old family friend, contacted Pei, whose father had been a director of ALICO from 1932 to 1942.

The corner site was, according to the architect, "100% location," strategically located in the downtown civic and business district where it shares a city block with a landmark brick church from 1737 and a three-story Italianate brownstone occupied by the exclusive Wilmington Club.[1] Rather than fill the site with a low building, Pei answered ALICO's request for a strong corporate image with a slender twenty-one-story tower that echoes the verticality of the church steeple. The tower was tightly aligned with the corner and a four-story bar building was inserted along the back to create a sheltered entry plaza and landscaped buffer between ALICO and its neighbors. The plan was similar to the one Pei had used at Mile High to revitalize downtown Denver, in both cases scooping out less valuable mid-block footage to create an urban amenity. "Individual buildings in a city are not important," he explained. "The important thing is how they fit into their location. . . . That is why the building covers only seventy percent of the ground. That is why we designed a mall to separate us from the club. And that is why the building is narrow, not massive. Compatibility is the key."[2]

For all of its understatement, this urbane little tower was quite revolutionary. Pei's first architectural concrete office building, it reveals with great

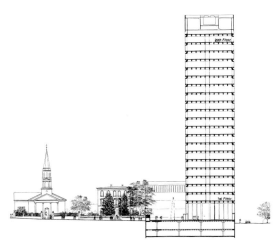

Section looking west

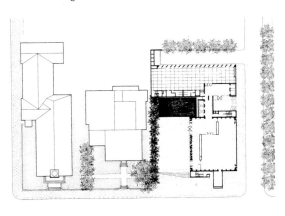

Block plan

precision and refinement his continuing interest in the plastic qualities of concrete, its walls imprinted with the crisp wood grain textures of the boards that gave shape to the liquid pours. Quietly, it also realized the long-span structure, which he had pioneered in 1959 for the unbuilt, award-winning Pan Pacific Tower in Honolulu. As at MIT, and

View south along Market Street

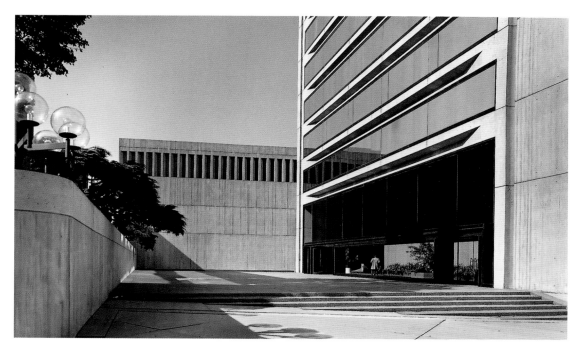

Entry plaza

subsequently at Overseas Chinese Banking Centre, the service cores were split in two at opposite ends of the building to make maximum use of the small office floors stretched in between. Then, in a way that had not been done before, 72-foot-long (22 m) beams were spanned across the full length of the building so that there was no need for vertical support, inside or outside, other than the twin end cores.[3] Unlike conventional towers, the column-free office space offered complete flexibility. In yet another innovation, the airy structure was dramatized by long mullion-free ribbon windows in what was perhaps the first application of butt-joined structural glazing.

Once the plan and general parti were established on the model of Pan Pacific Tower, Pei turned the project over to Araldo Cossutta, who most among his partners shared a mutual interest in concrete and long-span structures. "My involvement was very, very deep in the beginning," Pei explained. "A lot of salesmanship is needed at the start. You need to know the client, and understand his needs. I did all of the planning, but when it became architectural I had to have help because then it takes time."[4]

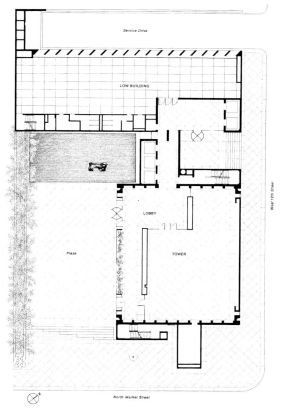

Site plan

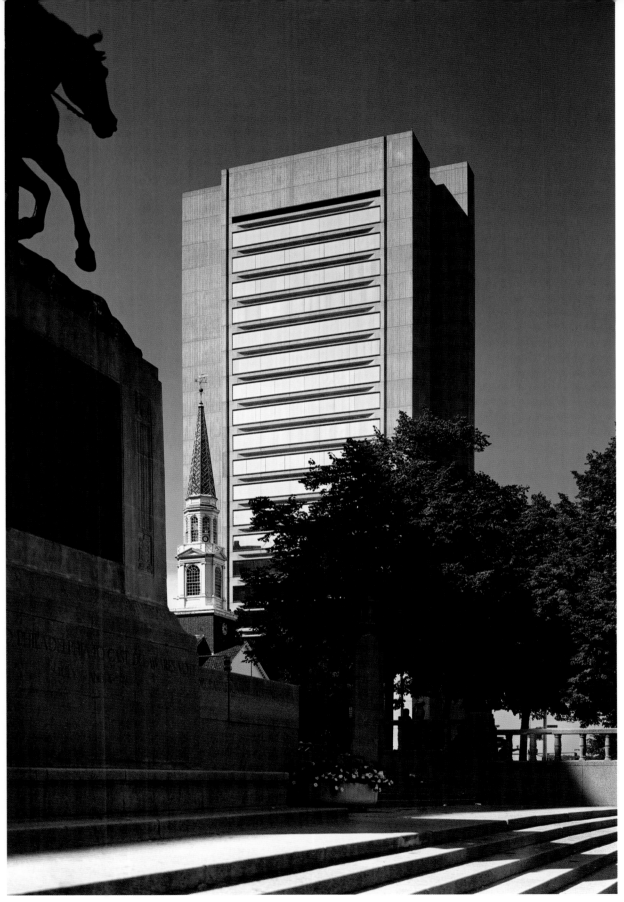

General view from south

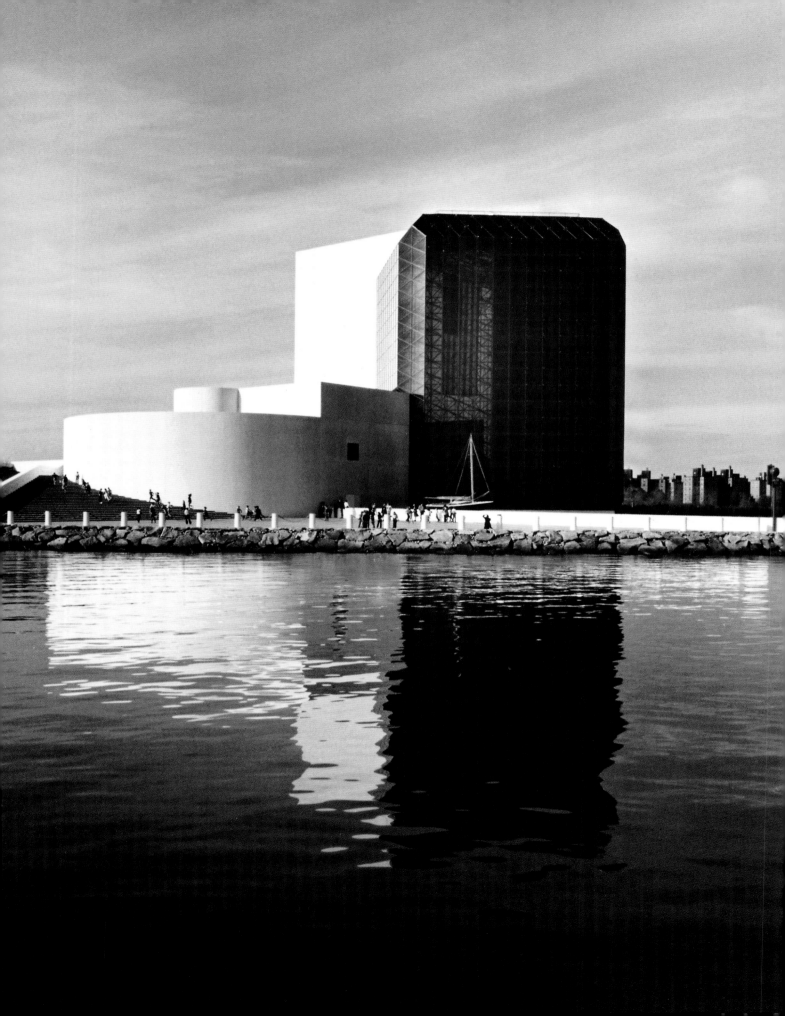

JOHN FITZGERALD KENNEDY LIBRARY

Dorchester, Massachusetts
1964–79

In October 1963, John F. Kennedy secured a 2-acre (0.8 ha) site for a presidential library at his alma mater, Harvard University, envisioning an archive, museum, educational center, and offices from which to continue his career. The concept changed radically after Kennedy's assassination the following month, propelled forward by outpourings of support from the grief-stricken nation. There were few precedents since none of the five existing presidential libraries was in a metropolitan center, none had attempted to collect the records of an entire administration, least of all in a television era, and none had confronted the raw challenge of memorializing a recently slain leader.[1]

Mrs. Kennedy invited prominent architects and designers to a two-day meeting to develop a building program and advise how best to select an architect.[2] The first day involved a site visit and group discussions, followed by a reception at Harvard's Robinson Hall (where an exhibition on I. M. Pei & Associates would open serendipitously the following week). Before departing for the Kennedy compound in Hyannisport the next morning, attendees nominated an architect by secret ballot. Pei was among six finalists.[3]

Several weeks later Mrs. Kennedy visited the modest offices Pei rented from Zeckendorf, freshly painted white for the occasion. He presented a small portfolio of independent work and strategically, Southwest Washington Redevelopment. But the real agenda was personal chemistry. Mrs. Kennedy's advisor William Walton recalled Pei was "a hedge gamble — the hedge being his executed work. . . . He isn't a fashionable

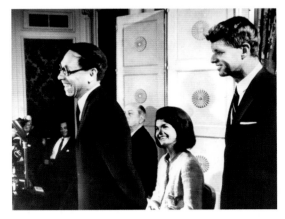

The New York Times, December 14, 1964

Tally of the architects' recommendations shortlist

architect, he isn't the best known, and he doesn't work for one of the big corporations. He's a guy who worked his own way up. I don't know what he'll do, but it will be an exciting building."[4]

View from
Dorchester Bay

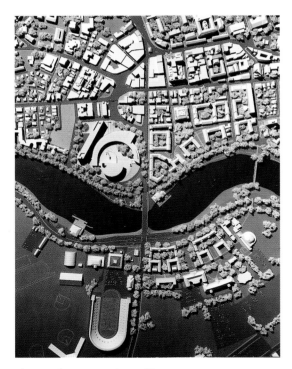

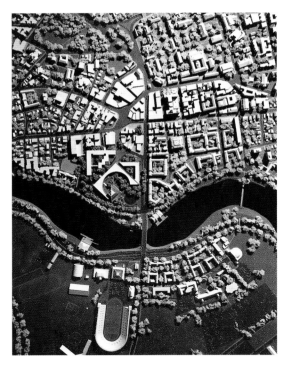

First massing presentation, 1966

First public presentation, February 1973

The commission was announced on December 13, 1964 whereupon Pei became front-page news, catapulted overnight to international celebrity. He became a household name, a frequent clue in crossword puzzles and game shows, and the recipient of some of the era's most important commissions, one right after another. Although the library would be his greatest professional disappointment, Pei always acknowledged, "It was really the beginning of our firm."[5]

The original site, encumbered by traffic and an unsightly power plant, was feared too small for the growing program. Pei recommended instead the Massachusetts Transit Authority's (MTA) open rail yards opposite Harvard and the Charles River. Kennedy himself having expressed interest in the site, his mother appealed to the state senate in 1965 after which the Commonwealth purchased the 12-acre (4.9 ha) parcel. Opportunities expanded to include not just the library, museum, and memorial but also a school of government, institute of politics, dormitory, and community resources, which collectively would create a much greater living memorial.

Mrs. Kennedy approved a preliminary massing scheme in 1966 but difficulties relocating the MTA delayed development. Meanwhile the Kennedy mystique faded with the greater urgencies of Vietnam, fueled by student unrest, racial riots, political rivalries, and concerns over university expansion in space-starved Cambridge. Harvard, it became clear, had its own vested interests in keeping the bonanza piece of land that it had eyed for years. Questions now swirled around the quality of archives from so brief an administration while community activists militated against the projected ruin of Harvard Square by tourists. Buffeted from every corner, the project was further derailed in 1968 by Robert Kennedy's assassination and Jacqueline Kennedy's remarriage. Pei was left to work in a vacuum without a client.

The first public presentation of the library, a truncated pyramid scheme in 1973, was bitterly attacked, triggering a series of scaled down alternatives that initially separated, and ultimately removed the crowd-attracting museum off campus.[6] Splitting the project undermined

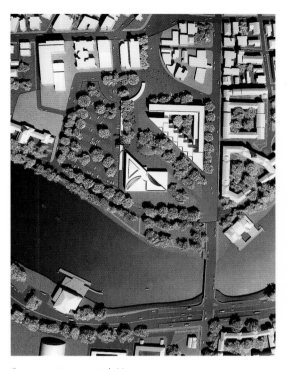

Components separated, May 1974

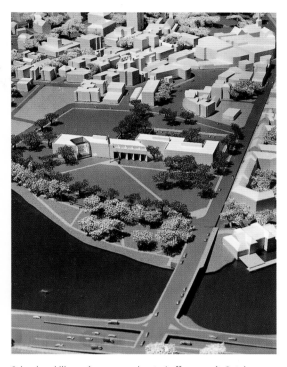

School and library (museum relocated off campus), October 1975

the fundamental idea of the living memorial. Scores of alternative sites were investigated and preliminary designs prepared, as required by newly enacted environmental impact legislation. Much of the work fell to Ted Musho who "had the fortitude not to be crushed by all the problems," said Pei. "I lost my spirit. I couldn't give anymore after so much had been given for years and years and finally, nothing but disappointment. The whole project was for me tragic. It could have been so great."[7] To make matters worse, the $23 million raised so easily after the assassination continued to diminish, compounded by soaring inflation. Now, ten years later, there was very little left for construction.

The Kennedys were anxious to get something, almost anything, built. Out of sheer exasperation in 1975, they abandoned Harvard for the University of Massachusetts in Dorchester, outside Boston, where Kennedy began his public life in the House of Representatives. Pei resisted the landfill site, overcome with tidal mud and stench, only to learn that another architect had quietly prepared a design for it. Ever diplomatic,

he avowed simply that it would be "a terrible mistake."[8] The library committee agreed after a site visit at low tide.

The gauntlet dropped, Pei gathered his most senior staff and pushed the job through from design to completion in just three years. He was allowed to relocate the library to a former garbage dump farther out on Columbia Point, where the water is always deep. The site was protected against methane gas, a natural byproduct of decomposing matter, and raised 15 feet (4.5 m) to overcome an obstructive sewerage pipe. From this new plateau developed a split level design with the museum below ground, and the library and memorial above, almost scaleless in dramatic isolation from the lumbering brick buildings of UMass and a neighboring housing project, free of Cambridge, Harvard, politics, and everything else except the water and open sky. The underlying challenge throughout had been how to memorialize the young president in contemporary yet timeless terms without resorting to historical prototypes like the Lincoln Memorial, where a monumental statue is enthroned in

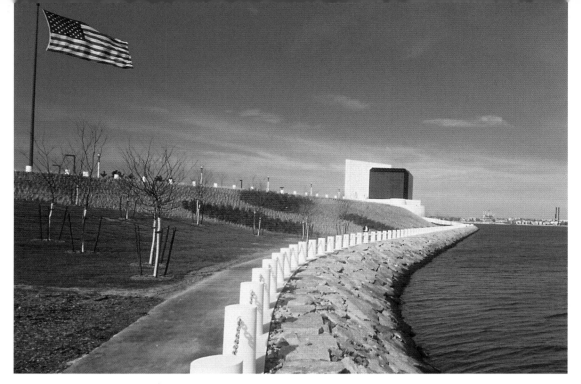

Columbia Point, view toward downtown Boston

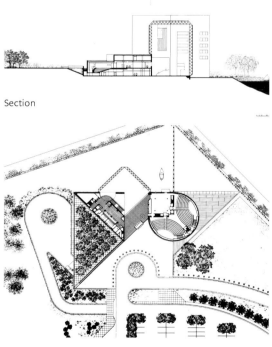

Section

Site plan

a neoclassical pavilion. The president's wife provided the key by insisting there be no bust.

The building was organized in three major parts: a ten-story tower housing the library, archives, and administration; a two-story base containing two 300-seat theaters atop the lower level museum; and a unifying 110-foot-high (33 m)

memorial pavilion. Visitors to the museum start with a film about Kennedy's life, after which they descend into exhibition spaces (designed by Chermayeff & Geismar) displaying memorabilia and photographs of Kennedy's family and administration. From this darkened setting they emerge into the light-filled pavilion occupied solely by a suspended American flag with quiet views out to the sky and sea. "The emptiness is the essence," Pei explained. "People coming from the exhibition don't want to see or hear anymore, they just want silence. Their thoughts become the memorial."[9] Inscribed on the wall, and hauntingly recited at the library's dedication in 1979, fifteen long years after the project began, is a quote from Kennedy's inaugural address that might well have been written for the building: "All this will not be finished in the first 100 days. Nor will it be finished in the first 1,000 days, nor in the life of this Administration, nor even perhaps in our lifetime on this planet. But let us begin."

opposite:
Memorial pavilion,
view up

CANADIAN IMPERIAL BANK OF COMMERCE (CIBC)

Commerce Court
Toronto, Canada
1965–73

"I hate black buildings," said Neil J. McKinnon, president of the Canadian Imperial Bank of Commerce (CIBC), when he commissioned Pei in 1965 to design new headquarters for CIBC in the heart of Toronto's financial center.[1] McKinnon was referring specifically to rival Toronto-Dominion Centre (1963–69) directly across the street, for which Mies van der Rohe was then constructing a three-building complex in black-painted steel, including a fifty-four-story tower that dwarfed CIBC's existing headquarters. Pei, who like other modernists, had worked inescapably under Mies' pervasive influence, now found himself toe-to-toe with the celebrated master of landmark skyscrapers even as Pei had yet to build one.[2] He responded with a four-building, 2.9-million-square-foot (270,000 sq m) complex, including an iconic 784-foot-tall (240 m) stainless-steel tower that restored CIBC's skyline priority and signaled a sophistication of urban design previously unknown in the downtown core.

Challenged also by CIBC's decision to save its existing building, Pei once again harmonized old and new.[3] On a superblock site increased to 4 acres (1.6 ha) at his urging, the new tower was set back 72 feet (22 m) from prestigious King Street to leave the prominence of the old building unchallenged. The 1930s interior was renovated, and a new side entrance opened directly opposite the new tower.[4] Its rear flank was refaced and made into a second main facade onto Commerce Court, the defining outdoor space that created a public setting for CIBC, unified its disparate buildings, and sheltered and connected it to the city.

Site plan

Two new buildings of five and fourteen stories were clad in limestone to match the original headquarters and positioned respectively along the courtyard's south and east to allow sun to enter even in winter. Unlike the windswept plazas left exposed by nearby skyscrapers, CIBC's four buildings pinwheel around the courtyard to provide easy through-block access on every side but in a way that leads unexpectedly to a welcoming 1-acre (0.4 ha) retreat in the thick of downtown. With street noises muffled by the 64-foot-diameter (20 m) fountain amid terraced seating, an outdoor café, planters, and a grove of trees, Commerce Court quickly became a popular gathering place. Five levels below ground, direct links to the city subway and a high-ceilinged public concourse with coordinated storefronts and signage significantly advanced the then developing all-weather shopping network that would knit together Toronto's core.

Commerce Court
at night

Exterior view into long span banking hall

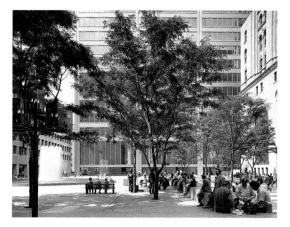

Courtyard

Providing a counterpart to Mies's freestanding banking pavilion directly opposite, but at the same time leaving open the site for public use, Pei put the pavilion inside the tower and made it the three-story public lobby. He pushed back the elevator core to create a 112-foot-by-112-foot-by-33-foot-high (34 x 34 x 10 m) space at front and connected it with escalators through a 52-foot (16 m) diameter cut—a geometric echo of the courtyard fountain—to special banking and virtually unlimited expansion on five lower levels. The interior opens to the outdoors through the largest panes of glass ever produced in Canada,

perhaps in the world at that time—8-foot-4-inches high-by-25-feet-6-inches wide (2.5 m x 7.8 m), each butt joined for maximum transparency.

The sense of openness is the result of the tower's long-span structure in which 56-foot-long (17 m) girders and 13-foot-high (4 m) columns are faced in ⅛-inch (0.3 cm) stainless steel rolled out in sheets of unprecedented size, each spandrel weighing some 3,000 pounds (1,360 kg). Together with the fabricators Pei's team developed a method of skintight assembly that still allowed the spandrels complete freedom of movement for expansion and contraction while remaining visually flat across the entire surface.[5]

"Stainless steel is an interesting material," said Pei, "but it has a kitchen sink look to it. So we experimented and found that by embossing with rollers to make tiny dots across the surface it becomes very beautiful."[6] Simplified to the extreme, the tower's curtain wall depends also on an early application of reflective gray glass, both as an integral part of the climate control system and expressively as a luminous mirror of the moody Ontario sky.[7]

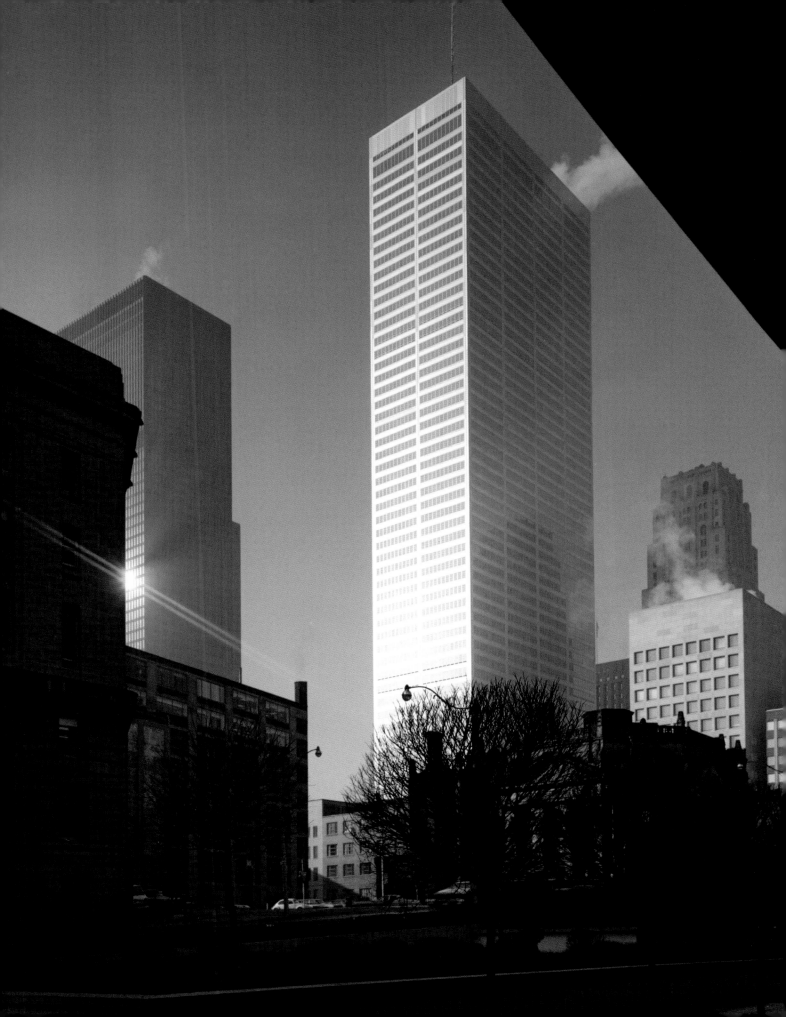

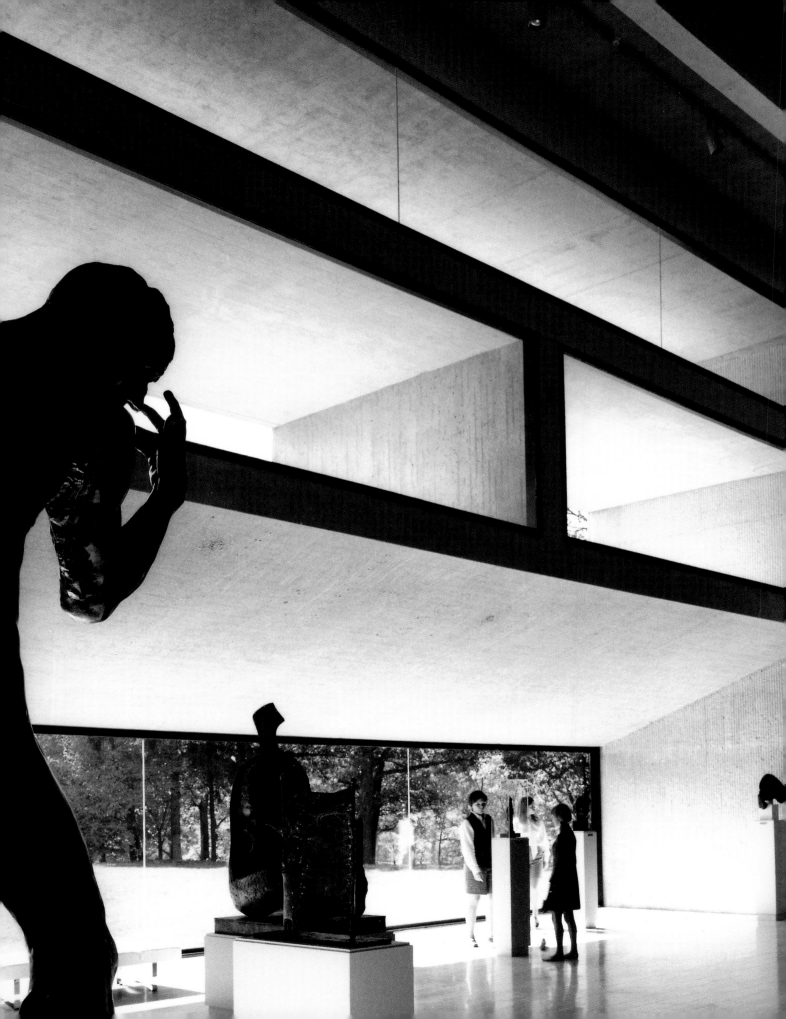

DES MOINES ART CENTER ADDITION

Des Moines, Iowa
1965–68

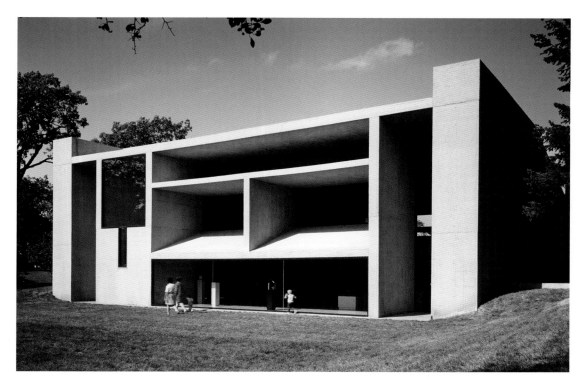

Garden facade

Des Moines Art Center is distinguished among Midwest museums as much for its architecture as for the quality of its collection. The original Cranbrook-style building was built by Eliel Saarinen in 1948, expanded by Pei and later by Richard Meier, each architect, twenty years apart, using a different approach and materials to create a powerful statement of his time.[1]

In 1965 the Art Center's trustees approached Eero Saarinen about a new sculpture wing for his father's building, but finding him too busy, David Kruidenier, chairman of the board, made an impromptu call to Pei. Kruidenier later recalled how Pei "took out a piece of tracing

paper on the spot and in ten or fifteen minutes had sketched a plan and elevation so close to the final product that the sheer act of creativity left me breathless."[2] The 21,000-square-foot project (2,000 sq m), one of Pei's smallest, officially began the following year.

For architects accustomed to designing iconic freestanding buildings, the notion of adding to an existing landmark presents a new kind of challenge. Pei seized the opportunity to relate to—and improve—an important early modern building in a way, he explained, that would "marry old and new without compromising either."[3] His interest steeled with the

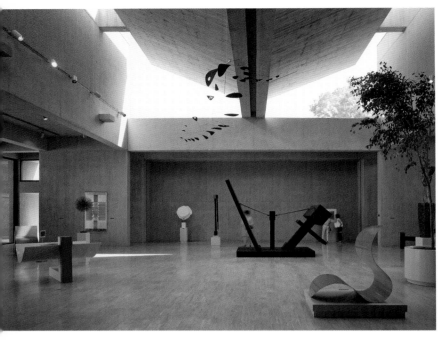

Upper sculpture gallery

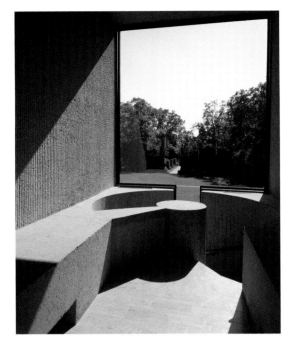

Keyhole window and stair to lower gallery

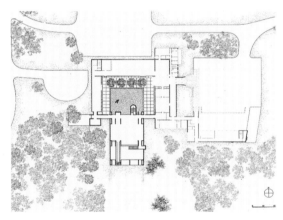

Site plan

realization that the job was "not only challenging but very necessary [because the museum] didn't work" since the U-shaped galleries required visitors to retrace their steps. Pei inserted a rectangular box across the open end of Saarinen's three-sided courtyard to create a continuous circulation loop. He included two large exhibition spaces for sculpture, a small supplemental gallery off to one side, and a 240-seat auditorium below. He also reconfigured the courtyard so that its original 3-foot-deep (1 m) pool, stagnant and filled with grasses, was transformed into a 6-inch-

deep (15 cm) "architectural sheet of water" with radial granite pavers centered on an existing sculpture by Carl Milles, offset by a new row of trees. Within these limited interventions Pei created a space of remarkable variety and drama.

One of the trustees' few requirements was respect for the original building, which Saarinen faced in a 4-inch (10 cm) veneer of golden Lannon stone. Pei's complementary, but more structurally honest, response continued the practice he first developed at NCAR. bush-hammering concrete to reveal the texture and color of added local aggregates to produce, in this case, a rough surfaced honey brown. Its tactile appeal is apparent from the countless visitors who have rubbed the corduroy-like walls over the past forty years.

Pei maintained the original low roofline so that from the main approach only the tips of his folded skylight hint at the sculpture gallery's existence. On the opposite side, he took full advantage of the sloped site to carve out a lower floor onto a public park. Its enormous panes of glass are protected by 13-foot-deep (4 m) embrasures that block direct sun but bounce soft glowing light inside. The sculptural sunscreens advance beyond

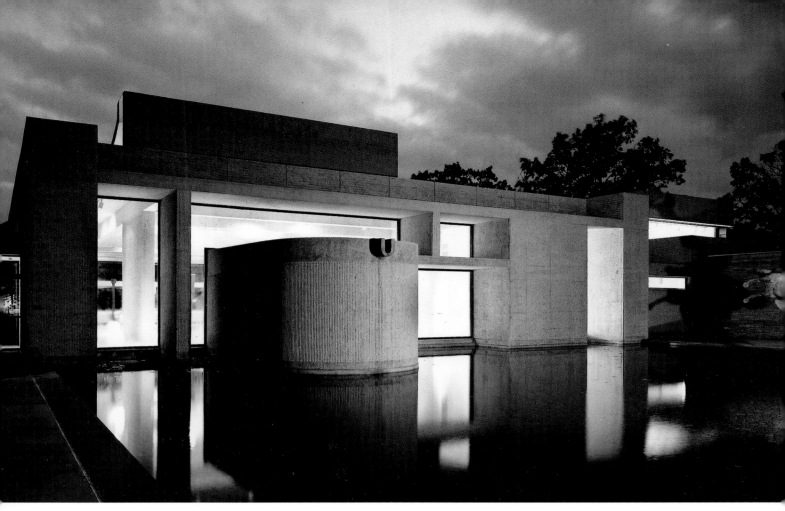

Courtyard facade

Le Corbusier's *brise-soleil*, typically independent elements in front of the wall plane, since here the concrete screen is itself the wall.

From the original building one enters the upper sculpture court almost at the same level as the reflecting pool, a curved stair projecting into it between watery reflections and polished travertine floors. The 1,760-square-foot (164 sq m) room appears at first glance to be a single open space but every turn reveals a hidden recess, light shaft, or unexpected view that beckons further exploration. The biggest surprise comes where the floor drops away to the double-height lower gallery. A bridge spans across to a spiral stair and a garden window, like a framed still life, that intensifies with each step down. From the lower level one can enter the auditorium or garden, or enjoy the current exhibition before returning on monumental stairs to the upper gallery. The rich path of experience is heightened by varied levels of natural light, nowhere more dramatic than under the great butterfly roof.[4] From its splayed ends, as in the intimate clerestoried links to the original building, leafy views come inside with unexpected immediacy.

When the sculpture gallery opened (to the largest audience in the Art Center's history), the building itself was praised as sculpture. "The opening tonight," said a prominent guest, "could have been as impressive with the building empty."[5]

In 1969 Pei received national honor awards from the American Institute of Architects for Des Moines Art Center Addition and Everson Museum. It was the first time the AIA honored a single architect for two museums in the same year—a building type that Pei had never before explored.

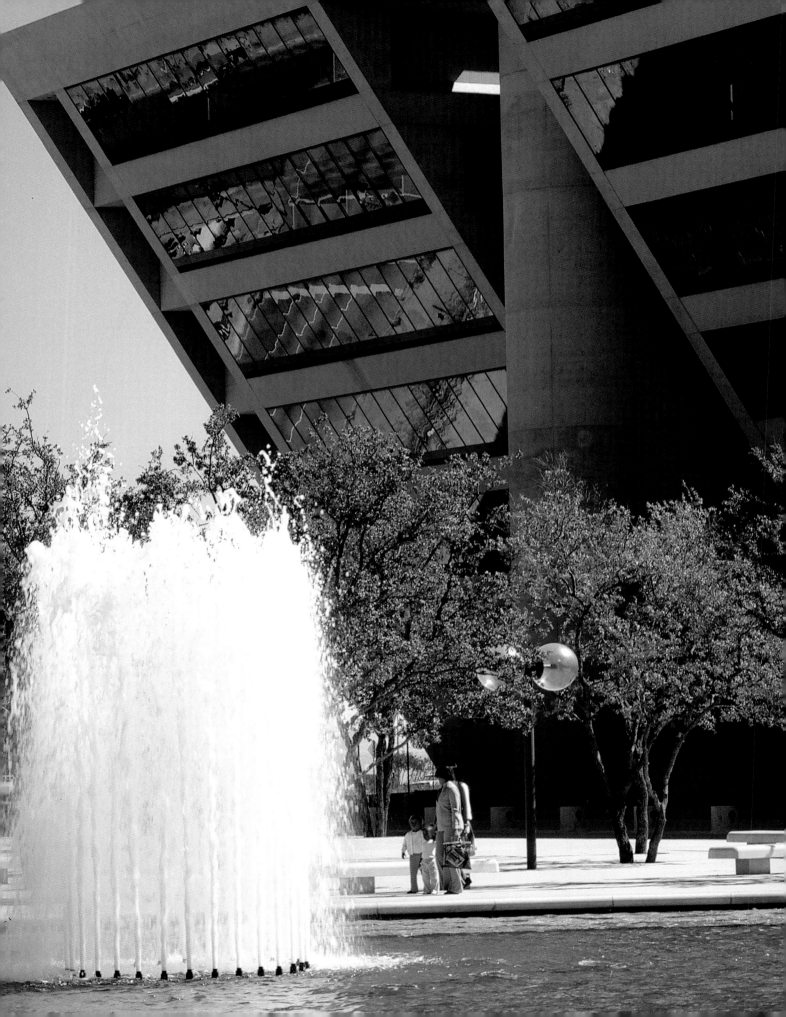

DALLAS CITY HALL

Dallas, Texas
1966–77

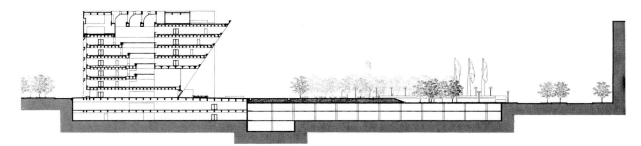

Section through building and parking garage

Dallas City Hall was the summary of everything Pei had done before, but bigger, bolder, and more heroic as demanded by a proud young city. When Erik Jonsson, the former CEO of Texas Instruments, was appointed interim mayor of Dallas in 1964, he applied to government the same scientific methods that he'd followed in the corporate world, producing in 1966 the two-volume Goals for Dallas, a visionary and unprecedented document for municipal growth. With this blueprint he charted the development of modern Dallas out from under the pall of John F. Kennedy's assassination with new highways, a medical center, art museum, major public library, convention center, concert hall (built by Pei two decades later), Dallas–Fort Worth Airport, and a new city hall to replace the building where Jack Ruby shot Lee Harvey Oswald, Kennedy's accused assassin, before stunned television audiences nationwide. The ambitious mandate was to create "the best building in the world for the best city in the world."[1]

Eight architects were interviewed, including Skidmore, Owings & Merrill (SOM), Philip Johnson, and Pei,[2] whom Mayor Jonsson had met at the opening of MIT's Earth Science Building in 1964, saying casually "maybe someday you'll do something for us in Dallas."[3] Asked in the interview how he would approach City Hall's design, Pei requested several weeks to study the site and its relation to the rest of the city before answering. He then conducted the city council's first environmental study and on its merit won the commission in what was perhaps the first municipal appointment of a non-Texan architect. "I looked around with the eyes of Zeckendorf behind me and saw problems," said Pei. The 7-acre (2.8 ha) site, located in a dilapidated area at the edge of the city, was large enough for the building but not for parking or expansion. It was oriented so that the building could look straight out to downtown, but also to the ramshackle stores and parking lots directly across the street.

To create a proper environment Pei recommended that the adjacent block be purchased and, to the astonishment of the city council, converted into a park for City Hall. Were it not for Mayor Jonsson, who recommended building a municipal parking garage underneath, Pei might well have lost the job. The issue was taken

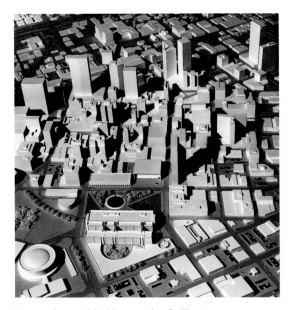

Master-plan model with expansion facility at rear

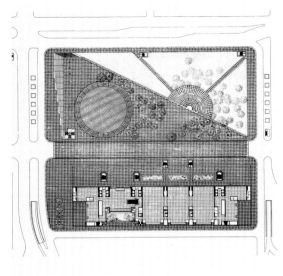

Site plan

to the public as Pei explained to one assembly after another, "almost like a preacher," how the initiative would benefit City Hall, and also stimulate private development on sites overlooking the first major civic space downtown.[4] "It was so obvious to me that this was the right thing to do," he recalled. "I urged the officials to buy the land before they really could not afford it."[5] The City Council ultimately bought the block in question and also surrounding properties for a future civic center. Sale of a single parcel to the Federal Reserve several years later covered the cost of all seventeen acres.

A comprehensive program specified different amounts of space on each floor, with heavily trafficked agencies near the ground for easy public access and the much larger engineering and clerical departments on the upper floors. Pei decided to translate functional requirements into a form both exciting and expressive. If the design suggests Le Corbusier at Firminy (1965) or Chandigarh (1963), it yet speaks directly to Dallas, gathering the city around it like the early courthouse in a frontier Texas town. It's all about the big gesture.

The 113-foot-high (34 m) building slopes out at a 34-degree angle, each floor 9-foot-4-inches

(2.8 m) deeper than the one below so that it grows from 130 feet (40 m) at the base to 192 feet (59 m) at top. The slant symbolically welcomes citizens, acting as a gigantic "front porch," while practically, it offers shade from the wilting Texas sun. The building slopes Pei motioned, to become one with the plaza, with a Henry Moore sculpture, fountain pool, and grove of gnarled live oaks. According to landscape architect Dan Kiley, who worked with Pei on the project, "I. M. understood, like few other architects, that architecture and the land are two facets of the same thing; it's all one."[6] "It's not just the plaza and park that the building embraces," said Pei, "but downtown and all the skyline."[7] A simple sketch of City Hall leaning toward Dallas made clear the essential relationship between private development, tall and vertical, and government, low and horizontal—a "landscraper" instead of a skyscraper in a part of the country where the flat ground plane and open sky were often the most defining features. Internally, the slope, together with the building's skylit central hall, made it possible to bring daylight into the enormous 2-acre-plus (0.8 ha+) top floors.

City Hall was the first building Pei designed to express specialized functions, the entrance, city council chamber, and mayor's office occupying

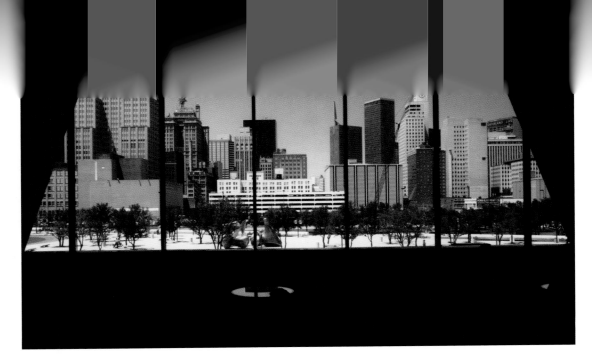

Downtown viewed from inside the Great Court

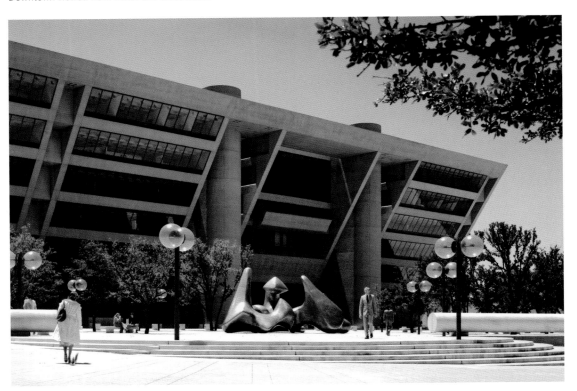

Main facade with unique entry bay and Henry Moore sculpture in plaza

a unique bay on the main facade. The building is propped up visually by three 19-feet-wide (5.8 m) stair towers (structurally independent). Three 64-foot-long (20 m) windows distinguish the main public hall from some 200,000 square feet (18,600 sq m) of offices as they put downtown on spectacular display for the enjoyment of taxpayers inside. Surrounding the 100-foot-high (30 m) barrel vaulted main hall are loftlike offices, flush on the north and stepped back on the south with planted open corridors. The interior is animated by people moving on every level in tiered

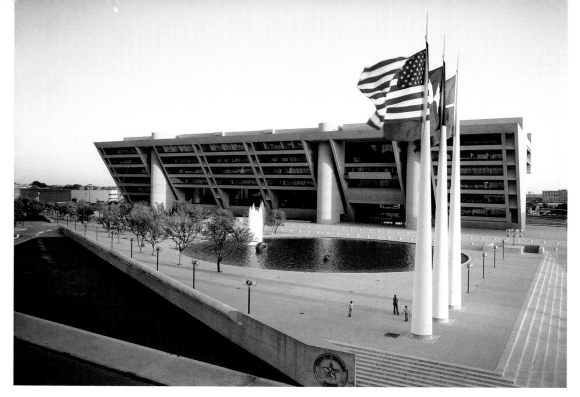

City Hall and plaza mitigating 8-foot change of grade

echo of the sloped facade, as coffered ceilings ("air floors") provide a powerful unifying element.

Inside and out City Hall is a virtuoso display of the precision architectural concrete for which Pei's firm was by this point renown. Unlike NCAR, for example, which is effectively a series of linked small buildings, City Hall is a monumental whole nearly two football fields long—larger than any building yet attempted by Pei with no budget for bush-hammering or other treatment to hide construction imperfections.[8]

"Up to this point," Pei said, "I hadn't had the opportunity to do many buildings with personality."[9] It was the first time he made a conscious effort to study the character of a city, which in this case was run by a benign oligarchy of prominent businessmen, strong, independent and above all, proud. They wanted a big iconic building as a landmark.[10]

In the 1960s Texas building boom, great size was not a failing, at least not in terms of identity, but it became a major problem as inflation, concrete shortages, and labor strikes doubled construction costs. The building was downsized and re-bid with its interior intact but unfinished,

only to come in again at the same $50 million as the larger original so rapid were escalating costs. Thereafter the project was shelved until City Manager George Schrader devised an ingenious bond system to fund construction. For years a series of political cartoons lampooned City Hall for its high cost and delays, inadvertently spreading its reputation well beyond Dallas limits. It was the first time Pei experienced such notoriety, but not the last.

If the stripped-down building lacked the finesse of his later works, City Hall was nonetheless a triumph of civic spirit, public architecture, and urban design, which redefined Dallas with forward-looking optimism. With the symphony center that Pei would design in the 1980s and three office towers by his partner Henry Cobb, Pei introduced and sustained the notion of quality architecture in Dallas, exerting a formative influence on the fast-growing city through more than twenty years of almost continuous construction.

opposite:
Terraced Great Court on second level, 250 feet long x 100 feet high

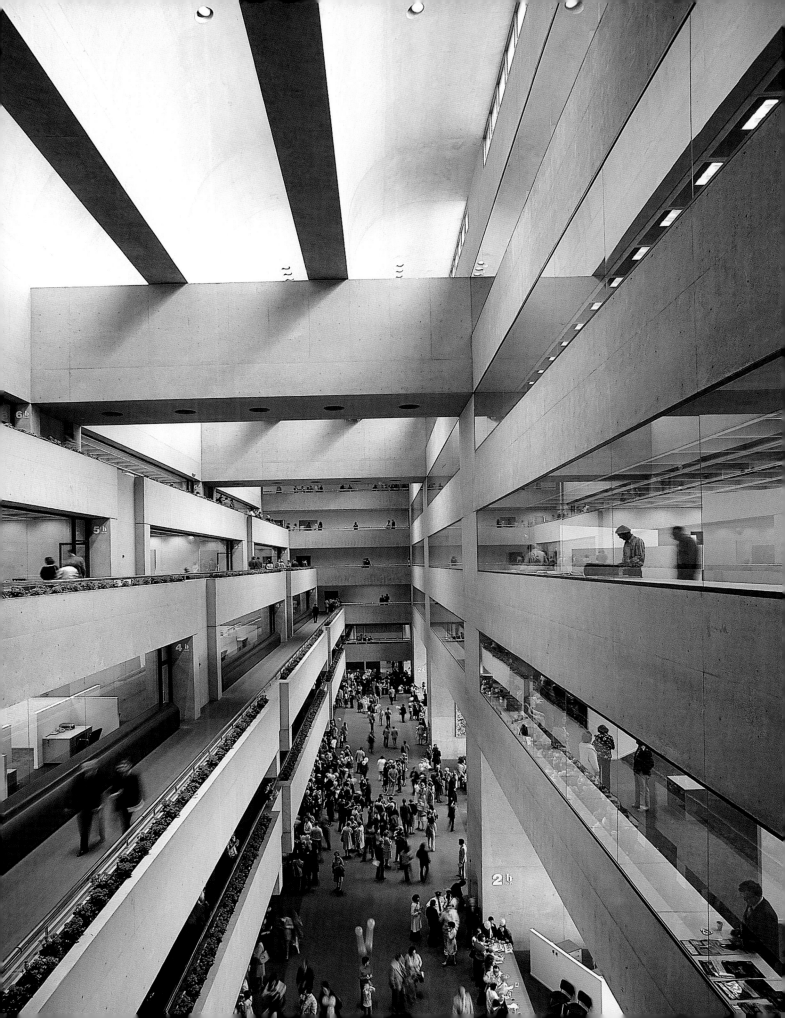

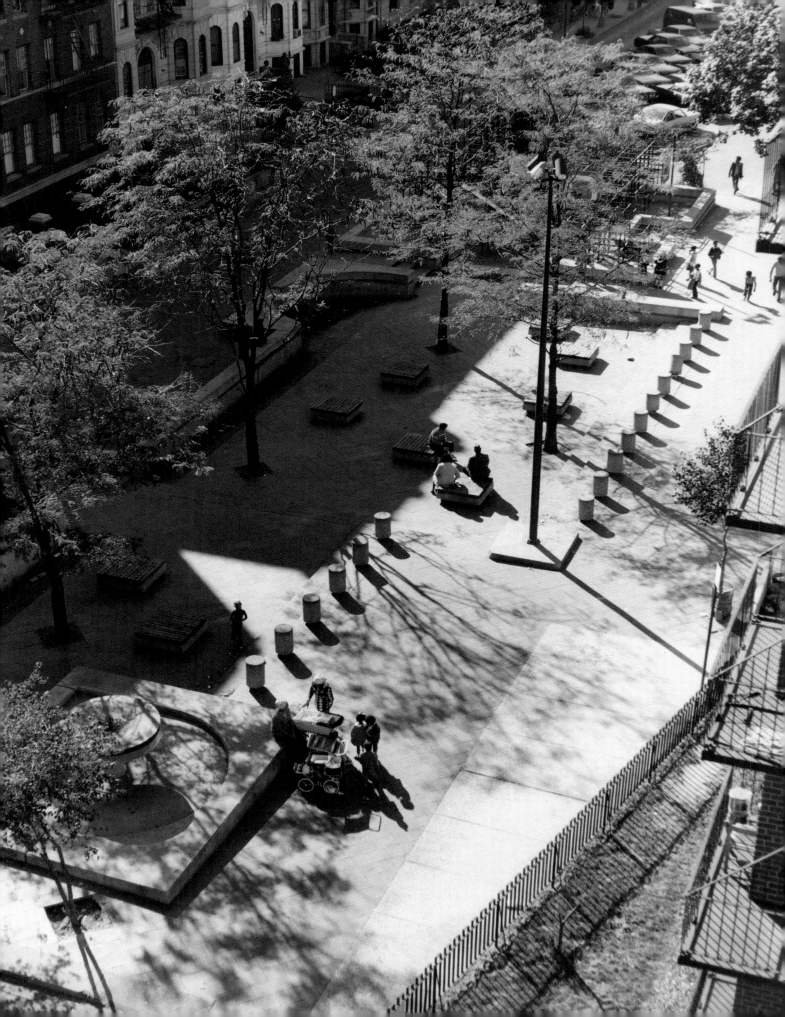

BEDFORD-STUYVESANT SUPERBLOCK

Brooklyn, New York
1966–69

In 1966 Senator Robert Kennedy took a highly publicized tour of the Bedford-Stuyvesant section of Brooklyn, where some 450,000 people lived on 653 city blocks — roughly the size of Minneapolis — in the nation's second largest black ghetto (after Chicago's South Side). Rebuffed as simply another politician exploiting Bed-Stuy's misery for personal advantage, Kennedy was jarred into action, and returned ten months later with one of the boldest, most ambitious programs for community rehabilitation ever proposed for an American city.[1] The main focus was the creation of jobs, but also better housing, education and business development. Architecture was not a priority but to provide physical evidence of far-reaching changes to come, RFK asked Pei, then working on the John F. Kennedy Library in Boston, to recommend physical improvements for immediate implementation at minimal cost without resident relocation.

Pei visited Bed-Stuy to find "the community had no focus, no center of gravity. It was a town without definition or boundaries, just an endless grid of long straight streets leading to and from nowhere." Years of redevelopment allowed him to see, as others did not, that abandoned cars and the absence of traffic signaled the streets were not being used. "Two of every three cross streets comprised city real estate that could be put to better use," he exclaimed. "What a windfall!"[2]

A week later Pei recommended the creation of seventeen superblocks, each comprised of two or three parallel city blocks, the unnecessary streets converted into parks, playgrounds,

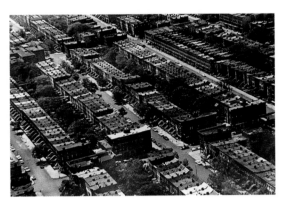
Bed-Stuy, typical city blocks

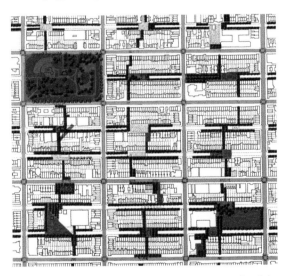
Greenway proposal for mid-block parks and pedestrian links

and other community uses. Derelict buildings could be demolished and open lots landscaped to create a network of mid-block garden paths. Home ownership in Bed-Stuy was high at twenty percent (compared to two percent in Harlem). If the community could be refocused around nodes of neighborhood activity, Pei reasoned, local pride would increase, property values would

St. Mark's Avenue park

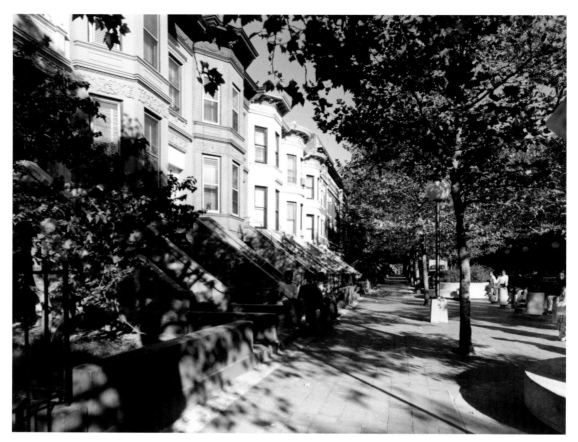

Prospect Place

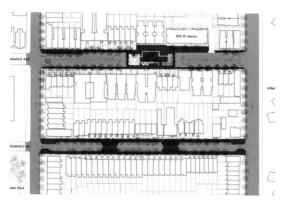

Site plan

rise, and banks would grant mortgages — all of which would help turn Bed-Stuy around.

A pilot project was undertaken between Albany and Kingston avenues, where Prospect Place and parallel St. Marks Avenue represented the range of typical conditions in what Pei termed a "contrast of geraniums and lace curtains with crime."[3] The project was funded by

a $700,000 grant from the Astor Foundation; the architect worked pro bono.

Prospect Place was a solid middle-class neighborhood with owner-occupied brownstones. Residents formed a client committee and detailed what was needed to reinforce the quiet character of stoop and street. To Pei's disappointment they did not want the mid-block park he envisioned, but only to prevent cars from racing through. New trees were planted and lighting installed together with bollards, sidewalk improvements, and benches. The street was narrowed at both ends and speed bumps introduced.

By contrast, St. Marks Avenue had a poor, transient tenement population, with high rates of crime and drugs, but no play places for children nor anyone vested enough to get involved. Working with landscape architect Paul Friedman, Pei and his team closed the street with a mid-

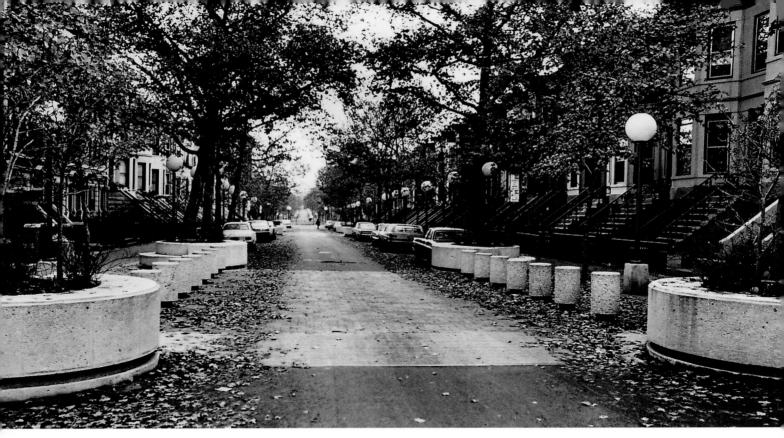

Enhanced residential neighborhood

block playground, adding a fountain, wading
pool, and seating, with book-mobile access and
perpendicular parking at the end of the block.
New infill housing was also constructed.

Emphasis was placed on community involve-
ment since the objective, beyond neighborhood
improvement, was to demonstrate what could be
achieved through united efforts. Implementation
was challenged by funding shortages, the resolve
to use local, often unskilled labor, and the
complicated coordination of numerous private
and public agencies, including police, fire, trans-
portation, parks, and sanitation departments
(the latter vigorously opposed to street closings)

Several years after the superblock's comple-
tion, a follow-up study indicated increased
stabilization, reduced crime, and ongoing main-
tenance by residents. There were positive benefits,
"from every point of view: economically, socially,
morale-wise, politically, physically, etc."[4], yet also
the awareness that isolated physical intervention
could not alone resolve much larger social issues.
Hopes to develop additional superblocks ended

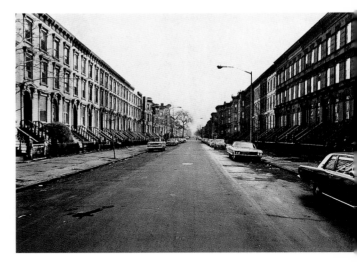

Typical existing conditions

with Robert Kennedy's assassination in 1968;
the pilot demonstration remained just that.

Bed-Stuy presaged Pei's involvement in other
significant projects, including the design of
Robert Kennedy's gravesite at Arlington Cemetery
and perhaps also the Louvre.[5]

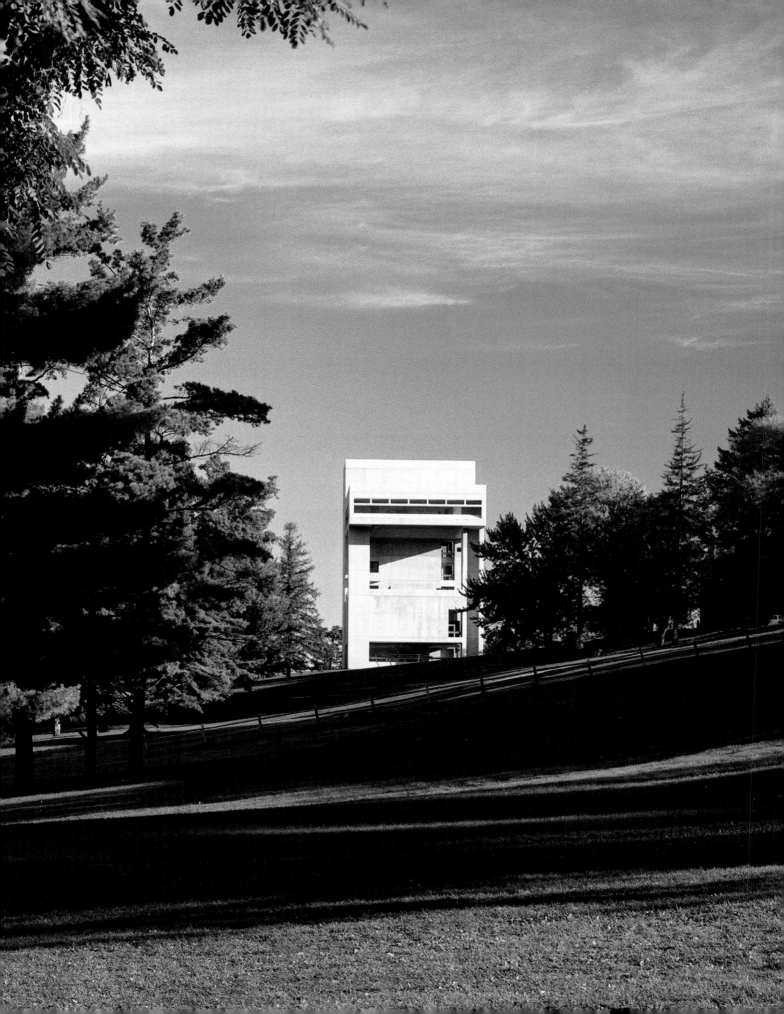

HERBERT F. JOHNSON MUSEUM OF ART

Cornell University
Ithaca, New York
1968–73

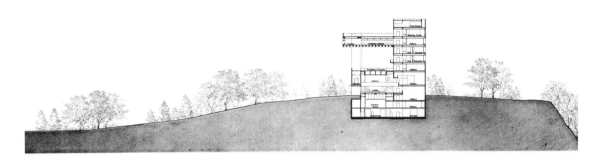

Section

In 1968, Cornell University commissioned Pei to design his third and most complex museum to date. Alumnus Herbert F. Johnson, whose house and corporate headquarters in Racine, Wisconsin, were designed by Frank Lloyd Wright, told Cornell's trustees he wanted a museum by the new master.[1] Like a three-dimensional puzzle, the building responds to a program of varied uses and opposing demands for transparency and closure.

Johnson is a teaching museum, equipped with some eighteen study galleries in which students learn firsthand about art. It includes work, reference, and art storage areas, a student lounge, curatorial and administrative offices. A lecture hall doubles as a gallery, and a raised outdoor sculpture gallery, designed for security in an era of campus unrest, doubles as a scenic lookout. The building houses temporary and permanent exhibition galleries, an important prints collection, a prized bequest of Asian art, and the boardroom of Cornell University's trustees. It is a cultural focus for the campus, for Ithaca, and for the entire Finger Lakes region of upstate New York.[2]

The slender nine-story tower with a hole cut through its center lies on a near-sacred site, where

Site plan

Ezra Cornell decided to found a great university in 1865. "It was very challenging," said Pei, "not only because of its importance in the history of the university but because of its many physical aspects; each demanded something different. The back drops into a gorge while the front sweeps into the campus. For the long view you need a certain scale." A gap in the adjacent Arts Quad, Cornell's oldest architectural grouping, also needed closure: "When you look from the quadrangle you don't want to see something that doesn't belong; we had to be a good neighbor."[3]

The design evolved from a large site model into which were inserted variously sized blocks

General view at head of Library Slope

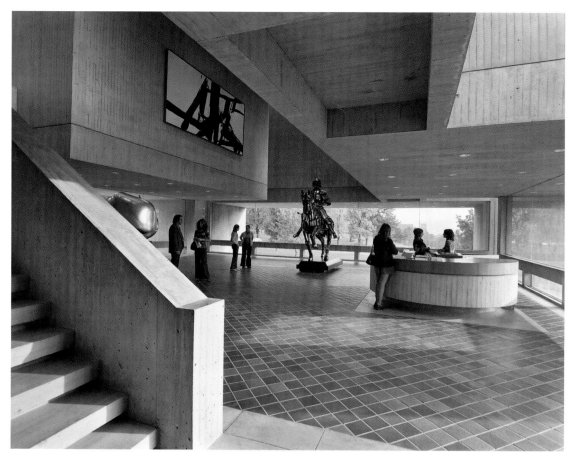

Ground-floor lobby

for the building's different functions.[4] The mass quickly became a perforated, view-permitting vertical at a height to match the Arts Quad and in buff-colored concrete specially blended to match its limestone trim. Johnson Museum was the first cast-in-place building constructed at Cornell. Inside and out, it is imprinted with the 3-inch-wide (7.6 cm) Douglas fir boards used to mold its walls, the vertical patterning disguising joints from adjacent pours, while horizontal joints were clearly expressed for scale. Each level was erected in one continuous pour to make the building appear sculpturally as an assemblage of solid blocks.

At 60,000 square feet (5,600 sq m) Johnson Museum is the same size as Everson, and employs similar strategies for moving through the galleries, here with exciting transitions from floor to floor, no two of which are the same. Visitors are surprised by sudden changes from open to closed volumes,

from art to outdoors, on stairs and open perches with dramatic views into a central court. Sited so that exterior paths continue visually through the lobby in a blurring of indoors and out, the building's enormous windows are mullionless throughout. Views are framed in quick glimpses from narrow slots as well as in expansive panoramas from the cantilevered student lounge. Similar views are enjoyed from the trustees' meeting room on the floor above: "You can't help but think big in a room like this," a board member exclaimed.[5]

For all of its achievements, the small multi-purpose building stumbles on the functional threshold between architecture and sculpture. Pei confessed, "I missed something here. I tried to make sculpture but was not successful. When you have a building with multiple uses all mixed together, it becomes difficult to do, whereas Everson's very simple volumes made it possible."[6]

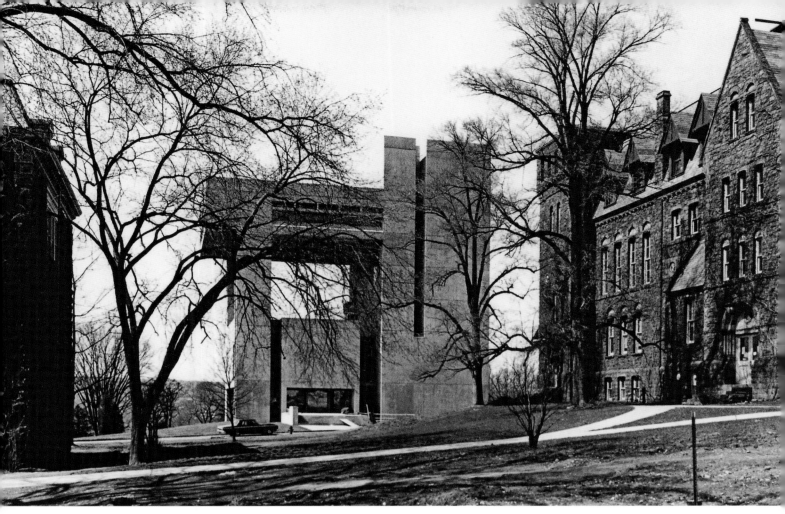

In context with historic neighbors

The architect was arguably his own greatest critic as others, including benefactor Herbert Johnson, applauded the building as "a truly great work of art."[7] *The Washington Post* went further: "This is a perfect museum. . . . In the way the openings between galleries are arranged and because of its various levels, the viewer gets an overview of what he is about to see . . . You don't suffer museum fatigue, because the gallery spaces vary in size and height. There is always a point of rest— a place to look out the window or some other little intermission."[8]

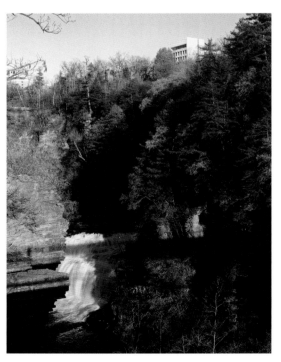

North facade overlooking Fall Creek Gorge

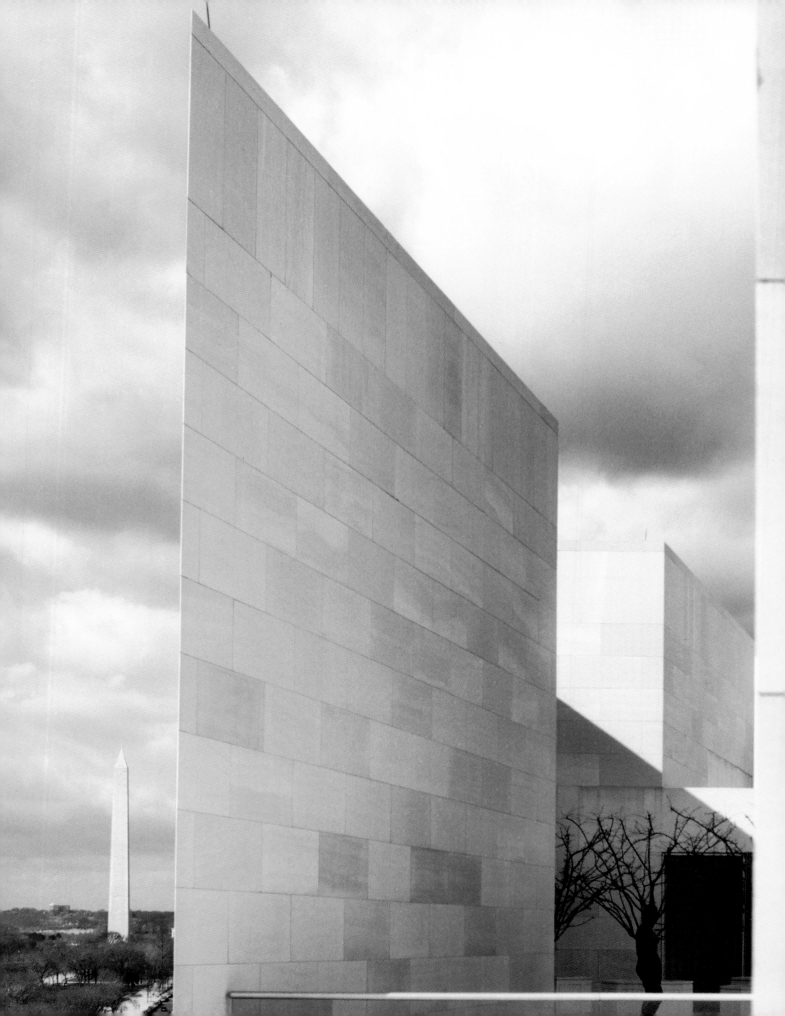

NATIONAL GALLERY OF ART, EAST BUILDING

Washington, D.C.
1968–78

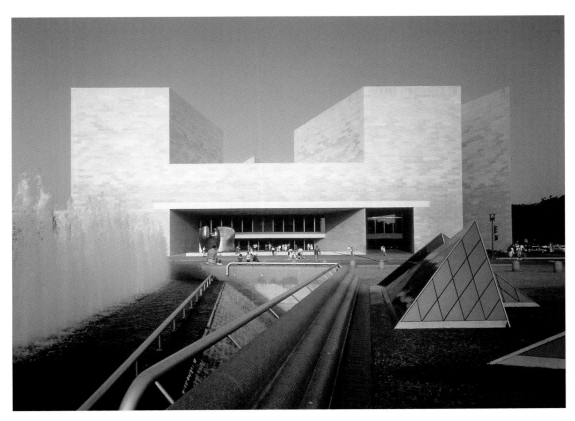

Main facade and plaza

The East Building of the National Gallery of Art positioned Pei solidly in the forefront of the profession, champion of a new museum type at the center of popular culture (witnessed by the unprecedented attendance of over a million people in the first two months). It was an ideal commission for which everything in Pei's past had prepared him. All of the essentials were in place: a strategic site, an enlightened client with an expansive budget, an unhurried schedule, and Pei's newfound freedom to practice the art of architecture. Add to this the technical expertise

of his now mature firm and a legion of workmen committed to the cause. From the outset it was understood by everyone involved that the East Wing was to be of the highest quality humanly possible — no compromises.[1]

Paul Mellon and his sister Ailsa Mellon Bruce donated $95 million for the building, supplemented by contributions from the Andrew W. Mellon Foundation. "I have commissioned a variety of works of art in my lifetime," Mellon wrote, "but only one great work of art. This was the East Building. To me it seems a majestic modern

I. M. Pei, concept sketch, fall 1968

I. M. Pei, impromptu site sketch, 1978

sculpture to be seen in the round with its massive walls of marvelous proportions and the precision of its many surprising angles. The choice of I. M. Pei as architect was ultimately mine, and I shall always be proud that I made that choice."[2]

The 8.8-acre (3.6 ha) site was arguably the most sensitive in the country, located at the foot of the Capitol where Pennsylvania Avenue converges with the national Mall in a trapezoid formed by Pierre L'Enfant's historic city plan. Andrew Mellon, Paul's farsighted father, secured the land for expansion when he built the original National Gallery in 1937. Schemes were proposed intermittently over the years but, as National Gallery director J. Carter Brown joked, they always looked as if the Beaux-Arts museum had a pup since architects invariably ignored the site's awkward shape and envisioned a small rectangular building on axis with the original.[3]

Beyond the requirement to complement the existing building, the expansion would also have to agree with its mostly neoclassical neighbors. It had to adhere to established setbacks and, in a difficult urban construct, respect the disparate cornice lines of both Pennsylvania Avenue and the much lower buildings on the Mall. In this monumental setting, Brown wanted a human-scaled environment for viewing art, and a study center to add scholarship "after the models of ancient Pergamon and Alexandria."[4] This was the

real catalyst to build: the existing museum had ample exhibition space but no research library nor sufficient support space.

Pei's response grew directly from the site at a size much larger than anyone had previously thought possible, classic but not classical, fully of its own era without historical reference or hint of then-popular postmodernism. The solution came early on a flight home from Washington when he drew a diagonal to connect two points on a site diagram, creating a large isosceles triangle (the museum) and a smaller right triangle (the Center for Advanced Study in the Visual Arts). In a stroke Pei cut through stunting complexity to a simple solution, obvious only after he conceived it. The site's triangular geometry became the leitmotif of the entire design.[5]

Pei located the entrance to the East Building at the midpoint of the large triangle's base, directly opposite the then-unused but now important side entrance of the original museum. The new building mirrors the symmetry of the old and continues its powerful east-west axis. This was the key to harmoniously tying together two buildings separated by a city street, four decades, and a revolution in architecture that distanced modernism from everything before.[6] But once inside, the Beaux-Arts axis disappears; movement veers south in the shifting space of the central atrium, a third triangle that links the other two and unifies the East Building as a whole.

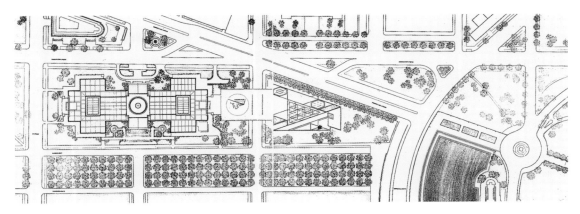

Site plan

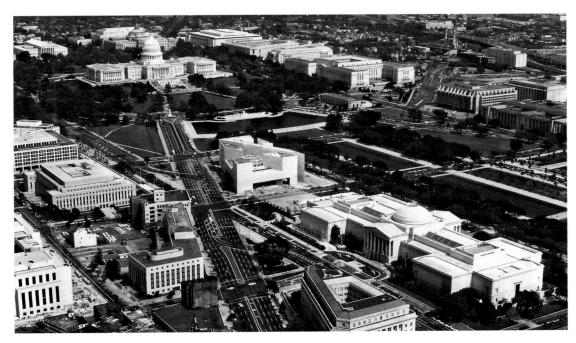

Bird's-eye view above Pennsylvania Avenue toward the Capitol

The East Wing was undertaken to attract not the connoisseur but families and youths visiting the Mall. The building would have to entice people inside and make them want to stay. "It's not the amount of time spent in a museum that's important," Pei explained. "It's the quality of the experience. I learned that many years earlier when we'd take our children to museums. They were never very interested in the Metropolitan, despite its terrific collections, but always loved to go to the Guggenheim. I never forgot that."[7] Although the trustees' program made scant reference to public space, Pei carved out a 16,000-square-foot (1,500 sq m) atrium. It provided the National Gallery what the original museum lacked, including a large ceremonial space for receptions and special events, a place where museumgoers could wait and groups gather, a change of pace between galleries where visitors could recharge. Critically for a big public building filled with people, it provided a clear center of circulation and orientation (in marked contrast to the original museum whose rigid symmetry confused even Paul Mellon).[8] In a city known more for the status quo than for achievement in contemporary art, the East Building gave

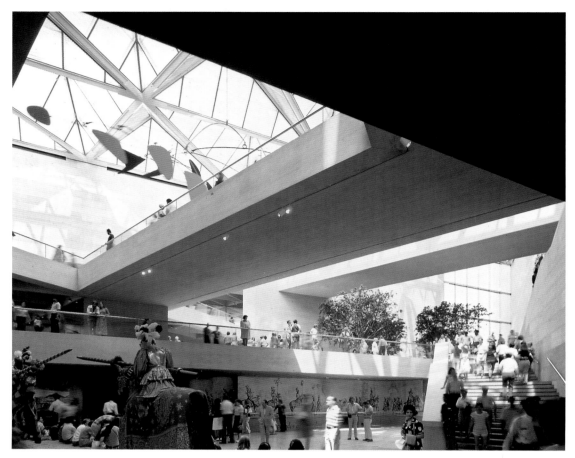

Atrium, concourse level

Washington a cutting-edge showcase for highly competitive blockbuster shows.

Since 1964, when Pei visited baroque churches Vierzehnheiligen (1772), near Bamburg, Germany, and the Käppele (1744) in Würzburg, Germany, he had been interested in multipoint perspective and the richer spatial experience it provides. "I knew that if I could only bring the extra vanishing point into play I could create more exciting spaces. But one doesn't often get the opportunity. What can you do with a housing project?"[9] The East Building's irregular site seemed to demand a triangular module.

Pei brought in perspectivist Steve Oles to give coherent form to the design team's gestures and ideas, ensuring that everyone visualized the same, often tricky, triangular relationships.[10] William Pedersen, now principal of Kohn Pedersen & Fox, recalled how "I. M. painted word pictures

while mentally walking through the building. It was magical. He'd envision going through the galleries, coming up on a bridge, and overlooking the central court. I realized he thought through the building in an entirely different way. He had in mind a sequence of images, of experiential movement."[11] It was an architectural approach that Pei first explored in Everson Museum but a way of seeing he had known since childhood in his ancestral gardens in Suzhou, where zigzag paths shift views to expand space and engage the imagination. "I was intrigued by movement as an important part of the experience," Pei gestured. "We tried very hard to develop the possibilities fully, but carefully to ensure there was no loss of clarity. This is important because without discipline spatial richness would simply lead to confusion. Instead, through control we created interest."[12] A formidable challenge came from the

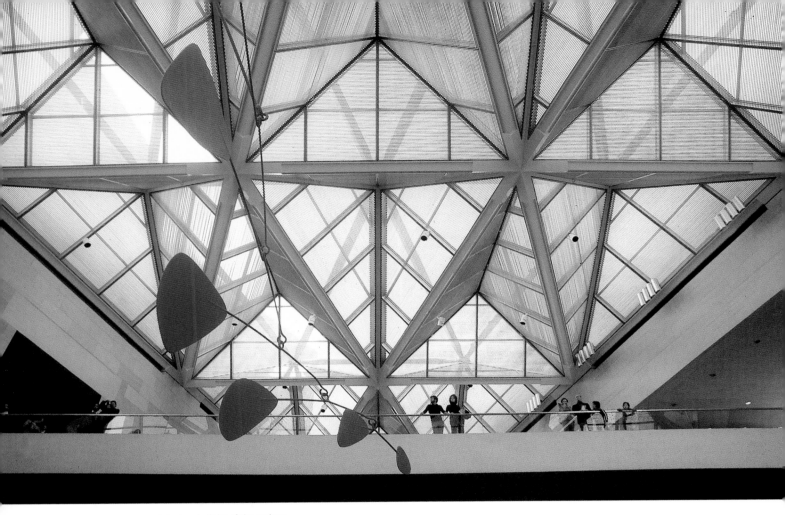

Interior skylight of the atrium

atrium's triangular shape which, wide at one end, races uncomfortably to the opposite point. Pei discharged the momentum through a monumental window onto the Mall, continuing it with the 20-foot-high (12 m) trees positioned in the atrium as carefully as the museum's collection, art, architecture, and nature in balance, indoors and out.

Whether arriving via the underground link from the original building or from the compressed main entrance on Fourth Street, the atrium sweeps up in dramatic contrast, animated by changing angles, patterns, and perspectives, an Alexander Calder mobile revolving slowly overhead, and people moving through the building on different levels above and below, on bridges, stairs, and on an escalator recessed into a wall scoop to meet the building's rigorous module. "That it fit," sighed a team member, was "a little gift from God."[13]

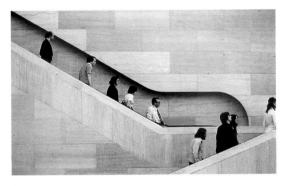

Escalator scoop

Without the usual urgencies Pei could refine the design to satisfaction, most notably the atrium's iconic skylight, which was a late substitution and major advance over the coffered roof originally planned. Pei's late partner, Eason Leonard, recalled how "I. M. came into the office one morning and you could just tell that a bell had gone off during the night. He always kept a sketchpad by his bed.

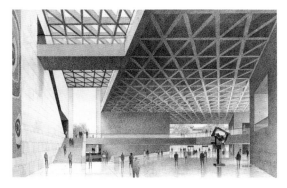

Coffered concrete atrium, Oles rendering, 1969

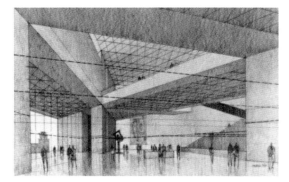

Atrium ceiling carved open, November 6, 1970

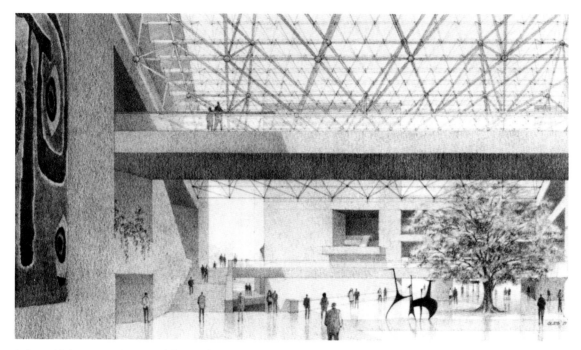

Atrium with large space frame module, March 4, 1971

I heard Jake [project manager Leonard Jacobson] screaming. We were probably nine months into the job. A lot of drawing had been done and we'd already gotten a price that everyone seemed to like for the concrete roof. And I. M. changed it to a skylight. . . . There was no way to adjust the fee or ask for extra service to cover this. But now that he saw the light, there was no way I. M. would ever go back to that solid concrete ceiling. And, of course, the skylight makes the building."[14]

No one had ever seen anything like it: a 500-ton (450,000 kg), 80-foot-high (24 m), one-third-acre (0.13 ha) engineering tour de force in glass and steel of the most exacting design and fabrication.

Individual components were connected by 6-ton (5,400 kg) steel nodes placed 45 feet (14 m) apart in one direction and 30 feet (9 m) in another, scaling the building module to the huge space. Spectacular by any measure, the structure rests on sliding bearings that compensate for thermal expansion while concealing lighting, heated snow removal, and water runoff. The skylight's laminated glass was equipped with a protective ultraviolet interlayer and screened by a newly developed system of polished aluminum rods (hereafter a frequent component of Pei's architecture) that not only reduced the amount of light and heat admitted but diffused what otherwise

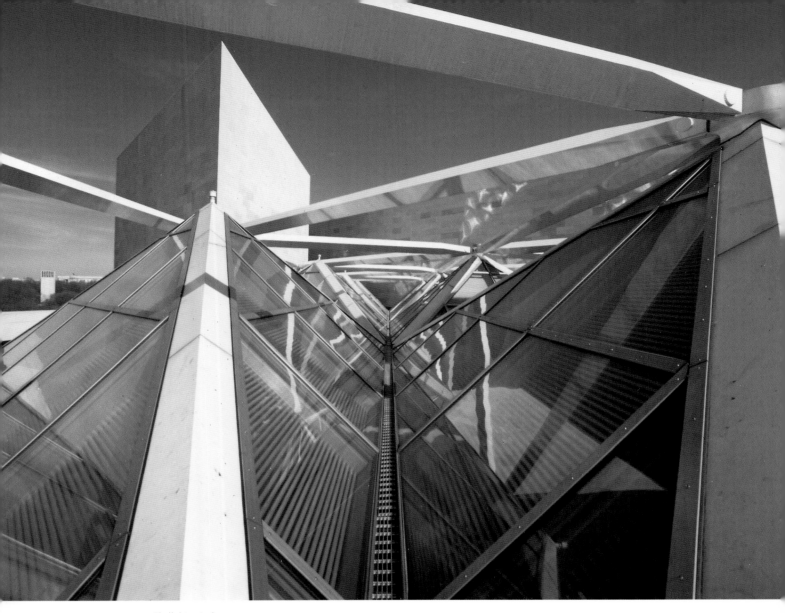

Skylight exterior

would have been sharp black shadows on the art specially commissioned for the space.[15] "What I really wanted was a public plaza, just as open and outdoors as possible. In the right climate I might not have covered it over, but in Washington a skylight was a must. We were able to achieve this because the three-dimensional coffers that comprise the skylight are structural. If I were to span this huge space without these tetrahedrons, the members of the skylight would have been enormous."[16]

Exhibition areas are tucked into the corners of the museum in three diamond-shaped towers, their sharp angles walled off to create hexagonal rooms more suitable for viewing art (housing spiral stairs and utilities in the blunted points). Each tower has three levels of exhibition space, four including the concourse, that range in height from 10 to 40 feet (3-12 m) to ensure objects the correct scale, whether a miniature watercolor or an enormous canvas. The rooms can function independently for multiple small exhibits, link horizontally or vertically for larger exhibitions, or completely interconnect for a blockbuster show. As if borrowing a page from cubism, the galleries allow the simultaneous presentation of multiple viewpoints and experiences. Such an organization was especially appropriate because

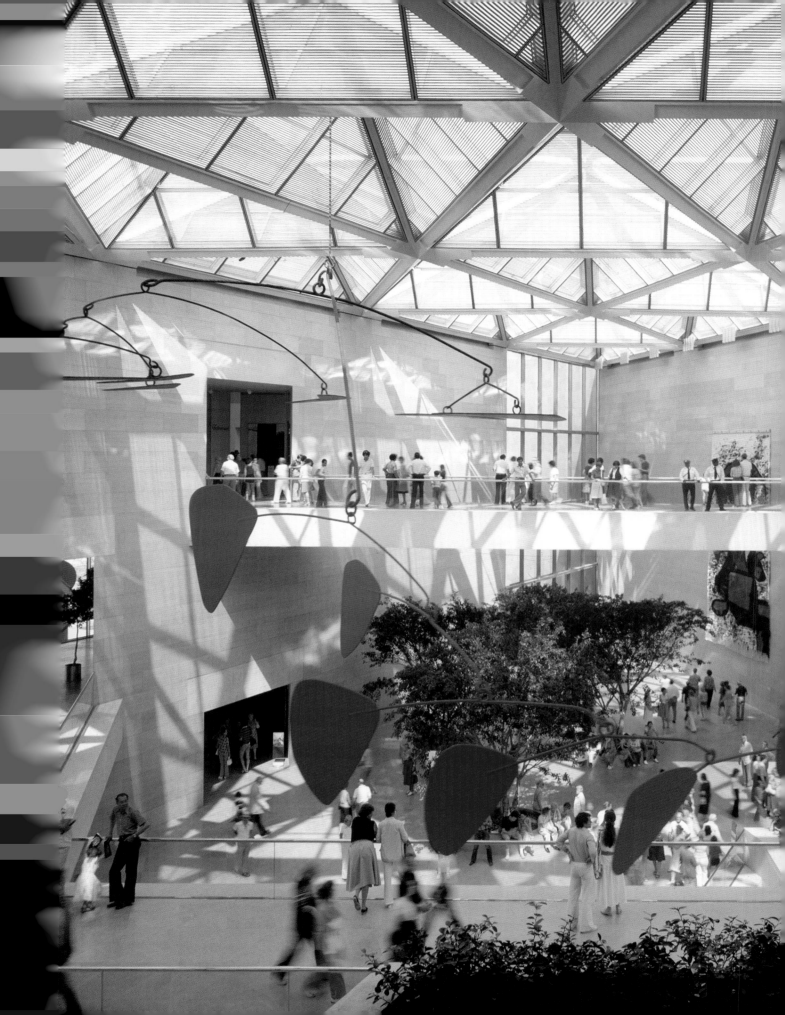

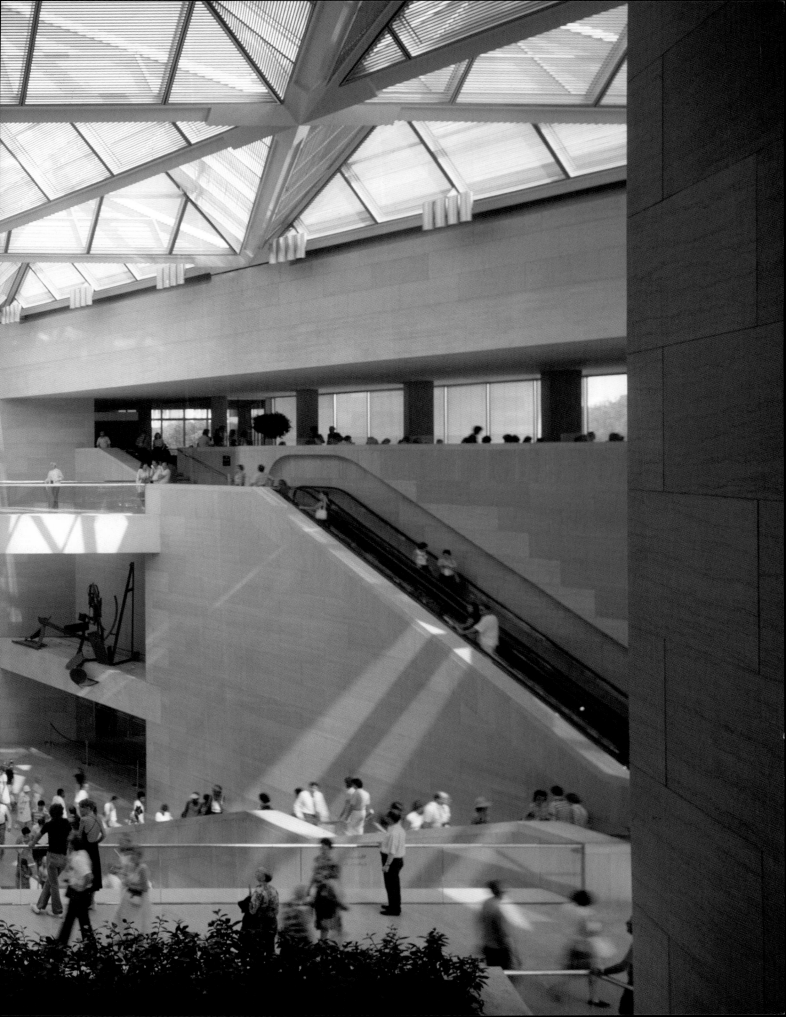

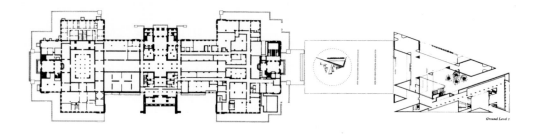

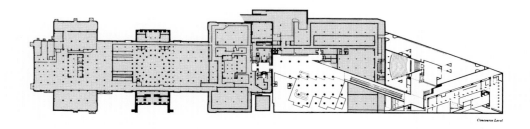

Concourse and ground-level plans

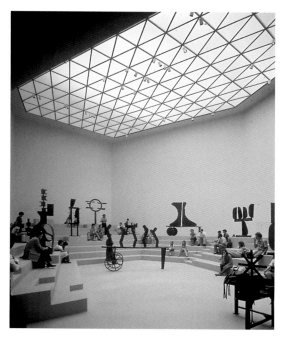

Gallery with David Smith's *Voltri* sculptures

unlike the original building, where permanent installations are ordered chronologically through the nineteenth century, the East Building focuses on temporary shows and modern art, where there is no single line of development but a lot of coeval experimentation. Providing the house

museums Brown admired, the towers were each limited to 10,000 square feet (930 sq m), which visitors can comfortably cover in forty-five minutes or roughly the amount of time before "museum fatigue" sets in. "You come out from the galleries and see where you are and where you've been," Pei explained. "Then you can go back inside refreshed, and enjoy more art."[17]

Most people think of the East Building solely as a museum, yet it comprises only one-third of the whole, another third being the Study Center, which occupies a smaller footprint but has twice as many floors. Administrative and curatorial offices around a 72-foot-high (22 m) library reading room are topped by a refectory where scholars and museum personnel can interact, with separate access below. Resolution of the difficult problem of putting two entrances next to each other, one public and dominant, the other relatively private and not unimportant, was achieved asymmetrically on the symmetrical facade in one of the more accomplished, but unsung, parts of the building. More celebrated is the building's knife-edge prow, whose unintentional soiling from the strokes of admirers over

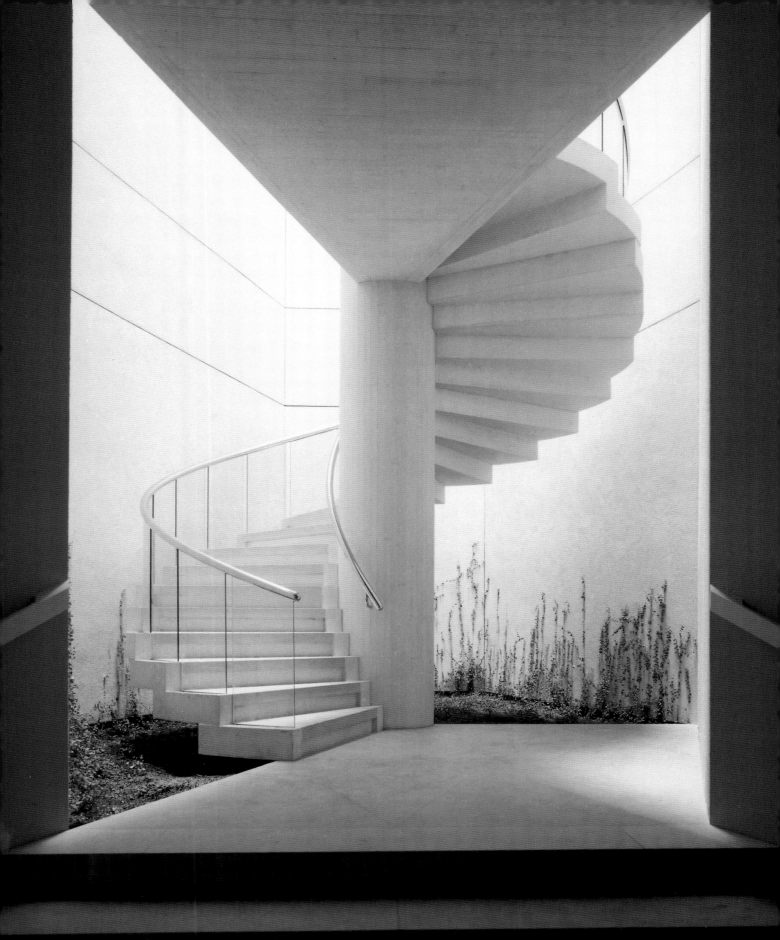

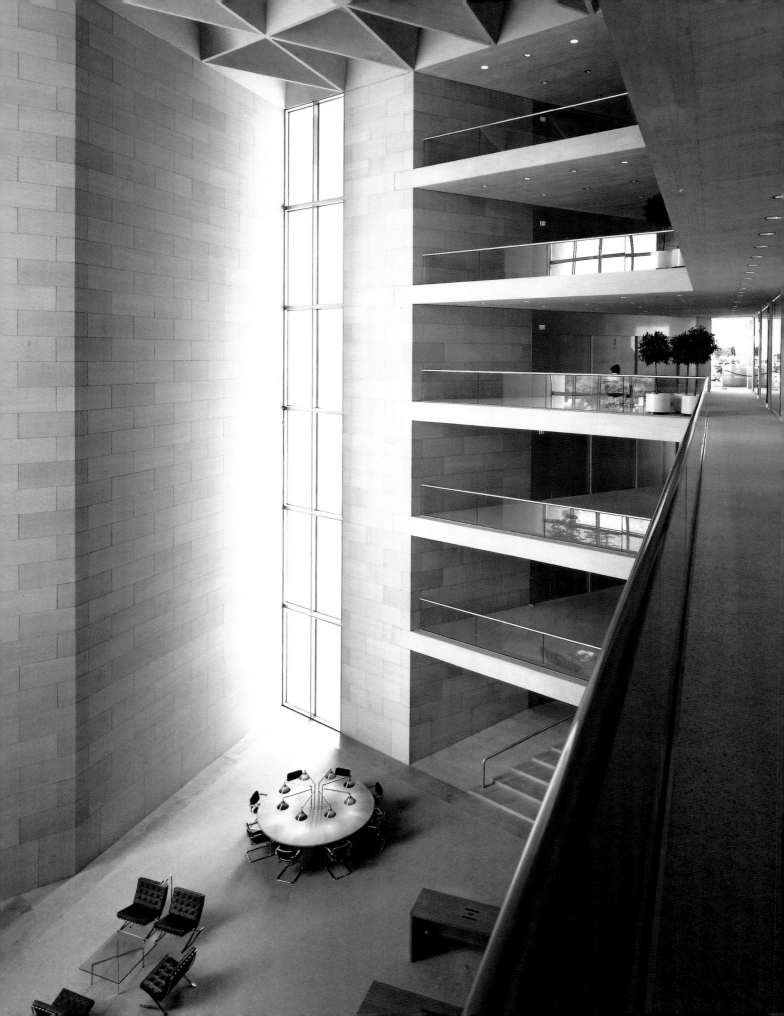

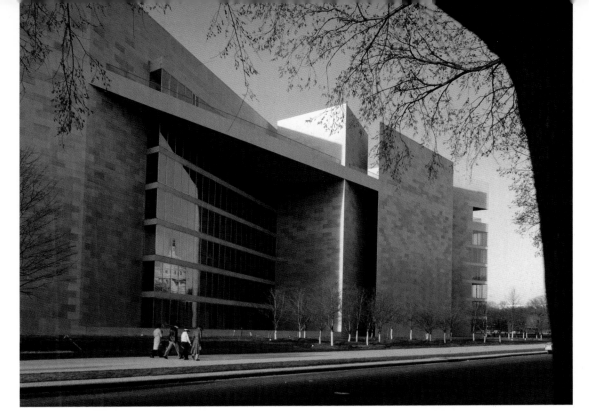

Mall facade

the years has been accepted by the administration as the East Wing's palimpsest.[18]

Paul Mellon specified the same pink Tennessee marble used by his father.[19] The quarry was reopened and an original stoneworker brought out of retirement to help but Pei had to settle for a blend of five color gradations (instead of fifteen), and 3-inch (7.6 cm) slabs instead of the now cost prohibitive 9-inch (23 cm) blocks previously used. The real problem, however, were thermal stresses because, unlike the Beaux-Arts building, there were no columns or moldings to conceal expansion joints, just great unbroken expanses of wall, as much as 180 feet (55 m) in length. A new system of double-wall construction was developed whereby marble panels were individually supported by stainless-steel plates anchored into a brick wall behind so that each stone, floating free in space, could expand and contract independently. Non-weight-bearing neoprene gaskets, colored to match the stone, filled the spaces in between.[20]

The East Wing ended Pei's development of monolithic concrete buildings, and began his use of architectural concrete as fine-finish structural expression. Blending marble dust with concrete to complement the walls, but not so much to mistake it as the same material or a near miss, Pei employed concrete's tensile strength to span entrances, bridges, and roofs, all executed with meticulous care in Douglas fir formwork crafted like fine cabinetry by workmen wearing slippers to protect against blemishes.[21]

While the addition appears smaller than the original museum, it is actually 150,000 square feet (14,000 sq m) larger; one-third of its mass is tunneled under Fourth Street to functionally unite the entire National Gallery. The two-story link houses temporary exhibition space, a ninety-seat lecture hall, 422-seat auditorium, 700-seat cafe, museum shop, loading docks, storage, laboratories, work areas, and all the other in-house services that could be squeezed in to update the museum, overcoming tremendous physical challenges.[22]

In its connection of old and new, the East Building anticipated Pei's solution at the Louvre, although he emphasizes the plaza's glass prisms are unrelated to the pyramid.[23] They complement

Seventy-foot-high study-center reading room

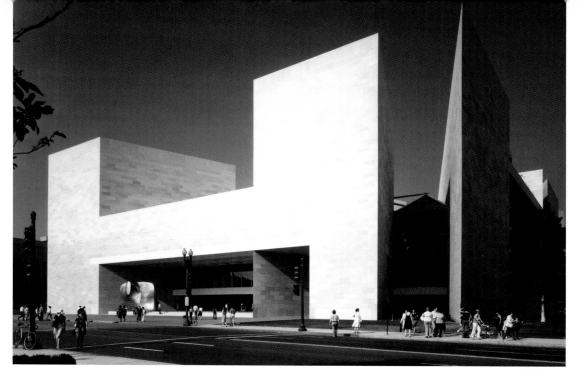

Main facade, museum and study center

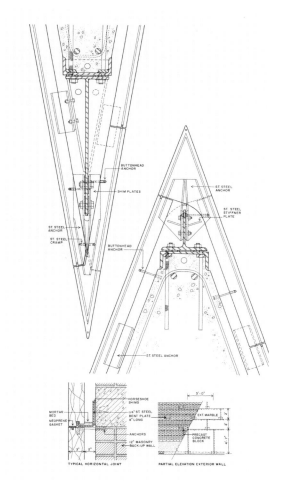

opposite:
Anthony Caro,
National Gallery,
Ledge Piece, 1978

Construction details

the angled chadar (water wall) alongside the tunnel between buildings, which tumbles white water onto a glass wall in the concourse-level cafeteria. All three of the building's main components — museum, study center, and underground link — are thus animated by a dramatic core of light and movement. Pei explained, "The importance of light in architecture is well known, but again it's a question of opportunity. I reached a point in this building where I was able to explore the richness of light and certain mysteries of form and space. I went beyond the obvious and began to experiment." The introduction of an additional vanishing point, he continued, "allowed us to move beyond Mies and the limited spatial possibilities of an orthogonal grid — which is not to say we were better architects but only that we were able to build upon what had gone before. I knew that if, in the future, I could explore curved surfaces with their infinite number of vanishing points, I could create even more exciting spaces, but as always, I had to wait for the right moment."[24] It came several years later with the commission to design the Morton H. Meyerson Symphony Hall in Dallas.

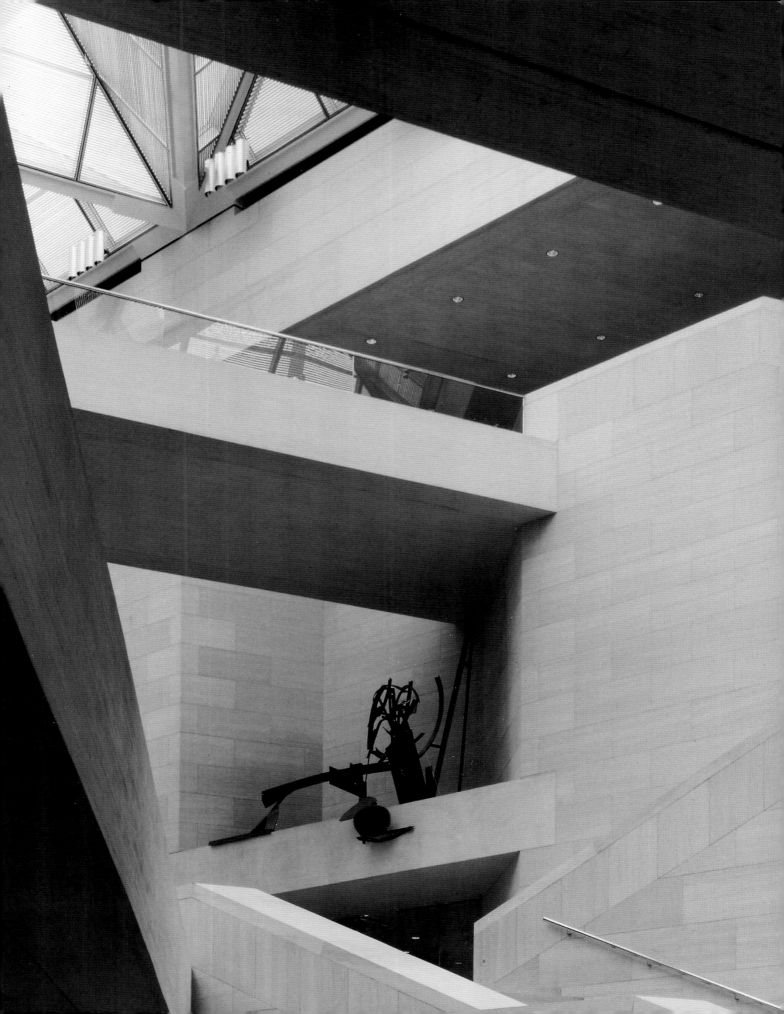

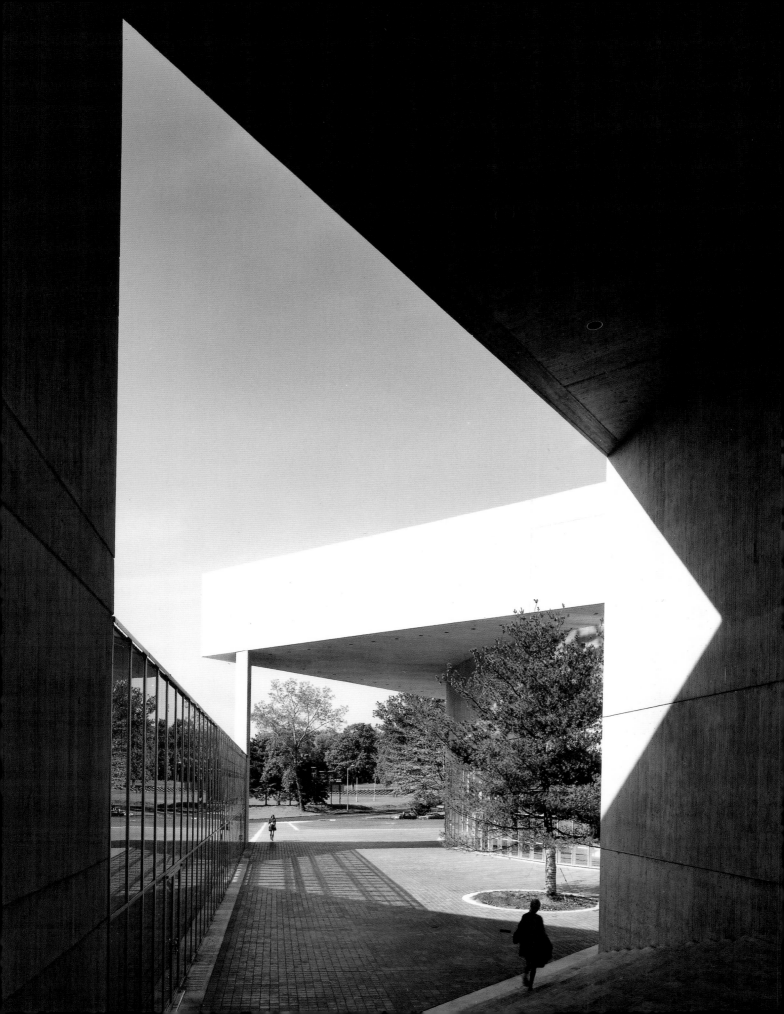

PAUL MELLON CENTER FOR THE ARTS

The Choate School
Wallingford, Connecticut
1968–73

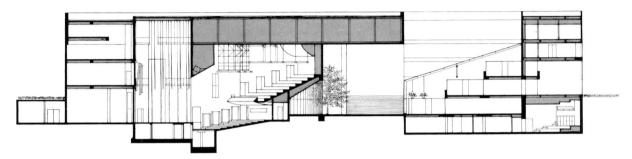

Section

This project began in the early days of co-education when the merger of The Choate School with Rosemary Hall was under consideration. The two initiatives were independent but evolved together and became inseparable, Mellon Center providing a gateway between the two schools and the most visible evidence of their union. For boys to reach girls on the upper campus or girls to meet boys down the hill, they had to pass through the open space at the center of the building. It was, according to Pei, "a trap" to expose even those with no interest to art.[1]

In 1967, Choate's trustees conducted a nine-month search for an architect who "knew Georgian and would fit in" with the existing campus. Reverend Edward Miller challenged other board members: "Why not choose the best architect in the country?"[2] The commission, awarded on October 20, 1967, got underway a year later, by which time the Art Center's namesake benefactor had independently commissioned Pei to expand the National Gallery of Art.

Ralph Heisel, who worked closely with Pei on the project, recalled making a simple functional diagram that worked so well it gave basic

Connection from
upper campus

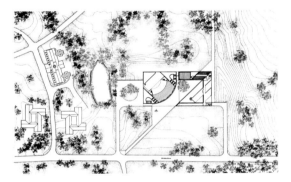

Site plan

form to the actual building. In a neutral rectangle, a quarter-circle denoted a theater with radiating seating. To minimize bulk in this very big volume—it was to house the entire eight-hundred-person student body—the theater was set into a hillside and carved away until only the essentials remained. The extracted elements were then combined with art and music facilities in a right triangle off to the side, with one leg parallel to the street and another aligned with a bordering meadow. Between the two halves was the theater lobby.

Pei's immediate response to the diagram was "Let's pull it apart."[3] Separation facilitated the

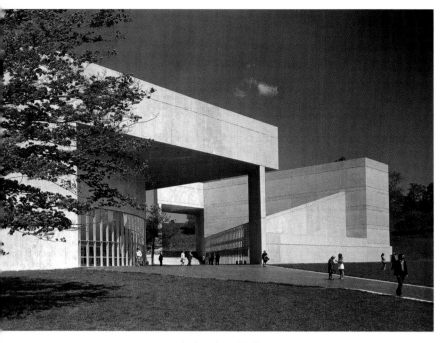

Main facade and link to upper campus

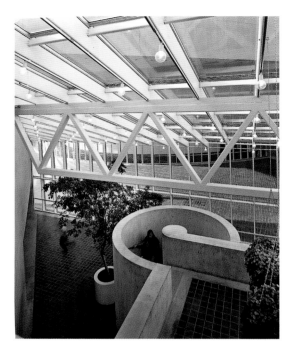

Spiral stair up from student lounge

different functions: the theater was used by many people but only occasionally, and the arts triangle — classrooms, studios, exhibition spaces, department offices, lounge — was used daily but by fewer people. The real reason for the split, however, was to create a passage.

Isolated at Choate's edge, Mellon Center created its own context with geometric forms in buff-colored concrete unlike anything else on campus. The goal was not to blend in, but to stand out and provoke students to respond to the building and the activities taking place inside its glass walls. An unprogrammed student union was included on the ground floor as a magnet; teens passing by might drop in on impulse. "You can walk through the building without going into it," the headmaster grinned, "but you cannot walk away from it without knowing you've been there."[4]

Mellon Center is one building, physically separated but visually integrated. Conversely, the theater and arts components are so different functionally that they really comprise two separate buildings joined together. The volumes are linked underground by an experimental theater and above ground by a corner pier, freestanding

yet engaged, that transitions from the wall of the arts triangle to the theater roof. On the opposite front the components are connected by a stair canopy to the upper campus.

Mellon Center started after the National Gallery but with its smaller size was finished first. The two buildings have no formal connection, although Pei was thinking in both about separation and connection, solids and voids, light, movement, and the play of complex geometries. One senses at Choate a greater freedom to experiment with a bold, sculptural approach to spatial possibilities. The building has much greater interest and excitement than it would as single mass, underlining Pei's conviction that spaces are as important, if not more so, than buildings. The approach, he explained, "comes directly out of a Western tradition of art based on relationships between solids and voids you can trace to Picasso."[5] Forty years later, Pei thought of the Mellon Center when he saw a previously unknown Picasso drawing in the *New York Times*: "Picasso was there! Cubism's influence on modern architecture, at least my kind of architecture, is very strong."[6]

opposite:
Entrance to lower campus

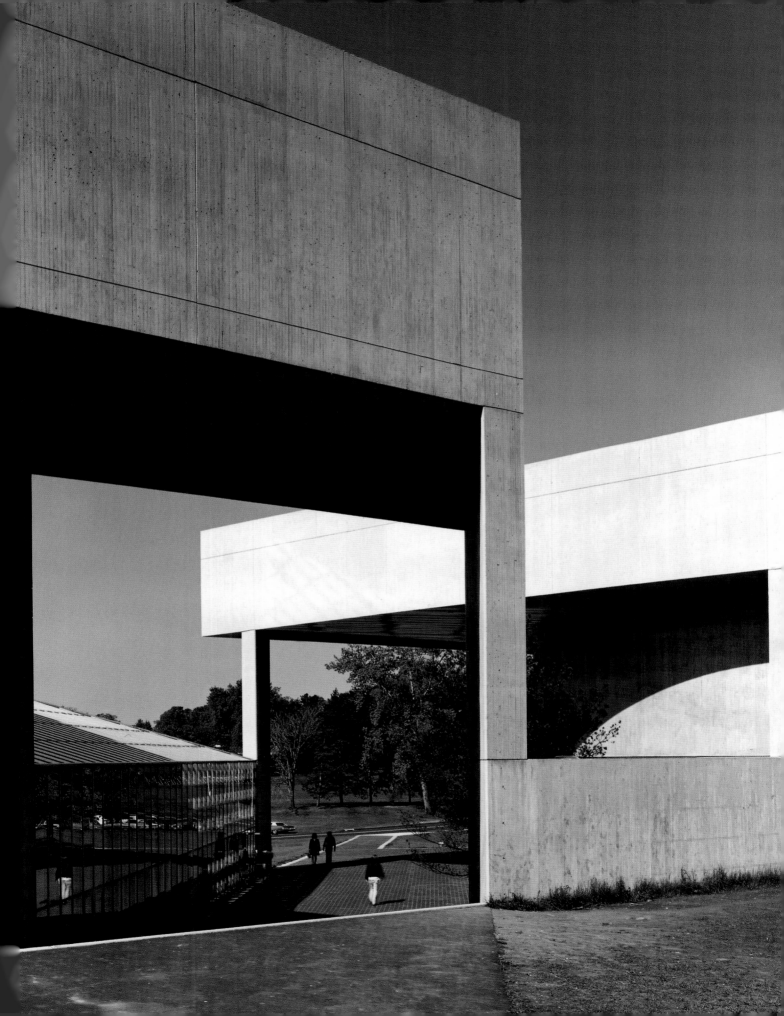

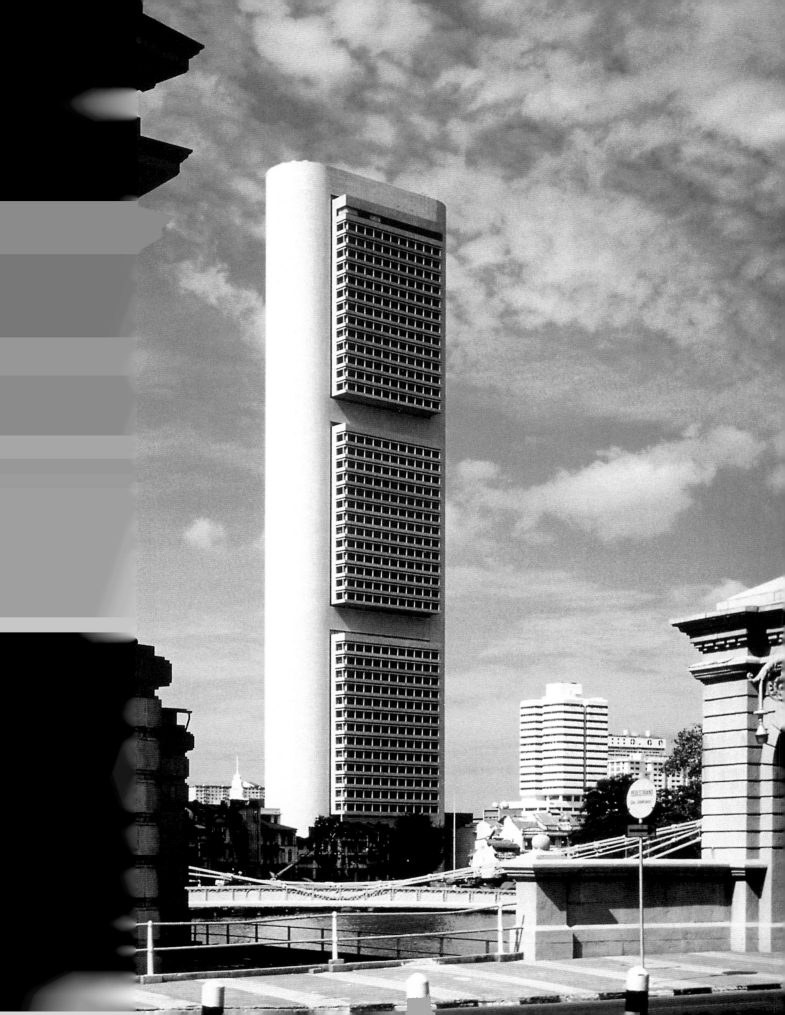

OVERSEA-CHINESE BANKING CORPORATION CENTRE (OCBC)

Singapore
1970–76

The tallest building in Southeast Asia upon completion in 1976, the fifty-two-story Oversea Chinese Banking Centre (OCBC) is located on a key downtown site in the "Golden Shoe" center of commerce. Pei was among the first outside architects invited to Singapore after its independence in 1965. He exerted a significant and enduring impact on the nation's physical development through a series of master plans and three tall building projects that, sited strategically along Singapore River or on large open greens, connect the modern city with highly visible urban markers, like the obelisks of Renaissance Rome.

Pei was first contacted in 1967 by Dato Lee Kong Chian, president of Chung Khaiw Bank, who had apprenticed with Pei's father and now wanted to build a landmark headquarters. "In China family is very important," Pei explained.[1] A tower was designed but not built as Chung Khaiw underwent a hostile takeover just before groundbreaking, yet it led to a commission directly across the street for OCBC, the largest private bank in Singapore.[2] OCBC's president Tan Sri Tan Chin Tuan, also a Pei family friend, made clear that he wanted a "national monument" to replace OCBC's existing six-story headquarters, as well as tenant offices and an imposing banking hall that would "meet the eye of anyone entering the building."[3]

It was rumored that Tan Chin Tuan inspired the twin-core design when he explained the need for a powerful building to express OCBC's "Solid as a Rock" corporate motto, and raised his fisted forearms in a show of strength.[4] Singaporeans also saw in the design Pei's Chinese signature ("Just

I. M. Pei, sketch of OCBC (left) and "Pei" Chinese character, 2007

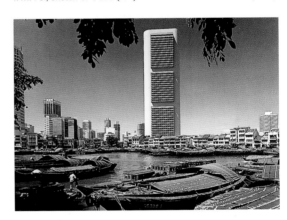

Singapore River view, 1976

local gossip," dismissed the architect with a laugh. "The important part, the legs, are not even there!"[5]). In reality, the design was motivated by pragmatic concerns for the quality execution of a 929,000-square-foot (86,000 sq m) tower on a tight site in a distant, still-developing country where the tallest building at the time was eight stories. Pei determined to build a straightforward expression of structure, simplifying the complex so that the wary contractor was not challenged by Singapore's first skyscraper, but—three fifteen-story buildings stacked on top of each other.

Beginning with the two structural cores, concrete was poured into "slipform" molds that

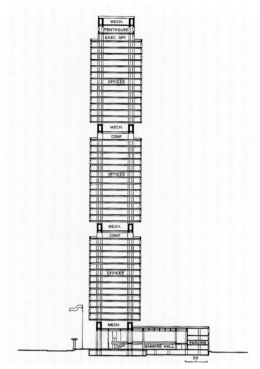

Section

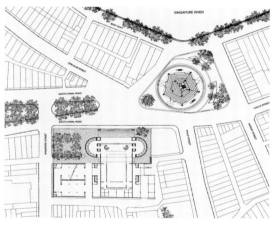

OCBC site plan with unbuilt Chung Khaiw Bank above

Pei discussing maquette with Henry Moore and Michel Muller

its loads to the cores. "With the trusses," Pei explained, "the loading doesn't continue all the way down. It's like water; you want to channel off some before it becomes a flood."[6]

Pei had originally hoped to construct the tower in architectural concrete but when it was found too porous to prevent discoloration from an indigenous fungus, he realized OCBC's rock-solid imagery by facing the cores in granite. Matching off-white glass mosaics protect exposed surfaces of the sunscreened office floors, which cantilever out 15 feet (4.5 m) to widen office floors to 95 feet (29 m).

Below the fourth-floor truss is the ground-floor banking hall, a vast column-free space that extends into an attached six-story garage along the back of the site. The tower appears to stand alone in a long plaza, sculpturally presenting its slender ends to the narrow streets while broadly fronting on a major intersection. The breezy companion of this powerful building is a walk-through bronze that Pei, after three trips to Henry Moore's studio, finally convinced the sculptor to enlarge from a 13-inch (33 cm) maquette made in 1938 into a 25-foot-long (7.6 m) reclining nude. Challenged by Pei to explore new limits to the point where Moore considered it "almost like a piece of architecture," the figure was the largest and one of the last of Moore's sculptures.[7]

opposite:
Chulia Street view

moved up continuously in minute increments, leaving an ever-growing extrusion of hardened concrete behind. At the fourth, twentieth, and thirty-fifth floors the freestanding cores were spanned, like the rungs of a ladder, by tremendous steel trusses that effectively formed the ground floor of each "15-story building" and allowed them to be constructed simultaneously, even while the floors below were incomplete. The trusses house all the mechanical and electrical systems for each "building" and transfer

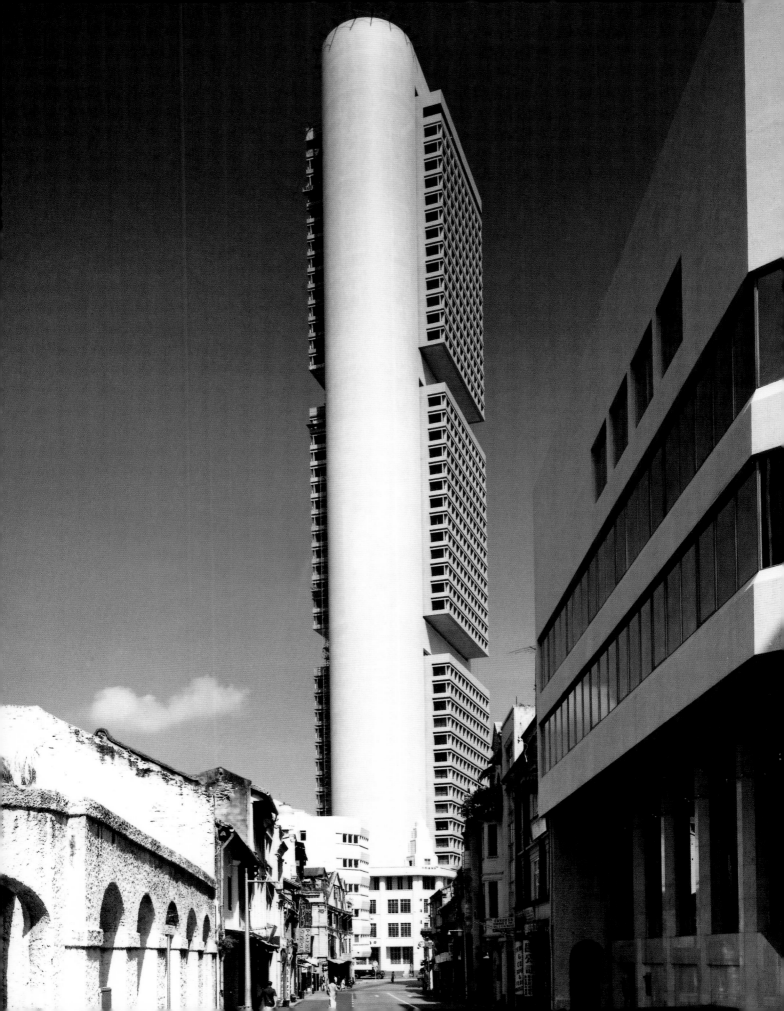

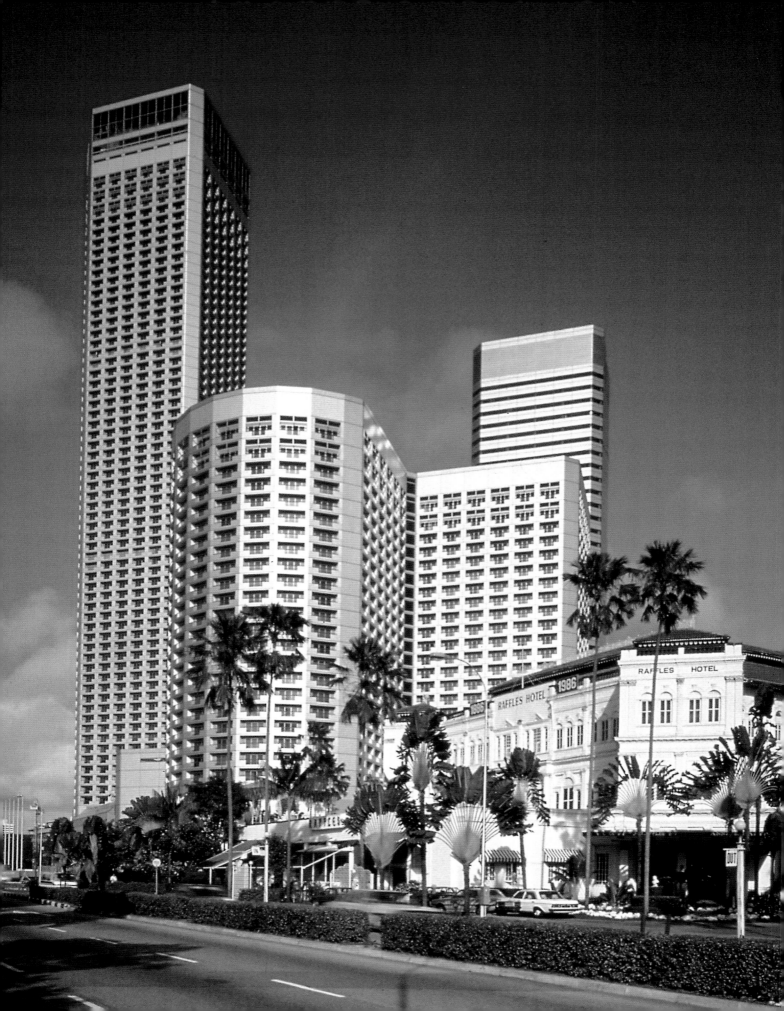

RAFFLES CITY

Singapore
1969–86

Raffles City began in 1969 when the founding fathers of modern Singapore set out to transform the remote port of trade into an international center of banking and commerce. It was Pei's largest and longest-running project, stretching over seventeen years, during which the client and the program changed, as did its location, through landfill, from Singapore's watery edge to a more central location.

Pei already had a local presence when he was asked by the quasi-government Development Bank of Singapore (DBS) to identify possible uses for 32 acres (13 ha) slated for urban renewal. DBS decided to concentrate on the commercial end of the site, ultimately the only parcel developed, an 8.5-acre (3.4 ha) superblock. "We had to find ways to break it up, and introduce some kind of organizing grid, otherwise it would have just fallen apart," Pei explained. " In the beginning, ideas about use were only generalized so the scheme had to be flexible enough to serve a program that came much later."[1] A nine-square plan provided the solution, with curves and notches carved out to make the volume more dynamic. Bulk was shifted away from the historic Raffles Hotel across the street, where Rudyard Kipling wrote exotic tales of the Far East, so that the 733-foot-high (223 m) tower anchors the Padang, the cricket field and ceremonial center of colonial Singapore. "This was the most important corner," said Pei, "because it would always have the open space so therefore it was clear that this was where the symbolic building should be."[2]

As an antidote to Singapore's traffic congestion, Raffles City was envisioned as an innovative

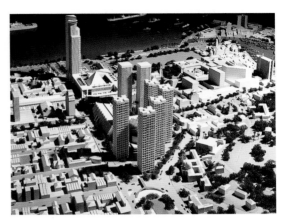

Raffles International Center, early master plan, 1970

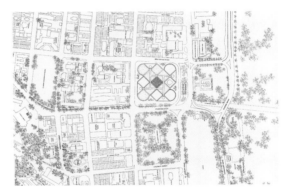

Site plan

one-stop world where people could spend an entire day, or more, without ever getting into a car. With an immense complexity unprecedented in Asia, it was to include an office tower, an apartment building, two mid-rise hotel towers, a convention hall, and nearly 1,000,000 square feet (93,000 sq m) of retail, with mass transit and a 3,000-space parking garage, all connected by a seven-story atrium. Working drawings were completed in 1970 just as Singapore's economy dipped into recession; DBS decided to wait.

General Beach Road view with orthogonal hotel tower and historic Raffles Hotel

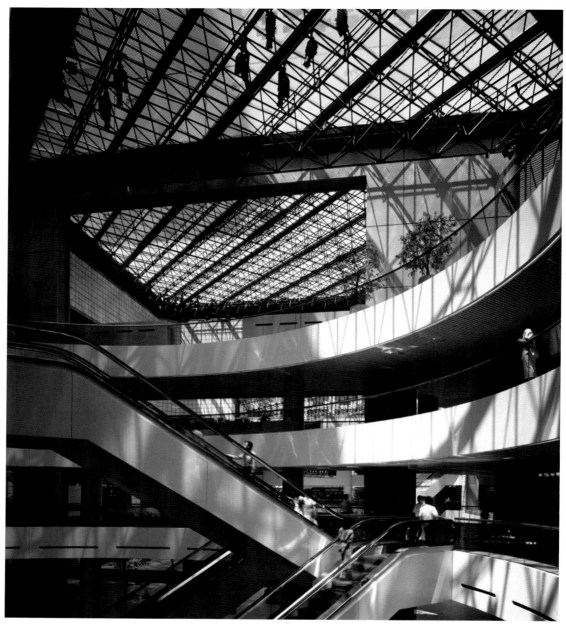

Subdivided atrium

When the project was revived nearly a decade later, DBS requested sweeping changes, most significantly the transformation of the iconic office tower into a hotel and the apartment building into offices. The modifications effectively comprised a renovation since the decision to proceed was based on construction readiness: exterior massing couldn't change.[3]

A 1.5-acre (0.6 ha) atrium animates the center of the superblock with light and the color and motion of people on crisscross escalators, bridges, and curved open balconies. Proscenium-like screen walls divide the whole into discreet spaces while offering glimpses into spaces beyond. "Complexity is necessary to sustain interest," Pei explained, "especially in a dense multiuse complex like this. Even though the building is very large, people can feel comfortable here because the space is lively. It's not just a question of size, but of activity."[4]

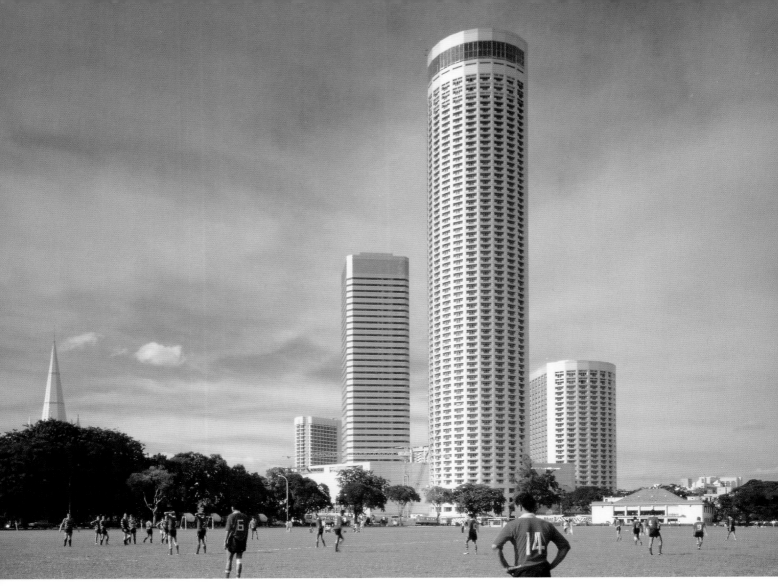

View from the Padang with radial hotel tower facade

On the exterior, Raffles City's diverse functions are unified by one of the earliest large-scale aluminum curtain walls in Southeast Asia, with ribbon windows in the office building and balconies that shade hotel guest rooms. Aluminum was recommended for protection against the surface-streaking fungus pervasive in Singapore's equatorial climate, for its durability and light weight, and also because it expressed in Raffles City's shimmering skyline Singapore's lofty aspirations for the future.

"In spite of many problems," said Pei, "we managed to get Raffles City built. And I think we made more of the project than it ever would have been if we hadn't been involved."[5]

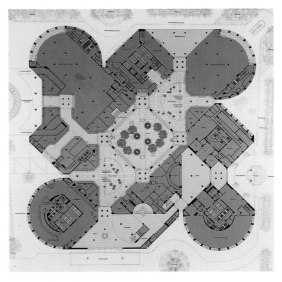

Ground-floor plan

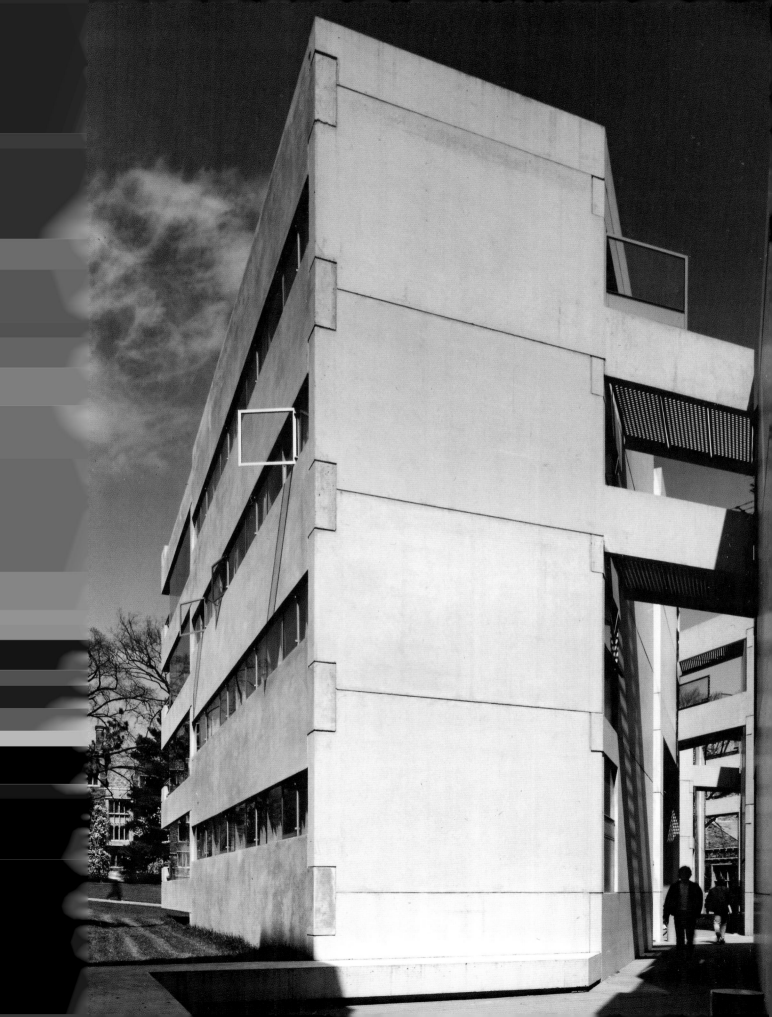

LAURA SPELMAN ROCKEFELLER HALLS

Princeton University
Princeton, New Jersey
1971–73

General view from Elm Drive

In September 1969, Princeton University admitted its first class of female undergraduates, arguably its greatest challenge since opening in 1764. To meet its new needs the trustees commissioned a study of the university's amorphous southwest corner, a 2.2-acre (0.9 ha) site adjacent to the train station. The general plan was approved in 1971 but not implemented for various reasons, chiefly budgetary.[1] In a separate contract two years later Princeton alumnus Laurance Rockefeller engaged Pei to design co-ed Spelman Halls in memory of his grandmother, who championed equal opportunities for women until her death in 1915.[2]

Pei worked closely with his associate Harold Fredenburgh to develop the scheme not merely as housing but as an important pedestrian nexus, establishing its strong diagonal spine as the primary connection between the train station and the main campus, with spurs, paved in bluestone, linked to bounding streets and campus walkways. The challenge was how to weave the 60,000-square-foot (5,600 sq m) complex into the landscape without destroying the magnificent trees that are one of Princeton's great legacies. "I liked the site because of its many trees," said Pei, "but they turned out to be a bit of a liability from a design point of view. One of the university's conditions was 'build but keep the trees.' I therefore suggested breaking down the whole into small units. Once the form and size of the units were determined, it became a question of combination."[3]

Pedestrian corridor
with overhead bridges

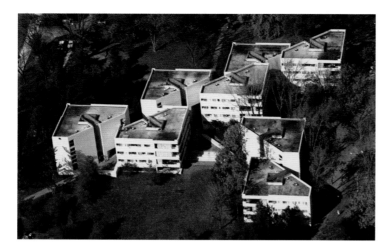

Aerial view

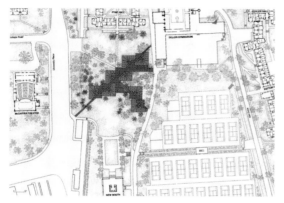

Site plan

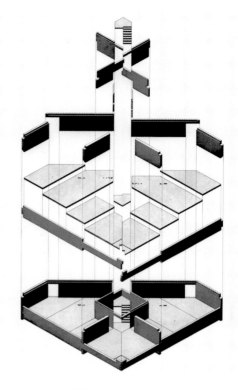

Precast-concrete building system

Eight individual cells are three or four stories high in two basic configurations, the smaller units housing one-bedroom apartments for married students, but most with four separate bedrooms. All fifty-eight apartments have a full kitchen and bathroom, generously glazed living room, and outdoor corner balcony. Typical of Pei's buildings, the units are organized around a central core of activity and light, here a skylit glazed entrance and stair hall.

The cells are linked by upper-level bridges with perforated floors that cast patterned shadows and light. Prefiguring the tubular sunscreens of the National Gallery of Art, the complex suggests the influence of the Middle East (where Pei was working at the time), particularly the narrow bamboo-screened corridors of street bazaars, and in its episodic passages, Princeton's own

tradition of sequential courtyards. Triangular terraces inflect the geometry of the cells and mediate changes of grade up to the main campus. The terraces invite lingering with edge seating and occasional tables yet entice movement with unexpected views. For the many people who walk through Spelman Halls each day, the flickering spatial sequence, opening rhythmically to the left and right to different clearances and perspectives all the while axially focused straight ahead, is an exciting path of experience filled with such surprise that one is apt to overlook the long distance traversed—length of one and a half football fields.

Spelman Halls address public and private needs with the quiet modesty and confidence of a comfortable fit. The buff-colored units complement the limestone trim of Princeton's mostly

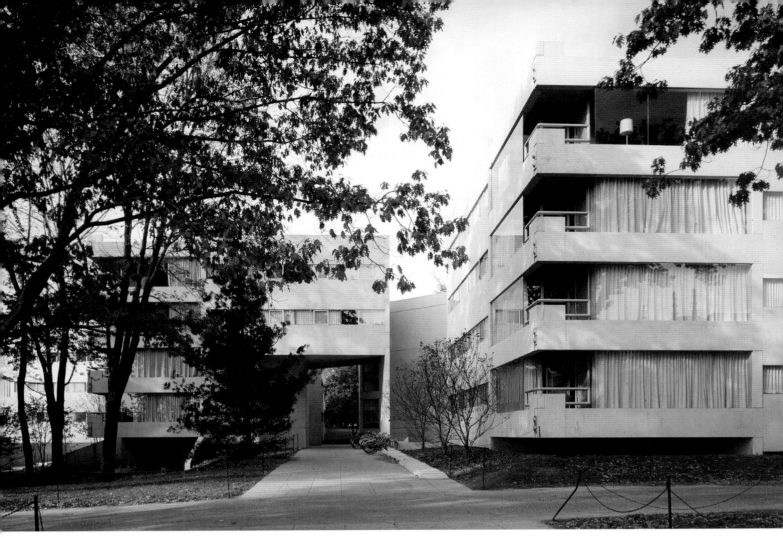

General view

collegiate Gothic buildings, blending in unob-
trusively even while commanding attention for
technical mastery. Pei's office was known pri-
marily for quality design, yet it was also driven by
the well-honed craft of putting buildings together.
Here the architects worked closely with the
industry to fabricate 979 precast concrete wall
and floor panels, some as long as 57 feet (17.4 m)
and weighing as much as 19 tons (17,200 kg).[4]
Since the fine-finish components required no
further treatment inside or out, the entire complex
was assembled in just thirteen months (half the
time of conventional construction) to quickly pro-
vide housing for increased enrollments.

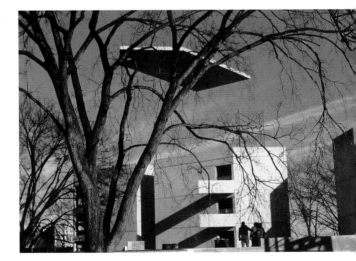

Construction view, installation of precast-roof slab

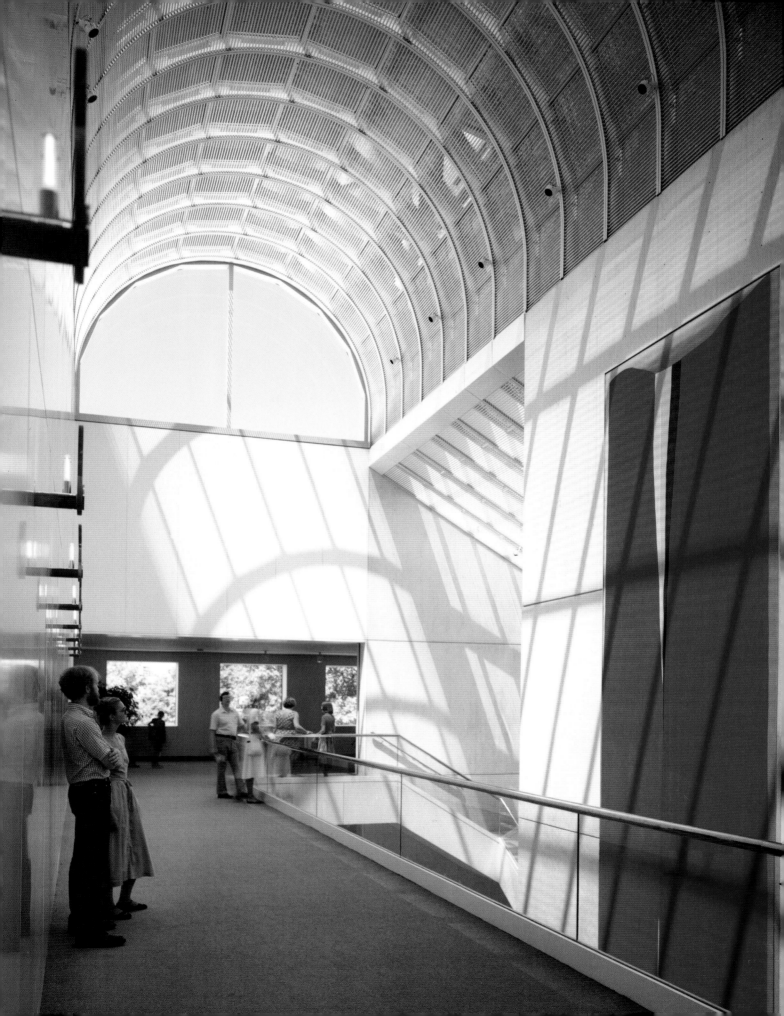

MUSEUM OF FINE ARTS, WEST WING AND RENOVATION

Boston, Massachusetts
1977–81 (renovation 1977–86)

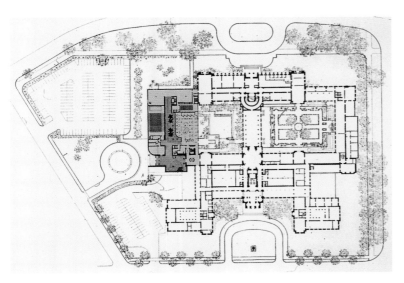

Site plan

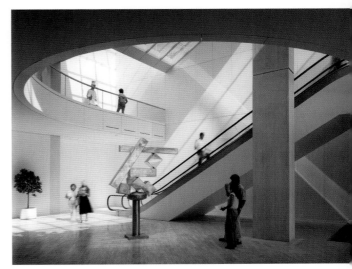

Lobby escalator court

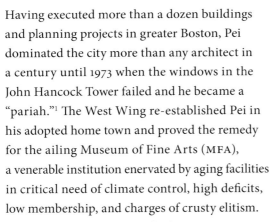

Galleria with tubular sunscreened barrel vault

Having executed more than a dozen buildings and planning projects in greater Boston, Pei dominated the city more than any architect in a century until 1973 when the windows in the John Hancock Tower failed and he became a "pariah."[1] The West Wing re-established Pei in his adopted home town and proved the remedy for the ailing Museum of Fine Arts (MFA), a venerable institution enervated by aging facilities in critical need of climate control, high deficits, low membership, and charges of crusty elitism.

MFA president Howard Johnson sat next to Pei at a meeting in New York so that he could discuss the museum's problems.[2] The architect flew to Boston the following morning and shortly thereafter presented a plan that took "a whole new look at circulation and the way we treated visitors," Johnson explained. "Pei's genius was his insight that the museum had to be an interesting place to go, in addition to art, that families would

find exciting and young people would find an interesting place to spend an evening. . . . The result speaks for itself. It remade the museum."[3]

Like the East Wing of the National Gallery of Art, then nearing completion, the West Wing was an addition to a Beaux-Arts building, which in this case was never finished. Instead, ad hoc additions left the MFA a discontinuous labyrinth, especially along its unsightly western end, where truck docks and the stucco-covered White Wing (a 1960s office addition) dead-ended public access. "A museum grows as its needs grow," Pei told the trustees, "but it should expand like a tree in annular rings so that it is always complete."[4] As in Des Moines, he looped circulation so that museumgoers no longer had to retrace their steps, opening walls and gutting the lower floors of the White Wing and then wrapping the new building around it, "like putting a cap on a tooth." A great curve was cut from the existing floors

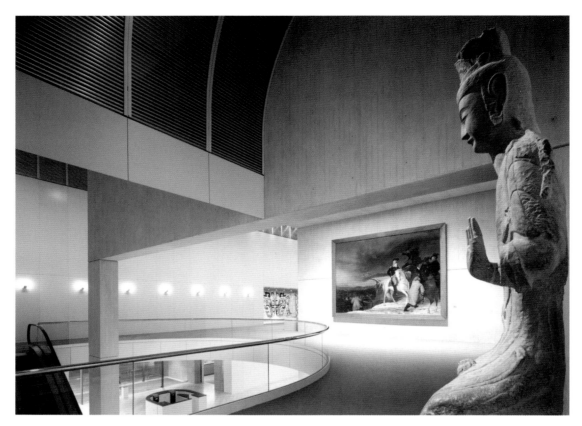

Upper level escalator court

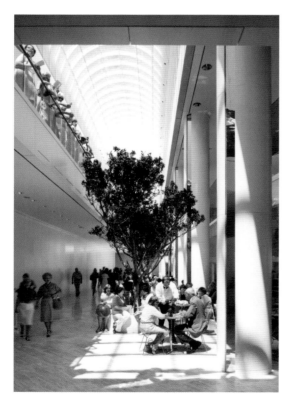

Galleria with café and bookstore

to open space to the Galleria. This vital 225-foot-long (69 m) barrel-vaulted passageway organizes the West Wing and fills it with light through tubular aluminum sunscreens that were becoming something of a Pei signature. An escalator and elevator introduced at one end and stairs at the other continue public flow.

As a student Pei had frequented the MFA's Asian galleries—to study, since the invariably empty museum was quieter than MIT's library. Returning in the 1970s, he saw it as if for the first time. "It was lifeless and dreary, uncomfortably warm and badly lit, a sad place for art. The building was not well." Given the trustees' directive to help "rethink" the interior, Pei became heavily involved in programming, "sort of prescribing remedies to restore the museum's health. The architect," he explained, "is frequently required to serve as doctor."[5]

Treatment involved a two-pronged approach, one focused on renovation and climate control

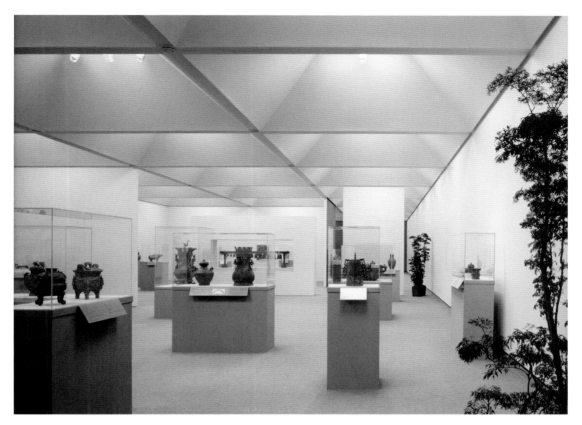

Exhibition gallery with coffered skylights

in the original building, the other to provide all the modern facilities it lacked. The 75,000-square-foot (7,000 sq m) West Wing houses a 400-seat auditorium, museum shop, staff and private dining rooms, restaurant, cafeteria, and sidewalk café under an indoor grove of trees. It includes a monumental lobby and orientation suite, offices, education department, and support spaces as well as a seminar room, sculpture terrace, several small display areas, a 4,000-square-foot (370 sq m) contemporary art gallery, and a 9,000-square-foot (836 sq m) special exhibitions hall for blockbuster shows. Skylight coffers, 15-feet-square, were designed to accept the museum's prefabricated wall panels so that the hall could be modularly configured for any size exhibition. Advancing beyond the East Wing's achievement, the coffers combine both natural and concealed artificial lighting in a solution Pei would further develop at the Louvre.

Architecturally the West Wing was a relatively modest intervention. Yet equipped with its

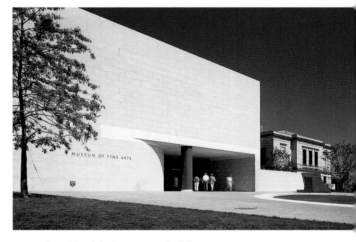

West Wing with original Beaux-Arts building

own entrance and parking, it functioned like a small independent museum, filled with activities on an extended schedule. By concentrating modern social functions in the new building, the original museum could better focus on its collections.[6]

IBM OFFICE BUILDING

Purchase, New York
1977–84

General view to south

When Pei promised to be a "good neighbor" at the groundbreaking of this Westchester County project, he spoke as the architect and as a home-owner in nearby Katonah, with shared concerns about overdevelopment in this affluent once-rural community 45 miles (72 km) north of Manhattan.[1] Throughout the 1970s private estates increasingly found themselves cheek-by-jowl with major corporations.

In 1977 Nestlé commissioned Pei to design a 500,000-square-foot (46,000 sq m) headquarters for 1,100 employees (expandable to 1,500) with centralized kitchens for testing coffee, tea, and chocolate. Given community sensitivities, Nestlé suggested the ideal of a wealthy family building

Site plan

a secluded residence back in the trees with a staff of gardeners to keep its grounds. Pei responded with a Palladian villa construct in which two wings curve into the landscape from a central core.

Curved office pavilion and faceted central core

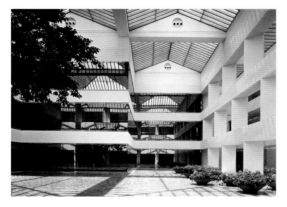

Atrium in west pavilion

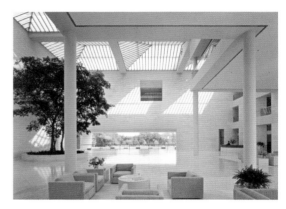

Main atrium lobby

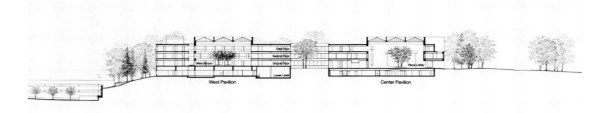

Section

Construction began in 1979, shortly after which Nestlé suffered a downturn, and in 1982 sold the half-complete building to International Business Machines (IBM). Changes were made to suit the new owner, particularly in the now unnecessary test kitchens, yet by coincidence the basic three-part design reflected IBM's internal organization, whereby semi-autonomous divisions relate back to an executive hub. Pei praised IBM for breathing "new life into the design," much as it did for his firm.[2] Having lost IBM's commission to design a prominent New York office tower ten years earlier and spurned by other large companies in the wake of John Hancock Tower's glass failure, Pei now slipped back into the fold of one of modern architecture's greatest corporate patrons.[3] "We needed a new facility and were able to buy the building at a great price," explained Arthur Hedge, head of IBM's real estate and construction division. "The result of working with Pei and his people was so satisfactory—the quality of their work was extraordinary—that I wanted to use them in other situations, and did."[4]

The building occupies less than twenty percent of the 46.8-acre (19 ha) site, which was extensively rehabilitated from neglected farmland into rolling lawns. It stands back a quarter-mile from the street on a natural plateau amid a spectacular collection of specimen beech trees and giant multitrunk ginkos. Pei nestled a three-level parking garage into the hillside behind and cut a new road along the site's northern boundary to relieve local traffic and connect to the highway.

The centerpiece of the corporate villa is a sawtooth parallelogram that both fragments the bulk of this very large building and multiplies its corner offices. The low-lying façade is a travertine echo of the recently completed East Wing of the National Gallery of Art; its museum-like atrium, a 50-foot-high (15 m) skylit reception hall that puts nature, indoors and out, on seamless display.

The building's quarter-circle office wings are similarly organized around landscaped atria, but the setting is less formal, allusively residential, with gabled skylights. Fine-finish concrete screen walls reinforce human scale and add variety to

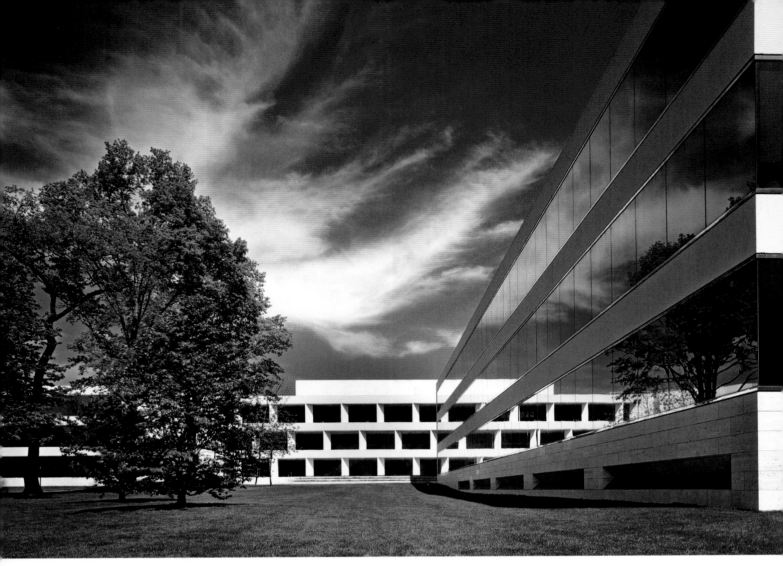

Garden facade

the internal "Main Street" that stretches nearly a third of a mile through the building. Like the sawtooth offices along the third side of each court, the seemingly freestanding screens aid orientation and open even the deepest sections of the interior to nature. Along the building perimeter secretarial stations and executive offices are separated from the outdoors only by floor-to-ceiling windows whose highly reflective glass expands the abundant landscape into another, almost surreal dimension. The corner of each wing is anchored by an elevator drum wrapped in a spiral ramp. By virtue of the riveting panoramas that unfold with each step and embrace even the New York skyline, the ramps constitute the most popular means of floor-to-floor circulation. "Walking up,

it's always nice to expand your view by looking out; it takes the focus away from the fact that you're climbing," explained Pei. "I've always been interested in movement systems as a kind of theater. They're a design problem, a complication, that not every architect likes to tackle. I like to focus on them as an important spatial experience."[5]

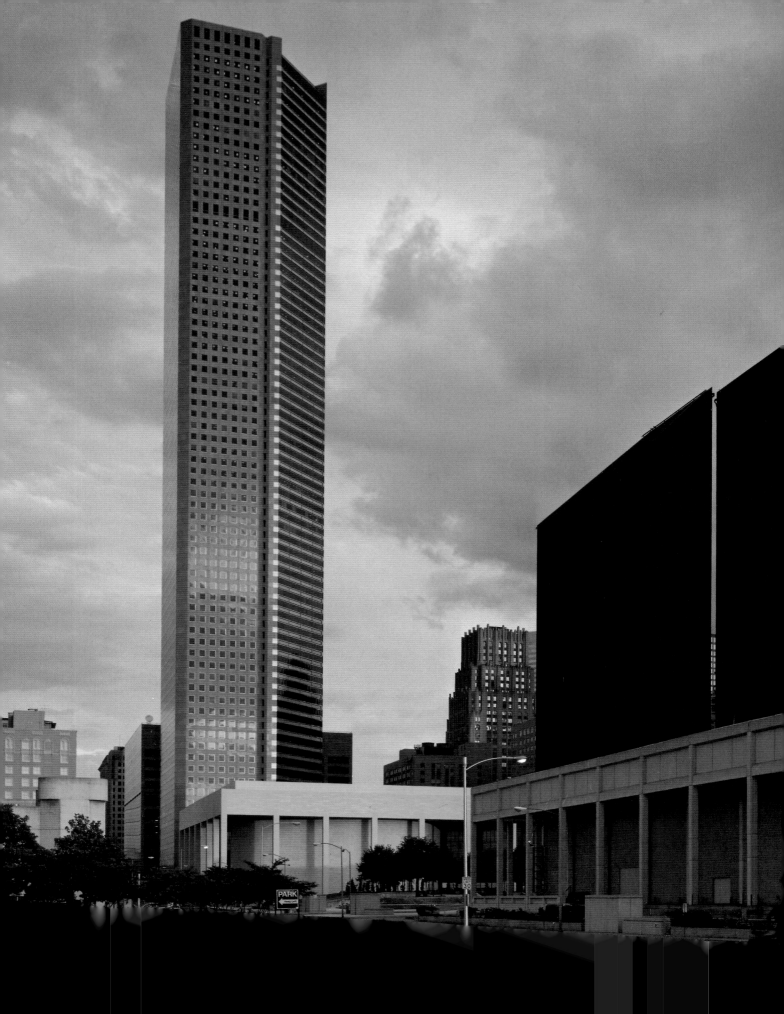

TEXAS COMMERCE TOWER

United Energy Plaza
Houston, Texas
1978–82

In the mid-1970s Texas Commerce, the second largest bank in the largest city in Texas, consulted Houston developer Gerald Hines about acquiring expanded headquarters, and ultimately joint-ventured in building a new 2,000,0000-square-foot (186,000 sq m) tower. Pei was unanimously selected from among eight leading architects because, Texas Commerce CEO Ben Love explained, "he had done such a thorough research job on the area and all the buildings nearby before he ever came to us with a concept."[1]

Houston was then in the midst of a dizzying growth surge which had, in less than three years, significantly transformed the central business district with a thicket of bold new skyscrapers competing in materials and sculptural form for distinction.[2] Pei countered with a 1,030-foot-high (314 m) tower, the tallest outside New York and Chicago, working closely with associate partner Harold Fredenburgh to achieve a design at once classic and unique. In weighty contrast to its neighbors, the seventy-five-story building was clad in pale gray polished granite, 2 inches (5 cm) thick, which in a technological tour de force was affixed with a newly developed anchoring system to an equally remarkable composite (concrete and steel) tubular structure.[3]

The western corner of the square tube was sliced at a 45-degree angle to create a fifth side for the main facade. The 85-foot-wide (26 m) column-free expanse of glass and stainless-steel spandrels runs the entire height of the building, opening at its base to a five-story lobby that responds to the open arcade of a neighboring a performing-arts center. "The form and shape

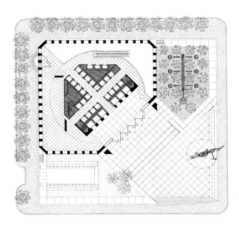

Site plan

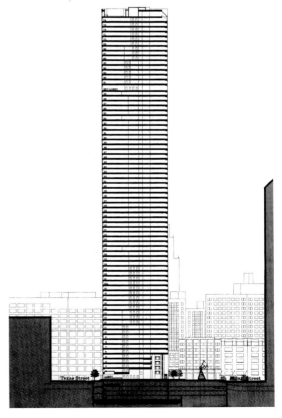

Section

General downtown
view from northwest

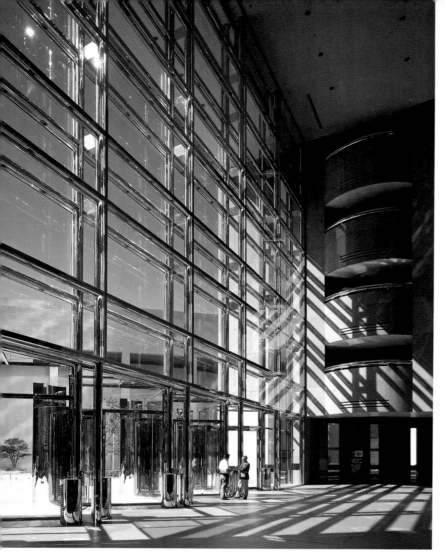

Lobby

Pei discussing maquette with Joan Miró, November 23, 1980.

Fifty-five-foot-high sculpture with tower

of the [tower] was very much influenced by how it [would] appear on the skyline," explained Pei, while its siting was a conscious attempt to create a significant open space for Houston."[4]

The tower occupies just a third of its square city block site to leave open a 1-acre (0.4 ha) plaza of pink-and-gray granite pavers with flanking gardens. The space is focused by the painted-steel and bronze sculpture *Personnage et Oiseaux* (originally 1970), which Pei had seen in a book about Joan Miró. He flew with Love and Hines to the artist's studio in Palma de Mallorca, Spain, to convince Miró to expand the original piece to 55 feet (17 m). "Because it was abstract," he explained, "I knew it could be enlarged to any size. I wanted something big, colorful, and playful" to animate the street level, which locals

typically bypassed for the all-weather shopping concourse tunneled below center city.[5]

With frequent reference to Greece, whose agoras teamed with life in a climate similar to Houston's, Pei waged a campaign for urban vitality, lobbying for mass transit and for people to live downtown rather than simply work there. He urged most ardently an alliance of municipal government with private development in the creation of parks, plazas, and other street forums where the community could celebrate public life, and "let people come to the surface and enjoy the light of day."[6] In Houston, as elsewhere, the building for Pei was merely the beginning.

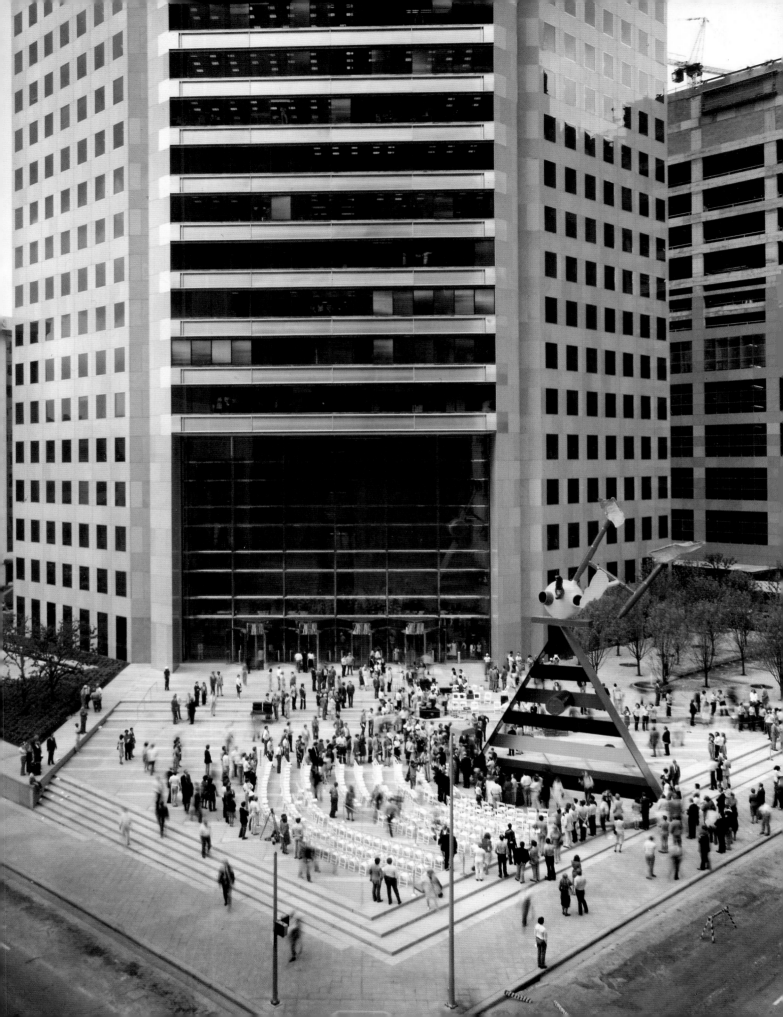

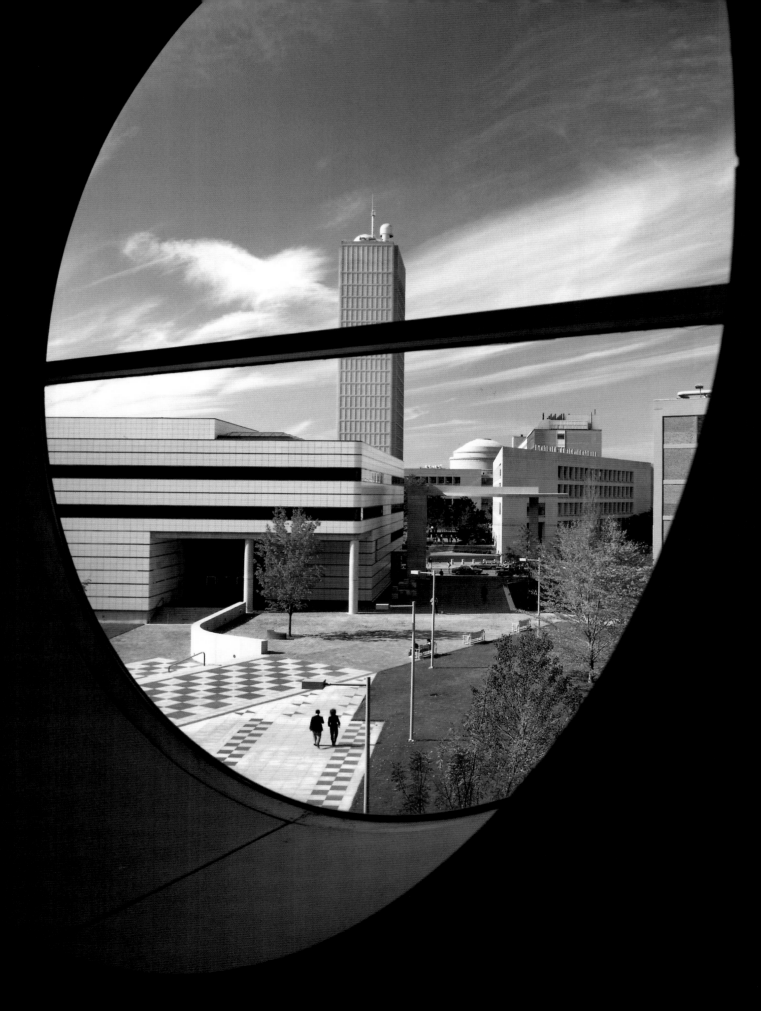

WIESNER BUILDING, CENTER FOR ARTS & MEDIA TECHNOLOGY

Massachusetts Institute of Technology
Cambridge, Massachusetts
1978–84

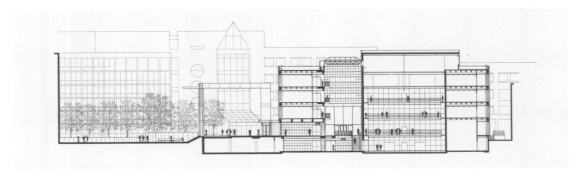

Section through black-box theater

Wiesner was the smallest and most challenging of Pei's four buildings at MIT, both a physical and symbolic gateway to its developing East Campus and an ambitious continuation of MIT's tradition of advanced research — the building itself was an experiment. Consolidating nine disparate arts programs from curricula grounded in science, it combined traditional and vanguard media to create a world center of art and emerging technology wherein the future would not so much be predicted as invented. The boundary-dissolving decision was made to commission art at the beginning of the project, allowing close collaboration between architect and artists from the early stages of design.[1] The goal was to create an integrated environment in which works of art would merge with architecture in a larger whole. "I had commissioned many pieces for earlier buildings," Pei explained, "but I wasn't completely satisfied because the process always came late, when the buildings were complete or nearly so. The art therefore remained an accessory, added like a brooch or necklace. Here, we had the opportunity to jointly explore form, space, and light."[2]

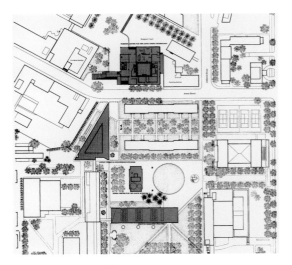

Site plan, four Pei buildings

To accommodate its multiple uses the building was rendered a shell around a flexible interior containing three ground floor exhibition galleries, a 196-seat auditorium below, and offices and laboratories on the three upper levels. The interior centers on two defining vertical spaces: a mysterious four-story black-box theater layered with catwalks — a building within the building — and the adjacent public atrium, half its size, accessible from every side and filled with light.

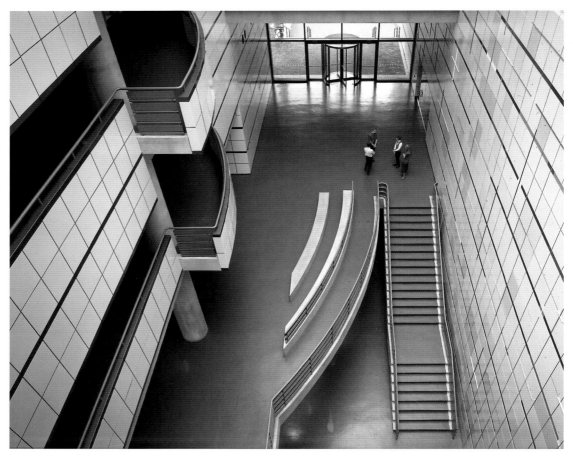

Central atrium

Scott Burton railing against Kenneth Noland's colored wall

The prominent and extremely difficult site is located at the precise line where MIT's new and old campus grids collide, surrounded by five major buildings of different scale, materials, and style. The most problematic was Pei's own Landau Chemical Engineering Building of

1976 whose insistent triangular thrust needed to be addressed. "If we hadn't designed the building," he laughed, "we would probably curse that architect!"[3] Wiesner was made to stand apart as an independent linchpin with a white aluminum panel exterior that suggests the high-tech activities housed inside. A monumental concrete arch cantilevers over the main pedestrian axis between the two campus precincts, focusing surrounding buildings and signaling in its sculptural form the experiment in artistic integration.

The three collaborating artists focused on different aspects of the built environment. Site artist Richard Fleischner concentrated on the amorphous space around the building, for which he specified every detail from lighting and sight lines to gradient changes and ground cover. He emphasized circulation patterns with gridded pavements that echo the building's paneled skin,

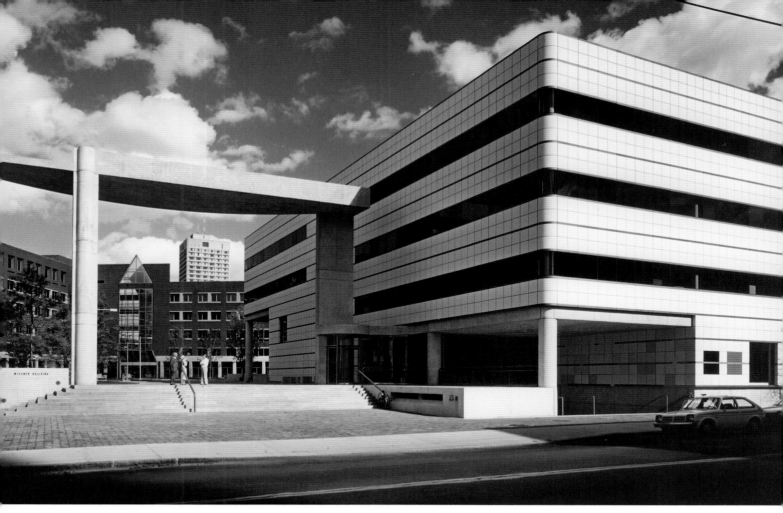

Gateway to East campus

while protecting it with faceted granite bollards that are at once also sculpture and seating. In the atrium, sculptor Scott Burton focused on layered explorations of railings, benches, and curves, which, in turn, prompted Pei to fan out three balconies into the open space. Painter Kenneth Noland similarly collaborated in a study of wall planes, variable light, and color—an element typically absent from Pei's modernist palette. Three color squares on the street facade are bisected by a blue band that circuits the building before surging through the interior like colored electrical impulses in the narrow horizontal and vertical recesses between the wall panels (some of which Noland toned to create an off-white aluminum plaid). Pei suggested that Noland variously insert three-dimensional splines that project out from the wall plane as if sculpted with color.

The experiment to create a total environment— ultimately more a test of process than product— yielded results neither simple nor conclusive. It required artists to surrender the autonomy of private studio work for the larger scale, bigger budget, tighter, and longer scheduling of the architect's practice, governed by building codes and functional constraints, more methodical, public, and dependent on team input than the artist's more typically singular pursuit. For the architect, the experiment required relinquishing a degree of control to others not necessarily of the same mind or vision. And for every participant, each accustomed to personal recognition, success required individual contributions to blur inseparably in a larger whole.[4]

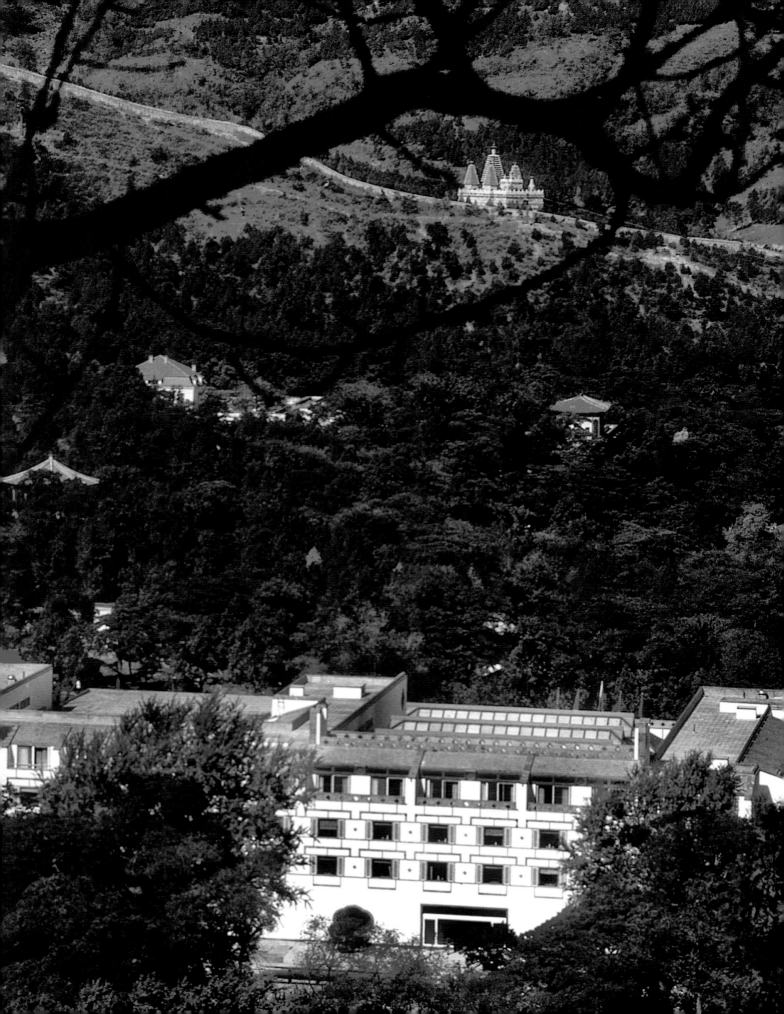

FRAGRANT HILL HOTEL

Beijing, China
1979–82

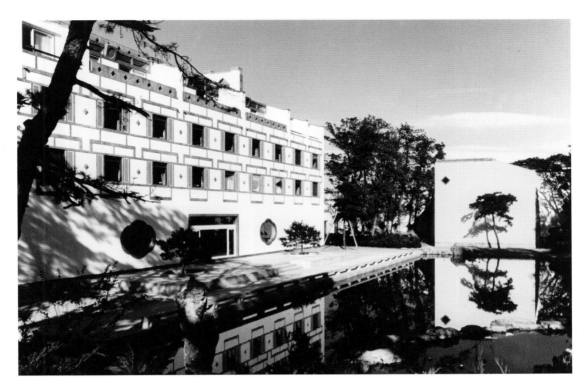

Garden facade

Fragrant Hill Hotel is a low-rise, low-tech, nonurban building, driven by neither structure nor formal geometry and unlike anything Pei had done before. Having left China at age seventeen, he infused modernist buildings with innate Eastern sensibilities, only to return forty years later, completely Western in training and practice, to pursue an intense personal search for the essence of Chinese architecture. Steeped in nature, cultural tradition, living history, and dreams, Fragrant Hill was about going home.

Pei first visited Beijing with the AIA in 1974, soon after China opened its borders. He urged the prodevelopment government to exercise

caution since tall buildings near the Forbidden City would ruin its defining relationship with the open sky. Four years later Pei voiced similar concerns at a banquet in his honor in the Great Hall of the People.[1] As a celebrated Oversea-Chinese he could freely express opinions where others had no voice against official policy. When tall buildings were banned within a critical radius of the Forbidden City shortly afterwards, Pei reflected: "This, more than anything, is my greatest contribution to China."[2]

Although thwarted in its wish for a high-rise hotel in Beijing's ceremonial center, the government yet wanted a building by Pei and thus offered

Hotel and historic shrines in Jingyiyuan National Park, the Garden of Tranquility and Pleasure

Tile and stucco wall detail

Pei discussing vernacular construction at ancestral home, Suzhou

three outlying sites, including a privileged piece of land in Fragrant Hill, a public park in the former imperial hunting grounds about 25 miles (40 km) outside the city, rich in history and cultural monuments.[3]

Pei looked beyond decades of Soviet influence to observe that the International Style was not only taking hold in China but taking over, triggering a reactionary nationalism that crowned Western-style buildings with pagoda roofs. "Ridiculous!" He said, "Like a man in a tailored suit wearing a coolie hat! Chinese architecture was at a dead end. The two approaches—historical imitation and the wholesale importation of Western technology and style—left no place to go. . . . I wanted to see if aspects of Chinese tradition were still valid parts of people's lives. If so, perhaps Chinese architects could use their own language rather than turn to foreign countries. China is a country with a long history and a deep culture. Its architecture should grow naturally from its own past."[4]

Pei looked to traditional courtyard houses, where individual family units gather around a communal open space, and in the process resumed

a search dating back to his student days. "As you probably know," he wrote from Harvard to a friend, "for some time I have been wondering about the process of searching for a regional or national expression in architecture. To my surprise, [Walter] Grop[ius] agrees with me that there is a definite reason for it. . . . My problem is to find an architectural expression that will be truly Chinese without resort to traditional Chinese architectural details and motives."[5] On the envelope was typed "The Impossible Dream of Ioeh Ming Pei—1946." The attempt to realize that dream at Fragrant Hill was arguably the first time since the Revolution that architecture in China aspired beyond mere functionalism to cultural expression.

The search for an all-purpose vernacular freely adaptable to different building types led Pei and his small team to study widespread precursors of the Modern movement.[6] In place of the ochres favored in Beijing and the northern provinces, he adopted white stucco walls, as in Suzhou in the south, where his family had lived for more than eight centuries. He revived a withering thousand-year-old industry of making gray clay tiles in kilns dating back to the Ming dynasty, aided by a seventy-five-year-old craftsman who knew the secrets of production. At Fragrant Hill, the tiles serve traditionally to prevent cracks by breaking up the expansive walls into smaller areas and also to allow creative pattern making—here threaded across the surface to relieve the repetition inherent in hotel design.

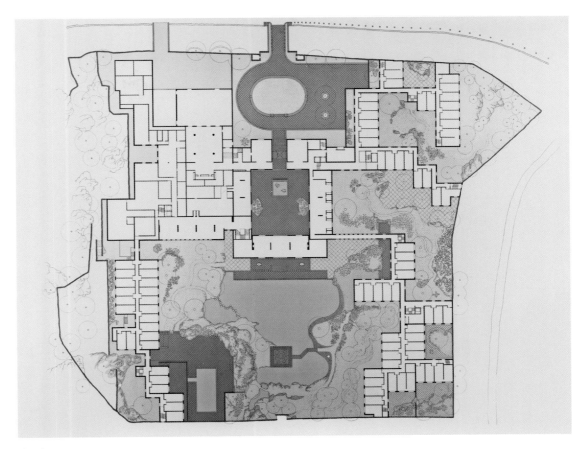

Site plan

Unlike most of Pei's buildings, freestanding sculptural forms, Fragrant Hill is more painterly since indoors and outdoors unfold together, a garden in a park, as in a Chinese scroll. "A Chinese garden is like a maze," he explained. "You never see straight or clear to the end, never apprehend the whole. You enter, something attracts your attention so you pause. It might be just a single tree or a rock or crevice of light. Then you move further on a path or perhaps across a bridge, zigging and zagging so you always see something different. . . . It's a matter of scale, of multiple vanishing points and also of surprise — the delight of the unexpected."[7]

Pei reversed the traditional Chinese entry from the south to maximize the main garden within existing retaining walls. Combining classic Chinese axiality and spatial sequencing that alternately expands and contracts (not unlike the Forbidden City), the hotel radiates out from the central atrium with guestroom wings shifted asymmetrically to preserve the site's many trees, including two eight-hundred-year-old ginkos. In addition to the main public garden, a series of smaller, more private walled enclosures took shape — eleven gardens in all, each different but unified in the larger landscape. Views are dramatized by fancifully shaped windows intended primarily as picture frames for nature, carved into unarticulated walls. Lattice side panels identify the guestrooms, and large carefully aligned plum blossoms denote the main ceremonial spaces Unlike Western hotels where public spaces are open to view, diamond-shaped lattice openings in the corridors and the lobby's great moon window provide a bit of privacy.

Pei added water to the main garden by reopening a stream, and recreated a badly damaged *liu shui yin*, one of only several ancient water mazes in China.[8] The greater problem was

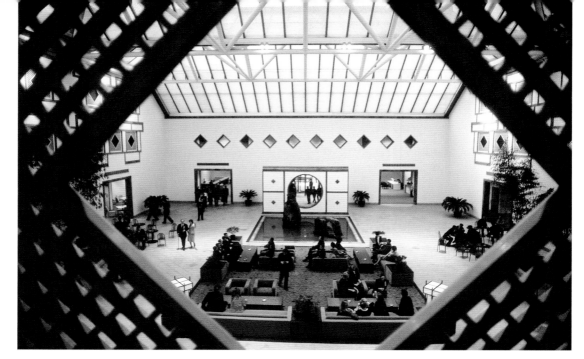

Corridor window into lobby

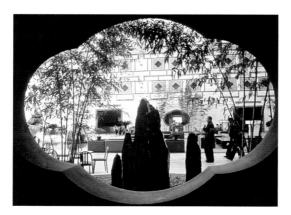

Plum blossom window onto lobby

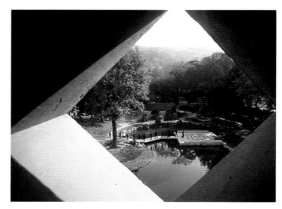

Main garden and water maze framed

finding the right rocks, as local varieties were too rusty and coarse and southern counterparts too delicate and mannered to achieve the heroic scale required. The answer came during a flight to Beijing from a travel brochure featuring the more than two-million-year-old Stone Forest in China's remote Yunnan Province ("beyond the clouds"). By a stroke of "luck—the kind that comes to you when you're ready to embrace it"— Pei secured rocks from this protected national treasure, had them trucked some 2,000 miles (3,220 km) to Beijing, and lacking necessary equipment, rolled into place on logs.[9]

Except for the atrium spaceframe and some specialized mechanical equipment, Fragrant Hill was built by Chinese workers using indigenous materials and methods. Pei recalled it as "one of the most difficult experiences I've ever had, a mixture of elation and frustration, trying to work in a system I did not understand. We could not give orders, only advice, and the Chinese do not make decisions lightly. . . . The authorities had their say, the workers had their say, and Beijing's architects had their say—not only 'Why do you have these white walls?' but also 'Why should someone from America tell us how to build in China?' We tried our best to explain what we were trying to do.[10]

Reactions to Fragrant Hill were mixed. The Western architectural world, unaware of Chinese tradition, misunderstood it as Postmodern,

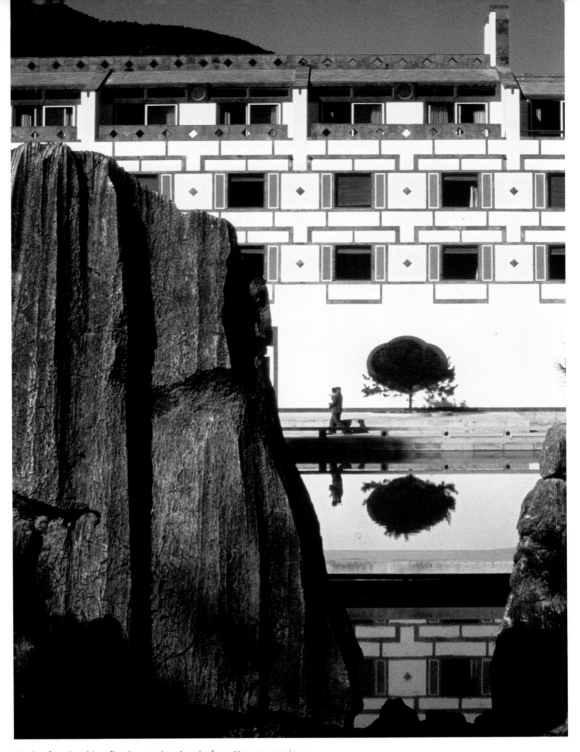

Garden facade with reflecting pool and rocks from Yunnan province

overleaf:
Garden facade with
restored ancient
water maze

while Chinese architects and officials, familiar with Pei's modernist buildings, were disappointed he didn't deliver one. "What good would it have done for China if I'd designed some reflective glass tower?" he theorized. At the hotel's opening a high-ranking official sniffed that it looked "Chinese" — a comment not lost on Pei, who explained it was "the beginning of the Four Modernizations and the government wanted things to look Western, so it was not intended as a compliment. But I took it as such."[11] Twenty-five years later, he would continue the effort with greater confidence at Suzhou Museum.

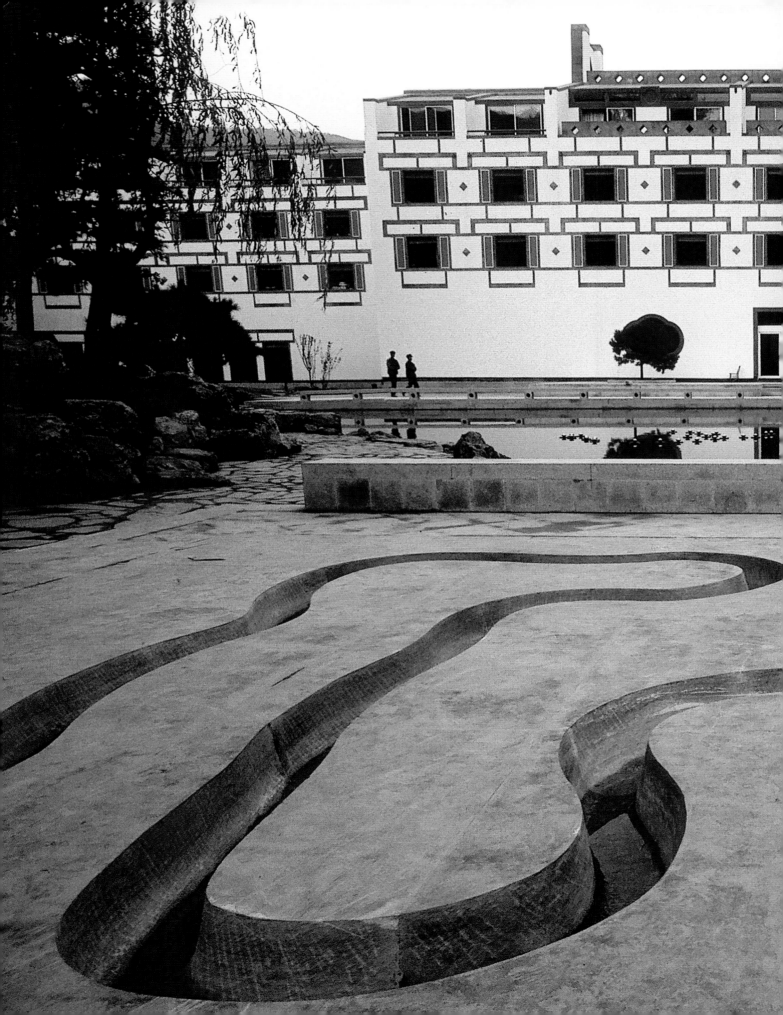

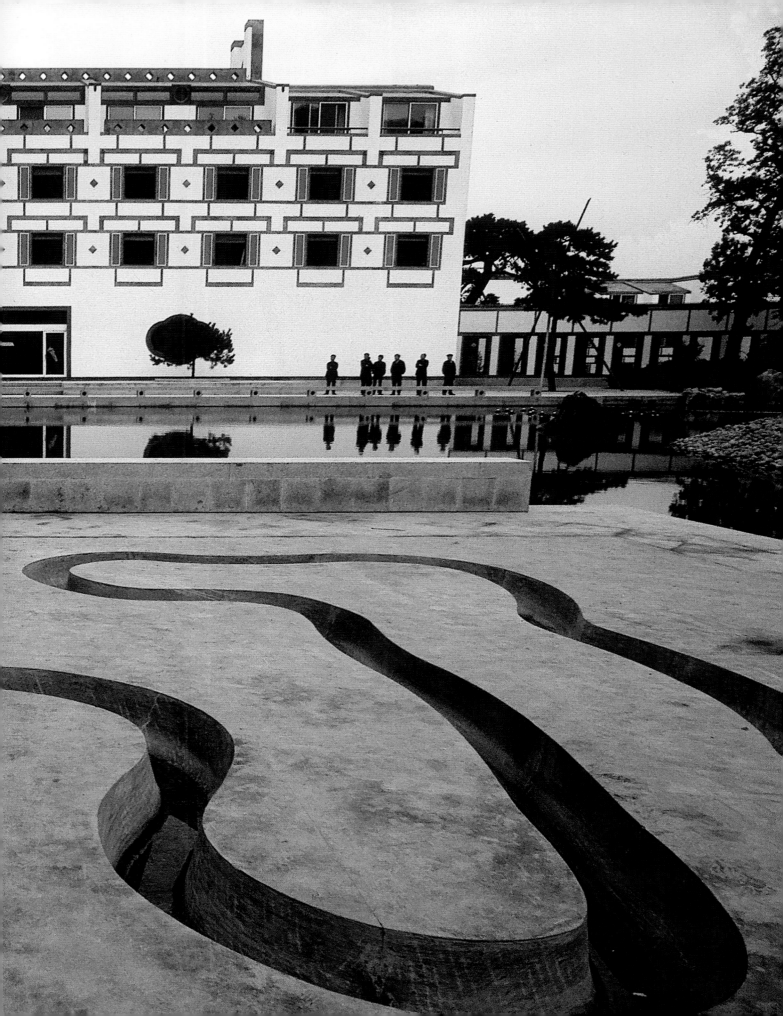

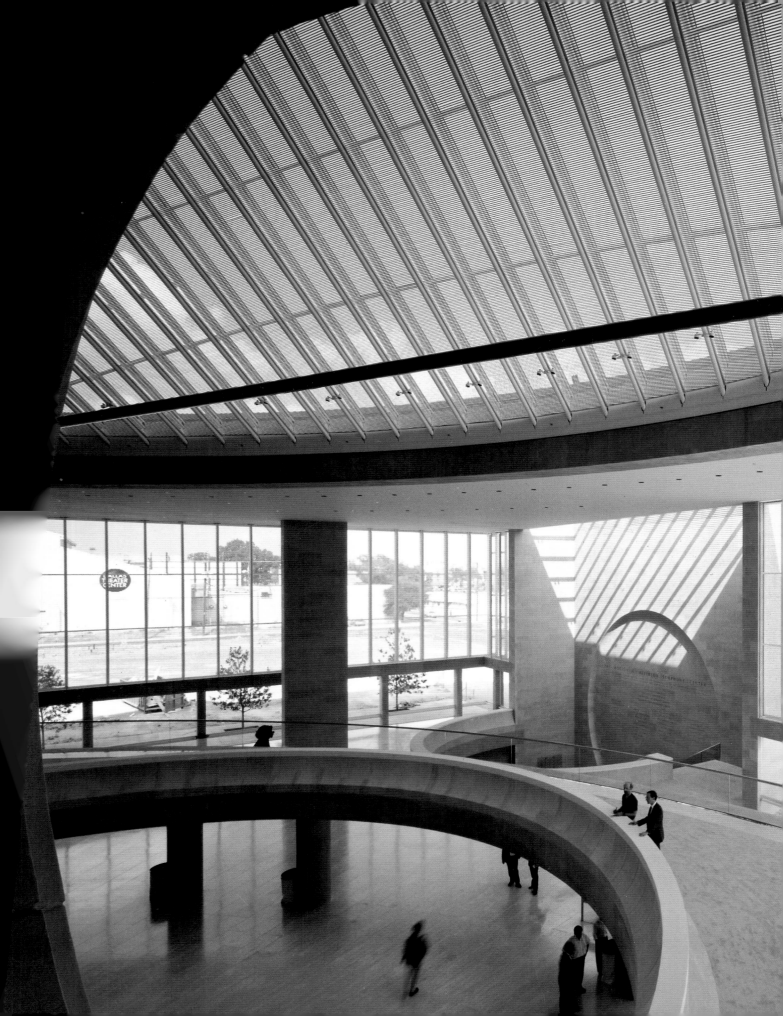

MORTON H. MEYERSON SYMPHONY CENTER

Dallas, Texas
1981–89

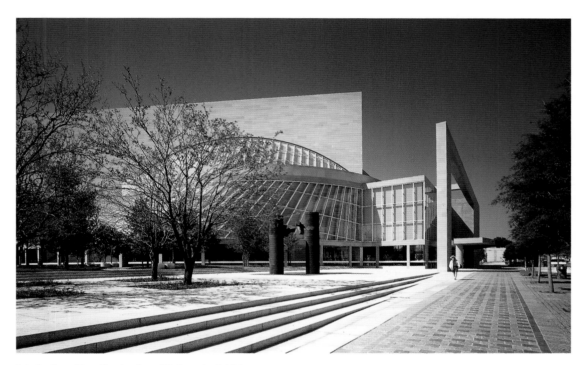

Exterior from Flora Street spine of Dallas arts district

Main lobby

Among the architects short-listed for Meyerson Symphony Center Pei was the write-in frontrunner, but having recently completed City Hall (1977), he was certain he would never be awarded a second major public building and declined to be considered.[1] When deliberations deadlocked, chairman Stanley Marcus persuaded him to reconsider. "I was very frank," said Pei. "I told the building committee that I'd never designed a concert hall before and that, in fact, I didn't know much about them, but that I wanted to do a great one before I died."[2] Leonard Stone recalled that "it was Pei's amplification of 'great' that caught attention. There was no doubt that he was going to nail a beauty."[3] As for his inexpe-

rience with the building type, Marcus lent perspective. "Nobody good ever did two symphony halls. They're such a son-of-a-bitch to tackle that if an architect ever got through one, he'd swear off ever doing another!"[4]

Pei accepted the challenge in 1981, by which time acoustician Russell Johnson, hired months earlier, had already configured the music hall. "We presented [the scheme] to the committee," Johnson recalled, "and then had a meeting with Mr. Pei. . . . Six weeks later we all reconvened and I. M. announced, 'We've studied this basic design, and I believe we can make it into good architecture.' That sentence has been embedded in my mind ever since."[5]

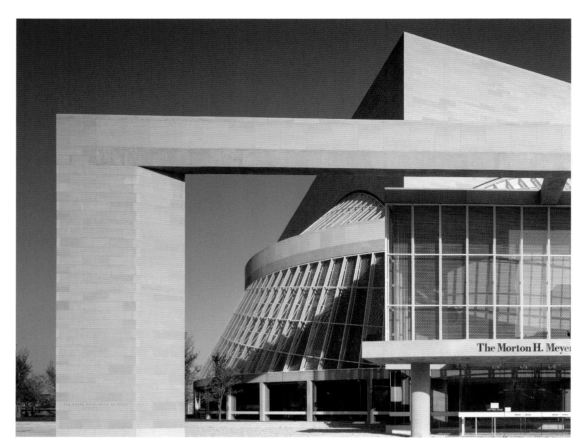

Entry arch and conoid exterior

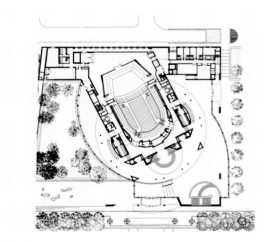

Site plan

Pei had never before shared equal power with another consultant. "We knew there would be some chaffing," said committee member Mary McDermott, "but Russell couldn't be in charge of aesthetics, and in the same breath I. M. couldn't be in charge of acoustics. They had to be co-czars."[6]

Ideas for Meyerson, particularly its lobby, crystallized during a tour of the world's great concert halls, after which Pei, on family holiday, sketched the building remarkably close to final form.[7] He developed the scheme with Ralph Heisel in New York, angling the concert hall on the tight site to expand the lobby and back-of-house facilities while establishing a dialogue with downtown and the fledgling Arts District. "The design of a civic building requires a certain seriousness of the architect," Pei explained. "One has to think not only about function but also about what the building represents and how it relates to its context."[8]

To diminish visual impact of the large windowless music chamber, a radial outer shell of limestone and glass breaks out from the rectangle to dance around the hall, animated by multiple vanishing points in a step beyond the National Gallery. "Meyerson is not a better

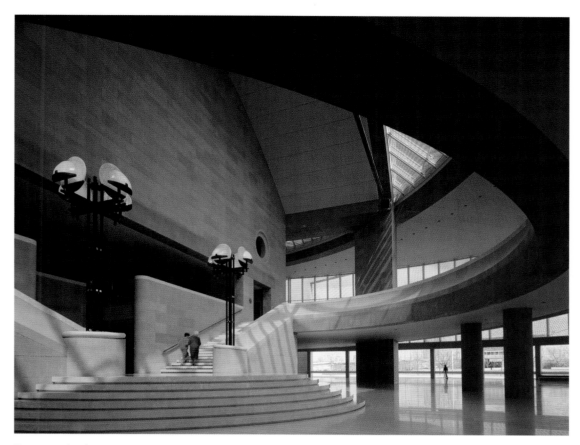

Monumental stairs

building than the East Wing," weighed Pei, "but spatially it is more complex. The curvature in Dallas makes the space more fluid and sensuous. You cannot just look and understand it. You have to walk and, as the space unfolds, you're drawn in. . . . There's mystery, surprise."[9] Perspectivist Steve Oles helped visualize the spatial sequence with step-by-step drawings in Pei's first use of computer-aided design.

The audience chamber is encircled by a loge-level balcony that curves into the lobby to expand public space; three 20-foot-high (6 m) elliptical "lenses" admit light overhead. A larger arc, circumscribed around the entire western side of the hall, shapes the building's emblematic conoid: a sunscreened glass membrane that begins vertically and fans out perpendicular to the wall supported by an intricate system of deepening bowstring trusses, like some great stringed instrument.[10]

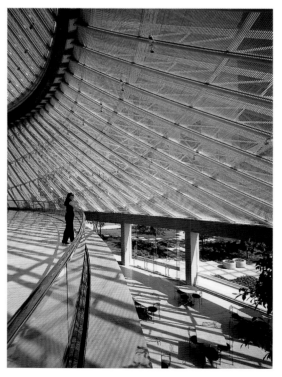

Conoid interior

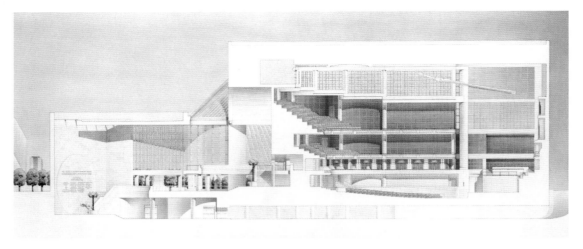

Longitudinal section

Curvature continues in light fixtures, balustrades, pavements, and walls, including a large circular scoop leading up from the garage.[11] The other main entrance is an almost freestanding 60-foot-by-90 foot (18 x 27 m) arch that aligns the building's radial geometries squarely with the Art District's central spine. The arch monumentalizes entry from the street and frames a procession of increasing formality as the lobby's lively asymmetry gives way to acoustically mandated symmetry in the concert hall. The transition takes place on the Beaux-Arts–inspired central stair where great steel and onyx lanterns embellish the space to become important sculptural components of the total design.[12]

The music chamber itself is a traditional 'shoebox' engineered "to keep good sound in and bad sound out."[13] Technical constraints caused it to be approached as a renovation, adopting a surface grid to establish human-scale and an organizing system to regularize the uneven spaces created by ideal sound and sight lines.[14] The night blue ceiling, inspired by atmospheric theaters of the 1920s, offsets the required 42-ton (38,000 kg) acoustical canopy which Pei labored to tame architecturally. "I told Russell time and again, 'You are all ears, you have no eyes,'" he confessed candidly. "A concert hall depends on sound but also mood. This is where the architect comes in."[15] Pei sought inspiration in Bach,

Beethoven and Mozart but in hindsight he wondered if he'd been too conservative. "It's quite possible to enjoy the music of the seventeenth and eighteenth centuries without having to conform to the same sort of materials and palette. If I'd felt more at ease, the hall might have been very different. But at the time I felt the game was lost to acoustics. I could not as an architect do much to shape the space so why spend my time decorating?"[16]

A two-team approach allowed the building to proceed while technical problems were resolved on an independent schedule. Pei relied heavily on Charles Young in the concert hall while he personally concentrated on the surrounding spaces, which he could manipulate more freely.[17] Unlike other symphony centers, Dallas's light-filled lobby serves throughout the year as a great public gathering place. "Meyerson is not an elitist building; it's a public institution in all senses," Pei explained. "It is not just to make or to listen to music and it's not only for the people who sit in the audience. . . . What good are all of our public facilities if, in the final analysis, they don't serve the widest possible audience?"[18]

opposite:
Eugene McDermott
Concert Hall interior

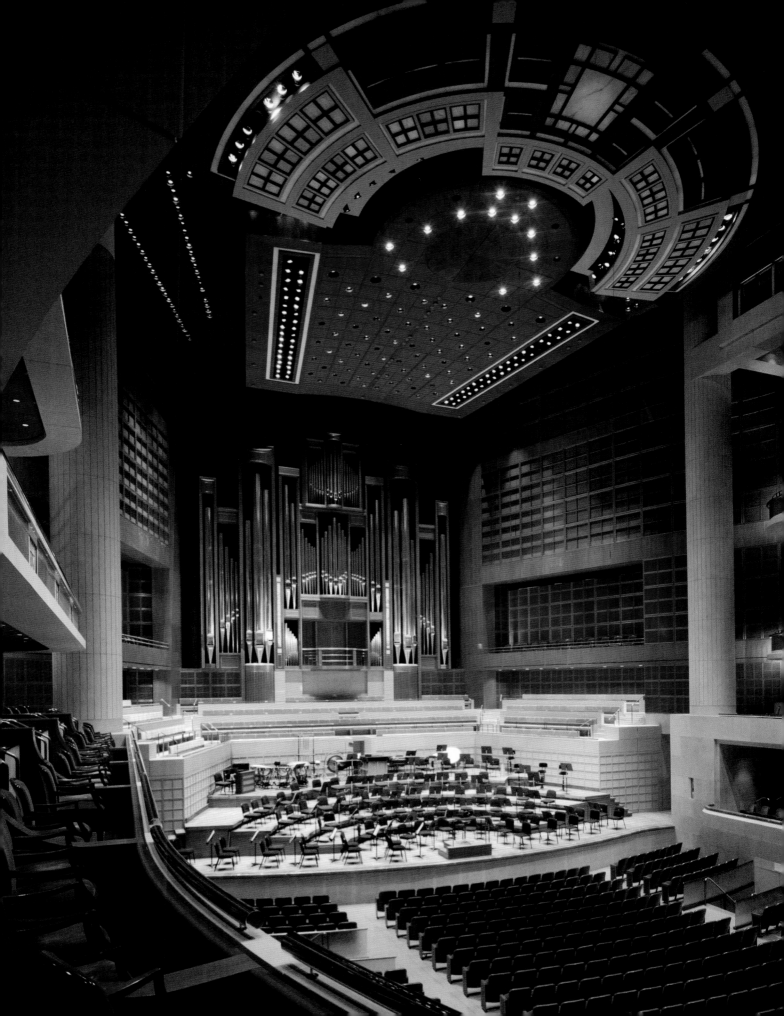

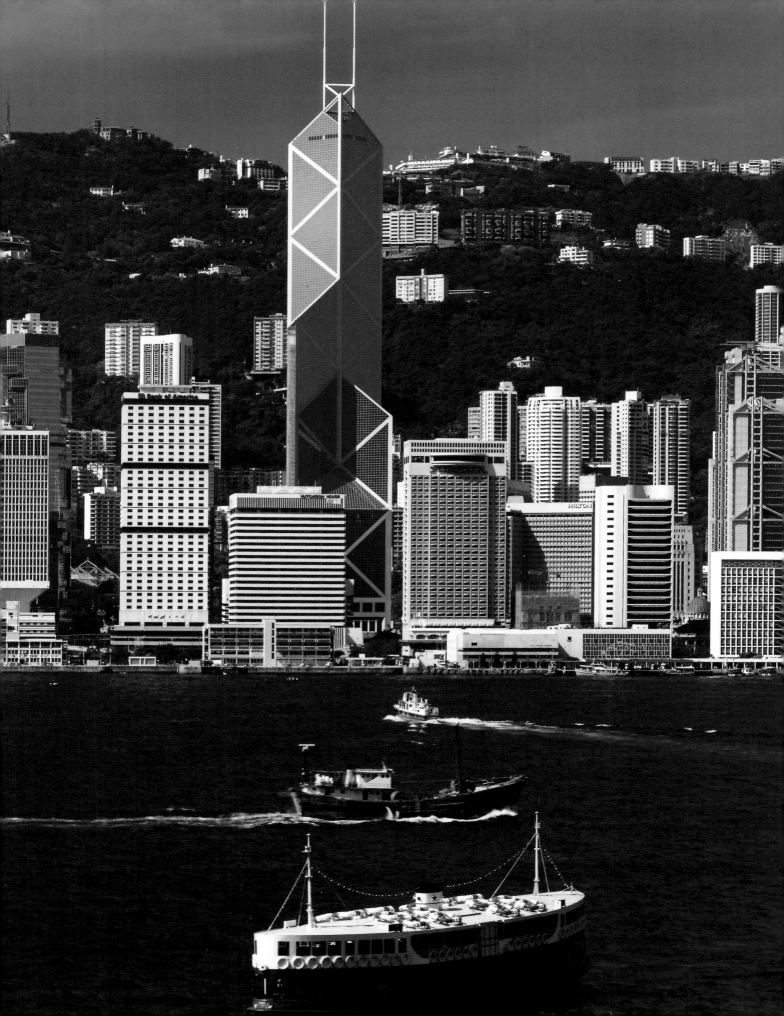

BANK OF CHINA

Hong Kong
1982—89

In early 1982 the president and the chairman of the board of the Bank of China (BOC) flew to New York to visit I. M. Pei's father, who had previously served as a high-ranking bank official.[1] In a traditional gesture of respect they asked permission for his son to design a new building for the Hong Kong branch of BOC, headquartered in Beijing, to house its foreign exchange and investment operations.[2]

The only input from Beijing was the budget, which was set at HK$1 billion (US$130 million) and remained firm notwithstanding inflation. Pei explained, "After a budget was set, one did not go back to the Peoples Congress to ask for more. China was a poor county; anything more would have been extravagant. So I never asked; I was determined to do our best with the amount given."[3] The building program was simple: stay within budget, provide an imposing banking hall and 1.4 million square feet (130,000 sq m) of office space, forty percent for BOC, the rest for leasing.

Pei accepted the commission on two conditions related to the site, which he did not like, but which BOC had already purchased in Hong Kong's dense Central district.[4] The difficult inland parcel, sloped some 30 feet (9 m) at the foot of Mount Victoria, was located at the far edge of the business district, skewed out of alignment with the street grid and encircled by elevated highways. Moreover, the site's square configuration dictated that a building of the required size would front onto a municipal garage. Meanwhile Norman Foster was erecting the vastly expensive Hong Kong Shanghai Bank (HKSB) on a privileged site nearby, adjacent

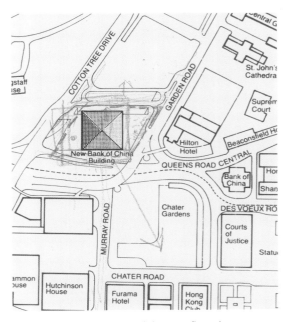

I. M. Pei, impromptu sketch of site reconfiguration, 2005

to and towering over, BOC's existing building. Pei sensed the implicit rivalry, just as he understood the importance of BOC's new tower as a symbol of modern China upon Hong Kong's return from the British in 1997.

Pei's solution was to negotiate a land swap with the government whereby one corner of the site was traded for another, reconfiguring it as a parallelogram to create triangular gardens on either side of the proposed building. By this magical shift it was not only possible to reorient BOC parallel with the city fabric but it could now be rotated away from the garage and axially situated for harbor visibility, and also faced onto Chater Gardens, one of the few open spaces downtown. Pei's second requirement was a new transverse road along the site's upper boundary to

Hong Kong harbor skyline

Pei shifting bundled sticks to achieve building form

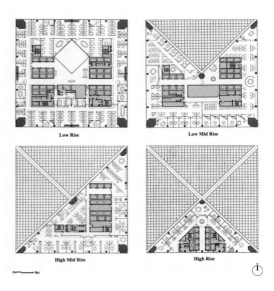

Low Rise — Low Mid Rise — High Mid Rise — High Rise

Typical floor configurations

make BOC accessible from surrounding streets, and provide the bank with its own formal entrance. "Both of my conditions — a land swap and the new road — were very important," said Pei, "because if a building isn't properly sited, no matter how beautiful or how well it functions, it will not have the right context. Siting is the first major step toward architecture."[5]

Despite the site's many problems, it had a unique advantage over other downtown buildings because, just outside the flight path, it permitted much greater height. It was clear that structural issues would be paramount since typhoon forces in Hong Kong are twice the wind loads in New York or Chicago and equivalent to four times the seismic forces in Los Angeles. Pei explained, "As in life, if you have only so much money, you spend it on essentials. I knew that if we could find economy in structure, we would have an economical building. Structure, in fact, was the generating force behind the design, even before we had an engineer."[6]

On the notion of stacked tetrahedrons, Pei played over a weekend in Katonah with four triangular sticks tapered at one end, each slipped higher until a single quadrant remained. From this emerged the form of the building. Pei likened it to bamboo, which every Chinese would understand as an auspicious symbol of strength and incremental growth.

Engineer Leslie Robertson confirmed the scheme's inherent structural rigidity and, working closely with Pei, designed for it an innovative composite megatruss that combines two structural systems, one to carry the tower's weight,

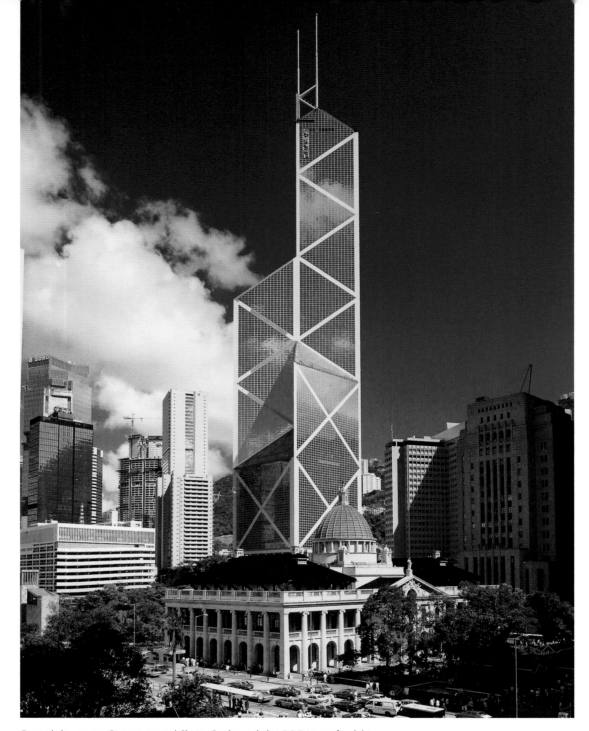

General view across Queensway and Chater Garden; existing BOC tower, far right

the other to resist lateral wind thrust. Involved is a vertical spaceframe where cross-bracing continues diagonally through the heart of the building to transfer all loads to its four massive corner columns—almost 33 feet (10 m) per side. A fifth central column extends down to the twenty-fifth floor where loads are channeled to the tip of a skeletal pyramid out to the columns.

All of the forces being transferred to the corners, the building's interior is column free while its structural frame remains light yet rigid and stable, like a four-legged stool.

The engineering tour de force is BOC's composite bonding. Instead of welding the many very complex, time consuming and therefore costly three-dimensional connections, the

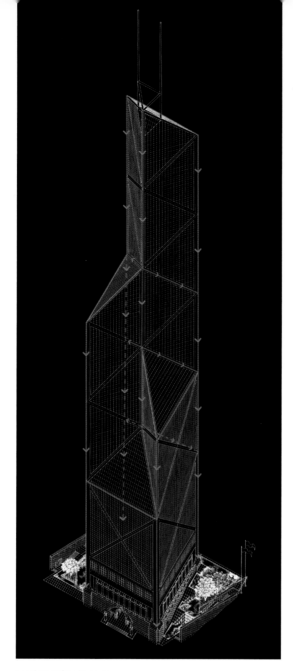

Load transfer diagram

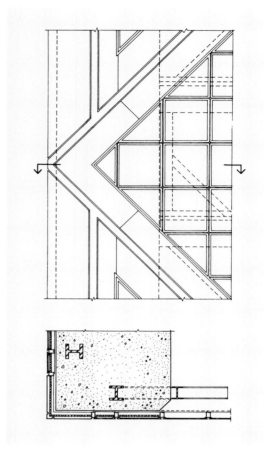

Curtain wall detail (top) and corner column section

various structural members were solidified in concrete. "It's almost like a giant drop of glue with the different components coming together but not connected," Pei explained. "You pour the concrete, with all the lugs in, of course, then you let it set. And that's your joint. . . . Like most great ideas, it turned out to be simple. Absolutely brilliant."[7] So efficient was the system that the structural steel requirement was only sixty-five percent of that for conventionally constructed buildings of comparable size.

The structural system is clearly expressed on the exterior where aluminum panels quite literally trace the corner columns and diagonal braces. The tower's horizontal trusses were also to have been expressed but when the client objected to the stack of x's, which have negative connotations in China, Pei removed the offending horizontals (assured by Robertson of their secondary importance) and thereby transformed the tower into a string of diamonds.[8] At once mysterious and inexorably logical, the reflective glass tower is like a monumental sculpture that changes with the viewer's position and time of day, drawing light from the sky even on overcast days. "It is a question of external form and movement on an urban scale," said Pei. "A building like this, which is seen from all angles, is more exciting when you're moving than standing still. . . . It has a dynamism distinct from other buildings since

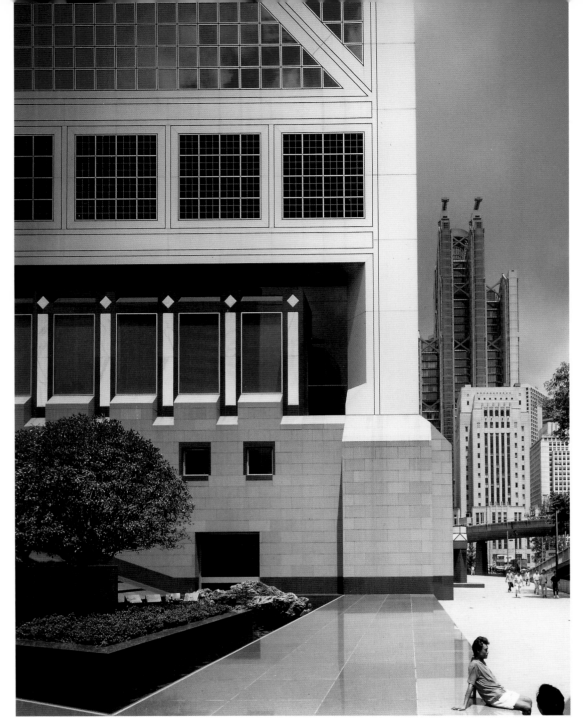

Northeast corner on Queensway; existing BOC and HKSB beyond

its disposition of volumes creates many facets that mirror everything around."[9]

As if carved from a natural outcropping of Mount Victoria the tower rests atop a granite base that mediates the site's steep slope as the modern Chinese gardens on either side offer tranquil retreat with tumbling waters and cooling breezes.[10] The stone base also satisfied client concerns for

security and a solid image, and made it possible to locate BOC's monumental banking hall— 30 feet high by 170 feet square (9 m x 52 sq m) without interior supports—on the third floor, above encircling roadways. An atrium telescoped up to BOC's seventeenth-story executive lounge, under the tower's first slope, adds both grandeur and natural light, and visually links the bank's

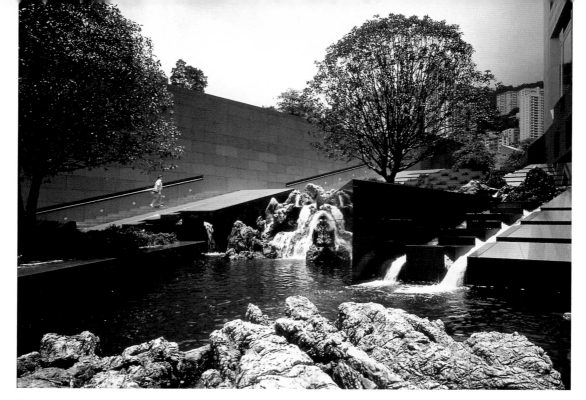

East water garden

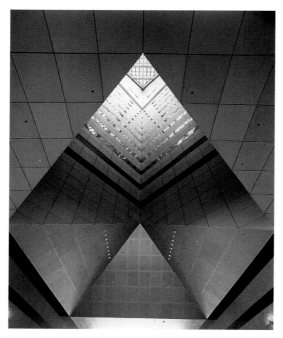

Fifteen-story banking hall atrium rising to first building slope

Never one to adopt modern architecture's multiple "isms," least of all one focused almost exclusively on external form, Pei emphatically distanced himself from contemporaneous Postmodern skyscrapers. "When you're dealing with a building of great height and tremendous forces, you can't worry about decoration. There is so much to be accomplished by staying structurally pure, which in turn will be pure aesthetically." He went on to weigh the many advances of modernism, but observed that Mies, Gropius, Le Corbusier, and others of "the first generation generally gave technology short shrift. I can't think of a single example where they pushed structure, or technology, and made it serve an aesthetic result. It is in the union of technology and design that architecture has its fullest potential."[11]

opposite:
Seventieth-floor
penthouse

supporting offices above. Atop tenant floors are BOC's executive dining rooms and seventieth-story penthouse where architecture and engineering come together in structure exposed against breathtaking views of Hong Kong harbor and the towering skyline.

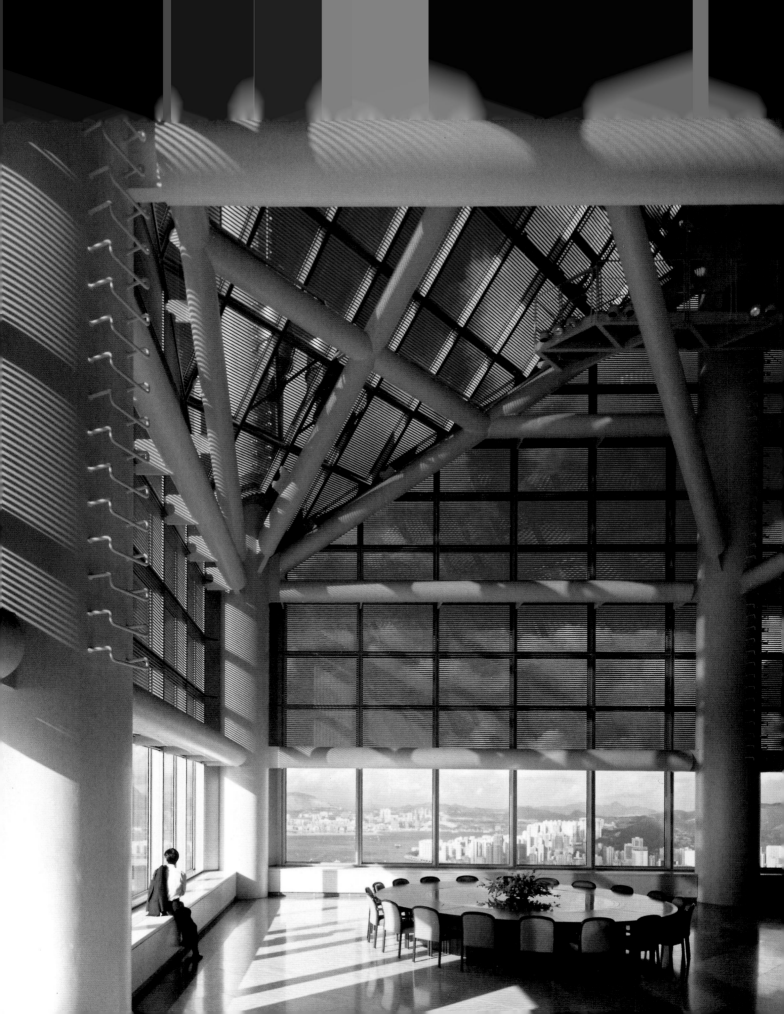

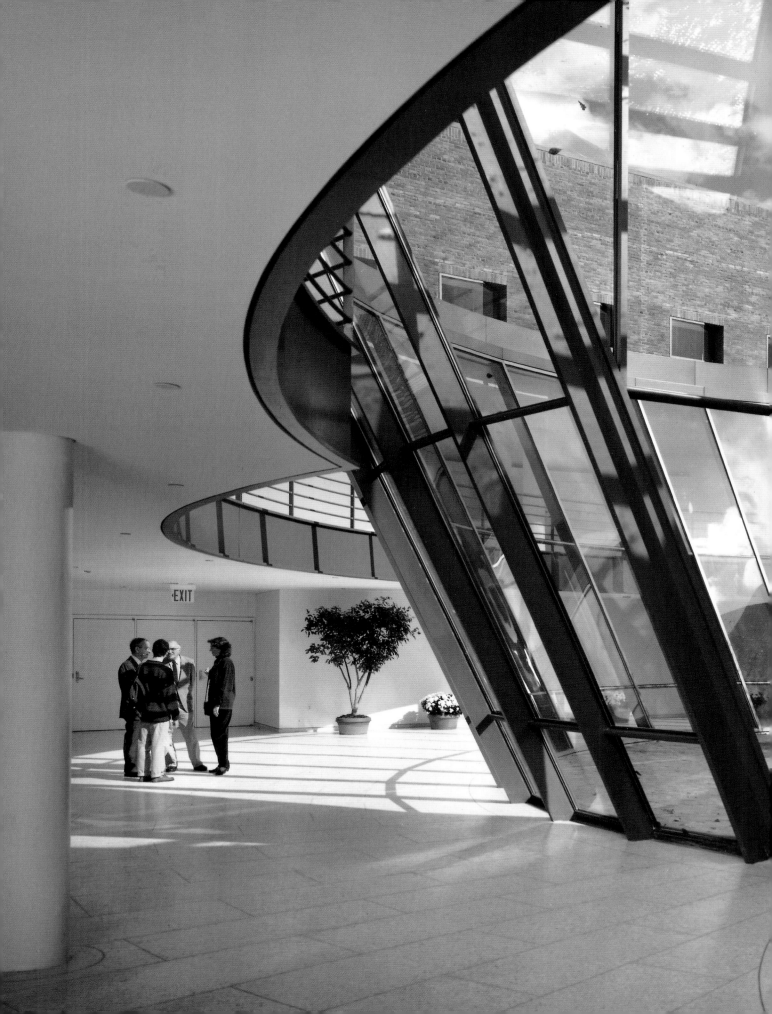

CHOATE ROSEMARY HALL SCIENCE CENTER

Wallingford, Connecticut
1985–89

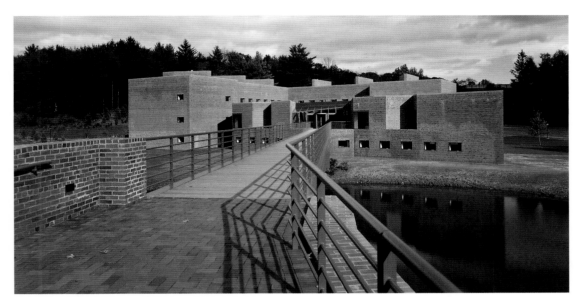

Bridge to second-floor entrance

Pei was commissioned in 1985 to design a new science center for Choate Rosemary Hall, where seventeen years earlier he had completed a new Arts Center for alumnus Paul Mellon, benefactor of Choate's original science building in 1938 and now its modern replacement. At the dedication ceremony, Mellon focused on architecture as the visible fusion of art and science. "Men have learned both, unconsciously, from the daily sight of great buildings. . . . Architecture remains the crossroads."[1]

The reference was especially apt since both of Pei's buildings are about connection. But whereas the Art Center facilitated the co-ed merger of the Choate School for boys and Rosemary Hall for girls, the Science Center was undertaken when the two prep schools were already one. "The situation was very different," explained Pei. "The new challenge was how to unify the campus."[2]

Location plan

Headmaster Charles Dey selected a wetlands site between the upper and lower campuses, which Pei transformed into a scenic nexus at the very heart of the combined schools. He dammed a running stream to create a reflecting pond (used for ecological studies) and angled across it

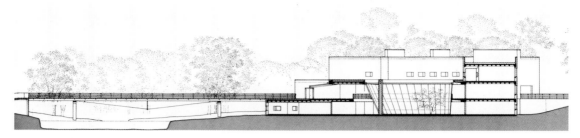

Longitudinal section

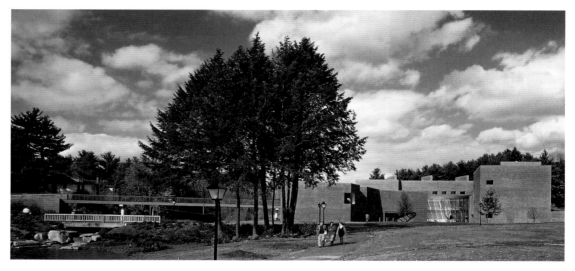

General view from east

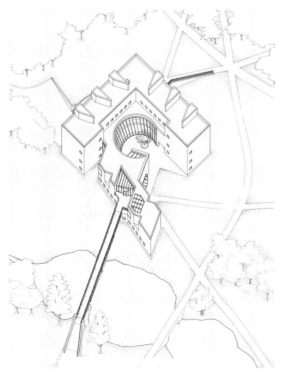

Axonometric

a 160-foot-long (49 m) bridge to provide exciting barrier-free access over the previously impassable terrain. "I fought long and hard for that bridge," he said. "It's very important because it brings students together and connects the campus. It's the key to the design."[3] The bridge and its railings continue straight through the building and out to the upper campus on a 100-foot-long (30 m) walkway ramped into the hillside; entrances on the north and south create other links. The building as a whole, faced in water-struck regional brick, mediates between the Georgian architecture of the academic core and newer buildings, its own bulk fragmented to create richly varied, almost domestic-scaled masses.

The building is layered internally by scientific discipline: physics on the lower level, biology on the main floor, and chemistry on top, with mechanical towers strategically located between laboratories to allow direct air supply and return.

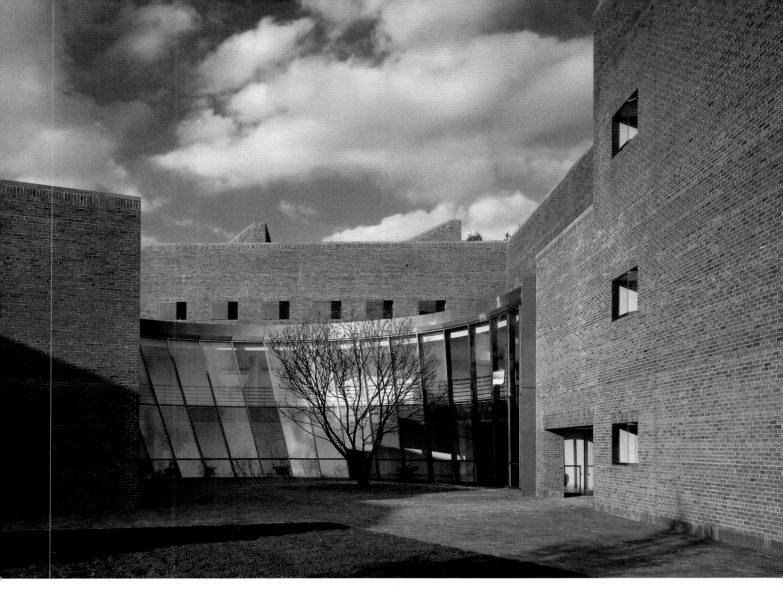

Conoid exterior

The complex is organized in a three-story "L" and an angled two-story wing, which interact around a transparent conoid (like a section of an inverted glass ice cream cone), carved from the center of the building to create an outdoor garden with a single flowering magnolia tree. The conoid leans back to light the building's open circulation spaces and fill them with the outdoors in a balance of movement and nature.

After intense personal involvement in conceptualization and siting, Pei developed the Science Center with Ian Bader, dividing his pre-retirement time among an unusually full cycle of buildings that opened one right after another across the world.

Choate was the most modest of the five, and the most accessible demonstration of what Paul Mellon praised as "organic beauty." In this small, but complex, building with its bridge, sculptural forms, and painterly reflections, and in the intimate balance of nature improved by man, are key elements of Pei's architecture and the seeds of some of his finest post-retirement buildings.

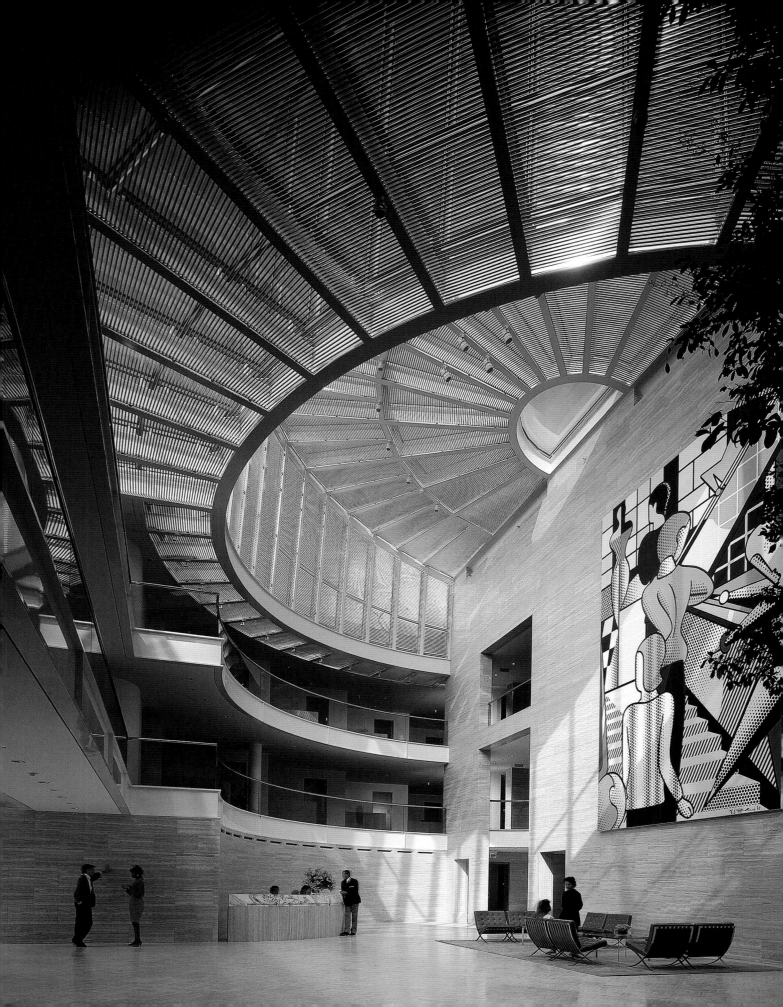

CREATIVE ARTISTS AGENCY

Beverly Hills, California
1986–89

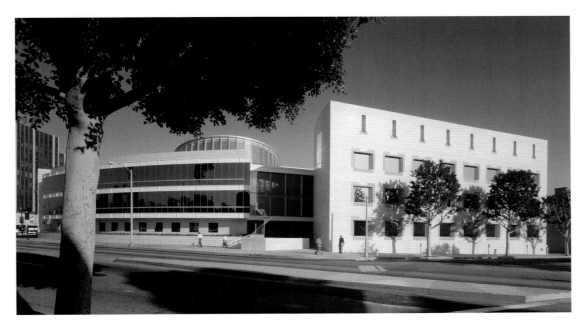

Exterior

As anomalous as it may have seemed for Pei to tackle the Creative Artists Agency's (CAA) small headquarters while engaged in major projects like the Louvre, the silver screen first drew Pei to the United States, and thus there was a certain poetry to the decision to take on the project.[1] Although initially declined for its size, the 75,000-square-foot building, completed just prior to Pei's retirement in 1990, previewed the smaller scale projects that he would prefer and the greater opportunity they offered for his close personal involvement in design.

When CAA president Michael Ovitz decided to relocate to premises more appropriate to his company's growing distinction as the most powerful literary and talent agency in the country, he wanted a "timeless, classic design that would

Site plan

project elegance and solidity. I spent three to four years looking at the work of almost every architect," he said, "before reaching the conclusion that Pei was the only one I wanted."[2]

The primary challenge was the site: an awkward assemblage at the gateway to Beverly Hills

Atrium

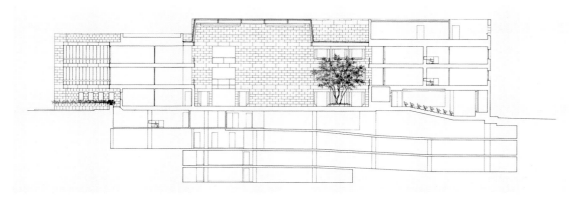

Section

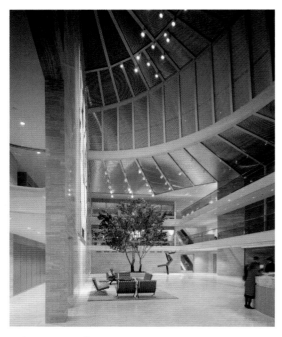

Atrium screen wall

where Wilshire and Santa Monica boulevards meet in one of the busiest intersections in Los Angeles. Pei responded with a curved wing of cantilevered offices, reflecting the movement of a half-million daily motorists. At the opposite end, the building fronts a quiet residential street with a straight stone facade and windows surrounded by dark brown frames of the same Onda Marina ("sea wave") travertine that clads the building throughout. Blocks of the honey-colored stone were fabricated not as standard flat panels but were cut to the building's curve to avoid shadows or faceting, allowing the building to

appear as a monolithic whole. Slices from each block were then matched end to end so that the travertine's "veinyness" threads continuously from outside into the atrium's walls and parquet floors.

The central space rises 57 feet (17 m) to a skylit crown sliced "like a wedge of an orange," said Pei, which glows beaconlike at night. "In New York," he explained, "the streets are lively, filled with people. But in California every-one drives a car." To create a sense of community he made the functional main entrance an under-ground valet parking garage with elevators that rise only to the ground floor so that everyone, employees and celebrities alike, must pass through the atrium, or what Pei called "the stage," before continuing on.[3]

Equipped with a gourmet kitchen, 100-seat screening room, and specially commissioned works of art, including a freestanding bronze by Joel Shapiro (Ovitz's cousin) and a 26-feet-high (7.9 m) mural by Roy Lichtenstein modeled after Oskar Shlemmer's *Bauhaus Staircase* in the Museum of Modern Art, the atrium draws from both the National Gallery and Meyerson Symphony Center to provide CAA with a formal reception hall; it has all the lights and action of a cinematic production, but with sophisticated elegance rather than Hollywood glitz. Enlivened by fleeting glimpses of people coming and going behind a honeycomb wall, in open corridors, on bridges and high-visibility stairs at either end, the atrium reinforced CAA's high-energy opera-

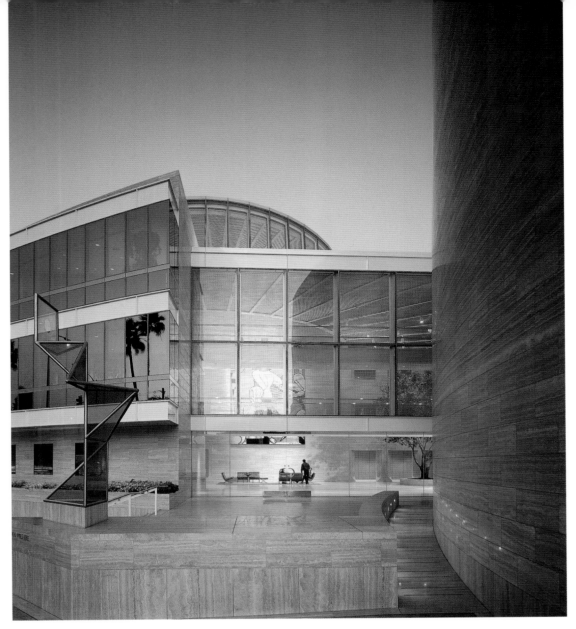

Street entrance

tions. "It's really an extraordinary design," said Ovitz. "Aesthetically, programmatically, there's nothing about it that doesn't work, all the way down to the loading docks. It's all incredibly well thought out."[4]

Among the most fluid and exquisitely executed of Pei's works, CAA recalls in its mantle of refinement the headquarters he created for Zeckendorf four decades earlier. CAA's distinction was immediately recognized, although interpretations differed: *The New York Times* hailed CAA as what "may be the most beautifully made modern building Los Angeles has ever seen,"[5] while

the *Los Angeles Times* asked, "Pei Masterpiece: Too Elegant Here?"[6] CAA was a coming-of-age building that established a new epicenter for Hollywood's highly competitive talent industry, and in a larger sense brought world-class architecture to Los Angeles.[7]

Michael Ovitz resigned as president of CAA in 1995, after which the agency vacated the headquarters understood as his personal monument. Asked whether he would sell the building, Ovitz replied, "Never. It is part of my art collection."[8]

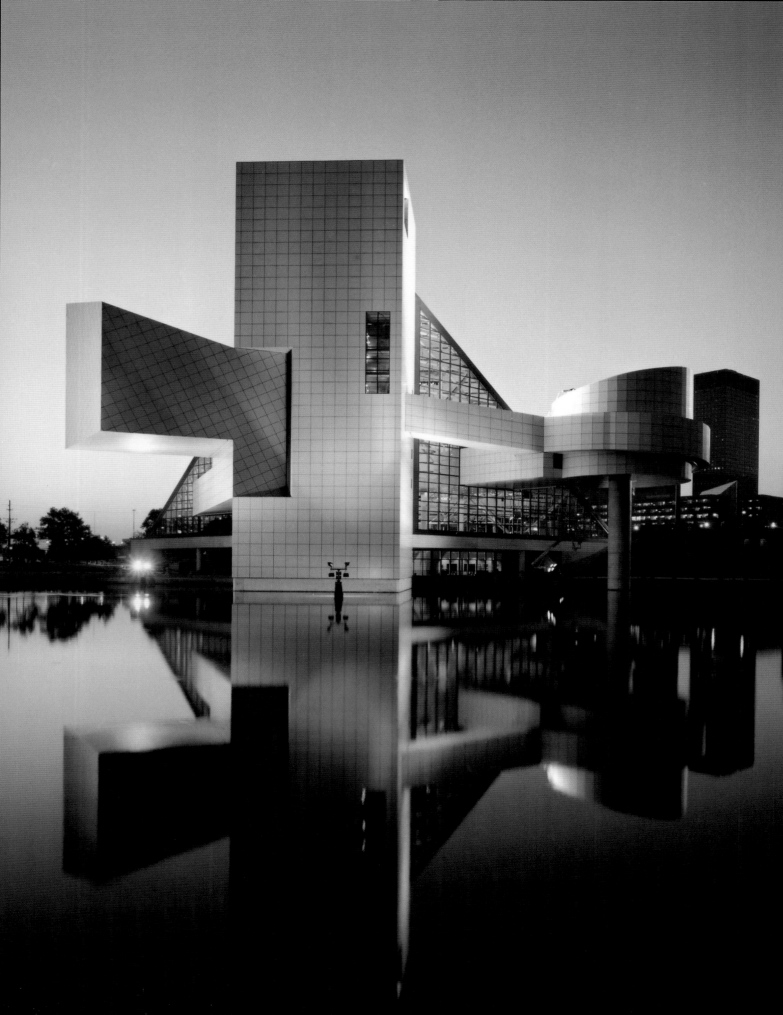

ROCK AND ROLL HALL OF FAME + MUSEUM

Cleveland, Ohio
1987–95

When Pei was commissioned to design the Rock & Roll Hall of Fame and Museum, he bore the imprimatur of the Louvre, the National Gallery of Art, and numerous other bastions of high culture. Aside from the credibility sought in hiring so highly credentialed an architect — the very persona of the establishment against which rock and roll rebelled — the commissioning of sixty-eight-year-old Pei to design the Valhalla of this young, raw, American-grown music was not as incongruous as it might seem. Pei had lived in China until age seventeen and had built his career bridging cultures, young and old. His Chinese heritage, moreover, predisposed him to honor the roots of tradition, which was precisely the goal — to legitimize rock and roll as a respectable art form. Urbanistically, Pei also brought decades of experience to the ongoing effort to revitalize the North Shore of Lake Erie.[1] That the Hall of Fame ended up in Cleveland was the result of a related vigorous city-state-public initiative, serendipitously validated by local disc jockey Alan Freed who had coined the term "rock & roll" on his 1950s radio show.[2]

Pei confessed that he had no experience with rock and roll other than to tell his children to turn it down; indeed, it was only at their urging that he accepted the commission. Ahmet Ertegen, head of Atlantic Records, and Jann Wenner, publisher of *Rolling Stone,* took Pei to stadium concerts and a week-long trip to New Orleans by way of Nashville and Memphis. "It was an experience," Pei recalled. "After seeing all that awful furniture and that big white Cadillac I certainly didn't want anything of Graceland!

Location plan

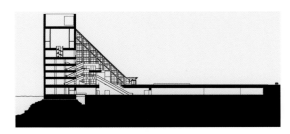

Section

But Elvis Presley was a hot number; Little Richard, too. I learned a lot about early music during that trip, especially in New Orleans. I became convinced that the roots of rock and roll were very deep. This is what encouraged me. Even though it is not my kind of music, I was interested in the phenomenon. I wanted to express the energy of the music."[3]

The building stands in North Coast Harbor, amplified by watery reflections as its sculptural mass bursts out from a 162-foot-high (49 m) tower clad in gleaming white aluminum panels. On one

North Coast Harbor view

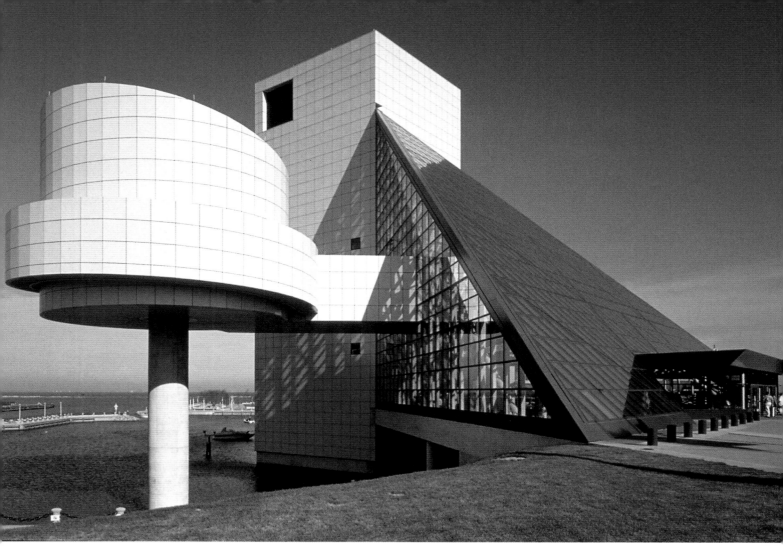

Tented tower and ramped exhibition rotunda, rising from Lake Erie

side a 175-seat auditorium hovers 65 feet (20 m) above Lake Erie and on the other, a ramped theater-in-the-round balances atop a single concrete column rising from the water. The disparate elements are unified by a five-story transparent tent (often likened to the Louvre Pyramid but really a steel and glass lean-to) which gives a certain symmetry to the asymmetrical whole as it inclines toward the city across a 1.5-acre (0.6 ha) outdoor plaza on the roof of the museum's main underground exhibition hall. A passage through the back of the building leads to a waterfront promenade and neighboring civic and recreational facilities.

"Designing an art museum is very natural for me," said Pei. "It doesn't matter which period. But here I was coming from a different vantage point, faced with a different culture, people with different interests," many of whom might never before have been to a museum.[4] The difference is apparent immediately upon entry as visitors see not a graceful Alexander Calder mobile but painted and faux-fur–covered Trabants, stage props from a U2 concert tour, suspended from the tent's sturdy bowstring trusses. Unlike the fine cable structure of the Louvre Pyramid, the tubular steel components have a robust industrial quality appropriate to the museum's location in America's "Rust Belt" and to the gritty connection Pei mentally forged with Liverpool and the Beatles.[5]

Visitors can linger on the ground floor before descending by escalator to paid admission into the main 3,000-square-foot (280 sq m) exhibition

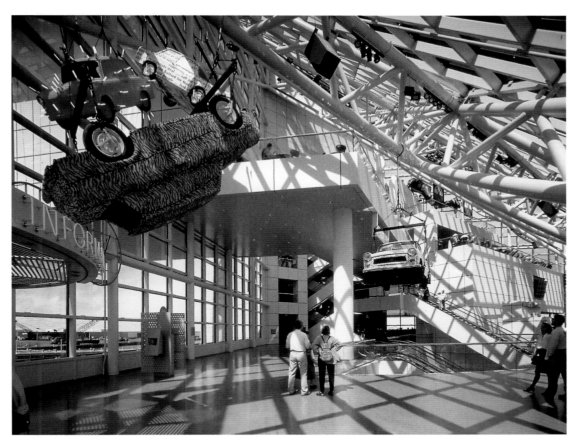

Entry lobby

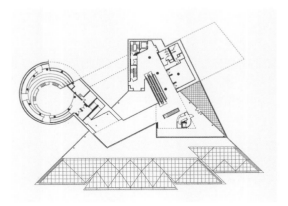

Level 3 plan (café, outdoor terrace, ramp to exhibition rotunda)

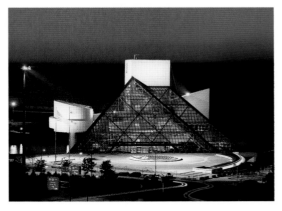

Main facade and plaza

hall that explores the evolution of rock and roll in still and interactive acoustic and video installations, all in a controlled black-box environment. The tour continues as museum-goers ascend on crisscrossed escalators to energize the interior by their own color and movement, constantly returning to the public space of the tent as they pass from one exhibition area to another on floors

that change shape and decrease in size as they rise. "It's an active building with many parts. That's what makes it go," explained Pei. "The sequencing is interesting so people enjoy walking around and through the space. It's pure movement."[6]

From the café level and outdoor terrace, which afford spectacular views of the lake, the city, and the museum itself, visitors proceed to

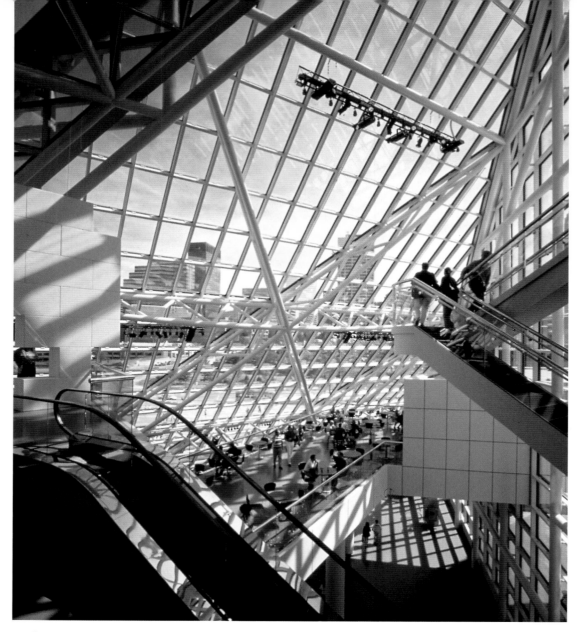

Tent interior, overlooking downtown

the fifth floor on a staircase cantilevered dramatically into the tallest public space Pei ever designed. By climbing rather than riding visitors become more personally involved in what he described as "the ascent up the mountain."[7] In dark and mysterious contrast, jostling excitement transforms into an aura of dignity and respect in a measured procession that quietly winds into the Hall of Fame — the literal and symbolic apex of the building — where inductees' signatures are laser etched onto the backlit glass walls of the 30-foot-high (9 m) contemplative black-box chamber.

A dozen years after the museum opened, Pei confessed to an uncertainty seeded by his latest, mostly deeply rooted work. "I have more confidence about other buildings than I do about this one. I came at it the best way I could based on what I was able to learn at the time. I'm much older now, and farther away from rock and roll," said the ninety-year-old architect, "but I think today I might do it better."[8]

opposite:
View up to cantilevered stair and Hall of Fame

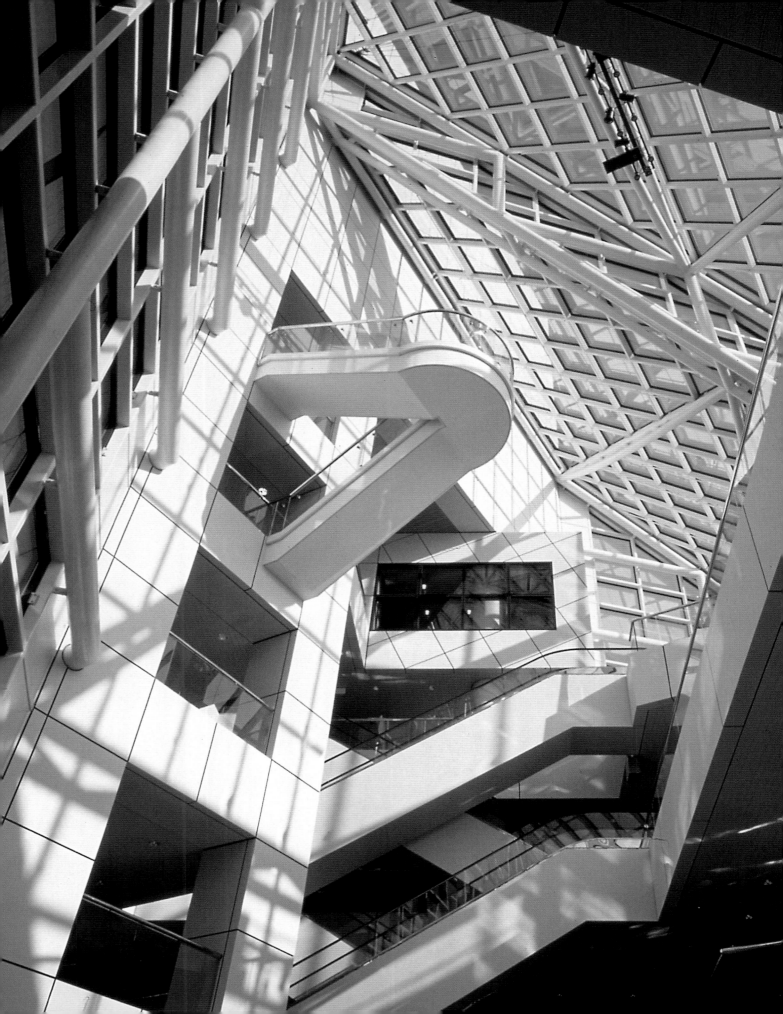

1983-2008: I. M. PEI AND THE CHALLENGE OF HISTORY

Philip Jodidio

In the preface to this book, I. M. Pei describes how in 1946, as a graduate student in Walter Gropius's studio at Harvard, he designed a museum that bears resemblance to one of his most recent works, the Suzhou Museum, in its focus on history and culture. Before the 1980s Pei had designed buildings outside the United States, but a pivotal transition occurred, when he was called on to create the Grand Louvre and approached retirement from Pei Cobb Freed & Partners. "The challenge of history was there with the Louvre," says Pei. "In America, history was less present for me—even the National Gallery project—the Mall is less than two hundred years old. For the Louvre I had to go far back into history. I was able to defend myself against people who attacked me at the time because I had read the history of the Louvre."[1] The Louvre project was carried out with a skilled team and relied on the resources of Pei's office in New York, but thereafter, he created a new and very small firm—I. M. Pei, Architect—which consisted of himself and his two assistants, Nancy Robinson and Shelley Ripley. Architects and staff from Pei Cobb Freed and his sons' firm, Pei Partnership, participated in the post retirement projects according to the needs of each building. After 1989 Pei accepted only those commissions that interested him, and it is no accident that his more recent buildings have been located in Luxembourg, Germany, England, Japan, China, and Qatar. He encountered and interpreted the culture of each of these places with a fresh perspective and curiosity, which have informed the designs. But Pei has not forsaken modernism, which runs through his work from first to last. Rather, what he has sought is the "essence" of the cultures that have offered some of their most prestigious sites and projects to his designs. This may be his greatest effort and accomplishment.

The Cour Napoléon in the Louvre with its Pyramid and fountains does not echo the surrounding architecture of the palace so much as it evokes the sky and reflections of France. The Louvre forms one end of the great axis of the Champs Elysées originally laid out by André Le Nôtre. Pei's investigation of French culture went beyond the history of a palace to recognize a kindred spirit in Le Nôtre, a master of geometry and space who died nearly three hundred years before the inauguration of the Pyramid. In doing this, he identified an aspect of French culture that effectively reunites past and present.

"I came to Europe for the first time in 1951 for a Harvard fellowship," says Pei. "That was the most important trip I made in my life. I went to France, Italy, England, and Greece. I was never the same after that. That opened me to European culture. Europe for me is the most important place because of its cultural diversity. Asia is more similar from one country to another. Europe is the richest continent historically and culturally."[2] His search for the essence of cultures—including some unfamiliar to him, such as Islam with the Doha Museum of Islamic Art—has led him to explore and discover the deep links that can bring together modernism and the architecture of the distant past. Describing his study of Islamic architecture, Pei said, "I was finally coming closer to the truth, and I believe I found what

I was looking for in the mosque of Ahmad Ibn Tulun in Cairo (876–879). The small ablutions fountain surrounded by double arcades on three sides, a slightly later addition to the architecture, is an almost cubist expression of geometric progression from the octagon to the square and the square to the circle."[3] In Doha, the geometry of modernism finds its way into a new museum inspired by the forms of Islam.

The Grand Louvre is I. M. Pei's most significant work of architecture, because it reunites the disparate parts of the palace and allows the museum to become modern. "The challenge for me was the plan — to make the Louvre whole," states the architect. "The plan is the greatest accomplishment — more important than the Pyramid. Covering the two courtyards in the Richelieu Wing [which had served as open-air parking lots for the French Ministry of Finance] was the most important architectural gesture in the project."[4] Pei's proposal for the courtyards was crucial to gaining the approval of the seven senior curators of the museum, without whom the entire project would have been in peril. Placing grand sculptures in the covered courts was essential, along with opening the Passage Richelieu, permanently linking the Louvre to the city. Perhaps it was Pei's experience in urban design at Webb & Knapp that gave him the depth of understanding that allowed him to place his own design at the service of France — or, more likely, it was his respect for history. Bringing the Louvre back to life was a feat that few architects in the world could have mastered as adroitly as Pei.

While still a student at Harvard, I. M. Pei dared to tell Walter Gropius that history and architecture were inextricably bound, and the founder of the Bauhaus replied, "Fine. Prove it." In many ways the oeuvre of Pei, particularly his post retirement projects, has been about that exchange. With the inauguration of his museums in Doha and Suzhou, Pei has come full circle, and proven his point. In doing so he has redefined modernism, shifting architecture itself away from the tabula rasa advocated by Gropius and forging enduring links between past and present.

GRAND LOUVRE

Paris, France
Phase I: 1983—89, Phase II: 1989—93

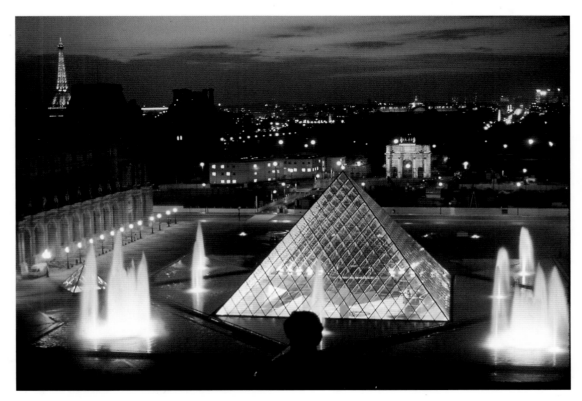

View of the Louvre with the pyramid in the foreground, the Champs-Elysées to the right, and the Eiffel Tower in the distance

A lead cast of Giancarlo Bernini's equestrian sculpture of Louis XIV marks the axis of the Champs-Elysées near Pei's pyramid

In 1989, I. M. Pei stated, "The Grand Louvre will hold the first place in my life as an architect."[1] To the casual observer, this might seem a surprising statement. The only part of Pei's work visible from the exterior of the palace is a glass pyramid and the square around it, the Cour Napoléon. But the Louvre is more than a museum or a former royal residence. François Mitterrand, the president who selected Pei, explained its place: "Several forms of history overlap and give the Louvre its strength as a symbol. The first of these is set in stone, from the fortress of Philippe Auguste[2] to the Second Empire[3] wings, this is the place where

France was made."[4] Mitterrand told Pei that he liked his work because of the ability he showed to unite the old and the new in the East Building of the National Gallery of Art in Washington, D. C. But Pei disagrees with the comparison. As he says, "Only forty years separate the East and West Buildings of the National Gallery — whereas there are eight centuries of history in the Louvre."[5] Pei's Grand Louvre project thus concerned nothing other than the heart of France. Though controversy greeted the first announcement of the pyramid, the architect convinced the president, museum authorities, and then the

Chateau du Louvre from the Limbourg Brothers'
Très Riches Heures du Duc Berry, 1416

Le Salon Carré, 1861

country at large that his vision could best bring
the Louvre into the twentieth century. Indeed,
Mitterrand's Grands Travaux — a program of
ambitious building projects mostly located in the
French capitol — was meant to emphasize the cen-
tral role of culture in the country. Geographically
set between Jean Nouvel's Institut du Monde
Arabe (1987) at one side of the city and the Arche
de la Défense (1989) by Johan Otto von Sprekelsen
and Paul Andreu on the other, the Louvre, beyond
its place as a museum, was without a doubt a vital
element of government policy, a key to understand-
ing the evolution of modern France. Today, the
pyramid has become as much a symbol of Paris
as the Eiffel Tower. This achievement, born of a
daring but practical design, and a quest for the very
essence of French culture, clearly places the Grand
Louvre in "first place" in the work of I. M. Pei.

Built by Philippe Auguste starting in 1190,
the original Louvre was not a royal residence, but
a rectangular arsenal — 256 by 236 feet (78 x 72 m)
in size — surrounded by moats. Circular towers
protected the angles and the middle of the north
and west facades. At the center of the structure,
stood the Grosse Tour (Great Tower), an impressive

circular keep 50 feet (15 m) in diameter and 100
feet (30 m) high. It was during the reign of King
Charles V (1338–1380), which began in 1364, that
the architect Raymond du Temple transformed
the medieval fortress into a sumptuous royal
residence. Dormant for more than a century, the
Louvre was again transformed by King François I.[6]
The projects that began in 1527 with the demolition
of the Grosse Tour, and the construction after
1546 of a new western wing designed by Pierre
Lescot and decorated by the sculptor Jean Gougon,
continued under the successors of François 1er
through the reign of Louis XIV. Constant work on
the palace annoyed Queen Catherine de Medici[7]
to such an extent that she asked the architect
Philibert de l'Orme (1510–1570) to design a new
palace to the west of the Louvre, to be known
as the Tuileries (1564).

A century later, Louis XIV resided at the
Tuileries during the construction of Versailles.
Although he was to leave Paris shortly thereafter,
the king ordered the architect Louis Le Vau
(1612–1670) to redesign the facades of the Tuileries,
and André Le Nôtre (1613–1700) was given the
task of designing a long perspective garden in
the direction of what was to become the modern
Champs-Elysées. In 1665 Louis XIV asked Bernini
to design an eastern wing for the Cour Carrée,
near the location of the original Grosse Tour,
but this project and others were stopped in 1668
when the court moved to Versailles.

The history of the Louvre as a place for the dis-
play of art began before the end of the seventeenth

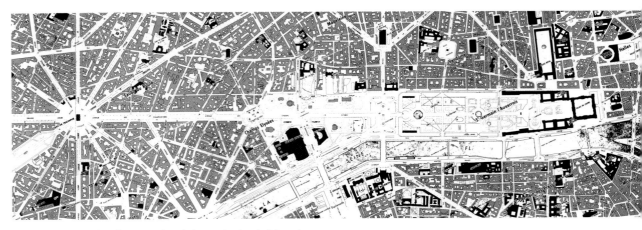

An aerial view showing the Louvre in relation to the Arc de Triomphe

century when the Académie Royale de Peinture et de Sculpture (Royal Academy of Painting and Sculpture) held an exhibition in its Grande Galerie for first time in 1699. Subsequent to 1725, regular shows or salons were held in the palace. It was under the revolutionary government in 1791 that the Louvre was officially dedicated to the gathering together of all the monuments of the sciences and the arts. More importantly, the Museum Central des Arts opened there on August 10, 1793, administered by the painters Hubert Robert and Jean-Honoré Fragonard, the sculptor Augustin Pajou, and the architect Charles de Wailly. Although priority was given during the week to artists, the Museum was open to the public free of charge on Sundays, and exhibited works primarily from the royal collections.

The Louvre continued to evolve throughout most of the nineteenth century, with Napoleon I building the Arc de Triomphe du Carrousel in 1805 to commemorate his victories and Napoleon III adding a wing intended to connect the palace to the Tuileries (1852–57), which was designed by architects Louis Visconti and Hector Lefuel. In 1871, the French Ministry of Finance took up residence in the Richelieu Wing. This type of occupation of the Louvre, for purposes other than that of the museum, had a long and check-ered history. The Pavilion de Flore, for example, housed the French National Lottery until 1968. In unexpected ways, however, the future of the

Louvre was already being imagined long before the work launched by François Mitterrand began to transform it. Few might know that as early as 1889, a monument to the "glory of the French Revolution" in the form of a pyramid was pro-posed for a location not far from I. M. Pei's crystalline design.[8] More significantly, in 1950, Georges Salles, director of the Direction des Musées de France in the Ministry of Culture, proposed to move the Ministry of Finance out of the Richelieu wing and to create underground spaces in the courtyards of the Louvre. He com-pared the museum in 1950 to a "theatre without a backstage" Built as a royal palace over a period of centuries, the Louvre could hardly claim to be a modern museum, despite its ample size and spectacular spaces such as the Grande Galerie.

It was the following year, 1951, that I. M. Pei and his wife Eileen came to Paris for the first time. They stayed at the St. James & Albany Hotel, just steps away from Pei's "favorite museum," the Louvre. Despite the vision of Georges Salles, the old palace would undergo no major changes until François Mitterrand became president of France on May 10, 1981. Within four months of his election, Mitterrand announced on September 26, 1981, that the whole palace would become a museum. Emile Biasini—a former head of the French national television network and member of the cabinet of French Minister of Culture André Malraux—was named by

An early sketch by Pei for the pyramid's entrance

An early sketch by Pei for the public spaces around the pyramid

Mitterrand to head a study on the subject in October 1982. It was Biasini who recommended that the architect of the East Building of the National Gallery of Art be selected for the Grand Louvre project without a competition, because the architect took the firm position that he would not participate in such an exercise, even if his selection had been "guaranteed" in advance. Biasini writes that he had been impressed by Pei's work, in particular the East Building of the National Gallery of Art, and that he had conducted a personal poll of museum directors in London, Rome, Berlin, Stuttgart, Munich, and Amsterdam. He asked these professionals which architect they would select to design a major renovation. Though Richard Meier, Renzo Piano, Norman Foster, and James Stirling were cited by various museum directors, Biasini said that all listed Pei. Working with Robert Lion, the powerful head of the Caisse des Dépôts et des Consignations bank, and Louis-Gabriel Clayeux, who had originally suggested to Mitterrand that the Louvre should be renovated under his mandate, Biasini obtained the agreement of the president on his choice of Pei.[9] Biasini then approached the architect with the help of their mutual friend, the painter Zao Wu Ki, and met with Pei and his wife Eileen for the first time at the Hôtel Raphael in Paris in November 1982.

Before accepting the commission, Pei surprisingly asked for four or five months to study the problem. He was given access, albeit secretly, to every inch of the Louvre and made three visits there in the winter of 1982–83. Pei explains his request in these terms, "I didn't accept the project right away, excited though I was. Instead, I told Mitterrand that I needed four months to explore the project before I could accept it. I wanted that time so I could study the history of the Louvre, which corresponds very closely to the history of France. The first portions were built in the twelfth century, and a succession of rulers came, added on, built something, and demolished something else. For eight hundred years the Louvre has been a monument for the French — the building mirrors their history. I thought by asking him for this time it might make him say no, thank you very much, because he was in a hurry — he'd been elected in 1981 and his term would last only seven years, and this was 1983 — so there was some pressure for him to accomplish something."[10] Pei's careful examination of the building and its history led him to conclude that, much as Georges Salles had imagined, digging into the Cour Napoleon, the open courtyard between the two wings built by

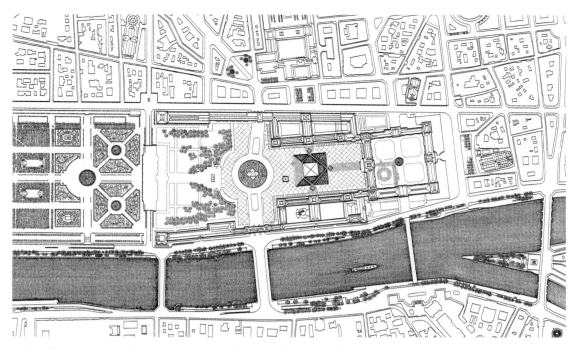

A plan of the entire Louvre shows its proximity to the Seine and to the Tuileries Gardens

Napolean III, was the only solution. A central entrance would thus be created, partially solving the difficulties raised by the very large scale of the structures and the distance between its long wings along the Seine on one side, and the rue de Rivoli on the other. In line with the President's announcement concerning the use of the entire palace by the museum, Pei's scheme depended in part on the refurbishment of the Richelieu Wing, at that time still occupied by the Ministry of Finance. A competition had been organized to select an architect for a new structure for the Ministry in the Bercy area of Paris, and Paul Chemetov had emerged victorious in 1982, making feasible the displacement of the Ministry. Politics would interfere with the clear logic of this plan when the opposition minister of the economy, Edouard Balladur, simply refused to move his five thousand employees out of the palace. But, when Pei went to see the President in June 1983, these difficulties were still in the future, and he accepted the commission that had been proposed to him by Biasini. He explained the need to dig into the Cour Napoleon, though he had not yet formulated the idea of the pyramid. The architect recalls that the

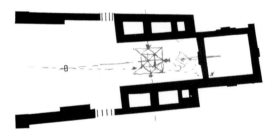

The pyramid and its basins are indicated in red on the plan

president gave him a two-word answer: "Très bien."

From the outset, the Grand Louvre project was the story of more than one person. Without the political will of the French president, nothing would have been possible. But Mitterrand himself made clear that this complex undertaking could not have been successfully carried forward without the tireless energy of another man. "I must say," he declared, "that the essential man, the one without whom nothing would have been possible, was Emile Biasini. He conceived and organized the project. He went all over the world, devoting himself first to the Louvre and then to what has been called the Grands Travaux. I want to express my gratitude and my affection," concluded the president at the inauguration of

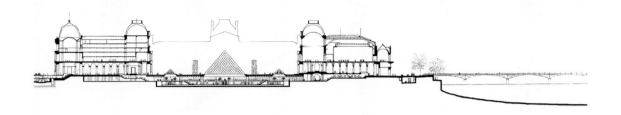

An elevation shows the relative volume of the pyramid vis-à-vis the neighboring pavilions of the Louvre

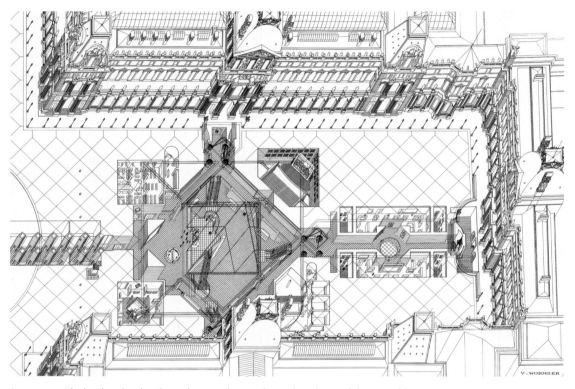

An axonometric drawing showing the underground spaces beneath and around the pyramid

the Richelieu Wing.[11] Biasini presided over the Etablissement public du Grand Louvre (EPGL), the public authority created in 1983 to carried forward the president's plan for the museum, and then became the minister responsible for the entire Grands Travaux program — a position he held up to the early work on Dominique Perrault's French National Library, which was completed in 1997, two years after Mitterrand left power. The French system, which accords great power and prestige to the presidency, was directed by Mitterrand with the specific intention of carrying forward his cultural projects. Emile Biasini

explains how it was possible to revamp the Louvre so completely: "The president of the Republic gave me the responsibility for the Grand Louvre. . . . He followed the project personally and closely from the outset. I consider that I had a direct and loyal relationship with him that became a kind of real collaboration — and this is what permitted me to carry forward with a real sense of authority, with independence and efficiency that could never have been obtained in more ordinary circumstances."[12]

Once I. M. Pei accepted the commission, Emile Biasini made clear the nature of their own

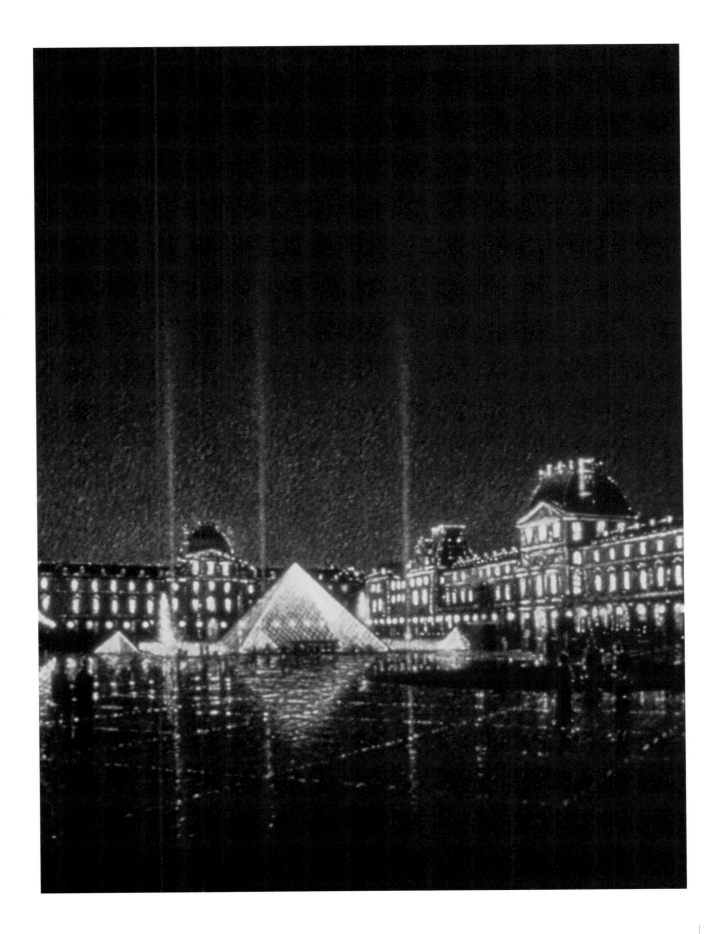

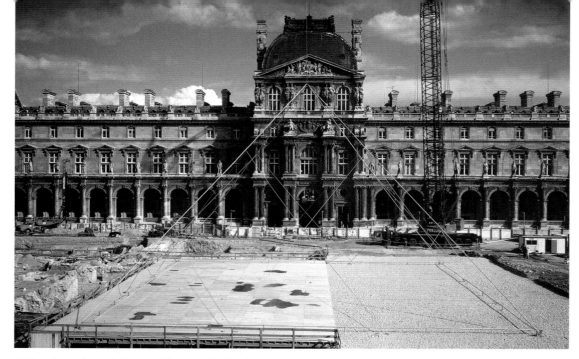

A full-scale mock-up of the pyramid was put in place in May 1985 to give an idea of its scale

collaboration, "We were at the beginning of an adventure that would surely encounter a number of prejudices, habits, and methods, but that we had to work within a very strict schedule. The project had to be made irreversible before the end of the first mandate of François Mitterrand in May 1988. I did not seek to hide from I. M. that the obstacles would be numerous and that I could not plan for all of them. . . . Backed by François Mitterrand and totally committed to winning his wager, I made it my business to clear the way so that the architecture could advance."[13] A master of the French bureaucracy, Biasini saw to it that Pei became an associate of the official architect of the Louvre, a specialist of historic monuments called Georges Duval. This obviated many potential problems or roadblocks, and Biasini took care of the rest of them.

The Grand Louvre project lasted for a total of fifteen years, from 1983 to 1998. It concerned a site area of 22 acres (9 ha). In the first phase — involving the pyramid, the square around it, and the larger underground spaces, including a new public entrance, shops, restaurants, temporary exhibition galleries, and much needed "backstage" space (construction 1984–89) — a total of 667,254 square feet (62,000 sq m) of

space was added to the Louvre. Also included in the first phase was work related to the discovery of substantial archeological elements, in particular in the Cour Carrée, where the base of the former Grosse Tour was restored and integrated into an underground presentation of the history of the palace. The second phase (construction 1989–93) involved the demolition of 592,000 square feet (55,000 sq m) in the Richelieu Wing of the palace and 538,000 square feet (50,000 sq m) of new construction. The project budget was 6.9 billion French francs (approximately $1 billion). Where historic areas of the Louvre were concerned, Pei and his team worked with Duval, and later Guy Nicot, the *Architectes en chef* (head architects) of the palace. Michel Macary and his firm SCAU was the Paris-based associate architect, while Jean-Michel Wilmotte worked on interiors such as the temporary exhibition spaces beneath the Pyramid and the decorative arts rooms in the Richelieu Wing.

Pei first presented his project, including the Pyramid in the midst of the Cour Napoléon, to the Commission Supérieure des Monuments Historiques (the official historic sites committee) in January 1984. Considerable controversy, led in particular by former Culture Minister Michel

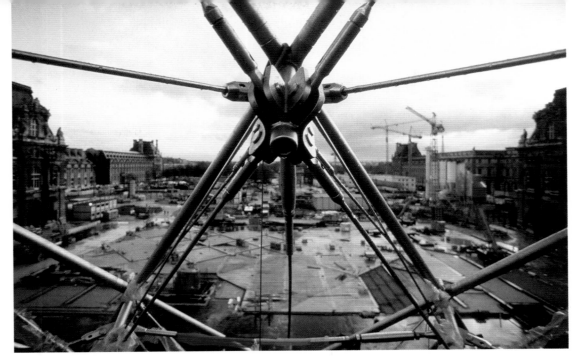

A pyramid node and its struts manufactured by Navtec, photographed during construction

Guy and the right-wing daily *Le Figaro,* greeted the scheme, and at the request of the mayor of Paris, Jacques Chirac, a full-size mock-up consisting of wires and poles was erected in the Cour Napoléon in May of the following year. To his credit, Chirac, who was to succeed Mitterrand as president of France, allowed that the mock-up was "not that bad," and did not oppose the construction of the pyramid, as he could have done. As I. M. Pei recalls, the critical moment with Jacques Chirac, who would later become president of France, was a meeting organized by Emile Biasini: "We hardly talked about the Pyramid at all, rather I got on well with Mr. Chirac because he was very interested in oriental art and we talked about that instead."[14] Pei believes that the support for the project of Madame Claude Pompidou, widow of the former French President George Pompidou and an important figure in French modern culture, was critical in obtaining Chirac's agreement. A certain degree of xenophobia was evident in the response to a "Chinese" architect being selected for the most prestigious site in France, but much of the polemic was obviously politically motivated. The left-right cleavages in the country were quite strong at the time, and Mitterrand was very much the symbol

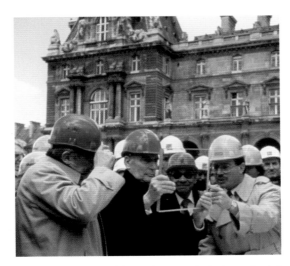

Pei with Mitterrand holding a glass sample during a site visit

of the rise of the left. More than sixty thousand persons viewed the simulation, and the project was given final approval shortly thereafter.

The involvement of I. M. Pei in the Grand Louvre project had at least two unusual features with respect to how major public projects are conducted in France. The first of these, already mentioned, was that the architect refused to participate in a competition—as he has throughout the latter part of his career. Pei's analysis was that a fair competition required that the client and the architect have little direct contact during

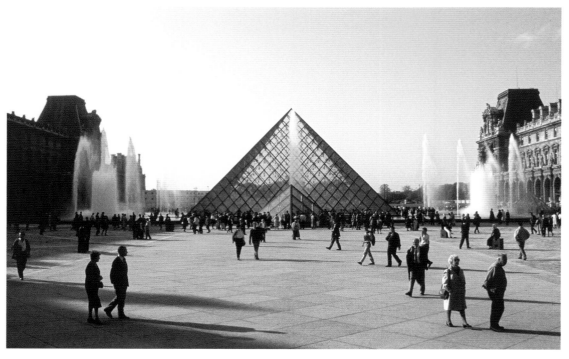

The completed Cour Napoléon with the pyramid and its fountains

the selection process, resulting in an inevitable separation of conceptual development from an early design scheme. Particularly in the context of such a visible project, institutional logic would tend to make substantial changes difficult despite the schematic nature of the original design. Under French law, the Grand Louvre project would normally have required a competition, but the power of the French president was centralized such that François Mitterrand was able to select Pei directly. Some saw an echo of the methods of the French kings in this process, but the Louvre had indeed been fashioned by the will of monarchs.

The second, ultimately more significant change that Pei succeeded in imposing on the design and construction process was that he officially held the *mandataire*, the final contractual obligations and responsibilities. In the usual French construction process, engineers tend to play a larger role in the construction documents and building process. Fee structures, which grant payment to architects early in the process, make it difficult for architects to follow up on inevitable changes that occur during construction — particularly in such a large project as the Grand Louvre. Thus, final responsibility for the project is usually in the hands of the client and the engineering firms. Had this been the case for the Louvre, the architects would have had little interaction with, for example, the museum curators. With the approval of the government, Pei's office took on the legal responsibility for carrying through the project to the end, in close collaboration with the EPGL and the museum curators. In the midst of the controversy surrounding Pei's pyramid scheme, Biasini organized a meeting with the architects and the heads of the seven departments of the Louvre in the resort town of Arcachon in January of 1984. With the seven senior curators, and most importantly with Michel Laclotte, then chief curator of the paintings department and later the first real Director of the Louvre, Pei and Biasini formed a consensus from which the rest of the project could proceed. On February 3, just a few days after the Arcachon meeting, the principal curators of the museum made their support for the project

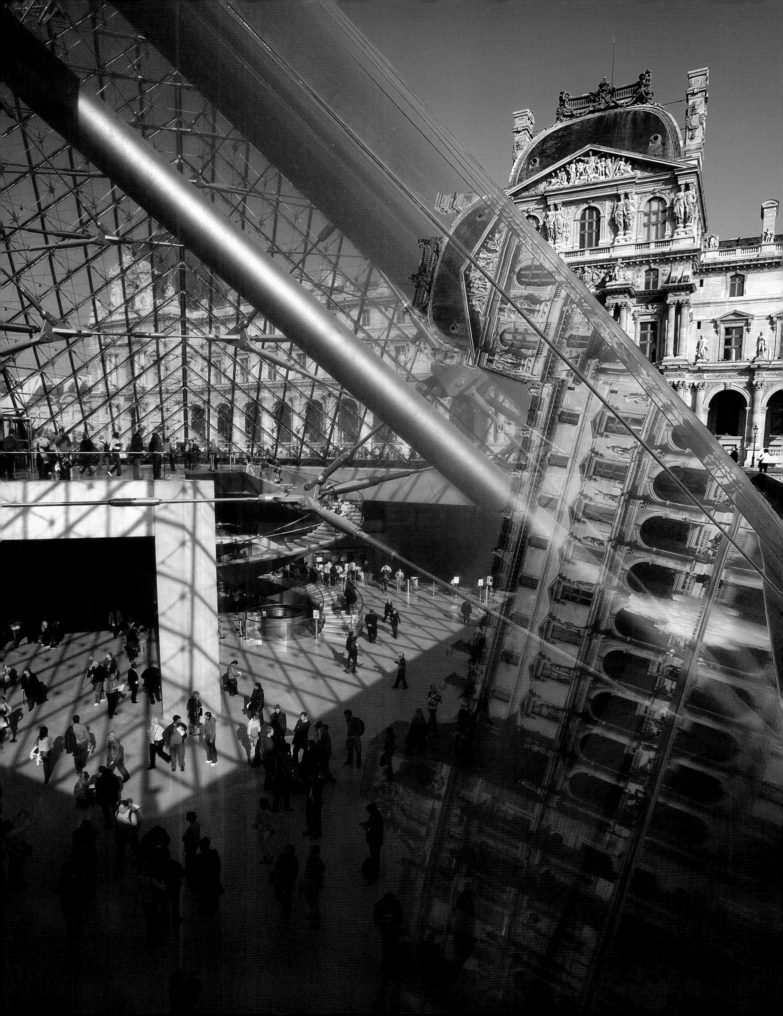

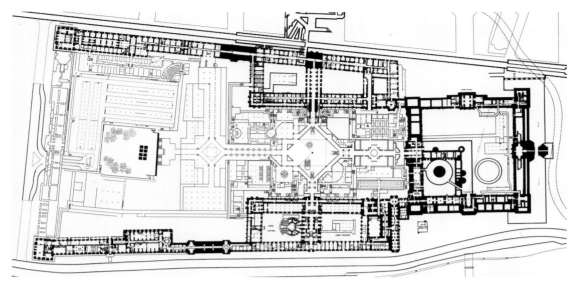

Plan showing the underground spaces in the Cour Napoléon and the Cour Carée (right)

public in a letter published in the daily newpaper *Le Monde*. Though there had been marked hesitation about the idea of greatly expanding the museum on the part of the staff, Laclotte's weight in the organization all but guaranteed that the Grand Louvre could go forward without internal opposition. Some retained their doubts, but the momentum of the project was such that it could no longer be stopped. I. M. Pei recalls that the meeting in Arcachon, organized by Emile Biasini, was in many senses the turning point in what has been called "the battle of the Pyramid." The agreement of the museum's seven curators was critical for the project to go forward. "One essential element was finding a solution to a problem posed by the curator in charge of the sculpture department of the museum, Jean-René Gaborit. He wanted to exhibit the famous *Chevaux de Marly*[15] in natural daylight, but within a covered space. I proposed to put a glass skylight over two internal courtyards of the Richelieu Wing used at the time by the ministry of finance as parking lots in order to give these spaces to the sculpture department. These became the Marly and Puget courtyards, and I believe that this idea is what convinced Mr. Gaborit to throw his support behind the Grand Louvre project in Arcachon."[16]

The significance of the Arcachon meeting was underlined by Jean Lebrat, president of the EPGL in 1997, "The division of the spaces inside the palace was decided in January 1984, at the beginning of the project, during the meeting at Arcachon in the presence of the seven curators, the program director Jérôme Dourdain, I. M. Pei and his associate Michel Macary, the directors of the Museums of France, and those responsible for the EPGL. The agreement of the curators, and, in particular, their public support for I. M. Pei's Pyramid, at the moment of the most intense debate in 1984, weighed heavily in the success of the enterprise, which had been threatened by some who supported an absolute conservatism. The Arcachon agreement, which was never questioned thereafter, contributed greatly to a project that had been firmly carried forward by I. M. Pei from the outset. This project was, of course, also the fruit of a political constancy over a period of fifteen years at the highest level."[17]

The consequences of the Arcachon meeting transformed the Louvre in ways as significant as Pei's glass pyramid, but not as apparent. As the architect explains to *Architectural Record*, "The biggest challenge of the Louvre was beyond mere architecture. When I first went there in 1983, it was divided into seven departments, and each

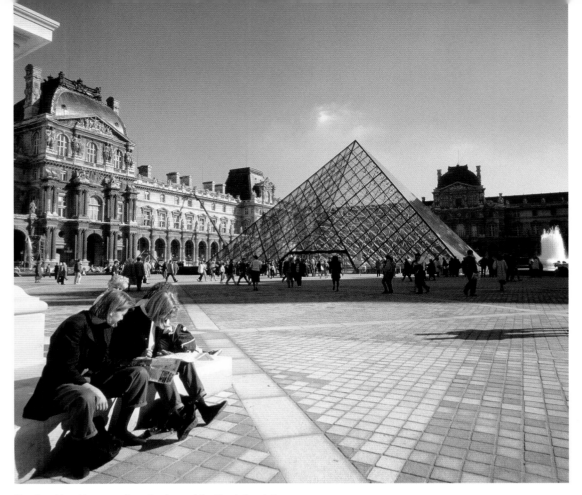

The Cour Napoléon seen from the base of the Bernini sculpture

was totally autonomous. They were very competitive for space and money. So, architecturally we had to change this situation — make seven departments into one and unify them as a single institution. I'm not so sure even Mitterrand realized how big a challenge this was; I certainly didn't. But the result worked out. Today the departments are all unified under one president, and they're also unified architecturally. The fact that people don't realize this huge challenge of the Louvre is totally mind-boggling to me."[18] The consequences of the Grand Louvre project clearly went far beyond the usual reach or audience of contemporary architecture. This is one reason that Pei places the project as the most important of his career. It involved not only his thoughts about form, but history, sociology, engineering, and the complex workings of France, a country where culture holds a position that is difficult to imagine in the United States. The "mind-boggling" lack

of understanding to which Pei refers reveals part of his frustration at the fact that the Louvre project was largely misunderstood, or rather underestimated, by U.S.–based critics. Though the French themselves are specialists at what they call *nombrilisme,* or the art of contemplating one's navel, architectural criticism in the United States has a distinct tendency to consider achievements outside of America as secondary. Though its only iconic form is a shimmering glass pyramid, the Grand Louvre is the most important architectural commission granted to an American architect in the latter part of the twentieth century, and that fact has yet to fully enter into American thinking.

For such significant projects as the East Building of the National Gallery of Art in Washington, D. C., Pei had been working in his own country, but to build in the center of Paris, and to bring the Louvre, with its thousand-year

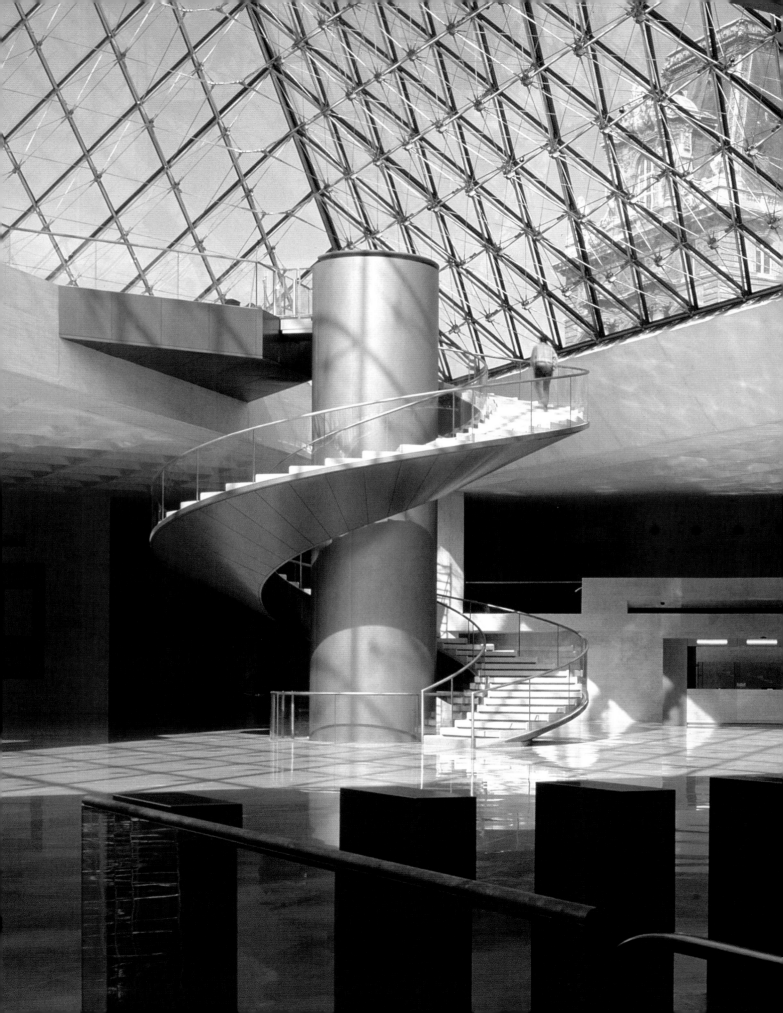

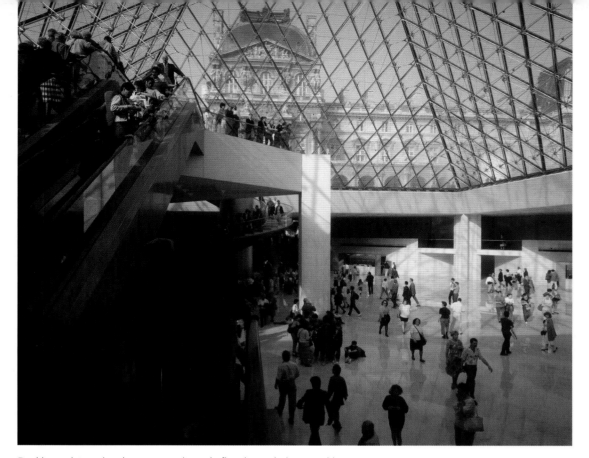

Double escalators also give access to the main floor beneath the pyramid

history, firmly into the twentieth century was an achievement that few architects could have brought to such successful fruition. Pei's tactful approach and, even more importantly, his sensitivity to history are factors that made him the correct choice for this extremely complex intervention. Mitterrand's willingness to engage his own popularity and reputation with a foreign architect, coupled with Biasini's tough forward-looking approach are the elements that allowed Pei's mastery to be expressed fully in this instance. As Pei felt, history in the Cour Napoléon of the Louvre could not be reenacted or imitated, rather it would have to be sublimated — expressed in more modern terms than a grand stone facade. Pei would not have been called on for the Louvre had his oeuvre to that point not been singularly impressive, and in the early 1980s an exceptional series of circumstances gelled in a way that gave him this historic opportunity. No French president before or since had such a concentrated interest in cultural projects on a large scale. Nor

The spiral staircase encloses a cylindrical, open elevator

Drawing of the machinery for the cylindrical elevator

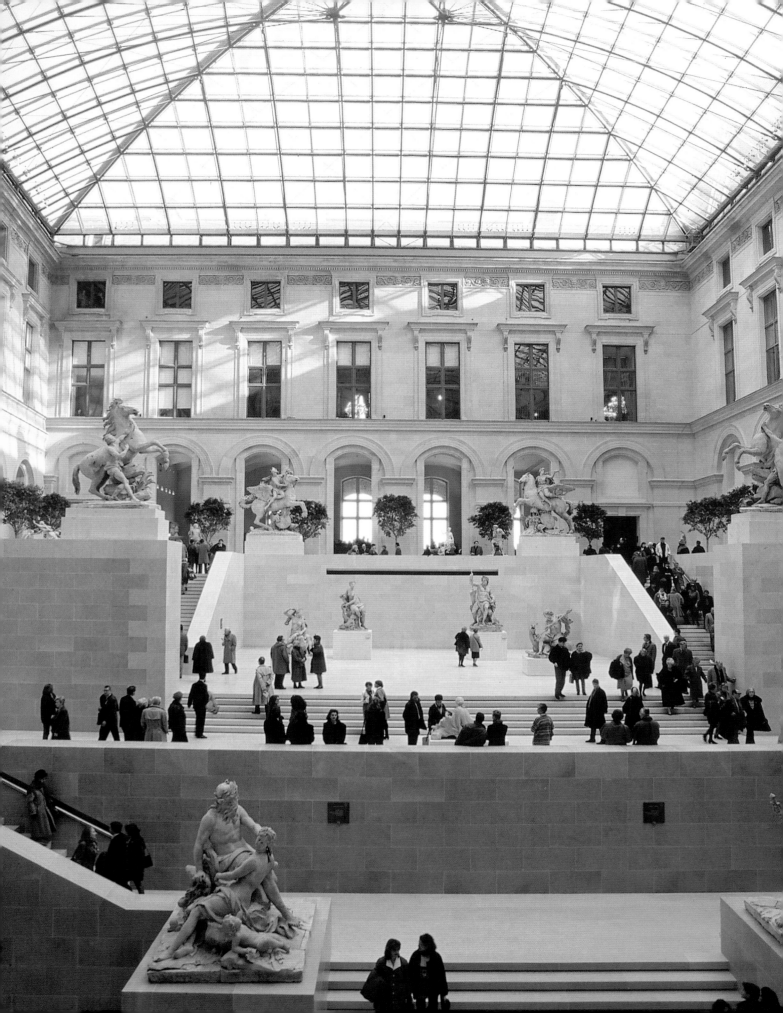

were the Grands Travaux simply the brainchild of Mitterrand's ebullient minister of culture Jack Lang, they were presidential projects, with all the power of the various French bureaucracies aligned behind them — once factors such as the internal resistance of the curators had been obviated. The budgets concerned were not those of the ministry of culture — Mitterrand had a separate budgetary line created for his Grands Travaux. Thus Pei had a measure of good luck in obtaining this commission and being able to carry it forward, but he was also clearly the right man in the right place. It may be that most American architecture critics, occasional visitors to Paris, did not grasp the significance of the Grand Louvre project because it appears from ground level to consist of only a glass pyramid. In fact, it required the complete reorganization of what is by many standards the greatest museum in the world and a daunting confrontation with centuries of history. Few works of late twentieth-century architecture brought together the same factors in such proportions, and none was more skillfully executed than the Grand Louvre.

That Pei was able to take on the considerable responsibility of following the Grand Louvre through to its conclusion is in good part due to his collaborators in Paris. One of the first of these was Michel Macary, who was later to help design the Stade de France (2007), a football stadium in Saint-Denis. Originally brought into the process by Biasini, Macary knew French methods better than Pei's team and had experience with government contracts. He played an important role not only in overall coordination on the two phases of the Grand Louvre but also by designing important areas such as the underground shopping area and the parking garage for buses and cars. Even here, I. M. Pei singled out certain aspects of the spaces that he followed personally. Thus, in the area near Macary's shopping arcade, he worked closely with the engineer Peter Rice on the "Inverted Pyramid" — a glass structure that brings daylight into the underground space. As Pei describes it, one of the most significant challenges of this particular part of the design was to find a way to allow the inside of the Inverted Pyramid to be cleaned. Its lower point, near the ground, touches a smaller stone pyramid that rises from the floor. This stone element keeps visitors, and children in particular from injuring themselves, and when it is withdrawn, allows the lower tip of the Inverted Pyramid to be removed giving access to cleaners. The Inverted Pyramid gained new notoriety with Ron Howard's 2006 movie *The Da Vinci Code*, which suggested that the glass structure marks the spot of the burial of Mary Magdalene.

In the Pei team, which included up to twenty-eight persons during the construction, three individuals stand out. Pei's son Didi (Chien Chung Pei) was a key member of the group from the outset, as was Pei's partner from New York, Leonard "Jake" Jacobson, who became the project manager. In the ongoing design work, which continued for various reasons well into the construction process, Yann Weymouth, who speaks fluent French, was in many ways Pei's closest collaborator in Paris. With Pei acting as *mandataire*, his team "created a model for following the con-

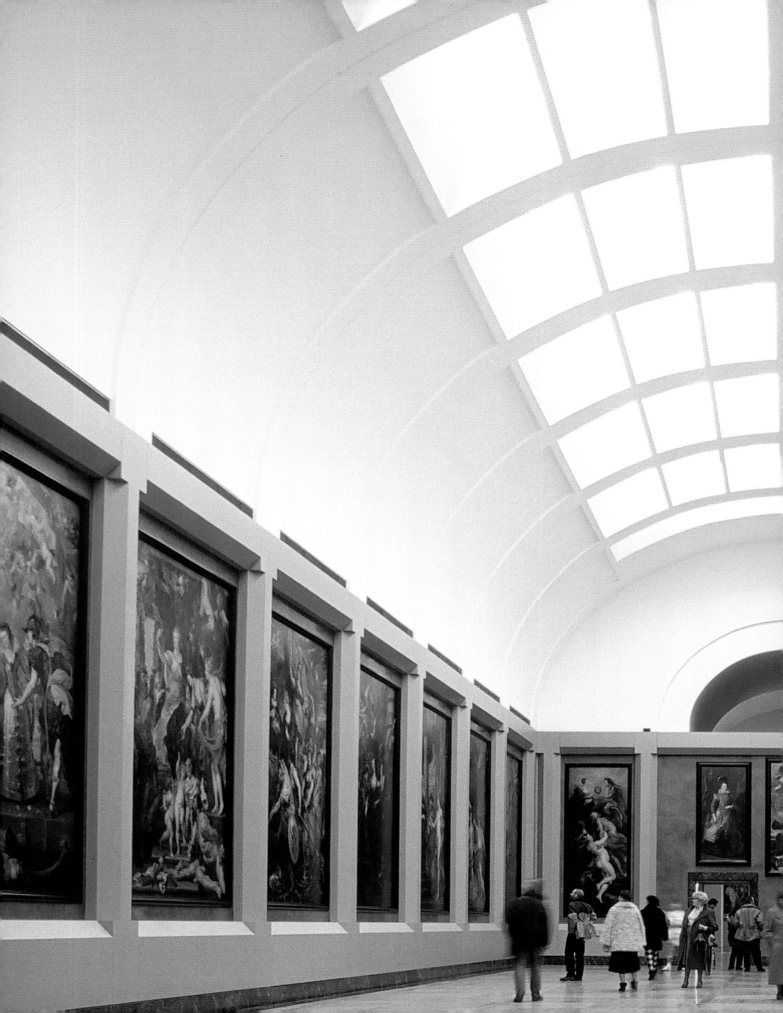

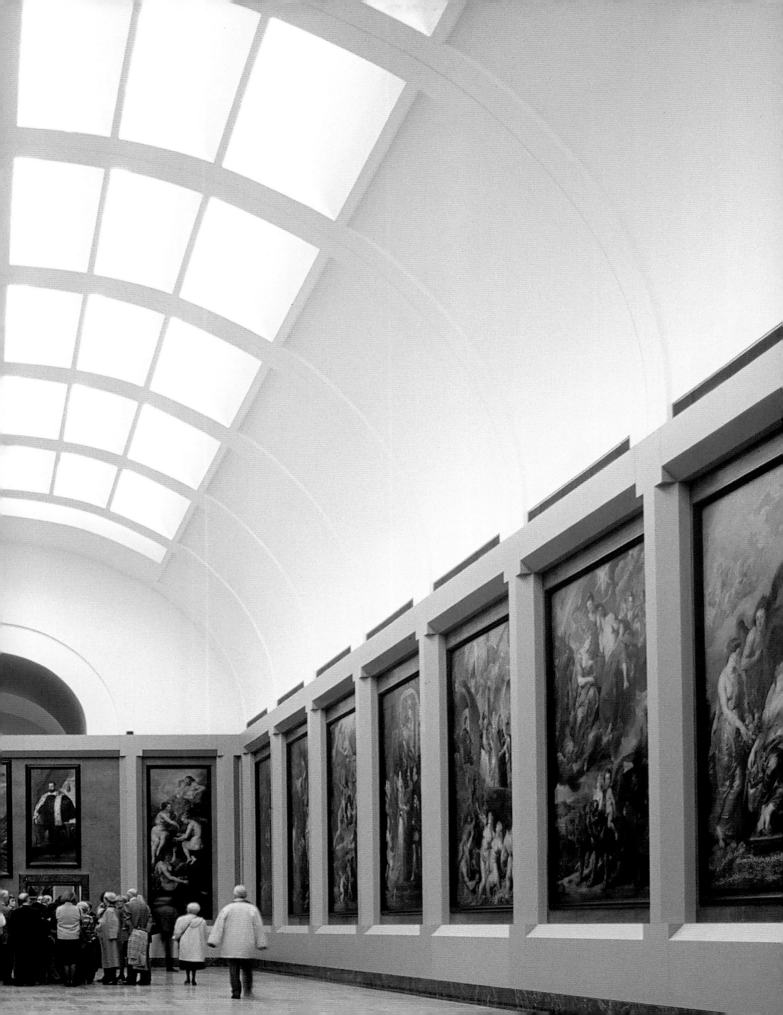

struction documentation process all the way through to the end. Therefore, they retained control over how the documents would be produced."[19] The importance of this fact for the quality of the completed project cannot be underestimated, nor can the professional competence of the Pei team, coupled with Macary, in a constant dialogue with Biasini. While France is often known for bitter infighting in its bureaucracies, the weight of the president of the country, relayed by Biasini, and the design and prestige of the architect brought any potential opposition into line, allowing the Grand Louvre to be created in a relatively brief span of time.

On the occasion of the opening of the Pyramid in March 1989, President François Mitterrand reflected on the significance of the project. "Here," he said in a television interview, "we are located precisely at the heart of the history of France, next to the tower of Philippe Auguste, where the king first signaled the unity of the country. We are also near the site of the former Tuileries Palace, which formed, from Catherine de Medici onward, the place where we are. It is exalting for the spirit, with all due modesty, to add something to this edifice. I do not pretend to decide in any sense what the aesthetics of France should be, but I have contributed to the Louvre."[20]

Early in the design process, I. M. Pei, who is not given to elaborate sketches, laid out the form of the Pyramid in a few lines. Several years later, the final result closely resembles this sketch. The architect made it clear from the outset that the Pyramid had to be as transparent and light as possible. Since almost all commercially available glass with traces of iron oxide had a green tint, Pei, with the full support of the contractor and client, devised a special manufacturing process using white sand from Fontainebleau with the French firm Saint-Gobain. Pei explains the behind-the-scenes reality of this process and the French president's direct involvement: "With a good client, you can do the right things. When you have a double pane of glass, it's green, but when you have four corners, four panes of glass, it would be dark bottle green. If you have that kind of glass, the whole Louvre would change because the building is honey colored. It simply would not be acceptable. I would be damned forever by the French. So I went to Mitterrand and I asked him, 'Do you have that white glass?' He said, 'What do you mean by white glass? Clear glass?' He said, 'Yes, so why don't we use it?' I said, 'Saint-Gobain won't make it.' Saint-Gobain's chairman simply said 'If you have one thousand pyramids, I'll make it for you, but one pyramid jamais [never].' That was the beginning. But Mitterrand just said, 'Do it' and that's it. So you have to have a good client."[21] The glass had to be polished in England to assure that it would be perfectly flat and not induce any appearance of distortions in the final structure. Holding the 675 diamond-shaped panes and 118 triangular ones in place in a stable pyramidal structure was an engineering challenge. Under the direction of Jake Jacobson, with design work partially by Weymouth, Pei's team called on Navtec, a Massachusetts firm better known for the rigging on America's Cup boats than architectural systems. Navtec manufactured the nodes and

A plan shows the location of the Richelieu Wing

Drawing of the ceiling system in the Richelieu Wing

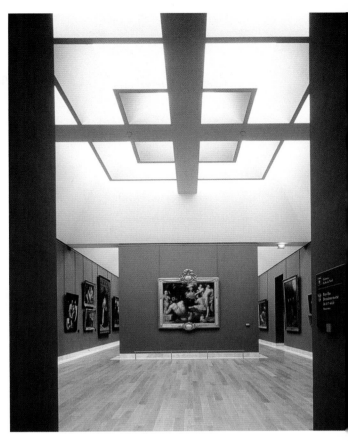

Photo of a Richelieu gallery showing the overhead lighting

struts for the system that includes 128 girders held in place by sixteen very thin cables.

While others, including Jean Nouvel, had proposed underground solutions for the new Louvre, Pei insisted that the pyramidal emergence in the Cour Napoléon was necessary to avoid making the underground spaces feel like a subway station. As it happens, the main hall beneath the Pyramid is not only flooded with light, it offers spectacular views of the historic facades of the Louvre. A dramatic spiral staircase encircling a round open elevator marks the descent from the courtyard level to the new main entrance. Using a blond French sandstone called Magny Doré, Pei fashioned a kind of vessel in the heart of the old palace, which he compared to the keel of a ship — an apt metaphor given Navtec's role in the "rigging" of the Pyramid and the museum's proximity to the Seine. Indeed as early as 1210, during the reign of Philippe Auguste, the

Mercator Aquae Parisius (Corporation of the Water Merchants of Paris) used a seal depicting a fully rigged sailing ship, which later inspired the coat of arms of the city still in use today. From the bright, high spaces in the center of the first phase of the Grand Louvre, visitors today can choose to go in any one of four or five basic directions — toward the "old" Louvre and the Denon entrance with the *Victory of Samothrace* (c. 200 BCE) and Da Vinci's *Mona Lisa* (1519); to the Sully entrance leading to the excavated remains of the medieval Louvre; to the Richelieu Wing completely rebuilt by Pei in the second phase of the project; or to the new shopping arcade to the west, designed in good part by Macary. Also beneath the Pyramid is a generous auditorium for the museum and temporary exhibition spaces, both of which the museum lacked before the project. Beyond, around, and below, reserves for the art, technical spaces,

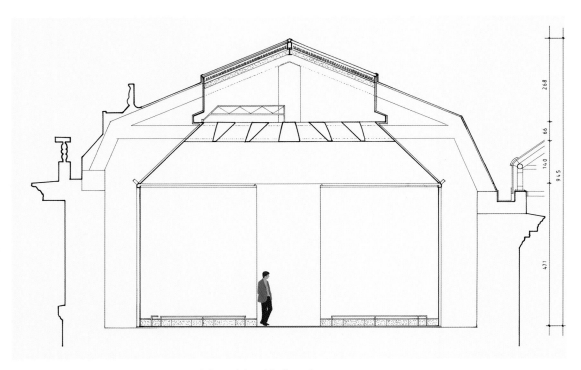

Drawing of gallery number 16 on the second floor of the Richelieu Wing

and an ample vehicle access tunnel ring the public spaces, finally giving the Louvre the "backstage" that Georges Salles had imagined in 1950. As Mitterrand wrote in 1989, "The epicenter of the redeployment of the Louvre is the Pyramid. A visible signal and pure fruit of necessity, it participates in the dialogue of forms and integrates light."[22] Pei says, "What makes the Pyramid important is not the form but the fact that it enables you to bring light to two levels below ground. It's a centralized entrance that enables you to go in the three surrounding wings of the Louvre, not one, because they're all interconnected."[23]

Though Pei had originally imagined planting trees in the Cour Napoléon, he bowed to the idea that a French square is minimal by nature. He did design black granite fountains around the pyramid, and in an unexpected gesture worked on the placement of a replica of a statue by Giancarlo Bernini (1598–1680) near his geometric entrance. Commissioned by Louis XIV in 1665, Bernini's Carrara marble equestrian portrait of the king did not meet with royal favor, and it was modified by François Girardon and

left at the far end of the gardens of Versailles. Pei had this sculpture cast in lead and placed it to the right of the Pyramid, on the same axis as the Champs-Elysées. With this gesture, the architect points out that the Pyramid could not have been precisely aligned on the famous avenue because the Cour Napoléon is itself slightly off axis. He also bows to the kings who made the Louvre, and to the great Bernini who never had a chance to build in this heart of France. Thus, a twisting rearing equestrian sculpture, Baroque in spirit, stands guard over Pei's transparent diamond.

The observer standing near the Pyramid will note that the reflections in the glass and water bring the very sky of Paris into the architecture. It had been assumed by many of Pei's early critics that his unbridled taste for the modern had lead him to commit an unpardonable "crime" by bringing a dull, geometric object into what was clearly a traditional setting, despite the broad swaths of time covered by its architecture. Rather, the Pyramid is evidence of a profound understanding of French tradition. Pei carefully

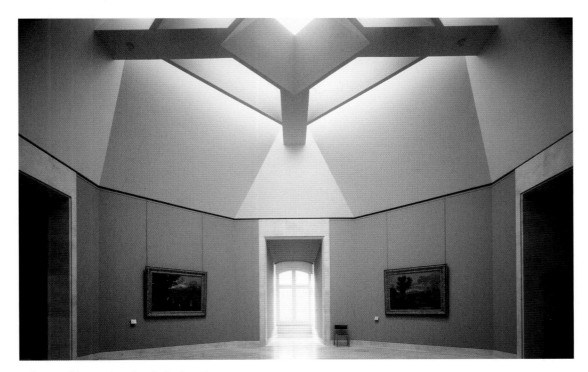

Gallery 16 with *Les Saisons* by Nicolas Poussin

studied the work of the great French garden designer André Le Nôtre, and noted his masterful use of light, air, and water, and geometric lines, such as the long axes laid out in Paris or at Versailles. It is no accident that the glass surface of the pyramid reflects the Parisian sky, even as it defines the entrance area below, which is flooded with generous light. There is no doubt that Pei is quite sincere in saying that he was far from thinking of the pyramids of Giza, a fact which did not keep some from labeling Mitterrand's taste for monuments and expenditure "pharaonic." Only through careful examination of the correct size and shape for this particular site did Pei decide that his glass pyramid would have proportions which turned out to be quite close to those of the Great Pyramid in Giza. Just as he composed triangles to generate the structure of the East Building in Washington, D. C., the geometric shapes that emerge from the Cour Napoléon can be traced more easily to the traditions of Modernism than to any historic reference, at least to any built form. Pei's willful discovery is of course that pure geometry and an understanding

of space and light linked his Pyramid to Le Nôtre more surely than to any funerary monument in the desert. On the other hand, the ancient Egyptians did refer to pyramids as *mer,* literally "the place of ascendance." If there is any link between this world and the next what better place to find it than in the heart of the Louvre, the greatest museum in the world?

The Louvre marked an important turning point in Pei's career. Even as the Pyramid project drew to a close in 1988, he engaged the process of leaving his firm Pei Cobb Freed and created the small office I. M. Pei Architect. Almost all of the projects he would undertake as of that time had to do with what might be called voyages of discovery. "I learned about something at the Louvre that I thought I would never learn," says Pei. During his study trips to Paris in the winter of 1982 to 1983, clearly he was seeking to solve the practical design problems posed by an ancient palace and a very large museum, but he was also looking for something less tangible. In explaining his design for the later Doha Museum of Islamic Art, I. M. Pei says clearly that he was looking for

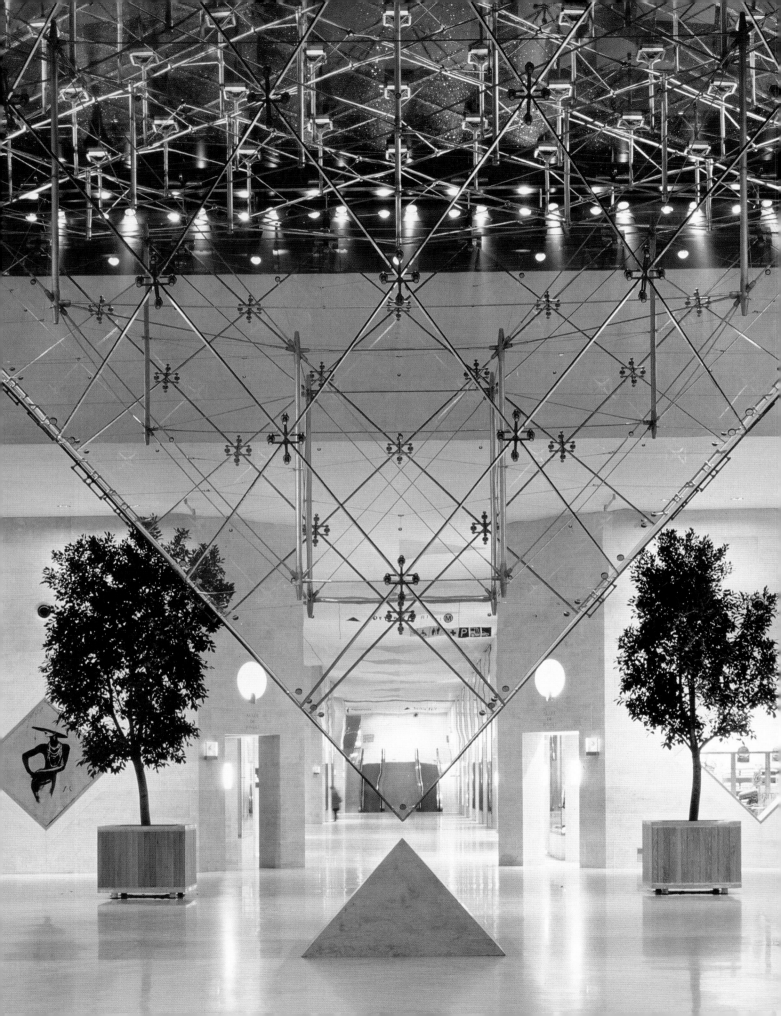

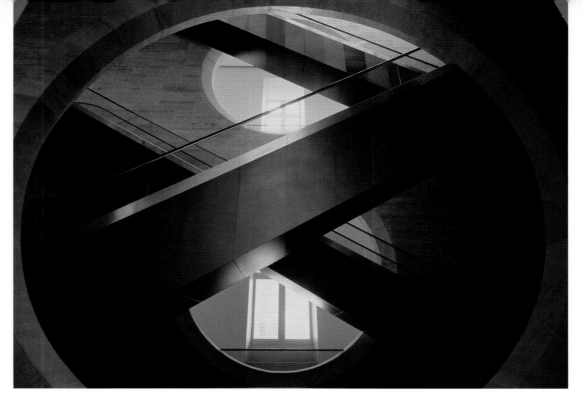

The escalators in the Richelieu Wing

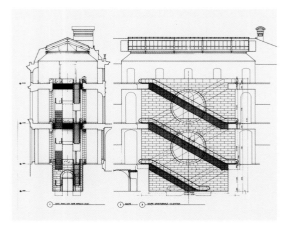

Section of escalators and stairs in the Richelieu Wing

the "essence" of Islamic architecture. In the heart of Paris, not far from gardens originally designed by Le Nôtre, Pei also found an essence, if not the essence of French culture. Le Nôtre's "modernity" or his sense of space and geometry escapes from the Baroque complexity of his time and expresses a universality that also transcends any notion of simple garden design. Pei's explanation of why he called on the ideas of Le Nôtre confirms that he is in a willful fashion forming a deep link between past and present and searching for the very soul of a culture in his work. In his 1989

preface to the *Grand Louvre,* he wrote, "For the French, the Louvre is not only a collection of masterpieces, it is at the heart of their history and often of their daily life. Catherine de Medici, Henri II, Henri IV, Louis XVI are familiar figures for them. They weren't for me. I had to learn to see the Louvre with the eyes of the French, and to take into account the past as well as the present. I understood that it was impossible to create a break in the architecture of the Louvre because it has such a strong identity that the eye would reject any addition to the building immediately. This is why I decided to work as a landscape designer rather than as an architect. Le Nôtre more than by anyone else inspired me. The very geometry of the grid that gives its rhythm to the Pyramid is French. The glass reflects the Louvre and the sky, playing with the light of Paris, a light that is so beautiful because it changes constantly. I like to imagine that it is a French spirit that gives life to the fountains, to the Pyramid, even if they were designed by an American."[24]

Beginning with this experience of France, a country he thought he knew, I. M. Pei embarked on a quest that would lead him to Japan, back to

President Mitterrand and Pei

Pei receives the Legion of Honor from Mitterrand

his native China, and to the shores of the Persian Gulf. Whereas the modernity of his youth, formed by Gropius and others, showed few signs of acknowledging the past, his work would not seek to imitate what came before so much as it would attempt to find its "essence" — a form of history so rarified that its ultimate expression is the universal — a modernity that embodies what has come before without sacrificing its own clear identity. Although earlier Pei projects, such as the East Building of the National Gallery, took into account their site and its history with an uncommon sensitivity, it is with the Louvre that Pei adopted what would become his *modus operandi* in the later years of his career. After a careful study of the history of the palace, and thus of the very history of France, Pei found a solution that was at once modern and in harmony with the past. Pei's cogent analysis of the strengths of Le Nôtre, as considered from a twentieth-century perspective, allowed him not only to reference French culture, but to identify its essence even more accurately than many French thinkers.

The second phase of the Grand Louvre project, incorporating the Richelieu Wing, was more subdued architecturally than the first. For reasons of historic preservation, it was decided to retain the exterior walls of the nineteenth-century building, although its insides were quite literally demolished. Working with Georges Duval and later Guy Nicot, Pei's team retained

the original rhythm of the interior spaces of the former Ministry of Finance. The result is a modern sequence of exhibition galleries that does not fundamentally challenge the palatial order evident elsewhere in the museum. The most astonishing parts of the project surely concern the covered courtyards, called the Cour Marly and Cour Puget, where sculpture is exhibited under a soaring glass canopy. No less important, a covered passageway called the Passage Richelieu runs between these courtyards and is open to the public, linking the Pyramid with the rue de Rivoli and the outer courtyard of the Palais Royal beyond. This passageway, which houses an entrance for groups to the museum, is a significant element in Pei's concept of the new Louvre. In many senses, the kilometer-long (3,280 ft) palace had cut one part of Paris from the other. With openings such as the Passage Richelieu or the paths through the Cour Carrée, leading to the Seine and the Pont des Arts, the Louvre was made more permeable to pedestrian traffic. When the mayor of Paris, Jacques Chirac, gave his approval to the overall project, he singled out the "urban" aspect of the design, and in particular the idea of opening the Passage Richelieu to the public.[25] Indeed, had the architect had his way, numerous entrances to the museum would have dotted its exterior, reducing the pressure created by crowds attracted to the Pyramid. For reasons of security and budget, the museum

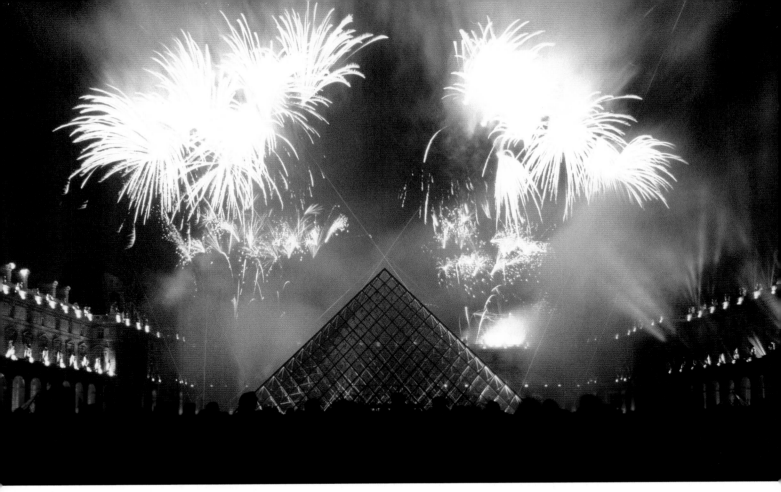

Fireworks in the Cour Napoléon for the opening of the pyramid

decided not to follow Pei's recommendations on this point, though the lines near the Pyramid have since been recognized as a significant problem.

Another feature of the Richelieu Wing that draws the attention of visitors is a monumental escalator featuring a great round opening, which gives the internal configuration of this part of the museum a transparency it would otherwise have lacked. "For me a circle is the most perfect geometric form," says Pei. "I have a memory of this form because my family came from Suzhou in China, and the Moon Gate is frequently used there. I also used it in the Miho Museum."[26] Though he does not render any reference to China explicit in the case of the Louvre, it is clear that deep cultural roots influence his design, especially as their forms and geometries confirm and amplify his modernist penchants. What is clear in the Richelieu Wing, perhaps even more than in the rest of the Grand Louvre project, is the

way the architect has made history his own — in how the rhythm of the great mass of this part of the Louvre, with its chimneys and pavilions, has been maintained despite a thorough renovation that made a rabbit warren of offices into a truly modern museum. In many ways, the completed Richelieu Wing does not speak openly in the architectural style of Pei, except insofar as the round escalator opening is concerned. There is a clear continuity between his underground spaces and the transition to the Richelieu Wing that underlines the significance of the project as a whole in the architect's mind. His priority was not so much the architectural gesture marked by the Pyramid, as it was the creation of a new and real unity for the Louvre. The Pyramid and its associated spaces provide, in a sense, enough contemporary architecture in this place. The rest of the Grand Louvre gave coherence to a complex, multilayered palace, and made it into

Window washer on the pyramid

Node and struts of the pyramid

a modern museum. More than most other works by I. M. Pei, the Richelieu Wing is about ideas more than forms — about giving wholeness to the Louvre that it never really had because of the nineteenth-century additions, which never played a royal function.

In a sometimes humorous speech given for the inauguration of the Richelieu Wing in 1993, François Mitterrand said, "With Pei, we didn't make a mistake, but then again there wasn't any competition . . . maybe that's why. He came, at first alone, and then with a small team, his son and Leonard Jacobson, who has since passed away. We discussed this decision again and again, but I knew from what I had been told, and what I had seen of his work in the United States or in China that it was worthwhile trying. You can see the result of this decision. I don't have to add another word."[27] Mitterrand had a deep sense of the culture of his country, particularly in its literary forms. In ending his speech, he said, "Daily effort is the joy of life, and I don't think it requires any other form of recompense. I would like to cite the words of the writer Marguerite Yourcenar[28] who loved the Louvre and wrote, 'There was the Louvre, the beginning of the great dream of history, the world of all the living of

the past.' And she added, 'When you love life, you love the past, because it represents the present as it has survived in human memory,'" concluded the French President, "because the past also draws the lines of the future."[29] In describing the Louvre project, Pei invariably makes reference to the persons who made the project possible, foremost amongst them the president of France. He recalls, "Because of my involvement with the Louvre, President Mitterrand named me Officier in the Légion d'honneur in 1993. He made it very special by inviting my whole family to the Elysée to witness the ceremony."[30]

Though Pei and Mitterrand may not have shared knowledge of the Chinese classics, as was the case with his Japanese client Mihoko Koyama for the Miho Museum, they did share a sense of history. "After a conversation with I. M. Pei," said Mitterrand speaking in a television interview in the museum, "I realized that he loved not only the Louvre, but also the history of France, and that he would never commit the fault, or I might even say the crime, of damaging the unity of what surrounds us."[31] Though very much a man of the present, a man of action, Mitterrand recognized in Pei a similar attachment to the past and to culture. The past that interested both the

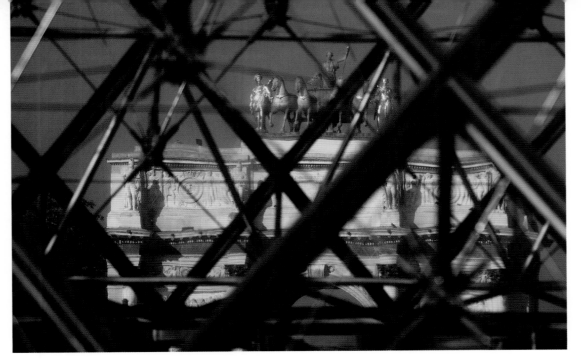

The Arc de Triomphe du Carrousel (1809) seen through the pyramid

president and the architect was precisely that which "draws the lines of the future."

One proof of the success of the Louvre is certainly the number of visitors crowding into the Pyramid. In 2006, 8.3 million people visited the museum, up from 7.5 million the previous year. As Pei explains, the planning during the Grand Louvre project was based on four million visitors per year, while current projections call for nine million in 2010 if not before. "Was it an error not to have planned for such success?" asks Pei. "Perhaps," he responds, "but certain other factors such as the rise in security needs after 11 September 2001 could not have been imagined. The security installations now required by the museum constrain space and the movement of visitors."[32] In 2006, the director of the Louvre, Henri Loyrette, asked I. M. Pei to develop possible solutions to the very real traffic problems arising most notably in front of and beneath the Pyramid. (Pei says that Loyrette explained that the Pyramid had become, "the fourth most important object in the collections of the museum — after Da Vinci's *Mona Lisa*, the *Victory of Samothrace,* and the *Venus of Milo*."[33]) "The Louvre has a particularly rigid architecture," says the architect. "It is necessary to resolve complex functional problems while preserving the quality of the space, most notably the appearance of the Cour Napoléon."[34]

Although Pei has stated his intention to undertake no further large-scale projects, and Henri Loyrette has made it clear that he does not have the budget required to modify the Pyramid or its associated spaces in the near future, the architect has carefully studied the difficulties that have made the entrance to the museum over-crowded. "If you make major changes below the Pyramid, how do you do it so that it can receive eight million people and still have construction going on at the same time?" he asks. "Sixty-six percent of the attendance comes down the escalator and the stair. At the moment we are catching them in the wrong place, under the Pyramid. The key is to catch them elsewhere. Is it bad to get rid of the restaurant, because they say it is not a problem? I suggested that they should not have a restaurant. A good café could be enough."[35] Pei admits that the decision he made jointly with the directors of the Louvre to place ticketing facilities directly under the Pyramid may not have been a good decision because it contributes greatly to congestion in that space: "It was meant to be open space, for the public to look up and

The Grand Louvre team with I. M. Pei, Emile Biasini, Jean Lebrat, and Michel Laclotte in the front row

see the sky and the facades of the Louvre, not a place to stand on line."[36] By reducing the presence of the Louvre bookshop on one side of the entrance area, and the restaurant on the other, Pei feels that the crowds could be alleviated. Further, he suggests that tour groups enter the museum from the bus parking garage already holding tickets, which would substantially ease the pressure on the ticket windows below the Pyramid. Twenty-five years after commencing his own journey of discovery in the Louvre, I. M. Pei remains passionately interested in its future. An article published by the daily newspaper *Le Monde* in 2006 was titled, "Les propositions de Pei pour modifier 'son' Louvre" (Pei's Proposals for Modifying "His" Louvre).[37] Early in 2008 Henri Loyrette announced that a total of twenty-three *points d'acceuil* (help desks) would be created in the museum, as opposed to the single source of information located up to the present under the Pyramid. "Ieoh Ming Pei will not be responsible for the specific work to be done," Loyrette told *Le Figaro*, "but this redistribution of the spaces beneath his building is being carried out with his full agreement."[38] Whereas a storm of protest greeted the first announcement of the Pyramid, nearly twenty years after its creation the director of the Louvre feels he can only work on the space with the benediction of the architect.

Emile Biasini writes, "I imagine that if today it was decided to destroy the Pyramid, that public indignation would be far more intense than it was in 1984."[39] Not only has Pei's design been accepted by the French, but it has become one of the most famous French monuments.

The work to be carried out at the Louvre will be financed in good part by sums paid by the Emirate of Abu Dhabi (UAE) for the establishment of a new Louvre near other cultural facilities on Sadiyaat Island, opposite the city of Abu Dhabi. The French architect Jean Nouvel was selected for this project and proposed a great spherical section to cover galleries and public spaces. Pei's recent comment on these projects reveals the difference he senses between his own approach and that of architects, like Nouvel or Zaha Hadid, who are working in Abu Dhabi on new museums: "I was brought up in a certain way architecturally speaking—it was not Chinese, it was American. That is what makes it interesting for me to be exposed to different cultures. I selected places to work where I did not know the cultures. Even in Suzhou I did not know how conservative that place was. The West may look at Suzhou and say I have not done anything very different, but the East may think I have gone too far. Suzhou has too much tradition, Abu Dhabi doesn't have any. How can [Tadao] Ando and

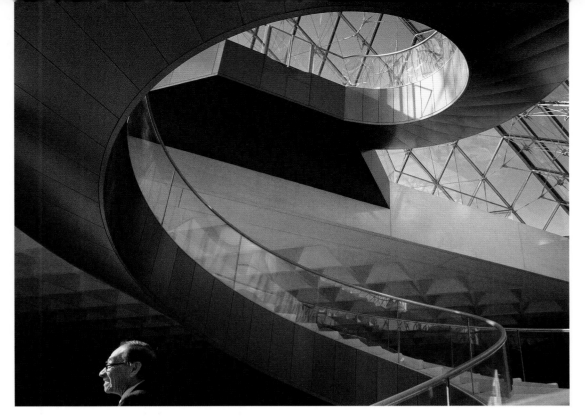

I. M. Pei beneath the spiral stair of the Pyramid

Nouvel do something there? They are trying to do something new. 'The Shock of the New,' as Robert Hughes wrote[40]. I don't go along with that, because I am not competent to do it that way."[41]

Pei has made it clear that the reasons for the placement of a pyramid in the Cour Napoléon were not truly related to form. They had to do with light, space, and his own reading of the essence of French culture, linked to the spatial purity of André Le Nôtre for example. When he moved on to the Richelieu Wing, form was even less of a concern, while function and a connection to history became recognizable leitmotifs. Surely the Louvre represented a catharsis in his career that gave its full measure in his retirement projects. "I am old and I have done a lot," said Pei in 2006, "and I was not in need of doing things. Paul Goldberger[42] wrote my 'epitaph' in 1989 when I opened five projects in one year, but that was the beginning of something else rather than just an end. The Louvre persuaded me to look else-where—opportunities came that would not have come otherwise."[43] Though Pei has clearly explained such sources of inspiration as the work

of André Le Nôtre, it would seem that critics have a hard time reconciling his avowed links to Modernism with his fascinating quest for the essence of the past. The rich history of the Louvre, and the strong symbolism with which it is invested were the ideal ground for Pei's fundamental shift toward the post-retirement projects. From the foundations of the Grosse Tour to the abstracted reflections of the Paris sky in the Pyramid, there is a link that runs as deep as the culture of France. Light and space are conjugated in the Cour Napoléon around an institution that serves in many ways as the great museum, the "world of all the living of the past" as Marguerite Yourcenar put it. Where the far-flung wings of the former palace spoke more of division and distance before his work, the Grand Louvre— Pei's Louvre—is held together by a keel fashioned from steel, concrete, Magny Doré stone, and glass. Eight million souls crossed through the glass doors in 2006 to commune in varying degrees with the past, with the art and culture not only of France but of the world's civilizations. No other architectural project in living memory

has brought so many forces and influences into a coherent whole. The sturdy walls of the Louvre, and even its rich soil, were part of the project from the first, but making a modern museum in this place required the combined efforts of a country's leader, a dedicated team, and an architect with a vision. "You have to go modern, too, you can't just go back to history," says Pei. "This is history, but what happened since then. What is the best you can find?"[44] Though he did not travel alone, I. M. Pei's quest in Paris began in a sense when he dared to ask for four months to study the Louvre and the history of France. As always, Pei expresses himself with a modesty and reserve that honor him. Might it be this modesty that permits some to underestimate his achievement in Paris and elsewhere? "Ever since 1990," says I. M. Pei, "I haven't been all that interested in form, not at all. To create a work of architecture that looks exciting and different is not the challenge for me anymore. The challenge is for me to learn something about what I'm doing. I've been more interested recently in learning about civilization. I know something about the civilization of China, with my background, obviously, and I think I know something about American history. But that's about all. And I've traveled all over the world, and for a long time I didn't know very much about it, really."[45]

As for the Louvre, it might be appropriate to end with the words to I. M. Pei's client, the president of France, François Mitterrand: "For the Louvre to live, it was necessary to adapt it to our time. This has now been done. The museum today embraces the palace without any further restriction. The collections are better presented, the necessary services better installed, and visitors better taken care of. This is due to the talent of I. M. Pei and his team, and to the untiring work of all those who were mobilized to carry out this important project. The epicenter of the project remains the Pyramid. It is the visible signal and pure consequence of necessity; it participates in a dialogue of forms that integrates light."[46] Just as Pei identified the essence of French culture as the lines and reflections of Le Nôtre, Mitterrand correctly identified the achievement of the architect — to bring light into a palace that lacked it, and to bring order where centuries of additions had brought the museum to the point of asphyxiation, as the president defined it. One substantial reason architectural critics have underestimated I. M. Pei's achievement in the Louvre might be that it is about architecture in the broadest sense of the term, incorporating the daily functions of a building more than simply an aesthetic gesture. It is about history, too, and modern critics may find this disconcerting. In the Louvre, Pei showed that there need not be a chasm between past and present and that contemporary architecture can integrate itself into a historic setting and improve it. The study of historic monuments is generally separated from contemporary architecture for reasons that have more to do with doctrine than with any disciplinary or practical divide. In the hands of Pei, the Pyramid and the project it represents can be imagined as the healing of old wounds, the reconciliation of centuries past and the moment in which we live.

The pyramid seen from the Passage Richelieu

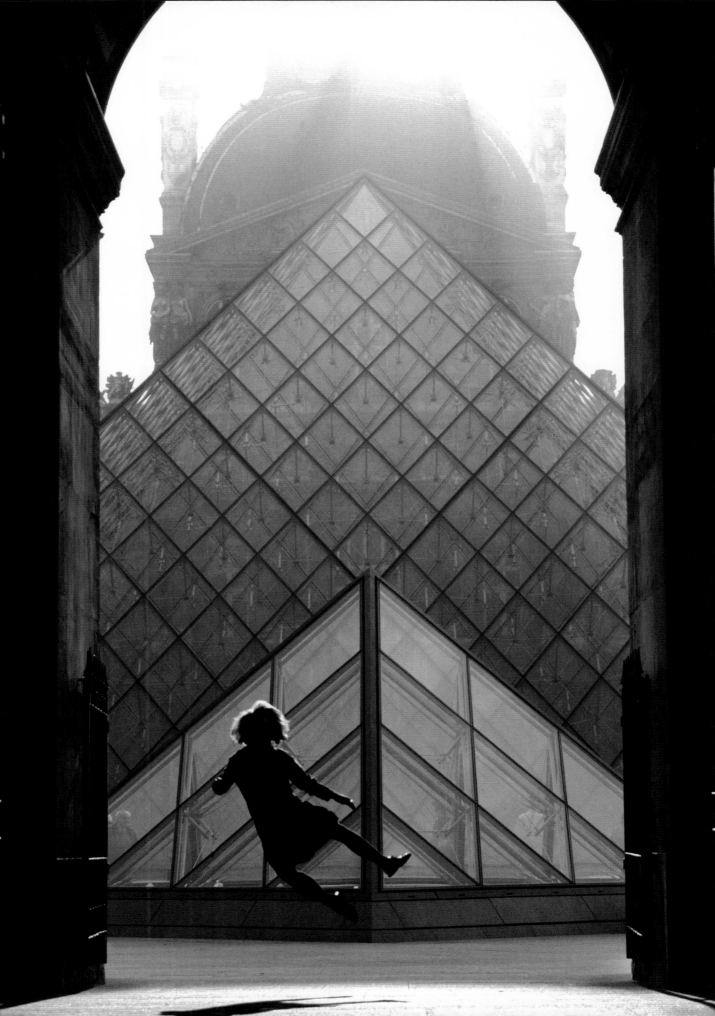

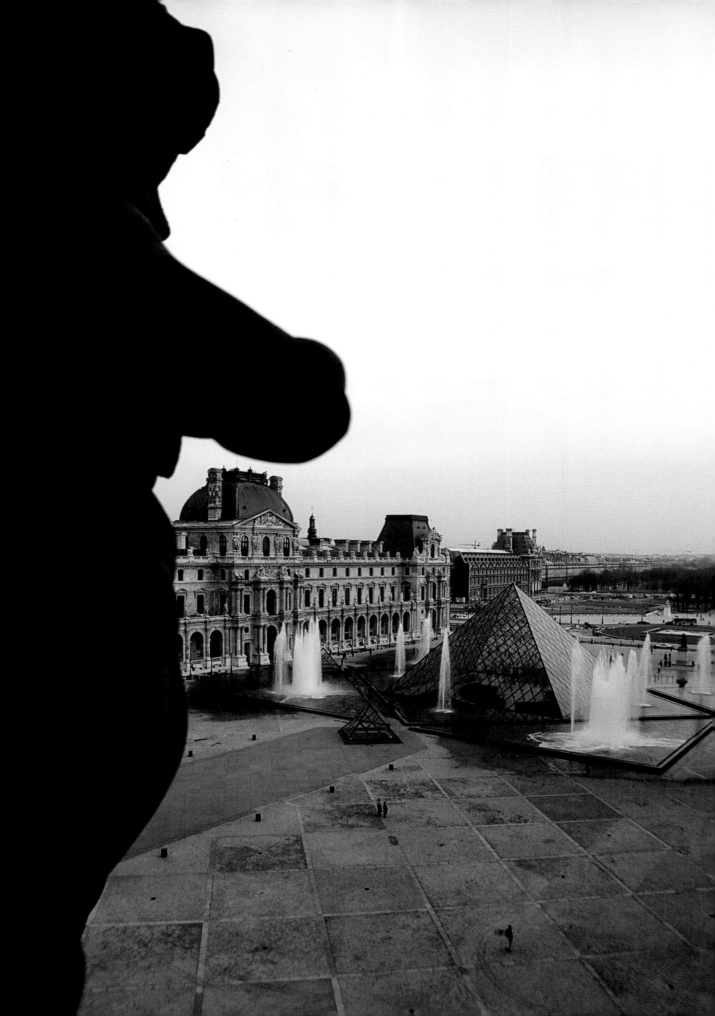

PEI AND THE LOUVRE: "OF COURSE IF YOU REDO THE LOUVRE . . ."

Emile J. Biasini, former French Minister for the Grands Travaux

In March 1982, François Mitterrand gave me the responsibility of creating what was already called the "Grand Louvre," and my first thought was to find the architect with whom such an adventure could be engaged. With an area of 16 hectares (40 acres) in the heart of Paris, the Louvre Palace has been an exceptional monument in the history of France since the thirteenth century. Every French leader has participated in its development.

In reality only one architect's name ever came to me — that of I. M. Pei. I did not know him personally, but I had admired his work in Boston, from the Kennedy Library to his discrete extension of the Museum of Fine Arts. I of course also knew the East Building of the National Gallery in Washington. Then too, Pei's colleague Marcel Breuer, who had worked on a tourism project with me in the Aquitaine region of France, spoke to me frequently about him. In my mind, I had had the idea of one day working with I. M. Pei long before the Grand Louvre came along. One of my tasks in preparing the work in Paris was to visit a total of fifteen major European museums. I asked each museum director if they might have a preference for an architect should they engage in an expansion plan. Fourteen out of fifteen evoked the name of I. M. Pei. My personal referendum was thus conclusive, but before going further, I had to assure myself that he would accept such a commission. It was our mutual friend, the painter Zao Wu Ki, who organized my first meeting with I. M. and Eileen Pei at the Raphael Hotel in Paris in October of 1982. It was clear that behind his courteous smile, I. M. Pei was somewhat surprised by the nature of my question. "Redo the Louvre ? Of course, if you redo the Louvre…" The project seemed enormous, but

that first meeting led me to understand that I. M. would be interested if he were officially asked to participate. My next step was to see if the president of France might agree to this choice.

Though I did not realize it at the time, François Mitterrand, too, had a secret ambition to call on I. M. Pei for one or another of his cultural projects, baptized the Grands Travaux. I thus went to New York and proposed a four-month contract to Pei for a study of the project. That work completed, François Mitterrand formally designated I. M. Pei as the architect of the Grand Louvre on July 28, 1983.

My collaboration with I. M. Pei was from that moment forth close and complete, becoming a veritable friendship. In the ten years we worked together, this trust and friendship was never questioned, a fact of which I am particularly proud, especially given the complexity of the project. A wonderful partner in this process, I. M. Pei brought his constant intelligence to our work. Beyond his exceptional talents as an architect, I discovered, bit by bit, the remarkable qualities of a man who was able to draw forth the best of two civilizations while always respecting individuals.

Today the Louvre has become a modern museum, fully open to the public and admirably housed within its historic walls. A legitimate source of national pride, its only real problem today is facing the influx of visitors — who were about 3 million in 1982, 6 million in 1994, and 8.11 million in 2007. Projected numbers exceed 10 million within the next few years. Though it was possible with I. M. Pei to go from the Louvre to the Grand Louvre, the museum can no longer be enlarged. Its goal remains to open the doors of culture to all.

— *Paris, April 25, 2008*

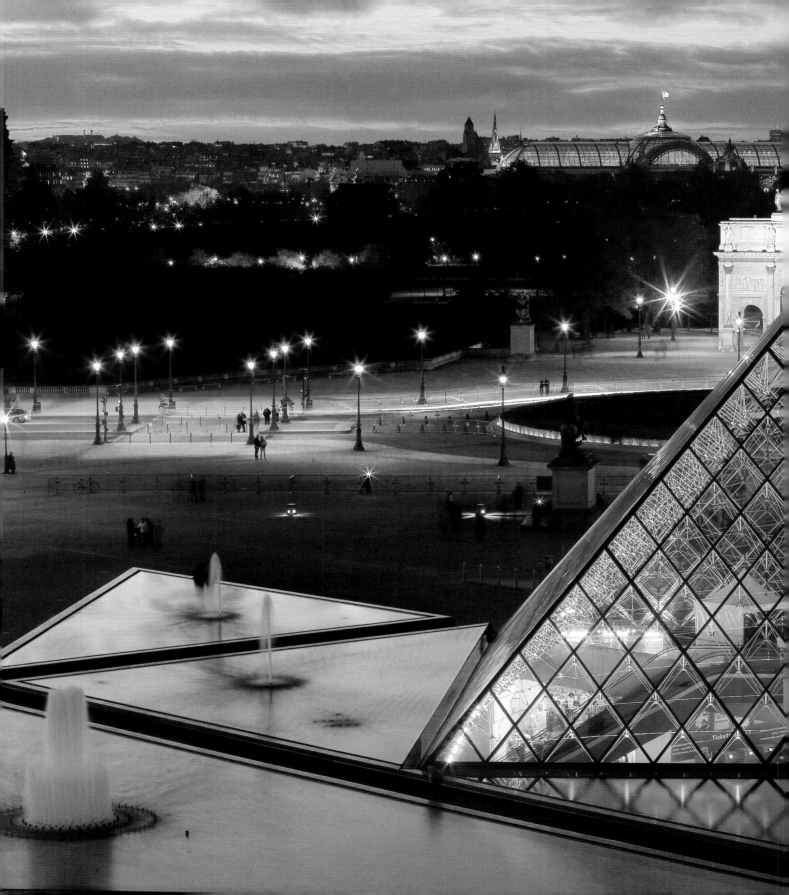

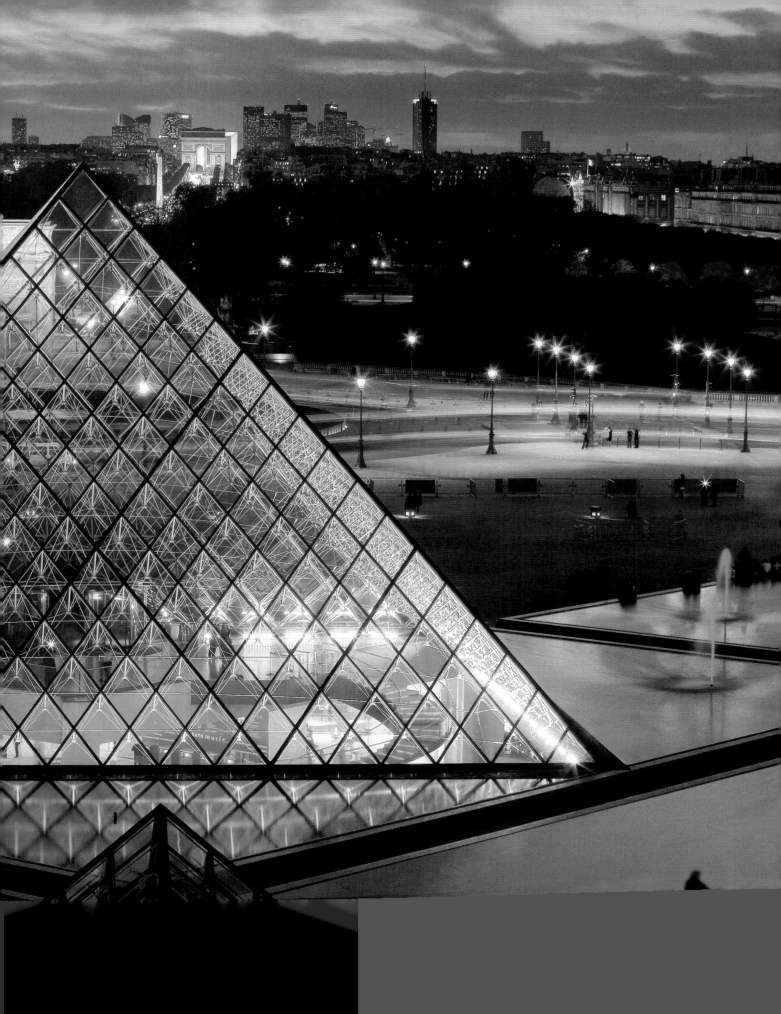

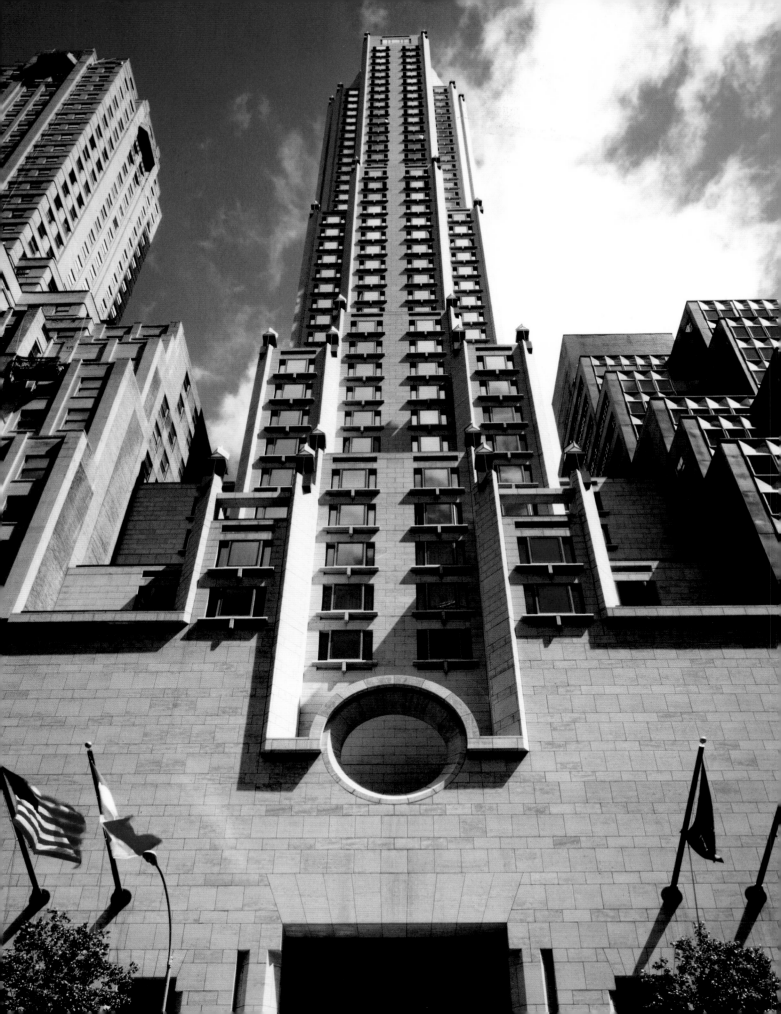

FOUR SEASONS HOTEL

New York, New York
1989–93

Although it may not be the project he speaks about the most readily, the Four Seasons Hotel in New York corresponds in many ways to the criteria that appear again and again in the "retirement" projects of I. M. Pei. Indeed, this building, for which design work started one year before the inauguration of the Louvre Pyramid, is listed as the work of Pei Cobb Freed & Partners with I. M. Pei as partner in charge of design. Set in the heart of Manhattan on 57th Street between Madison and Park Avenues, the structure stands out, an unusual beacon in the midtown skyline — a symbol of "Gotham" with its cruciform top and carefully designed 12-foot-high (3.6 m) lanterns marking each setback required by local zoning codes. Designed to highlight the sculptural facade, these lanterns give the building a unique presence at night. Because the lot was an assemblage of three parcels in two different zoning districts, determining the optimum massing for the tower was a significant element in the success of the project. Much as the East Building of the National Gallery of Art is as close to the heart of American power as possible, or the Louvre at the center of the history and culture of France, so too, the Four Seasons stands almost at the geographic middle of Manhattan, the city where Pei spent most of his career working. Although he has worked on other structures in the city, this gesture, late in his career, assures that his presence in the most cosmopolitan metropolis in the United States will long be felt.

The tallest hotel in New York, the tower stands 682 feet high (208 m) and includes fifty-one stories above grade and four stories below ground. The

The Four Seasons Hotel as seen from Fifty-seventh Street

site area is 26,585 square feet (2,467 sq m) and the gross floor area measures a total 532,227 square feet total (49,391 sq m) with 372 guest rooms in the hotel. At an average size of 600 square feet (56 sq m), these rooms are fifty percent larger than comparable hotel accommodations in New York. Typical floors in the lower part of the building (floors 19–29) measure a relatively modest 8,065 square feet (748 sq m) while the upper levels (32–49) are even smaller at 5,941 square feet (551 sq m). These facts are a function of the site and zoning requirements rather than a deliberate decision of the architects. A 4,444-square-foot (412 sq m) Presidential Suite is located on the fifty-second story of the building. The top three floors of the tower have an unusually tall 14-feet-2-inch (4.3 m) floor-to-floor height. The Pei Partnership description of the project explains, "The client requested a new hotel that would 'epitomize the highest standards of luxury.' In a city whose consenting spirit, international business, and cultural climate had already give rise to more than a dozen four- and five-star hotels, the objective was to 'stand apart from the competition' by offering the best possible combination of location quality and service. The mandate to the architect was to realize these goals in appropriately grand form, creating an image that would be at once dignified and luxurious, durable and festive. The solution required a building of classic elegance to transcend both time and fashion."[1]

When situating the origin of the job, Pei focuses on the individuals involved: "I decided to work on the Four Seasons Hotel because of my friendship with Bill Zeckendorf Jr. and for Bob

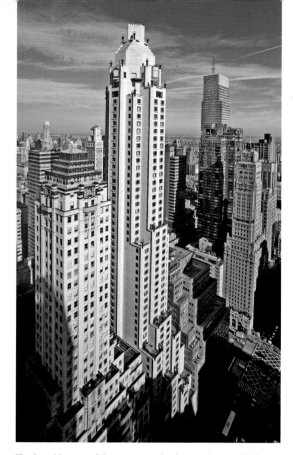

The hotel has a striking presence in the Manhattan skyline

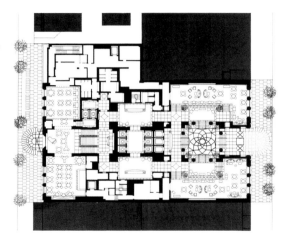

Plan of main lobby, with the 57th St. entrance on the right

Burns, the chairman and founder of Regent Hotels. The actual client . . . was the Japanese Industrial Credit Bank. A California firm, Chhada Siembieda & Partners, worked on the mezzanines in the lobby, but I have recently advised Joël Robuchon and the building's owner, Ty Warner, for changes concerning a restaurant on the ground floor and an apartment at the top of the building."[2] Atelier de Joël Robuchon, to the rear of the Grand Foyer, is now considered one of New York's finest restaurants. Warner's apartment, at the top of the tower required modifications in the upper facade. William Zeckendorf Jr. — like his father, William Zeckendorf Sr., with whom Pei collaborated in the early part of his career — was an important figure in the New York real estate world, involved in the redevelopment of Broadway north of 86th Street and the Union Square area, for example. Burns's Hong Kong hotel group provided pre-opening services for the hotel, which is currently managed by Toronto-based Four Seasons Hotels Limited.

The exterior appearance of solidity that the tower projects comes from its form but also to the use of Magny Doré French limestone cladding, handset up to a height of 85 feet (26 m) from the street level. Selected for the Louvre and elsewhere by Pei thereafter, this limestone is not typical of New York facades, although this is very much a Manhattan building. The very visible 57th Street ground level is marked by 5,500 square feet (510 sq m) of retail space, assuring continuity in street-level activity along this artery, which includes such stores as Tiffany's, Chanel, and Louis Vuitton. The 28-foot-wide (8.5 m) hotel entrance is signaled by a cantilevered steel-and-glass canopy topped by a 14-foot (4.3 m) oculus. This round form may not be directly related to the larger round openings seen in the Richelieu Wing of the Louvre and elsewhere in Pei's oeuvre, nor is this gesture typical of contemporary buildings in New York. It is, however, an echo, a reminiscence, a sign. A transitional foyer leads visitors up a small flight of steps into the axially aligned Grand Foyer, an approximately cubic space measuring 31 feet 8 inch (9.7 m) on each side and 39 feet 9-inch (12.1 m) high. The entrance sequence, and indeed all of the hotel's public spaces are clad in Magny Doré for the walls and a beige French Chassagne stone for the floors, another choice first employed by Pei in the Louvre. Although, as Pei himself points out, he did not

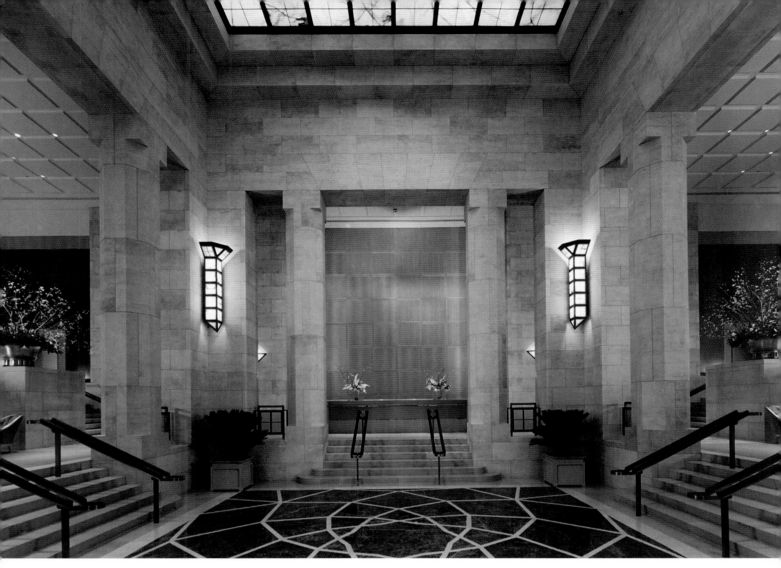

The lobby and front desk as seen from the entrance, spaces designed by I. M. Pei

design the mezzanine restaurant or lounge areas that look down on this Grand Foyer, the space has every mark of the architect's sense of drama and space. An onyx ceiling and eight-sided columns in the foyer emphasize the same sort of solidity projected by the exterior of the tower.

In the tradition of grand New York spaces, like the main hall of Grand Central Station or the former Palm Court of the Plaza Hotel, this is a location to see and be seen—a room that speaks of the grandeur of New York. Although there are views to 57th Street from the mezzanine spaces, this space is not infused with natural light, which is a characteristic of so much of Pei's architecture, but this fact is due to the nature of the site and the density of the program. As the

Pei Partnership states, "The Four Seasons has been designed to continue the long tradition of grand hotels with luxurious accommodations and a public presence, highlighted by a sense of theater, that offers a salonlike environment in which visitors and New Yorkers alike can socialize graciously. One enters the hotel through an imposing glass and stone entranceway and passes into a rich lobby court that conveys an air of both grandeur and intimacy."[3] With its strict geometry and opulent materials palette, the entrance sequence of the hotel and its Grand Foyer exude a quiet dignity, which surely meets the client's request for a building that "possesses a classic elegance that transcends both time and fashion."[4]

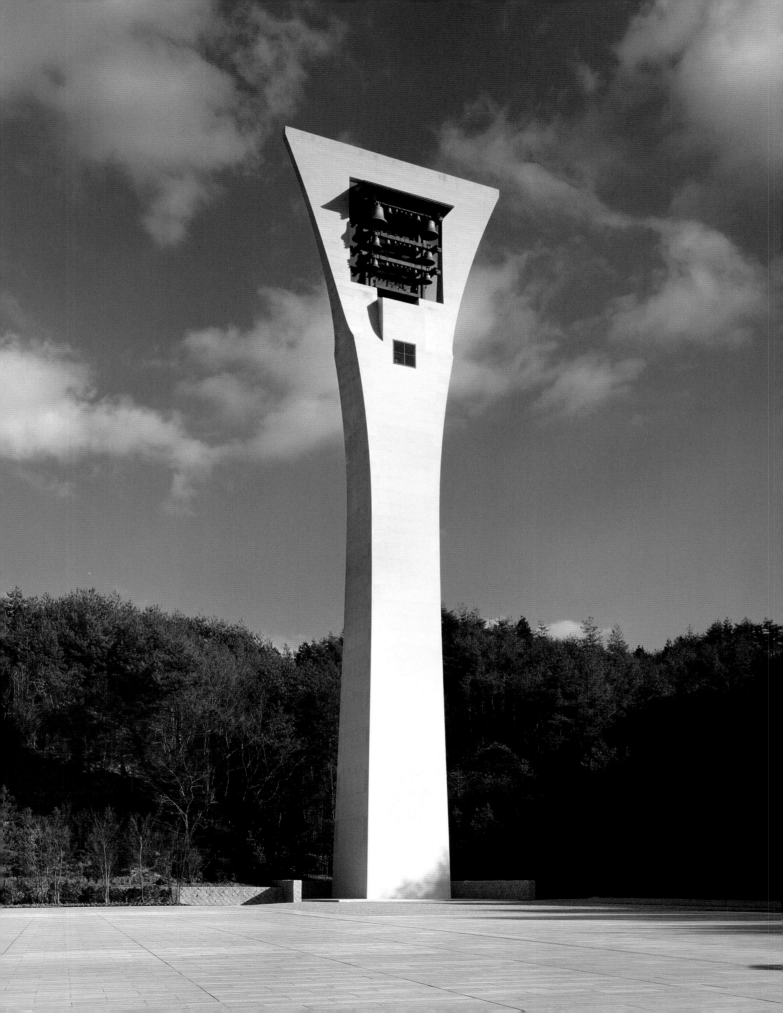

"JOY OF ANGELS" BELL TOWER

Misono, Shigaraki, Shiga, Japan
1988–90

The first project I. M. Pei undertook after deciding to retire from Pei Cobb Freed was a bell tower, inaugurated in 1990 near Shigaraki, in the Prefecture of Shiga, Japan. In a wilderness site called Misono located about an hour and a half from Kyoto, the spiritual organization Shinji Shumeikai, had already called on Minoru Yamasaki (1912–1986), designer of New York's Twin Towers to build a vast sanctuary named Meishusama Hall. Completed in 1983, this edifice, set on a 14,000 square meter (3.5-acre) Italian marble plaza seats over 5,500 people. It's upward curving form was inspired by Mount Fuji and it was named for Mokichi Okada (1882–1955). Founder of Sekai Kyusei Kyo (SKK) or the Church of World Messianity, Okada is also known as Meishusama by the followers of Shinji Shumekai.[1] His philosophy, linked to the practice of Shintoism in Japan, involves an effort ". . . to create Paradise on Earth . . . where people have beauty in their hearts, a beauty in the spirit. Words and deeds," he said, "should embody this beauty. This is beauty at the individual level. And when individual beauty spreads, social beauty comes into being . . ."[2] Okada's paradise on earth was based on the juxtaposition of beauty in nature, architecture and art. His Mokichi Okada Association (MOA) was established in 1980, and created the MOA Museum in Atami, Japan (1987) which continues to receive more than 700,000 visitors a year. Shinji Shumeikai was the result of a 1970 schism within the SKK. Under the leadership of Mihoko Koyama (also known as Kaishusama), heiress to the Toyobo textile business, and one of the richest women in Japan, the organization prospered

The bell tower seen from the large ceremonial square

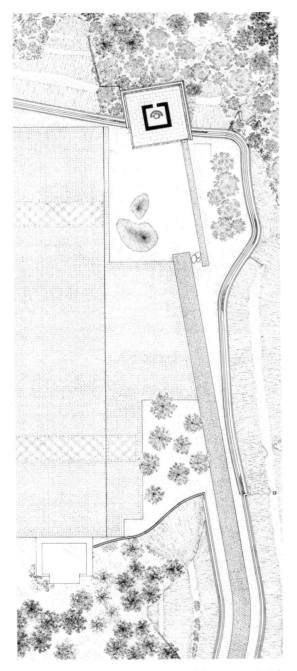

Site plan with the bell tower at the top, and the square to its left

Pei with clients, Miss Hiroko Koyama and her mother Mrs. Mihoko Koyama

and today has several hundred thousand members. Mrs. Koyama decided in 1988 to erect a bell tower in Misono and in the spirit of the quest for beauty outlined by Okada, she set out to find the "best architect in the world." Her search lead her to New York, where she met I. M. Pei that year. Although historically, the relations between China and Japan have not always been easy, these two cultured individuals found they had a great deal in common.

Pei's design for the tower evolved quickly on the basis of an object he had bought during a 1954 trip to Kyoto — a *bachi*, which is a plectrum used to play the three-stringed *shamisen*. He explains that "My decision was not rational, except to the extent that the *bachi* and the tower both have a musical function. It was a choice I would almost qualify as mystic."[3] Begun in New York in February 1988, the design was completed in April 1989. Pei chose Bethel white Vermont granite for the cladding of the tower because he found local stone too dark. Baptized

"The Joy of Angels" by Shinji Shumeikai, the tower is 60 meters (197 feet) high and houses a set of fifty bells cast by the Royal Eijsbouts Bell Foundry in The Netherlands. Its base is a seven-meter (23-foot) square, while the 18-meter (60-foot) upper edge of the structure is just 60 centimeters (24 inches).

opposite:
The bell tower is located near carefully designed gardens

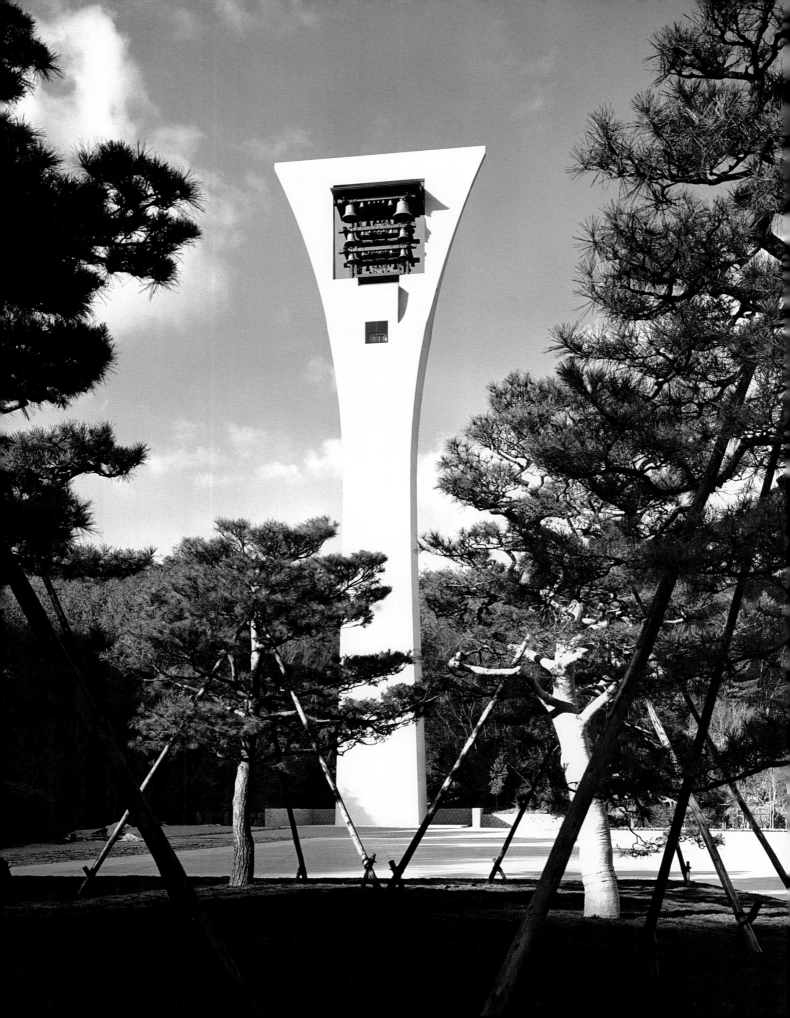

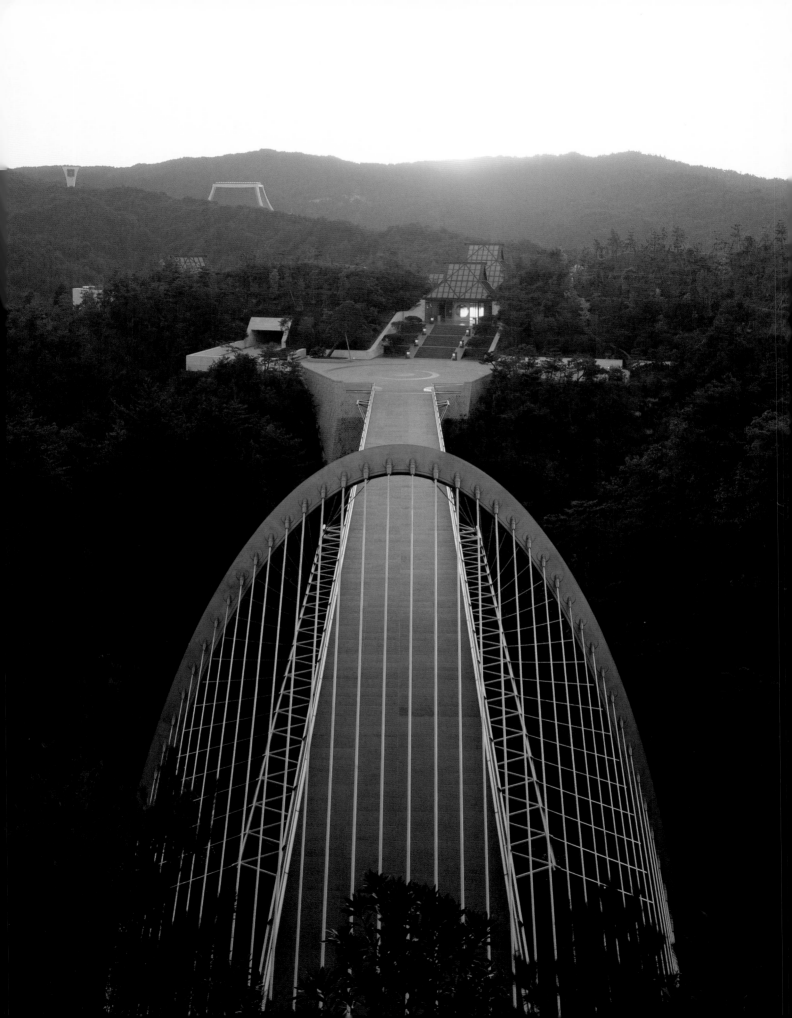

MIHO MUSEUM

Misono, Shigaraki, Shiga, Japan
1991–97

When asked how his involvement with the Miho Museum came about, Pei responds, "In 1988, I decided that I would no longer take on very large projects, only carefully selected smaller ones. The Bell Tower, which I completed in Misono, was the first of that series. Mrs. Mihoko Koyama, heir to the Toyobo textile business and a leader of Shinji Shumeikai, was then very active. She had built a collection, essentially of Japanese and Chinese art, over many years, and she wanted to have a museum to show it. I liked the idea of a small museum for oriental art."[1] Pei rejected the first site at the confluence of two streams because it had to be approached from above in the hilly terrain near Misono. Mihoko Koyama then suggested another location, which was preferable to Pei but was difficult to approach. I. M. Pei made an unusual proposal to overcome this problem by constructing a tunnel and a suspension bridge. "I became very interested in this project when the possibility of tunneling under the mountain was confirmed," says Pei. "That permitted what I considered to be the surprise in the final approach to the museum."[2]

I. M. Pei's relationship with Mihoko Koyama was in part formed by their shared literary culture. He explains, "Mrs. Koyama was a very well-educated person with respect to the Chinese classics. She had studied all of the Chinese classics, and we were able to communicate in writing in Chinese. So I was able to quote a fourth-century poem called the 'Peach Blossom Spring' [when describing my ideas for the site]. She never forgot that reference. She immediately embraced my suggestion. Although its scale differs from that

Sketch of the tunnel by Pei

which one encounters in China, the site is reminiscent for me of a typical Chinese landscape, with hills and valleys, and the rest is mist. You don't see the whole building. Its mass is concentrated to the west, and the approach is from the east. She and I became very excited about this possibility, and that is how it all began."[3]

Tim Culbert, a project architect who worked for Pei on the Miho Museum, explains the specific design evolved from this conversation with Koyama about "Peach Blossom Spring": "We mapped out a deliberately prolonged approach to the museum characterized by an alternating play of concealment and unveiling. The orchestration of the visit as an elaborate and measured procession heightens the temporal experience of the site, invoking the Japanese principle of *ma*, or the time-structured experience of space. A single route leads up to the museum site. Visitors arrive from Kyoto by car or bus at the reception pavilion, located a short distance from the museum amid a forest of cedars. From this point the museum building remains out of sight,

View over the suspension bridge to the Miho Museum with the top of the bell tower visible in the distance, left

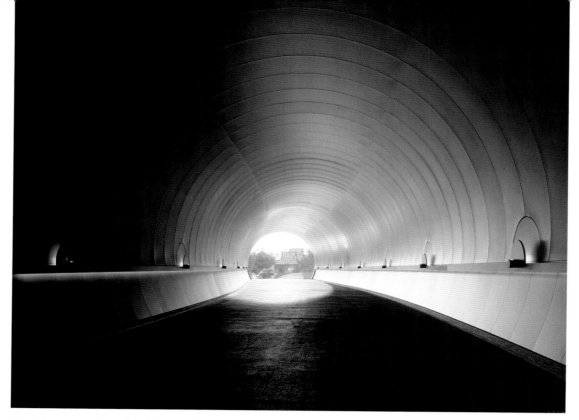

Inside the approach tunnel, looking toward the museum entrance

obscured by a mountain slope. Visitors may make their way on foot or take electric cars through a tunnel in the mountain that opens onto a 120-meter (394 ft) bridge spanning a deep valley. As the visitor enters the tunnel the museum site can be detected at the far end, seemingly receding at his advance. The view of the museum is enmeshed in the splayed cables of the bridge as one exits the tunnel. Anchored to the tunnel mouth and cantilevered over the valley, the post-tensioned bridge has a unique structural design that provides dramatic continuity from tunnel to bridge even as its asymmetry literally draws out the approach to the lofty museum site. The bridge lands directly onto a paved plaza at the foot of the museum complex. Terraced steps similar to those of a Japanese temple ascend from the plaza to the entrance hall, cradled between slopes atop a high ridge. A series of glass roofs rise above the undulating mountain slopes. With the bulk of the building not yet in view, the visitor's first impression is of a hovering and elusive architecture."[4]

The original plan for a small museum based on the Japanese art collected by Mihoko Koyama

was modified as her daughter Hiroko began to take on more responsibility in Shinji Shumeikai. With the assistance of the dealer Noriyoshi Horiuchi, the organization acquired a substantial number of objects related to the Silk Road, and Pei had to reconsider the design. "Japan and the West were originally connected by the Silk Route," says Pei. "I liked the idea, but I did not realize at what pace the museum design would have to be revised. From the point of view of the plan, the project may lack a certain elegance because of a piecemeal addition of spaces. When you build underground, however, you may care less about the formal aspects of the plan. In a sense, that was what saved us—we were able to expand to accommodate our needs."[5]

Long considered sacred land, the area near Shigaraki is characterized by hilly terrain and dense vegetation. Carefully protected by local authorities, the land could only be used under specific conditions. I. M. Pei outlines this aspect of the project: "The shape of the structure was naturally informed by the topography of the site, but also by prefectural regulations. They allowed

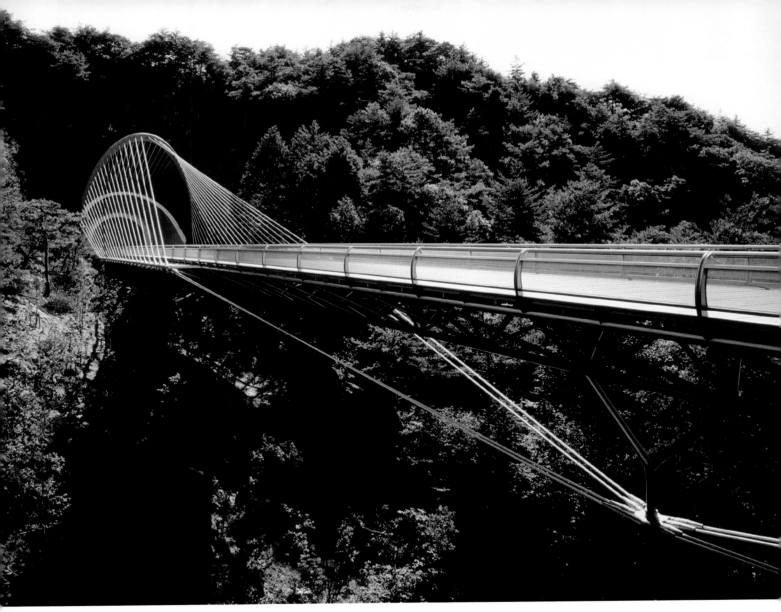

The suspension bridge designed by Pei with the engineer Leslie Robertson

only about 21,528 square feet (2,000 sq m) of the total of 182,990 square feet (17,000 sq m) to be exposed to the surface. Eighty-five percent of the museum is underground. Normally I would not have accepted to allow a plan to expand as it did, but since it was underground, I agreed. I don't think it matters that much, as long as the internal spaces are interesting. The new collections are now located in the South Wing, and the objects acquired by Mrs. Mihoko Koyama are in the North Wing." Pei's comments on his relation to this specific site, but also to Japanese contemporary architecture are particularly revealing: "The site is, of course, on a hill. I did not want to put

the building too low. I thought that steps were the right approach for an important building, not unlike many Japanese temples. I am a firm believer in the spirit of the site, and the place, and the historical roots. You cannot arbitrarily start something and hope that it will take root. I wanted to search for the reason that Japanese structures such as the Imperial Villa of Katsura were built the way they are. I know that they were made of wood, which has some structural limitations. They have a weather problem, which explains the pitched roofs. More important, I think, is the landscape."[6]

In a way, with the Miho Museum, Pei continued the search for a modern Asian vernacular

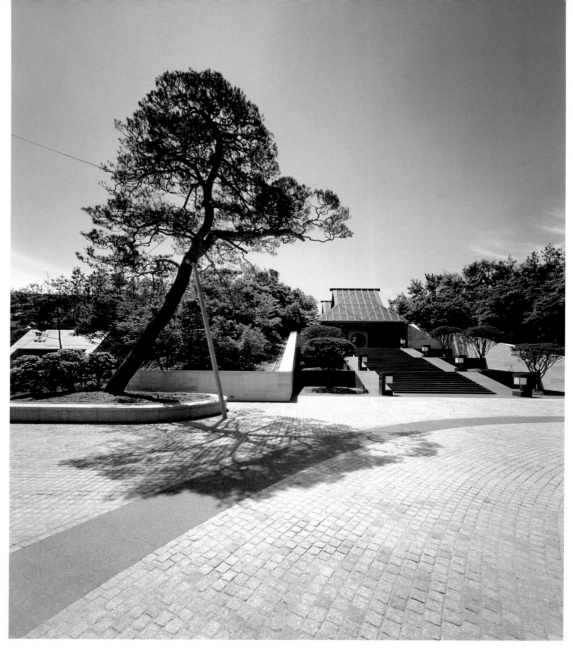

The museum entrance seen from the square at the exit of the suspension bridge

that had began in his design for the Fragrant Hill Hotel near Beijing. The most intriguing aspect of this quest is Pei's attachment to his modernist geometric vocabulary. "A flat roof would not have been suitable in this landscape," he explains, "particularly since it can be seen from above from many angles. I searched for a form that would give an interesting silhouette without imitating wooden architecture. We started with a tetrahedron, and the entire structure is elaborated on the basis of that geometric form. The tetrahedron produces peaks and valleys. Having done that, there is a conscious attempt to find a silhouette that is Japanese, but at the same time is comfortable with that landscape. I wanted to use glass, and I did not want a tile roof. The roof is also a facade for me."[7]

A comparison of the Miho Museum and the Louvre reveals a number of affinities. Pei uses his preferred French limestone, Magny Doré, in Shigaraki as he did extensively in the Louvre. His signature use of glazing and geometric forms such as the triangle (Louvre Pyramid) or the tetrahedron here are clearly related to the archi-

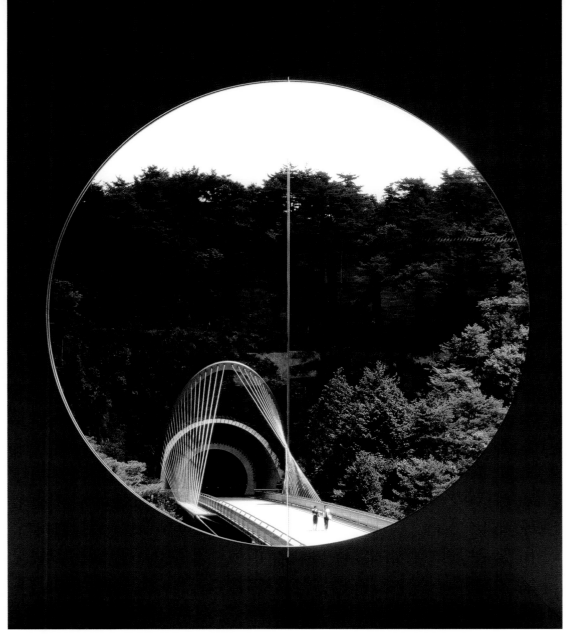

The suspension bridge seen from inside the main doors of the museum

tectural innovations of the twentieth century, but they are also profoundly anchored in much more ancient ideas. Pei's reference to Katsura and Japanese temples has clear meaning in this instance, as the work of the great French garden designer André Le Nôtre (1613–1700) informed his use of light, air, and water in Paris. It is no accident that the glass surface of the Pyramid reflects the Parisian sky, even as it defines the entrance area below, which is flooded with light. Similarly, the path to the museum recalls traditional Japanese garden and temple design.

The generous, 656-feet-long (200 m) tunnel approaching the museum leads to a 394-feet-long (120 m) cable-stayed bridge designed by Pei with the noted New York engineer Leslie Robertson. A subtle curve in the tunnel assures that the entrance to the museum becomes visible only at the last moment. Although small electric cars are available, most visitors approach the museum on foot from the parking areas. This indirect pedestrian approach is typical of Japanese temples, which are rarely visible before the last moment. Then, too, the evolution of the project, which led

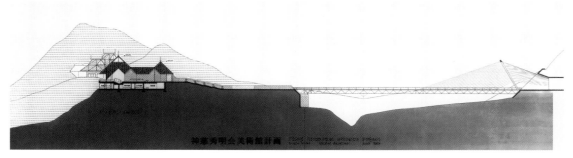

A section shows the suspension bridge (right) and the insertion of the museum into the site (left)

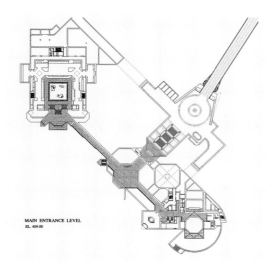

MAIN ENTRANCE LEVEL
EL. 409.00

The entrance level with the bridge upper right

LOWER LEVEL
EL. 405.00

The lower level with galleries and the restaurant lower right

to what Pei refers to as "a certain lack of formal elegance," might bring to mind the seemingly irregular development of an ancient Japanese site such as that of Katsura Villa.

On November 2, 2002, the Miho Museum bridge received the prestigious "Outstanding Structure Award" from the International Association for Bridge and Structural Engineering. The citation highlighted the "light and airy structure epitomizing structural beauty and artistic elegance while preserving the nature reserve below."[8] I. M. Pei, the structural engineer Leslie Robertson, the contractors Shimizu Corporation, and Kawasaki Heavy Industries shared the distinction, which is usually reserved for much larger projects such as the Guggenheim Museum Bilbao (1997) or the Grand Stade (2007) in Saint-Denis near Paris. The bridge uses an innovative combination of cantilevered, cable-stayed, and post-tensioned

design that permits it to be just 6.5 feet (2 m) deep. As Pei said during the ceremony at the Miho Museum, "About twelve years ago Kaishusama [Mihoko Koyama's name within Shinji Shumeikai] had a tent pitched not far from here so that we could look at the site. It was perfect, but access posed a problem. We looked around and happily we found a solution. A tunnel combined with a bridge was the only way to get to the site without destroying the natural environment."[9] The tunnel and bridge are another part of the story of Pei's work, in particular in this privileged project. Although costs were undoubtedly higher than for many other projects, the quality of the design and the materials used for the Miho Museum, the bridge, and the tunnel make it exemplary.

In Frank Capra's 1937 film *Lost Horizon*, a plane crashes in the Himalayas. Its passengers, who had been fleeing the turmoil of China,

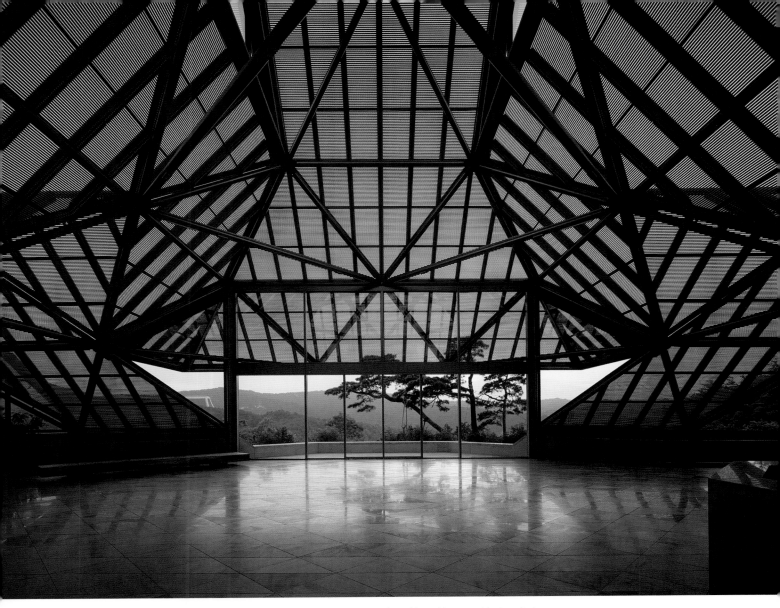

The main entrance area of the museum, with a tree selected by Pei just outside the windows

are led by Tibetans to the hidden valley of Shangri-la, where peace is a way of life and the very process of aging has come to a halt. Based on a novel by James Hilton, *Lost Horizon* is merely one recent version of a story which recurs throughout the history of literature and art. It is the story of the Garden, of Paradise, lost and regained. Another, much more ancient telling, the story of the "Peach Blossom Spring" goes something like this:

> During the reign-period T'ai Yuan of the Chin dynasty, there lived in Wu-ling a fisherman. One day, as he followed the course of a stream, he lost track of the distance he had traveled. All at once he discovered a grove of blossoming peach trees that lined either bank for hundreds of paces. No tree of any other kind stood amongst them, and their flowers were fragrant, delicate, and lovely to the eye. The air itself was filled with drifting peach blooms. The fisherman, marveling, went on further to discover where the grove would end. It ended at a spring, near a hill. In the side of the hill, there was a small opening which seemed to promise a gleam of light.[10]

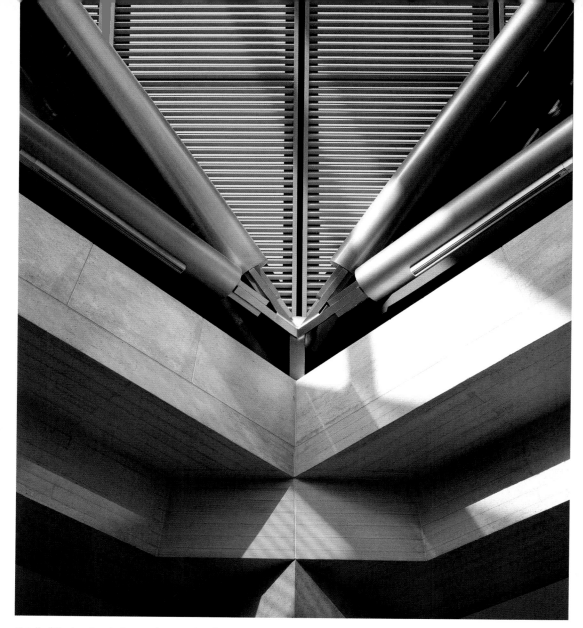

Detail of the juncture between glass, steel and stone at the base of the skylight

The story of "Peach Blossom Spring" is directly related to the origin of the Miho Museum, located in the hills near Shigaraki in Japan. A shared knowledge of the Chinese classics gave I. M. Pei and Mihoko Koyama rich subjects for conversation when they first spoke of a museum for her collections, and the otherworldly beauty of the peach blossoms, together with that promise of a "gleam of light," at once matched the dream of the architect and his patron. Literature and art clearly played a significant role in the development of the Miho Museum project, but so did the natural setting and the history of architecture. Mokichi Okada, the founder of Sekai Kyusei Kyo, from which Shinji Shumeikai developed, dreamt of "creat[ing] Paradise on Earth . . . where people have beauty in their hearts, a beauty in the spirit," in many ways takes form as visitors first see the gleam at the end of the tunnel in Shigaraki.[11] This is not to suggest in any way that Pei has given a specifically religious meaning to his architecture in Shigaraki. Rather, he has selected his site within the area delineated by the client, and then worked to create a synthesis, or perhaps more accurately to isolate the essence of different historical and

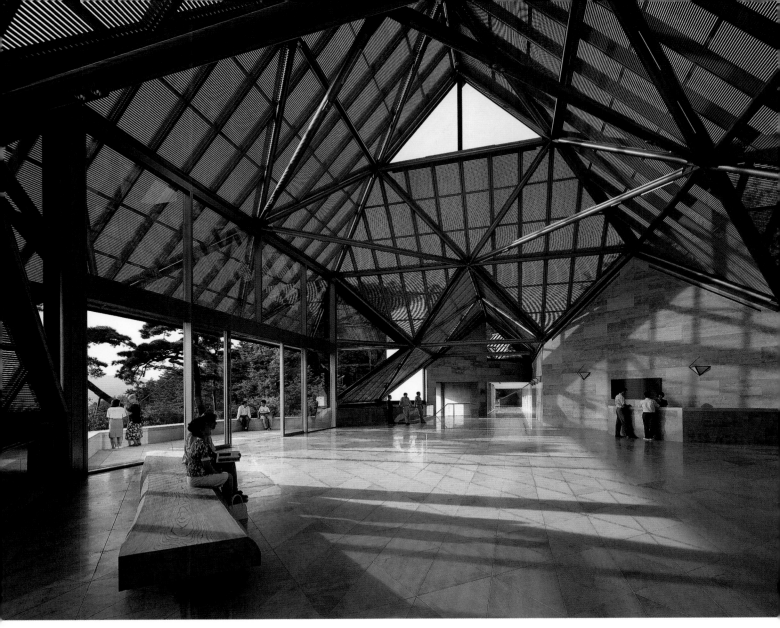

The entrance lobby area with Pei's favored Magny Doré cladding

philosophical strands, and to bring them together in a resolutely modern form. This deep and voluntary connection between past and present, but also between the client's will and the site, sets Pei's architecture apart in the spectrum of modern — which is not to say modernist — approaches. While most of his colleagues have worked within a self-referential or purely modern framework, Pei, especially after 1989 has branched out, as he says himself, seeking to learn about countries or civilizations that he felt he did not know enough about. From his study of the countries involved with his "post-retirement" work he has evolved

toward designs that embody something of the soul of the places and cultures where he has built. In Japan Pei is deeply aware both of Japanese pride and history, but he also knows that the culture of this place ultimately flowed from his native China. This unstated truth, perhaps best evoked through the story of "Peach Blossom Spring," a Chinese classic, may be far more revealing about the importance and nature of Pei's architecture than a specific reference relevant only to this project. The "gleam of light" seen by a fisherman might be a metaphor for the uplifting curves of the Bell Tower in Misono, or the rays

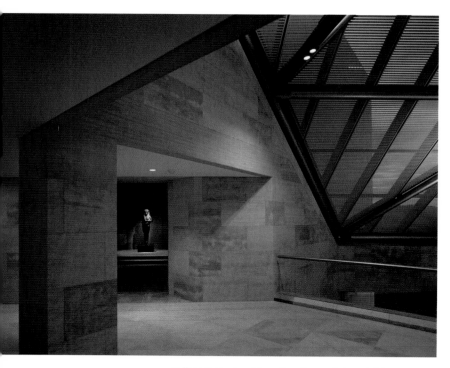

Gallery entrance with an Egyptian sculpture visible

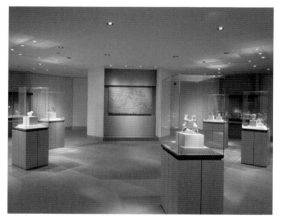

Typical gallery with an Assyrian sculpture on the far wall

of sun spread at angles across the stone floor of the Miho Museum's entrance.

The objects selected by Mihoko Koyama and her daughter Hiroko Koyama are equally extraordinary, telling as they do the story civilization through the Silk Road and other traditions. Often, these objects like the Silver Horus, a cult figure of a falcon-headed deity dating from the early nineteenth dynasty of Egypt, vibrate with an energy that even the casual tourist can sense.[12] When Pei completed the Bell Tower in Misono, he was already on the road that led him to the Miho Museum. His choice of the *bachi*, a plectrum used to play the three-stringed *shamisen*, as the form of the tower links it to the history of Japan and to the function of the structure, but it must be seen in its site to make its significance felt. A "sacred road" made of Kyoto cobblestones curves toward the Bell Tower so that it, too, can only be discovered after the visitor has walked a certain distance.

Tim Culbert connects the design of the Miho Museum to Japanese tradition, via Bruno Taut's interpretation of the Katsura Villa: "For I. M. Pei,

the design process usually evolves through a dialogue of elaboration and simplification of a basic geometric strategy. The Miho project constitutes a departure from this process in that a pure geometrical plan never dominated the design; as a result, the museum is somewhat unique in his body of work. In his desire to fit the building into the mountain, Pei created an interconnected series of spaces underground that spin off from the core of the plan; the concealment of the bulk of the building enabled a certain degree of flexibility in the design. In regard to the Miho project one might well adopt the notion of 'improvised lyric,' as applied by Bruno Taut to describe Katsura Villa. Like Katsura's jointed zigzag of villas, the Miho Museum demonstrates a fluid integration of structure and setting. With its constant bending of views and loose connection of forms in the landscape, the design encompasses variation in the site and scale of spaces without compromising the overall impression of unity."[13]

Although it was Mihoko Koyama who came to him, Pei was clearly prepared by that time in his life, as he was retiring from his long career at Pei Cobb Freed, to look beyond the United States. As he had already accomplished with the Louvre, Pei sought to delve deeply into the culture of another country, to try to understand another land in a profound way that could give form to his own dream. He has spoken of searching for a way to express the essence of a culture — to express

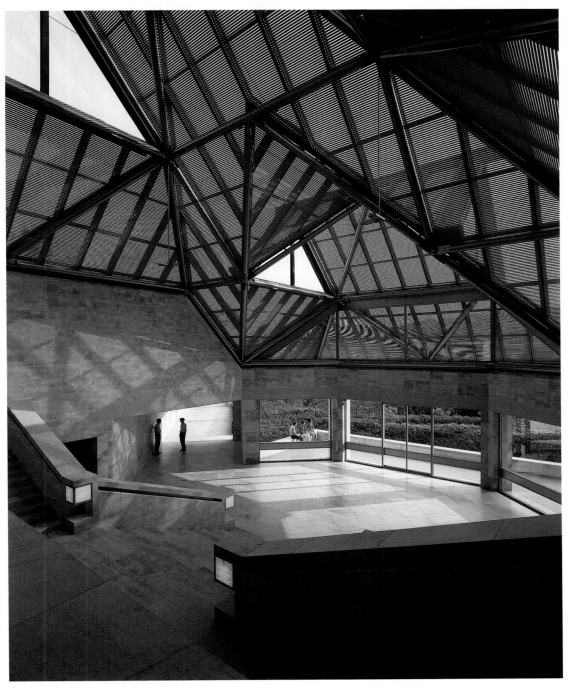

The north wing lobby area with steps leading to the galleries for Japanese art

it, but above all, to render it modern. One might say that the long rising, curving path from the reception pavilion to the entrance of the Miho Museum, passing through a broad tunnel and crossing a suspension bridge was a strict response to the complex topography of the site. But the attentive visitor of Japan's many temples will note that almost none of these edifices can be approached in a direct way. An effort, going up many steps, or changing direction frequently are always necessary to reach the inner sanctum. This is no accident, nor is the joining of the beauty of art, architecture, and nature in these places. The philosophy of the client of the Miho Museum,

Shinji Shumeikai, has it that paradise on earth can be found where nature, art, and architecture come together in a propitious way. But these thoughts also occur throughout the history of Japanese culture, be it in its Shintoist or other forms. The power of geometry as it is employed by Pei can be read in many ways, and his own

words rarely impose a specific reading. It is clear however in his references from Chinese classics to the garden designer [André] Le Nôtre, that history is very much in his mind, as is the potential of modernity to reweave connections with the past that do not contradict the spirit of modernity. The "essence" that Pei has sought in Japan, Qatar,

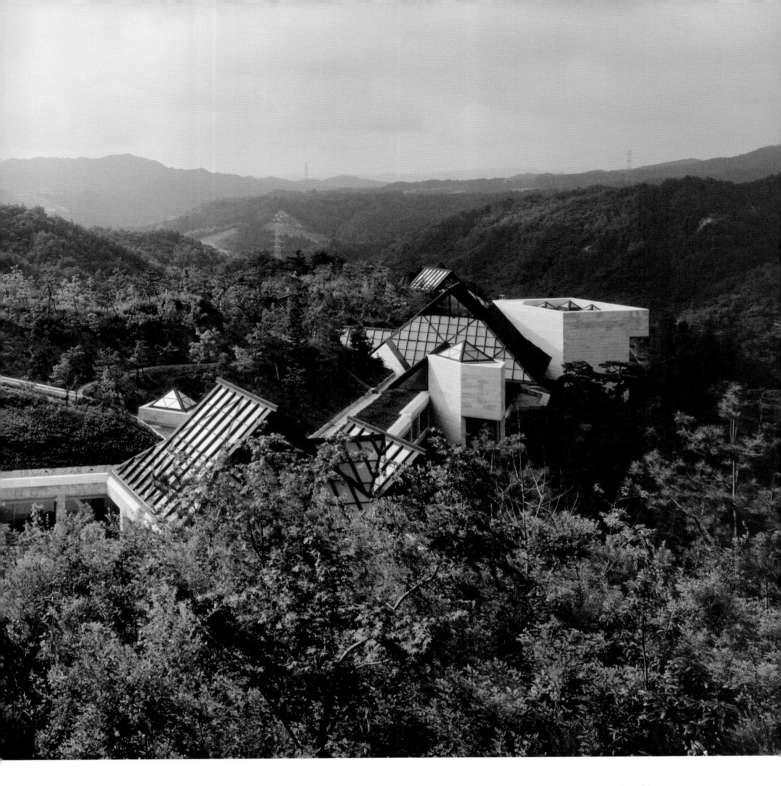

above:
The museum all
but disappears into
its luxuriant natural
setting

or even Paris since his official retirement, can surely be likened to the "gleam of light" seen only after passing through a valley of ethereal peach blossoms. Giving concrete form to such an indefinable ideal subjects the architect to the constraints of the "real" world — limits that did not exist for Tao Yuan Ming, yet stone, glass, and steel are the chosen materials of I. M. Pei. Be it an expression of his client's desire or his own inner search, in Shigaraki, Pei went down the road to Peach Blossom Valley.

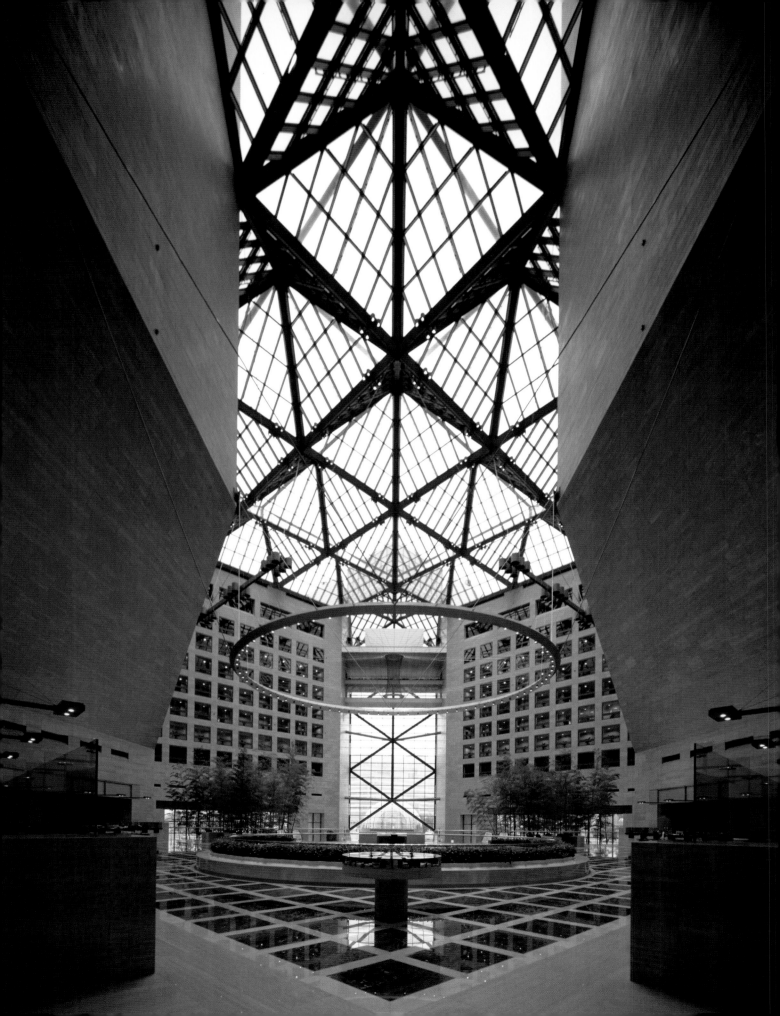

BANK OF CHINA, HEAD OFFICE

Beijing, China
1994–2001

I. M. Pei's involvement with the Bank of China is first and foremost a family story. His father Tsuyee Pei (1893–1982) was a central figure in the creation of the modern banking system of China. Born in Wuxian, Jiangsu, he graduated from Suzhou University in 1911, and joined the Bank of China in Peking (now Beijing) in 1915. He became manager of the bank's Shanghai office in 1927. In 1941, Tsuyee Pei was named acting general manager of the Bank of China, and was a member of the Chinese delegation at the Bretton Woods Conference of June 1944. He served as governor of the Central Bank of China in 1946 and 1947.[1] After a long absence from his country, I. M. Pei was invited to visit China with his family in 1978. Amongst other subjects, he discussed the architectural environment of the Forbidden City with officials and firmly suggested that the height of new buildings in the area be strictly limited, preserving the unobstructed view of the sky from within the City's walls. As he describes it, his idea was quickly accepted because Premier Chou En Lai (1898–1976) had also expressed very similar reservations about tall buildings in central Beijing.[2] Pei's first project in China was the Fragrant Hill Hotel near Beijing. In part because of these circumstances, Pei was contacted shortly before his father's death to work on the tower of the Bank of China in Hong Kong, completed in 1989. Given the family history, it was quite natural that the Bank of China, now one of the "big four" state-owned commercial banks of the country, again approached Pei, together with his sons Li Chung and Chien Chung Pei and their firm, the Pei Partnership, to design their Beijing

The bank at a distance with the prominent corner skylight visible

headquarters. I. M. Pei is listed as a design consultant for this project, with his sons assuming the role of lead architects.

It might be said that one of the problems posed for the site chosen by the bank, near the Forbidden City, was the strict 148 feet (45 m) height limit imposed at the architect's suggestion. The bank head office is at the intersection of Xidan Street, a north-south shopping thoroughfare, and Changanjie, the city's main east-west axis, which leads directly to Tiananmen Square. This key location is emphasized by the building's main entrance located at the corner, topped by a reception room with a peaked skylight, which "overlooks forth the ancient and the modern city" as the Pei Partnership describes it.[3] This very large

The entrance lobby with its peaked corner skylight

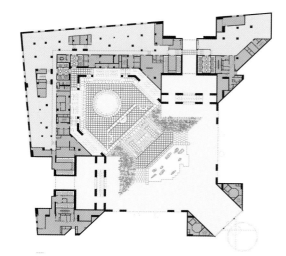

Second floor plan

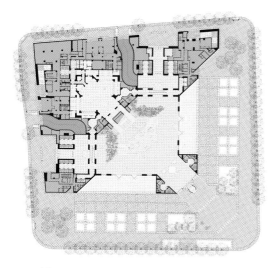

Ground floor plan

The roofs of old Beijing with the bank in the background

structure—1,808,000 square feet (168,000 sq m) in total area—rises fifteen stories and includes a spectacular 130-feet-high (40 m), 180-feet-square (17 sq m) atrium, enclosed by two L-shaped office blocks. Inside, bank offices look down into the atrium. The atrium garden is decorated with 40 tons (36,000 kg) of rock brought from the Shilin (Stone Forest) in Yunnan Province.[4]

I. M. Pei's great interest in Chinese gardens, expressed more recently in the Suzhou Museum, found an expression in Beijing that in part obviates the very high density of the building, concentrated on a 145,000-square-foot (13,500 sq m) site. Pei had 65-feet-tall (20 m) bamboo trees brought from

Hangzhou, southwest of Shanghai, creating public areas and a banking hall in which the idea that Chinese culture can find its own way in the modern world is clearly present. Features such as the large circular openings near the garden recall similar gestures in the Richelieu Wing of the Louvre, but also evoke a connection to the history of Chinese architecture and its recurring theme of round doorways. Pei has frequently stated his desire to search for a "modern vernacular" specific to contemporary China, and he clearly pursued this quest in the Fragrant Hill Hotel and more recently in the Suzhou Museum. The Bank of China Head Office does not speak so overtly of

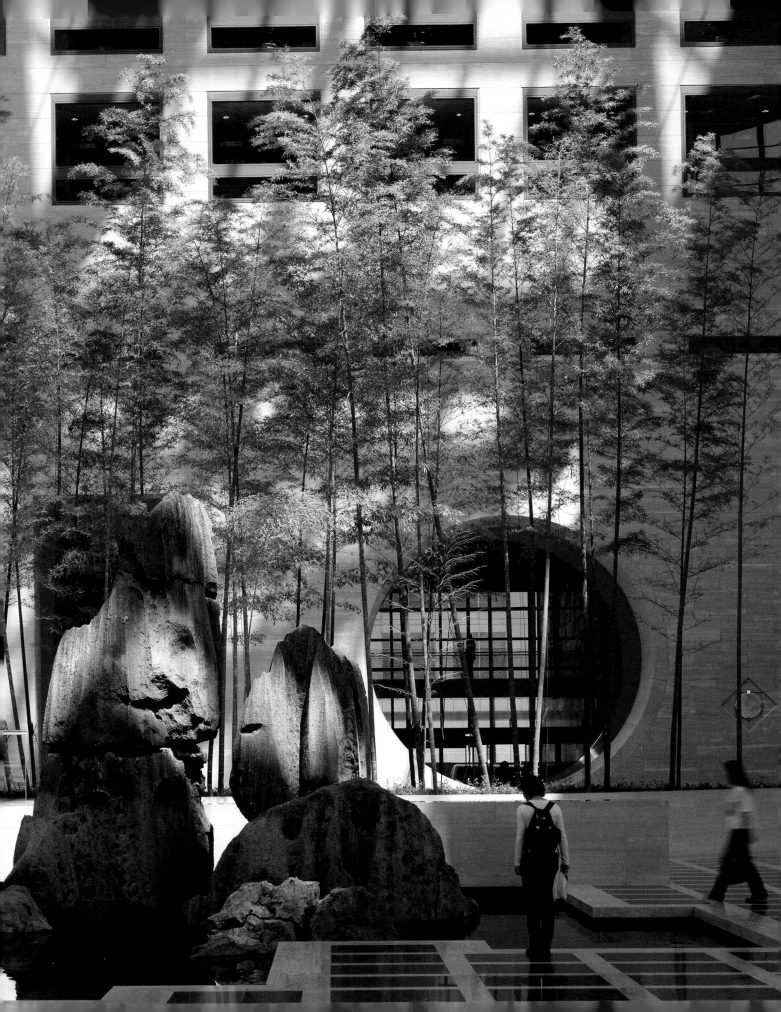

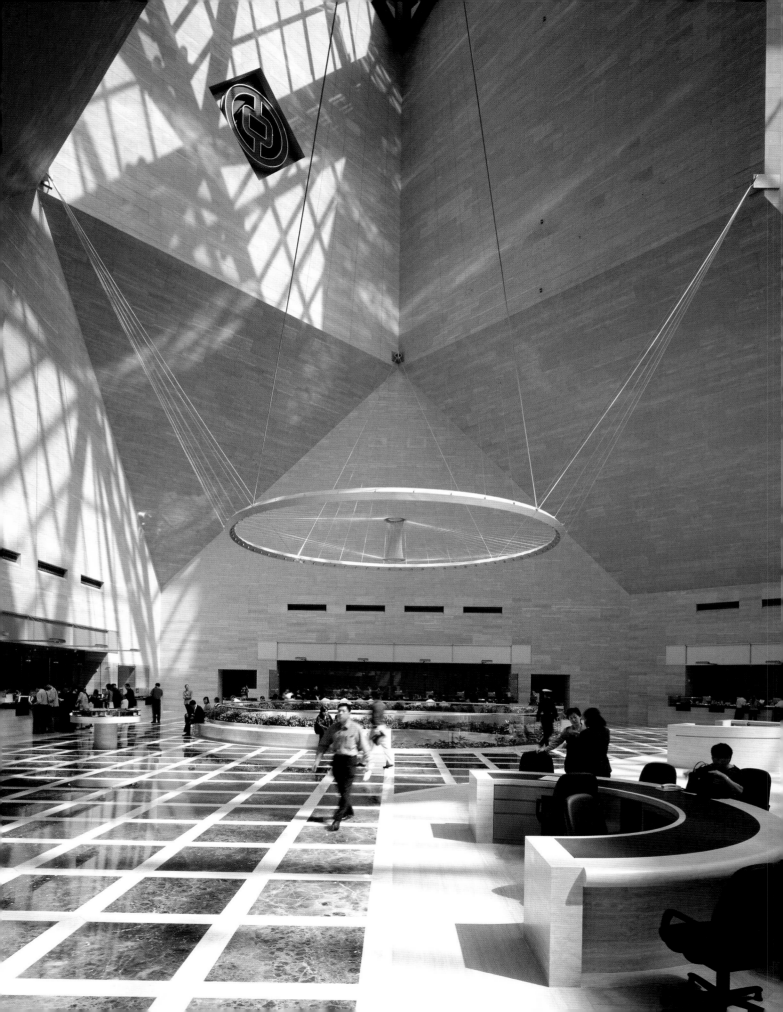

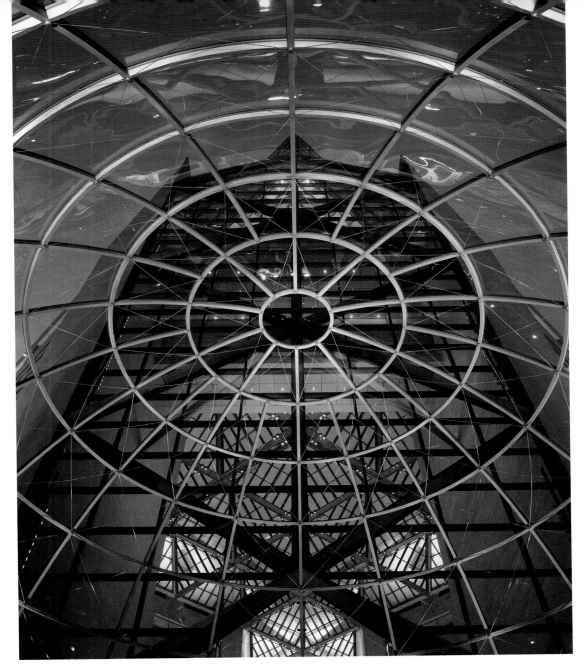

A webbed skylight above the main banking hall

The large, hanging circular lamp resembles one later designed for Doha by Pei

its Chinese origin, perhaps because of its density and massive scale, but also because the client's desire for modernity may well have been stronger than the need to connect this building to the past of the country.

A 2,000-seat auditorium set below the courtyard, near a cafeteria, and no less than one million square feet (43,000 sq m) of office space and 145,000 square feet (13,500 sq m) of leasable tenant space, give an idea of the sheer scale of the structure. A generous use of stone cladding including buff-colored Italian travertine for the facade, and Chinese gray granite for the exterior paving mark the building and underline the solidity of the structure and thus of the bank itself. In the public interiors and banking halls, Pei chose Roman travertine, gray granite, and marble floors and walls with natural anodized aluminum ceiling panels.

Though it is not always obvious which traits of the building are most closely related to I. M. Pei's design ideas, the central atrium is an area

Interior spaces outside of the banking hall recall Pei's style

The two-thousand-seat auditorium

where his influence is clearly felt, from the garden to the triangular web of the atrium glazing, recalling many of his other structures such as the interior courtyards of the Louvre. In a 2002 interview, the architect confirmed this and told the story of the commission in his own manner: "My father was general manager of the Bank of China until 1948. After the new government took over, all banks were nationalized. As a consequence, my whole family left and I thought that that would be the end of our relationship. But a new general manager came to see my father when he was still alive and

asked him if his son could do some work for the Bank of China. I accepted the first commission, with the permission of my father, to do the first building in Hong Kong. This second building in Beijing came many years later, and I told the Bank that I could no longer do such a large project, and—very Chinese in this way—they said, what about your sons? My sons did take on the project, but I had a great deal to do with the atrium. The solution for the inside has to do with the site and the bank requirements. The site is limited in size and the zoning regulation mandated that it could not exceed a certain height. You had to pack a lot of square footage into a very limited site. In order to provide windows for hundreds of offices, the only solution was to leave a hole in the middle. With a big opening in the center, why not make it into an all-weather piazza? This piazza is not an Eastern concept—the Chinese would not find it useful. They do not encourage large crowds to gather. I thought of using that space as a banking hall as well as a meeting place. The banking hall is part of the open space; there are two levels of banking. So it became a banking hall rather than a piazza, and that the bank officials found acceptable."[5]

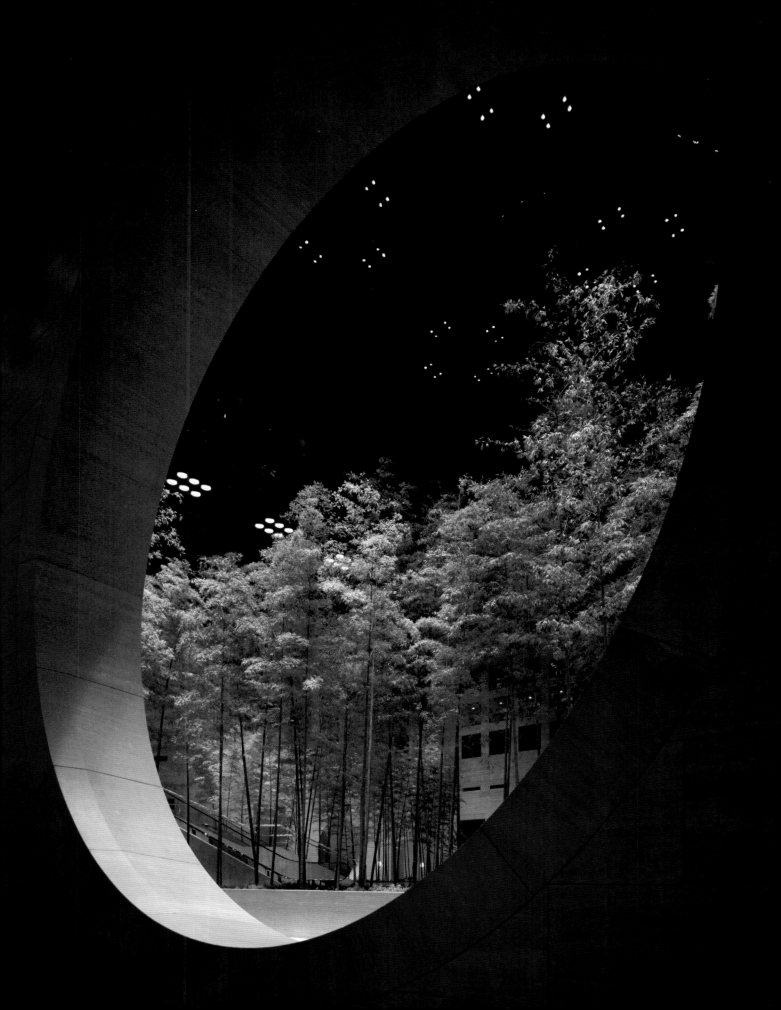

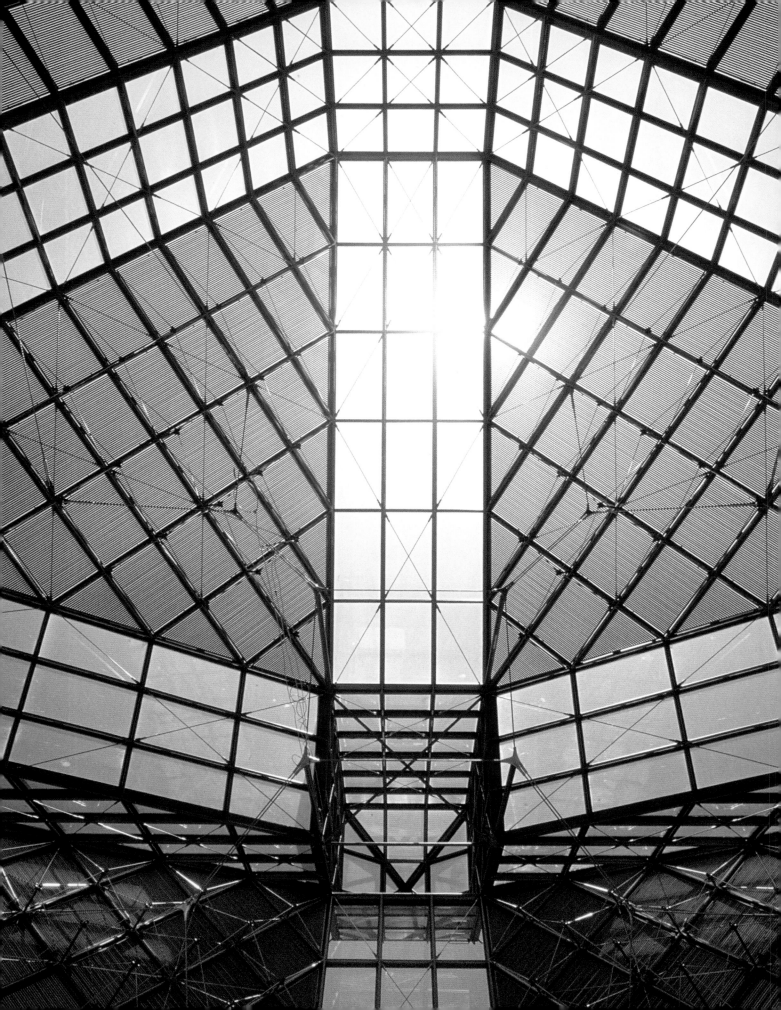

MUSÉE D'ART MODERNE GRAND-DUC JEAN (MUDAM)

Luxembourg
1995–2006

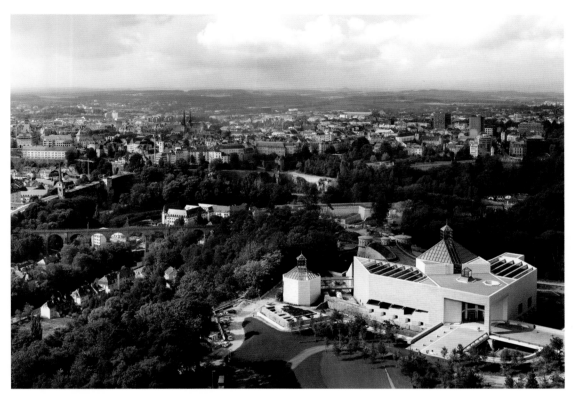

A general view of the site of the museum with the main part of the city in the distance

The geometric pattern of Pei's skylight brings sunlight and shadow into the atrium

Musée d'Art Moderne Grand-Duc Jean, colloquially known as MUDAM, was built on the rampart walls of the former Fort Thüngen on the Kirchberg plateau, above the main part of the city of Luxembourg. The arrowlike plan of the museum is directly derived from the plans of the fortifications, which were originally the work of the celebrated French military engineer Sébastien le Prestre, Seigneur de Vauban (later the Marquis de Vauban, 1633–1707). Because of a long history of foreign invasions, the city of Luxembourg developed into one of the most impressive complex of fortresses ever built — so impregnable that

it became known as the "Gibraltar of the North," protected by three defensive walls, twenty-four forts, and a 17-mile (27 km) network of manmade underground caverns called Casemates. After the 1867 Treaty of London declared Luxembourg neutral, the fortress was dismantled, but parts of it, such as the remains of the former Fort Thüngen, can still be discerned. Named after the Austrian commander-in-chief of the fortress, Baron Von Thüngen, the fort was built in 1732 to enclose the defensive works called the Redoute du Parc (Park Redoubt), which Vauban created fifty years earlier. In 1870 and 1874 the fort was demolished,

Third floor plan

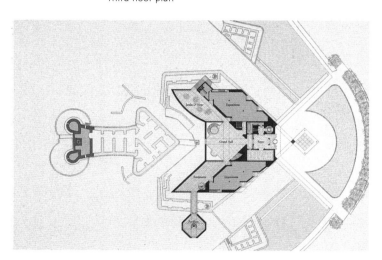

Second floor plan

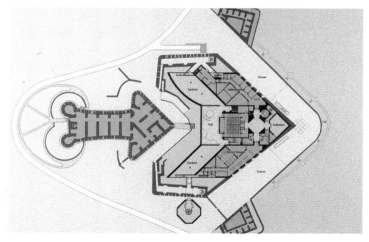

Ground floor plan

and only its three round towers, called the Three Acorns, and the foundation walls, uncovered in 1991, remain.

As is often the case with the projects of I. M. Pei, this museum is strategically located, in a sense summing up the transition of the city from the past to an increasingly modern present. The museum was built on the outer embankment walls that originally surrounded the arrow-shaped inner fort. Pei explains, "The foundation of the fortress was in very bad condition. The plan was by Vauban, but it was built by the Austrians with a great deal of rubble. They asked me to use the plan of the fortress, an arrow. The geometry was fine, but the most difficult problem was to reinforce the foundation. They continued to insist on the old foundations had to be maintained, so we had to build new, modern foundations inside the old walls."[1] The resulting design is asymmetrical, with one side of the V-shaped building cantilevered over the ruins. As the official description of the project states, "The intention is to merge the historic walls with the new building, acknowledging and continuing the rich history and use of the site."[2]

Long delayed for purely political reasons, the museum was designed by Pei without any specific collection in mind. Under the direction of the French curator Marie-Claude Beaud, a good selection of contemporary art was united for the opening in July 2006. Pei used the same honey-colored Magny Doré limestone cladding employed in the Louvre, on the walls and parapets and on a number of interior floors and walls. The most spectacular space of the museum is the

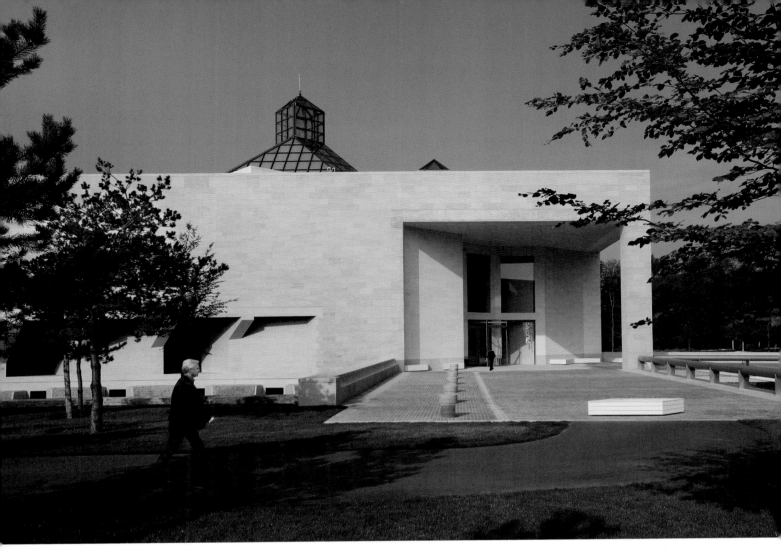

Park areas near the entrance to the museum

141-foot-high (43 m) Grand Hall, occupied for the opening by a single work created by the Chinese artist Cai-Guo Qiang. The generous volumes of the Grand Hall are due in part to the programmatic requirement to provide a space for formal dinners for five hundred guests of the Grand Duchy. Built near the curved Philharmonie Luxembourg (2003), designed by Christian de Portzamparc, the MUDAM participates in a marked effort on the part of the authorities of Luxembourg to upgrade the cultural institutions of their country.

Built at a cost of ninety million euros and offering 31,215 square feet (2,900 sq m) of exhibition space on three levels, the MUDAM has a gross floor area of 113,000 square feet (10,500 sq m). The ground floor includes the reception and orientation area, with a column-free, skylit winter

garden and sculpture court. The main exhibition spaces are located on the upper floor. The below-grade first level houses two exhibition galleries, administration and curatorial spaces, and a 128-seat auditorium, while a second basement level comprises art storage, conservation labs, and mechanical spaces.

I. M. Pei's recollection of the project adds considerable insight to its form and nature: "The Louvre Pyramid opened in 1989. It was still controversial. It was after that moment that the original client, then prime minister of Luxembourg, Jacques Santer, came to see me in New York. He decided, like Mitterrand, to award me the project without a competition. There was no collection as such, but there was some hope that the Grand Duchess would give hers to the new

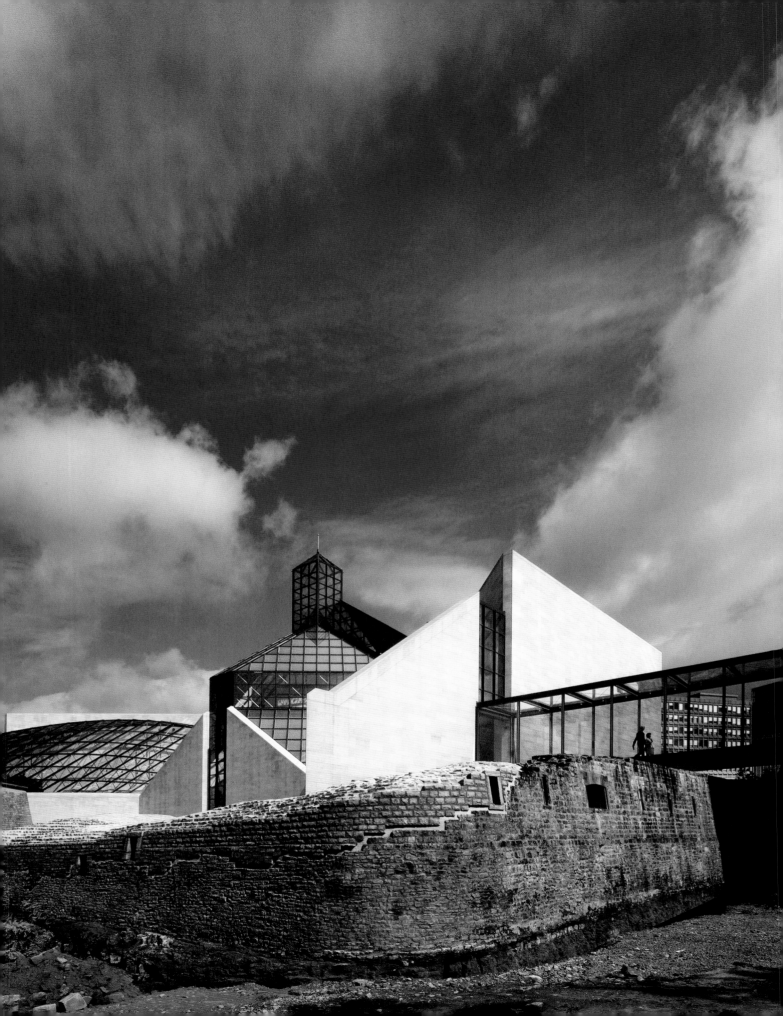

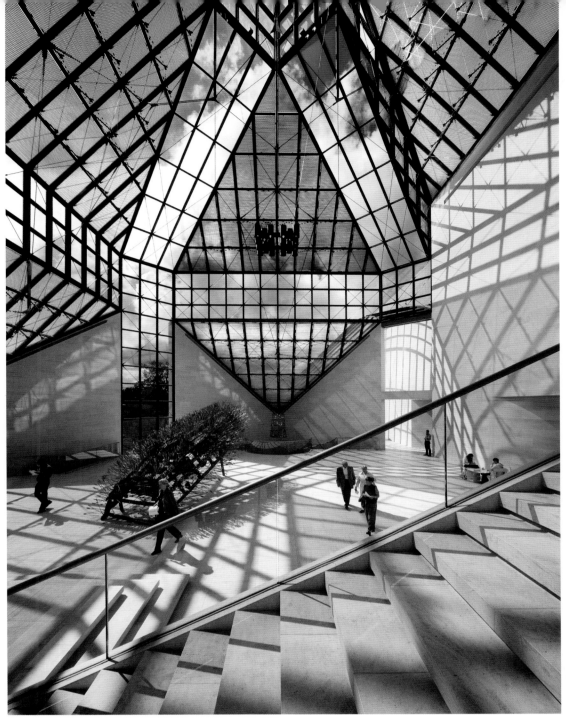

The main atrium with a single work by the Chinese artist Cai Guo-Qiang

museum, and I designed a special pavilion there, hoping to attract her. But she didn't give anything."[3]

One piece of good fortune in the project was the relative stability of the client-architect relationship despite the long period of gestation. As I. M. Pei explains, "After Jacques Santer left the prime ministership, he became the president of the European Commission (1995–99) and then [went] to Strasbourg as a member for the European Parliament (1999–2004). When he returned to Luxembourg, he became the chairman of the Commission of the Museum. His successor as prime minister of Luxembourg, Jean-Claude Juncker, was neutral vis-à-vis the project, and in a sense he allowed Mr. Santer to continue to guide it."[4]

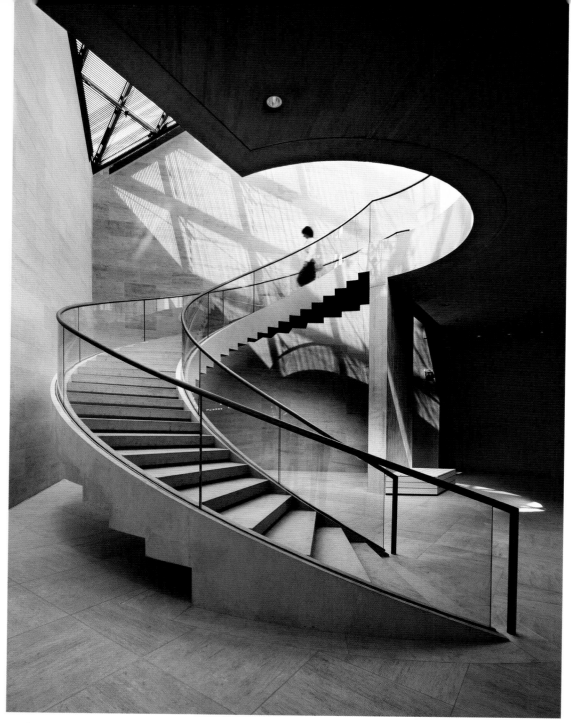

A spiral staircase leads down from the main atrium to the lower level of the museum

Despite the positive client-architect relationship, the completed building is quite different than what the architect originally imagined: "It was an unhappy project for me," says Pei, "One of the problems had to do with the site. Two locations were proposed to me in 1990, one favored by the mayor, Lydie Wurth-Polfer, and one by the prime minister, Jacques Santer. I studied the sites and selected the one suggested by Mr. Santer. It is on top of a fortress and that interested me. Part of the building still exists and the rest, to the rear, was just a foundation. The original plan was to enter the new museum through the old structure, so that visitors would get a sense of the history of the fortress. The program I received was a very open-ended one. It said, we need so many square

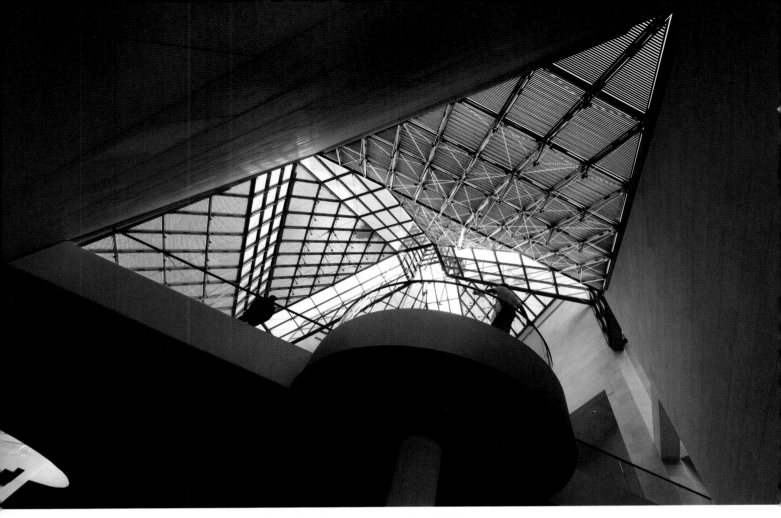

The spiral staircase seen from below, looking up to the atrium skylights

feet for exhibition space, and I believe that the intention was to attract a good number of tourists. There was no collection at all and so I used my imagination. If I were collecting, what would I do? I would create disparate parts, each with a certain character. Big paintings in one place, drawings in a lower, smaller space. My design was approved, but it was quickly attacked. The Service des Sites et Monuments Nationaux rose up and said that I couldn't use the old building as an entrance, so I had to change the back door into the front door. But I persevered. The next battle was the one of the budget, but that is a frequent problem. The museum was too big, they said, so I reduced its size. Political disagreements constantly raised problems. In the fifteen years that this process went on, at least seven, maybe more, were lost to this sort of debate. Another of the sticking points was my specification for the

Mature planted trees in the water garden

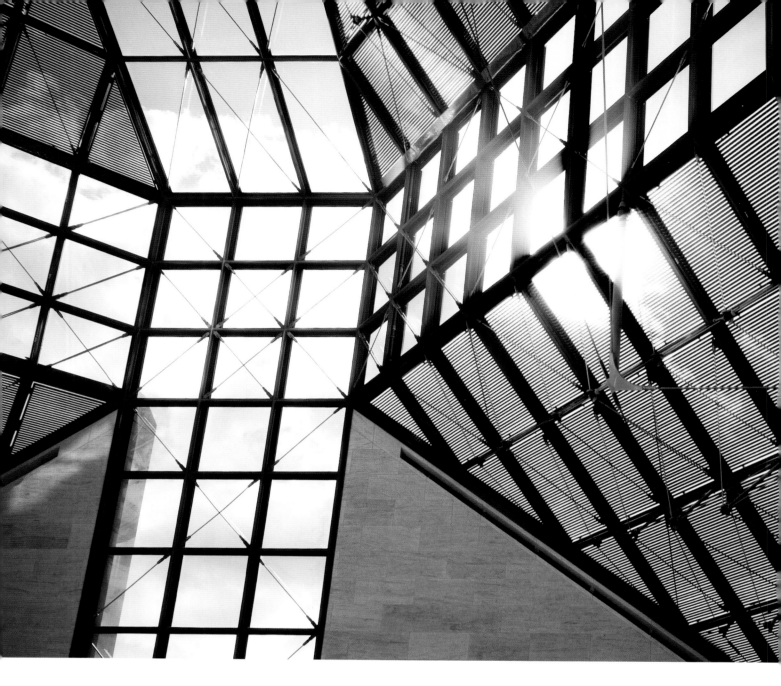

stone. I wanted to use the same Magny Doré French limestone I used in the Louvre. It is the best limestone in the world without question. I won that battle."⁵

As with the Louvre, and most of Pei's other post–Pei Cobb Freed projects, a great deal of attention was paid to siting the building. Given his reputation, Pei has had the luxury of selecting his sites with increasing freedom as time has gone on. He states, "This is one of the most prominent sites in Luxembourg. The museum commands a wonderful position to look at the old city."⁶

The fact that it is built on the foundations of an eighteenth-century fortress, in a city best known for its fortifications, links the MUDAM to its site and to the history of the country in a unique way. Pei describes the arrowlike form of the plan more in practical terms than in any specific homage to Vauban.

Given his preference, he describes the project in terms of two essential factors: light and geometry. As Pei states, "Architecture is really space and form. In order to make space and form come alive, you need light. There is no light better than

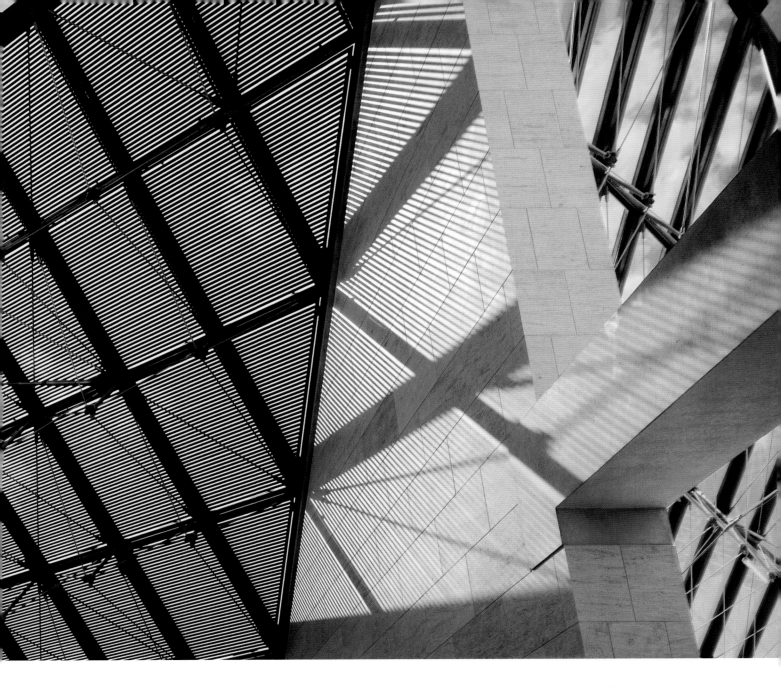

daylight. In the cathedrals, the amount of glass used was very limited, but modern technology permits the use of large glass surfaces. With a combination of solid walls and glass, there is a play between the two—light creates patterns on the solid surfaces." His respect for geometry gives a specific, modern basis to the architecture of the MUDAM. Pei explains, "Geometry came to my work early on because in the United States, the inner city is ordered by geometry. Until Frank Gehry, most contemporary architecture was very geometric. Geometry is a discipline, and I have been very disciplined."[7] In Luxembourg, the essential geometry of Pei's design is based on forms imagined by Vauban in the seventeenth century. Once again, the architect's discipline has forged, or perhaps underlined a link between history and modernity—a link that has taken on an increasing importance in I. M. Pei's later work.

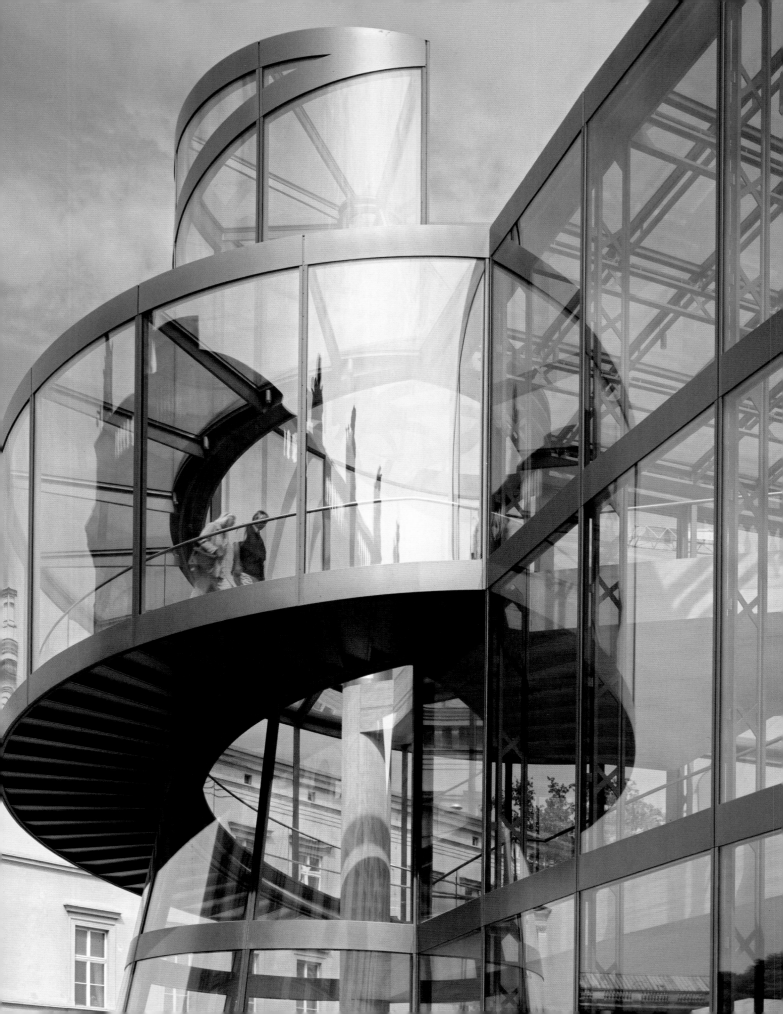

DEUTSCHES HISTORISCHES MUSEUM ZEUGHAUS

Berlin, Germany
1996–2003

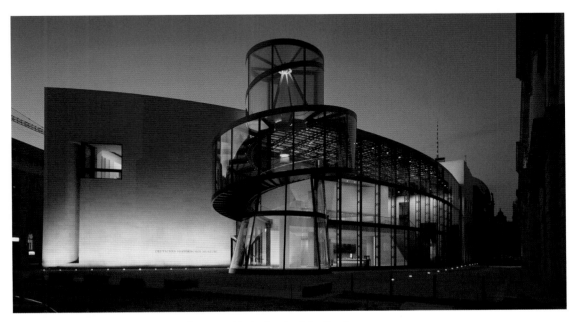

The same staircase seen from a greater distance, with the facade of the Zeughaus

An external spiral, glass staircase marks the space between the old and new

It was Frederick III, elector of Brandenburg and future King Frederick I of Prussia, who laid the first stone of the Zeughaus (Old Arsenal) in Berlin on May 28, 1695, which would eventually become the German Historical Museum.[1] Built from the plans of the architect Johann Arnold Nering, the building was given its final exterior form by Jean de Botd in 1706, but construction was not completed until 1730. Used as the arsenal of the Prussian army from 1731 to 1876, it is the oldest surviving building on the legendary Unter den Linden boulevard and the oldest Baroque structure in the city. As such it occupies a very particular place in the pantheon of German architecture, particularly in the context of the capital city, largely devastated in the closing days of World War II. In fact, bombs severely damaged the building in 1944 and 1945.

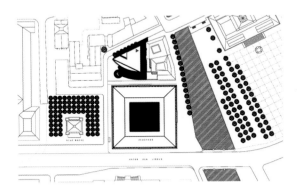

Site plan showing Pei's addition at top and the Zeughaus below

In 1815 the architect Karl Friedrich Schinkel (1781–1841) was asked to carry out a restoration of the structure to exhibit the royal collections. When the "Königliche Waffen- und Modellsammlung" (Royal Weapons and Model Collection) was first opened to the public in 1831, Schinkel also designed

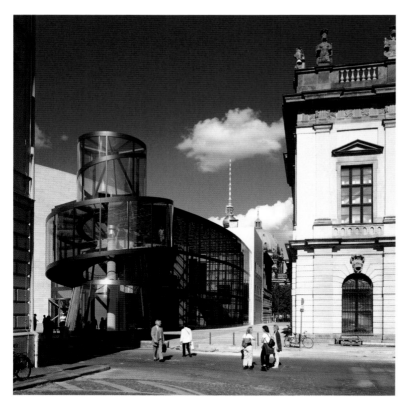

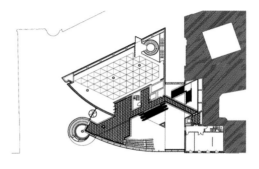
Second floor plan

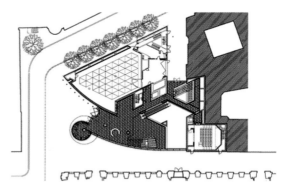
Ground level plan

The corner of the Zeughaus (right) and Pei's addition to the left

the displays. Emperor Wilhelm I (1797–1888) had the Zeughaus rebuilt from between 1877 and 1880 by Friedrich Hitzig, creating the "Pantheon of the Brandenburg-Prussian Army." Parades and commemorations were later held by the Nazis in the open courtyard of the Zeughaus until 1944. In 1945 the Allied Military Command closed the "War Museum Zeughaus," as it was then called, and reconstruction was carried out between 1948 and 1965. In 1987 the Federal Republic of Germany and the Region of Berlin founded the Deutsches Historisches Museum (German Historical Museum). The agreement creating the institution was signed by the Federal Chancellor Helmut Kohl, and Mayor of Berlin Eberhard Diepgen, on October 28, 1987, in the Reichstag on the occasion of the seven-hundred-fiftieth anniversary of the city. Originally a new building for the museum was to be built near the Reichstag. The Italian architect Aldo Rossi (1931–1997) won a competition for the project in 1988, but the reunification of Germany in 1990 changed

these development plans. It was decided that an extension to the Zeughaus would better meet the needs of the Historical Museum, especially considering that its location on Unter den Linden is in the historic center of Berlin and not far from the Museuminsel (Museum Island), which would be more recently reconstructed in work led in part by David Chipperfield. The area near the Reichstag first selected for the Rossi project was slated for the construction of a new Chancellery complex.

I. M. Pei explained his involvement in this project in a 2002 interview: "The project came to me from Chancellor Helmut Kohl himself. I considered the site to be extremely important, even though it is small and hardly visible from the Unter den Linden Avenue. It is situated between two important buildings designed by Karl Friedrich Schinkel, who is felt by many to be the most important German architect.[2] The building is an addition to an existing German Historical Museum, which is called the Zeughaus, and

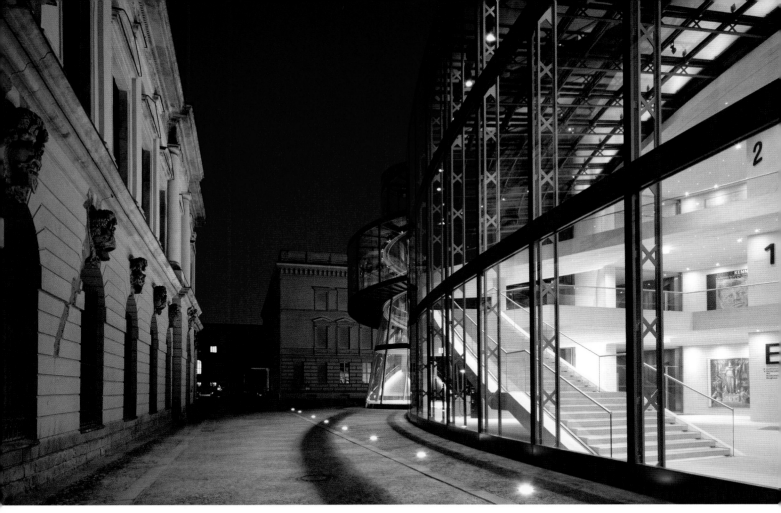

The passage between the Pei building and the Zeughaus at night

contains mostly military objects collected by the Prussians. It has no permanent collection. It does however have galleries intended for temporary exhibitions meant to tell the world another story about German history, which is precisely what Chancellor Kohl wanted."[3] The architect further comments: "The very difficult site in close proximity to Schinkel's Neue Wache, was the main feature of the project. Obviously, I made an effort to connect the two, at the circular stair."[4] The Neue Wache (New Guardhouse) was built in 1816 according to plans drawn by Schinkel. Orginally a watchhouse for troops of the Crown Prince of Prussia, the building has been a war memorial since 1931.

Called the Wechselausstellungsgebäude (Exchange Exhibition Building), and colloquially know as "Pei-Bau," the new structure is a 100,105-square-foot (9,300 sq m) addition to the Zeughaus and located on the former site of the armory's casting factory for cannons. It is a freestanding building with 27,000 square feet (2,508 sq m) for temporary exhibits as well as a gift shop, café and restaurant. It is connected via a passageway under the Hinter dem Zeughaus alley to the German Historical Museum's existing building. The project includes a large glass skylight covering the courtyard of the Zeughaus. The viability of the project required that the two buildings be connected without obstructing Berlin's scenic view corridors. It was thus deemed impossible to close the alleyway separating the new building from the old. Access to the Wechselausstellungsgebäude requires visitors pass through Pei's glass-covered courtyard in the Zeughaus.[5] "One important contribution," says Pei "is the connection linking the Zeughaus to the Schauhaus underground. We turned the outdoor courtyard of the Zeughaus,

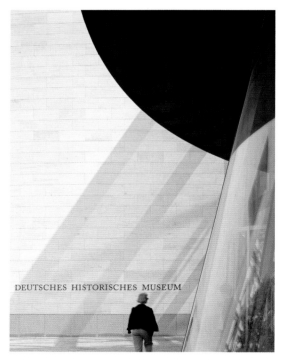

Generous space and light characterize the entry areas

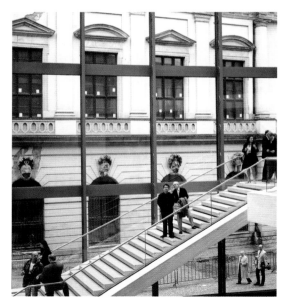

A stairway leads past the glass facade facing the Zeughaus

which had displayed cannons, into a people's place—under glass. That connection is a significant part of the design."[6] The Pei building is thus approached through an underground passage, but a four-story glazed foyer and a glass stairway give visitors ample occasions to view the forms of the Zeughaus and other neighboring buildings. The two structures are also joined at the third and fourth levels, facilitating movement between the exhibitions in the Zeughaus and the temporary ones in the Pei-Bau. A marked feature of the new building is its exterior glass-clad spiral stairway. When asked why he included this element, Pei responds, "Because of the limited dimensions of the site, we have galleries on four levels; therefore connecting the levels became an important design consideration. In this museum we have four different ways to go up each floor—each level change is a physical and a visual experience."[7] This is the circular stair to which the architect refers in explaining the relation he established with the nearby Neue Wache of Schinkel.

Set on a triangular lot, akin to that of the East Building of the National Gallery of Art in Washington, D.C., the structure is finished in Pei's preferred sandstone, and in concrete for the staircases and lintels. Some criticism of the complexity of the display areas in the new building was generated by the sometimes unusual shapes implied by the triangular plans and forms. A large round opening in one of the dividing walls brings to mind similar geometries in the Richelieu Wing of the Louvre. When asked about this element, Pei responds, "For me a circle is the most perfect geometric form. I have a memory of this form because my family came from Suzhou in China, and the Moon Gate is frequently used there. I also used it in the Miho Museum."[8] Here as elsewhere, the deep roots of more than one tradition run through Pei's architecture in ways that can be interpreted as the simple expression of geometric forms—an unrepentant Modernism. They can also be seen as signs of a quest for the links between past, present, and future, so often absent in contemporary architecture.

I. M. Pei was given the commission by Chancellor Helmut Kohl in October 1995. The design was presented to Kohl and the Berlin Senate in January 1997. The groundbreaking ceremony, with the Chancellor and Pei in attendance took place on August 27, 1998, and construction started

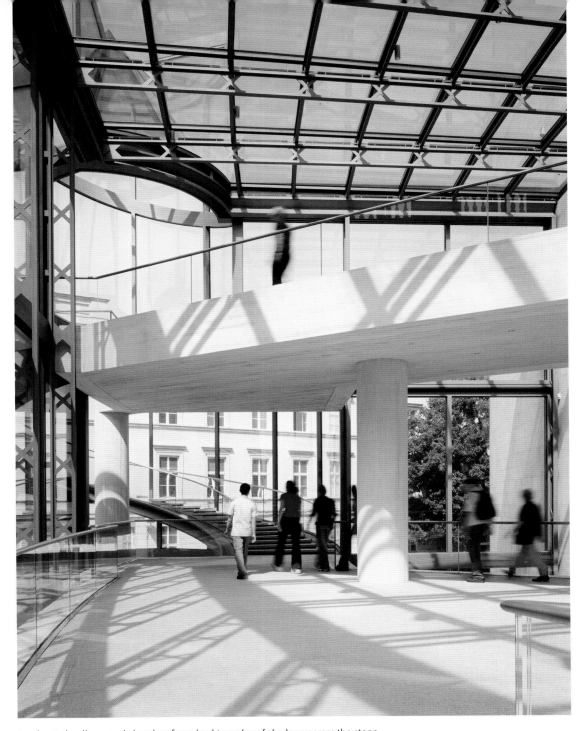

An elevated walkway and glazed surfaces lead to a play of shadows across the stone

in the spring of 2000. The building was inaugurated in 2003. The inauguration was the occasion for the opening of two exhibitions: *The Idea of Europe: Concepts for an Eternal Peace* depicted Europe's centuries-old history of cultural diversity, and on the upper floors, Pei's architectural designs, plans, models, and photos were displayed in a show titled *Pei's Museum Buildings*.

The constraints of this particular site, from a formal point of view, but also in historical terms made the Berlin project a particularly complex one. If there is one element that has come forward in the post-Pei Cobb Freed work of I. M. Pei, it may well be his careful and intentional study of the history of the sites he has worked with. In the case of the Wechselausstellungsgebäude, Pei declared,

An exhibition gallery admits lateral natural light where required

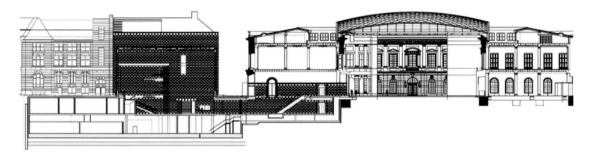

A section shows the connection of the new building to the old via a passage below grade.

"I kept thinking Schinkel . . . Schinkel . . . Schinkel. But you know I cannot reproduce something that is Neoclassic. We live in the twenty-first century. It has to be modern. At the same time one has to be respectful of the past. By making the work transparent, there's no clash of style. In that way I pay respect to the past but at the same time say we are of the twenty-first century."[9] Pei's transparency might also be said to be a reaction to the complex military history of the Zeughaus, where solidity—indeed opacity—was the rule much more than any desire to offer views to the public. Working directly at the request of the German Chancellor on a highly sensitive site linked both to the new Germany and the old—as in Paris or Washington D.C.—Pei was close to the very heart of the national spirit.

The Neoclassical architecture of Washington D.C., or the mixture of periods and styles seen in the Louvre might be less than auspicious terrain for the introduction of modernity. These factors are even more present on a site opposite a restored Baroque monument on the most symbolic of German avenues, or closer still, in a courtyard impregnated with history, some of it less than glorious. Nor did Pei attempt here to force a marriage of modernity and the burden of the past. His intervention declared that Germany has moved on to a new era, one in which "the idea of Europe" has taken the place of Prussian nationalism or militarism. Though willfully respectful of its neighborhood, the Pei-Bau also speaks a language of light and harmony that contrasts with the weight of the Zeughaus.

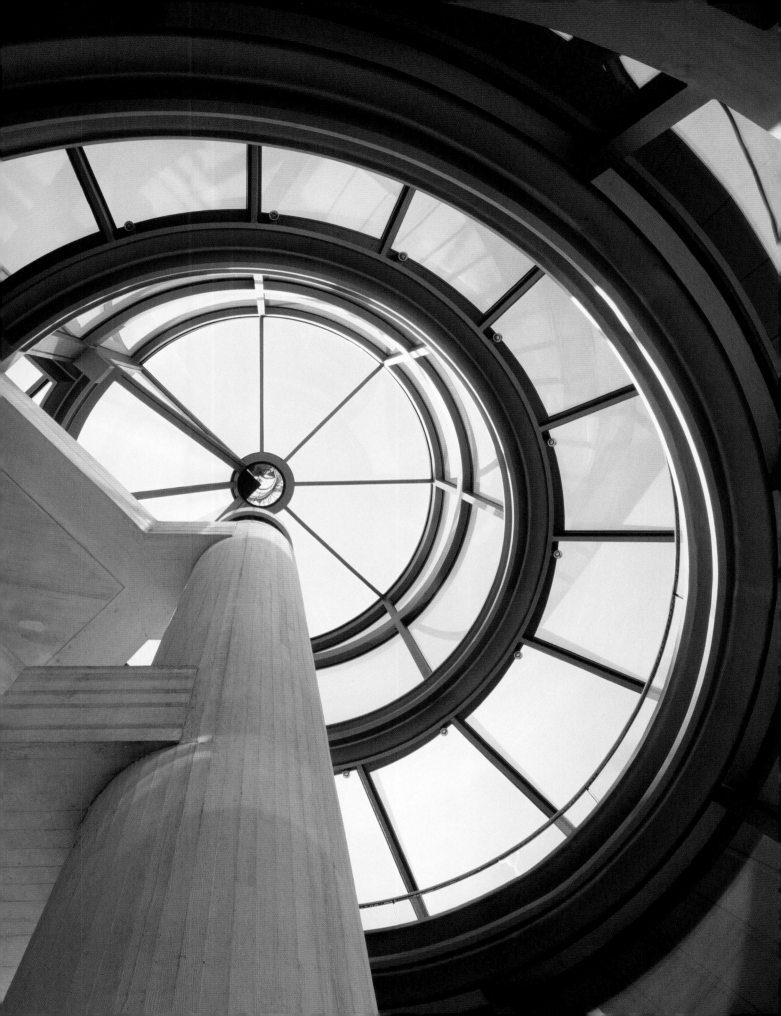

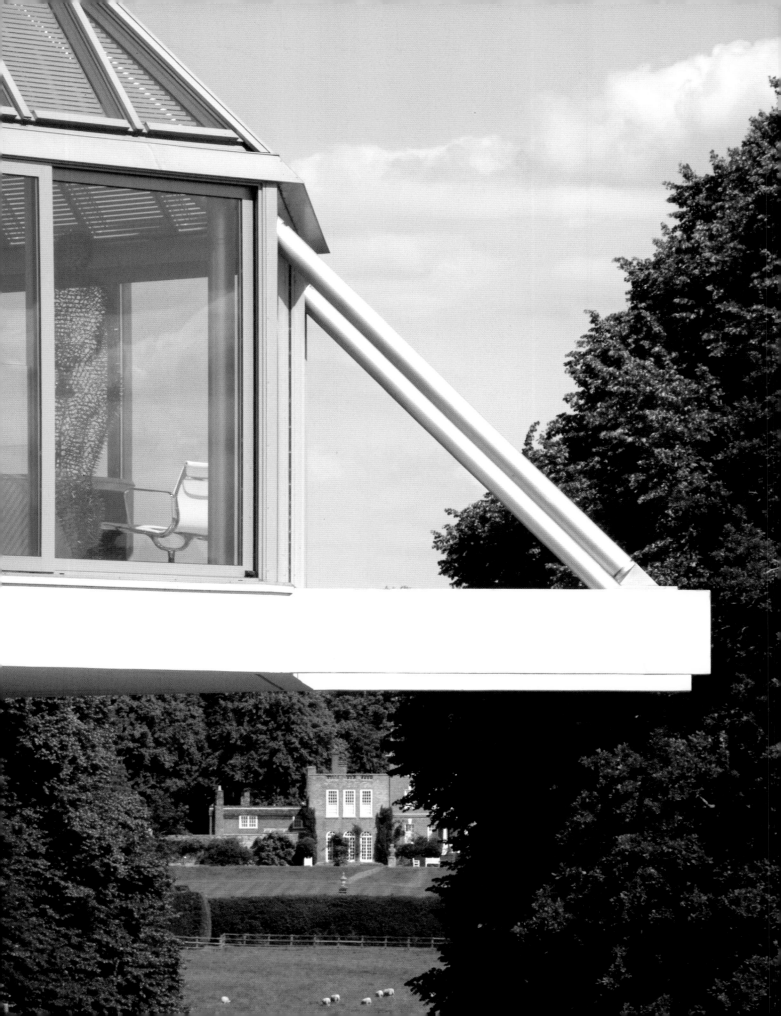

OARE PAVILION

Wiltshire, United Kingdom
1999—2003

Oare House is located in Wiltshire, England, and is surrounded by 96 acres (39 ha) of woods and farmland estate, with an 8-acre (3.25 ha) formal garden. This is where I. M. Pei erected one of his smallest buildings, a 3,110-square-foot (289 sq m) freestanding pavilion for viewing the landscape, entertaining, and receiving guests. I. M. Pei was commissioned to build this pavilion by the Keswick family in October 1999, and it was finished early in 2003. Despite its restrained dimensions, the structure has the recognizable flair of I. M. Pei's recent work and brings to mind some aspects of the design of the Miho Museum, a fact confirmed by the architect. When asked how it was that he came to build in Wiltshire, I. M. Pei responds, "This is a tea pavilion in an English garden. The tea pavilion is something of a European tradition. And there is a connection between this building and the Miho Museum. A few years ago, a lady came to visit the Miho Museum all the way from London; she returned and told her husband that she had been to one of the most peaceful and spiritual places she has ever seen and that she would like to create something reminiscent of that in a small version called a pavilion. This lady's husband's family happened to have a long connection to China. When Mrs. Keswick mentioned my name to her husband, he said he knew the Pei family."[1] As is usually the case, Pei responds in formal, architectural terms when asked about the design of this project, "The structure is an octagon 43 feet by 43 feet (13 m x 13 m). You enter the pavilion from below. There is a square opening in the center and you go up steps into the space. You have a 360-degree view of the property which is

The upper part of the structure over-hangs the relatively slim base

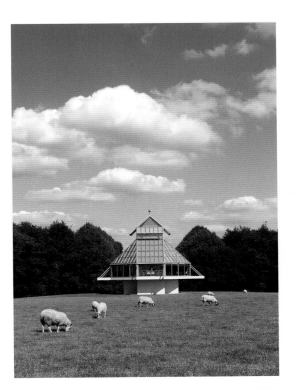

The pavilion recalls the tradition of 18th-century garden follies

very beautiful. The structural frame was designed with the assistance of Leslie Robertson who also collaborated with me on the Bank of China in Beijing and the Miho Bridge."[2] With its flared and amply glazed design, the structure does evoke the skylit spaces present in the Miho Museum but also in the MUDAM in Luxembourg.

The earliest recorded use of tea in China dates back to the first millennium BC, but its role as a part of Chinese culture was formalized in the three-volume book *Ch'a Ching*, or *Tea Classic*, written by Lu Yu in around 780 AD. In the early seventeenth century, a ship of the Dutch East India Company brought the first green tea leaves

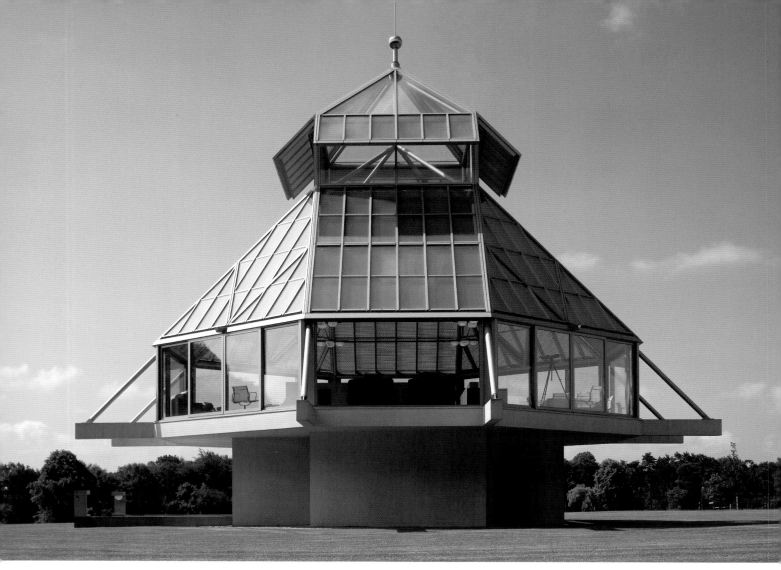

The pure lines and cantilevered forms of the pavilion give it both lightness and a strong presence

to Amsterdam from China. Tea was known in France by 1636, but appeared in England during the 1650s, where it was introduced through coffee houses. It is an interesting turn of history that the Pavilion at Oare House built by I. M. Pei was built for the Keswick family. Henry Keswick is the chairman of Jardine Matheson Holdings Limited. Formed in Canton in 1832 by the Scots William Jardine and James Matheson, Jardine Matheson sent the first private shipments of tea to England in 1834 following the Dutch East India Company's loss of its monopoly on trade with China. In 1836 the company promoted the founding of Hong Kong. Jardines, as the firm is also known, opened the first spinning and weaving factory in Hong Kong in 1897, and helped to establish the

Star Ferry Company there the following year. It was Henry Keswick's wife, Tessa Keswick, deputy chairman of the Centre for Policy Studies in London, who made the journey to the Miho Museum and discovered the architecture of I. M. Pei.

The introduction of tea into Europe, beginning in the early seventeenth century by the Dutch East India Company, was a significant event in the taste for *chinoiseries* — objects, but also architecture, influenced by often inaccurate views of China. Amongst these creations were such curious buildings as the Chinese Pavilion (1753) at the Swedish royal family's residence, and Drottningholm Palace, or The Chinese House (1755–64), designed by Johann Gottfried Büring at Sans Souci in Potsdam, Germany. This is not

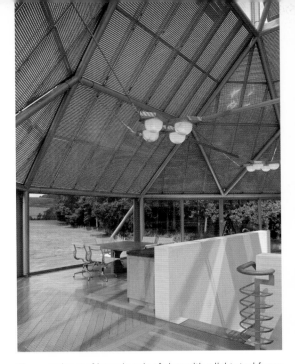

The sweeping roof is made only of glass with a light steel frame

The pavilion interior as seen roughly from its center

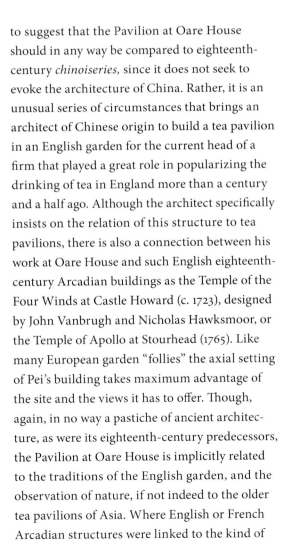

to suggest that the Pavilion at Oare House should in any way be compared to eighteenth-century *chinoiseries,* since it does not seek to evoke the architecture of China. Rather, it is an unusual series of circumstances that brings an architect of Chinese origin to build a tea pavilion in an English garden for the current head of a firm that played a great role in popularizing the drinking of tea in England more than a century and a half ago. Although the architect specifically insists on the relation of this structure to tea pavilions, there is also a connection between his work at Oare House and such English eighteenth-century Arcadian buildings as the Temple of the Four Winds at Castle Howard (c. 1723), designed by John Vanbrugh and Nicholas Hawksmoor, or the Temple of Apollo at Stourhead (1765). Like many European garden "follies" the axial setting of Pei's building takes maximum advantage of the site and the views it has to offer. Though, again, in no way a pastiche of ancient architecture, as were its eighteenth-century predecessors, the Pavilion at Oare House is implicitly related to the traditions of the English garden, and the observation of nature, if not indeed to the older tea pavilions of Asia. Where English or French Arcadian structures were linked to the kind of

nostalgia for a past that never existed, as expressed for example in the paintings of Nicolas Poussin (1594–1665) or Claude Lorrain (1600–1682), and the *chinoiseries* were based largely on misapprehensions of a little known civilization, Pei has in a sense renewed the genre of the garden folly.

While not rejecting the historic roots from which such structures grow, he sets aside the earlier models to make a modern building, one that of course functions as a tea pavilion, but also as a place to observe nature in a contemporary way. The unexpected form of the building set up off the ground on a large columnar support confirms its relationship to the tradition of the "folly," a word I. M. Pei uses and pronounces with the appropriate French accent (as in *folie*). On the occasion of the remittal of the 2003 Turner Prize at the National Building Museum in Washington, D.C., Pei said of the structure, "This is a *folie,* you know what a *folie* is, and I could only do a small garden pavilion like this after I retired. I couldn't afford to do it before but here you are a tiny little tea pavilion."[3] In architecture, a folly is an extravagant, frivolous or fanciful building, designed more for artistic expression than for practicality, a fact that did not prohibit most of these buildings from having a specific function. The French definition

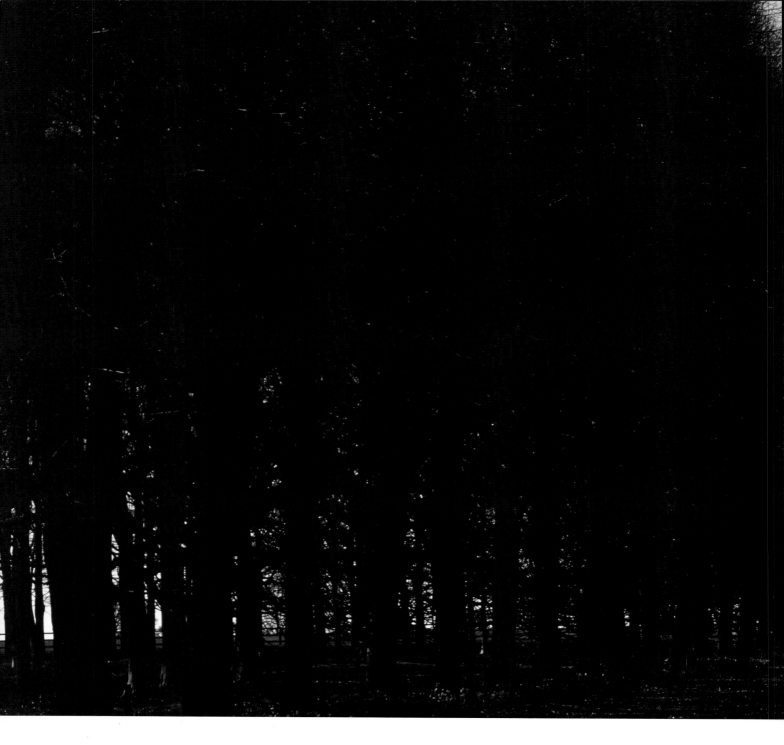

of the word *folie* is somewhat less restrictive or negative, which may well explain Pei's use of French pronunciation in this instance. In his book *Historic Gardens of Wiltshire*, Timothy Mowl makes the intended connection between the past of English gardens, and this *folie*, "I. M. Pei's Pavilion at Oare House looks like a spaceship just landed in the fields — a modern-day equivalent of the Temple of Hercules at Stourhead."[4]

The part played by the "Hongs" — of which Jardines, the Swire Group, and Hutchison Whampoa are modern-day descendants — in the Opium Wars (related in part to the tea trade) makes the historic dynamics of this meeting between a Keswick and I. M. Pei all the more intriguing. How appropriate that a Chinese-born architect, educated and formed in the West, has brought a sense of modernity to a tea pavilion in

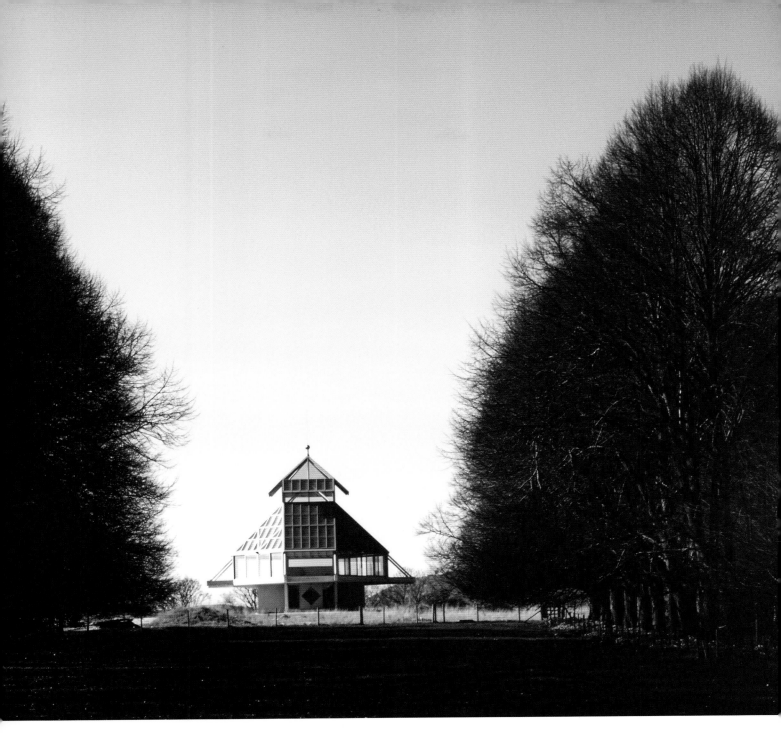

above:
The pavilion stands as an isolated modern presence in the park of Oare House

an English garden: rather than fake ruins and nostalgia, a forward-looking link between East and West, then and now. The Georgian Group, the English national charity for the protection of Georgian buildings, townscapes, monuments, parks, and gardens, gave an architectural award to the project in 2005, declaring, "This striking building, the only one in the United Kingdom by the Chinese-American architect I. M. Pei punctu-ates the view from Oare House to the Wiltshire Downs beyond and serves both as an eye catcher and a comfortable living space-cum-function room. Given that the site is 400 yards (365 m) from the main house, a fairly large building was needed to perform these two roles. This could have led to an overpowering intervention, but this building is light, airy, and ethereal — bravely contemporary in its design but also entirely harmonious in its setting."[5]

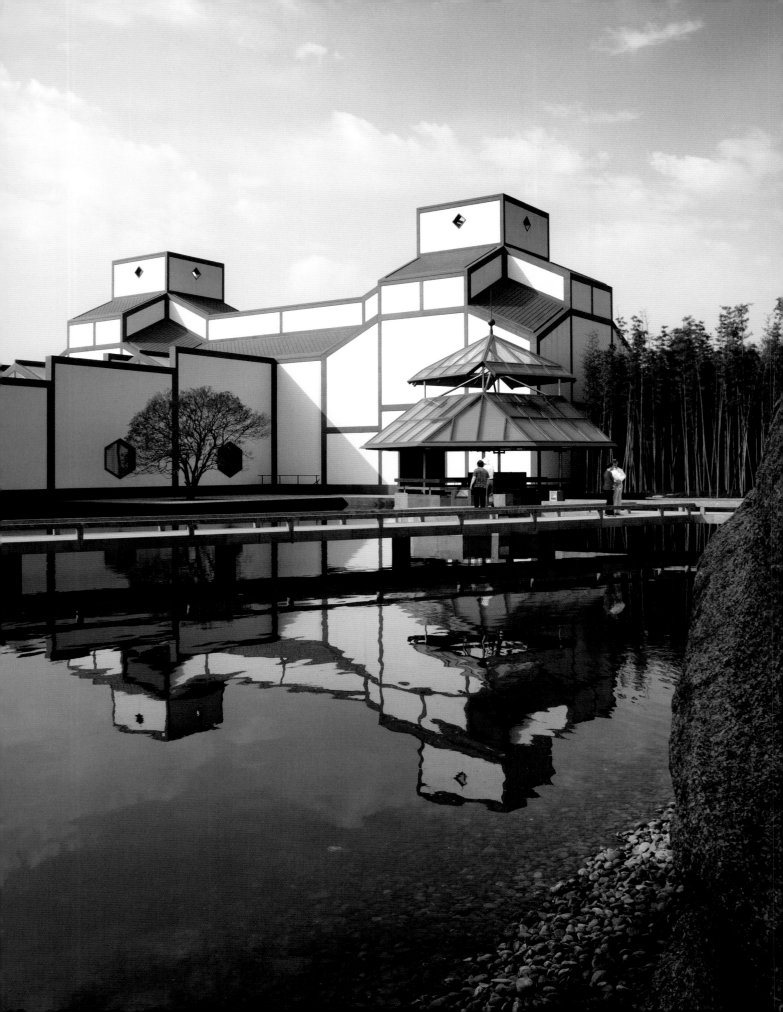

SUZHOU MUSEUM

Suzhou, China
2000–06

The Suzhou Museum is the third building designed by I. M. Pei in his native China, after the Fragrant Hill Hotel and the Bank of China in Beijing, although his Bank of China tower in Hong Kong is now technically located in China as well. Like the Beijing headquarters, the Suzhou Museum was built in collaboration with his sons' firm Pei Partnership Architects. In many ways, though, this new structure is a legacy that Pei has intentionally left to the city that was the home of his ancestors. Featuring a selection of archeological treasures as well as an interesting group of contemporary art works, the building seeks to build on Chinese tradition and remains modest in scale, in part due to local zoning rules in a historic district next to the famous Humble Administrator's Garden.[1] With 81,000 square feet (7,500 sq m) of exhibition space, a 200-seat auditorium, an attractive museum shop, offices, a research library, and a study center, the Suzhou Museum is a fitting tribute to this city of canals, once compared by Marco Polo to Venice. With its central garden, pond, and tea pavilion, the building relates closely to the typology of local gardens (one of which belonged to Pei's family) without any hint of pastiche. The gray and white forms recall those of the region, but they remain resolutely modern. Smaller than most of Pei's other cultural buildings, the Suzhou Museum, carefully set into the ancient heart of the city, represents a sensitive and successful call to respect the past while turning to the future.

In 514 BC, during the Spring and Autumn Period, King Helu of Wu established "Great City of Helu," the ancient name for Suzhou, as his capital.[2] When the Grand Canal was completed,

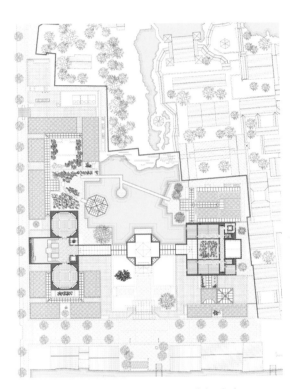

A site plan shows the pond at the heart of the design

Suzhou found itself strategically located on a major trade route. In the course of the history of China, it has been a center of industry and commerce located less than 40 miles (64 km) from the modern metropolis of Shanghai. "Suzhou can be compared to Florence or Venice in a sense," says I. M. Pei. "It has been called 'the Oriental Venice.' The sad part of it is that the canals have been partially filled. I was approached more than fifteen years ago to do something there. Five or six mayors have come and gone since then. I told them, you don't need me, you don't need a modern building. What you do need is a plan for the preservation of the city, and also you need to

The inner courtyard of the museum and its tea pavilion

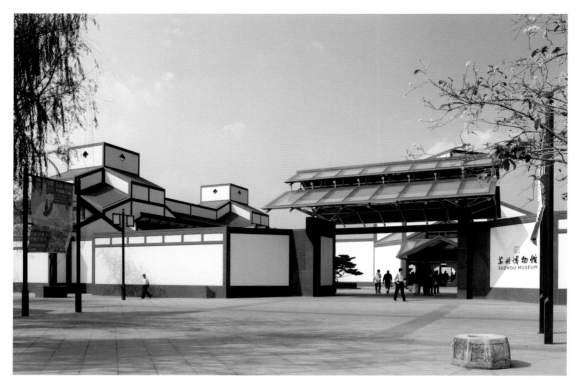

The main entrance seen from the street

clean the water. I told them I would come back as soon as the water was clean, which is very demanding, it is like saying 'no.' My late son did a lot of urban planning for them. They have worked on the water — and perhaps in five years it will be clean. I did some good for the city. There is a 'can do' attitude in China. They were interested in having input because nobody has ever really told them what to do. Suzhou is located on the Grand Canal, which was the main source of communication, but it has been polluted by industry. The Grand Canal fed into the smaller canals of Suzhou. I told them that if they did not clean the water, the city would die, and they do not disagree with that. It is very difficult to clean the canals — they had to bring water from the Yangtze River."[3]

The new Suzhou Museum is located almost adjacent to the Humble Administrator's Garden in the heart of the historic city. The garden, the largest in Suzhou, measures almost 13 acres (5.3 ha) and was built after 1513 by a retired imperial inspector named Wang Xian Chen, in collaboration with the famous artist Wen Zheng Ming.[4] This garden, together with three others in Suzhou was added to the UNESCO World Heritage List in 1997. The evaluation published by UNESCO on that occasion reads in part, "The classical Suzhou garden is a microcosm of the world depicted in the basic elements of water, stone, plants, and buildings. The Humble Administrator's Garden, the Lingering Garden, the Garden of the Master of the Nets, and the Mountain Villa with Embracing Beauty, which make up this nomination are the finest examples of the Suzhou gardens, and hence of the art of the Chinese landscape garden."[5] In 2000, an extension to the original listing was made, to include several smaller sites in the city including the former garden of the Pei family. "The Lion Forest Garden was created by a group of Zen Buddhist disciples of the famous Abbot Tianni in 1342, during the Yuan Dynasty, as the Budhist Orthodox Monastery. It acquired its present name because of a group of grotesque rocks and a bamboo forest, referring obliquely to a Buddhist legend. The garden, which attracted

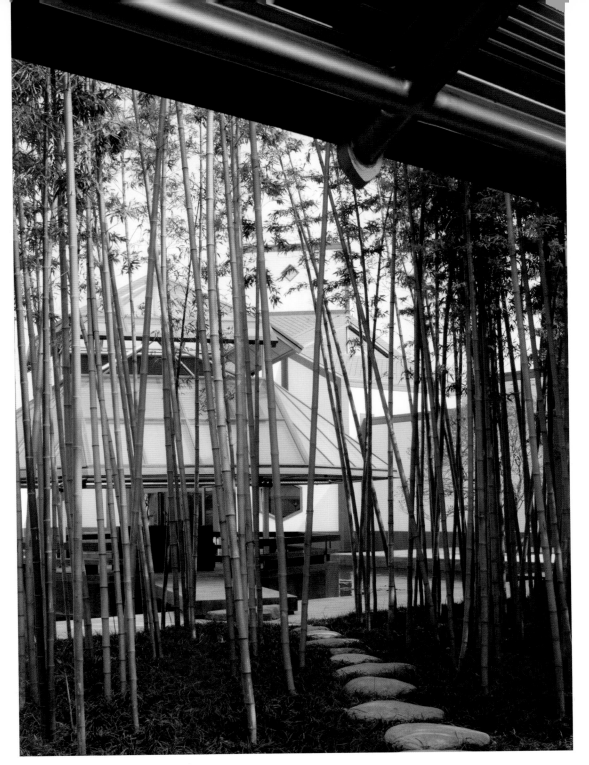

A bamboo grove near the tea pavilion

scholars and artists, was detached from the temple in the seventeenth century. Purchased by an industrialist in 1918, it was donated to the state after the foundation of the PRC [People's Republic of China]."[6] The industrialist concerned was Pei's great uncle.

Given the history of his family, connected to that of Suzhou for over six hundred years, Pei's intervention in the historic center was bound to have particular significance for him. As he describes the works there, "I think the Suzhou Museum is a very strongly contextual building.

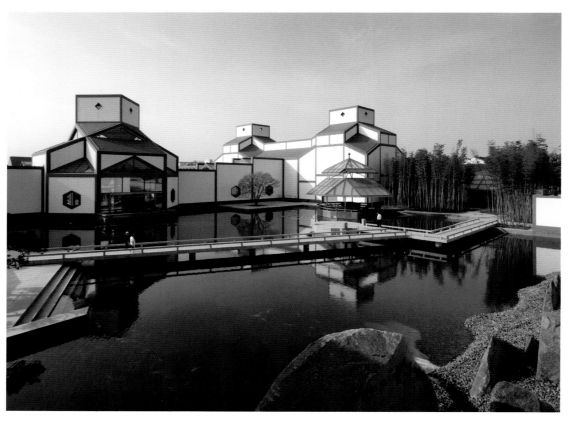

The main body of the museum as seen from behind the central pond

The local authorities wanted something contextual. I had an opportunity to try to do something that blends with the old city and yet at the same time shows we are in the twenty-first century. That is very difficult. There was no question about the materials — they would be plaster, stone, or tile. It was going to be gray and white." Indeed the Pei family had already been involved in efforts to preserve and develop the historic areas of Suzhou, which was being increasingly threatened by the economic explosion of the country. As he explains, the architect's late son T'ing Pei (1945–2003), who studied city planning at MIT was notably involved in a 1996 workshop there called "Suzhou, Shaping an Ancient City for the New China." In the afterword of a book published on that occasion, Pei wrote, "The question of preserving China's ancient and historical cities in the face of the unprecedented and explosive modernization and industrialization of the country is one of the most important issues to be tackled entering

the new millennium. This was the challenge I asked my son T'ing to address on behalf of our family's native Suzhou. Together with his colleagues from the firm EDAW, Inc., they prepared a set of guiding principles for one of the most sensitive districts of Suzhou, which can show the way for the redevelopment and revitalization of the area while maintaining and enhancing its historical character. This is a formula which can surely be adapted to other ancient cities in China and perhaps elsewhere. As with any plan, however, the ultimate question is whether there is the political will and administrative capacity to see it through to execution. This does not mean that it has to be pursued inflexibly, as conditions are constantly in flux, but it does mean that there should be a long-term determination to go from a plan to implementation."[7] The involvement of the Pei family in the study and implementation of policies for the preservation of Suzhou's historic district is significant not only because it was a

opposite:
The pond is crossed
by a footbridge

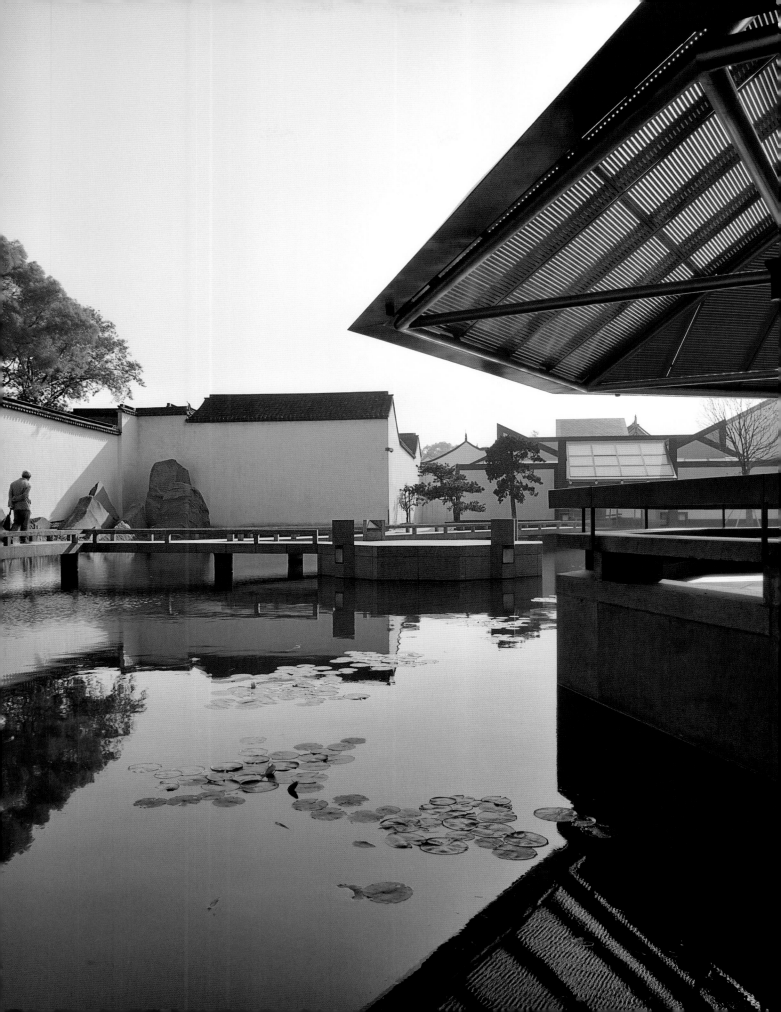

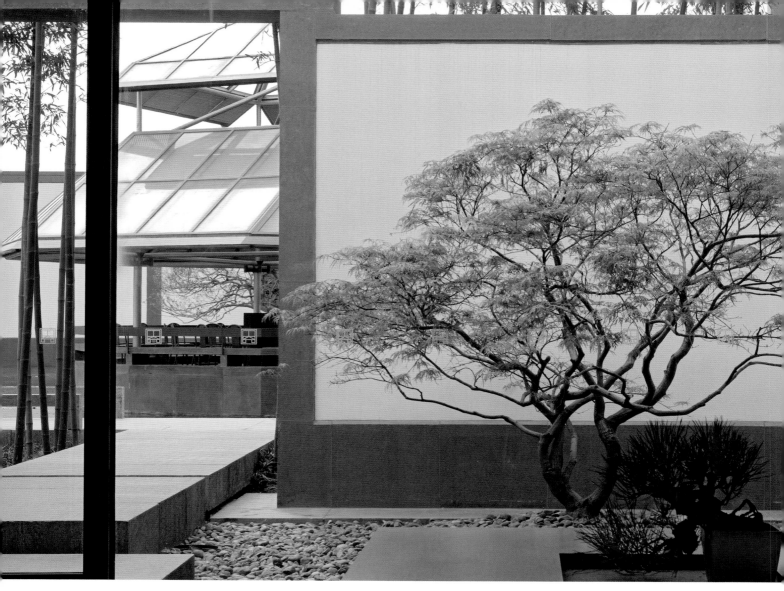

Carefully selected trees grace the gardens within the museum

kind of return to his roots for I. M. Pei, but also because it demonstrates his strong belief in the importance of history. Pei acknowledges the ambiguities of redevelopment and revitalization in such a complex context, but he sees no contradiction between his own designs and the ancient city. His interest in the past does not make of him an apostate of modernism; rather it reveals, yet again, his personal search for ways to express the deep links that can exist between a truly modern building and the past. Where the utopian blank slate proclaimed by Walter Gropius or Le Corbusier's famous Plan Voisin (1925) might have dismissed such concerns, Pei's retirement projects, taken together, represent a formidable

quest — for the undeniable essence of cultures, near to his own origins, such as China, or more distant, like Islam. There is a continuity that links the Louvre to Suzhou and Doha, and it is not merely stylistic.

Pei was clearly inspired by the surroundings and notably the gardens of Suzhou in designing this museum. "When you are looking for old architecture in China, there is not that much of it," he explains. "There are palaces like the Forbidden City or Buddhist temples and monasteries. The rest is made up of villages and towns where people live and work. In cultural buildings, garden and building are one — they are not separate. I can't imagine doing a building in China without a garden.

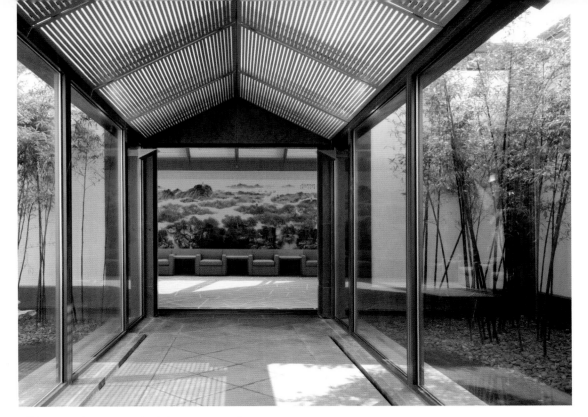

A light, covered passageway leads to a museum gallery

There is no distinction between garden and rooms; they are joined together. The garden cannot be big — they are always are on a human scale." The Suzhou Museum is also related to the tradition of the Chinese house, as the architect explains: "Big houses in China are measured by how many courtyards they have. The family is the basic unit, but they do not wish to flaunt wealth, so they build high walls. In the case of my own family garden, which was not a place to live but to entertain, there is a very simple black or red back door and white walls with gray tiles. Inside, there are courtyards after courtyards. You have a tradition of gardens behind walls."[8]

The architect points out that there is a significant distinction to be made between his earlier work in China and the new structure: "There is a difference between the Suzhou Museum on the one hand; and the Fragrant Hill Hotel and many other projects in regard to the third dimension," he says. "They all have flat roofs. I have given the Suzhou Museum a volumetric solution, and this is a major change."[9] Though there are slopes in the roof configurations, the basic design remains rectilinear rising in an orchestrated pattern, which might bring to mind the main structure of the Doha Museum of Islamic Art, albeit on a smaller scale and with different materials. The sloping roofs of China are echoed fleetingly in the angles the architect brings to this "volumetric solution," as they are in the tea pavilion in the central garden.

Within the walls of the Suzhou Museum, one of the most notable features is a large pond. "Water is very important," says Pei. "Chinese gardens consist of three elements — water, rocks, and plants. There is no such thing as a lawn in China. You don't go out in the garden and play badminton. That kind of Western life in the garden does not exist. People like to meander and to lose themselves in a garden. I used to play hide and seek in the rocks of our garden — they are wonderful for children to get lost in. In the case of the museum, we did not want people to meander outside, but to stay in the museum. There is a tea pavilion that is very popular. The wisteria garden and the tea pavilion are the most popular places since the museum opened." As is evident, the Suzhou Museum is replete with references to

Chinese tradition and the wisteria to which Pei refers is no exception. The architect explains, "That is very Chinese. Chinese always talk about tradition, continuity, the family, the ancestors. . . . In the big house next to the museum, there was a little courtyard with a wisteria planted there by one of the great painters of China. His name was Wen Zheng Ming. I wondered if I could have a cutting and the Chinese gardener said yes. It is growing. The cutting is spliced on and one day they will cut the rest off and let that cutting be the main wisteria. It doesn't matter how much work it represents, if the Chinese like the idea, they will do it. One day, it will be called the Wen Zheng Ming Garden and that will attract a lot of visitors."[10] Wen Zheng Ming was a designer of the Humble Administrator's Garden, and one of the most famous figures of Suzhou. Pei explains, "Suzhou is only 50 or 60 miles (80-97 km) from Shanghai, but traditional and extremely conservative. Many of its people still live the ideal life of the Ming and Ching Dynasties, the golden age of Suzhou: they still talk about the great painters and poets of those eras."[11]

A work made of sliced rocks runs along the long rear wall of the interior garden of the Suzhou Museum. Though not precisely part of the architecture, this wall, designed by I. M. Pei is another important element in his exploration of tradition and modernity. Pei explains, referring to the Lion Forest Garden, "My family garden started in the Yuan Dynasty with Taoist priests. Taste declined over time, and my great-uncle changed it. He selected rocks from Lake Tai, which is not far away. They call what they do there rock farming.

Volcanic rocks are selected and left to erode in the water for periods of fifteen or twenty years. They cut a hole here and put it back into the water and let it erode more until it becomes a beautiful thing. This is how these rocks, quite typical of Suzhou, are made. Rocks became very important in gardens. They are like sculptures. Poets and painters worked on rock gardens beginning in the Yuan Dynasty,[12] but they don't have painters and poets who do this anymore. I told my client, a mayor of Suzhou, that we didn't have the painterly eyes necessary—the craftsmen for rocks. I wanted to try something else, something new. I sent a young architect to Shandong Province (near Korea) where there are many stone quarries. They have huge boulders that can be cut with a steel wire—a silhouette I was looking for. Forty or fifty slices of rock were brought to Suzhou. I selected about thirty of them, and then in 2005, I went there and they were all on the ground, so I sat in the middle of what is now the pond at a table and looked at that wall. I had the reproduction of a work by a painting by a great Song Dynasty painter in front of me, Mi Fei's *Mountains and Clouds*.[13] There was a crane there—so they put pieces up and down as I wished. I did that for about a week and finally got something that looked reasonably good. At least it is a way of using rock in Suzhou within the limited space we have. Have I done anything that will be useful for the future? I don't think so, but it is a way to use rocks to create a sort of a three-dimensional painting after the work of Mi Fei."[14] This particular intervention of the architect is quite unusual. In projects like the Doha Museum of Islamic Art,

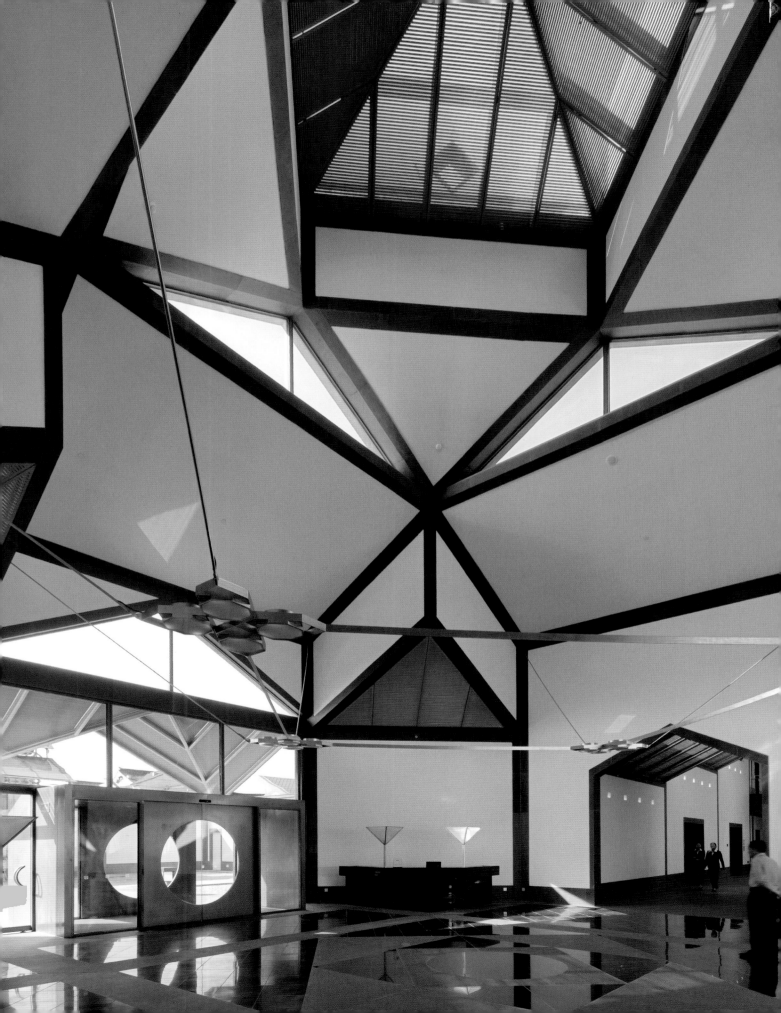

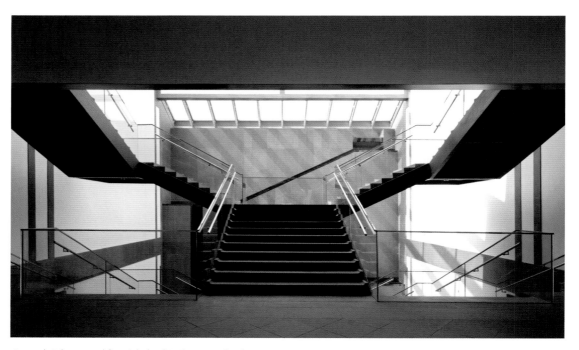

A grand staircase and fountain lead to the upper level

he has shown a direct interest in decorative floor patterns or elements such as the Islamic-inspired light fixtures. These additions have usually been conceived in Pei's strict geometric vocabulary, but in Suzhou, he has ventured into the nonlinear and almost to the figurative. Though the gardens of Suzhou are decidedly three-dimensional forms of expression, I. M. Pei links them to Chinese painting and speaks of a "painterly eye" when referring to the craftsmen who created a garden in the spirit of the city. The link between Mi Fei and the gardens of Suzhou is a sublimated search for the essence of nature, a symbolic evocation of the world. Though the relief of Pei's wall rock sculpture is low, he calls it "sort of a three-dimensional painting," bridging the gap between the first two dimensions and the third. Though it may appear natural for Pei to seek the past in the city where his family has been for six hundred years, the Suzhou Museum is not simply a fortuitous opportunity; it is part of his quest for a modern vernacular that can be linked to a place even as it speaks to a broader audience. Although some lines, colors, or materials may openly echo local usage, what Pei has sought in Suzhou and

elsewhere, is a sublimation of tradition in architecture that bridges the chasm between the brutal march of China's new skyscrapers and its real roots, its culture. Though forging such a link is not within the power of many architects, in this place it is a signal of what can be done, and an indicator of what remains to be accomplished.

The design for the new structure was displayed publicly in 2003 in the old Suzhou Museum, and visitors were asked to give their opinion. A thousand residents of the city visited the exhibition in the course of seven days. Of 421 votes recorded, ninety-three percent of the votes were in favor of the design and only four percent against, mostly for reasons related to the site.[15] This unusually favorable public reaction may be related to the fact that Pei has made a considerable effort to fit the gray and white structure into its historical environment, while providing a modern facility. The very high numbers of visitors recorded since the opening in October 2006 confirm this initial positive reaction. Set on a 107,000-square-foot site (10,000 sq m), the museum has a gross floor area of 183,000 square feet (17,000 sq m), and aside from the exhibition

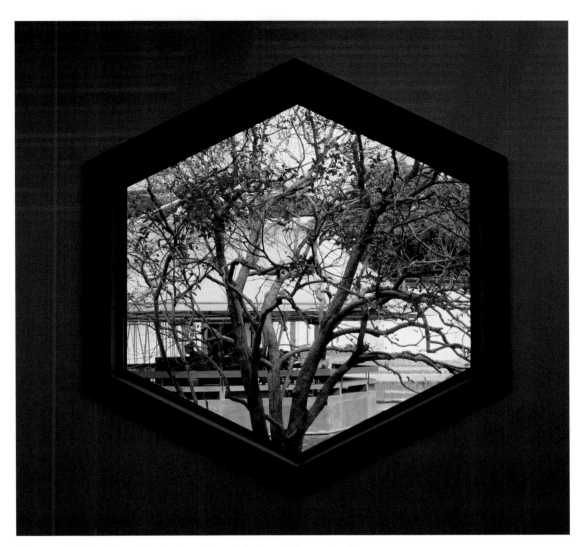

A hexagonal window frames the view toward one of the trees in the courtyard

spaces includes 32,291 square feet (3,000 sq m) of public amenities including the auditorium, a multipurpose hall, museum shop, and tearooms. Visitors enter on foot from the newly restored Dong Bei Jie street, and come through the main entrance gate to the entrance court. Located to the right of the entrance court is the museum shop, and to the left is the museum admissions office. A Great Hall is the first interior space, with a terrace looking out onto the central pond and garden. The pond is crossed by a two-part pedestrian walkway, with a tea pavilion, in some ways similar to the Oare Pavilion in England, built on a small octagonal island in the pond. In the East Wing, to the right of the entrance,

contemporary art galleries are located as well as the Wisteria Court and a tea house and library. To the left in the West Wing are more traditional art forms in galleries 1 and 2, which are devoted to the Hu Qiu Pagoda treasures, Neolithic pottery and jades, tomb relics, a Ming scholar's study, and textiles. Galleries on the second floor of the West Wing show Wu painting and calligraphy. The auditorium is in the West Wing basement. The museum is adjacent to the Zhong Want Fu, former residence of Prince Zhong, the leader of the Boxer Rebellion. This building contains a Classical Opera Theater, used for a special performance on the occasion of the opening of the museum in October 2006.

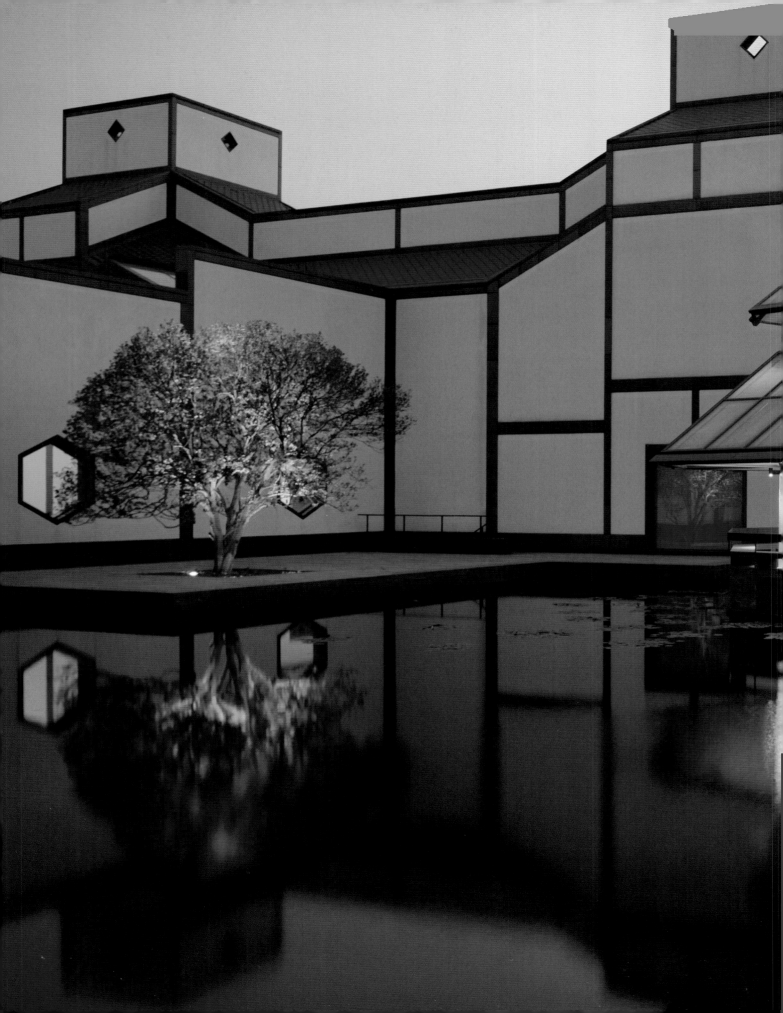

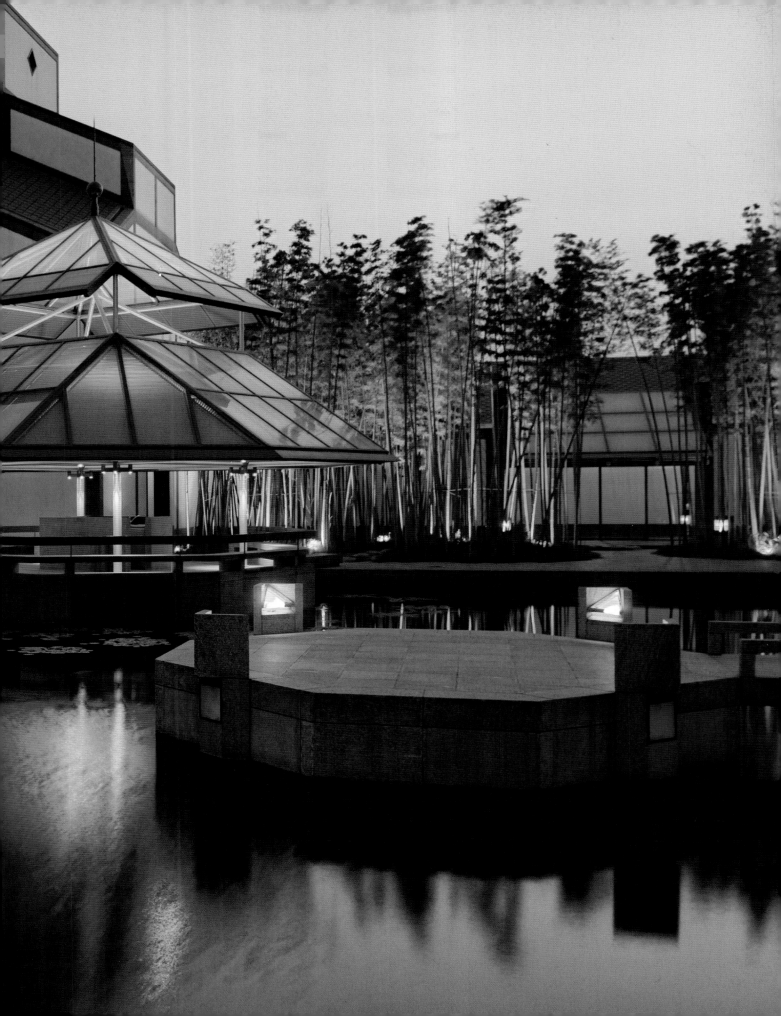

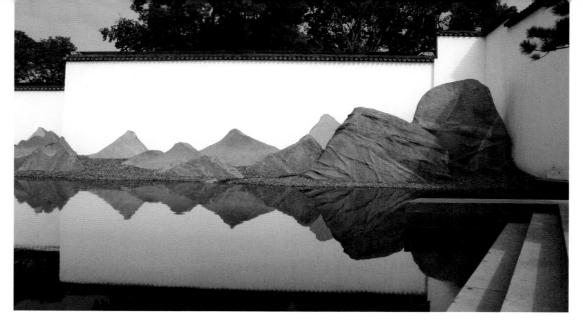

The sliced-rock design at the back of the pond is by I. M. Pei

The heterogeneous nature of the collections from the Neolithic to the contemporary makes sense in the context of this building where ancient Chinese traditions are sublimated and brought forward into the present. I. M. Pei remains modest about his accomplishment, although he had willfully imagined that this would be his last work.[16] In this instance, Pei was not offered a selection of different possible sites, since the old city of Suzhou is densely built, but he has, as usual, occupied a central, significant location, set not far from his former family garden, clearly a source of much of his inspiration, not only in the case of the Suzhou Museum, but elsewhere as well. Round openings and geometric forms are as present here as they have been in so many other buildings by Pei. The modesty of the scale of this building, partially imposed by local zoning restrictions, is as much a factor in its harmonious presence as many of the more subtle, historically oriented gestures of the architect, such as the Wen Zheng Ming wisteria garden. In many ways, building here was very much a way of going home for I. M. Pei, even though he was born not in Suzhou but in Canton. His family roots and much of his aesthetic sense came from the gardens and buildings of this ancient city, which is today threatened by an overwhelming wave of mediocre towers and shopping centers. Though Pei does

not frequently speak of the accomplishments of his sons, he is visibly proud of the work that the late T'ing Pei did to give local authorities a better understanding of the potential of tourism and reasoned development offered by the gardens, canals, and alleys of China's glorious past. It is certainly appropriate that this project, more than many other late works of I. M. Pei, is a family project; his three sons, as well as other family members, contributed in numerous ways to the success of the museum. As Tessa Keswick, the client for the Oare Pavilion, wrote in article for the English press on the occasion of the 2006 opening of the Suzhou Museum, "The great Mandarin has recreated the essence of what his family lost, but this time in his unique modern idiom. We see many whitewashed buildings with low grey roofs and flyaway eaves surrounding a beautiful stretch of glimmering water. Reflected in the water is a marvelous *enfilade* of tall architectural stones positioned against a brilliant white wall. A modernist pavilion shimmers in the water, its stone bridge edged with giant bamboos. Throughout the museum are hidden courtyards planted with ginko, pines, and willow."[17]

opposite:
A gallery with a large square window opening toward the bamboo grove

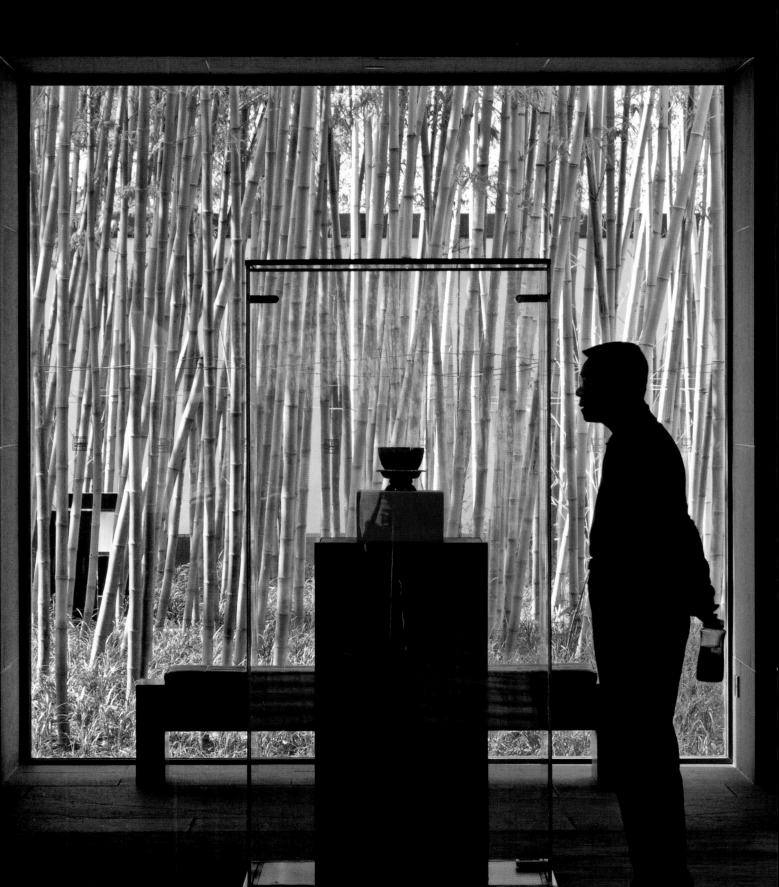

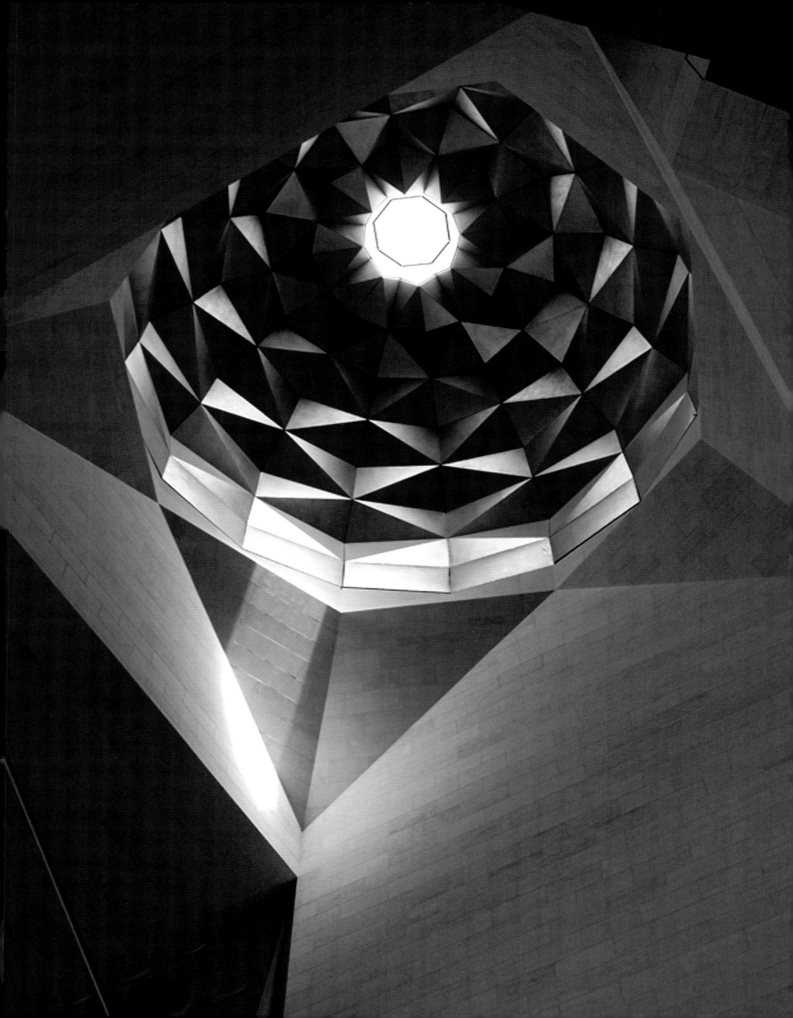

MUSEUM OF ISLAMIC ART

Doha, Qatar
2000–08

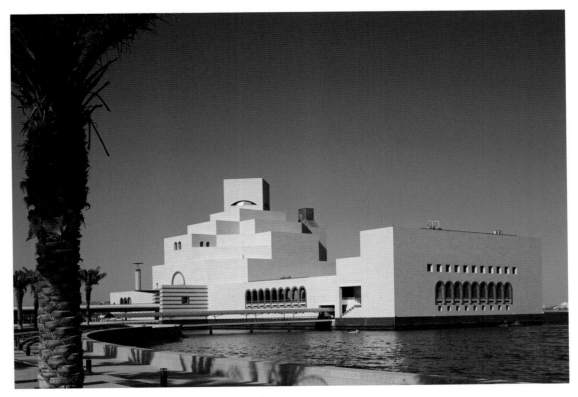

A view of the museum from the park along the water's edge

The main dome
in the atrium
of the museum

The Museum of Islamic Art in Doha, Qatar, opened to the public in November 2008, may be I. M. Pei's last large-scale building. He has stated that he wishes to take on no further major projects, athough he is at work on a new private commission. The Doha building was originally scheduled to open before the Suzhou Museum, but political issues in Qatar delayed the inauguration and the completion. In fact, a number of major projects in the Perisan Gulf emirate launched by Sheikh Saud al-Thani with architects, including Santiago Calatrava and Arata Isozaki, were halted altogether when questions were raised about his purchasing policies. The architects' intentions or actions were never part of the problem, but Saud al-Thani's methods were. Saud al-Thani, the former chairman of the National Council for Culture, Arts, and Heritage (NCCAH), was replaced, allowing the Museum of Islamic Art, already quite advanced in planning, to move forward while other projects, such as Arata Isozaki's National Library of Qatar, were cancelled or put on indefinite hold.

Doha is located on a peninsula in the Persian Gulf, more commonly called the Arabian Gulf by Arab residents of the region. The Greek geographer

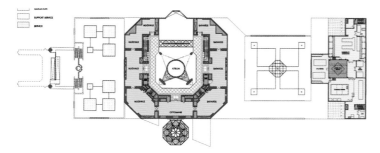

Third floor plan

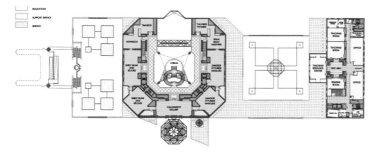

Second floor plan

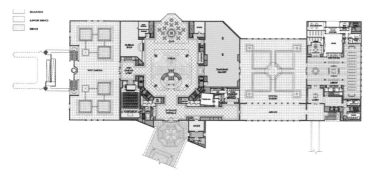

First floor plan

Ptolemy (83–161 AD) showed a town called Qatara in his "Map of the Arab World" — probably the Qatari town of Zubara, an important Gulf trading post. Qatar converted to Islam in the mid-seventh century and gained a reputation for the skill of its people in weaving and fabric making. Early in the sixteenth century, Qatar came under the influence of the Portuguese, who controlled trade and navigation in many areas of the Gulf. In 1538 the Ottomans expelled the Portuguese and Qatar began a four-century-long period of Turkish rule. The Turks withdrew from the area in 1916, and Qatar became a British protectorate, which it remained until 1971. Oil was first discovered in Qatar in 1939, and the discovery of natural gas

later added to the substantial energy reserves of the state. With the accession of His Highness Sheikh Hamad bin Khalifa Al Thani in 1995, Qatar entered a new period of modernization and social transformation. The most visible aspect of this transformation can be seen in Doha, a modern yet rather austere city, which retains many aspects of its traditions, a fact that earns it the name "City of Balance." Its 4.6-mile-long (7.5 km) water-front Corniche, bordered by hotels, government offices, and an increasing number of high-rise buildings, is Doha's most central and spectacular feature, with the new Museum of Islamic Art standing at its tip on an artificial island.

As I. M. Pei explains, his project in Doha was the result of rather complex circumstances: "I believe that the Aga Khan organized a competition in 1997 from which two architects emerged. The first choice of the jury was Charles Correa and the second choice was a Lebanese architect called Rasem Badran. Badran was selected by the State of Qatar to build the museum on the Corniche. His project unfortunately did not go forward, and I was contacted by Luis Monreal, who had been a member of the original jury. Mr. Monreal, now general manager of the Aga Khan Trust for Culture, knew that I did not participate in competitions, but he persuaded the Emir that I might be a good choice to design the new museum. I was offered a number of sites along the Corniche including the originally planned location, but I did not accept these options. There were not yet too many buildings nearby, but I feared that in the future, large structures might rise that would overshadow it.

I asked if it might not be possible to create my own site. This was very selfish of me of course, but I knew that in Qatar it is not too complicated to create landfill and thus, the Museum of Islamic Art is located on the south side of Doha's Corniche on a manmade island 60 meters (197 ft) from the shore. A new C-shaped peninsula provides protection from the Persian Gulf on the north and from unsightly industrial buildings on the east."[1]

I. M. Pei has explained that his work on the Louvre changed his approach to architecture, and led him to engage in extensive studies of new sites and cultures in the hope of better grasping local imperatives. The Doha project was no exception. Although the Gulf emirate has produced relatively little art over its history, it was decided by His Highness the Emir of Qatar that Doha, in the heart of the lands of Islam, could become a place where some of the finest artworks of the Muslim world could be assembled. Purchases of carpets, glass, ceramics, jewels, and miniatures went forward and continue to this day. As Pei points out, the situation of the Miho Museum, or even of the MUDAM in Luxembourg were similar in that the collections were being formed even as he worked on the designs. Though not itself a producer of these works, Qatar aimed to become a center for their conservation and exhibition. In itself, this was an innovative or even daring concept, given that most of the major collections of Islamic art in the world are not located in the region where they were created. It was in this spirit that Pei approached the architecture of the future museum. "This is was one of the most difficult jobs I ever undertook," he says.

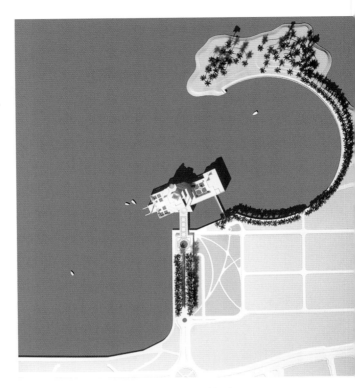

The museum island with its crescent-shaped basin

"It seemed to me that I had to grasp the essence of Islamic architecture. The difficulty of my task was that Islamic culture is so diverse, ranging from Iberia to Mughal India, to the gates of China and beyond. I was familiar with the Grand Mosque in Cordoba (784–66, 961–66, 987–90) and I thought that it represented the pinnacle of Islamic architecture, but I was wrong. The combined influence of climate and the culture of Spain meant that Cordoba was not the pure expression I was seeking. The same was true, for different reasons of Fatehpur Sikri, a Mughal capital where one of the largest mosques in India, the Jama Masjid, was built. I recognize that my intellectual process might be considered very subjective, but here the Indian influence is tangible, and again, I had not found my inspiration. Even the Umayyad Great Mosque in Damascus (709–15), the oldest extant monumental mosque seems to carry with it elements of the history of Rome or of early Christianity. A Roman temple and a Byzantine church had stood on this site before the mosque was built. Where Byzantine influence could be

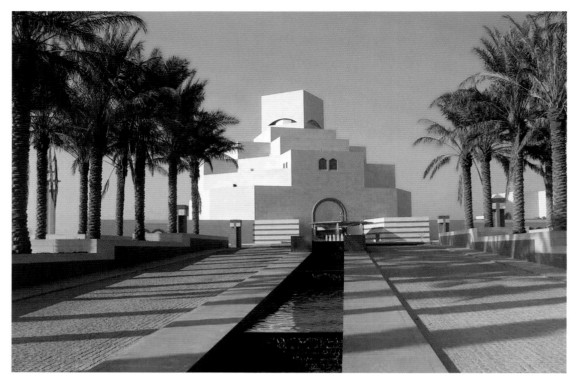

The main entrance drive to the museum with its central watercourse

felt, I again decided that my quest had not reached its goal. I went to Tunisia and although my intention had been to examine the mosques, I was taken with another type of architecture in the form of the Ribat Fortress at Monastir (796). There I felt I was coming closer to the essence of Islamic architecture, where sun brings to life powerful volumes and geometry plays a central role."[2]

Pei's drive to select the best possible site in Doha, even going to the extent of creating his own site in the water, together with his insistence of attempting to isolate the "essence of Islamic architecture" most certainly characterizes his later projects, as though he has been searching throughout for a kind of unattainable perfection — an essence of his own art. "I began to understand why I felt that Cordoba was not truly representative of the essence I was seeking," says Pei. "It is too lush and colorful. If one could find the heart of Islamic architecture, might it not lie in the desert, severe and simple in its design, where sunlight brings forms to life? I was finally coming closer to the truth, and I believe I found what

I was looking for in the Mosque of Ahmad Ibn Tulun in Cairo (876–79). The small ablutions fountain surrounded by double arcades on three sides, a slightly later addition to the architecture, is an almost Cubist expression of geometric progression from the octagon to the square and the square to the circle. It is no accident that Le Corbusier learned much from the architecture of the Mediterranean and the architecture of Islam. This severe architecture comes to life in the sun, with its shadows and shades of color. I had at last found what I came to consider to be the very essence of Islamic architecture in the middle of the mosque of Ibn Tulun."[3]

The relationship between the final form of the Doha Museum of Islamic Arts and the high domed *sabil* (ablution fountain) erected in the central courtyard of the Ibn Tulun mosque in the thirteenth century is clear, even if the scale of the Pei building is much larger. "I remained faithful to the inspiration I had found in the Mosque of Ibn Tulun, derived from its austerity and simplicity.

opposite:
The museum seen across the water from the Corniche

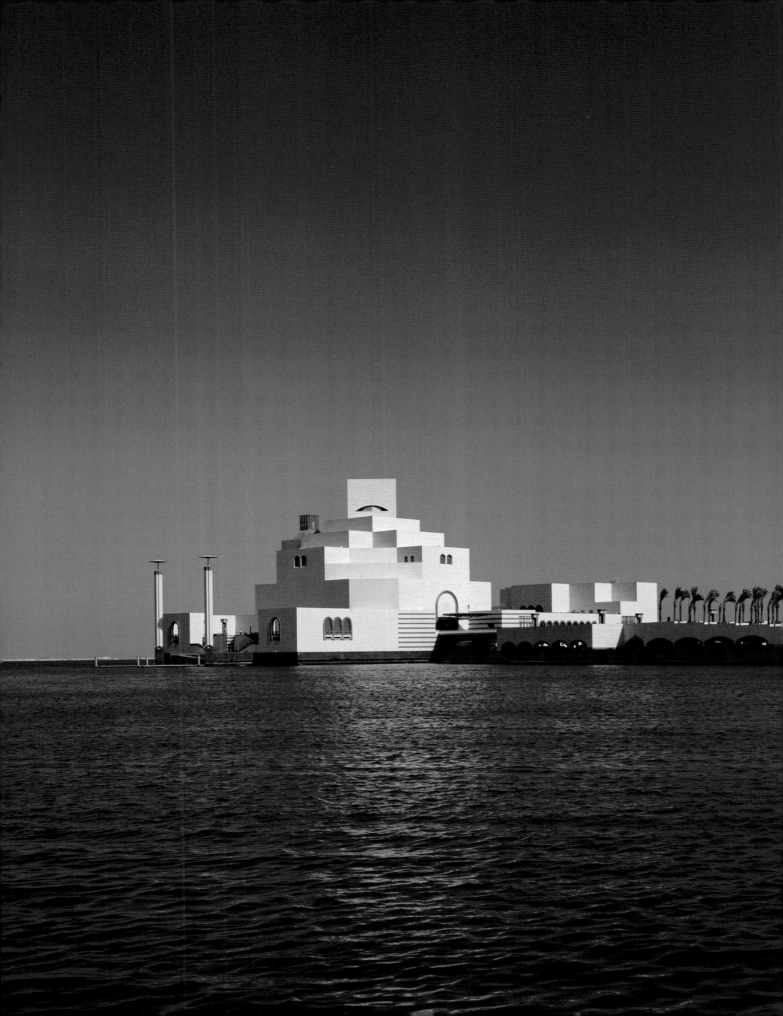

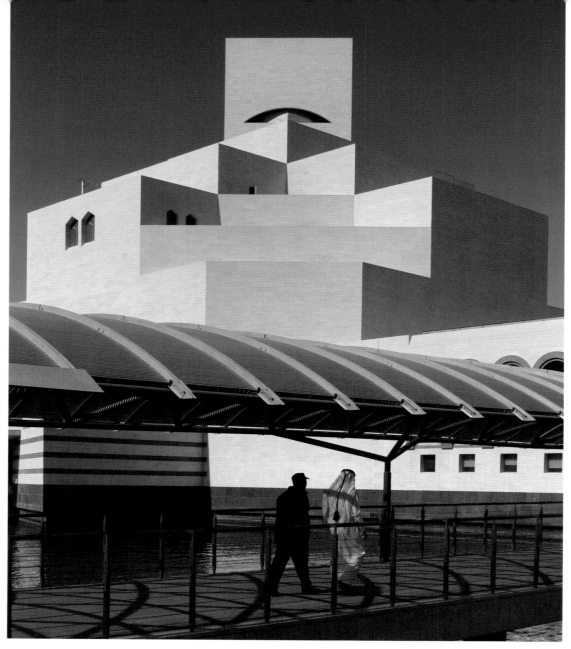

A light walkway leads from the shore to the education center

It was this essence that I attempted to bring forth in the desert sun of Doha. It is the light of the desert that transforms the architecture into a play on light and shadow. My design has only one major window—it is 148 feet high (45 m) and faces the Persian Gulf. I must admit that I have allowed myself another subjective decision, which was based on my feeling that Islamic architecture often comes to life in an explosion of decorative elements: in the courtyard of the Umayyad Mosque in Damascus, or the interior of the Dome of the Rock in Jerusalem (687–91)

for example. I have also particularly admired the perforated metalwork in Egypt. One-hundred-foot-high (30 m) perforated lanterns hang near the dock of the museum, visible from great distances across the water. The central space climaxes in the oculus of an ornate stainless steel dome that captures patterned light in its multiple facets. A geometric matrix transforms the dome's descent from circle to octagon, to square, and finally to four triangular flaps that angle back at different heights to become the atrium's column supports."[4]

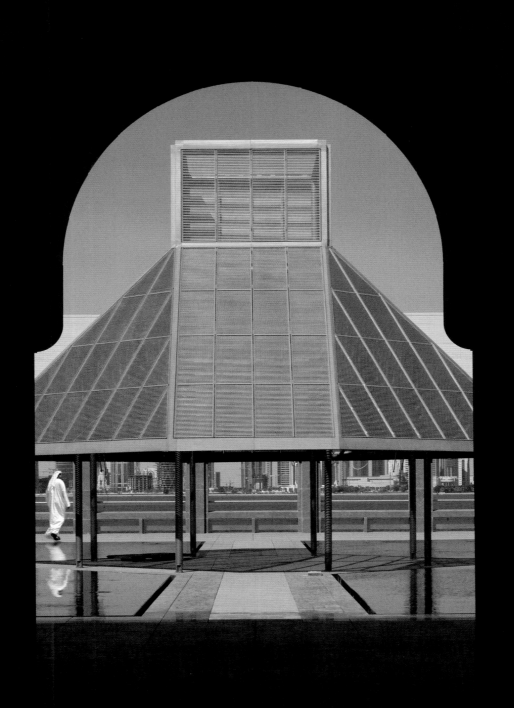

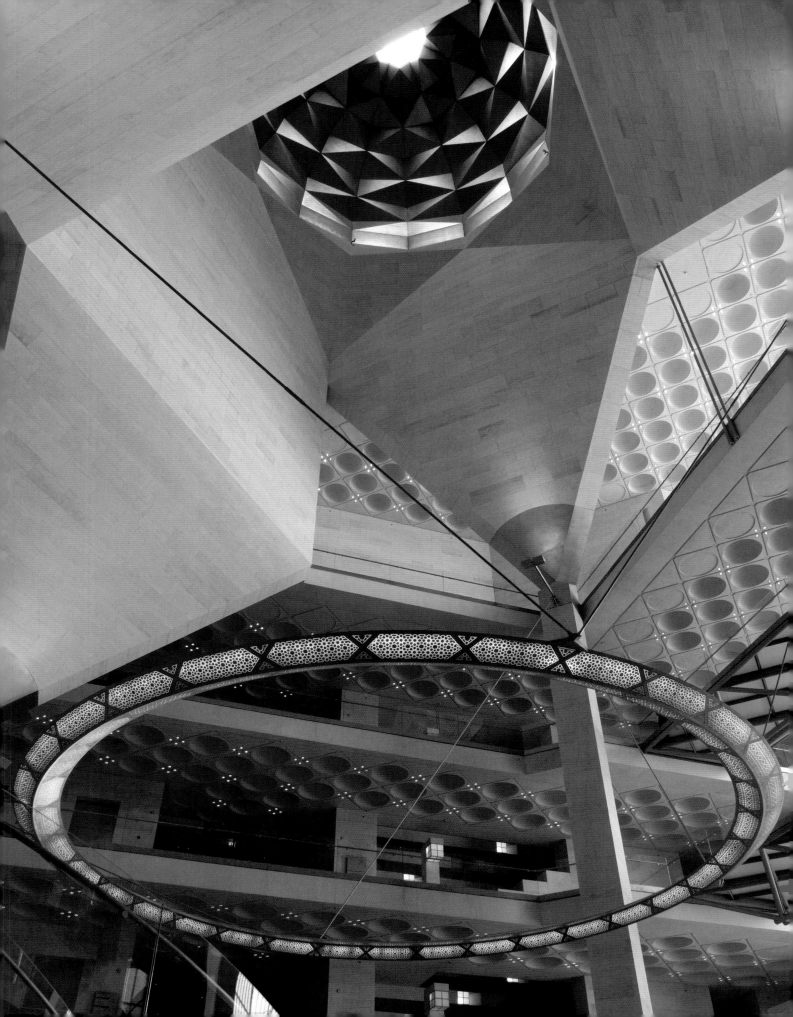

When describing the project, Pei pays homage to the French interior designer Jean-Michel Wilmotte, who worked with him previously on the Louvre and again in Doha, principally in the exhibition gallery, bookshop, and offices: "The interior will be the best ever. It is the fanciest interior I have ever seen. I recommended Wilmotte, and Sheikh Saud went to see his work at the Louvre and decided he was good. In Doha, you can see an installation like nothing you have ever seen before. There are huge glass doors on the display cases that move at a touch of the button. They work perfectly. I am more than satisfied, I think it is incredible."[5] Wilmotte explains, "It was quite simply at the request of I. M. Pei and with the encouragement of Luis Monreal that I became involved. I have known I. M. for quite sometime, and I believe that in the context of this complex project, he did not wish to call on architects with whom he had not worked in the past. We have an easy, natural rapport and that has greatly facilitated the process."[6] Though Pei speaks of a display "like nothing you have ever seen before," in a sense the objective of Wilmotte has been to have his remarkable display cases disappear in semi-darkness, leaving just the objects themselves visible. The curator's intention to underline the universality of Islamic art blends well with the discretion sought by Wilmotte and the discovery of the essence of Islamic culture — the avowed goal of Pei.

Because it is physically isolated on its on its own manmade island set 200 feet (60 m) off the shore, the Museum of Islamic Arts is visible from much of Doha's capital city, on the multilane thoroughfares that run along the Corniche, or from across the bay that forms the city. The general public is meant to approach the building on the south, through a formal *allée* of date palms and a sloping path with a cascade running through the middle from the fountain plaza in front of the building. These palms, larger than those indigenous to Qatar, posed some problems. "To find good looking trees is very difficult," explains Pei. "The only trees I could find are palms, but I didn't realize what a headache getting them would be. The only point the Emir disagreed with me was on the choice of palms. Palms take a long time to get used to a new location. They don't have big palms in Qatar. The building is a strong building and you need big palm trees — 50 to 60 feet (15-18 m)."[7] The rising path that takes visitors from the Corniche toward the museum is by no means as indirect and complex as the approach to the Miho Museum, for example, but the trees and even the sound of water in the cascading fountain make it clear that a transition has occurred from the more mundane environment of the city to this rarified place where art and architecture come together in an exceptional way. Islamic gardens with their axial layout, water courses, and implied evocation of heaven indirectly inspired this grand approach path.

The visitor entering the museum is almost immediately confronted with the surprising vision of a sculptural double Grand Stair designed specifically to allow a view toward the monumental window described by Pei. The third step in this stairway is precisely below the center of

The atrium of the museum with the dome and large ring-shaped lamp designed by Pei

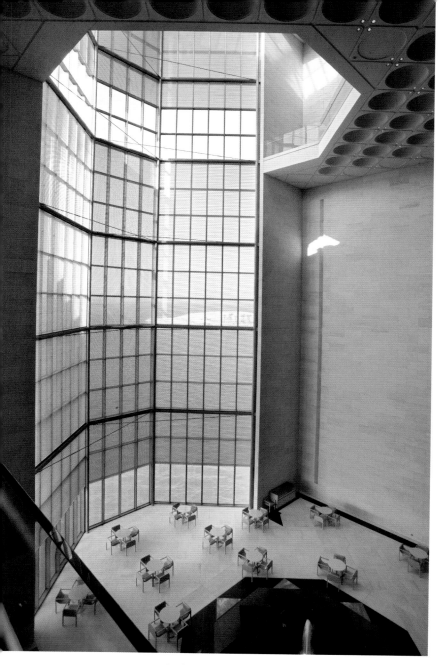

The forty-five-meter-high window in the atrium

the dome, while the floor below shows an intricate decorative pattern, inspired by the geometric interlaces of Islamic tradition but still visibly modern. The curving lightness of this main stair brings to mind the single spiral Pei designed for the Louvre Pyramid. Arcing upwards, the stairway allows visitors to discover the atrium space from different angles, similar to how the Pyramid spiral gives a panoramic sense of the facades of the palace, or alternatively, the entry area below. The main or ground level houses

temporary exhibition galleries together with prayer halls for men and women, the museum shop, a 200-seat auditorium, and a fountain café. The window is protected from sun and dampens sound through the use of a screen of acoustical aluminum rods. Each level of the exhibition floors is spanned by glass bridges that pass above the fountain café, completing a circulation path of the U-shaped balconies cantilevered around the atrium. Bridges are a frequent fixture of Pei's spectacular atrium spaces, as in the East Building of the National Gallery of Art, for example. The use of glass in the bridges in Doha heightens the sense of motion already engendered by the light filtering through the oculus of the dome and the great window.

With a building area of 376,740 square feet (35,500 sq m), this is not simply a place of display for a new collection of Islamic art. True to the original vision of the Emir and his wife Sheikha Moza, who saw it as a center of culture and education in the Emirate, the museum includes an expansive education center, reached by walking through a covered passageway that opens onto an arcaded garden with a fountain and central gazebo. This garden, perhaps best suited to the cooler months of the year (summer temperatures can reach over 120 degrees Fahrenheit), has a spectacular view across the bay to the rising forest of towers that form the new heart of Doha. The central gazebo surely bears comparison to the tea pavilions in England or Suzhou. A thin, elegant bridge from the exterior also allows visitors to approach the education center directly, without passing through the museum lobby.

Stairways lead up from each level of the atrium

Although its formative period was somewhat complex, the Museum of Islamic Art in Doha has taken on the ambitious task of altering views of Islamic art. Long the province of non-Muslim Western curators and specialists, this institution is intended to show Islamic art where it was made, in a figurative sense if not literally. The task of bringing all this together fell, relatively late in the process, on the young curator Sabiha Al-Khemir, whose interpretation of both the building and her own collections fits very closely with Pei's search for an "essence" of architecture and, indeed, of art. Of Tunisian origin, Al-Khemir insists on the fact that Islamic art is here in its region of origin, but that thanks to Pei, the open spirit of the objects themselves can be transmitted to a wide public. "Here is a museum in the Muslim world capable of bridging the gap between tradition and modernity," says Sabiha Al-Khemir. "This is what I. M. Pei did with the building. He actually reinterpreted Islamic architecture, giving it his own expression, one that is simultaneously personal and universal. In the manner that the building itself has created a bridge between tradition and modernity, so, too, the displays can embody the same link between the past and the present where the art is concerned. I feel, in a broader sense, that Qatar is positioning itself precisely at this essential point between East and West."[8] More austere than many of Pei's other buildings, this architecture is intended, like the central fountain of Ibn Tulun, to live in the desert light. Harsh and uncompromising, this light makes the forms and colors of the museum change throughout the day, glowing orange in the setting sun.

I. M. Pei remains typically modest in discussing his own accomplishments in Doha, and it is true that opinions are divided as to the wisdom of attempting to distill the "essence" of the architecture of such a vast domain as Islam. There are architectural gestures here, such as the monumental round chandelier that hangs below the dome, similar to the great perforated metal lighting fixtures in many mosques, which make the reference to Islam all but explicit. Pei is faithful to his sense of geometry and to the wealth of possibilities that it offers, especially forms like circles, squares, and octagons, are rotated and exploited to create varied perspectives and unexpected patterns.

Might it be though that another crucial element of Pei's accomplishment comes to light under the great dome in Doha? Pei is a product of the Harvard Graduate School of Design, at a time when Marcel Breuer and Walter Gropius, heralds of the tabula rasa and modernism held sway. Pei has often been categorized as a modernist

himself, with the subtle distinctions that that word has had in America as opposed to the Bauhaus agenda. Seeking the essence of Islamic architecture and indeed correctly finding it in a ninth-century Cairo mosque or its thirteenth-century fountain, Pei reveals, as he has in so many other cases, particularly from the Louvre onwards, a deep and significant attachment to the past. As the architect explains, "In my younger days I traveled extensively around the world and saw many of its architectural masterpieces, including those of the Islamic world; but I never thought of them—for instance, those of Cordoba or Samarra—as being Islamic. Only since I received this commission did I begin to look at them differently. I looked at them as Islamic architecture for the first time."[9] From within, it might well be said that the dome of the Doha Museum of Islamic Art brings to mind many mosques, but its faceted, geometric metal surfaces are also irreproachably modern. Even as he looks back to the great mosques and other buildings of Islam, Pei also refers to Le Corbusier and to "an almost Cubist expression of geometric expression" in Ibn Tulun. There is no contradiction in the references precisely because his goal is to make a modern building that is in no sense a pastiche or postmodern collage. Qatar itself is the product of numerous foreign influences. Today, with an American-Chinese architect, Doha has inaugurated one of the first significant museums in the Muslim world that focuses on the art of Islam. The reference to the past seen in Pei's architecture is visible in the light and shadows that play across the facade of the Doha Museum of Islamic Art.

It is in an artistic expression that is as universal as the beauty of a ninth-century Iraqi bowl in the museum's collection with just half a line of calligraphy that reads, "What was done was worthwhile."

More precisely, I. M. Pei has attempted to reweave the links between the past and the present that have informed architecture throughout history. The geometry or rationality of modernism was initially considered a clean break with the ornamental or decorative past. Pei delves further into the ornamental in Doha than in most of his earlier work, but he does not abandon his passion for geometry. In the round moon gates of his native China or in the geometric progressions of Islamic art and architecture, he finds the "essence" that he fears may have eluded him. Building on the foundations imagined by Vauban in Luxembourg, or in the historic center of the storied city of Suzhou, he isolates and brings forth what is essential—a pond, a stone-work, or a wisteria can speak of centuries past to those who know how to look. So, too, in Doha, his point has not been in any sense to create an enlarged replica of a part of Ibn Tulun. It is interesting to note that his points of reference, both inside and out in Doha, are religious buildings—mosques. His view of light as it falls in the great crescent from Morocco to the Persian Gulf, and his understanding of geometry as the key to form, variety, and expression in architecture, bridge the gap opened by the early modernists who sought in many ways to set aside tradition. He is modern in Doha without breaking with the past, an accomplishment perhaps more difficult and significant than any other in contemporary architecture.

opposite:
The juncture between the folded metal surfaces of the dome and the stone of the atrium

overleaf:
The large ring-shaped lamp in the atrium

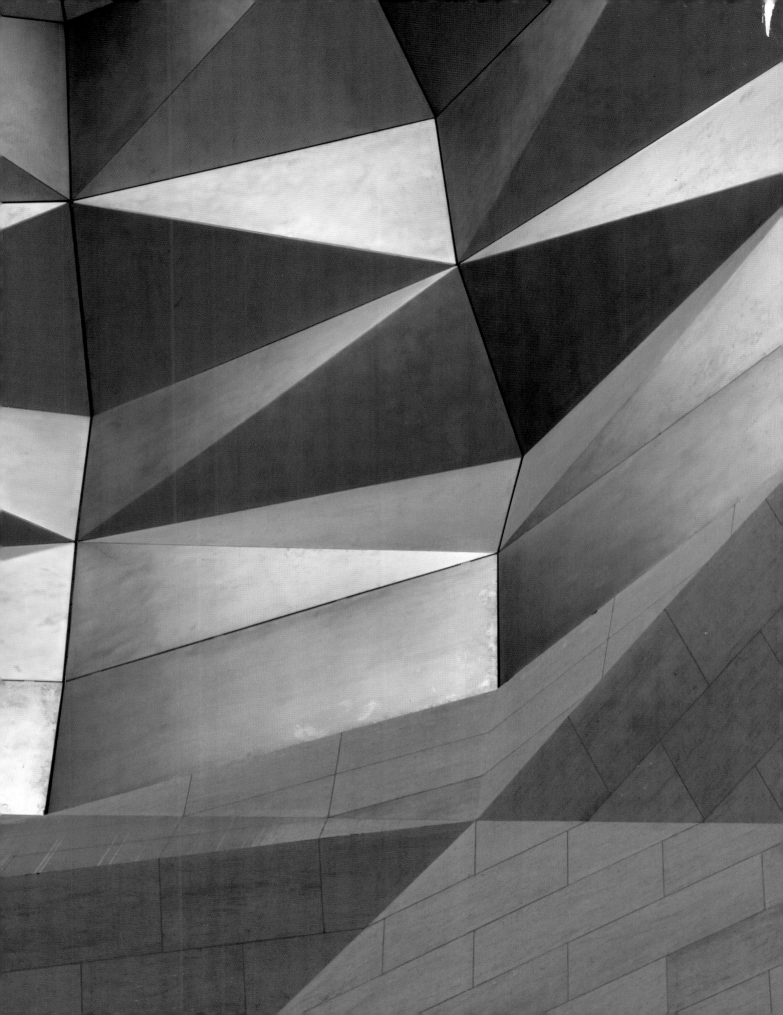

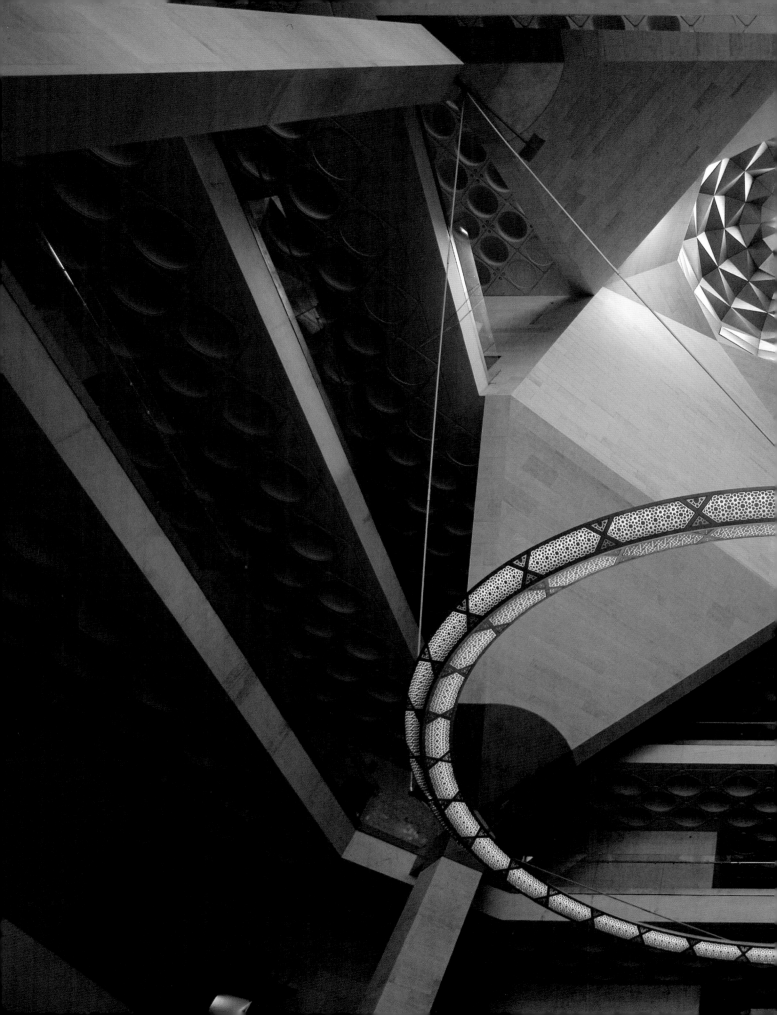

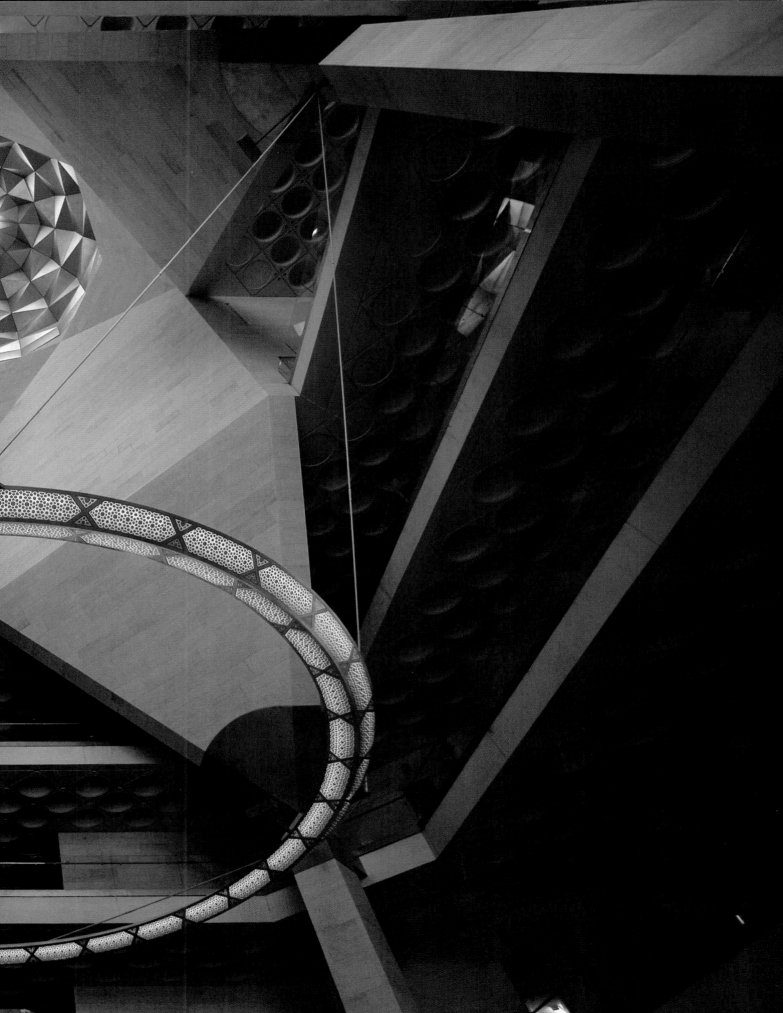

NOTES

I. M. Pei
Architecture Is Art and History
Pages 6–7
1. William Emerson was dean of the MIT School of Architecture from 1919 to 1939.
2. Walter Gropius, founder and first director of the Bauhaus, became a professor of architecture and chairman of the Department of Architecture at Harvard in 1937.
3. William Zeckendorf, Sr. (c. 1905–1976) was one of the most prominent real estate developers in the United States. He began working at Webb and Knapp in 1938 and purchased the firm in 1949.
4. Walter Orr Roberts (1915–1990) presided over the founding of the National Center for Atmospheric Research (NCAR) as its first director and was the first president of the University Corporation for Atmospheric Research (UCAR).

Carter Wiseman
Introduction
Pages 9–15
1. *MacMillan Encyclopedia of Architects*, Vol. 2 (New York: The Free Press, 1982), 18.
2. Carter Wiseman, *I. M. Pei: A Profile in American Architecture* (New York: Harry N. Abrams, 2001), 250.
3. Ibid., 49.
4. Ibid., 50.
5. Ibid., 99.
6. Ibid., 114.
7. Ibid., 205.

The Helix, New York, New York, 1948–49 (unbuilt)
PAGES 20–23
1. I. M. Pei, in discussion with Janet Adams Strong, September 18, 2007. Zeckendorf criticized contemporary apartment buildings for ignoring recent technological developments and consequent higher cost. See William Zeckendorf, "Saving Building Dollars from the Owner's Standpoint," *Cleveland Engineering* (December 6, 1956): 27–29, 31. See also "Apartment Helix," *Architectural Forum* (January 1950): 90–96; I. M. Pei Archives; "Une maison hélicoidale à New York," *Le décor d'aujourd'hui* (March 1955): 158–61; "The Flexible Cliff," *Interiors*, February 1950: 10; Robert A. M. Stern, Thomas Mellins, and David Fishman, *New York 1960: Architecture and Urbanism between the Second World War and the Bicentennial* (New York: Monacelli Press, 1995), 800; Carter Wiseman, *I. M. Pei: A Profile in American Architecture* (New York: Harry N. Abrams Publishers, 1990), 51.
2. Pei enlisted the help of Henry Cobb and several classmates from Harvard's Graduate School of Design.

3. IFS/FE Publications (April 1953), unidentified typescript, I. M. Pei Archives.
4. Jaros Baum & Bolles, *Architectural Forum* (January 1950): 96.
5. United States Patent #2,698,973, filed December 22, 1949; patent for "Multistory Building Structure," issued January 11, 1955.
6. William Zeckendorf, quoted by E. J. Kahn, "Big Operator — 1," *The New Yorker* (December 8, 1951): 57.
7. I. M. Pei, in discussion with Janet Adams Strong, June 6, 2006. See also I. M. Pei in John Peter, *The Oral History of Modern Architecture: Interviews with the Greatest Architects of the Twentieth Century* (New York: Harry N. Abrams Publishers, 1994), 264–65. Le Corbusier, letter to I. M. Pei, April 11, 1949, I. M. Pei Archives.
8. John D. Rockefeller, Jr., letter to William Zeckendorf, March 33, 1951, I. M. Pei Archives.

Gulf Oil Building, Atlanta, Georgia, 1949–50
PAGES 24–27
1. I. M. Pei, in discussion with Janet Adams Strong, April 18, 1995.
2. "Small Office Buildings," *Architectural Forum* (February 1952): 108.
3. George Erwin, "Top Realty Expert Plans Revamp Here," *Atlanta Journal* (January 25, 1952), 9:1. Zeckendorf with Edward McCreary, *The Autobiography of William Zeckendorf* (Chicago: Plaza Press, 1987 ed.), 99.
4. The Atlanta Preservation Center had added the building to its 2007 Endangered Historic Places List. See Paul Donsky, "Ahead of the Curve," *Atlanta Journal Constitution* (February 18, 2007) and Atlanta Preservation Center, http://www.preserveatlanta.com/endangered07_04.htm. See also DOCOMOMO, Georgia Chapter News, http://www.docomomoga.org/wordpress/?p=84.

Webb & Knapp Executive Offices, New York, New York, 1949–52
PAGES 28–31
1. I. M. Pei, in discussion with Janet Adams Strong, April 18, 1995, and November 1, 1995.
2. I. M. Pei, in discussion with Janet Adams Strong, September 12, 2006.
3. Pei, quoted in E. J. Kahn Jr., "Profiles: Big Operator – 1," *The New Yorker* (December 8, 1951): 59–60.
4. William Zeckendorf with Edward McCreary, *The Autobiography of William Zeckendorf* (Chicago: Plaza Press, 1987 ed.), 99. See also "Astragal on Zeckendorf," *Architectural Forum* (October 1952): 92. See "Lobby of Light," *Architectural Forum* (January 1952): 118ff, and "Lighting in Design," *Interiors* (October 1952): 103–04.

5. Pei charged his small team with different assignments, including Ulrich Franzen, who did much of the lighting and furniture, and Henry Cobb who created an ingenious burled-wood liquor cabinet, which doubled as Zeckendorf's wardrobe.
6. "William Zeckendorf's Office," *Fortune* (June 1952): 112. See also "Rooftop Showboat," *Architectural Forum* (July 1952): 105–13; Robert A.M. Stern, Thomas Mellins, and David Fishman, *New York 1960: Architecture and Urbanism between the Second World War and the Bicentennial* (New York: Monacelli Press, 1995), 563–64; Carter Wiseman, *I. M. Pei: A Profile in American Architecture* (New York: Harry N. Abrams Publishers, 1990), 54; Michael Cannell, *I. M. Pei: Mandarin of Modernism* (New York: Carol Southern Books, 1995), 98, 103–05.

Pei Residence, Katonah, New York, 1952
PAGES 32–35
1. I. M. Pei, in discussion with Janet Adams Strong, June 22, 2007. Perhaps more influential than either Mies or Johnson was Pei's friend Marcel Breuer, whose house Pei particularly admired.
2. I. M. Pei, in discussion with Janet Adams Strong, December 27, 2007. In a recent discussion with Fumihiko Maki, Pei explained that his interest in prefab systems was short lived. "Interview with I. M. Pei," April 23, 2007, scheduled for publication by A+U in May, 2008.
3. I. M. Pei, op. cit., June 22, 2007.
4. Factory-applied shellac protects the beams and exposed ends, painted temple red, against moisture. The plywood walls are standard lumber frame construction, insulated and sealed with a newly developed, rubberized, waterproof white paint survives to this day.
5. "Small House Perfection," *Vogue* (January 15, 1961): 86–93. See also "Maison de week-end de I. M. Pei aux environs de New-York," *L'Architecture d'aujourd'hui* (September 1962) n. 103, 160–61. See also Bruno Suner, *Ieoh Ming Pei* (Paris: Fernand Hazan, 1988), 40–42.
6. The stair originally led to an outdoor terrace below the house, but was subsequently changed to accommodate a growing family.
7. I. M. Pei, op. cit., June 22, 2007.
8. While still at Harvard, Pei designed a house on Brattle Street in Cambridge for the father of a GSD classmate, Getty Hill, and did not attempt another house until designing his similarly flat-roofed house in Katonah, New York. Pei subsequently designed a house with Kellogg Wong for William Slayton in Washington, D.C. (1961) and a residential museum (1969) for art

collector Mrs. Charles Tandy in Fort Worth, Texas. Pei credits the former to Wong; he disowned the latter when the owner involved another architect in unapproved changes. I. M. Pei, op. cit., December 27, 2007.

Mile High Center, Denver, Colorado, 1952–56
PAGES 36–39
1. Courthouse Square, Zeckendorf and Pei's initial engagement in Denver, was the first major development in any American city to combine parking and public precinct with a hotel, designed by Araldo Cossutta, and department store, designed by Henry Cobb. See Zeckendorf with Edward McCreary, *The Autobiography of William Zeckendorf* (Chicago: Plaza Press, 1987 ed.), chapter 9, "The Town That Time Forgot": 107–19.
2. Bill Hosokawa, "Zeckendorf: What makes Him Tick?" *Empire: The Magazine of the Denver Post* (November 6, 1955): 12 of Zeckendorf, op. cit.: 119. See also "New Thinking on Fenestration and Ground-floor Use," *Architectural Forum* (September 1953): 114–117, "Denver's Mile High Center," *Architectural Forum* (November 1955): 128–37, and "Building Facade with Functional Meaning," *Engineering News Record* (June 24, 1954): 32–36. See also Carter Wiseman, *I. M. Pei: A Profile in American Architecture* (Harry N. Abrams Publishers: New York, 1990), 57–58, and Ian McCallum, "Coast to Coast," *The Architects' Journal* (August 16, 1956): 225–234.
3. I. M. Pei, in discussion with Janet Adams Strong, March 1, 2006.
4. Pei credited Zeckendorf for recognizing the economic force of intangibles such as architectural quality. "Architecture without Pomp," *Architectural Forum* (November 1954): 170.
5. Zeckendorf with Edward McCreary, op. cit.: 118. See also Richard Weingardt, "Colorado Architecture: The Best Buildings of the Modern Age," *Colorado Business Magazine* (February 1990): 38–39, 41.

Southwest Washington Urban Redevelopment, Washington, D.C., 1953–62
PAGES 40–43
1. Keith Melder, "Southwest Washington, Where History Stopped," in *Washington at Home: An Illustrated History of Neighborhoods in the Nation's Capital*, Kathryn Schneider Smith, ed. (Windsor Publications: Northridge, Calif., 1988), 70.
2. Pei enlisted the help of Harry Weese, a friend from MIT who had worked with Pei at the Bemis Foundation and had planning experience in Chicago. They were subsequently joined by planner Dean McClure and administrator William Slayton. Dean McClure,

in discussion with Janet Adams Strong, November 21, 1995. William Slayton, in discussion with Janet Adams Strong, November 9, 1995.
3. Jane Jacobs, "Washington," *Architectural Forum* (January 1956): 97. See also I. M. Pei, "Urban Renewal in Southwest Washington," *AIA Journal* (January 1963): 65–69; *The Autobiography of William Zeckendorf*, chapter 16; and "Southwest Washington, Finest Urban Renewal Effort in the Country," *Architectural Forum* (January 1956): 84–91. See also Carter Wiseman, *I. M. Pei: A Profile in American Architecture* (Harry N. Abrams Publishers: New York, 1990), 58–61, and Michael Cannell, *I. M. Pei: Mandarin of Modernism* (New York: Carol Southern Books, 1995), 131–36.
4. I. M. Pei, in discussion with Janet Adams Strong, April 28, 1995.
5. I. M. Pei, in discussion with Janet Adams Strong, June 13, 2006. For Town Center Plaza see Walter McQuade, "Pei's Apartments Round the Corner," *Architectural Forum* (August 1961): 107–14; Araldo Cossutta, "From Precast Concrete to Integral Architecture," *Progressive Architecture* (October 1966): 196–207.
6. Pei took the exam for his license while steeped in Southwest, and failed the planning component.

The Hyperboloid, New York, New York, 1954–56 (unbuilt)
PAGES 44–47
1. Joseph Borkin, *Robert R. Young: The Populist of Wall Street* (New York: Harper and Row, 1969), 196–97. See also "80-Story Building Considered to End Grand Central Deficit," *Washington Star* (September 8, 1954): A27; Damon Stetson, "World's Loftiest Tower May Rise on Site of Grand Central Terminal," *The New York Times* (September 8, 1954): 1, 36; and "Young's Dream Building Grows More Fabulous by the Minute," *Washington Evening Star* (September 12, 1954): B22.
2. "The Hyperboloid: A Webb & Knapp Project for the Grand Central Terminal," Preliminary Concept Presentation, 1954–56.
3. More than just an engineering tour de force, the Hyperboloid symbolized a newly revitalized New York Central. I. M. Pei, in discussion with Janet Adams Strong, November 29, 2001.
4. I. M. Pei, in discussion with Janet Adams Strong, November 29, 2001.
5. The design of the Hyperboloid was kept secret by NYCR and only recently published. See Robert A. M. Stern, Thomas Mellins, and David Fishman, *New York 1960: Architecture and Urbanism between the Second World War and the Bicentennial* (New York: Monacelli Press, 1995), 1140–41; John Belle and Maxine R. Leighton, *Grand Central: Gateway to a Million Lives* (New York and

London: W. W. Norton, 2000), 3ff; Meredith L. Clausen, *The Pan Am Building and the Shattering of the Modernist Dream* (Cambridge, Mass.: MIT Press, 2005), chapter 1, "Grand Central City," esp. 22ff.
6. Borkin, *op. cit.*: 223, 221.

Kips Bay Plaza, New York, New York, 1957–62
PAGES 48–53
1. William Zeckendorf with Edward McCreary, *The Autobiography of William Zeckendorf* (Chicago: Plaza Press, 1987 ed.), 237.
2. I. M. Pei, in discussion with Janet Adams Strong, April 28, 1995.
3. Charles Grutzner, "East Side Housing Revamped to Delete 'Institutional Look'," *The New York Times* (April 26, 1958). See also Robert A. M. Stern, Thomas Mellins, David Fishman, *New York 1960: Architecture and Urbanism between the Second World War and the Bicentennial* (New York: Monacelli Press, 1995), 83–88; Edward Friedman, "Cast in Place Technique Restudied," *Progressive Architecture* (October 1960): 158–75; James Marston Fitch, "Housing in New York, Washington, Chicago and Philadelphia," *Architectural Record* (1963): 193ff; Walter McQuade, "Pei's Apartments Round the Corner," *Architectural Forum* (August 1961): 107–14; Araldo Cossutta, "From Precast Concrete to Integral Architecture," *Progressive Architecture* (October 1966): 196–207; "Domesticating Glass Walls," *Progressive Architecture* (October 1961): 148–54. See also Carter Wiseman, *I. M. Pei: A Profile in American Architecture* (New York: Harry N. Abrams Publishers, 1990), 62–64, and Michael Cannell, *I. M. Pei: Mandarin of Modernism* (New York: Carol Southern Books, 1995), 144–46.
4. As a result of Pei's involvement, the FHA officially revised its housing standards in 1961, and later conferred on Kips Bay the first FHA award for residential architecture. See "HHFA Honor Awards, 1964," *Architectural Record* (November 1964): 165ff. For a discussion of FHA requirements and their reduction of design to a secondary consideration see Richard Miller, "The Rise in Apartments," *Architectural Forum* (September 1958): 105–11, also Zeckendorf, *op. cit.*: 238–41.
5. Construction began in August 1959. The south slab and shopping center were completed in 1961 for $10.15 per square foot, compared to $9.75 for the traditional brick housing project Webb & Knapp built at the same time at Park West Village. The north slab was completed two years later at somewhat higher cost.
6. I. M. Pei, in discussion with Janet Adams Strong, July 2, 1996. During a visit to London, Pei realized that it

was the trees, not just the buildings, that made a space so rich. See I. M. Pei, "The Nature of Urban Spaces," *The People's Architects*, Harry S. Ransom, ed. (published for William Marsh Rice University by the University of Chicago Press, 1964), 68–74.

Luce Memorial Chapel, Tunghai University, Taichung, Taiwan, 1956–63
PAGES 54–59
1. Pei explained that "it was Gropius's name that attracted the job, not mine." I. M. Pei, in discussion with Janet Adams Strong, February 6, 1996. See "American Firm Loans Architectural Head: I. M. Pei to Advise on Building Plans," *NEW HORIZONS of Christian Service in the Field of Higher Education* (February 1954): 1. I. M. Pei, in discussion with Janet Adams Strong, June 8, 2006.
2. Pei turned the master plan over to Chang Chao-Kang and Chen Chi Kwan, two young architects.
3. Pei's emotional ties to the project were strengthened by visits with his father, who was at the time director of the Shanghai Commercial Bank, the largest in Taiwan. Pei encountered Gothic cathedrals for the first time in 1951 when he toured Europe for four months. I. M. Pei, in discussion with Janet Adams Strong, March 11, 2007.
4. Years later Pei vividly recalled the funding problems he encountered: "[Henry Luce] was so rich, but he hemmed and hawed. I had to beg for the money. It took about six or seven years before he gave us $125,000. That's what we built the chapel for. I worked for free. I didn't get a single cent." I. M. Pei, in discussion with Janet Adams Strong, June 18, 2006. See also Henry Luce, letters to William Fenn, December 19, 1958, and March 26, 1959; William Fenn, letter to Henry Luce, April 1, 1959; Archives of The United Board for Christian Higher Education in Asia, previously The United Board of Christian Colleges, preserved at the Yale Divinity School Library, New Haven, Connecticut. The chapel was tabled for a year in the aftermath of unusually fierce typhoons and flooding in late 1959, followed by government restrictions on the construction of nonessential buildings.
5. Heon-san Fong, letter to Roberts & Schaefer, consulting engineers in New York, August 2, 1962, I. M. Pei Archives.
6. C. K. Chen, letter to I. M. Pei, September 4, 1963, I. M. Pei Archives. In discussion with Janet Adams Strong, New York, December 19, 1996.
7. William Fenn, letter to Edward A. Sovik, May 12, 1964, I. M. Pei Archives.
8. I. M. Pei, in discussion with Janet Adams Strong, February 21, 1996.

Society Hill, Philadelphia, Pennsylvania, 1957–64
PAGES 60–63
1. "Urban Renewal: Remaking the American City," *Time* (November 6, 1964): 60ff.
2. John Gerfin, "The Bright Promise of the New Society Hill; Planner is Careful to Save Famed Waterfront Skyline," *Philadelphia Bulletin* (November 15, 1959): 1.
3. "Urban Renewal: Remaking the American City," *Time* (November 6, 1964): 70. See also I. M. Pei, "The Nature of Urban Spaces," *The People's Architects*, Harry S. Ransom, ed. (published for William Marsh Rice University by the University of Chicago Press: 1964), 68–74; Edmund Bacon, "Downtown Philadelphia: A Lesson in Design for Urban Growth," *Architectural Record* (May 1961): 131–46; "Philadelphia: Blueprint for Urban Renewal," Master Shooting Script, August 17, 1961, I. M. Pei Archives; Stephen Thompson, "Philadelphia's Design Sweepstakes," *Architectural Forum* (December 1958): 94ff; "Society Hill: Elegance and Politesse," *Progressive Architecture* (December 1964): 189ff; Carter Wiseman, *I. M. Pei: A Profile in American Architecture* (New York: Harry N. Abrams, Publishers, 1990), 64–66. See also Mildred Schmertz, "A Long Wait for the Renaissance," *Architectural Record* (July 1965): 119–31; Philip Herrera, "Philadelphia: How Far Can Renewal Go," *Architectural Forum* (August–September 1964): 180–93; "No Longer Are They Laughing at Pei Homes," *Philadelphia Inquirer*: 1ff.
4. See Edmund Bacon, *Design of Cities* (New York, The Viking Press: 1967). In an ironic circle of experience, Bacon's episodic greenway system was inspired by Chinese gardens, where paths change direction to focus on a different view and escape from evil spirits. See Alexander Garvin, "Philadelphia's Planner: A Conversation with Edmund Bacon." *Journal of Planning History.* Vol. 1, No. 1 (February 2002). 58–78

Massachusetts Institute of Technology: Cecil and Ida Green Center for Earth Sciences (1959–64), Camille Edouard Dreyfus Chemistry Building (1964–70), and Ralph Landau Chemical Engineering Building (1972–76), Cambridge, Massachusetts
PAGES 64–67
1. Pietro Belluschi, quoted in Meredith Clausen, *Pietro Belluschi: Modern American Architect*, (Cambridge, Mass.: MIT Press, 1994), 281.
2. I. M. Pei, in discussion with Janet Adams Strong, August 20, 1996.

3. I. M. Pei, quoted in "ARTS Interviews I. M. Pei '40," *The Tech* (March 5, 1985): 8. See also "Flagpole in the Square," *Time* (August 22, 1960): 48; Carter Wiseman, *I. M. Pei: A Profile in American Architecture* (New York: Harry N. Abrams Publishers, 1990), 66–67.

4. PAS, Office of the Vice President and Treasurer, letter to I. M. Pei, May 5, 1960. Institute Archives. See also "A Magnificent Obsession," *The MIT Observer* 7, no. 3 (December 1960): 1–2; "A Tower Built Like a Bridge, *Architectural Forum* (August 1960): 100–103.

5. "The Highest Tower in Cambridge," *Technology Review* (December 1964): 17; "New Landmark for M.I.T.," *Progressive Architecture* (March 1965): 157–63; "Wind Whistles through FHA Tower," *Progressive Architecture* (March 1967): 168–71; David Guise, "MIT Earth Sciences Laboratory," *Design and Technology in Architecture* (New York: John Wiley, 1985): 206–12. See also "Sculpture: Boiler Plate Beauty," *Time* (May 13, 1966): 78–79.

6. I. M. Pei, in discussion with Janet Adams Strong, April 18, 1995, February 6, 1996, and July 9, 1996.

7. The commission introduced Pei to fellow alumnus Cecil Green, president of Texas Instruments, who funded the tower, and his colleague Eugene McDermott, who paid for the Alexander Calder sculpture, the courtyard, and auditorium. Pei's introduction to Alexander Calder on the Earth Sciences Building would develop further in the East Wing of the National Gallery of Art.

East-West Center, University of Hawaii, Manoa, Hawaii, 1960–63
PAGES 68–71

1. Stephen W. Bartlett, "Hawaii's East-West Center: A Dialogue between Cultures," *Saturday Review* (July 18, 1964): 42. See also Jonathan Rinehart, "Hawaii, The New Frontier," *Paradise of the Pacific* 72, no. 8 (1960): 11–13, 38. The catalyst was the announcement by Russian president Nikita Khrushchev of a competing plan to build Friendship University in Moscow.

2. Victor N. Kobayashi, "The Building Boom," *Building a Rainbow: A History of the Buildings and Grounds of the University of Hawaii's Manoa Campus* (Manoa, HI: Hui O Students, University of Hawaii at Manoa, 1983), 111ff. See also "East Meets West in Architecture Symbolic of Neither," *Architecture/West* (November 1963): 24–25; "East-West Center in Honolulu, Hawaii," *Arts & Architecture* (February 1964): 30–34; "Architects View Achievements," *The Honolulu Advertiser* (January 16, 1966): A14:5

3. I. M. Pei, in discussion with Janet Adams Strong, July 19, 2007. Also discussions with associate

architect Clifford Young (September 21, 2006) and John Fitzgerald Kennedy Theater director Marty Myers (August 22, 2007).

4. Designed by Araldo Cossutta. The intricate composition contrasts with the monumental theater opposite, in which Pei actively participated.

5. The theater opened with *kabuki*, followed on the second night by *Hamlet*, and on the third, by a musical comedy hastily substituted for Gershwin's "Of Thee I Sing," a presidential satire rendered inappropriate by John F. Kennedy's assassination just days before. East-West Theater was renamed for Kennedy prior to its opening on November 28, 1963.

6. I. M. Pei, in discussion with Janet Adams Strong, July 19, 2007. Kennedy Theater began as a lecture hall for East-West Center but, retooled as a first class theater through the involvement of the University of Hawaii's drama department, it became the shared training ground of UH students, among them Bette Midler.

University Plaza, New York University, New York, New York, 1960–66
PAGES 72–75

1. "Ten Buildings That Point to the Future," *Fortune* (October 1964); "Ten Buildings That Climax an Era," *Fortune* (December 1966). See also Cervin Robinson, "Bright Landmarks on a Changing Urban Scene," *Architectural Forum* (December 1966): 21–29; Robert A. M. Stern, Thomas Mellins, and David Fishman, *New York 1960: Architecture and Urbanism between the Second World War and the Bicentennial* (New York: Monacelli Press, 1995), 234–6, 1237 n. 94.

2. Working with Pei on the project was Mies–trained James Ingo Freed, who carefully resolved the detailed design to make the minimalist buildings do exactly what they needed to do. James Ingo Freed, in discussion with Janet Adams Strong, October 12, 1995 and September 19, 1996.

3. I. M. Pei, in discussion with Janet Adams Strong, July 11, 1996. Over a few glasses of wine Carl Nesjar invited Pei to see the pieces he'd enlarged for Picasso using a new technique called *Naturbetong* (concrete engraving). Pei, always receptive to new ideas, later expanded the technique for architectural use, beginning with NCAR, where he added locally quarried stone to concrete and bush-hammered the surface to reveal the aggregate's color. *Sylvette* was the first such piece outside Europe and only the second monumental Picasso in the country. See "A Picasso Will Rise 36 Feet above Bleecker Street," *The New York Times* (January 20, 1968): 49; Raymond C. Heun, "Picasso's

Adventures in Concrete," *Concrete International* (September 1988): 53–54; Carl Nesjar, "Picasso in Concrete," *Cembureau Technical Newsletter* (April 5, 1966); "Picasso in New York," *Journal of the American Institute of Architects* (January 1968): 101; "Picasso's Prestressed Sculpture," *Engineering News-Record* (August 8, 1968): 20–21; Stern, et al., *op. cit.*, 236, 1237 n. 95.

National Airlines Terminal, John F. Kennedy International Airport, New York, New York, 1960–70
PAGES 76–79

1. Eason Leonard, in discussion with Janet Adams Strong, June 23, 1995.

2. Kellogg Wong, in discussion with Janet Adams Strong, October 28, 1995, and November 13, 2007. Window walls of such enormous size had not been used before, least of all in an airport. The architectural message was not lost on National Airlines, which celebrated the start of construction with an illustrated full-page ad in *The New York Times* entitled "Our New Glass House" (August 17, 1966): 40, and the opening of its "Glass Dazzler" three years later with special coverage in the *National Reporter* (December 1969): 1–5. See also Robert E. Rapp, "Space Structures in Steel," *Architectural Record* (November 1961): 190ff.

3. I. M. Pei, quoted in "Pavilion at Kennedy," *Architectural Forum* (October 1971): 22; see also Robert A. M. Stern, Thomas Mellins, and David Fishman, *New York 1960: Architecture and Urbanism between the Second World War and the Bicentennial* (New York: Monacelli Press, 1995), 1018–19; "Multi-Airline Terminal," *Architectural Record* (September 1961): 168–69; Mark Blacklock, *Recapturing the Dream: A Design History of JFK's Airport* (London: Mark Blacklock, 2005).

National Center for Atmospheric Research, Boulder, Colorado, 1961–67
PAGES 80–85

1. Lucy Warner, in discussion with I. M. Pei, May 14, 1985. Pei explained that after years in urban renewal he "had to loosen up. I had to learn all over again. And then came NCAR. It saved me. I realized I had to reorient my priorities." I. M. Pei, in discussion with Janet Adams Strong, November 1, 1995. See Clyde Soles, *A Positive Occurrence in the Countryside* (Boulder: Adventure Wilderness Enterprises, 1988); Carter Wiseman, *I. M. Pei: A Profile in American Architecture* (New York: Harry N. Abrams Publishers, 1990), chapter 4, 73–91; Michael Cannell, *I. M. Pei: Mandarin of Modernism* (New York: Carol Southern Books, 1995), 157–61; Bruno Suner, *Ieoh*

Ming Pei (Paris: Fernand Hazan, 1988), 52–57. See also Jonathon Barnett, "A Building Designed for Scenic Effect," *Architectural Record* (October 1967): 145–51; "High Monastery for Research," *Architectural Forum* (October 1967): 31–43; Henry Lansford, "A Cathedral for Science," *Horizons* 19, no. 9 (September 1967): 55–57; Bernard F. Spring, "Evaluation: From Context to Form," *AIA Journal* (June 1979): 68–74.

2. Pei quoted in files of the National Center for Atmospheric Research, Archives & Records Center, including memo, September 26, 1960, Coll. 8731, Box 2 of 2, Site and Architect Selection Folder: 21 anColl. 850215d, Box 2 of 3, Admin. Division, Physical Facilities Services, Mesa Lab Records, *c.* 1961–1967. Folder Book C, Pei Corresp. 1961. Important records of site and architect selection are also preserved in: UCAR Building File memo, October 29, 1960, Coll. 850215e, Box 1 of 2, Admin. Division, Physical Facilities Services, Records, Site & Architect Selection" Folder: Selection of Table Mountain Site, I. M. Pei, Architect; unsigned note: Coll. 8731, Box 2 of 2, Site & Architect Selection, Folders 23 & 24; Memo March 13, 1961, Coll. 8731, Box 2 of 2, Site & Architect Selection, Folder 21; unsigned notes: Coll. 8732, Box 2 of 2, Site & Architect Selection, Folder 25; Coll. 850215a, Box 1 of 4, Admin. Division, Physical Facilities Services, Pei & Eby Contracts + modifications, corr. 1959–1963. Folder Book 3082 1-f-10, 1961; Coll. 850215e, Box 1 of 2, Admin. Division, Physical Facilities Services, Records, Site & Architect Selection" Folder: Selection of Table Mountain Site, I. M. Pei, Architect; Choice of Architect Memo, n.d., Coll. 8731, Box 1 of 2, Folder 12.

3. I. M. Pei, in discussion with Janet Adams Strong, November 1, 1995.

4. Without approval there would be no building. Planning Commissioner Janet Roberts, wife of NCAR's director in time was won over by Pei's sensitivity to the land.

5. Pei acknowledged "NCAR was still somewhat reminiscent of [Louis I.] Kahn. At the time the building very much talked about by architects was Phillips Engineering Laboratories at the University of Pennsylvania. There's a little bit of that at NCAR. NCAR was my first [venture into the art of architecture] and I was not quite ready." I. M. Pei, in discussion with Janet Adams Strong, June 16, 1996. See Richard Weingardt, "Colorado Architecture: The Best Buildings of the Modern Age," *Colorado Business Magazine* (February 1990): 38–39, 41.

6. Pei used the technique developed by Norwegian Erling Viksjoe for

Picasso's monumental concrete *Bust of Sylvette* at NYU's University Plaza. (Report of the Planning Committee Meeting, UCAR Board of Trustees, January 31, 1962; UCAR/NCAR Archives, 850215a, Box 1 of 4, Folder 3082-1-f-11, 1962.)

7. "Transcript of the John Tusa Interview with I. M. Pei," BBC Radio (August 14, 2006), see bbc.co.uk/radio3/johntusainterview/pei_transcript.shtml. "The reason I was attracted to [Roberts], and to a certain extent he was attracted to me," Pei explained, "is because of my love of nature. . . . We talked about [the site] a lot, how to deal with it, how to put a building [there] . . . and this was where my interest in nature came in to help me."

8. Forty years later Pei would again heighten the anticipatory approach through nature at Miho Museum.

9. I. M. Pei, in discussion with Janet Adams Strong, February 6, 1996. In the same discussion Pei acknowledged the influence of his friend Anthony Caro. Incremental construction was a requirement of the building program. After the federal budget cuts in 1964 there were several attempts to remedy the fact that NCAR was "a tower too small."

Everson Museum, Syracuse, New York, 1961–68
PAGES 86–91

1. I. M. Pei, in discussion with Janet Adams Strong, June 18, 1996.
2. "Museum of Art," *Progressive Architecture* (November 1962): 128. See also "Architecture: Object Lesson in Art and Museology," *The New York Times*, October 29, 1968). Everson was instrumental in winning the National Gallery commission for Pei. See Carter Wiseman, *I. M. Pei: A Profile in American Architecture* (New York: Harry N. Abrams Publishers, 1990), 161–2; Michael Cannell, *I. M. Pei, Mandarin of Modernism* (New York: Carol Southern Books, 1995), 143; Bruno Suner, *Ieoh Ming Pei* (Paris: Fernand Hazan, 1988), 58–63.
3. Max Sullivan was engaged in 1960 to head up the new museum, and he narrowed down a list of fifteen architects to Philip Johnson and Gordon Bunshaft. "Philip would have gotten the job if he wanted it. Bunshaft rejected it. They were approached first," explained Pei. "I was number three on the list." I. M. Pei, in discussion with Janet Adams Strong, February 6, 1996. "Once you're involved with very large-scale projects, it's very difficult to get out of it. . . . So on the one hand I was overqualified, and on the other hand I had nothing of quality to show." I. M. Pei, in discussion with Janet Adams Strong, June 18, 1996. As post–World War II prosperity sprouted museums across the country, Sullivan asked Pei to "do something distinctive for Syracuse," (quoted in Dave Ramsey, "I. M. Pei: Everson Architect Created Sculpture in 'the middle of nowhere,'" *Syracuse Herald American Stars* (June 1, 1997): 3. See also Russell Lynes, "Museums Playing the Cultural Odds," *Harper's Magazine* (November 1968): 32ff.

4. I. M. Pei, in discussion with Janet Adams Strong, February 6, 1996, and June 18, 1996.
5. In the process, Everson gained parking and also a sheltered entry that has proven especially important during Syracuse's snowy winters. which Pei similarly lobbied to construct the entire building in a single campaign. " . . .if only a partial building was built and it wasn't strong enough to hold its place in the enormously empty lot, it would just fall apart. It had to be whole." I. M. Pei, in discussion with Janet Adams Strong, June 18, 1996. Construction was therefore postponed for eight years while the $1 million bequest Helen S. Everson was settled and the remaining $1.6 million raised by community subscriptions.
6. William Henderson, in discussion with Janet Adams Strong, March 1, 1996.
7. I. M. Pei, in discussion with Janet Adams Strong, June 18, 1996.
8. I. M. Pei, in discussion with Janet Adams Strong, March 6, 2007. "I. M. Pei: On Museum Architecture," *Museum News* (September 1972): 14.
9. I. M. Pei, in discussion with Janet Adams Strong, June 18, 1996. Pei's discovery was related by project manager Kellogg Wong, in discussion with Janet Adams Strong, September 11, 2007.
10. "Stirring Men to Leap Moats," *Time* (November 1, 1998): 76. Pei elaborated. "Why is it that I use atriums so often? . . . When you have disparate objects like [the Everson galleries], the atrium becomes the unifying element, not only in circulation but spatially." I. M. Pei, in discussion with Janet Adams Strong, June 18, 1996 and July 2, 1996.
11. I. M. Pei, in discussion with Janet Adams Strong, July 2, 1996. See also James Bailey, "Concrete Frames for Works of Art," *Architectural Forum* (June 1969): 58.
12. I. M. Pei, in discussion with Janet Adams Strong, June 18, 1996.

Federal Aviation Administration Air Traffic Control Towers, Various locations, 1962–65
PAGES 92–95

1. The pentagon provided the non-directional benefits of a circle while still allowing an expressive axis. Equally adaptable to all wind, weather, and soil conditions, the freestanding FAA tower was effectively a new building type.
2. To work with the industry in developing the prototype, Pei dispatched job captain Michael Flynn to a Canadian aircraft company, where he produced the assembly manual and gained invaluable expertise in steel enclosures. For operational discussion of the cabs and illustrated comparison of the new prototype and an earlier (typically eight-sided) counterpart, see Bergthor F. Endresen, "Crux of the Matter: Systems to Keep Them Flying," *AIA Journal* (September 1970): 46.
3. The verticals in the FAA towers curve inward for sculptural effect. The simplified form belying the tremendous effort expended by James Ingo Freed in its achievement. Multiple preliminary sketches for the towers and base buildings appear in Freed's sketchbooks, preserved in the Library of Congress.
4. Quoted by Barbara Goldsmith, "The Agile Eye of I. M. Pei," *Town and Country* (August 1965): 105.
5. "New Tower to Grace Airports," *Architectural Forum* (November 1963): 113–14. "I hope we have proved that beauty and efficiency are not incompatible," said Pei, quoted in "Our Tower Architect Believes in Beauty, Efficiency," *The Lawton Constitution & Morning Press* (April 11, 1965): 1. See also Walter McQuade, "A Better View at Airports," *Fortune* (February 1967): 159.
6. Report to Congress of the United States by the Comptroller General of the United States, June 1966, published by Lois A. Craig, "Designs for Technology," *The Federal Presence: Architecture, Politics, and National Design* (Cambridge, Mass.: MIT Press, 1984).

Cleo Rogers Memorial County Library, Columbus, Indiana, 1963–71
PAGES 96–99

1. Irwin Miller, quoted by George Vecsey, "Columbus, Ind., Grows Used to its Fine Architecture," *The New York Times* (May 17, 1971).
2. Gerald M. Born, letter to I. M. Pei, July 6, 1964. See also Stan Sutton, "Library, Civic Center Plans Explained by Architects," *The Evening Republic*, Columbus, Indiana (April 14, 1964).
3. In the energy-extravagant 1960s, the library included an innovative conservation system that transferred heat generated by the waffle ceiling lights to water storage tanks that warmed the building after hours. See also Wilmington Tower, note 4.
4. I. M. Pei, in discussion with Janet Adams Strong, August 6, 1996.
5. So important was the sculpture to the total scheme that the library's dedication was postponed three years until it could be installed. See Charlotte Sellers, "Library Dedication Speaker Praises 'Brilliance' of City," *The Republic*, Columbus, Indiana (May 17, 1971). See also James Baker, "The Making of a Civic Space," *Architectural Forum* (November 1971): 40–45; Jean Flora Glick, "Camelot in the Cornfields," *Metropolis* (October 1988): 91ff; Marilyn Wellemeyer, "An Inspired Renaissance in Indiana," *Life Magazine* (November 17, 1967): 74–88; and Columbus Area Chamber of Commerce, *A Look at Architecture, Columbus, Indiana* (sixth ed., 1991). The author gratefully acknowledges insights gained in discussions with project architect Kenneth D. B. Carruthers (August 23, 1996) and Cleo Rogers Library director John Keach, (January 30, 1997).

ALICO (Wilmington Tower), Wilmington, Delaware, 1963–71
PAGES 100–03

1. I. M. Pei, in discussion with Janet Adams Strong, October 18, 2007.
2. I. M. Pei, quoted in Sidney C. Schaer, "No Whipped Cream but it Vibrates," *Wilmington Evening Journal* (undated photocopy in clippings portfolio, 1970), I. M. Pei Archives. Pei explained the bigger issue: "The problem in this city is that buildings don't seem to hang together. They're just a lot of separate buildings." I. M. Pei, quoted by George Monaghan, "Architect Glimpses Face Lift in City," *Wilmington Evening Journal*, October 8, 1970
3. "Alico Home Office," *Contact* (June 1966): 2. See also David Guise, "American Life Insurance," *Design and Technology in Architecture* (New York: John Wiley, 1985), 215, and "Wilmington, Delaware," *Architecture Plus* (March 1972): 46–47
4. I. M. Pei, in discussion with Janet Adams Strong, *op. cit.* According to Cossutta, "I. M. asked me if we could [include air floors] in the tower for ALICO, which was designed first and then we transformed it into an integrated system," Araldo Cossutta, in discussion with Janet Adams Strong, January 23, 1996. See Araldo Cossutta, "From Precast Concrete to Integral Architecture," *Progressive Architecture* (October 1966): 196–207.

John Fitzgerald Kennedy Library, Dorchester, Massachusetts, 1964–79
PAGES 104–09

1. Christopher Lydon, "Kennedy's Library To Be Most Complete of Its Kind," *The Sunday Star*, Washington, D.C. (January 5, 1964). At Kennedy's funeral former president Harry S. Truman took a moment to caution Mrs. Kennedy against the fundraising mistakes of his own library and urged her to begin immediately. The

John Fitzgerald Kennedy Library was incorporated the following week (December 5, 1963). Harry S. Truman, thirty-third president of the United States (1945–53), interview by Harold L. Adams (December 6, 1963), Arthur Schlesinger Collection, John F. Kennedy Library.

2. Advising Mrs. Kennedy throughout were members of the architecture and design establishment, including building committee chairman William Walton architect John Carl Warnecke, Pietro Belluschi (dean of the school of architecture at MIT), Ben Thompson (chairman of the department of architecture at Harvard); Hideo Sasaki (chairman of Harvard's department of landscape architecture), and industrial designer Raymond Lowey (who specially designed Air Force 1 for JFK). Among the American architects were Louis I. Kahn, Mies van der Rohe, I. M. Pei, Hugh Stubbins, and Paul Thiry. Foreign architects and planners included Alvar Aalto, Sven Markelius, Sir Basil Spense, Kenzo Tange, and Franco Albini. Lucio Costa could not attend. (Transcript of the Advisory Committee Meetings, April 11–12, 1964, John F. Kennedy Library. Cf. also Summary of Preliminary Meeting on Arts & Architecture of the Kennedy Library, William Walton Papers, John F. Kennedy Library).

3. William Walton suggested that Mrs. Kennedy be given the names of five or six architects to use as a "shopping list." Everyone was asked to cast a ballot for his top three choices, foreign architects insisting that only Americans be considered. The ballots, which were each architect's "ticket" to board the plane to Hyannisport, placed Mies in the lead, followed by Lou Kahn and John Carl Warnecke, Pei, and absentees Paul Rudolph and Philip Johnson. Walton announced that it was "a hell of a good list," noting that all the people on it were nodding in agreement. (Minutes of the Advisory Committee Meetings, April 14, 1964: 50, John F. Kennedy Library.) Although Walton reported that he burned the ballots in the airline hangar, he retained a handwritten tally of the votes. File 1, William Walton Collection, John F. Kennedy Library.

4. Walton, quoted by Donald Graham, "Why Pei?" *Harvard Crimson* (January 8, 1965).

5. I. M. Pei, in discussion with Janet Adams Strong, June 18, 1996.

6. Proposed off-campus locations included the Charlestown Navy Yards, Quincy Market, Otis Air Force Base, and an unused basement parking area of the Kennedy Center for Performing Arts in Washington, D.C.

7. I. M. Pei, in discussion with Janet Adams Strong, August 20, 1996.

Years later Jackie Kennedy Onassis, writing to Pei upon his receipt of the Gold Medal of the National Arts Club, spoke of the Library's enduring impact, adding "I will always think of it as a monument to your spirit — to your humanity and perseverance." (Jacqueline Kennedy Onassis, letter to I. M. Pei, February 4, 1981, I. M. Pei Archives).

8. I. M. Pei, in discussion with Janet Adams Strong, August 20, 1996. An alternate scheme prepared by Hugh Stubbins, an original contender for the library commission, was published together with the announcement of the selection of the Columbia Point site. See Nick King, "UMass Gets Kennedy Library," *The Boston Globe* (November 25, 1975): 1, 5.

9. I. M. Pei, in discussion with Janet Adams Strong, July 2 and December 19, 1996. Pei conveyed similar sentiments at the Library's dedication on August 15, 1979 (typescript, I. M. Pei Archives). See also Carter Wiseman, *I. M. Pei: A Profile in American Architecture* (New York: Harry N. Abrams Publishers,1990), chapter 5, 93–119; Michael Cannell, *I. M. Pei: Mandarin of Modernism* (New York: Carol Southern Books, 1995), chapter 6, 144–72; "Complicated Shapes, Moving Experiences," *AIA Journal* (Mid-May 1980): 180–189; William Marlin, "Lighthouse on an Era," *Architectural Record* (February 1980): 81–90.

Canadian Imperial Bank of Commerce (CIBC), Commerce Court, Toronto, Canada, 1965–73
PAGES 110–13

1. I. M. Pei, in discussion with Janet Adams Strong, December 15, 2007. From 1965 through 1967 predesign efforts focused on programming and negotiating the acquisition of new properties and rights of way for the expanded site.

2. Pei usually relied on Araldo Cossutta and Henry Cobb for tall buildings, but by the mid-1960s, for practice-development reasons, Pei was eager to become personally involved to win these commissions. The commission to design CIBC was due in part to the success of Cossutta and Cobb's Place Ville Marie, in Montreal.

3. The challenge at CIBC required a response to both past and future, relating to CIBC's original Art-Déco building (designed in 1929–31 by York & Sawyer together with local architects Darling & Pearson) and also to Mies's powerful new complex. Pei's initial response called for an innovative concrete tree structure (a development of his Hyperboloid design a decade earlier). "It really would have been something had we built that scheme!" said Pei, but he felt compelled to abandon it "because the client was very conservative."

I. M. Pei, in discussion with Janet Adams Strong, December 15, 2007.

4. See Adele Freedman, "A Lofty Concept Comes to Grief," *The Globe and Mail*, Toronto (November 19, 1994): C6.4

5. Led by Fritz Sulzer, Pei's team perfected the curtain wall and fabrication process as well as related systems for window washing and installation of the enormous stainless-steel components without distortion. The facade was designed to remain visually flat over a 200-degree temperature range (from -20 degrees to 180 degrees in direct sun). Fritz Sulzer, in discussion with Janet Adams Strong, May 15, 1996. See *Architecture+* (March 1973): 38–41; The Steel Company of Canada's *Trend* (April 1974): 12–15; and *Canadian Building* (August 1972) and *Inco Nickel News* 8, no. 2 (1973); also William Dendy and William Kilbourn, *Toronto Observed* (Toronto: Oxford University Press, 1986): 280–81. The author gratefully acknowledges the insights of project team members Kenneth Carruthers (August 23, 1996), Fritz Sulzer (November 10, 1997 and December 19, 2007), and Abe Sheiden (October 26, 1995).

6. I. M. Pei, in discussion with Janet Adams Strong, December 15, 2007.

7. Commerce Court was included virtually upon completion in Toronto's Inventory of Heritage Properties (1973), and designated under the Ontario Heritage Act of 1991. In 1992 the Toronto City Council singled out the complex for an Urban Design Award, citing it as an "exquisite oasis" and "the best modern office tower in Toronto." Marc Baraness and Larry Richards, eds., *Toronto Places: A Context for Urban Design* (Toronto: University of Toronto Press, 1992), 42.

Des Moines Art Center Addition, Des Moines, Iowa, 1965–68
PAGES 114–17

1. Pei said, "In an addition as intimate as this I had to find some way to bring the two buildings together." Respect for modernist Saarinen led him to seek a compatible solution, but that, with "the greater confidence of third generation modernists," Meier's approach was "absolutely opposite." I. M. Pei, in discussion with Janet Adams Strong, August 6, 1996 and October 9, 2007. See also "An Uncommon Vision: Architectural Trinity, 50 Years at the Des Moines Art Center," videotaped panel discussion, Drake University, Des Moines, October 17, 1998; and Jason Alread, AIA, and Thomas Leslie, AIA, "A Museum of Living Architecture: Continuity and Contradiction at the Des Moines Art Center Addition" typescript of unpublished article.

2. Kruidenier, quoted by Franze

Shulze, "Architectural Trinity in Des Moines," *Des Moines Art Center: Uncommon Vision* (New York: Hudson Hills Press Inc., 1998), 24 n. 6.

3. I. M. Pei, in discussion with Janet Adams Strong, October 9, 2007. Pei's strategy of marrying old and new led to some of his most important future commissions, notably the National Gallery of Art and the Louvre. National Gallery director J. Carter Brown acknowledged Des Moines Art Center as "perhaps the greatest single influence on what we ended up doing" at the East Building. J. Carter Brown, quoted by George T. Henry, "C[edar] R[apids] Architecture Draws High Praise," *Des Moines Sunday Register* (December 17, 1989): 7F.

4. The skylight is similar to Pei's concrete roof at Everson Museum, but folded.

5. Gene Raffensperger, "First Look at Art Center's New Addition," *Des Moines Register* (October 5, 1968): 1. See also, Emily Genauer, "On the Arts: They Grow More Than Corn in Iowa," *The New Haven Register* (June 15, 1969). See also Stephen Seplow, "A Record Crowd Flocks to Enlarged Art Center," *Des Moines Register* (October 7, 1968): 1.

Dallas City Hall, Dallas, Texas, 1966–77
PAGES 110–23

1. Stanley Marcus, in discussion with Janet Adams Strong, January 18, 1999. See also "New Landmark for Dallas," *The Dallas Times Herald* (March 20, 1966).

2. Mayor Jonsson appointed Stanley Marcus, president of luxury retailer Neiman Marcus, to head the architect search committee, and arranged for John Burchard, dean of humanities at MIT, to educate committee members. After several weeks, conservative wishes for a building "with dignity and columns" opened to new possibilities. Stanley Marcus, *op. cit.*

3. Erik Jonsson, quoted by I. M. Pei, in discussion with Janet Adams Strong, August 28, 1996.

4. I. M. Pei, ibid. Dallas had 190 acres (77 ha) of parking lots, but only 4 acres (1.6 ha) of parks. Pei reinforced his argument with the example of Boston City Hall where, as a direct result of his master plan, hundreds of millions of dollars flowed into Government Center, increasing land values and invigorating the future city. See also Pei, quoted by Ron Calhoun, "New City Hall to Set Pace" and Carolyn Barta, "City Hall Model: Unique Titled Design Unveiled," *Dallas Times Herald* (April 23, 1969).

5. I. M. Pei, ibid. See also "Park Concept Important Too," *Dallas Times Herald* (April 28, 1967): 3. Beyond City Hall and its park, Pei promoted residential and related

development of the area as "a center of culture — of life itself — a center in every sense of the word." See "Large Downtown Residential Community Proposed," *Dallas Morning News* (June 23, 1966).

6. Dan Kiley, in discussion with Janet Adams Strong, January 26, 1996.

7. I. M. Pei, ibid. The canted form cross-fertilized an early "horse hoof" sloped scheme for the contemporaneous Kennedy Library. Ted Musho, who worked closely with Pei on both projects, recalled "I. M. and I did an awful lot of sketching, flying back and forth between Boston and Dallas. I. M. very often used his hands to express what he wanted to do. . . . The client saw very clearly what he was saying. The building became a vehicle for the city of Dallas to welcome an official visitor." Ted Musho, in discussion with Janet Adams Strong, April 24, 1997.

8. After two years of testing in Texas laboratories, some 90,000 cubic yards (23,000 cubic meter) of shrinkage compensating concrete were set using neoprene gaskets between pours to minimize joints and emphasize the monolithic whole. The gravity-defying design was made possible by a complex three-way post-tensioning systems, at a time when few post-tensioned buildings were attempted in this country, least of all in three directions. The complex erection sequence of pouring the concrete, drying, and post-tensioning cables horizontally, vertically and diagonally, was developed by the architect on site with precomputer hand-drawn sketches, the process made more demanding by Pei's insistence that there be no trace of the specialized hardware or equipment employed. Dennis Egan, in discussion with Janet Adams Strong, January 16, 1996. Pei allowed "We used everything we knew about concrete in this building." See also John Morris Dixon, "Connoisseurs of cast-in-place," *Progressive Architecture* (September 1974): 90–93.

9. I. M. Pei, ibid. See also Carter Wiseman, *I. M. Pei: A Profile in American Architecture* (New York: Harry N. Abrams Publishers, 1990), chapter 6, 121–37. See also "Dallas," *Architecture+* (March 1973): 52–55.

10. The impact of City Hall far exceeded Dallas limits, appearing as a futuristic backdrop in the feature film *Robocop* (1987) while its "strong, clean lines" were the haute couture inspiration of international designer Ruben Campos. Michele Weldon, "Chilean Designer Takes Cue from Dallas Skyline," *Dallas Times Herald* (May 25, 1988). See also John Pastier, "Bold Symbol of a City's Image of Its Future," *AIA Journal* (mid-May 1978): 112–17, and Peter Papademetriou, "Angling for a Civic Monument," *Progressive Architecture* (May 1979): 102–5.

Bedford-Stuyvesant Superblock, Brooklyn, New York, 1966–69
PAGES 124–27

1. "To Save a Slum," *Newsweek* (November 20, 1967): 48. See also "RFK's Favorite Ghetto," *Architectural Forum* (April 1968): 47ff; Fred Powledge, "New York's Bedford-Stuyvesant: Rare Urban Success Story," *AIA Journal* (May 1976): 41ff; and Kilvert Dun Gifford, "Neighborhood Development Corporations: The Bedford-Stuyvesant Experiment," *Agenda for a City: Issues Confronting New York*, Lyle C. Fitch and Annmarie Hauck Walsh, eds. (Sage Publications: Thousand Oaks, Calif., 1970), 421–50; Robert A. M. Stern, Thomas Mellins, and David Fishman, *New York 1960* (New York: Monacelli Press, 1995), 91–93, 917–19.

2. I. M. Pei, in discussion with Janet Adams Strong, New York, October 7, 1997. The Department of Transportation corroborated in-house estimates that thirty percent of the streets could be deactivated without affecting movement.

3. I. M. Pei, in discussion with Janet Adams Strong, October 7, 1997 and July 24, 1996.

4. August Nakagawa, in an internal report to I. M. Pei, March 18, 1974.

5. Pei prepared a preliminary scheme for a business and civic project on Fulton Street in Brooklyn. The project was not executed but in its central skylight one can see an idea that would survive, unconsciously, as Pei typically explored geometries over many years, and resurface some two decades later in the main entrance and inverted pyramid at the Louvre.

Herbert F. Johnson Museum of Art, Cornell University, Ithaca, New York, 1968–73
PAGES 128–31

1. Wolf von Eckardt, "Heart, Hand and the Power of His Talents," *Washington Post* (September 15, 1973): C1.

2. The public accounted for roughly half of the museum's 83,000 annual visitors in 2006. See Katherine Graham, "Johnson Museum receives $150K for Expansion," *Ithaca Journal* (July 25, 2006).

3. I. M. Pei, in discussion with Janet Adams Strong, October 4, 2007. See also "Cornell," *Architecture Plus* (January–February 1974): 52–60; "I. M. Pei's Newest Museum," *Museum News* (September 1974); and "Art and Building, Ithaca, New York," *Architecture+* (March 1973): 59.

4. John L. Sullivan III, "The Design of the Herbert F. Johnson Museum of Art: A Recollection," typescript (September 26, 1997).

5. Jane Marcham, "Museum is Special to Architect," *Ithaca Journal* (May 27, 1973).

6. I. M. Pei, in discussion with Janet Adams Strong, June 18, 1996. See also Ada Louise Huxtable, "Pei's Bold Gem — Cornell Museum," *The New York Times* (June 11, 1973): 47.

7. Samuel C. Johnson recognized the building as a work of art at the public dedication of the museum. See "A Museum Comes Alive," *Cornell Alumni News* (July 1973): 18.

8. Von Eckardt, *op. cit.* Cornell recently decided to expand the museum, realizing the potential Pei anticipated with a knock-out panel some forty years earlier.

National Gallery of Art, East Building, Washington, D.C., 1968–78
PAGES 132–47

1. "This was a situation in which you couldn't cut too many corners. . . . If it was going to be part of the National Gallery it had to be done correctly." (Paul Mellon, in discussion with Robert Bowen, July 26, July 27, and November 10, 1988, National Gallery of Art, Washington, D.C., Gallery Archives). Even as costs soared in 1970s stagflation, Mellon did not waver. Pei recalled "He never once said 'You can't do that; we don't have the money.' He listened to each case individually, and in matters where he was uncertain or where large sums were involved he asked me if it was important. If I said yes, Mr. Mellon approved it. So I never answered lightly. I took great care to make sure I was right." I. M. Pei, in discussion with Janet Adams Strong, September 26, 1996. "The fact that we got a building of such high quality was due to Jake," said Pei of his future partner Leonard Jacobson, who oversaw the job. I. M. Pei, in discussion with Janet Adams Strong, February 12, 2008. Jacobson, in turn, celebrated the workers, "Usually taken for granted: their execution shows the same concern with perfection and permanence" as the design team. (I. M. Pei & Partners, Drawings for the East Building, National Gallery of Art, Its Evolution in Sketches, Renderings, and Models 1968–1978, Adams Davidson Galleries, Washington, D.C., 1978.) of the extraordinarily high standards established is evident in the guidelines for marble fabrication. "The joints between the pieces of marble are 1/16-inch, so half of a joint is 1/32-inch," said the project manager, "Make an aluminum template the correct size [and put it on each piece of marble]. If you can feel the difference, reject the marble. That's your tolerance." (William Mann, in discussion with Anne G. Ritchie, March 26 and April 14, 1992, National Gallery of Art, Washington, D.C., Gallery Archives).

2. Paul Mellon with John Baskett, *Reflections in a Silver Spoon: A Memoir* (New York: William Morrow and Company, 1992), 378. With Carter Brown at his side, Mellon would become one of the special clients with whom Pei would achieve his greatest work. The commission brought to conclusion a year-long search for an architect that began when the trustees' advisor Pietro Belluschi recommended twelve leading candidates, among them Louis I. Kahn, Philip Johnson, and Kevin Roche. Mellon and Brown flew with several board members to visit representative buildings by the different architects, including Pei's NCAR, which "exuded such a sense of research and scholarship that it made you want to immediately go to a desk and start work. We just fell in love with that building!" J. Carter Brown, in discussion with Janet Adams Strong, January 9, 2001. As a sensitive addition to an existing landmark, Des Moines Art Center Addition was "perhaps the greatest single influence on what we ended up doing" at the East Building. Brown, quoted by George T. Henry, "C[edar] R[apids] Architecture Draws High Praise," *Des Moines Sunday Register*, December 17, 1989: 7F.

3. J. Carter Brown, "The Designing of the National Gallery of Art's East Building," *The Mall in Washington 1791–1991*, Richard Longstreth, ed. (Washington, D.C.: National Gallery of Art, 1991), 280. See also J. Carter Brown, in discussion with Anne G. Ritchie, February 7, 1994, National Gallery of Art, Washington, D.C., Gallery Archives.

4. J. Carter Brown, in discussion with Janet Adams Strong, *op. cit.* Pei and Brown undertook a whirlwind tour of eighteen museums in Greece, Italy, Germany, Denmark, France, and England. Determinations about optimum viewing conditions, natural lighting, and indoor-outdoor correspondence largely came out of this trip.

5. The building's different angles, including the razor sharp prow (19 degrees, 28 minutes, 68 seconds), necessitated the development of special tools to help workers more accustomed to right-angle construction. As Pei explained "The geometry is such that once you have it, it's locked in. You couldn't do anything else." I. M. Pei, in discussion with Janet Adams Strong, September 26, 1996. Working with the triangular geometry was like "learning a whole new language. Actors must feel this way when they are told 'No more proscenium. From here on it's going to be theater in the round.'" See also Paul

Richard, "A New Angle on The Mall," *The Washington Post* (December 18, 1977): L1, 12; "Pope + Pei," *Skyline* (June 1, 1978): 6; "P/A on Pei: Round Table on a Trapezoid," *Progressive Architecture* (October 1978): 49–59.

6. See Ada Louise Huxtable, "Geometry with Drama," *The New York Times Magazine* (May 7, 1978): 59–60; J. Carter Brown, "A Step-by-Step Guide to Designing a New Arty Neighbor for the Mall," *Potomac Magazine, The Washington Post* (May 16, 1971): 10–13, 62; see also James Carlton Starbuck, Pei's East Building Addition to the National Gallery of Art, Vance Bibliographies, Architecture Series: #A 123, 1979; and National Gallery of Art, Center for Advanced Study in the Visual Arts, "The East Building in Perspective," abstracts of symposium (April 30 – May 1, 2004).

7. I. M. Pei, in discussion with Janet Adams Strong, January 21, 1998.

8. J. Carter Brown, in discussion with Janet Adams Strong, *op. cit.*

9. I. M. Pei, in discussion with Janet Adams Strong, September 26, 1996.

10. The commission was career-defining for Oles, who later played a similar role for Pei in designing the Louvre. "As far as I'm concerned, it doesn't get any better. I can't conceive of a process that is more effective, appropriate, pleasureful [than we had at the National Gallery]." Paul Stevenson Oles, in discussion with Janet Adams Strong, March 11, 1996.

11. William Pedersen, in discussion with Janet Adams Strong, May 3, 1996.

12. I. M. Pei, in discussion with Janet Adams Strong, June 18, 1996. Pei characterized the buildings as "Rubato . . . freedom within discipline." See Sally Quinn, "Celebrate Non-Celebrity," *The Washington Post* (May 14, 1978): F1, 14. About his Chinese heritage Pei allowed "I always delight in surprises, which is not a Western tradition. Western tradition is usually quite frontal, quite open, quite axial, particularly gardens, Versailles for instance. . . . The Chinese garden is just the opposite. It's very small, very personal, and full of surprises. . . . That element of surprise, or human scale . . . if anything has influenced my design, that would be it." I. M. Pei, in discussion with Anne G. Ritchie, February 22, 1993, National Gallery of Art, Washington, D.C., Gallery Archives.

13. Tom Schmitt, in discussion with Janet Adams Strong, May 17, 1996.

14. Eason Leonard, in discussion with Janet Adams Strong, June 23, 1995.

15. With Pei's close involvement major works of art were commissioned to accommodate the huge scale of the atrium. See Richard McLanathan, *East Building, National Gallery of Art: A Profile* (Washington, D.C.: National Gallery of Art, 1978). See also David W. Scott, in discussion

with Anne G. Ritchie, August 26, 1993, National Gallery of Art, Washington, D.C., Gallery Archives and related interviews in the National Gallery's Oral History program.

16. I. M. Pei, in discussion with Janet Adams Strong, February 12, 1999. "In those days," Pei continued, "atriums were still fairly new. This really is an outdoor space with a covering on top. The three towers are very important; that's why I light them at night. You look up and see them through the skylight. The towers enclose the space. Without them it would not be as interesting, just a triangular opening."

17. I. M. Pei, in discussion with Janet Adams Strong, September 26, 1996.

18. In personal engagement with the building, guests have also burnished I. M. Pei's name on the bronze dedication plaque in the museum's entrance lobby by rubbing it. Of the knife-edge angle Pei recalled, "I had to fight for that sharp point. The stone fabricators had never done anything like this and kept insisting it would break. They suggested instead that we blunt the edge by cutting back a couple of inches to create a more durable flat plane. Impossible! The 19-degree angle is the key to the whole design. I was prepared to take the risk. I'm glad I did." I. M. Pei, in discussion with Janet Adams Strong, February 12, 1999. See also Joseph Giovannini, "Getting in Touch with Favorite Buildings," *The New York Times* (August 23, 1988): 30.

19. "Up to this time most of my work was architectural concrete, largely because of limited budget, also because I'd become so expert in it. But at that time a concrete building would not be accepted by the Fine Arts Commission. Mr. Mellon made marble a given. It's as simple as that." I. M. Pei, in discussion with Janet Adams Strong, September 26, 1996.

20. To simulate the original building's load-bearing walls, the 3-inch-thick (7.6 cm) marble panels were laid up in similarly sized 2-foot-by-5-foot (0.6 x 1.5 m) pieces and cut to wrap around the corners to reinforce apparent solidity "Total durability. This building is built to last." (Richard Cutter, in discussion with Janet Adams Strong, September 10, 1996). The East Building has the character of monumental sculpture, all of its mechanical systems and infrastructural complexity concealed behind its finely crafted stone walls and tight joints (1/16" in the interior, 1/8" on the exterior). Air supply is discreetly integrated along the edges of the bridges, floors, and upper atrium walls where the flow is channeled to rotate the Calder mobile. Air return is concealed under the stair treads and stone benches.

21. In a final effort to overcome the deeply entrenched tradition of rough-formed dark gray concrete in the fashion of Le Corbusier's *beton brut* Pei brought the French contractor to see the East Building. After his initial disbelief that the smooth satinlike walls were actually concrete, the contractor determined the East Building as the standard to exceed. See "I.M. Pei Speaks Out for Concrete," *Concrete International* (August 1979): 25–27.

22. Pei had wanted to include a second level underground for additional support space but was prevented by the water table and high cost of excavation. The dead load of the old and new buildings created a tremendous uplift force that threatened to float away the unweighted open plaza in between. In an operation rather like pushing a wooden raft underwater, the plaza was secured by some 570 high-strength steel tie downs, each 40 to 60 feet (12-18 m) long, anchored into a specially waterproofed 6-foot-thick (2 m) concrete foundation mat. See "Concrete in Use: National Gallery of Art Expansion," *Journal of the American Concrete Institute* (October 1975): 513–20.

23. "They're really very different," Pei insists. "To begin with, the glass prisms in Washington are reflective, not transparent, so you can look out but not in. Also, they are not perfect geometric forms. They are skylights in all different sizes, some very small, the largest only two meters, whereas the Louvre pyramid is a 20-meter-high (66 ft) main entrance. So the functions are different, just as the form and visual impact are different. I don't think there is any relationship." Partial typescript of an interview broadcast on Columbian Radio (1989), I. M. Pei Archives.

24. I. M. Pei, in discussion with Janet Adams Strong, September 26, 1996.

Paul Mellon Center for the Arts, The Choate School, Wallingford, Connecticut, 1968–73
PAGES 148–51

1. I. M. Pei, in discussion with Janet Adams Strong, February 12, 1999. "Headmaster Discloses Future Ideas for Arts Program," *The Choate News* (October 21, 1967): 1.

2. Rev. Miller, quoted by Seymour St. John, in discussion with Janet Adams Strong March 26, 1997. The headmaster wrote to Pei in July "We have talked to many architects. All are competent and could put up a fine building. I have met only one who I believe could build our [dream] . . . "Seymour St. John, in a letter to I. M. Pei, July 17, 1967, I. M. Pei Archives.

3. I. M. Pei, quoted by Ralph Heisel, in discussion with Janet Adams Strong, May 26, 1999.

4. "Gateway to the Arts," *Building Progress* (March 1974): 8. See also Edward King, "An Arts Center Designed to Excite Students" and J. Ernest Gonzales, "Choate to Dedicate New Gift of Mellon," *The New Haven Register,* May 7, 1972; "The Choate Arts Center," *Choate Alumni Bulletin* (May 1970): 16–22; and "An Arts Center by I. M. Pei Designed To Be a Gateway and Campus Center linking Two Prep Schools," *Architectural Record* (January 1973): 113–118.

5. I. M. Pei, quoted by Andrea Oppenheimer Dean, "Refining a Familiar Vernacular," *Architecture* (September 1983): 43–48. See also *World Architects in Their Twenties: Renzo Piano, Jean Nouvel, Ricardo Legorretta, Frank O. Gehry, I. M. Pei, Dominique Perrault,* Ando Tadao Laboratory, Department of Architecture, Graduate School of Engineering, The University of Tokyo, originally published in Japan in 1999, Chinese translation (Garden City Publishing Ltd., 2003), 129–150.

6. I. M. Pei, in discussion with Janet Adams Strong, February 25, 1999. See also "Nervous Dance between a Blissful Dreamer and a Master of Control," *The New York Times* (February 17, 1999): 2.

Oversea Chinese Banking Corporation Centre (OCBC), Singapore, 1970–76
PAGES 152–55

1. I. M. Pei, in discussion with Janet Adams Strong, New York, December 17, 1998.

2. Chung Khaiw Bank's long-span pentagonal tower was designed for a five-sided site by Pei working closely with Pershing Wong.

3. "OCBC Centre," *Building Materials & Equipment Southeast Asia* (September 1976): 28.

4. Ibid.: 31.

5. I. M. Pei, in discussion with Janet Adams Strong, October 18, 2007

6. I. M. Pei, in discussion with Janet Adams Strong, October 18, 2007. See "Steel and Concrete Ladder-frame Straddles Four-story-high Lobby," *Engineering News Record* (June 19, 1975): 57–58; "Bank Headquarters Symbolic of 'New' Singapore," *Architectural Record* (April 1980): 118–21; *Building Materials & Equipment Southeast Asia* (September 1976): 28–82; and "Aspects of Modern Architecture: A Detailed and Comprehensive Interview with I. M. Pei," *Development and Construction,* Singapore (September 10, 1976): 53–59.

7. "Henry Moore: 1938-Reclining Figure," eight-page dedication brochure (Oversea-Chinese Banking Centre: Singapore, 1985). See also "The Perfect Piece for the Plaza," *The Sunday Times,* Singapore (October 27, 1985).

Raffles City, Singapore, 1969–86
PAGES 156–59

1. I. M. Pei, in discussion with Janet Adams Strong, November 19, 1996.
2. I. M. Pei, in discussion with Janet Adams Strong, July 17, 2007. See also Teh Cheang Wan, Minister for National Development, "A New Supercity," *Asiaweek* (August 22, 1980): 21ff.; "Exclusive Interview with I. M. Pei," *Southeast Asia Building* (March–April 1975): 6–7 and *Southeast Asia Building* (February 1985, August 1986, January 1987 issues); "Aspects of Modern Architecture: A Detailed and Comprehensive Interview with I. M. Pei," *Development and Construction*, Singapore (September 10, 1976): 53–59.
3. In the nine-year lull between 1960 and 1969, a new generation had ascended. Singapore felt it no longer needed, nor wanted, outside help. Pei was contacted because it was believed the completed design could be easily and economically recycled, despite its significant recasting.
4. I. M. Pei, in discussion with Janet Adams Strong, December 17, 1998. Pei was reluctant to take on large-scale commercial developments after struggling for years to break free from his developer beginnings. "[But] we had very little work in the United States," Pei recalled, "so we had to go abroad. One wants not to do these big developments, yet we knew how to do them so well. We had the people and experience to analyze complex urban situations very quickly. And we needed the work. These projects were what kept our office alive. I just wish I could have used all that time and energy to do something more artistically satisfying."
5. I. M. Pei, in discussion with Janet Adams Strong, November 19, 1996.

Laura Spelman Rockefeller Halls, Princeton University, Princeton, New Jersey, 1971–73
PAGES 160–63

1. The study was undertaken by Pei's partner, Henry Cobb. The four-phase plan called for various social centers/dining halls, student and community housing, a new residential college, underground parking, a new infirmary, university store and retail, street realignment, and relocation of the railroad station. Interim reports to Trustee Committee on Grounds and Buildings (January 17, 1970). See also Michelle Neuman, "Building Educational Opportunity: The Impact of Coeducation on Architecture and Campus Planning at Princeton University" (January 10, 1995), http:etcweb.princeton.edu/CampusWWWW/Studentdocs/Coed.html. By 1969, Pei's office had extensive experience in campus development, Pei himself having

been appointed campus architect of Columbia University the previous year and having previously designed Tunghai University in Taiwan and New College in Sarasota.
1. Pei knew Laurance Rockefeller socially. A year after the completion of Spelman Halls, Laurance's grandfather, John D. Rockefeller, engaged Pei to design Asia House in New York (unexecuted). For Spelman Halls, see William Marlin, "Pei at Princeton," *Architectural Record* (January 1976): 123–30; Raymond P. Rhinehart, *The Campus Guide: Princeton University* (New York: Princeton Architectural Press, 1999).
3. I. M. Pei, in discussion with Janet Adams Strong, December 12, 2007. Pei would adopt a similar tree-saving fragmentation strategy at Fragrant Hill Hotel.
4. Precast concrete was ultimately chosen as the quickest and most economical construction method. A. Preston Moore (September 14, 1998) and Harold Fredenburgh (February 27, 2008).

Museum of Fine Arts, West Wing and Renovation, Boston, Massachusetts, 1977–81 (renovation 1977–86)
PAGES 164–67

1. Howard Johnson, in discussion with Janet Adams Strong, March 4, 1997.
2. Howard Johnson, op. cit. See also Thatcher Freund, "Art & Money" *New England Monthly* (October 1987): 49–57ff and Kay Larson, "At the Boston Museum of Fine Arts: A Giddy Program of Rebirth and Renewal," *ARTnews* (November 1979): 110–16.
3. Howard Johnson, op. cit. Pei's plan was more comprehensive, and costly, than anticipated by the underfinanced museum, Johnson explained. "It took some time [to raise $30 million,] but we did it."
4. I. M. Pei, handwritten notes for presentation to MFA trustees, undated, I. M. Pei Archives.
5. I. M. Pei, in discussion with Janet Adams Strong, December 12, 1996. See also Robert Taylor, "The MFA's West Wing: Bridge to the Future," *The Boston Globe Magazine* (December 20, 1981): 10ff; Donald Canty, "An Addition of Space, Light—and Life," *AIA Journal* (Mid-May 1982): 188–95; Ada Louise Huxtable, "Pei's Elegant Addition to Boston's Arts Museum," *The New York Times* (July 12, 1981): 23, 26; Franz Schulze, "A Temple of Cultural Democracy," *ARTnews* (November 1981): 132, 134; "The Talk of the Town" *The New Yorker* (August 24, 1981): 23–5; "Museums," *Architectural Record* (February 1982): 90–97.
6. The education center Pei hoped for was never built, and the West Wing's austere exterior wall "is still unfinished and that is why I hope

they will build here one day." I. M. Pei, in discussion with Janet Adams Strong, October 7, 2003.

IBM Office Building, Purchase, New York, 1977–84
PAGES 168–71

1. Michael Meaney, "Nestlé Arrives in Purchase," *Reporter-Dispatch*, White Plains, New York (November 2, 1979).
2. Carleton Knight III, "Geometric Plan in a Suburban Setting," *Architecture* (May 1986): 215.
3. The tower was to have been on the corner of 57th Street and Madison Avenue, where Edward Larabee Barnes ultimately built a replacement. In a splendid display of professional ethics, Barnes refused involvement until speaking with Pei. "I. M asked me to give him a week. One week later he called back and said, 'It's yours.'" Edward Larrabee Barnes, in discussion with Janet Adams Strong, January 23, 1996.
4. Art Hedge, in discussion with Janet Adams Strong, January 13, 1997. See Mary McAleer Vizard, "Marketing Opulent Waifs Abandoned by Austerity," *The New York Times*, January 23, 1994: 15.
5. I. M. Pei, in discussion with Janet Adams Strong, November 17, 2007.

Texas Commerce Tower, United Energy Plaza, Houston, Texas, 1978–82
PAGES 172–75

1. Quoted by Ann Holmes, "Innovative Designer Comes to Town," *Houston Chronicle*, undated article in clippings file [c. 1978], I. M. Pei Archives. See also "Texas Commerce Reaches for the Sky," *Corporate Design* (March–April 1983): 58–63.
2. William K. Stevens, "Houston's Face-Changing Building Boom May be Abating," *The New York Times* (July 23, 1978): 20.
3. "The 'Tower': Houston's Tallest Building," *Building Stone Magazine* (Jan–Feb. 1981): 26–28. Texas Tower was the tallest composite structure in the world. Concrete was pumped (rather than lifted) to record heights so that the top seventy-two floors of the tower were constructed in a mere eleven months. See "Pumped Concrete Lifts Highest Pour," *Concrete Products* (April 1982): 21–23; also Scott S. Pickard, "Ruptured Composite Tube Design for Houston's Texas Commerce Tower," *Concrete International* (July 1981): 13–19.
4. I. M. Pei, "Introduction," *Texas Commerce Tower at United Energy Plaza*, leasing brochure, n.d.
5. I. M. Pei, in discussion with Janet Adams Strong, November 17, 2007. Pei had originally chosen a different sculpture, but encountering construction problems, selected the more structurally stable *Personnage* from one of Miró's recent

catalogues. See Laura Coyle, William Jeffett, Joan Punyet Miró, *The Shape of Color: Joan Miró's Painted Sculpture* (London: Corcoran Gallery of Art, catalogue published in association with Scala Publishers, 2002), 53–57.
6. "Let People Come to Surface," *Houston Chronicle* (November 19, 1978): 31.

Wiesner Building, Center for Arts & Media Technology, Massachusetts Institute of Technology, Cambridge, Massachusetts, 1978–84
PAGES 176–79

1. The experiment was funded in part by MIT's "Percent for Art Program," together with the largest grant that had yet been awarded by the Art in Public Places Program of the National Endowment for the Arts. See Robert Campbell, "Pei in Harmony with a Trio of Artists," *Architecture* (February 1986): 39–43; Calvin Tomkins, "The Art World," *The New Yorker* (March 21, 1983): 92; Andrea Truppin, Northeast Revival Teamwork," *Interiors* (April 1986): 160–67; Douglas C. McGill, "Sculpture Goes Public," *The New York Times Magazine* (April 27, 1986): 42–45ff; Kay Wagenknecht-Harte, *Site + Sculpture: The Collaborative Design Process* (New York: Van Nostrand Reinhold, 1989), 9ff; Stewart Brand, *The Media Lab: Inventing the Future at MIT* (New York: Viking Press, 1987).
2. I. M. Pei, in discussion with Janet Adams Strong, July 19, 2007. Of his own explorations, Pei explained the Wiesner Building "is a conscious attempt on my part . . . to make a laboratory of volume and space in which exciting activities can take place. . . . there is one statement that I did make there, and that is the gate. . . . Without that portal—to the East Campus—that building wouldn't stand." "Arts interviews I. M. Pei '40," *The Tech* (March 5, 1985): 8.
3. I. M. Pei, quoted in "Interview: I. M. Pei & Partners," MIT Committee on the Visual Arts, *Artists and Architects Collaborate: Designing the Wiesner Building* (Cambridge, Mass.: MIT Press, 1986), 52. See also in same volume, "Art in Architecture" by Robert Campbell and Jeffrey Cruikshank.
4. Acknowledging his loyalty to MIT, Pei allowed "If [it] had been another institution, I don't think I would have done it." *Artists and Architects Collaborate: Designing the Wiesner Building*, 52.

Fragrant Hill Hotel, Beijing, China, 1979–82
PAGES 180–87

1. When television and newspaper reporters appeared at the Great Hall of the People, Pei realized that his host had planned the surprise press conference to broadcast sentiments shared quietly in academic and

other progressive circles. He explained philosophically: "It was easier for me to express such ideas, and then to wait and see what happened. If there was agreement, forces would join. And that is exactly what happened." I. M. Pei, in discussion with Janet Adams Strong, November 26, 1997.
2. Lise Friedman, "I. M. Pei, Architecture Rooted in Time," *Vis à Vis* (September 1987): 74. See also Carter Wiseman, *I. M. Pei: A Profile in American Architecture* (New York: Harry N. Abrams Publishers, 1990), chapter 9, 185–207; Michael Cannell, *I. M. Pei: Mandarin of Modernism* (New York: Carol Southern Books, 1995), chapter 12, 264–97; Thomas Hoving, "More than a Hotel," *Connoisseur* (February 1983): 68–81.
3. Autumnal red leaves in Xiangshan (Fragrant Hills) is one of the top sights in Beijing. The site was close to historic shrines and temples, the Ming tombs, the Summer Palace, and the Great Wall. Mao also encamped here on his march to Beijing. The fact that such privileged land could be secured "was nothing short of miraculous," said Pei. "It was occupied by a cheap 'hotel' with outdoor plumbing. Terrible! Nature was so beautiful and the man-made buildings were a disgrace. As soon as I saw those magnificent trees, I knew this was where I wanted to build." I. M. Pei, in discussion with Janet Adams Strong, February 27, 1996. Only the retaining walls were salvaged from the previous establishment. In the late 1970s government-encouraged foreign investors hastily planned some hundred thousand hotel rooms for an anticipated influx of tourism. Pei himself was approached by Hong Kong developers who, with Hyatt, wanted to build twenty-five thousand rooms, but rather than build standardized units across China, he determined to design a standard from which other buildings could draw. I. M. Pei, in discussion with Janet Adams Strong, November 26, 1997.
4. I. M. Pei, in discussion with Janet Adams Strong, November 26, 1997. Pei stated that there were only three types of Chinese architecture: palaces, temples, and houses. As houses comprised the only type with continued vitality, "where people live, rich and poor, it is here that one will find the so-called Chinese vernacular." See also Christopher Owen, "Exploring a New Vernacular," *Architecture*: 34–42; Paul Goldberger, "I. M. Pei Rediscovers China," *The New York Times Magazine* (January 23, 1983): 26ff; William Walton, "New Splendor for China," *House & Garden* (April 1983): 95–8ff; "A Conversation with I. M. Pei," *Building Journal* Hong Kong (June 1985): 47–51.
5. I. M. Pei, in a letter to Frederick S. Roth, January 8, 1946, I. M. Pei

Archives. See also "Museum for Chinese Art, Shanghai, China," *Progressive Architecture* (February 1948): 50–52. At MIT, Pei's thesis focused on standardized mobile bamboo structures "in strict accordance with traditional native usages and methods" for China's reconstruction. I. M. Pei, "Standardized Propagation Units for Wartime and Peacetime China," (June 1940), MIT Institute Archives.
6. The team investigated architecture of the Sung and T'ang dynasties, China's Golden Age and the Japanese architecture it influenced, and further afield but stylistically related, early Renaissance buildings by Filippo Brunelleschi, all similar in their elimination of color and distillation of wall and contrasting detail. "Since no one knew much about China in those days, we had to learn," said Pei. "We started not by studying Chinese architecture, but Chinese culture, history, learning customs and traditions, how people live. Architecture reflects the human condition and if you don't understand how people live, what their roots are, you can only offer technology. Life comes first, technology second." I. M. Pei, in discussion with Janet Adams Strong, October 21, 2001.
7. See also I. M. Pei: is Exploring the Chinese Way in Architecture," *China Reconstructs* (February 1983): 23ff.
8. The ancient water maze was historically the gathering place of poets who challenged each other to complete a verse before a cup of wine floated to the end of the meandering 165-foot-long (50 m) runnel. The use of plants, water, and rocks to microcosmically simulate the natural world was part of Pei's cultural heritage, intuitively understood as a youth but seriously studied at Fragrant Hill, aided by master gardener Professor Chen Congzhou. For centuries, Pei's family owned the Lion Grove in Suzhou, where as a boy he spent three summers playing hide and seek among the garden's famous rocks.
9. Pei had tried for nearly a year to secure the right type of rocks when he discussed his predicament over dinner one night and won the support of his host, one of the most important generals in the country. Although the Stone Forest is a protected national treasure, Pei was allowed to select some 230 tons (209,000 kg) of rocks, fallen around the perimeter from the craggy peaks and trained on flatbeds to Beijing. "The rocks are so beautiful," said Pei, "very sculptural, like natural works of Henry Moore." I. M. Pei, in discussion with Janet Adams Strong, October 21, 2001. See also Hoving, *op. cit.*: 77. For the importance of rocks and Pei's discussion of traditional rock farming see William Marlin, "The Sowing and Reaping

of Shape," *The Christian Science Monitor* (March 16, 1978): 32–3.
10. Goldberger, *op. cit.*: 32. Also I. M. Pei, in discussion with Janet Adams Strong, October 21, 2001.
11. "I. M. Pei on the Past and Future," *The Christian Science Monitor* (April 29, 1985). See also Tao Zongzheng, "Architect Seeks Chinese Style in Hotel Designing," *China Daily* (May 13, 1983): 5l. Ironically, the very "Chineseness" of Fragrant Hill has contributed to its demise, as the hotel has been mainly used by the municipal government for political patronage, Chinese guests finding it more comfortable than Beijing's new Western-style hotels. Pei has refused to return in an effort to prompt officials into action. "What happens next," he said, "is entirely up to the Chinese." Dale Keller, in discussion with Janet Adams Strong, November 8, 1996. For conditions at Fragrant Hill, see Orville Schell, "The New Open Door," *The New Yorker* (November 23, 1984): 88. I. M. Pei, in discussion with Janet Adams Strong, November 26, 1997.

Morton H. Meyerson Symphony Center, Dallas, Texas, 1981–89
PAGES 188–93

1. Committee chairman Stanley Marcus explained the committee's disappointment, "Because we felt Pei was right for the job. But we had to be stoical. If he didn't want it, we had to find somebody else." Stanley Marcus, in discussion with Janet Adams Strong, January 18, 1999. See also Laurie Shulman, *The Meyerson Symphony Center* (Denton, Texas: University of North Texas Press, 2000); Carter Wiseman, *I. M. Pei: A Profile in American Architecture* (New York: Harry N. Abrams Publishers, 1990), 267–86; Michael Cannell, *I. M. Pei: Mandarin of Modernism* (New York: Carol Southern Books, 1995), 352–60.
2. I. M. Pei, in discussion with Janet Adams Strong, November 18, 1998.
3. Leonard Stone, in discussion with Janet Adams Strong, March 9, 1999.
4. Stanley Marcus, *op. cit.*
5. Russell Johnson, in discussion with Janet Adams Strong, June 14, 1996. The acoustician explained his preliminary work: "We prepared a basic design that showed how many balconies there would be, how many seats in each balcony, how the balconies would be shaped, how the envelope of the room would be shaped, the size of the stage, the shape of the stage, where the chorus sits, where the organ is positioned. . . . We also work on things like the texture on the walls and ceilings. We call it micro-shaping. . . ."
6. Mary McDermott, in discussion with Janet Adams Strong, March 23, 1999.

7. Having visited the Musikvierensaal in Vienna where, Pei recalled, people enjoyed music in one of the world's greatest concert halls only to "squeeze into a tiny lobby during intermission and smoke like chimneys," he determined then that Meyerson's lobby would be different. For inspiration he looked to the Paris Opera, which was "so festive, with people gathering around the stairs under those great chandeliers, that it almost made you look forward to intermission!" Pei objected, however, to the mean treatment of inexpensive-ticketholders in Paris, where they had to climb dark, treacherous stairs to their uppermost seats, and managed to keep the same fine finishes in upper tiers reached by stairways and passages—"Getting to your seat is part of the fun." I. M. Pei, in discussion with Janet Adams Strong, January 2, 1997.
8. Pei used limestone for coherence in the Arts District but the stone was cut vertically from the quarry and then wire brushed to accentuate its natural texture, as in accelerated weathering.
9. I. M. Pei, in discussion with Janet Adams Strong, September 26, 1996.
10. None of the 211 glass panes are similar because the conoid is a section of a skewed cone (unlike an ice cream cone, which is symmetrical). Pei worked on the conoid with engineer Les Robertson, who suggested the need for additional support by drawing a diagonal across the drawing they were discussing. "I. M. instantly liked it," recalled Robertson, "and in seconds put together the whole design of the sloped 'racing stripes.' He turned a liability into an asset." Leslie Robertson, in discussion with Janet Adams Strong, March 28, 1996.
11. "In this," said Pei, "I remembered an important lesson from Everson Museum where. . . most people arrived straight from parking. Here the underground entrance is monumental, quite nice." I. M. Pei, in discussion Janet Adams Strong, September 26, 1996.
12. From the beginning Pei had envisioned sculptural terminations to the stairs but they were casualties of cost-cutting. It was only as the building neared completion that he convinced the committee of the lanterns' importance for creating the right ambience. With a $250,000 gift from Mary McDermott, Pei and his associate Chris Rand rushed to complete the lanterns (eleven in total) in time for the opening, traveling to Italy to ensure they could be done by the same husband and wife team who fabricated the onyx sconces in the concert hall. Influenced by the Paris Opera and also by Secessionist designs of Josef Hoffman, the lanterns continued a long tradition of sculptural

custom lighting in Pei's firm dating back to the multiglobe lanterns developed for Roosevelt Field (1951–56), which became somewhat of a signature of Pei's early projects.

13. Soundproofing was a critical concern since the concert hall is located in the flight path of busy Love Field. Its walls consist of a double envelope of 12-inch-thick (30 cm) concrete blocks filled solid with mortar, sound and light locks at every perforation, and by isolation of the concert hall from potentially noisy areaslike practice rooms and service spaces.

14. The grid starts off small at the bottom of the room where the spacings are quite tight and then expands up to the bottom of the reverberance chamber. From there, it continues upward as an open grill, providing the entire surface of the room with a sense of order. "A room like this is all about lighting," explained Charles Young." It's not a rational space in the sense that you would want to see everything equally so the only way to make it work is to dematerialize it. We used lighting and color and value to emphasize the parts you want to see and de-emphasize those you don't." Charles T. Young, in discussion Janet Adams Strong, November 12, 1996.

15. I. M. Pei, in discussion with Janet Adams Strong, January 2, 1997.

16. Ibid.

17. Hockney, Diebenkorn, Stella, and Kelly were all considered for a major piece over the grand stairs, but finally bold-color panels were commissioned for the east lobby from Ellsworth Kelly. Eduardo Chillida designed the 15-foot-high (4.5 m) stainless-steel sculpture *De Musica* as a counterpoint to the building.

18. I. M. Pei, in discussion with Janet Adams Strong, January 2, 1997.

Bank of China, Hong Kong, 1982–89
PAGES 194–201

1. Tsuyee Pei was manager of BOC's branch in Canton during China's civil war. Refusing the bank's assets to local warlords, he was forced to flee with his family under the cover of night, his two-year old son Ieoh Ming strapped to his amah's back as they ran for the boat to Hong Kong. There Tsuyee Pei re-established the bank under the protection of the British crown, before being promoted to BOC's leading office in Shanghai. Rising to prominence, he specialized in foreign exchange and was entrusted with converting China's outmoded monetary system to a silver standard (Tsuyee Pei's signature appeared on paper bank notes). The elder Pei's global contacts were to prove an important asset for his son. See Carter Wiseman, *I. M. Pei: A Profile*

in American Architecture (New York: Harry N. Abrams Publishers, 1990), chapter 12, 262ff; and Michael Cannell, *I. M. Pei: Mandarin of Modernism* (New York: Carol Southern Books, 1995), chapter 13, 327ff.

2. Tsuyee Pei had lost everything to the communists but now, elderly and ill, he no longer wished to settle old accounts and left the decision to Ieoh Ming. Notwithstanding the importance of the commission, the architect had serious reservations and deferred until later in the year when he was in Hong Kong for another project and met the chairman of BOC's branch office, a savvy western-educated man who convinced him to accept the job. The family affiliation with BOC extended to a third generation in 1994 when I. M. Pei worked with his sons Chien Chung and Li Chung Pei at Pei Partnership on a new head office for the Bank of China in Beijing.

3. I. M. Pei, in discussion with Janet Adams Strong, July 8, 1999. Pei's administrative partner, Eason Leonard, tried to have the fee adjusted beyond the standard rate of architects working on 10-story apartment buildings across the harbor in Kowloon, "but the client would not budge." After extended negotiations, an exasperated Leonard made a last ditch appeal to reason: "But you want something special!" To which the client replied, "Okay. Do something special, but do it for the standard fee." Eason Leonard, in discussion with Janet Adams Strong, November 5, 1996.

4. BOC paid as much for the 2-acre (0.8 hectare) site as they did for the building. That so large a property was even available in Central is explained by its formidable physical challenges and because of its blood-stained past as the site of a World War II police station where the Japanese had tortured Chinese prisoners. It was thought to have bad *feng shui*.

5. I. M. Pei, quoted by Fredrica A. Birmingham, "In Search of the Best of All Possible Worlds: I. M. Pei" *Museum Magazine* (May/June 1981) p. 65. Also I. M. Pei, in discussion with Janet Adams Strong, February 18, 1997. The knot of high-speed "flyovers" isolated the building on three sides while the steeply sloped fourth side pressed against an equally inaccessible municipal lot further up the hill. Pei, working closely with Bernard Rice and Kellogg Wong, convinced authorities of the mutual benefits of the new transverse road as it would open up the city's previously landlocked property while allowing the bank its own entrance. Negotiations took nine long months before there ever was a design since British civil servants, anticipating Hong Kong's return to China, were indisposed to complicated realignments.

See also "Bank of China Tower," *Building Journal* (June 1990): 52–60.

6. I. M. Pei, typescript of remarks at presentation in Hong Kong, undated, I. M. Pei Archives. L. C. Pei, who worked on the project from the start, recalled his father asking him to have the model shop hone four triangular shafts "without ever telling me what he really had in mind — very typical of my father. He likes people to discover on their own. We didn't sit down with paper or draw anything. It was simply a game of form, although I realized later that it was an idea he probably had been thinking about for some time. I trussed the sticks with a rubber band and wrapped tape around to represent the diagonal bracing that would later carry into the building." L. C. Pei, in discussion with Janet Adams Strong, January 17, 1997. See also William H. Jordy, "Bank of China Tower," *A+U* (June 1991): 42–97, 98–124.

7. I. M. Pei, in discussion with Janet Adams Strong, July 13, 1999 and October 13, 2007. Leslie Robertson explained that "I. M. has a very long attention span so it's possible to get into the soul of a building, which is much more difficult with most architects. . . . he thinks like an architect . . . [about] structure that can be seen and understood. In this case structure was fundamental because if we couldn't bring it in at a very low cost, the building wouldn't get built." Leslie A. Robertson, in discussion with Janet Adams Strong, March 20, 1996. The tower was built with great economy in building time and materials, twenty stories higher than HKSB for a quarter of the price. So little steel was used, in fact, that Pei often marveled that the building was used so extensively in steel advertisements. See *Nikkei Architecture* (December 26, 1988): 157–72. See also "Tower, like bamboo, reaches high simply," *Engineering News Record* (September 13, 1984): 10–11; Virginia Fairweather, "Record High-rise, Record Low Steel," *Civil Engineering* (August 1986): 42–45; Janice Tuchman and Robina Gibb, "Architect's Vision, Bank's Visibility," *Engineering News Record* (October 13, 1988): 36ff; Janice Tuchman, "Man of the Year: Leslie E. Robertson," *Engineering News Record* (February 23, 1989): 38–44; Peter Blake, "Scaling New Heights," *Architectural Record* (January 1991); Forrest Wilson, "Star of the East," *Blueprints* (Fall 1991): 5–6.

8. The original scheme expressed the Vierendeel trusses used for mechanical and code required "refuge floors" every thirteen stories. Removal of the horizontals allowed one to see rotated squares, or diamonds, rather than a stack of thirteen-story packages, each inscribed with

an X, while also removing all sense of scale for a more purely sculptural form. The felicitous diamond allusion helped, in part, to neutralize charges that the tower had bad *feng shui*. BOC officially discredited such superstition, although they privately harbored concerns. Pei was frequently criticized for not consulting a local geomancer. In defense he said, "All architects are to a certain degree *feng shui* experts. They have to be. *Feng* is literally wind and *shui* is water. I deal with this every time I site a building. Much of it is common sense. . . ." I. M. Pei, in discussion with Janet Adams Strong, February 18, 1997.

9. I. M. Pei, *op. cit.*, February 18, 1997. See also Kellogg Wong, "The Bank of China Tower — The Architect's Perspective," *Proceedings of the Fourth International Conference on Tall Buildings*, ed. Y. K. Cheung & P. K. K. Lee, Hong Kong & Shanghai (April/May 1988) p. 216–23. See also in the same proceedings "Structural Systems for the New Bank of China Building, Hong Kong (p. 85–90) and "Wind Engineering Study for the Bank of China" (p. 143–47).

10. Because of the sloped site, the two upper corner columns are shorter than the two corner columns at the bottom, likened by Pei to "a man with legs of different length. Impossible! To rationalize this I took the sloped site — the whole thing is rock — and carved into it to make my base." I. M. Pei, ibid.

11. I. M. Pei, typescript of a lecture presented at MIT in 1985, edited as "4 Themes in the Work of I. M. Pei," *MIT Tech* (May/June 1986). Pei elaborated in discussions with Janet Adams Strong, February 18, 1997 and October 13, 2007. BOC was the summation of Pei's integration of architecture and structure, yet it constituted a beginning not an end. Having developed a new typology with enormous potential for the future of tall buildings, he was eager to prove that its structural idea was generic. Pei's chance came in 1990 when he amplified the potential with two "kissing towers," united at a single point on the thirty-second floor, which were to have been emblematic of Bilbao, Spain, but which were never built, to Pei's great disappointment.

Choate Rosemary Hall Science Center, Wallingford, Connecticut, 1985–89
PAGES 202–05

1. Mellon, quoted in Jacob Brownowski, *The Visionary Eye* (Cambridge, Mass.: MIT Press, 1978). "Remarks by Paul Mellon" delivered by Thomas H. Beddell, *The Choate Rosemary Hall Magazine* (Winter 1990): 6. See also Amy Ash Nixon, "Pei Building Dedicated at Choate Rosemary," *Hartford Courant*, October 22, 1989, and Marc Wortman,

"Choate Center," *New Haven Register*, October 22, 1989: D1, 10.
2. "Remarks by I. M. Pei", Ibid: 8.
3. I. M. Pei, in discussion with Janet Adams Strong, 1999. "The bridge was important," continued Pei, "because there was no more land available; development had to be in that direction. . . . We ran into some problems building on marshland, but we found a way. I consider the science center a very good building." See also Michael J. Crosbie, "Bridging Science with Art," *Architecture* (February 1990): 51–54.

Creative Artists Agency, Beverly Hills, California, 1986–89
PAGES 206–09
1. Pei recalled: "The movies were so spirited in those days. Bing Crosby in his letter sweater . . . I especially loved Betty Grable." I. M. Pei, in discussion with Janet Adams Strong, December 6, 2007.
2. Michael Ovitz, in discussion with Janet Adams Strong, March 25, 2003. Mutual friend Arne Glimcher, owner of the Pace Gallery in New York, made the introduction, but Pei sidestepped the commission, citing over-extension. Ovitz, undeterred invited Pei to dinner at his house with Sidney Pollack, Barbra Streisand, Dustin Hoffman, and other CAA celebrities. "It was Hollywood central!" laughed Glimcher who flew out for the occasion. "I. M. left agreeing to do the building." Arne Glimcher, in discussion with Janet Adams Strong, March 26, 2003.
3. I. M. Pei, in discussion with Janet Adams Strong, December 17, 2007.
4. Michael Ovitz, *op. cit.* "Personally I think [CAA] is the best thing I. M. has ever done," Ovitz said. "He did the overall design and Sandi worked really hard with his father in making it work. I give Sandi a lot of credit."
5. Paul Goldberger, "Refined Modernism Makes a Splash in the Land of Glitz," *The New York Times* (December 17, 1989): 44. See also Carter Wiseman, "Mr. Pei Goes to Hollywood," *New York* (May 21, 1990): 73–4; Julie Goodman, "Instant Stardom: Creative Artists Agency by I. M. Pei," *DesignersWest* (January 1990): 56–59; John Sailer, "Prominent Stone on a Prominent Site," *Stone World* (February 1990): 38ff.
6. Leon Whiteson, "Pei Masterpiece: Too Elegant Here?" *Los Angeles Times* (October 22, 1989): K1, 19.
7. Among the newcomers were Pei's own partners, Henry Cobb and James Ingo Freed, who executed the tallest and the longest buildings in Los Angeles—respectively, First Interstate World Center and Los Angeles Convention Center Expansion—even as Pei completed one of his smallest.
8. Michael Ovitz, *op. cit.* See Peter J. Boyer, "Hollywood King Cashes Out,"

Vanity Fair (February 1991): 105ff. See also Connie Bruck, "Leap of Faith," *The New Yorker* (September 9, 1991): 38ff.

Rock and Roll Hall of Fame + Museum, Cleveland, Ohio, 1987–95
PAGES 210–15
1. In 1963 Pei and Zeckendorf prepared the Erieview Redevelopment Plan, which revitalized downtown Cleveland. See Encyclopeida of Clevelend History, http://ech.case.edu/ech.cgi/article.pl?d=LJM1.
2. The Rock and Roll Hall of Fame was conceived in 1983 by a group of music industry executives who formed a foundation for its construction and invited interested cities to compete for a site. Cleveland outbid the other contenders, including New York and Chicago. See Benjamin Forgey, "Just One Look is All It Took: The Rock and Roll Hall of Fame is an Instant Hit for I. M. Pei," *The Washington Post* (August 27, 1995): G1; Thomas Hine, "I. M. Pei's glass 'tent' enshrines rock's best," *The Philadelphia Inquirer* (August 27, 1995); Blair Kamin, "Rock 'n' roll shrine is here to stay," *Chicago Tribune* (August 27, 1995), sec. 13: 9–10; and Herbert Muschamp, "A Shrine to Rock Music with a Roll All Iits Own," *The New York Times* (September 3, 1995): 30.
3. I. M. Pei, in discussion with Janet Adams Strong, December 17, 2007.
4. Ibid.
5. The museum was originally designed for an elevated site near Terminal City, a working-docks setting akin to Merseyside Liverpool. Although Pei strongly preferred this site, prohibitive real estate costs led it to be set in North Coast Harbor.
6. I. M. Pei, *op. cit.*
7. Ibid.
8. I. M. Pei, *op. cit.* Pei came to the project through the Beatles (whom he liked), their contemporaries, and their predecessors.

Philip Jodidio
1983–2008: I. M. Pei and the Challenge of History
Pages 216–217
1. I. M. Pei, in discussion with Philip Jodidio, April 22, 2008.
2. Ibid.
3. I. M. Pei, in discussion with Philip Jodidio, November 4, 2006.
4. I. M. Pei, in discussion with Philip Jodidio, April 22, 2008.

Grand Louvre, Paris, France, Phase I: 1983–89, Phase II: 1989–93
PAGES 218–55
1. I. M. Pei, quoted in *Le Grand Louvre* (Paris: Hatier, 1989).
2. Philippe Auguste (1165–1223) was king of France from 1180 until his death.

3. The Second French Empire, or Second Empire, was the regime of Napoleon III, which spanned from 1852 to 1870, and during this period, the last nineteenth-century additions to the Louvre were made.
4. François Mitterrand, quoted in *Le Grand Louvre* (Paris: Hatier, 1989).
5. I. M. Pei, in discussion with Philip Jodidio, May 29, 2007.
6. François I of France (1494–1547) was crowned in 1515 in the cathedral at Reims and ruled until his death.
7. Catherine de Medici (1519–1589)—the daughter of Lorenzo II de Medici, duke of Urbino, and Madeleine de la Tour d'Auvergne, countess of Boulogne—was queen consort of King Henry II of France from 1547 to 1559.
8. For this proposal, see Louis-Ernest L'Heureux (1827–1898), *Projet de Monument à la Gloire de la Révolution Française*, 1889, watercolor, Musée d'Orsay.
9. Emile Biasini, *Grands Travaux, de l'Afrique au Louvre* (Paris: Editions Odile Jacob, 1995).
10. I. M. Pei, quoted in Robert Ivy, "At the twilight of his career, I. M. Pei shows few signs of slowing down," *Architectural Record* (June 2004). See http://archrecord.construction.com/people/interviews/archives/0406IMPei-1.asp (accessed October 10, 2007).
11. François Mitterrand, speech on the occasion of the inauguration of the Richelieu Wing of the Louvre, Elysée Palace, November 18, 1993. See www.psinfo.net/entretiens/mitterrand/richelieu.html.
12. Emile Biasini, *Grands Travaux, de l'Afrique au Louvre* (Paris: Editions Odile Jacob, 1995).
13. Ibid.
14. I. M. Pei, in discussion with Philip Jodidio, by telephone, November 20, 2007.
15. Sculptures by Guillaume Coustou the Elder (1677–1746) were commissioned by King Louis XIV in 1743 for the Abreuvoir at Marly, later placed at the entrance to the Champs-Elysées, and then moved to the Louvre for conservation reasons.
16. I. M. Pei, in discussion with Philip Jodidio, by telephone, November 20, 2007.
17. Jean Lebrat in "Le Louvre," a special issue of *Connaissance des Arts*, Paris, 1997.
18. I. M. Pei, quoted in Ivy, "At the twilight of his career, I. M. Pei shows few signs of slowing down," *Architectural Record* (June 2004).
19. Shiro Matsushima with Spiro Pollalis, "The Grand Louvre," Center for Design Informatics, Harvard University Graduate School of Design, Cambridge, MA, 2003. http://cdi.gsd.harvard.edu/ (site now discontinued).
20. François Mitterrand, interview on the occasion of the inauguration of the Grand Louvre Pyramid,

Antenne 2 (Fench national television), March 4, 1989.
21. "Transcript of the Ceremony and Roundtable Discussion in Honor of I. M. Pei Upon His Receipt of the 2003 Henry C. Turner Prize for Innovation in Construction Technology" (with Carolyn Brody, David Childs, Thomas Leppert, I. M. Pei, Leslie Robertson, Carter Wiseman, and Norbert Young on April 15, 2003), National Building Museum, Washington, D.C., April 15, 2003. See http://www.nbm.org/Events/transcripts.html (accessed October 10, 2007).
22. François Mitterrand, quoted in *Le Grand Louvre* (Paris: Hatier, 1989). It is worth noting that some have seen in the Pyramid a sign of Mitterand's Masonic allegiance, but no documents attest to any such source of inspiration.
23. "Transcript of the Ceremony and Roundtable Discussion in Honor of I. M. Pei Upon His Receipt of the 2003 Henry C. Turner Prize for Innovation in Construction Technology," National Building Museum, Washington, D.C., April 15, 2003.
24. I. M. Pei, Preface, *Le Grand Louvre* (Paris: Hatier, 1989).
25. I. M. Pei, in discussion with Philip Jodidio, by telephone, November 20, 2007.
26. "Transcript of the Ceremony and Roundtable Discussion in Honor of I. M. Pei Upon His Receipt of the 2003 Henry C. Turner Prize for Innovation in Construction Technology," National Building Museum, Washington, D.C., April 15, 2003.
27. François Mitterrand, speech on the occasion of the inauguration of the Richelieu Wing of the Louvre, Elysée Palace, November 18, 1993. See www.psinfo.net/entretiens/mitterrand/richelieu.html.
28. Marguerite Yourcenar was the pseudonym of French novelist Marguerite Cleenewerck de Crayencour (1903–1987). Her best-known novel was *Mémoires d'Hadrien* (translated as *Memoirs of Hadrian*), first published in 1951.
29. François Mitterrand, speech on the occasion of the inauguration of the Richelieu Wing of the Louvre, Elysée Palace, November 18, 1993. See www.psinfo.net/entretiens/mitterrand/richelieu.html.
30. I. M. Pei, in a note to Philip Jodidio, January 28, 2008. The Légion d'honneur or Ordre national de la Légion d'honneur is a French order established by Napoleon Bonaparte, then First Consul of the First Republic, on May 19, 1802. The Legion of Honor is the highest decoration in France and is divided into five degrees: Chevalier (Knight), Officier (Officer), Commandeur (Commander), Grand Officier (Grand Officer), and Grand-Croix (Grand Cross). It is highly unusual

for a person to be granted the title of Officer without first being a Knight—a distinction that made Mitterrand's gesture to Pei all the more significant.
31. François Mitterrand, interview on the occasion of the inauguration of the Grand Louvre Pyramid, Antenne 2 (French national television), March 4, 1989.
32. I. M. Pei, quoted in "Les propositions de Pei pour modifier 'son' Louvre," *Le Monde*, June 26, 2006.
33. I. M. Pei, in discussion with Philip Jodidio, by telephone, November 20, 2007.
34. I. M. Pei, quoted in "Les propositions de Pei pour modifier 'son' Louvre," *Le Monde*, June 26, 2006.
35. I. M. Pei, in discussion with Philip Jodidio, November 11, 2006.
36. I. M. Pei, in discussion with Philip Jodidio, by telephone, November 20, 2007.
37. "Les propositions de Pei pour modifier 'son' Louvre," *Le Monde*, June 26, 2006.
38. "Le Louvre voit encore plus grand," *Le Figaro*, February 8, 2008.
39. Emile Biasini, *Grands Travaux, de l'Afrique au Louvre* (Paris: Editions Odile Jacob, 1995).
40. Robert Hughes, *The Shock of the New* (New York: McGraw Hill, 1991).
41. I. M. Pei in discussion with Philip Jodidio, March 27, 2007.
42. Paul Goldberger was the architecture critic for the *New York Times* in 1989.
43. I. M. Pei, in discussion with Philip Jodidio, November 11, 2006.
44. I. M. Pei, in discussion with Philip Jodidio, November 11, 2006
45. I. M. Pei, quoted in Ivy, "At the twilight of his career, I. M. Pei shows few signs of slowing down," *Architectural Record* (June 2004).
46. François Mitterrand, "Preface," *Le Grand Louvre du Donjon à la Pyramide* (Paris: Hatier, 1989).

Four Seasons Hotel, New York, New York, 1989–93
PAGES 256–59
1. Pei Partnership, "The Four Seasons Hotel," courtesy of the Pei Partnership.
2. I. M. Pei, in discussion with the author, May 29, 2007.
3. Pei Partnership, "The Four Seasons Hotel," courtesy of the Pei Partnership.
4. Ibid.

"Joy of Angels" Bell Tower, Misono, Shigaraki, Shiga, Japan, 1993–97
PAGES 260–63
1. Shinji Shumeikai: *shinji* is divine love, *shumei* means supreme light, and *kai* is the Japanese word for organization. Shinji Shumeikai is devoted to divine love and supreme light. The faith considers beauty in art and nature as furthering peace

over conflict, and Mokichi Okada's goal was delivering the world from poverty, illness, and conflict.
2. See http://www.shumei.org/artandbeauty/misono_tour.html.
3. I. M. Pei, in discussion with Philip Jodidio, January 21, 1997.

Miho Museum, Misono, Shigaraki, Shiga, Japan, 1993–97
PAGES 264–77
1. I. M. Pei, in discussion with Philip Jodidio, January 21, 1997.
2. Ibid.
3. Ibid.
4. Tim Culbert, in "Miho Museum," a special issue of *Connaissance des Arts* (1997).
5. Ibid.
6. Ibid.
7. Ibid.
8. See http://www.iabse.ethz.ch/association/awards/ostrac/mihomu.php.
9. See http://www.iabse.ethz.ch/association/awards/ostrac/mihomu.php/.
10. Tao Yuan Ming, "Peach Blossom Spring," fourth century AD.
11. See http://www.shumei.org/artandbeauty/misono_tour.html.
12. Egyptian, probably early Dynasty 19, c. 1295–1213 BC. Silver, gold, lapis lazuli, rock crystal, and Egyptian blue; height, 41.9 cm, weight, 16.5 kg.
13. Tim Culbert, in "Miho Museum," a special issue of *Connaissance des Arts* (1997).

Bank of China, Head Office, Beijing, China, 1994–2001
PAGES 278–85
1. Frank J. Prial, "Tsuyee Pei, Banker in China for Years," *New York Times* (December 29, 1982).
2. I. M. Pei, in discussion with Philip Jodidio, May 29, 2007.
3. Pei Partnership, "Bank of China Head Office," courtesy of the Pei Partnership.
4. The Shilin (Stone Forest) covers an area of 115 square miles (300 sq km) southeast of Kunming, the provincial capital. It is a former seabed where ranges of limestone pillars and stalagmites rise abruptly out of the ground, whence its name.
5. I. M. Pei, in discussion with Philip Jodidio, November 3, 2002.

Musée d'Art Moderne Grand-Duc Jean (MUDAM), Luxembourg, 1995–2006
PAGES 286–95
1. I. M. Pei, in discussion with Philip Jodidio, June 24, 2006.
2. "MUDAM Luxembourg," opening press kit, July 2006.
3. I. M. Pei, in discussion with Philip Jodidio, France, June 24, 2006.
4. Ibid.
5. Ibid.
6. Ibid.
7. Ibid.

Deutsches Historisches Museum Zeughaus, Berlin, Germany, 1996–2003
PAGES 296–303
1. Frederick of Prussia (1657–1713) was of the Hohenzollern dynasty and was the elector of Brandenburg from 1688 to 1713 and the first king of Prussia from 1701 until his death.
2. Pei's extension to the German Historical Museum is located near the Neue Wache (New Watch house), the first building Karl Friedrich Schinkel built in Berlin (1816–18) and one of the main works of German classicism.
3. I. M. Pei, in discussion with Philip Jodidio, November 3, 2002.
4. I. M. Pei, in a note to Philip Jodidio, January 21, 2008.
5. The glass covering of the courtyard was developed with the Stuttgart engineering firm Schlaich, Bergermann, and Partner.
6. I. M. Pei, in a note to Philip Jodidio, January 21, 2008.
7. I. M. Pei, in discussion with Philip Jodidio, November 3, 2002.
8. Ibid.
9. "Berlin's new Meisterwerk," see http://www.expatica.com.

Oare Pavilion, Wiltshire, United Kingdom, 1999–2003
PAGES 304–09
1. I. M. Pei, in discussion with Philip Jodidio, November 3, 2002.
2. Ibid.
3. "Transcript of the Ceremony and Roundtable Discussion in Honor of I. M. Pei Upon His Receipt of the 2003 Henry C. Turner Prize for Innovation in Construction Technology" (with Carolyn Brody, David Childs, Thomas Leppert, I. M. Pei, Leslie Robertson, Carter Wiseman, and Norbert Young on April 15, 2003), National Building Museum, http://www.nbm.org/Events/transcripts.html (accessed October 10, 2007).
4. See http://www.timothymowl.co.uk/wiltshire.htm.
5. See http://www.georgiangroup.org.uk/docs/awards/winners.php?id=4:36:0:6.

Suzhou Museum, Suzhou, China, 2003–06
PAGES 310–25
1. The Humble Administrator's Garden (Zhuozheng Yuan) in Suzhou is one of four great Chinese gardens.
2. The Spring and Autumn Period was a period in Chinese history. It roughly corresponds to the first half of the Eastern Zhou Dynasty (from the second half of the eighth century BC to the first half of the fifth century BC). Its name comes from the Spring and Autumn Annals, a chronicle of the state of Lu between 722 BC and 481 BC, which tradition associates with Confucius.

3. I. M. Pei, in discussion with the author, November 4, 2006.
4. Wen Zhengming (1470–1559) was a leading Ming Dynasty painter, calligrapher, and scholar.
5. "UNESCO Advisory Board Evaluation" (UNESCO, 1997). See http://whc.unesco.org/en/list/813/documents.
6. "The classical gardens of Suzhou (extension)" (UNESCO, 1999). See http://whc.unesco.org/en/list/813/documents.
7. "Suzhou: Shaping an Ancient City for the New China," an EDAW/Pei Workshop (Washington: Spacemaker Press, 1998).
8. I. M. Pei, in discussion with Philip Jodidio, November 4, 2006.
9. I. M. Pei, in a note to Philip Jodidio, January 21, 2008.
10. Ibid.
11. I. M. Pei, in a note to Philip Jodidio, January 21, 2008.
12. The Yuan Dynasty, lasting officially from 1271 to 1368, followed the Song Dynasty and preceded the Ming Dynasty.
13. Mi Fu or Mi Fei (1051–1107) was a scholar, poet, calligrapher, and painter, and dominant figure in Chinese art.
14. I. M. Pei, in discussion with Philip Jodidio, November 4, 2006.
15. Bing Lin, Pei Partnership Architects, in an e-mail to the author, June 3, 2007. The Suzhou Museum communicated this information to I. M. Pei in a letter dated August 18, 2003.
16. The Museum of Islamic Art in Doha was originally scheduled to open before the Suzhou Museum, but was not inaugurated until March 2008.
17. Tessa Keswick, "Cultural Renaissance in China's Venice," *The Spectator* (November 11, 2006).

Museum of Islamic Art, Doha, Qatar, 2003–08
PAGES 318–41
1. I. M. Pei, in discussion with Philip Jodidio, March 23, 2006.
2. Ibid.
3. Ibid.
4. Ibid.
5. I. M. Pei, in discussion with Philip Jodidio, November 4, 2006.
6. Jean-Michel Wilmotte, in discussion with Philip Jodidio, December 15, 2006.
7. Ibid.
8. Sabiha Al-Khemir, in discussion with Philip Jodidio, June 20, 2007.
9. I. M. Pei, in a note to Philip Jodidio, January 28, 2008.

CATALOGUE RAISONNÉ
Compiled by Janet Adams Strong

I. M. Pei began his career as the in-house architect of developer William Zeckendorf in 1948. He began independent practice in 1960 when, in an effort to secure licensing credits denied to architects by the AIA for time spent in a developer's office, he reestablished the architectural division of Webb & Knapp as I. M. Pei & Associates. Pei thereby kept his seasoned core group intact. Hoping also to trade speculative low-cost housing projects for more creative institutional commissions, the move was precipitated by Zeckendorf's now perilously overextended empire and more immediately, by Pei's exclusion from the consortium of architects entrusted to design Lincoln Center. The firm became I. M. Pei & Partners in 1966, and Pei Cobb Freed & Partners in 1989 in recognition of Pei's long-term design partners Henry N. Cobb and the late James Ingo Freed. Pei retired from the firm in 1990 at age 73, after which he took on a series of small projects in Europe, Asia, and the Middle East—all executed with his close personal involvement—several in association with his sons Chien Chung Pei and Li Chung Pei at Pei Partnership Architects.

Included in this catalogue raisonné are executed and unexecuted projects in which Pei played a leading role or was principally responsible for design. Except for Place Ville Marie in Montreal (Henry Cobb, 1953–62), Pei was involved in virtually every project in the various incarnations of his firm until the approach of his retirement. He was instrumental in bringing projects into the office, interpreting client needs, and conceptualizing design; periodically throughout the design process; and always at the end. Pei's responsibilities in leading the firm did not allow his direct long-term involvement in every project and so at a point where he felt comfortable (usually after the basic concept was established) he would assign the project to others for development. Beginning in the mid-1960s, the design process became increasingly independent as Pei assigned his partners individual responsibility for new projects in order to handle the tremendous influx of work.

TORONTO CITY HALL COMPETITION
Toronto, Ontario, Canada
1958 (unbuilt)
Area: 13 acres (5.25 hectares)
Project team: I. M. Pei (DP)
and Araldo Cossutta (DA)

WASHINGTON PLAZA APARTMENTS — PHASE I, LOWER HILL
Pittsburgh, Pennsylvania
1958–64
Area: 543,210 sq ft (50,456 sq m)
Project team: I. M. Pei (DP) and
A. Preston Moore (PA)

CECIL AND IDA GREEN CENTER FOR EARTH SCIENCES
Massachusetts Institute of Technology
Cambridge, Massachusetts
1959–64
Area: 130,500 sq ft (12,124 sq m)
Project team: I. M. Pei (DP),
Araldo Cossutta (DA), Werner
Wandelmaier (PM), James Morris
(RA), and Michael Vissichelli (JC)
(pp. 64–65)

CHANCELLERY FOR UNITED STATES EMBASSY
Montevideo, Uruguay
1959–69
Area: 85,800 sq ft (7,971 sq m)
Project team: I. M. Pei (DP) and
Pershing Wong (PA); associate
architect (construction documents):
John LoPinto and Associates,
New York, New York

METROPOLITAN TOWER
Honolulu, Hawaii
1960 (unbuilt)
Area: 400,000 sq ft (37,161 sq m)
Project team: I. M. Pei (DP) and
Pershing Wong (DA)

EAST-WEST CENTER
University of Hawaii
Manoa, Hawaii
1960–63
Area: 225,500 sq ft (20,949 sq m)
Project team: I. M. Pei (DP),
Eason H. Leonard (AP), Araldo
Cossutta (DA), Pershing Wong
(DA), Leonard Jacobson (PM),
Dean McClure (P), Charles Sutton
(SA), Kyu Lee (SA), and Robert
Lym (SA); associate architects:
McAuliffe, Young & Associates,
Honolulu, Hawaii, and Park &
Associates, Inc., Honolulu, Hawaii
(pp. 68–71)

ERIEVIEW GENERAL NEIGHBORHOOD REDEVELOPMENT PLAN
Cleveland, Ohio
1960
Area: 168 acres (67.9 hectares)
Project team: I. M. Pei (PP) and
William Slayton (AP)

ERIEVIEW I URBAN RENEWAL PLAN
Cleveland, Ohio
1960
Area: 96 acres (38.8 hectares)
Project team: I. M. Pei (PP) and
William Slayton (AP)

UNIVERSITY PLAZA
New York University
New York, New York
1960–66
Area: 747,000 sq ft (69,399 sq m)
Project team: I. M. Pei (DP),
Eason H. Leonard (AP), James
Ingo Freed (DA), A. Preston
Moore (PM), Theodore Amberg
(FA), William Jakabek (JC), and
Paul Veeder (SA); artist: Pablo
Picasso; fabricator: Carl Nesjar;
donor: Mr. & Mrs. Allan D. Emil
(pp. 72–75)

NATIONAL AIRLINES TERMINAL
John F. Kennedy International
Airport
New York, New York
1960–70
Area: 352,000 sq ft (32,702 sq m)
Project team: I. M. Pei (DP),
Eason H. Leonard (AP), Leonard
Jacobson (PM), Kellogg Wong
(DA/competition only), Kenneth
D. B. Carruthers (DA), William
Jakabek (PA), Paul Veeder (FA),
and Fritz Sulzer (G)
(pp. 76–79)

GOVERNMENT CENTER (GNRP)
Boston, Massachusetts
1960–61
Area: 64 acres (26 hectares)
Project team: I. M. Pei (PP) and
Henry N. Cobb (P)

WEYBOSSET HILL URBAN RENEWAL PLAN
Providence, Rhode Island
1960–63
Area: 55 acres (22.3 hectares)
Project team: I. M. Pei (P) and
A. Preston Moore (P)

DOWNTOWN NORTH GENERAL NEIGHBORHOOD RENEWAL PLAN
Boston, Massachusetts
1961
Area: 400 acres (162 hectares)
Project team: I. M. Pei (PP) and
Henry N. Cobb (P)

SCHOOL OF JOURNALISM, S. I. NEWHOUSE COMMUNICATIONS CENTER
Syracuse University
Syracuse, New York
1961
Area: 70,000 sq ft (6,503 sq m)
Project team: I. M. Pei (DP),
Werner Wandelmaier (PM),
Pershing Wong (DA), and Kellogg
Wong (PA); associate architect:
King and King, Syracuse,
New York

CENTURY CITY APARTMENTS
Los Angeles, California
1961–65
Area: 738,300 sq ft (68,590 sq m)
Project team: I. M. Pei (DP),
Leonard Jacobson (PA), and
Kyu Lee (DA); associate architect:
Welton Becket and Associates,
Los Angeles, California

NATIONAL CENTER FOR ATMOSPHERIC RESEARCH
Boulder, Colorado
1961–67
Area: 243,000 sq ft (22,575 sq m)
Project team: I. M. Pei (DP),
James P. Morris (RA), Donald
Gorman (PA), Arvid Klein (PA),
Richards Mixon (DA), Francis
Wickham (SA), Lo-Yi Chan (SA),
and Robert Lym (I); landscape
architect: Dan Kiley, Charlotte,
Vermont
(pp. 80–85)

EVERSON MUSEUM
Syracuse, New York
1961–68
Area: 56,800 sq ft (5,276 sq m)
Project team: I. M. Pei (DP),
Kellogg Wong (PM/DA), William
Henderson (DA), and Reginald
Hough (C/RA); associate archi-
tects: Pederson, Hueber, Hares &
Glavin, Syracuse, New York, with
Murray Hueber and Robert
Majewski, Syracuse, New York
(pp. 86–91)

HAMEDINA/NORDIA
Tel Aviv, Israel
1961 (unbuilt)
Area: 1, 610,700 sq ft (149,639 sq m)
Project team: I. M. Pei (DP) and
Araldo Cossutta (DA)

BUSHNELL PLAZA
Hartford, Connecticut
1961
Area: 291,400 sq ft (27,072 sq m)
Project team: I. M. Pei (DP),
A. Preston Moore (PA), and
Vincent Ponte (P); associate
architect: Henry F. Ludorf,
Hartford, Connecticut

INTER-AMERICAN UNIVERSITY CHAPEL
Puerto Rico
1961 (unbuilt)
Area: 15,000 sq ft (1,394 sq m)
I. M. Pei (DP)

FEDERAL AVIATION ADMINISTRATION AIR TRAFFIC CONTROL TOWERS
Various locations
1962–65
Area: 3,500–17,000 sq ft
(325–1,579 sq m)
Project team: I. M. Pei (DP),
James Ingo Freed (DA), Michael
D. Flynn (cabs), Reginald Hough
(C), James Nash (SA), and John
Laskowski (SA)
(pp. 92–95)

HOFFMAN HALL
University of Southern California
Los Angeles, California
1963–67
Area: 88,000 sq ft (8,175 sq m)
Project team: I. M. Pei (DP) and
Leonard Jacobson (PA); associate
architect: Welton Becket and
Associates, Los Angeles, California

CLEO ROGERS MEMORIAL COUNTY LIBRARY
Columbus, Indiana
1963–71
Area: 52,500 sq ft (4,877 sq m)
Project team: I. M. Pei (DP),
Kenneth D. B. Carruthers (DA),
Robert H. Landsman (PA),
John Laskowski (FA), Fritz Sulzer
(SA/windows), and Robert Lym
(I); artist: Henry Moore
(pp. 96–99)

ALICO (WILMINGTON TOWER)
Wilmington, Delaware
1963–71
Area: 210,500 sq ft (19,446 sq m)
Project team: I. M. Pei (DP),
Araldo Cossutta (DA), Pershing
Wong (PA), Michael Vissichelli
(PM), James P. Morris (SA), and
Lien Chen (SA)
(pp. 100–103)

**CENTRAL BUSINESS DISTRICT
DEVELOPMENT PLAN**
Oklahoma City, Oklahoma
1963
Area: 500 acres (202 hectares)
Project team: I. M. Pei (P),
Eason H. Leonard (A), and August
Nakagawa (P)

NEW COLLEGE
Sarasota, Florida
1963–67
Area: 98,295 sq ft (9,132 sq m)
Project team: I. M. Pei (DP) and
Shelton Peed (PA)

**CAMILLE EDOUARD DREYFUS
CHEMISTRY BUILDING**
Massachusetts Institute of
Technology
Cambridge, Massachusetts
1964–70
Area: 137,700 sq ft (12,793 sq m)
Project team: I. M. Pei (DP),
Werner Wandelmaier (PM),
Pershing Wong (DA), Fritz
Sulzer (PA/CW), and Robert
Landsman (PA)
(pp. 64–67)

**AIA HEADQUARTERS
COMPETITION**
Washington, D.C.
1964 (unbuilt)
Project team: I. M. Pei (DP) and
Araldo Cossutta (DA)

**CHRISTIAN SCIENCE CENTER—
MASTER PLAN**
Boston, Massachusetts
1963–64
Area: 32 acres (13 hectares)
Project team: I. M. Pei (PP) and
Araldo Cossutta (P)

**JOHN FITZGERALD KENNEDY
LIBRARY**
Dorchester, Massachusetts
1964–79
Area: 113,000 sq ft (10,498 sq m)
Project team: I. M. Pei (DP),
Eason H. Leonard (AP), Werner
Wandelmaier (A), Theodore
J. Musho (DA), Robert Milburn
(PM), Harry Barone (RA), Lloyd
Ware (C/precast), Fritz Sulzer
(CW/space frame), and Richard
W. Smith (S); landscape architect:
Kiley, Tyndall, Walker, Charlotte,
Vermont
(pp. 104–109)

**CANADIAN IMPERIAL BANK
OF COMMERCE (CIBC)**
Commerce Court
Toronto, Ontario, Canada
1965–73
Area: 2,475,125 sq ft (229,947 sq m)
Project team: I. M. Pei (DP),
Eason H. Leonard (AP), Kenneth B.
Carruthers (DA), Bartholomew D.
Voorsanger (A), Abe Sheiden (Pr),
Ralph Heisel (DA), Fritz Sulzer
(CW), and Fred Fang (SA); inter-
iors: Victor Mahler, Robert Lym,
and Walter Patton; associate
architects: Page and Steele,
Architects, Toronto, Ontario,
Canada (owner's consultants);
structural engineering: Weiskopf
& Pickworth, New York, New York,
with C. D. Carruthers & Wallace
Consultants Ltd., Toronto, Ontario,
Canada (owner's consultants)
(pp. 110–13)

TANDY HOUSE MUSEUM
Fort Worth, Texas
1965–69
Area: 18,750 sq ft (1,742 sq m)
Project team: I. M. Pei (DP) and
Dale Booher (DA)

**POLAROID OFFICE AND
MANUFACTURING COMPLEX**
Waltham, Massachusetts
1965–70
Area: 365,000 sq ft (33,910 sq m)
Project team: I. M. Pei (DP) and
Ralph Heisel (DA)

WASHINGTON POST
Washington, D.C.
1965–69 (unbuilt)
Project team: I. M. Pei (P), Yann
Weymouth (DA), and James Ingo
Freed (DA)

**DES MOINES ART CENTER
ADDITION**
Des Moines, Iowa
1965–68
Area: 21,300 sq ft (1,979 sq m)
Project team: I. M. Pei (DP),
Richards Mixon (DA), Graeme
A. Whitelaw (PM), James
Morris (PA), Robert Lym (I),
and Reginald Hough (C)
(pp. 114–17)

DALLAS CITY HALL
Dallas, Texas
1966–77
Area: 771,104 sq ft (71,638 sq m)
Project team: I. M. Pei (DP),
Eason H. Leonard (AP), Theodore
J. Musho (DA), Theodore A.
Amberg (PA), George Woo
(Assoc. PA), Harry Barone (RA),
Tom K. Barone (Assoc. RA), Fritz
Sulzer (G), Dennis Egan (SA),
Walter Patton (I), and Marianne
Szanto (D); associate architect:
Harper and Kemp, Dallas, Texas;
landscape architect: Dan Kiley,
Charlotte, Vermont; artist:
Henry Moore
(pp. 118–23)

**POLAROID SITE SELECTION
STUDY**
Metropolitan Boston areas
1966
I. M. Pei (PP)

**KIRYAT SIR ISAAC WOLFSON
DEVELOPMENT PLAN**
Jerusalem, Israel
1966
Area: 8 acres (3.2 hectares)
Project team: I. M. Pei (DP) and
James Ingo Freed (DA)

**BEDFORD-STUYVESANT
SUPERBLOCK**
Brooklyn, New York
1966–69
Project team: I. M. Pei (DP),
Yann Weymouth (DA), August
Nakagawa (P), and Dean McClure
(P); landscape architect: Paul
Friedberg Associates, New York,
New York; transportation
consultants: Travers Associates,
Clifton, New Jersey
(pp. 124–27)

FLEISHMAN BUILDING, NCAR
Boulder, Colorado
1966–68
Area: 4,320 sq ft (401 sq m)
Project team: I. M. Pei (DP) and
Ralph Heisel (PA)

**HERBERT F. JOHNSON
MUSEUM**
Cornell University
Ithaca, New York
1968–73
Area: 60,000 sq ft (5,574 sq m)
Project team: I. M. Pei (DP),
John L. Sullivan III (DA), Floyd
G. Brezavar (PM), Robert H.
Landsman (PM/A), Fritz Sulzer
(G), and Reginald Hough (C);
landscape architect: Dan Kiley
and Partners, Charlotte, Vermont;
contractor/concrete: William C.
Pahl Construction Co., Syracuse,
New York
(pp. 128–31)

**ROBERT FRANCIS KENNEDY
GRAVE SITE, ARLINGTON
NATIONAL CEMETERY**
Arlington, Virginia
1968–71
Project team: I. M. Pei (DP) and
F. Thomas Schmitt (DA)

88 PINE STREET
New York, New York
1968–73
Area: 571,000 sq ft (5,574 sq m)
Project team: I. M. Pei (DP) and
James Ingo Freed (DA)

**NATIONAL GALLERY OF ART,
EAST BUILDING**
Washington, D.C.
1968–78
Area: 604,000 sq ft (56,113 sq m)
Project team: I. M. Pei (DP),
Eason H. Leonard (AP), Leonard
Jacobson (PA), Yann Weymouth
(DA), William Pederson (DA),
F. Thomas Schmitt (DA), Owen
J. Afthreth (Marble), William
Jakabek (JC), Michael D. Flynn
(Space Frame), Fritz Sulzer (G),
Richard Cutter (FA), Martin Daum,
Mark Forster, John Gewalt, Chien
Chung Pei , J. Woodson Rainey,
Clinton Sheer, Richard Smith,
Klaus Vogel, Carl Weinbroer,
and W. Stephen Wood; structural
engineers: Weiskopf & Pickworthy,
New York, New York; foundations:
Mueser, Rutledge, Johnston &
DeSimone, New York, New York;

owner's construction consultant: Morse/Diesel, Inc., New York, New York; Marble: Malcom Rice, Concord, New Hampshire; skylight/window wall: Antoine-Heitmann & Associates, Kirkwood, Missouri (pp. **132–47**)

PAUL MELLON CENTER FOR THE ARTS
The Choate School
Wallingford, Connecticut
1968–73
Area: 67,000 sq ft (6,225 sq m)
Project team: I. M. Pei (DP), Ralph Heisel (DA), John Scarlata (PM), Paul Veeder (PM), Murray Kalender (RA), and Robert Lym (I)
(pp. **148–51**)

COLUMBIA UNIVERSITY COMPREHENSIVE MASTER PLAN
New York, New York
1968–69
Area: 28 acres (11 hectares)
Project team: I. M. Pei (PP), Henry N. Cobb (P), August Nakagawa (P), and Allen Hogland (P)

CHUNG KHIAW BANK
Singapore
1969 (unbuilt)
Area: 420,000 sq ft (39,206 sq m)
Project team: I. M. Pei (DP) and Pershing Wong (DA)

RAFFLES INTERNATIONAL CENTER
Singapore
1969–72
Area: 160 acres (65 hectares)
Project team: I. M. Pei (DP), Eason H. Leonard (AP), August T. Nakagawa (P), Ralph Heisel (DA), and Kellogg Wong (PA)

POLAROID (KENDALL SQUARE)
Cambridge, Massachusetts
1969 (unbuilt)
Area: 250,000 sq ft (23,226 sq m)
Project team: I. M. Pei (DP) and Henry N. Cobb (P)

IBM OFFICE TOWER
New York, New York
1969 (unbuilt)
Area: 500,000 sq ft (46,450 sq m)
Project team: I. M. Pei (DP) and James Ingo Freed (DA)

TÊTE DE LA LA DÉFENSE
Paris, France
1970–71 (unbuilt)
Area: 3.5 acres (1.4 hectares)
I. M. Pei (DP): second scheme

OVERSEA-CHINESE BANKING CENTRE (OCBC)
Singapore
1970–76
Area: 929,000 sq ft (86,307 sq m)
Project team: I. M. Pei (DP), Eason H. Leonard (AP), Kellogg Wong (PA), Bernard P. Rice (SA), and Pershing Wong (SA); structural engineers: Ove Arup & Partners, Singapore, with Mueser, Rutledge, Wentworth & Johnson, New York, New York; artist: Henry Moore
(pp. **152–55**)

RAFFLES CITY
Singapore
1969–86
Area: 4,207,700 sq ft (390,908 sq m)
Project team: I. M. Pei (DP), Eason H. Leonard (AP), Ralph Heisel (DA), Kellogg Wong (PA), Michael Vissichelli (PM), Fritz Sulzer (CW), Harry Barone (FA), Craig Dumas (RA), Christopher Rand (SA), Craig Rhodes (SA), Peter Aaron (PA), William Cunningham (PA), Herbert August (SA), John Bencivenga (S), Robert Lym (I), Jean Pierre Mutin, Robert Hartwig, Dorothy Hill, Patrick O'Malley, David Williams, and Deborah Campbell; part of 1973 team: August T. Nakagawa (P), Bernard Rice (PA), John L. Sullivan III (DA), Paul Veeder (SA), Patrick Lestingi (SA), and Richard Smith (S); associate architects: Architects 61, Singapore; structural engineers: Weiskopf & Pickworth, New York, New York; mechanical/electrical engineers: Cosentini Associates, New York, New York
(pp. **156–59**)

LAURA SPELMAN ROCKEFELLER HALLS
Princeton University
Princeton, New Jersey
1971–73
Area: 66,500 sq ft (6,178 sq m)
Project team: I. M. Pei (DP), Harold Fredenburgh (DA), A. Preston Moore (PM), Andrzej Gorczynski (DA), and Patrick Lesting (SA)
(pp. **160–63**)

RALPH LANDAU CHEMICAL ENGINEERING BUILDING
Massachusetts Institute of Technology
Cambridge, Massachusetts
1972–76
Area: 131,000 sq ft (12,171 sq m)
Project team: I. M. Pei (DP), Werner Wandelmaier (PM), John L. Sullivan III (DA), and Robert Landsman (PA)
(pp. **64–67**)

UNIVERSITY VILLAGE, EXCELLENCE IN EDUCATION
Dallas, Texas
1973
Area: 945 acres (382 hectares)
I. M. Pei (PP)

LONG BEACH MUSEUM
Long Beach, California
1974–79 (unbuilt)
Area: 75,000 sq ft (6,968 sq m)
Project team: I. M. Pei (DP) and W. Steven Wood (DA)

ASIA HOUSE
New York, New York
1974 (unbuilt)
Area: 120,000 sq ft (11,150 sq m)
Project team: I. M. Pei (DP) and Pershing Wong (DA)

COLLYER QUAY/RAFFLES PLACE DEVELOPMENT STUDY
Singapore
1974
Area: 3 acres (1.2 hectares)
I. M. Pei (P)

KAPSAD HOUSING
Teheran, Iran
1975–78 (unbuilt)
Area: 36 acres (14.5 hectares)
Project team: I. M. Pei (DP), Eason H. Leonard (AP), James Ingo Freed (PA), and Araldo Cossutta (DA)

SINGAPORE RIVER DEVELOPMENT
Singapore
1975
Area: 40 acres (16 hectares)
Project team: I. M. Pei (DP), Theodore Musho (DA), Kellogg Wong (PA), Pershing Wong (SA), and August Nakagawa (P)

NATHAN ROAD CONCEPT
Singapore
1975
Area: 12 acres (5 hectares)
Project team: I. M. Pei (DP) and Pershing Wong (PA)

ORCHARD ROAD SITE PLAN
Singapore
1975
Area: 5 acres (2 hectares)
Project team: I. M. Pei (DP) and Pershing Wong (PA)

INDUSTRIAL CREDIT BANK
Teheran, Iran
1976 (unbuilt)
Area: 640,000 sq ft (59,458 sq m)
Project team: I. M. Pei (DP) and James Ingo Freed (DA)

AL SALAAM
Kuwait City, Kuwait
1976–79 (unbuilt)
Area: 28 acres (11 hectares)
Project team: I. M. Pei (DP) and Harold Fredenburgh (DA)

MUSEUM OF FINE ARTS, WEST WING
Boston, Massachusetts
1977–81 (renovation 1977–86)
Area: 366,700 sq ft (34,068 sq m)
Project team: I. M. Pei (DP), Leonard Jacobson (AP), William Jakabek (JC), Fritz Sulzer (Sk), Chien Chung Pei (DA), Richard Cutter (RA), Leonard Marsh (PA/renovations), and Paul Veeder
(pp. **164–67**)

IBM CORPORATE OFFICE BUILDING
Purchase, New York
1977–84
Area: 764,000 sq ft (70,978 sq m)
Project team: I. M. Pei (DP),
Eason H. Leonard (AP), Leonard
Jacobson (AP), John L. Sullivan
III (DA), Richard Diamond
(PM), Michael D. Flynn (CW/Sk),
Kyle Johnson (DA/PM), Reginald
Hough (C), Fritz Sulzer (H),
Winslow Kosior (SA/CW/Sk),
Jacqueline Thompson, and August
T. Nakagawa (P); interiors: John
L. Sullivan III, Walter Patton,
and Stephanie Mallis; landscape
architect: Hanna/Olin,
Philadelphia, Pennsylvania
(pp. 168–71)

AKZONA CORPORATE HEADQUARTERS
Asheville, North Carolina
1977–81
Area: 140,400 sq ft (13,044 sq m)
Project team: I. M. Pei (DP) and
Charles T. Young (DA)

SUNNING PLAZA
Hong Kong
1977–82
Area: 457,000 sq ft (42,457 sq m)
Project team: I. M. Pei (DP),
Bernard Rice (DA), Kellogg Wong
(PA), and Pershing Wong (SA)

TEXAS COMMERCE TOWER
United Energy Plaza
Houston, Texas
1978–82
Area: 2,005,000 sq ft (186,271 sq m)
Project team: I. M. Pei (DP),
Harold Fredenburgh (DA),
Werner Wandelmaier (AP),
Michael D. Flynn (CW),
and Andrej Gorczynski (DA);
architectural production: 3D/
International Architects,
Houston, Texas (owner's consul-
tants); structural engineers:
CBM Engineers Inc., Houston,
Texas; artists: Joan Miró and
Helena Hernmarck
(pp. 172–75)

MIT NORTHWEST AREA
Cambridge, Massachusetts
1978
Area: 155 acres (63 hectares)
I. M. Pei (PP)

WIESNER BUILDING, CENTER FOR ARTS & MEDIA TECHNOLOGY
Massachusetts Institute of
Technology
Cambridge, Massachusetts
1978–84
Area: 111,430 sq ft (10,352 sq m)
Project team: I. M. Pei (DP),
Leonard Jacobson (AP), Michael D.
Flynn (CW), Li Chung Pei (DA),
David Martin (PM), Tom Woo
(PM), and Scott Koniecko (SA)
(pp. 176–79)

TEXAS COMMERCE CENTER
Houston, Texas
1978–82
Area: 1,200,000 sq ft (111,484 sq m)
Project team: I. M. Pei (DP) and
Harold Fredenburgh (DA)

FRAGRANT HILL HOTEL
Beijing, China
1979–82
Area: 396,800 sq ft (36,864 sq m)
Project team: I. M. Pei (DP),
A. Preston Moore (PM), Kellogg
Wong (A/pre-construction),
Chien Chung Pei (DA), David
Martin (PA), Fred K. H. Fang
(SA), Tracy Turner (Gr), Calvin
Tsao, Karen Van Lengen, and
Wang Tian-Xi; interiors: Dale
Keller & Associates, Hong Kong
(pp. 180–87)

JACOB K. JAVITS CONVENTION CENTER
New York, New York
1979–86
Area: 1,688,900 sq ft (156,904 sq m)
Project team: I. M. Pei (P) and
James Ingo Freed (DP)

AUSTRAL LINEAS
Buenos Aires, Argentina
1980 (unbuilt)
Area: 75,000 sq ft (6,968 sq m)
Project team: I. M. Pei (DP) and
W. Steven Wood (DA)

EAST COVE DEVELOPMENT
New York, New York
1980–81
Area: 2,750,000 sq ft (255,483 sq m)

UNITED ENGINEERS/ ROBERTSON QUAY DEVELOPMENT CONCEPT
Singapore
1980
Area: 30 acres (12 hectares)
I. M. Pei (PP)

THE GATEWAY
Singapore
1981–90
Area: 1,479,000 sq ft (137,404 sq m)
Project team: I. M. Pei (DP),
Kellogg Wong (A), Pershing
Wong (DA), and Bernard Rice
(PM/design)

IMMOBILIARIA REFOTIB
Mexico City, Mexico
1981 (unbuilt)
Area: 920,000 sq ft (85,471 sq m)
Project team: I. M. Pei (DP) and
W. Steven Wood (DA)

MORTON H. MEYERSON SYMPHONY CENTER
Dallas, Texas
1981–89
Area: 485,000 sq ft (45,058 sq m)
Project team: I. M. Pei (DP),
Werner Wandelmaier (AP),
George H. Miller (AP), Charles
T. Young (DA/concert hall),
Theodore A. Amberg (RA),
Michael D. Flynn (CWP), Ralph
Heisel (DA), Ian Bader (Asst. DA),
Michael Vissichelli (PM), Perry
Chin (CW), Abby Suckle (I),
Tim Calligan, Kirk Conover,
Kyle Johnson, David Martin,
Chris Rand, Walter Van Green,
and Gordon Wallace; acoustics/
Artec consultants: Russell
Johnson (principal); structural:
Leslie E. Robertson Associates,
New York, New York; artists:
Eduardo Chillida and Ellsworth
Kelly
(pp. 188–93)

UNITED STATES EMBASSY LAND USE REQUIREMENTS PROPOSAL
Beijing, China
1981
Area: 23 acres (9.3 hectares)
I. M. Pei (PP)

BANK OF CHINA
Hong Kong
1982–89
Area: 1,400,000 sq ft (130,064 sq m)
Project team: I. M. Pei (DP),
Eason H. Leonard (AP), Michael
D. Flynn (CWP), Kellogg Wong
(A/L), Abe Sheiden (P), Bernard
Rice (DA), Robert Heintges (CW),
Li Chung Pei (DA), Calvin Tsao
(L), Senen Vina-de-Leon (Cores),
William Cunningham (JC), Tom
Woo (RA), Gianni Neri (CA),
Richard Gorman (S), David Litz
(RA), Pat O'Malley (RA), Jennifer
Adler, Paul Bennett, Quin-Cheng
Chen, Wellington Chen, Monica
Coe, Oreste Drapaca, Jaon Dineen,
Ali Gidfar, Christa Giesecke,
Dorothy Hills, Ching-Ling Huang,
Kazuaki Iwamoto, Willie Lesane,
David Ling, Stephanie Mallis,
Alexandra Naoum, Stephen
Norman, Hema Patel, Shimon
Piltzer, Massimo Piamonti, Rob
Rogers, Gary Schilling, Linda
Schwenk, Nancy Sun, Marianne
Szanto, Gerald Szeto, Raul Teran,
Jose Valdes, King Wong, Pershing
Wong, and John Yuan; associate
architect: Kung & Lee Associate
Architects, Hong Kong; structural
engineer: Leslie E. Robertson
Associates, New York, New York,
and Vallentine, Laurie, and Davies,
Hong Kong
(pp. 194–201)

IBM HEADQUARTERS ENTRANCE PAVILION
Armonk, New York
1982–85
Area: 8,900 sq ft (827 sq m)
I. M. Pei (DP) and Theodore J.
Musho (DA)

GRAND LOUVRE—PHASE I
Paris, France
1983–89
Area: 667,255 sq ft (61,990 sq m)
Project team: I. M. Pei (DP),
Leonard Jacobson (AP), Yann
Weymouth (DA), Chien Chung Pei,
(DA/A), Michael D. Flynn, (CWP
Pyramid), Yvonne Szeto (CW
Pyramid), Norman Jackson,
Arnaud Puvis de Chavannes (Pr),
Beatrice Lehman (CD), Ian Bader,
Masakazu Bokura, Andrezej
Gorczynski, Anna Mutin, Chris
Rand, and Stephen Rustow;
associate architect: Michel
Macary, Paris, France; Architectes
en Chef du Louvre: Georges
Duval and Guy Nicot; Pyramid
structure design consultant:
Nicolet Chartrand Knoll, Ltd,
Montreal, Canada; Pyramid
structure, construction phase:
Rice Francis Ritchie, Paris, France;
art: lead casting of Gianlorenzo
Bernini's *Louis XIV*
(pp. 218–55)

GUGGENHEIM PAVILION,
MOUNT SINAI MEDICAL
CENTER
New York, New York
1983–92
Area: 900,000 sq ft (83,613 sq m)
Project team: I. M. Pei (DP) and
Chien Chung Pei (DA)

CHOATE ROSEMARY HALL
SCIENCE CENTER
Wallingford, Connecticut
1985–89
Area: 47,000 sq ft (4,366 sq m)
Project team: I. M. Pei (DP),
George H. Miller (AP), Ian Bader
(DA), Robert Madey (PA), Fritz
Sulzer (CW), Robert Rogers,
Jennifer Sage, Ching-Ling Huang,
Deborah Campbell, and Abby
Suckle
(pp. 202–05)

CREATIVE ARTISTS AGENCY
Beverly Hills, California
1986–89
Area: 75,000 sq ft (6,967 sq m)
Project team: I. M. Pei (DP), Li
Chung Pei (DA), Michael Flynn
(CWP), Michael Vissichelli (Pr),
Vincent Polsinelli (PM), Perry
Chin (CW), Gerald Szeto,
Rossana Gutierrez, Kazuaki
Iwamoto, Abby Suckle (I);
executive architect: Langdon
Wilson Architects Planners,
Los Angeles, California; artists:
Joel Shapiro and Roy Lichtenstein
(pp. 206–209)

ROCK & ROLL HALL OF FAME
+ MUSEUM
Cleveland, Ohio
1987–95
Area: 143,000 sq ft (13,285 sq m)
Project team: I. M. Pei (DP),
Leonard Jacobson (AP), Michael
D. Flynn (AP/T), Richard
Diamond (A), Jennifer Sage (DA),
Winslow Kosior (CW), Richard
Gorman (S), Marianne Lau, Hope
Dana, Steven Derasmo, David
Dwight, Mahasti Fakourbayat,
Kevin Johns, Sandra Lutes,
Christine Mahoney, Gianni Neri,
and Krista Williams; project
team (1987–90): I. M. Pei (DP),
Leonard Jacobson (AP), Michael
D. Flynn (AP/T), Charles T.
Young (DA), Andrzej Gorczynski
(DA), Craig Rhodes, Chris Rand,
Jean Christophe DuBois, and
Sophia Gruzdys; exhibition
designers: The Burdick Group,
San Francisco, California; structural
engineers: Leslie E. Robertson
Associates, New York, New York
(pp. 210–15)

"JOY OF ANGELS" BELL
TOWER
Shiga, Japan
1988–90
Project team: I. M. Pei (DP)
and Chris Rand (DA); structural
consultant: Prof. Yoshikatsu
Tsuboi, Nihon Architects,
Engineers & Consultants, Tokyo;
general contractor: Shimizu
Corporation, Tokyo, Japan and
Royal Eijabouts Bell Founders,
the Netherlands
(pp. 260–63)

THE KIRKLIN CLINIC,
UNIVERSITY OF ALABAMA
HEALTH SERVICES
FOUNDATION
Birmingham, Alabama
1988–92
Area: 750,000 sq ft (69,677 sq m)
Project team: I. M. Pei (DP) and
Chien Chung Pei (PA)

FOUR SEASONS HOTEL
New York, New York
1989–93
Area: 532,000 sq ft (49,424 sq m)
Project team: I. M. Pei (DP),
Eason H. Leonard (AP), Leonard
Jacobson (AP), Michael D.
Flynn (TP), Kellogg Wong (AP),
W. Steven Wood (DA), Peter
Aaron (PA), Bernard Rice (PM),
Fritz Sulzer (G), Li Chung Pei
(DA), Jennifer Adler (DA),
Young Bum Lee (PM), and Albert
Hennings; associate architect:
Frank Williams & Associates,
New York, New York; interiors:
Chhada Siembieda & Partners,
Long Beach, California, and
Betty Garber Design Consultant,
Beverly Hills, California
(pp. 256–59)

GRAND LOUVRE — PHASE II
Paris, France
1989–93
Area: 167,900 sq ft (15,598 sq m)
Project team: I. M. Pei (DP),
Leonard Jacobson (AP), Michael
D. Flynn (TP), Yann Weymouth
(DA), Stephen Rustow (DA),
Chien Chung Pei (PA), Andrezej
Gorczynski, Claude Lauter,
Valerie Boom, David Harmon,
Masakazu Bokura, Robert Crepet,
Madeline Fava, Marco Penenhoat,
Matthew Viderman, and Jean-
Christophe Virot; associate
architects: Agence Macary, Paris,
Agence Wilmotte, Paris, and
Agence Nicot, Paris; daylight
studies, painting galleries,
skylights, and courts: Ove Arup
International, London; skylights,
and galleries: RFR, Paris; lighting:
Claude R. Engle, Washington, D.C.
and Observatoire, Paris
(pp. 218–55)

BUCK INSTITUTE FOR
AGE RESEARCH
Marin County, California
1989–99
Area: 165,000 sq ft (15,329 sq m)
Project team: I. M. Pei (DP),
George H. Miller (AP), Li Chung
Pei (DA), Perry Chin (T), and
Harry Toung (DA); landscape
architect: Dan Kiley, Charlotte,
Vermont

BILBAO EMBLEMATIC
BUILDING
Bilbao, Spain
1990–92 (unbuilt)
Area: 1,308,000 sq ft (121,517 sq m)
Project team: I. M. Pei (DP), Chien
Chung Pei (DA), Li Chung Pei
(DA), and Bob Heintges (CW);
structural: Leslie E. Robertson
Associates, New York, New York

MIHO MUSEUM
Shiga, Japan
1991–97
Area: 198,000 sq ft (18,395 sq m)
Project team: I. M. Pei (DP), Tim
Culbert (DA), Perry Chin (T),
and Chris Rand (DA); associate
architect: Kibowkan International,
Tokyo, Osamu Sato, and Hiroyasu
Toyokawa, Japan; landscape
architects: Kohseki and Akenuki
Zoen, Noda Kenetsu; Structural
Engineers: Leslie E. Robertson
Associates, New York, New York;
structural engineers: Aoki
Structural Engineers, Tokyo,
Nakata & Associates, Tokyo,
Japan, and Whole Force Studio
(pp. 264–77)

SENTRA BDNI
Jakarta, Indonesia
1992–98 (unbuilt)
Area: 3,300,000 sq ft (306,580 sq m)
Project team: I. M. Pei (DP) in
association with Pei Partnership;
structural: Leslie E. Robertson
Associates, New York, New York

LA CAIXA
Barcelona (Sant Cugat), Spain
1993–1998 (unbuilt)
Area: 9,19,760 sq ft (85,449 sq m)
Project team: I. M. Pei (DP),
George H. Miller (AP), and Li
Chung Pei (PA)

BASIL & ELISE GOULANDRIS MUSEUM OF MODERN ART
Athens, Greece
1993–97 (unbuilt)
Area: 204,500 sq ft (19,000 sq m)
Project team: I. M. Pei (DP),
Peter Aaron (PA), and Andres
Petallas (SA)

BANK OF CHINA, HEAD OFFICE
Beijing, China
1994–2001
Area: 1,800,000 sq ft (167,225 sq m)
Project team: I. M. Pei Architect
with Pei Partnership Architects,
I. M. Pei, Chien Chung Pei,
Li Chung Pei, Ralph Heisel (DA),
Gerald Szeto (PM), Ping Mo (RA),
Michael Vissichelli (Pr); design
institute: China Academy of
Building Research, Beijing;
curtainwall & stonework
Consultant: P.Y. Chin, New
York, New York; interior design:
George C. T. Woo & Partners,
Dallas, Texas
(pp. 278–85)

MUSÉE D'ART MODERNE GRAND-DUC JEAN (MUDAM)
Kitchberg, Luxembourg
1995–2006
Area: 113,000 sq ft (10,498 sq m)
Project team: I. M. Pei (DP),
George H. Miller (AP), Michael
D. Flynn (TP), and Hitoshi
Maehara (PA); associate architect:
Georges Reuter Architectes s.a.r.l.,
Luxembourg and Christiane
Flasche (D/RA); project manager:
AT Osborne S.A., Luxembourg;
structural engineers: RFR, Paris,
France and Schroeder & Associés,
Luxembourg
(pp. 286–95)

REPUBLIC OF KOREA PERMANENT MISSION TO THE UNITED NATIONS
New York, New York
1995–99
Area: 79,000 sq ft (7,339 sq m)
Project team: I. M. Pei (DP),
George H. Miller (AP), Chris
Rand (DA), Young Bum Lee
(PM), and Winslow Kosior (CW)

DEUTSCHES HISTORISCHES MUSEUM ZEUGHAUS
Berlin, Germany
1996–2003
Area: 96,875 sq ft (9,000 sq m)
Project team: I. M. Pei (DP),
George H. Miller (AP), Brian
McNally (PM), Christiane Flasche
(D/PA/RA), Perry Chin (T),
Stefano Paci (SA), Kathy Ogawa
(SA), and William Collier (SA);
associate architect: Eller + Eller
Architekten, Berlin, Germany;
structural engineer: Kunkle &
Partner KG, Berlin, Germany and
Leslie E. Robertson Associates,
New York, New York
(pp. 296–303)

OARE PAVILION
Wiltshire, England
1999–2003
Area: 2,700 sq ft (251 sq m)
Project team: I. M. Pei (DP),
Perry Chin, (PA), Jennifer Adler
(D), and Hajime Tanimura (T);
associate architect: Digby Rowsell
Associates, Wiltshire, England;
interior designer: John Stefanidis
Ltd. Architecture & Design,
London, England
(pp. 304–309)

SUZHOU MUSEUM
Suzhou, China
2000–2006
Area: 162,000 sq ft (15,050 sq m)
Project team: I. M. Pei Architect
with Pei Partnership Architects,
I. M. Pei (DP), Chien Chung Pei
(AP), Gerald Szeto (PM), Bing
Lin (FA), Richard Lee (DA),
Kevin Ma (T), and Hajime
Tanimura (T); local design
institute: Suzhou Institute of
Architectural Design Co. Ltd.,
Suzhou; structural engineer:
Leslie E. Robertson Associates,
New York, New York; exterior
enclosure consultant: P. Y. Chin
Architect, New York, New York;
urban planning: T'ing Chung Pei,
AICP, New York; art: *Chun Qiu*
by Cai Guo-Qiang, *Background
Story III* by Xu Bing, *Range of
Stones* by I. M. Pei, inspired by
Mi Fu's *Spring Mountain and
Pine* (11th century)
(pp. 310–25)

MUSEUM OF ISLAMIC ART
Doha, Qatar
2000–2008
Area: 300,000 sq ft (27,871 sq m)
Project team: I. M. Pei (DP),
Perry Chin (PM), Hiroshi
Okamoto (DA/FA), and Toh
Tsum Lim (JC); interior/
exhibition gallery design: J. M.
Wilmotte, Architecte, Paris;
associate architect: Qatari
Engineer & Associates, Doha;
structural engineer: Leslie E.
Robertson Associates, New York,
New York; lighting consultant:
Fisher Marantz Stone, New York,
New York
(pp. 326–41)

EMBASSY OF THE PEOPLE'S REPUBLIC OF CHINA IN THE UNITED STATES OF AMERICA CHANCERY BUILDING
Washington, D.C.
2000–08
Area: 345,500 sq ft (32,098 sq m)
Project team: I. M. Pei Architect
with Pei Partnership Architects
(I. M. Pei, design consultant)

MACAO SCIENCE CENTER
Macao, China
2002–09
Area: 225,960 sq ft (20,992 sq m)
Project team: I. M. Pei Architect
with Pei Partnership Architects
(I. M. Pei, design consultant)

ACKNOWLEDGMENTS

I would like to thank I. M. Pei for his kindness, patience and generosity with his time and thoughts throughout the process of the preparation of this book, which, all told, took more than ten years. Here, more than is often the case, the architecture is a reflection of the man. Thanks also to Nancy Robinson who in many ways made this book possible.

—*Philip Jodidio*

I am indebted to I. M. Pei for his confidence and for the time and candid discussions he generously shared over the years, and also to Nancy Robinson and Shelley Ripley, Mr. Pei's unflagging assistants. I would like to thank Philip Jodidio for initially proposing this book, Charles Miers at Rizzoli for expanding its scope to include projects prior to the Louvre, McCall Associates for their responsive design, and my editors Dung Ngo and especially Meera Deean whose good advice and great skill helped shape my text. I am grateful to Pei Cobb Freed & Partners for supplying visual materials and more so for the opportunity to study this remarkable firm from the inside. Special thanks to Kellogg Wong whose generous and wise counsel has been invaluable. Thanks to Nancy Goeschel for her critical reading and insightful questions about key texts, and to Terry Hackford for her unerring advice throughout. James Balga of PCF&P and Nadja Leonard of Pei Partnership Architects also deserve special mention for their kind assistance.

For help on individual projects I am especially grateful to archivist Diane Rabson at the National Center for Atmospheric Research and also Edwin and Mary Andrews Wolff, who kindly shared their recollections; architect Jou Min Lin and the faculty of the department of architecture at Tunghai University for making possible my visit to Luce Chapel, and the archives of the United Board for Christian Higher Education in Asia, Yale Divinity School Library; Kimberly Shilland, curator of architectural collections at the MIT Museum; Phyllis Tabusa, research information specialist, East-West Center at the University of Hawaii, Manoa, John

Fitzgerald Kennedy Theater director Marty Myers, and Clifford Young, associate architect on East-West Center; Najeeb Halaby, former administrator of the Federal Aviation Administration, and Phil Edwards, technical information specialist, National Air and Space Museum Branch Library, Smithsonian Institution Libraries; John Keach, director, Cleo Rogers Memorial County Library; Robert Wood, former president, University of Massachusetts, Boston, and John Stewart, director of education and the staff of the John Fitzgerald Kennedy Library; Laura Burkhalter, assistant curator, Des Moines Art Center; George Shrader, city manager, Dallas, Texas; Franklin Thomas, former president and CEO of the Bedford-Stuyvesant Restoration Corporation and landscape architect Paul Freidberg; J. Carter Brown, director, and Maygene Daniels, chief archivist, National Gallery of Art; Seymour St. John, headmaster, The Choate School; Howard Johnson, former president, and Ross Farrar, former director of operations, Museum of Fine Arts, Boston; Arthur J. Hedge, Jr., former president, real estate and construction division, IBM, and also Edward Larrabee Barnes; Elena Escolar Cunillé, department of conservation, Fundació Joan Miró; Leonard Stone, executive director, Dallas Symphony, Morton H. Meyerson, Stanley Marcus, Mary McDermott Cook, Russell Johnson of Artec; Michael Ovitz, former head of Creative Artists Agency, and Arnie Glimcher, director, Pace Gallery, New York. I am also indebted to friends and consultants of I. M. Pei, including William Zeckendorf, Jr., Nicolas Salgo, Les Robertson and Saw Teen, landscape architect Dan Kiley, traffic consultant Warren Travers, interior designer Dale Keller, Richard Savignano, and William L. Slayton. For their guidance in helping to understand the nuances of Pei's Chinese heritage I am indebted to his longtime friend Henry Tang, to Shixuan Yang, and to Liu Thai-ker, former employee and later head of the Housing Development Board and Urban Redevelopment Authority in Singapore.

I am pleased to acknowledge research conducted in cooperation with the Library of Congress and Avery Architectural Library at Columbia University, and at public libraries in Atlanta, Boston, Cleveland,

Columbus, Indiana, Dallas, Denver, Des Moines, Houston, Los Angeles, New York, Syracuse, Washington, D.C., and Wilmington. Special thanks to Fran Housten of Cranford Public Library for help in finalizing details.

For generous insights in interviews with firm members, past and present, it is my pleasure to thank Peter Aaron, Theodore A. Amberg, Ian Bader, Harry Barone, Leicia Black, Deborah Campbell, Kenneth D.B. Carruthers, Chen Chi-Kwan, Perry Chin, Henry N. Cobb, Araldo Cossutta, Richard Cutter, Richard Diamond, Craig Dumas, Dennis Egan, Fred K.H. Fang, Michael D. Flynn, Ulrich Franzen, Harold Fredenburgh, James Ingo Freed, Edward Friedman, Ralph Heisel, William Henderson, Reginald Hough, Joan Jacobson, Ira Kessler, Arvid Klein, Eason H. Leonard, Robert Lym, Leonard Marsh, Dean McClure, Robert Milburn, George H. Miller, Richards Mixon, A. Preston Moore, Theodore J. Musho, Dale Nagler, August Nakagawa, Don Page, T.J. Palmer, Chien Chung Pei, Li Chung Pei, Vincent Ponte, Chris Rand, Craig Rhodes, Marianne Szanto, F. Thomas Schmitt, William Pederson, J. Woodson Rainey, Jennifer Sage, Abe Sheiden, Richard W. Smith, John L. Sullivan III, Fritz Sulzer, Gerald Szeto, Calvin Tsao, Tracy Turner, Karen Van Lengen, Paul Veeder, Bartholomew Voorsanger, Werner Wandelmaier, Richard Weinstein, Pershing Wong, George Woo, Tom Woo, Yann Weymouth, and Charles T. Young.

Finally, I would like to thank friends and family members, particularly Bruce, Alex, and Bennett for their forbearance and support.

—*Janet Adams Strong*

Courtesy of Pei Cobb Freed & Partners: 17, 21, 22 (top & bottom), 24, 25 (left & right), 29 (top & bottom), 33 (top & bottom), 37 (left & right), 40, 41, 45, 46 (left & right), 49, 50, 52 (left & right), 54, 55, 56 (top left & top right & bottom), 57 (top & bottom), 58 (top & bottom), 59, 61, 65, 69, 73 (top), 74 (bottom), 78 (bottom), 83 (top, middle & bottom), 87 (top & bottom), 88 (top & bottom), 93 (top & bottom), 97 (bottom), 101 (top & bottom), 102 (bottom), 106 (left & right), 107 (left & right), 108 (middle & bottom), 111, 116 (bottom), 119, 120 (left & right), 122. 125 (top & bottom), 126 (bottom), 127, 129 (top & bottom), 134 (left & right), 135 (top), 137 (bottom), 146 (bottom), 149 (top & bottom), 153 (top), 154 (top left & bottom left), 157 (top & bottom), 159 (bottom), 162 (bottom left & right), 163 (bottom), 165 (left), 169 (bottom), 170 (bottom), 173 (top & bottom), 177 (top & bottom), 182 (right), 183, 190 (bottom), 192, 195, 196 (left & right), 198 (left & right), 203 (bottom), 204 (top & bottom), 207 (bottom), 208 (top), 211 (top & bottom), 213 (bottom left), 221, 222 (left & right), 223 (top & bottom), 224 (top & bottom), 226, 227 (top), 230, 233 (top & bottom), 239 (top & bottom), 240, 241, 243 (bottom), 248, 252, 258 (right), 261, 262, 265, 270 (top, bottom left & right), 280 (top right & bottom right), 288, 297 (bottom), 298 (top right & bottom left), 300 (right), 302 (bottom), 308–309, 311 (right). Photo by Gil Amiaga: 124, 126 (top). Gabriel Benzur: 26 (top, bottom right & bottom left), 27. © Luc Boegly/ARTEDIA: 242. © Dennis Brack: 118, 121 (top). Fons F. Català-Roca-Arxiu Fotogràfic AHCOAC: 174 (top right). © Eric Chenal / Agence Blitz for Mudam: Cover. © Peter Cook: 190 (top), 296, 300 (left), 301, 302 (top), 303. © Stéphane Couturier/ARTEDIA: 239 (right), 243 (top), 249. George Cserna / Courtesy of Avery Architectural and Fine Arts Library, Columbia University in the City of New York: 43, 48, 51, 62 (left), 63, 66 (right), 67, 72, 74, 75, 76 (top), 78, 92, 94 (left & right), 95, 100, 102, 127 (top), 162 (top left), 163 (top). Robert Damora: 23, 32, 34, 35 (top & bottom), 60, 91, 103. Ara Derderian/Courtesy of PCF&P: 77 (left & right). Lionel Freedman/Courtesy of PCF&P: 44, 47. Allen Freeman/Courtesy of PCF&P: 132. © Michael Freeman 2008: 315, 322–323, 325. © Owen Franken: 234, 236–237, 244 (left & right). Shuichi Fujita/Courtesy of PCF&P: 260, 263.

Andrew Garn: 258 (left). Eddie Hausner/The New York Times/Redux: 105 (top). Koji Horiuchi/Courtesy of PCF&P: 231, 232. Kiyohiko Higashide: 264, 267, 268, 269, 274 (left), 278, 279, 285, 287, 289, 290, 291, 292, 293 (top & bottom), 294–295. Timothy Hursley: 210, 212, 213 (top & bottom right), 214, 215, 266, 271, 272, 273, 274 (right), 275, 276–277. Werner Huthmacher, Berlin: 286, 297 (top), 298 (left), 299. Kerun Ip: 280 (left), 281, 282, 283, 284 (top & bottom), 310, 312, 313, 314, 316, 317, 319, 320, 321, 324. JFK Library, "Notes" (1) folder, William Walton Papers, Box 3, John F. Kennedy Presidential Library: 105 (bottom). © Balthazar Korab, Ltd: 96, 97, 98 (left & right), 99 (left & right), 110, 113. Shang Wei Kouo/Courtesy of PCF&P: 152, 155, 156, 158, 159 (top). Lois Lammerhuber: 229, 247, 254–255. © Robert C. Lautman: 123, 135 (bottom), 139, 145. Courtesy of The Library of Congress/Prints and Photographs Division: 41 (right). Frank Lerner/Courtesy of PCF&P: 64. Erich Lessing/Art Resource, NY: 220 (left). © Thorney Lieberman: 66 (left), 82, 104, 108, 109, 121 (bottom), 128, 130, 131 (top & bottom), 150 (left), 151, 160, 161, 175, 188, 259. Joseph Molitor/Courtesy of Avery Architectural and Fine Arts Library, Columbia University in the City of New York: 148, 150 (right). John Nicolais/Courtesy of PCF&P: 136 (top). John Nye/Courtesy of PCF&P: 197. Paul Stevenson Oles, FAIA/Courtesy of PCF&P: 225. Paul Stevenson Oles/Courtesy of National Gallery of Art: 138 (top left, top right & bottom). © Victor Z. Orlewicz: 53, 256. © Rondal Partridge: 80. Richard Payne, FAIA: 172, 174 (left & bottom right), 189, 191 (bottom). C. C. Pei/Courtesy of PCF&P: 181. Benoit Perrin: 228. Réunion des Musées Nationaux/Art Resource, NY: 220 (right). © Marc Riboud: 180, 182 (left), 184 (top; bottom right & left), 185, 186–187, 227 (lower right), 246 (left). Cervin Robinson: 73 (right). © (1981) Steve Rosenthal: 164, 165 (right), 166 (top & bottom), 167 (top & bottom). © (1985) Steve Rosenthal: 168, 169 (top), 170 (top right & left), 171, 176m 178 (top & bottom), 179. © (1989) Steve Rosenthal: 202, 203 (top), 204 (middle), 205. Samir N. Saddi, Arcade: 326, 340–341, back cover. Deidi von Schaewen: 218, 245. James L. Stanfield/National Geographic Image Collection: 251. Courtesy Ralph Steiner Estate: 30 (right). Morley Von Sternberg: 304, 305, 306, 307 (left & right),

327, 331, 332, 333, 334, 336, 339. Ezra Stoller © Esto. All rights reserved: 20, 28, 30 (left), 31, 36, 38 (left & right), 39, 84 (top & bottom), 85, 86, 89 (top & bottom), 90, 112 (left & right), 114, 115, 116 (top left & right), 117, 133, 136, 140–141, 142 (bottom left), 143, 144, 146 (top), 147. Wayne Thom Photography: 153 (bottom). 2008 © University Corporation for Atmospheric Research: 81. © Paul Warchol: 191 (top), 193, 194, 199, 200 (top & bottom), 201, 206, 207 (top), 208 (bottom), 209. Courtesy of Wilmotte & Associés S.A.: 328. Alfred Wolf: 219, 246 (right). Wurts Brothers Photography Collection/Courtesy National Building Museum: 62 (right). James Y. Young/Courtesy of PCF&P: 68, 70 (top & bottom), 71 (top & bottom).

First published in the United States of America in 2008 by
Rizzoli International Publications, Inc.
300 Park Avenue South
New York, NY 10010
www.rizzoliusa.com

ISBN-13: 978-0-8478-3145-6
LCCN: 2008925165

Editor: Dung Ngo
Copy editor: Meera Deean
Photo coordinator: Lee Cerre
Book and jacket design: Mark Nelson, McCall Associates
Production: Maria Pia Gramaglia & Kaija Markoe

Distributed to the U.S. trade by Random House, New York

Printed and bound in China

2008 2009 2010 2011 2012 / 10 9 8 7 6 5 4 3 2 1